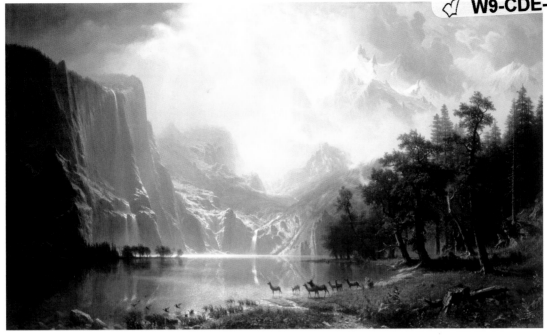

A WORLD OF ART

FOURTH EDITION

HENRY M. SAYRE

Oregon State University—Cascades Campus

Prentice
Hall

Upper Saddle River, New Jersey 07458

Library of Congress Cataloging-in-Publication Data
Sayre, Henry M., 1948–
 A world of art/Henry M. Sayre. — 4th ed.
 p. cm.
 Includes index.
 ISBN 0-13-047480-0
 1. Arts I. Title
 NX620.S28 2003
 709—dc21

 20022016995
 CIP

For my boys, Rob and John, and for Sandy

VP, Editorial Director: Charlyce Jones Owen
Publisher: Bud Therien
Director of Production and Manufacturing: Barbara Kittle
Production Editor: Harriet Tellem
Manufacturing Manager: Nick Sklitsis
Prepress and Manufacturing Buyer: Sherry Lewis
Editorial Assistant: Sasha Anderson
Marketing Manager: Chris Ruel
Copyeditor: Janet Masterson
Creative Design Director: Leslie Osher
Art Director: Ximena Tamvakopoulos
Interior and Cover Design: Ximena Tamvakopoulos
Director, Image Resource Center: Melinda Reo
Manager, Rights and Permissions: Zina Arabia
Image Permission Coordinator: Carolyn Gauntt
Photo Researcher: Francelle Carapetyan
Interior Image Specialist: Beth Boyd-Breuzel
Cover Image Specialist: Kim Marsden
Cover Image: *front cover* (detail), Albert Bierstadt (1830–1902), *Among The Sierra Nevada*
 Mountains, California, 1868. Oil on canvas, 71 × 120 inches (183 × 305 cm.). ©
 Smithsonian American Art Museum, Washington, D.C., U.S.A./Art Resource,
 New York. *back cover* (complete painting), Albert Bierstadt, *Among the Sierra Nevada*
 Mountains.

This book was set in 11/13 Sabon and was printed by RR Donnelley & Sons Company.
The cover was printed by Phoenix Color Corp.

© 2003, 2000, 1997, 1994 by Pearson Education
Upper Saddle River, New Jersey 07458

Printed in the United States of America
10 9 8 7 6 5 4 3 2 1

ISBN 0-13-047480-0

PEARSON EDUCATION LTD., *London*
PEARSON EDUCATION AUSTRALIA PTY. LIMITED, *Sydney*
PEARSON EDUCATION SINGAPORE, PTE. LTD.
PEARSON EDUCATION NORTH ASIA LTD., *Hong Kong*
PEARSON EDUCATION CANADA, LTD., *Toronto*
PEARSON EDUCACIÓN DE MEXICO, S.A. DE C.V.
PEARSON EDUCATION—JAPAN, *Tokyo*
PEARSON EDUCATION MALAYSIA, PTE. LTD.
PEARSON EDUCATION, UPPER SADDLE RIVER, *New Jersey*

CONTENTS

PART I

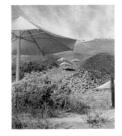

THE VISUAL WORLD
UNDERSTANDING THE
ART YOU SEE

PART II

**THE FORMAL ELEMENTS
AND THEIR DESIGN**
DESCRIBING
THE ART YOU SEE

Part III

THE FINE ARTS MEDIA
LEARNING HOW ART IS MADE

PART IV

**THE VISUAL ARTS IN
EVERYDAY LIFE**
RECOGNIZING
THE ART OF DESIGN

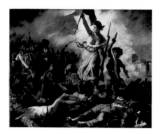

PREFACE

In the Preface to the last edition of this book, I said that it sometimes seemed to me that the whole world, let alone the world of art, had completely changed since I began working on the first edition of this book in the late 1980s. The Soviet Union was still a union in those days. We had no e-mail, no World Wide Web. Not a single textbook had been published with an accompanying CD-ROM. Only recently had work by women and ethnic minorities begun to find its place in the canon of art history, and the very idea of writing about "a world of art," instead of just the masterpieces of the Western canon, seemed daring, even radical.

Today, most of the innovations that drove the earlier editions of this book are part of the mainstream. Everybody has a Web page. A lot of texts come with CD-ROMs. And almost all art appreciation surveys incorporate the work of so-called "marginalized" voices to a greater degree than ever before. And yet, as I write these words in March 2002, I am sure that most teachers and students who pick up this new fourth edition of *A World of Art*, will probably feel that their world has been changed by the tragic events of 9/11 more than it ever was, or could have been, by the technological revolution of the preceding decade. We are, most of us, at least slightly different people than we were. Some of us are very different people. I remember sitting at my desk in the days after September 11, facing various deadlines for this edition, and not being sure that it mattered. But it was a lucky thing for me that I had this work to do. Because, reading over this text, I became more convinced than ever in the value of the enterprise—the value of thinking about things like representation, the imagination, and beauty. These are the things that give us hope, that allow us to rise above our basest instincts and foulest deeds. And we need desperately to engage them.

WORKS IN PROGRESS

Since the second edition, the major new feature of *A World of Art* has been the series of over thirty two-page spreads called *Works in Progress*, and the ten videos that accompany them. At the request of many instructors, we have added a new a video and a two-page spread on sculpture, specifically focusing on the carving process—so that now, there are eleven videos in the *World of Art* series. These were intended to give students insight into the process of artistic creation. Today, more than ever, these are crucial to what I hope this text begins to accomplish. These videos are meant to demonstrate that art, like most things, is the result of hard work and, especially, of a critical thinking process of questioning, exploration, trial and error, and discovery that I long to convey effectively and in a manner that students can generalize to their own experience—maybe even the experience of learning to cope with the implications of 9/11. As history has changed us, so too has it changed the videos, most dramatically the video on Mierle Ukeles's Fresh Kills Landfill project. The video was filmed, on Staten Island in New York harbor, on a day after a hurricane had cleared the skies and made the World Trade Center towers not just

visible but majestic, lit by bright sun and rising in the distance. Today, the Fresh Kills Landfill—Ukeles's land reclamation project—is the site where the refuse from the Trade Centers is being processed. But Ukele's vision remains relevant, as do the videos as a group. If you do not have access to it, the video series is available from PBS Adult Learning Services. For more information call 1-800-LEARNER (532-7637), or ask your Prentice Hall representative for more information.

THE CRITICAL PROCESS

At the end of each chapter of *A World of Art* is a revised feature designed to further the engagement with process already generated by the *Works in Progress* spreads. Called *The Critical Process*, each of these sections poses a number of questions based on the chapter material for students to think about on their own. Thus, we hope, students will be prompted to think critically and creatively on their own.

The questions raised in these *Critical Process* sections are by no means easy. Nor do they often lead to pat answers. But they should generate thought and provoke classroom discussion. Nevertheless, in order not to leave students completely on their own, at the back of the book are short paragraphs addressing each of the *Critical Process* sections. By comparing these responses to their own, students can test the quality of their own thinking.

THE COMPANION WEBSITE™

To further the student's sense of the process, we continue to offer a Prentice Hall Companion Website™. Authored by my colleague at Oregon State University, John Maul, the website features an Online Study Guide with a range of learning opportunities, a glossary, an audio pronunciation guide, and interactive timelines, as well as links to a variety of images and research tools. The Companion Website can be found at **www.prenhall.com/sayre**.

THE CD-ROM

A new interactive CD-ROM accompanies the text, and develops the idea of process even further. While we were very proud of the CD-ROM that accompanied the last two editions, technology has advanced to the point that we are able to expand, improve, and add to the material from before. The new CD-ROM features:

- **Video Demonstrations of studio processes** including sculpture, ceramics, printmaking, lost-wax casting, and oil painting.
- **Interactive Exercises** that allow students to experiment with basic elements and concepts of form, space, color, and design, and a "walking tour" of Florence Cathedral.
- **A Flashcard Feature including 100 fine art pieces from the history of art** provides students with an easy and accessible way to develop visual literacy.

OTHER ANCILLARY MATERIALS

Taken together, the text, the CD-ROM, the Website, and the *Works in Progress* video series offer the teacher and the student what we believe is the strongest teaching package available anywhere. But there are other important elements in our package as well.

Faculty Guide Created by website author John Maul and updated for the new edition by Art Appreciation instructors Patricia Carter and Julie McGuire of Georgia State University, the faculty guide included projects, lecture notes, and ways to integrate the teaching package into a coherent whole. The guide includes a Test Item File and background information about the CD-ROM and the artists featured in the *Works in Progress*.

Study Guide The study guide is directed particularly to distance learners, whose study plans are often self-directed and self-sustaining. It includes, for each chapter, a set of Learning Objectives, Key Concepts, an Overview of the chapter, a Viewing Guide to each video, and a CD-ROM study guide. In addition, each study lesson includes a summary of related material on the website, supplemental exercises, writing assignments, and additional projects for student enrichment.

Slides For this edition, a new set of 100 slides has been created, and is available from Prentice Hall. As well as providing the standard set of masterpieces, we included a wide variety of hard-to-find images and images pertaining to each of the video tapes. In combination with the 100 fine art images on the CD-ROM, this slide set should offer a range of images for teaching Art Appreciation. Ask your Prentice Hall representative for details.

ACKNOWLEDGMENTS

The video series *A World of Art: Works in Progress* and the CD-ROM were conceived in response to the demands of creating a distance education curriculum for the Annenberg/CPB Project, but both cannot help but improve teaching and learning in the standard classroom environment as well. The television series is a production of Oregon Public Broadcasting, in cooperation with Oregon State University. John Lindsay, of Oregon Public Broadcasting, and I have served as co-executive producers of the series. I closely supervised the writing, editing, and shooting of each segment, and I exercised complete control over the content of each episode. But I am not a filmmaker, and without the extraordinarily talented people at OPB, the resulting programs would have been considerably less distinguished. In addition to John Lindsay, at OPB I need to thank videographers Greg Bond and Steve Gossen, sound engineers, Merce Williams, Bill Dubey, and Gene Koon, editor Milt Ritter, and series producer Bobbi Rice. Our wonderful team of directors included Dave Bowden, Peggy Stern, John Booth, Marlo Bendau, and Sandy Brooke. Marlo especially did yeoman's service, and with the highest degree of skill.

The artists for the series were chosen in consultation with an advisory board, whose members have overseen the project at every level: David Antin, of the University of California, San Diego; Bruce Jenkins, of the Walker Art Center in Minneapolis; Lynn Hershman, of the University of

California, Davis; Suzanne Lacy, of the California College of Arts and Crafts; George Roeder, of the School of the Art Institute of Chicago; and John Weber, of the San Francisco Musuem of Modern Art. In addition, two members of the Annenberg/CPB staff have made major contributions, Hilda Moskowitz and Pete Neal. While I must accept responsibility for all of the weaknesses of what we have done, most of the strengths of the project are the result of these people's expert advice. I owe them more thanks than I can even begin to measure.

At Oregon State, I owe a special debt of gratitude to Jeff Hale, who helped guide this project through the beaucratic maze of the university and whose knowledge of grants and grant-writing got the project off the ground. Kay Schaffer, Dean of the College of Liberal Arts, fought for us and supported us. Bill Wilkins, her predecessor, has stood by this endeavor from the very first days. Two university presidents, John Byrne and Paul Risser, have honored the project by their interest, encouragement, and support. So too have my two chairs, David Hardesty and Jim Folts, both of whom have helped as much by being friends as anything else. Finally, in the first edition of this book, I thanked Berk Chappell for his example as a teacher. He still knows more about teaching art appreciation than I ever will.

A number of colleagues made valuable suggestions to this book, and I'd like to thank them for their contributions: Christie Nuell, Middle Tennessee State University; Dr. Eugene M. Hood, Jr., University of Wisconsin at Eau-Claire; William Squires, University of Georgia; Herbert R. Hartel, Jr., John Jay College CUNY; Frederick J. Zimmerman, SUNY at Cortland (retired); Mary Elizabeth Bilger, University of North Carolina at Charlotte; and Patricia Lechman, Shelby State Community College.

At Prentice Hall, Norwell "Bud" Therien remains the best publisher an author could want, and before moving on to a new assignment Wendy Yurash, his assistant, once again managed to get the best out of me. I owe them both my every thanks. Harriet Tellem has guided the book through production, and for her patience and cooperation, I am most grateful. I would also like to thank Kimberly Chastain and Deborah O'Connell for their extraordinary efforts revising and improving the CD-ROM for this edition.

Finally, I owe my greatest debt to my colleague and wife, Sandy Brooke. She directed the Milton Resnick video, served as project producer for the entire television series, and has lived every moment of this project with me. She is present everywhere in the videos and in these pages. It is safe to say she made all of this possible. For without her good counsel and better company, I wouldn't have had the will to get this all done, let alone found the pleasure I have had in doing it.

Henry M. Sayre
Oregon State University-Cascades Campus

A WORLD OF ART

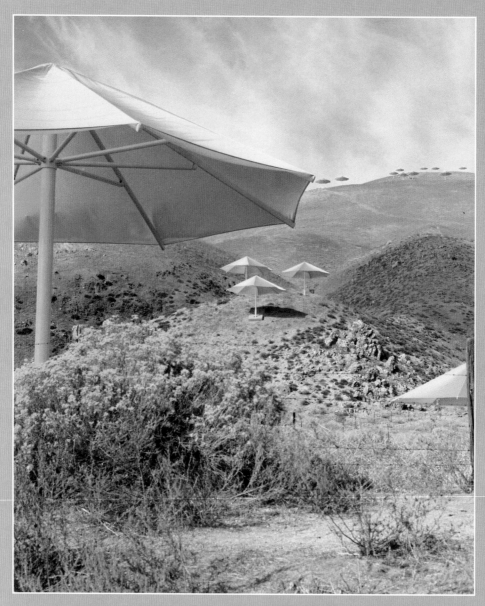

Fig. 1 Christo and Jeanne-Claude, *The Umbrellas, Japan–U.S.A.*, 1984–1991.
© 1991 Christo. Photograph by the author.

The Visual World

UNDERSTANDING THE ART YOU SEE

CHAPTER 1

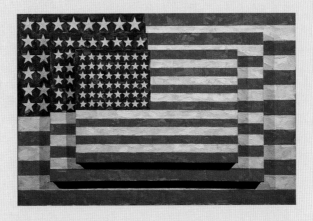

A WORLD OF ART

THE WORLD AS ARTISTS SEE IT
An American Vista
A Chinese Landscape
An Aboriginal "Dreaming"
A Contemporary Earthwork

WORKS IN PROGRESS
The Creative Process

THE WORLD AS WE PERCEIVE IT
The Physical Process of Seeing
The Psychological Process of Seeing

THE CRITICAL PROCESS
Thinking About Making and Seeing

Throughout the morning of October 9, 1991, along a stretch of interstate highway at Tejon Pass, north of downtown Los Angeles, 1,760 yellow umbrellas, each nineteen feet, eight inches in height, twenty-eight feet, five inches in diameter, and weighing 448 pounds, slowly opened across the parched gold hills and valleys of the Tehachapi Mountains (Fig. 1). Sixteen hours earlier—but that same morning, given the time change—1,340 blue umbrellas opened in the prefecture of Ibaraki, Japan, north of Tokyo, ninety of them in the valley's river (Fig. 2).

Built at a cost of $26 million, which the artists Christo and Jeanne-Claude raised entirely through the sale of their proprietary work, *The Umbrellas* symbolized for them

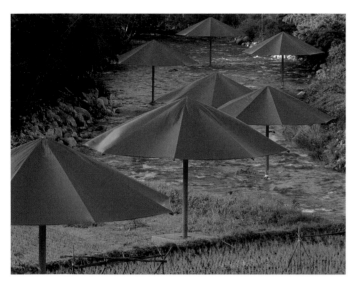

Fig. 2 Christo and Jeanne-Claude, *The Umbrellas, Japan–U.S.A.,* 1984–1991.
Ibaraki, Japan Site. © 1991 Christo. Photo: Wofgang Volz.

how vast and various the world of art has become. *The Umbrellas* changes with each shift in our point of view, with each change of light and weather. Their aspects—yellow or blue, seen from near or far, from above or below, surrounded by many others or isolated on a ridge—are virtually infinite. No single photograph of *The Umbrellas*, such as those reproduced here, can capture the many different experiences of it. To experience the work in California was to experience only half of it. In California *The Umbrellas* seemed to stretch to the horizon and beyond. Their yellow color echoed the dry grass on the hills, the aridity of the parched California landscape, which, in 1991, was deep in drought. In Japan, the blue umbrellas, identical but for their color to the yellow ones in California, had a completely different feel. In the fertile, green Japanese valley, with its small villages, farms, gardens, and fields, they appeared to grow out of the landscape itself, as if they were mushrooms or flowers. Placed closely together, they seemed almost intimate by comparison to those in California. They seemed to embody the precious and limited space of Japan itself. Blue on one side of the world and yellow on the other, the umbrellas symbolized crucial differences between the two cultures.

And yet, for all their differences, the umbrellas had a common meaning. In both cultures, the umbrella is an image of shelter and protection and is therefore a symbol of community life. The extraordinary amount of collaborative activity required to mount the project—the vast numbers of volunteer workers, the complex logistics of bringing everything together—itself underscored the communal meaning of the piece. The event became a sort of cultural umbrella, stretching across the Pacific Ocean to bring Japan and the United States together.

If the experience of *The Umbrellas* project was undoubtedly different for its Japanese and American viewers, both groups nevertheless asked themselves the same questions. What is the purpose of this work of art (and what is the purpose of art in general)? What does it mean? What are the artists' intentions? How did they do it? What do I think of it? Is it beautiful? Is it fascinating? What makes it beautiful or fascinating? Or do I consider it, as many did in the case of the Christos' work, an almost ridiculous waste of time, energy, and, above all, money? What do I value in works of art? Are there formal qualities about the work that I like—such as its color, or its organization, or its very size and scale? What does it mean not to be able to see it all at once? These are some of the questions that this book is designed to help you address. Appreciating art is never just a question of accepting visual stimuli, but of intelligently contemplating why and how works of art come to be made. By helping you understand the artist's creative process, we hope that your own critical ability, the process by which you create your own ideas, will be engaged as well.

THE WORLD AS ARTISTS SEE IT

The Umbrellas project demonstrates how the landscape is not only different in its appearance in two different parts of the world, but is appreciated and valued in different ways. Let us consider four different approaches to the landscape—works by a nineteenth-century American, a Chinese, an aboriginal Australian, and a twentieth-century American—in order to see how four different artists, from four very different times and places, respond to the same fundamental phenomenon, the world that surrounds them. But rather than emphasizing their differences, let's ask if they have anything in common.

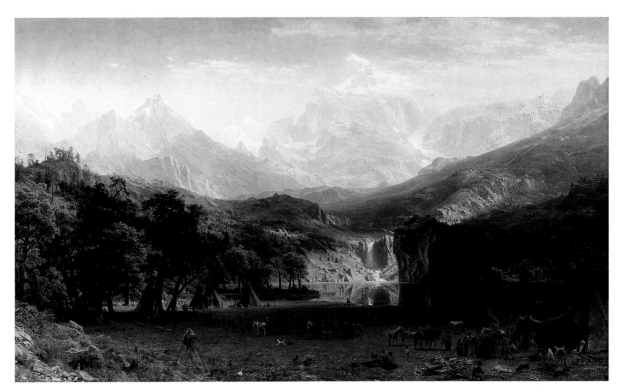

Fig. 3 Albert Bierstadt, *The Rocky Mountains, Lander's Peak*, 1863.
Oil on canvas, 73½ × 120¾ in. Signed and dated (lower right): ABierstadt/1863.
The Metropolitan Museum of Art, New York. Rogers Fund, 1907 (07.123). Photograph © 1979 The Metropolitan Museum of Art.

An American Vista

Albert Bierstadt's *The Rocky Mountains* (Fig. 3), painted in 1863, was one of the most popular paintings of its time. An enormous work, over six feet high and ten feet long, it captured, in the American imagination, the vastness and majesty of the then still largely unexplored West. Writing about the painting in his 1867 *Book of the Artists*, the critic H. T. Tuckerman described the painting in glowing terms: "Representing the sublime range which guards the remote West, its subject is eminently national; and the spirit in which it is executed is at once patient and comprehensive—patient in the careful reproduction of the tints and traits which make up and identify its local character, and comprehensive in the breadth, elevation, and grandeur of the composition." In its breadth and grandeur, the painting seemed to Tuckerman an image of the nation itself. If it was **sublime**—that is, if it captured an immensity so large that it could hardly be comprehended by the imagination—the same was true

of the United States as a whole. *The Rocky Mountains* was a truly democratic painting, vast enough to accommodate the aspirations of the nation.

But if it was truly democratic, it was not true to life. Despite Tuckerman's assertion that Bierstadt has captured the "tints and traits" of the scene, no landscape quite like this exists in the American West. Rather, Bierstadt has painted the Alps, and the painting's central peak is a barely disguised version of the Matterhorn. Trained as a painter in Europe, Bierstadt sees the landscape through European eyes. He is not interested in representing the Rockies accurately. Rather, it is as if he secretly longs for America to be Europe, and so he paints it that way.

Tuckerman assumes that Bierstadt's aim in painting this scene was to record it accurately. And, in fact, one of the traditional roles of the artist is *to record the world*, to make a visual record of the places, people, and events that surround them. To a certain degree—in his

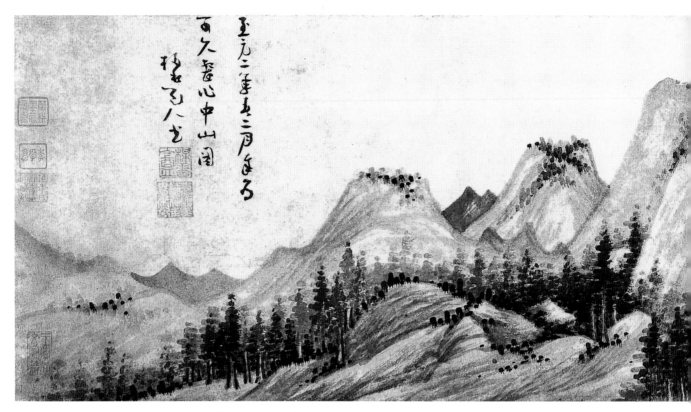

Fig. 4 Wu Chen, *The Central Mountain*, 1336.
Handscroll, ink on paper, 10 ⅙ × 35⅓ in. Collection of the National Palace Museum, Taipei, Taiwan, Republic of China.

accurate representation of Western flora and fauna, and in his equally accurate depiction of native dress and costume—Bierstadt accepts this role. But he also clearly wishes to accomplish something more. If the painting does not accurately reflect the American scene, it almost certainly reflects Bierstadt's own *feelings* about it. The Rockies, for him, are at least as sublime as the Alps. He wants us to share in his feeling.

A Chinese Landscape

A second traditional role of the artist, it follows, is *to give visible or tangible form to ideas, philosophies, or feelings*. Wu Chen's classic handscroll, *The Central Mountain* (Fig. 4), is a masterpiece of Chinese art. Composed according to strict artistic principles of unity and simplicity, it elevates the most bland, plain, and uninteresting view—the kind of scene the Chinese call *p'ing-tan*—to the highest levels of beauty, and reveals, in the process, profound truths about nature. In fact, if Wu Chen's deep

feelings and reverence for nature are evident in his handscroll, it is clear that he wants to reveal something more.

Wu Chen was one of the Four Great Masters of the Yuan Dynasty, the period of history dominated by Mongol rulers and lasting from 1279 until 1368, when Zhu Yuanzhang drove the Mongols back to the northern deserts and restored China to the Han people. Wu Chen worked in an intensely creative cultural atmosphere, dominated by gatherings of intellectuals organized for the appreciation and criticism of poetry, calligraphy, and painting, and for the appreciation of good wine. In addition, the culture was dominated by deep interest in both Buddhist and Taoist thought. Of the Four Masters, Wu Chen's tastes were perhaps the simplest and most devout. *The Central Mountain* embodies the teachings of the Tao.

In Chinese thought, the Tao is the source of life. It gives form to all things, and yet it is beyond description. It manifests itself in our world through the principle of complementarity

known as *yin* and *yang*. Representing unity within diversity, opposites organized in perfect harmony, the ancient symbol for this principle is the famous *yin* and *yang*:

Yin is nurturing and passive, and is represented by the earth in general and by the cool, moist valleys of the landscape in particular. *Yang* is generative and active. It is represented by the sun and the mountain.

In the natural world, the variety of visual experience obscures these principles, making it difficult to recognize them. The goal of the artist, therefore, must be to reveal the artist's feeling that the Tao is present in nature. In Wu Chen's handscroll only trees and mountains are depicted. The trees are simple dots of ink; the grassy slopes of the mountainsides are painted in a uniform flat, gray wash. There are no roads, houses, or people to distract us. The scene is without action, devoid of any movement or sense of change. The mountains roll across the scroll with a regular rhythm, as if measuring the serene breath of the spectator. The entire composition, composed of both mountains and sky, is symmetrically balanced around the central mountain. Heaven and earth, solid and void, fold into one, as if to reveal the absolute essence and universal presence of *yin* and *yang* lying at the heart of all our visual experience. In fact, *The Central Mountain*, the work of art, unites viewer and landscape in a greater harmony and whole.

An Aboriginal "Dreaming"

Wu Chen's painting suggests the third role of the artist: *to reveal hidden or universal truths.* Like Wu Chen, the Australian aboriginal artist Erna Motna wishes to reveal something larger than himself in his *Bushfire and Corroboree Dreaming* (Fig. 5). The organizing logic of most Aboriginal art is the so-called Dreaming, a system of belief unlike that of most other

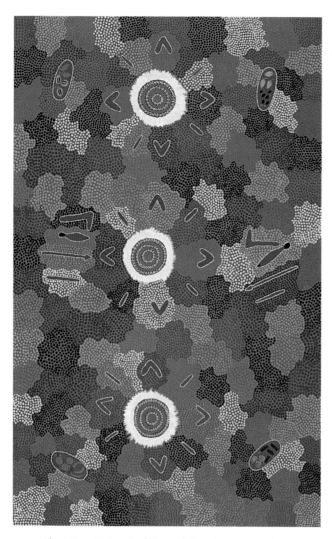

Fig. 5 Erna Motna, *Bushfire and Corroboree Dreaming*, 1988.
Acrylic on canvas, 48 × 32 in. Australia Gallery, New York.
Courtesy of the Australian Consulate General.

reveal the ancestor's being, both present and past, in the Australian landscape.

Ceremonial paintings on rocks, on the ground, and on people's bodies were made for centuries by the Aboriginal peoples of Central Australia's Western Desert region. Acrylic paintings, similar in form and content to these traditional works, began to be produced in the region in 1971. In that year, a young art teacher named Geoff Bardon arrived in Papunya, a settlement on the edge of the Western Desert organized by the government to provide health care, education, and housing for the Aboriginal peoples. Several of the older Aboriginal men became interested in Bardon's classes, and he encouraged them to paint in acrylic, using traditional motifs. By 1987, prices for works executed by well-known painters ranged from $2,000 to $15,000, though Western buyers clearly valued the works for their aesthetic appeal and not for their traditional meanings.

Each design still carries with it, however, its traditional ceremonial power and is actual proof of the identity of those involved in making it. Erna Motna's *Bushfire and Corroboree Dreaming* depicts the preparations for a *corroboree*, or celebration ceremony. The circular features at the top and bottom of the painting represent small bush fires that have been started by women. As small animals run from the fire (symbolized by the small red dots at the edge of each circle), they are caught by the women and hit with digging sticks, also visible around each fire, and then carried with fruit and vegetables to the central fire, the site of the *corroboree* itself. Other implements that will be used by the men to kill larger animals driven out of the bush by the fires are depicted as well—boomerangs, spears, clubs, and spear throwers.

Unlike most other forms of Aboriginal art, acrylic paintings are permanent and are not destroyed after serving the ceremonial purposes for which they were produced. In this sense, the paintings have tended to turn dynamic religious practice into static representations, and, even worse, into commodities. Conflicts have arisen over the potential revelation of secret ritual information contained in the paintings, and the star status bestowed upon certain painters, particularly younger

religions in the world. The Dreaming is not literally dreaming as we think of it. For the Aborigine, the Dreaming is the presence, or mark, of an Ancestral Being in the world. Images of these Beings—representations of the myths about them, maps of their travels, depictions of the places and landscapes they inhabited—make up the great bulk of Aboriginal art. To the Aboriginal people, the entire landscape is thought of as a series of marks made upon the earth by the Dreaming. Thus the landscape itself is a record of the Ancestral Being's passing. Geography is thus full of meaning and history. And painting is understood as a concise vocabulary of abstract marks conceived to

ones, has had destructive effects on traditional hierarchies within the community. On the other hand, these paintings have tended to revitalize and strengthen traditions that were, as late as the 1960s, thought doomed to extinction.

A Modern Earthwork

The abstract marks that make up Erna Motna's painting are not readily legible to us in the West. In fact, it is difficult for Westerners to view the painting in terms of landscape. Yet Robert Smithson's giant earthwork, *Spiral Jetty* (Fig. 6), is a large-scale mark very similar to Motna's. It exemplifies the fourth traditional role of the artist: *to help us see the world in a new or innovative way.* It is designed to transform our experience of the world, jar us out of our complacency, and create new ways for us to see and think about the world around us.

Stretching into the Great Salt Lake at a point near the Golden Spike monument, which marks the spot where the rails of the first transcontinental railroad were joined,

Spiral Jetty literally *is* landscape. Made of mud, salt crystals, rocks, and water, it is a record of the geological history of the place. But it is landscape that has been created by man. The spiral form makes this clear. The spiral is one of the most widespread of all ornamental and symbolic designs on earth. In Egyptian culture, the spiral designated the motion of cosmic forms and the relationship between unity and multiplicity, in a manner similar to the Chinese *yin* and *yang*. The spiral is, furthermore, found in three main natural forms: expanding like a nebula, contracting like a whirlpool, or ossified like a snail's shell. Smithson's work suggests the way in which these contradictory forces are simultaneously at work in the universe to reveal that hidden truth. Thus the *Jetty* gives form to the feelings of contradiction he felt as a contemporary inhabitant of his world. Motion and stasis, expansion and contraction, life and death, all are simultaneously suggested by the 1500-foot coil, the artist's creation extending into the Great Salt Lake, America's Dead Sea. It literally causes us to open our eyes to possibility.

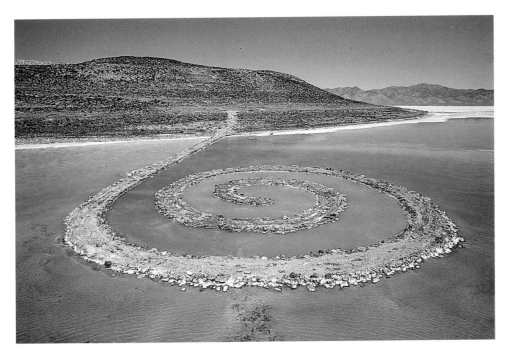

Fig. 6 Robert Smithson, *Spiral Jetty*, Great Salt Lake, Utah, April 1970.
Mud, precipitated salt crystals, rock, water; coil 1500 ft. long and 15 ft. wide.
Photo: Gianfranco Gorgoni. © Estate of Robert Smithson/Licensed by VAGA, New York, NY.

The Creative Process

To a greater or lesser degree, all four of the artists we have discussed assume all four of the traditional roles of the artist. To review, they record the world, give visible or tangible form to ideas, philosophies, or feelings, reveal hidden or universal truths, and help us see the world in new and innovative ways. But they share something even more basic as well. However diverse their backgrounds and their worlds, all four *create visual images*. All people are creative, but not all people possess the energy, ingenuity, and courage of conviction that are required to make art. In order to produce a work of art, the artist must be able to respond to the unexpected, the chance occurrences or results that are part of the creative process. In other words, the artist must be something of an explorer and inventor. The artist must always be open to new ways of seeing. The landscape painter John Constable spoke of this openness as "the art of seeing nature." This art of seeing leads to imagining, which leads in turn to making. Creativity is the sum of this process, from seeing to imagining to making.

For example, in discussing Albert Bierstadt's *The Rocky Mountains* (see Fig. 3), we claimed that his central mountain is more European than American, more a figment of his imagination than a reality. If we compare the final picture to an early oil sketch (Fig. 7), probably made in preparation for the much larger painting from sketches made on his trip west in 1859, we can see, in fact, that the mountain as it originally appeared to him was far less jagged, and though dramatic in its own right, far less dramatic than in its final realization. This tells us something important about Bierstadt's creative process. He evidently felt no compulsion to be "true" to the scene. He felt it his right, even his duty, to "elevate" the scene, to move his audience emotionally as much as possible. In 1859, Bierstadt had written to *The Crayon*, one of the leading art magazines of the day, describing his trip: "A lover of nature and Art could not wish for a better subject. I am delighted with the scenery. The mountains are very fine; as seen from the plains, they resemble very much the Bernese Alps, one of the finest ranges of mountains in Europe, if not

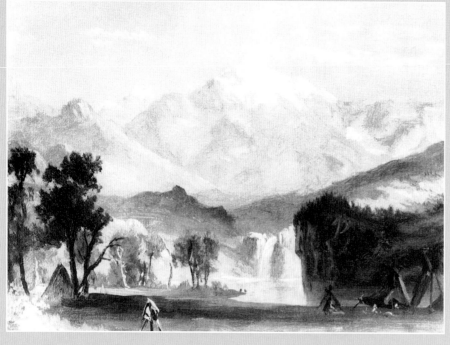

Fig. 7 Albert Bierstadt, Study for *The Rocky Mountains*, 1862?.
Oil on canvas, 7¼ × 10 in. Embassy of the Federal Republic of Germany.

the world. They are of granite formation, the same as the Swiss mountains and their jagged summits, covered with snow and mingling with the clouds, present a scene which every lover of landscape would gaze upon with unqualified delight." Evidently, Bierstadt painted *The Rocky Mountains* to match not the scene itself, but his description of it.

Robert Smithson's sketches for the *Spiral Jetty* (Fig. 8) seem to tell us something quite different. Smithson appears to be intent on exploring how the earthwork will appear from twenty different, mostly aerial, points of view. What are we to make of this? Smithson realized that the remoteness of the site precluded large numbers of people actually visiting it. The *Jetty* would exist, for most people, only in its photo-documentation, and he is anticipating that "photo-reality" in these drawings. These drawings, in other words, are about the *Jetty*'s reception. They reveal that Smithson is as interested in his audience as he is in the work itself.

But, in a manner comparable to Bierstadt's manipulation of his mighty peak, Smithson's drawings of the *Jetty* (and almost all the photographs we have of it, including the one reproduced in this book) literally "elevate" the scene. If you were to visit *Spiral Jetty* in person, it would seem far less spectacular, a pile of mud, salt, crystals, and rocks, jutting out into the water, and, at ground level, its spiral design would disappear. But from the air, it is, in Smithson's words, "abstract and illusive." It reveals itself to be, he would write, "but a dot in the vast infinity of universes, an imperceptible point in a cosmic immensity, a speck in an impenetrable nowhere—aerial art reflects to a

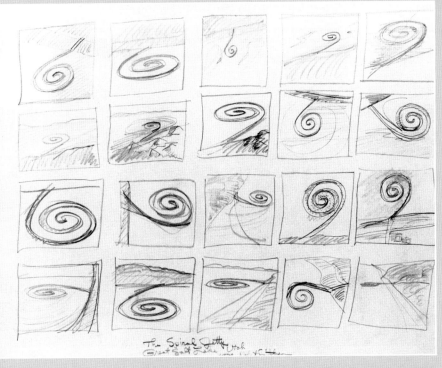

Fig. 8 Robert Smithson, *Spiral Jetty* (*Movie Treatment*), 1970 (20 panels).
Pencil on paper, 19 × 24 in. Collection of Virginia Dwan.
© Estate of Robert Smithson/Licensed by VAGA, New York, NY.

degree this vastness." Smithson's *Jetty*, in other words, participates in the same love of the **sublime** that Bierstadt celebrates in *The Rocky Mountains*, and the drawings help us understand how.

This book sets out to explore the creative process through examples such as these. Throughout the book, you will encounter "Works in Progress" spreads, such as this one, in which the creative process that generated a given work is explored in depth. But more than helping you to appreciate a given work of art, these examples are designed to help you understand the importance of thinking creatively for yourself. We hope you take from this book the knowledge that the kind of creative thinking engaged in by artists is fundamental to every discipline. This same path leads to discovery in science, breakthroughs in engineering, and new research in the social sciences. We can all learn from studying the creative process itself.

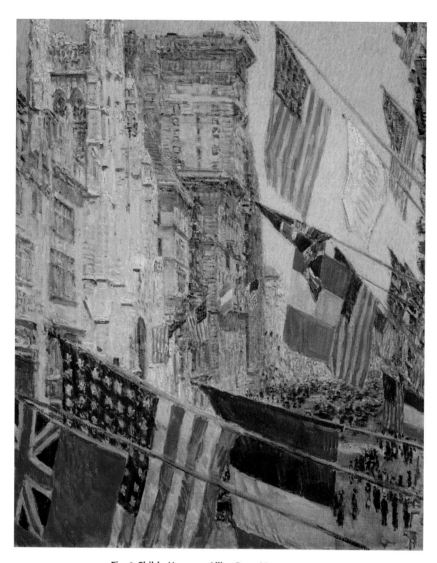

Fig. 9 Childe Hassam, *Allies Day, May 1917*, 1917.
Oil on canvas, 36½ × 30¼ in.
Gift of Ethelyn McKinney in memory of her brother, Glenn Ford McKinney.
© 1999 Board of Trustees, National Gallery of Art, Washington, D.C.

THE WORLD AS WE PERCEIVE IT

Many of us assume, almost without question, that we can trust in the reality of what we see. Seeing, as we say, is believing. Our word "idea" derives, in fact, from the Greek word *idein*, meaning "to see," and it is no accident that when we say "I see" we really mean "I understand."

Nevertheless, though visual information dominates our perceptions of the world around us, we do not always understand what we see. More to the point, no two people, seeing the same thing, will come to the same understanding of its meaning or significance. Consider the images on the two pages before you. Almost all of us can agree, I think without difficulty, on the subject matter. Both images depict flags.

Childe Hassam's *Allies Day, May 1917* (Fig. 9) is patriotic in tone. It celebrates the American entry into World War I, something that the nation put off until April 6, 1917, after five American ships had been sunk in a span of nine days. The scene is Fifth Avenue in New York City, viewed from 52nd Street, and the flags decorated the route of the parades held on May 9 and 11 to honor the Allied leaders who had come to New York to consult on strategy.

If Hassam's painting seems straightforward, Jasper Johns's *Three Flags* (Fig. 10) is, at first sight, a perplexing image. It is constructed out of three progressively smaller canvases that have been bolted to one another, and because the flag undeniably shrinks before your eyes, becoming less grand and physically smaller the

to vote. The artists' intentions in these two works are different, and so, potentially, are our reactions to them.

The crib quilt (Fig. 13) represents still another meaning for the flag. Created in Kansas in about the year 1861, it is a far more complex image than it at first appears. The blue center star contains thirty-four smaller white stars, and this allows us to date the quilt, because Kansas joined the Union as the thirty-fourth state in 1861. The quilt celebrates two "newcomers," Kansas and the baby for whom it was sewn. It might even be said to transform the new state's motto—"To the Stars Through Difficulty"—into a story about childbirth. But it is important to remember that the Kansas of 1861 was a state torn by the Civil War and the issue of slavery. John Brown had attempted to begin a war for the abolition of slavery at Potawatomie in 1856, and five years later the state was forced to choose between joining the Union or the Confederacy. This quilt, then, is a political statement—it could even be called Republican, the party of Lincoln—emphatically asserting the family's position concerning the issue of slavery.

One of the most controversial works of art concerning the flag in recent years is "Dred" Scott Tyler's installation, *What Is the Proper Way to Display the American Flag?* (Fig. 14). The piece was first seen on February 20, 1989, when the School of the Art Institute of Chicago opened an exhibition of works of art by 66 students who were members of minority groups. Tyler's work consisted of a 34 × 57 inch American flag draped on the floor beneath photographs of flag-draped coffins and South Koreans burning the flag. Beneath the photos was a ledger in which viewers were asked to record their opinions. The problem was not only that the flag was on the floor, but that it was difficult to write in the ledger without stepping on it. Thus the flag became a barrier to the freedom of expression it was meant to defend. Viewers had to choose which they revered most—the flag itself or freedom of speech.

Angry veterans wearing combat fatigues protested the exhibit soon after it opened, waving American flags, singing the national anthem, and carrying signs saying, "The American flag is not a doormat." Said one: "When I walked in

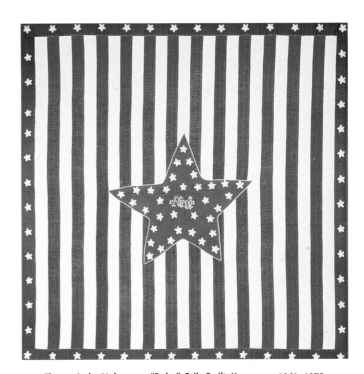

Fig. 13 Artist Unknown, *"Baby" Crib Quilt,* Kansas, c. 1861–1875.
Cotton with cotton embroidery, 36¼ × 36 in.
Collection of The Museum of American Folk Art, New York. Gift of Phyllis Haders. 1978.42.1

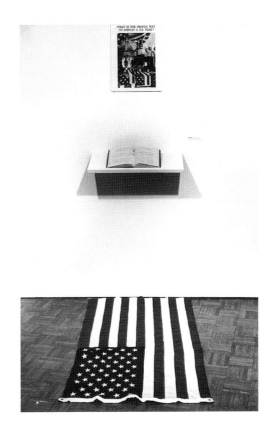

Fig. 14 Scott Tyler,
What Is the Proper Way to Display the American Flag?, 1989.
Installation. Photo: Michael Tropea.

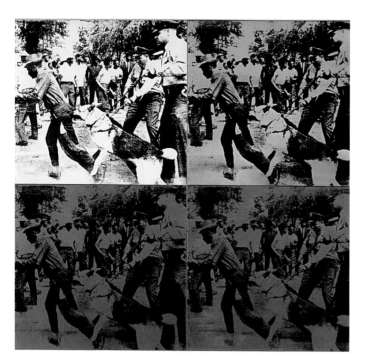

Fig. 15 Andy Warhol, *Race Riot*, 1963.
Acrylic and silkscreen on canvas, four panels, 20 × 33 in. each.
© 1999 Andy Warhol Foundation for the Visual Arts/Artists Rights Society (ARS), New York.

Thinking About Making and Seeing

In this chapter, we have discovered that the world of art is as vast and various as it is not only because different artists in different cultures see and respond to the world in different ways, but because each of us sees and responds to a given work of art in different ways as well. Artists are engaged in a creative process. We respond to their work through a process of *critical thinking*. At the end of each chapter of *A World of Art* is a section like this one titled The Critical Process, in which, through a series of questions, you are invited to think for yourself about the issues raised in the chapter. In each case, additional insights are provided at the end of the text, in the section titled *The Critical Process: Thinking Some More about the Chapter Questions*. After you have thought about the questions raised, turn to the back and see if you are headed in the right direction.

Here, Andy Warhol's *Race Riot* (Fig. 15) depicts events of May 1963 in Birmingham, Alabama, when police commissioner Bull Connor employed attack dogs and fire hoses to disperse civil rights demonstrators led by Reverend Martin Luther King Jr. The traditional roles of the artist—to record the world, to give visible or tangible form to ideas, philosophies, or feelings, to reveal hidden or universal truths, and to help us see the world in new or innovative ways—are all part of a more general creative impulse that leads, ultimately, to the work of art. Which of these is, in your opinion, the most important for Warhol in creating this work? Did any of the other traditional roles play a part in the process? What do you think Warhol feels about the events (note that the print followed soon after the events themselves)? How does his use of color contribute to his composition? Can you think why there are two red panels, and only one white and one blue? Emotionally, what is the impact of the red panels? In other words, what is the work's psychological impact? What reactions other than your own can you imagine the work generating? These are just a few of the questions raised by Warhol's work, questions to help you initiate the critical process for yourself.

there and saw those muddy footprints on the flag, I was disgusted. It would be different if it was his own rendering of the flag. But it was a real flag. And it belongs to the American people." Tyler responded that he had purchased the flag at a store for $3.95. It had been made in Taiwan.

By February 24, school officials had closed the show. A week later it reopened, and a school teacher from Virginia was arrested when she walked on the flag to write in the ledger. Finally, on March 12, 2,500 veterans and supporters from nine states marched on the Art Institute. Students reacted, brawls broke out, and five more people were arrested.

Because of the exhibition, the United States Senate, the Illinois Legislature, and the Chicago City Council all passed legislation banning display of the flag on the floor. These laws were all subsequently overturned when the United States Supreme Court ruled that even flag burning is protected as free speech by the First Amendment. Freedom of speech is a difficult issue, even for the courts, and in taking freedom of speech as its subject, Tyler's installation was equally problematic.

CHAPTER 2

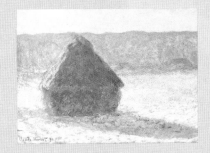

DEVELOPING VISUAL LITERACY

WORDS AND IMAGES

WORKS IN PROGRESS
Lorna Simpson's *The Park*

DESCRIBING THE WORLD
Representational, Abstract, and Nonobjective Art
Form and Content
Conventions and Art
Iconography

THE CRITICAL PROCESS
Thinking about Visual Conventions

Visual art can be powerfully persuasive, and one of the purposes of this book is to help you to recognize how this is so. Yet it is important for you to understand from the outset that you can neither recognize nor understand—let alone communicate—how visual art affects you without using language. In other words, one of the primary purposes of any art appreciation text is to provide you with a descriptive vocabulary, a set of terms, phrases, concepts, and approaches that will allow you to think critically about visual images. It is not sufficient to say, "I like this or that painting." You need to be able to recognize why you like it, how it communicates to you. This ability is given the name **visual literacy**.

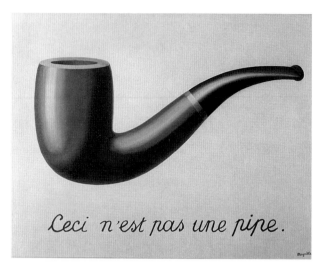

Fig. 16 René Magritte, *The Treason of Images*, 1929.
Oil on canvas, 21½ × 28½ in. Los Angeles County Museum.
Giraudon/Art Resource, New York.
© 2003 C. Herscovici, Brussels/Artists Rights Society (ARS), New York.

The fact is, most of us take the visual world for granted. We assume that we understand what we see. Those of us born and raised in the television era are often accused of being non-verbal, passive receivers, like TV monitors themselves. If television—and the mass media generally, from *Time* to MTV—has made us virtually dependent upon visual information, we have not necessarily become visually *literate* in the process. To introduce you to the idea of visual literacy, this chapter will begin by introducing you to the main tools needed for our discussion—the relationship between words, images, and objects in the real world, the idea of representation, the distinction between form and content in art, conventions in art, and iconography. With these in hand, we will then consider some of the major themes of art in Chapter 3.

WORDS AND IMAGES

The degrees of distance between things in the world and the words and images with which we refer to them is precisely the point of René Magritte's *The Treason of Images* (Fig. 16). We tend to look at the image of a pipe as if it were really a pipe, but of course it isn't. It is the *representation* of a pipe. *Ceci n'est pas une pipe,*

the painting tells us: "This is not a pipe." Nor is the word "pipe" the same as an image of it. The word is an abstract set of marks that "represents," in language, both the thing and its image. Language is even further removed from the real world than visual representation. And within language there are different degrees of distance as well. "This," finally, is not a "pipe." These two words are not the same: "This" is a pronoun that could point to anything, and only in this context does it point to a "pipe."

In the West, we tend to confuse words and the things they represent. This is not true in other cultures. For example, in Muslim culture, the removal of the word from what it refers to is seen as a virtue. Traditionally, those who make pictures with human figures in them are labeled "the worst of men," and to possess such a picture is comparable to owning a dog, an animal held in contempt because it is associated with filth. In creating a human likeness, the artist is thought to be competing with the Creator himself, and such *hubris*, or excessive pride, is, of course, a sin. As a result, **calligraphy**—that is, the fine art of handwriting—is the chief form of Islamic art.

The Muslim calligrapher does not so much express himself—in the way that we, individually, express ourselves through our style of writing—as act as a medium through which Allah can express himself in the most beautiful manner possible. Thus all properly pious writing, especially poetry, is sacred. This is the case with the page from the poet Firdausi's *Shahnamah* at the right (Fig. 17).

Sacred texts are almost always completely abstract designs that have no relation to the world of things. They demand to be considered at least as much for their visual properties as for their literary or spiritual content. Until recent times, in the Muslim world, every book, indeed almost every sustained statement, began with the phrase "In the name of Allah"—the *bismillah*, as it is called—the same phrase that opens the Koran. On this folio page from the *Shahnamah*, the *bismillah* is in the top right-hand corner (Arabic texts read from right to left). To write the *bismillah* in as beautiful a form as possible is believed to bring the scribe forgiveness for his sins.

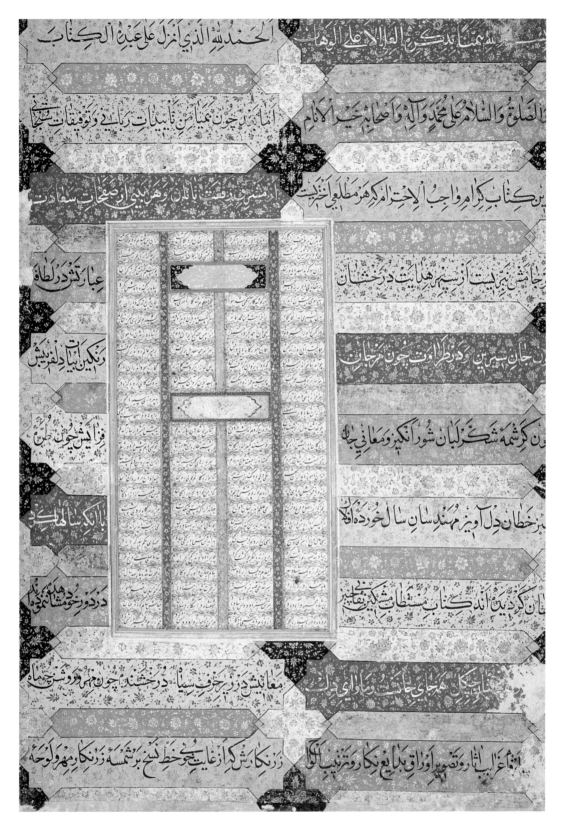

Fig. 17 *Triumphal Entry* (Page from a manuscript of the *Shahnamah*), 1562–1583.
Islamic, Iranian and Turkish. Opaque watercolor and gold on paper, 18½ × 13 in.
Museum of Fine Arts, Boston. Francis Bartlett Donation of 1912 and Picture Fund. 14.692.

Lorna Simpson's *The Park*

As a photographer, Lorna Simpson is preoccupied with the question of representation and its limitations. All of her works, of which the multi-panel *Necklines* (Fig. 18) is a good example, deal with the ways in which words and images function together to make meaning. Simpson presents us with three different photographs of the same woman's neck and the neckline of her dress. Below these images are two panels with four words on each, each word in turn playing on the idea of the neck itself. The sensuality of the photographs is affirmed by words such as "necking" and "neck-ed" (that is, "naked"), while the phrases "neck & neck" and "breakneck," introduce the idea of speed or running. The question is, what do these two sets of terms have to do with one another? Necklaces and neckties go around the neck. So do nooses at hangings. In fact, "necktie parties" conduct hangings, hangings break necks, and a person runs from a "necktie party" precisely because, instead of wearing a necklace, in being hanged one becomes "neckless."

If this set of verbal associations runs contrary to the sensuality and seeming passivity of Simpson's photographs, they do not run contrary to the social reality faced, throughout American history, by black people in general. The anonymity of Simpson's model serves not only to universalize the situation that her words begin to explore, but also depersonalizes the subject in a way that suggests how such situations become possible. Simpson seeks to articulate this tension—the violence that always lies beneath the surface of the black person's world—by bringing words and images together.

A group of large-scale black-and-white serigraphs, or silkscreen prints, on felt, take up different subject matter but remain committed to investigating the relationship between words and images. Created for the premier opening of the Sean Kelly Gallery in New York City in October 1995, all of the works but one are multi-panel photographs of landscapes (the one exception is a view of two almost identical hotel rooms). They employ a unique process. Simpson first photographed the scenes. Then she arranged with Jean Noblet, one of the premier serigraph printers in the world, to print them, blown up into several large panels, on felt, a material never before utilized in the silkscreen printing process. The felt absorbed vast quantities of ink, and each panel had to be printed several times to achieve the correct density of black. Furthermore, each panel had to match the others in the image. In less than two weeks,

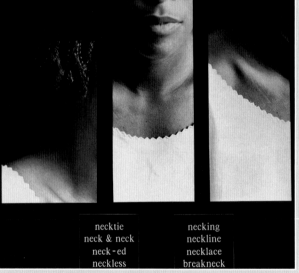

Fig. 18 Lorna Simpson, *Necklines,* **1989.**
Three silver prints, two plastic plaques, 68½ × 70 in.
Courtesy Sean Kelly Gallery, New York.

Fig. 19 Lorna Simpson, *The Park*, 1995. Edition of 3, serigraph on six felt panels with felt text panel (not shown), 67 × 67½ in. overall. Courtesy Sean Kelly Gallery, New York.

the entire suite of seven images, consisting of over fifty panels, was miraculously printed, just in time for the show.

Each of the images is accompanied by a wall text that, when read, transforms the image. On one side of *The Park* (Fig. 19), for instance, the viewer reads:

> *Just unpacked a new shiny silver telescope. And we are up high enough for a really good view of all the buildings and the park. The living room window seems to be the best spot for it. On the sidewalk below a man watches figures from across the path.*

On the other side of the image, a second wall text reads:

> *It is early evening, the lone sociologist walks through the park, to observe private acts in the men's public bathrooms. . . . He decides to adopt the role of voyeur and look out in order to go unnoticed and noticed at the same time. His research takes several years. . . .*

These texts effectively involve Simpson's audience in a complex network of voyeurism. The photographer's position is the same as the person's who has purchased the telescope, and our viewpoint is the same. Equipped with a telescope (or the telescopic lens of a camera) apparently purchased for viewing the very kind of scene described in the second text, we want to zoom in to see what's going on below.

There is, in fact, a kind of telescopic feel to the work itself. The image itself is more than 5½ feet square and can be readily taken in from across the room. But to understand it, we need to come in close to read the texts. Close up, the image is too large to see as a whole, and the crisp contrasts of the print as seen from across the room are lost in the soft texture of the felt. The felt even seems to absorb light rather than reflect it as most photographic prints do, blurring our vision in the process. As an audience, we zoom in and out, viewing the scene as a whole, and then coming in to read the texts. As we move from the general to the particular, from the panoramic view to the close-up text, the innocuous scene becomes charged with meaning. The reality beneath surface appearances is once again Simpson's theme—the photographer challenging the camera view.

Yet words, however beautifully written, have limitations. If you allow yourself to believe for a moment that the photograph of the tree in the diagram below (Fig. 20) represents a "real" tree, and that the drawing in the middle is its "image," the question arises: Should we trust the word "tree" more or less than the image of it? It is no more "real" than the drawing. It is made from a series of pen strokes on paper—not an action radically removed, at least in a physical sense, from the set of gestures used to draw the tree. In fact, the word might seem even more arbitrary and culturally determined than the drawing. Most people would understand what the drawing depicts. Only English speakers understand "tree." In French the word is *arbre*, in German *baum*, in Turkish *agaç*, and in Swahili *mti*.

An excellent case can be made, in other words, for the primacy of images over words. Most of us trust a photograph of an unusual event more than some witness's verbal description of it. "The camera never lies," we tell ourselves, while the reliability of a given witness is always in doubt.

Cameras, of course, can and do lie. Consider Duane Michals's photograph of an embracing couple (Fig. 21). The **subject matter** of the work—what the image depicts—and its **content**—what the image means—are radically opposed. The man in this photograph insists on using it as if it were proof in a court of law, and we are the jury. Evidently the relationship is over, but the man wants us to believe that "once upon a time" he was loved by someone, that this woman was happy in his company. His insistence is embarrassing. We read his protestation as a fairy tale that he has created in order to deceive himself.

Whichever we tend to trust more, the visual or the verbal (and it probably depends upon the context of any given situation), it should nevertheless be clear that words and images need to work together. Each is insufficient in itself to tell the whole "truth." It should be equally clear that any distrust of visual imagery we might feel is, at least in part, a result of the visual's power. When, in Exodus, the worship of "graven images" that is, idols, is forbidden, the assumption is that such images are powerfully attractive, even dangerously seductive. As we have noted, the page of Arab poetry reproduced previously (Fig. 17) depends for its power at least as much on its visual presence and beauty as it does on what it actually says.

DESCRIBING THE WORLD

In the last section, we explored the topic of visual literacy by considering the relationship between words and images. Words and images are two different systems of *describing the world*. Words refer to the world in the abstract. Images *represent the world, or reproduce* its appearance. Traditionally one of the primary goals of the visual arts has been to capture and portray the way the natural world looks. But, as we all know, some works of art look more like the natural world than others, and some artists are less interested than others in representing the world as it actually appears. As a result, a vocabulary has developed that describes how closely, or not, the image resembles visual reality itself. This basic set of terms is where we need to begin in order to talk or write intelligently about works of art.

Fig. 20 The visual to the verbal. On the left: C. E. Watkins, *Arbutus Menziesii Pursh*, California, 1861.
Albumen print, 14¼ × 21¼ in. The Museum of Modern Art, New York. Purchase. Copy print Licensed by Scala-Art Resource, New York.
© 2000 Museum of Modern Art, New York.

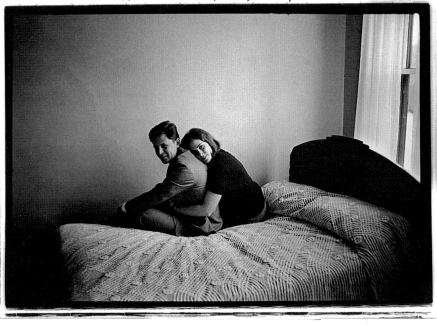

This photograph is my proof. There was that afternoon when things were still good between us ~~and she embraced me~~, and we were so happy. She did love me. It did happen. Look, see for yourself

THIS PHOTOGRAPH IS MY PROOF

This photograph is my proof. There was that afternoon when things were still good between us, and she embraced me, and we were so happy. It did happen. She did love me. Look, see for yourself.

Fig. 21 Duane Michals, *This Photograph Is My Proof*, 1967–1974.
Gelatin silver print with hand applied text. Paper 8 × 10 in. Signed, titled, dated and numbered recto in ink.
From an edition of 25. DMI.049. Copyright Duane Michals. Courtesy Pace/MacGill Gallery, New York.

Representational, Abstract, and Nonobjective Art

Generally we refer to works of art as either **representational**, **abstract**, or **nonobjective** (or **nonrepresentational**). The more a work resembles real things in the real world, the more **representational**, or **realistic**, it is said to be. You may also encounter the related terms **naturalistic**, meaning "like nature," and **illusionistic**, which refers to an image so natural that it creates the illusion of being real. Traditional photography is, in many ways, the most representational medium, because its transcription of what lies before the viewfinder appears to be direct and unmanipulated. The photograph,

therefore, seems to capture the immediacy of visual experience. It seems equivalent to what we actually see. It is important to remember, however, that photography captures only what is visible in the camera's viewfinder. As in the Duane Michals photograph, the photographic image does not necessarily capture the emotional world that lies beneath the surface, or what lies beyond the frame. Photography offers up only a replica of the visual or illuminated world, not the world as a whole.

The four images on the following pages, all by different artists, proceed in steps from the most representational to the most nonrepresentational art. As a series, they embody a

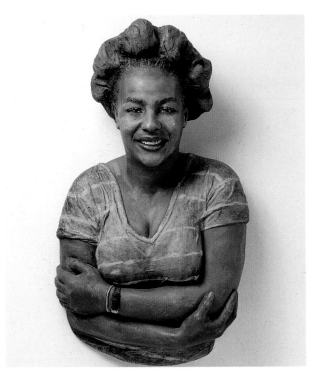

Fig. 22 John Ahearn and Rigoberto Torres, *Pat*, 1982.
Painted cast plaster, 28½ × 16½ × 11 in.
Courtesy Alexander and Bonin, New York. Collection Norma and William Roth,
Winterhaven, Florida. Photo Courtesy of Sotheby's.

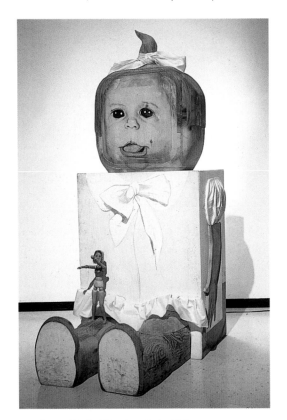

Fig. 23 Marisol Escobar, *Baby Girl*, 1963.
Wood and mixed media, height 74 × 35 × 47 in. Albright-Knox Art Gallery, Buffalo, NY.
Gift of Seymour H. Knox, 1964. © Marisol Escobar/Licensed by VAGA, New York, NY.

continuum from the representational through the abstract to the nonobjective.

Representational works of art portray natural objects in recognizable form. Thus, Albert Bierstadt's painting of *The Rocky Mountains* (Fig. 3) is representational, even though the scene it depicts may be imaginary. Erna Motna's *Bushfire and Corroboree Dreaming* (Fig. 5), with its lack of recognizable landscape features, is far less representational even though it refers to an actual Australian site. The sculpture of Pat, on the left (Fig. 22), is fully representational. The sculpture almost looks as if it is alive, and certainly anyone meeting the real "Pat" would recognize her from this representation of her. In fact, *Pat* is one of many plaster casts made from life by John Ahearn and Rigoberto Torres, residents of the South Bronx in New York City. In 1980, Ahearn moved to the South Bronx and began to work in collaboration with local resident Torres. Torres had learned the art of plaster casting from his uncle, who had cast plaster statues for churches and cemeteries. Together Ahearn and Torres set out to capture the spirit of a community that was financially impoverished but that possessed real, if unrecognized, dignity. "The key to my work is life—lifecasting," says Ahearn. "The people I cast know that they are as responsible for my work as I am, even more so. The people make my sculptures."

While natural objects remain recognizable in abstract works of art, they are rendered in a stylized or simplified way. Marisol's *Baby Girl* (Fig. 23), is still recognizable as a representation of a little girl, but it is much less realistic than *Pat*. Instead of rendering the human form exactly, Marisol simply draws the human form on the large, barely rounded blocks of wood. As a result, the work seems half sculpture, half drawing.

The less a work resembles real things in the real world, the more **abstract** it is said to be. Abstract art does not try to duplicate the world exactly but instead reduces the world to its essential qualities. It is concerned with the formal qualities of an image (such as line and form and color), or with the emotions that may be expressed through it. For example, Marisol's *Baby Girl* is over six feet tall, sitting down. Her exaggerated size lends her the emotional pres-

ence of a monster, an all-consuming, all-demanding force far larger than her actual size.

Joel Shapiro's *Untitled* (Fig. 24) is a barely recognizable, highly abstract version of a human figure lying on its side. Shapiro believes that we all inevitably see representational forms in any configuration (just as we see representational shapes in cloud formations), so he lets us see these nine wooden blocks as a figure. Nevertheless, their abstract formal quality as rectangular volumes is asserted even more completely than in Marisol's work.

Nonobjective works of art do not refer to the objective world at all. Shapiro's work is very close to becoming as **nonobjective** as Carl Andre's *Redan* (Fig. 25). Composed of twenty-seven wooden blocks piled in a zig-zag formation, Andre's work seems to be nothing more than an arrangement of geometric forms. If we look up its title in a dictionary, however, we discover that it refers to an architectural feature of fortifications in which two walls are set at an angle facing the enemy. Nevertheless, Andre is more interested in the form of his

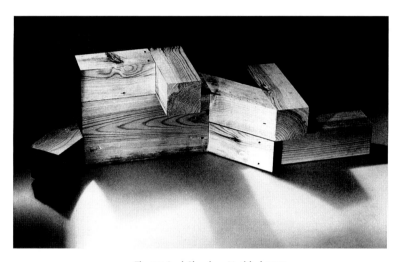

Fig. 24 Joel Shapiro, *Untitled*, 1981.
Wood, 8¾ × 31¼ × 8½ in. Photo Courtesy of PaceWilderstein.

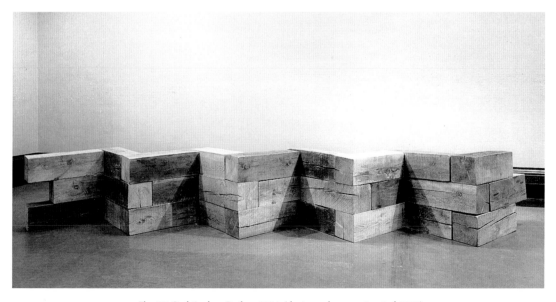

Fig. 25 Carl Andre, *Redan*, 1964 (destroyed; reconstructed 1970).
Wood, 27 units, 12 × 12 × 36 in each; 36 × 42 × 245 in. overall. Art Gallery of Ontario, Toronto;
Purchased with assistance from the Women's Committee Fund, 1971. © Carl Andre/Licensed by VAGA, New York, NY.

piece, its angles and its presence in the room, than in its actual reference.

It is not always easy, or even necessary, to make absolute distinctions between the representational, the abstract, and the nonobjective. Joel Shapiro's work, Fig. 24, is a good example. A given work of art may be more or less representational, more or less abstract. Very often certain elements of a representational painting will be more abstract, or generalized, than other elements. Likewise, a work may appear totally nonobjective until you read the title, and see that, in fact, it does refer to things in the actual world, however loosely. Purely nonobjective art, such as Kasimir Malevich's *Suprematist Painting* (Fig. 26), is concerned only with questions of form, and we turn now to those considerations.

Form and Content

When we speak of a work's **form**, we mean everything from the materials used to make it, to the way it employs the various formal elements (discussed in Part II), to the ways in which those elements are organized into a **composition**. Form is the overall structure of a work of art. Somewhat misleadingly, it is generally opposed to **content**, which is what the work of art expresses or means. Obviously, the content of nonobjective art *is* its form. Malevich's painting is really *about* the relation between the black rectangle, the blue triangle, and the white ground behind them. Though it is a uniform blue, notice that the blue triangle's color seems to be lighter where it is backed by the black triangle, and darker when seen

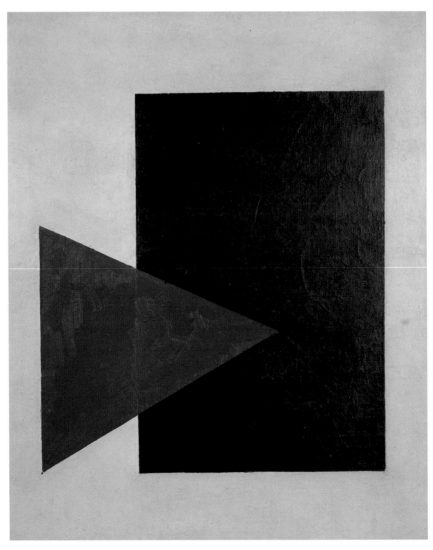

Fig. 26 Kasimir Malevich, *Suprematist Painting, Black Rectangle, Blue Triangle*, 1915.
Oil on canvas, 26⅛ × 22½ in. Stedelijk Museum, Amsterdam. Erich Lessing/Art Resource, New York.

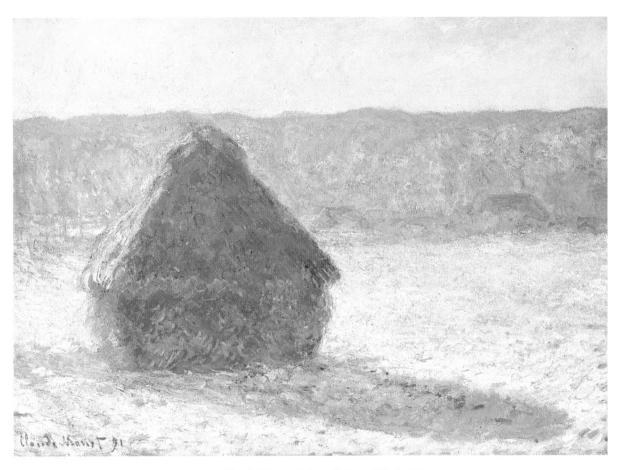

Fig. 27 Claude Monet, *Grainstack* (*Snow Effect*), 1891.
Oil on canvas, 25¾ × 36⅜ in. Museum of Fine Arts, Boston.
Gift of Misses Aimee and Rosamond Lamb in memory of Mr. and Mrs. Horatio A. Lamb. 1970.253.

against the white ground. This phenomenon results from the fact that our perception of the relative lightness or darkness of a color depends upon the context in which we see it, even though the color never actually changes. If you stare for a moment at the line where the triangle crosses from white to black, you will begin to see a vibration. The two parts of the triangle will seem, in fact, to be at different visual depths. Malevich's painting demonstrates how purely formal relationships can transform otherwise static forms into a visually dynamic composition.

Claude Monet uses the same forms in his *Grainstack* (Fig. 27). In fact, compositionally, this work is almost as simple as Malevich's. That is, the haystack is a triangle set on a rectangle, both set on a rectangular ground. Only the cast shadow adds compositional complexity. Yet Monet's painting has clear content. For

nearly three years, from 1888 to 1891, Monet painted the haystacks near his home in Giverny, France, over and over again, in all kinds of weather and in all kinds of light. When these paintings were exhibited in May 1891, the critic Gustave Geffroy summed up their meaning: "These stacks, in this deserted field, are transient objects whose surfaces, like mirrors, catch the mood of the environment. . . . Light and shade radiate from them, sun and shadow revolve around them in relentless pursuit; they reflect the dying heat, its last rays; they are shrouded in mist, soaked with rain, frozen with snow, in harmony with the distant horizon, the earth, the sky." This series of paintings, in other words, attempts to reveal the dynamism of the natural world, the variety of its cyclic change.

In a successful work of art, form and content are inseparable. Consider another two

examples of the relation between form and content. To our eyes, the two heads on this page (Figs. 28 and 29) possess radically different formal characteristics and, as a result, differ radically in content. Kenneth Clark compares the two on the second page of his famous book *Civilisation*: "I don't think there is any doubt that the Apollo embodies a higher state of civilization than the mask. They both represent spirits, messengers from another world—that is to say, from a world of our own imagining. To the Negro imagination it is a world of fear and darkness, ready to inflict horrible punishment for the smallest infringement of a taboo. To the Hellenistic imagination it is a world of light and confidence, in which the gods are like ourselves, only more beautiful, and descend to earth in order to teach men reason and the laws of harmony."

Conventions and Art

Clark is wrong about the African mask. His reading is *ethnocentric*. That is, it imposes upon the art of another culture the meanings and prejudices of our own. Individual cultures

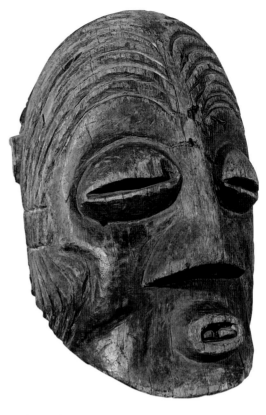

Fig. 29 African mask, Sang tribe, Gabon, West Africa.
Courtauld Gallery, Courtauld Institute, London.

always develop a traditional repertoire of visual images and effects that they tend to understand in a particular way. We call such habitual or generally accepted ways of seeing **conventions**. Different cultures possess different visual conventions and do not easily understand each other's conventions. It is important to recognize that what we think is expressed in an art work sometimes results from our own prejudices or mistaken expectations: this is why learning about the art in the context of the culture it reflects is so important to understanding it.

In the case of the African mask, its features are exaggerated at least in part to separate it from the "real" and to underscore its ceremonial function. Clark is reading it through the eyes of Western civilization, which has referred to the African continent as "darkest" Africa ever since the Europeans first arrived there. The best light in which Clark's reading of the African mask can be seen is to think of it as the manifestation of a traditional Western

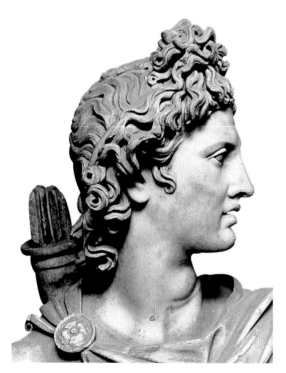

Fig. 28 *Apollo Belvedere* (detail),
Roman copy after a 4th century B.C.E. Greek original.
Vatican Museums, Rome. Alinari/Art Resource, New York.

convention in which the face is considered the outer expression of a psychological reality within. Distortions in the human face indicate or imply distortions or aberrations in the human psyche beneath. This particular convention can be traced back at least as far as Leonardo da Vinci's studies of grotesque heads (Fig. 30). Thus, when Clark sees an African mask, he reads into its features his own preconceptions of the psychic realities—violence, horror, or fright—that might lie beneath its surface.

The properties for which many in the Western world value African masks—the abstractness of their forms and their often horrifying emotional expressiveness—are not necessarily those most valued by their makers. For the Baule carvers of the Yamoussoukio area of the Ivory Coast, the Helmet Mask (Fig. 31) is a pleasing and beautiful object. But it has other conventional meanings as well.

This is the Dye sacred mask, according to one carver cited in Susan Vogel's *Perspectives: Angles on African Art.* "The god is a dance of rejoicing for me. So when I see the mask, my heart is filled with joy. I like it because of the horns and the eyes. The horns curve nicely, and I like the placement of the eyes and ears. In addition, it executes very interesting and graceful dance steps. . . . This is a sacred mask danced in our village. It makes us happy when we see it. There are days when we want to look at it. At that time, we take it out and contemplate it."

The Baule carvers pay attention to formal elements, but the mask is seen as much as part of a process, the dance, as an object. To the Baule eye, the mask projects its performance. It is a vehicle through which the spirit world is made available to humankind. In performance, the wearer of the mask takes on the spirit of the place, and the carver quoted above apparently imagines this as he contemplates it.

If we do not immediately share with the Baule carvers the feelings evoked by the mask, we can be educated to see it in their terms. When we see the mask only through the conventions of our own culture, then we not only radically alter its meaning and function, but we implicitly denigrate the African viewpoint, or, at best, refuse to acknowledge it at all.

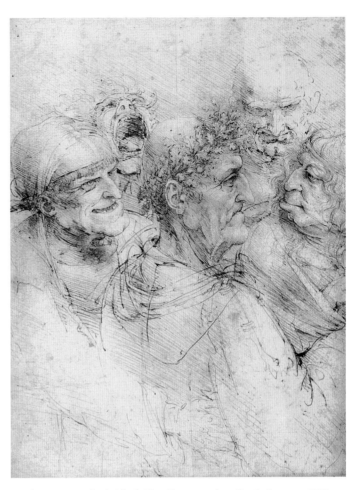

Fig. 30 Leonardo da Vinci, *Five Characters in a Comic Scene,* c. 1490.
Pen and ink, 10³⁄₁₆ × 8³⁄₈ in. The Royal Collection © 1992 Her Majesty Queen Elizabeth II.

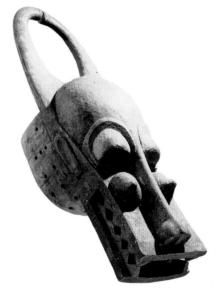

Fig. 31 Helmet mask, African, Baule, Ivory Coast, 19th–20th century.
Wood, coloring, length 34¼ in. Metropolitan Museum of Art.
Michael C. Rockefeller Memorial Collection.
Gift of Adrian Pascal LaGamma, 1973. (1978.412.664).

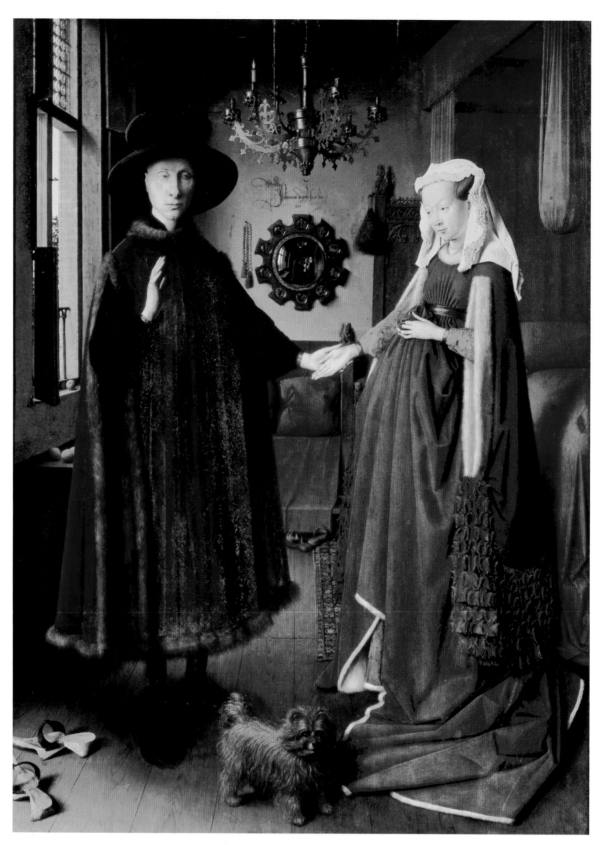

Fig. 32 Jan van Eyck, *The Marriage of Giovanni Arnolfini and Giovanna Cenami (The Arnolfini Marriage),* 1434.
Oil on oak panel, 32½ × 23½ in. National Gallery, London, UK/Bridgeman Art Library, New York.

Iconography

Even within a culture, the meaning of an image may change or be lost over time. When Jan van Eyck painted *The Marriage of Giovanni Arnolfini and Giovanna Cenami* in 1434 (Fig. 32), its repertoire of visual images was well understood, but today much of its meaning is lost to the average viewer. For example, the bride's green dress, a traditional color for weddings, was meant to suggest her natural fertility. She is not pregnant—her swelling stomach was a convention of female beauty at the time, and her dress is structured in a way to accentuate it. The groom's removal of his shoes is a reference to God's commandment to Moses to take off his shoes when standing on holy ground. A single candle burns in the chandelier above the couple, symbolizing the presence of Christ at the scene. And the dog, as most of us recognize even today, is associated with faithfulness and in this context, particularly, with marital fidelity.

The study or description of such visual images or symbolic systems is called **iconography**. In iconographic images, subject matter is not obvious to any viewer unfamiliar with the symbolic system in use. Every culture has its specific iconographic practices, its own system of images that are understood by the culture at large to mean specific things. But what would Arab culture make of the dog in the van Eyck painting, since in the Muslim world dogs are traditionally viewed as filthy and degraded? From the Muslim point of view, the painting verges on nonsense.

Even to us, viewing van Eyck's work more than five hundred years after it was painted, certain elements remain confusing. An argument has recently been made, for instance, that van Eyck is not representing a marriage so much as a betrothal, or engagement. We have assumed for generations that the couple stands in a bridal chamber where, after the ceremony, they will consummate their marriage. It turns out, however, that in the fifteenth century it was commonplace for Flemish homes to be decorated with hung beds with canopies. Called "furniture of estate," they were important status symbols commonly displayed in fifteenth-century Flanders in the principal room of the house as a sign of the owner's prestige

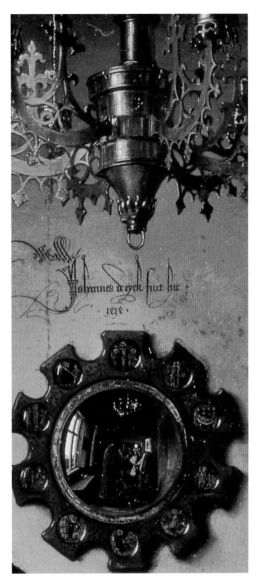

Fig. 33 Jan van Eyck, *The Marriage of Giovanni Arnolfini and Giovanna Cenami,* 1434, detail. National Gallery, London, UK/Bridgeman Art Library, New York.

and influence. The moment is not unlike that depicted by Shakespeare in *Henry V*, when the English king proposes to Katherine, the French princess: "Give me your answer; i' faith, do; and so clap hands and a bargain: how say you lady?" Such a touching of the hands was the common sign of a mutual agreement to wed. The painter himself stands in witness to the event. On the back wall, above the mirror, are the words *Jan de Eyck fuit hic. 1434*—"Jan van Eyck was here, 1434" (Fig. 33). We see the backs of Arnolfini and his wife reflected in the mirror, and beyond them, standing more or less in the same place as we do as viewers, two

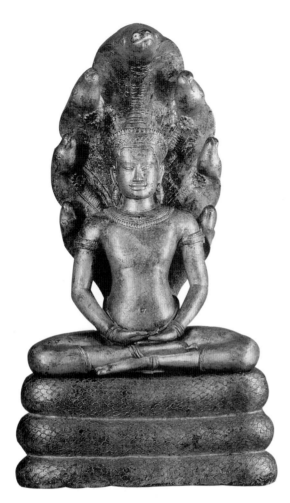

Fig. 34 Buddha, adorned, seated in meditation on the serpent Mucilinda, c. 1100–1150.
Photo: Superstock, Inc.

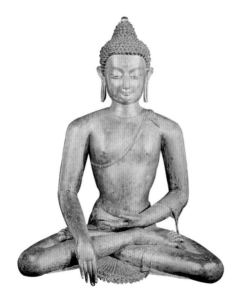

Fig. 35 Buddha subduing Mara, Nepal, late 14th century.
Gilted copper. Photo: Superstock, Inc.

other figures, one a man in a red turban who is probably the artist himself.

Similarly, most of us in the West probably recognize a Buddha when we see one, but most of us do not know that the position of the Buddha's hands carries iconographic significance. Buddhism, which originated in India in the fourth century B.C.E., is traditionally associated with the worldly existence of Sakyamuni, or Gautama, the Sage of the Sakya clan, who lived and taught around 500 B.C.E. In his thirty-fifth year, Sakyamuni experienced enlightenment under a tree at Gaya (near modern Patna), and he became Buddha or the Enlightened One.

Buddhism spread to China in the third century B.C.E., and from there into Southeast Asia during the first century C.E. Long before it reached Japan, by way of Korea in the middle of the fifth century C.E., it had developed a more or less consistent iconography, especially related to the representation of Buddha himself. The symbolic hand gestures, or *mudra*, refer both to general states of mind and to specific events in the life of Buddha. The *mudra* best known to Westerners, the hands folded in the seated Buddha's lap, symbolizes meditation (Fig. 34). The snake motif, seen here, illustrates a specific episode from the life of the Buddha in which the serpent-king Mucilinda made a seat out of its coiled body and spread a canopy of seven heads over Buddha to protect him, as he meditated, from a violent storm.

One of the most popular of the *mudra*, especially in East India, Nepal, and Thailand, is the gesture of touching the earth, right hand down over the leg, the left lying in the lap (Fig. 35). Biographically, it represents the moment when Sakyamuni achieved Enlightenment and became Buddha. Challenged by the Evil One, Mara, as he sat meditating at Gaya, Sakyamuni proved his readiness to reach Nirvana, the highest spiritual state, by calling the earth goddess to witness his worthiness with a simple touch of his hand. The gesture symbolizes, then, not only Buddha's absolute serenity, but the state of Enlightment itself.

A Buddhist audience can read these gestures as readily as we, in the predominantly Christian West, can read incidents from the story of Christ. Figure 36 shows the lower nine panels of the center window in the west front

of Chartres Cathedral in France. This window was made about 1150 and is one of the oldest and finest surviving stained-glass windows in the world. The story can be read like a cartoon strip, beginning at the bottom left and moving right and up, from the Annunciation (the angel Gabriel announcing to Mary that she will bear the Christ Child) through the Nativity, the Annunciation to the Shepherds, and the Adoration of the Magi. The window is usually considered the work of the same artist who was commissioned by the Abbot Suger to make the windows of the relic chapels at Saint-Denis, which portray many of the same incidents. "The pictures in the windows are there," the Abbot explains in his writings, "for the sole purpose of showing simple people, who cannot read the Holy Scriptures, what they must believe." But he understood as well the expressive power of this beautiful glass. It transforms, he said, "that which is material into that which is immaterial." Suger understood that whatever story the pictures in the window tell, whatever iconographic significance they contain, and whatever words they generate, it is, above all, their art that lends them power.

Fig. 36 Lower nine panels of the center lancet window in the west front of Chartres Cathedral, showing the Nativity, Annunciation to the Shepherds, and the Adoration of the Magi, c. 1150.
Chartres Cathedral, France. Giraudon/Art Resource, New York.

Thinking about Visual Conventions

Very rarely can we find the same event documented from the point of view of two different cultures, but the two images here, one by John Taylor, a journalist hired by *Leslie's Illustrated Gazette* (Fig. 37), and the other by the Native American artist Howling Wolf (Fig. 38), son of the Cheyenne chief Eagle Head, both depict the October 1867 signing of a peace treaty between the Cheyenne, Arapaho, Kiowa, and Comanche peoples and the United States government at Medicine Lodge Creek, a tributary of the Arkansas River, in Kansas. Taylor's illustration is based on sketches done at the scene, and it appeared soon after the events. Howling Wolf's work, actually one of several depicting the events, was done nearly a decade later, after he was taken east and imprisoned at Fort Marion in St. Augustine,

Florida, together with his father and seventy other "ringleaders" of the continuing Native American insurrection in the Southern Plains. While in prison, Howling Wolf made many drawings such as this one, called "ledger" drawings because they were executed on blank accountants' ledgers.

Even before he was imprisoned, Howling Wolf had actively pursued ledger drawing. As Native Americans were introduced to crayons, ink, and pencils, the ledger drawings supplanted traditional buffalo hide art, but in both the hide paintings and the later ledger drawings, artists depicted the brave accomplishments of their owners. The conventions used by these Native American artists differ greatly from those employed by their Anglo-American counterparts. Which, in your opinion, is the more representational? Which is the more abstract?

Both works possess the same overt content—that is, the peace treaty signing, but how do they differ in form? Both Taylor and Howling

Fig. 37 John Taylor, *Treaty Signing at Medicine Creek Lodge*, 1867.
Drawing for *Leslie's Illustrated Gazette*, September–December 1867, as seen in Douglas C. Jones,
The Treaty of Medicine Lodge, page xx, Oklahoma University Press, 1966.

Fig. 38 Howling Wolf, *Treaty Signing at Medicine Lodge Creek*, 1875–1878.
Ledger drawing, pencil, crayon, and ink on paper, 8 × 11 in.
New York State Library, Albany, NY.

Wolf depict the landscape, but how do they differ? Can you determine why Howling Wolf might want to depict the confluence of Medicine Creek and the Arkansas in his drawing? It is as if Howling Wolf portrays the events from above, so that simultaneously we can see tipis, warriors, and women in formal attire, and the grove in which the United States soldiers meet with the Indians. Taylor's view is limited to the grove itself. Does this difference in the way the two artists depict space suggest any greater cultural differences? Taylor's work directs our eyes to the center of the image, while Howling Wolf's does not. Does this suggest anything to you?

Perhaps the greatest difference between the two depictions of the event is the way in which the Native Americans are themselves portrayed. In Howling Wolf's drawing, each figure is identifiable—that is, the tribal affiliations and even the specific identity of each individual are revealed through the iconography of the decorations of their dress and tipis. How, in comparison, are the Native Americans portrayed in Taylor's work? In what ways is Taylor's work ethnocentric?

One of the most interesting details in Howling Wolf's version of the events is the inclusion of a large number of women. Almost all of the figures in Howling Wolf's drawing are, in fact, women. They sit with their backs to the viewer, their attention focused on the signing ceremony before them. Their braided hair is decorated with customary red paint in the part. This convention is of special interest. When the Plains warrior committed himself to a woman, he ceremonially painted her hair to convey his affection for and commitment to her. Notice the absence of any women in Taylor's depiction, as opposed to their prominence in Howling Wolf's. What does this suggest to you about the role of women in the two societies?

CHAPTER 3

THE THEMES OF ART

THE REPRESENTATION OF THE WORLD

THE POWER OF IMAGINATION

THE IDEA OF THE BEAUTIFUL

WORKS IN PROGRESS
Pablo Picasso's *Les Demoiselles d'Avignon*

THE CRITICAL PROCESS
Thinking about the Themes of Art

Claude Monet's *The Regatta at Argenteuil* (Fig. 39) is one of the great examples of **Impressionism**, a mode of painting that dominated late nineteenth-century art in the Western world, especially in France. Impressionism takes its name from its particular way of seeing—not the careful and exact gaze of a painter determined to represent every detail of a scene exactly as it appears, but a quick glance at a more fleeting or transitory scene. The impressionist painter captures the play of light on the surface of the world with a technique noted for its purposeful sketchiness. Impressionists do not paint things, so much as their *impressions* of things. Thus Monet would tell the

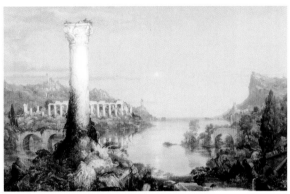

Figs. 41–44 Thomas Cole, *The Course of Empire*, 1834–1836.
Top left: *The Pastoral or Arcadian State*, 1834. Oil on canvas, 39¼ × 63¼ in.
Top right: *The Consummation of Empire*, 1835–1836. Oil on canvas, 51¼ × 76 in.
Lower left: *Destruction*, 1836. Oil on canvas, 39¼ × 63¼ in.
Lower right: *Desolation*, 1836. Oil on canvas, 39¼ × 63¼ in.
Collection of The New–York Historical Society, acc. no. 1858.2, neg. no. 6046; acc. no. 1858.3, neg. no. 6047; acc. no. 1858.4, neg. no. 6048;
acc. no. 1858.5, neg. no. 6049.

prehistoric hunters chase a stag, smoke rising from their encampment in the distance. Next comes the *Pastoral or Arcadian State*, where shepherds tend their flocks while a plowman tills his field to the left. Smoke rises here from a stone temple in the middle distance. This is the ideal "middle ground," half-way between wild nature and civilization proper, representing an ideal state of balance and harmony. The third painting of the series, *The Consummation of Empire*, is the largest of the five and was conceived to be surrounded by the other four. Here an emperor, robed in red and standing atop a carriage drawn by an elephant, returns to the city in triumph, but it is a triumph short-lived. In the fourth painting, *Destruction*, the Empire collapses in war. Finally, in *Desolation*, a scene reminiscent of the state of Greek and Roman

ruins as the eighteenth- and nineteenth-century tourists discovered them in Europe, nature reclaims the landscape.

The five paintings also represent the cycle of the seasons, beginning in spring and ending in autumn. They move, furthermore, from dawn to dusk, civilization reaching its apogee at high noon. The permanence of the natural world is symbolized by the rock-topped mountain that rises above each painting. As opposed to both the passing of time and the fleeting quality of human civilization, the promontory remains constant and enduring.

Cole's cycle rehearses a whole range of relationships between humankind and nature. At its most balanced, in the *Pastoral or Arcadian State*, the relationship resembles the harmonious world of the garden. The garden not

Fig. 45 Claude Monet, *The Artist's House at Argenteuil*, 1873.
Oil on canvas, 23⅞ × 29⅛ in. The Mr. and Mrs. Martin A. Ryerson Memorial Collection, 1933.1153.
Photograph © 2002, The Art Institute of Chicago. All rights reserved.

Fig. 46 Claude Monet, *Le Pont de l'Europe*, Gare Saint–Lazare, 1877.
Oil on canvas, 25¼ × 31⅞ in.
Musée Marmottan, Claude Monet, Paris, France.
Giraudon/Art Resource, New York.

only embodies the natural world, it reflects the sensibilities of its creator. In the tranquility of his own garden at Argenteuil, which he celebrates in painting after painting in the early 1870s (Fig. 45), Monet was able to find respite from the pressures of urban life. When he moved, in the 1880s, up river to Giverny, site of his famous water lily garden, he removed himself even farther from the kind of worldly turmoil he depicted in such paintings as *Le Pont de l'Europe* (Fig. 46). One of a series of paintings of the Saint-Lazare railroad station in Paris, it is strikingly similar in mood to Cole's *Destruction* from the *Course of Empire* cycle. Both paintings reflect not just the reality of modern life, on the one hand, and war, on the other, but their artists' feelings in the face of such smoke and storm. Both Cole and Monet depict the world as they do in order to tell us something about themselves, something about their own values and beliefs.

of modern life belied their emphasis on individual self-expression. Similarly, so-called "Minimal Art," such as Donald Judd's *Untitled* (Fig. 51), consisting of ten uniform stainless steel boxes spaced evenly on a wall, is mechanically impersonal. It seems purposefully devoid of any feeling or content. It insists on itself for itself. Frank Stella, whose singularly unexpressive painting is contemporary with Judd's sculpture, put it this way: "You can see the whole idea without any confusion . . . what you see is what you see."

But anyone who has ever fallen in love has experienced very real feelings that transcend the material presence of a soup can or a column of ten stainless steel boxes. There are many imaginative spaces that art has traditionally attempted to represent, from our spiritual or religious feelings, to our innermost desires and dreams, to our personal sense of what moves us emotionally. But the paradox is this: To represent the immaterial is to give it material form.

For example, the idea of daring to represent the Christian God has, throughout the history of the Western world, aroused controversy. In seventeenth-century Holland, images of God were banned from Protestant churches. As one contemporary Protestant theologian put it, "The image of God is His Word"—that is, the Bible—and "statues in human form, being an earthen image of visible, earthborn man [are] far away from the truth." In fact, one of the reasons that Jesus, the son of God, is so often represented in Western art, is that representing the son, a real person, is far easier than representing the father, a spiritual unknown who can only be imagined.

Nevertheless, artists in all cultures have always tried to depict their gods. It is the power of their imaginations that has allowed them to do so. One of the most successful in Western culture was painted by Jan van Eyck nearly 600 years ago as part of an altarpiece for the city of Ghent in Flanders (Fig. 52). Van Eyck's God is almost frail, surprisingly young, apparently merciful and kind, and certainly richly adorned. Indeed, in the richness of his vestments, van Eyck's God apparently values worldly things. Van Eyck's painting seems to celebrate a materialism that is the proper right

Fig. 52 Jan van Eyck, *God*, panel from the Ghent Altarpiece, c. 1432. St. Bavo's, Ghent. Scala/Art Resource, New York.

of benevolent kings. Behind God's head, across the top of the throne, are Latin words that, translated into English, read: "This is God, all powerful in his divine majesty; of all the best, by the gentleness of his goodness; the most liberal giver, because of his infinite generosity." God's mercy and love are indicated by the pelicans embroidered on the tapestry behind him, which in Christian tradition symbolize self-sacrificing love, for pelicans were believed to wound themselves in order to feed their young with their own blood if other food was unavailable.

Fig. 53 Pedro Perez, *God* (detail), 1981.
Gold leaf, acrylic, and costume jewelry on wood, 55 × 29½ × 2 in.
Collection Jock Truman and Eric Green. Photograph Courtesy Marilyn Pearl Gallery.

Pedro Perez, an artist born in Cuba in 1952, who emigrated to the United States at the age of fourteen, imagines God in an entirely different way (Fig. 53). Perez's God is caught up in the collision of two cultures. Here, the rich imagery of traditional Spanish Catholicism, embodied in the actual gold leaf that Perez has used to decorate the cross, is countered not only by his use of gaudy costume jewelry but also by the deeply satiric depiction of God at the work's center. Perez's God is not a conventional, dignified, white-bearded patriarch but a mellow, aging hippie, a gurulike and undeniably "cool" Santa Claus.

Both Perez's and van Eyck's Gods are extremely personal ones. They reflect each artist's imaginative response to the question of who God is and what God might look like. Any act of imagination of this kind is necessarily **subjective**—that is, it exists in the mind of the artist, not in the world as we know it. One of the most interesting differences between Warhol's *Campbell's Soup Can* and Franz Kline's *Untitled* is that the subject matter of the

Fig. 57 Pierre Auguste Renoir, *The Luncheon of the Boating Party*, 1880–1881.
Oil on canvas, 51 × 68⅛ in. Acquired 1923. The Phillips Collection, Washington, D.C.

THE IDEA OF THE BEAUTIFUL

If life itself is a fleeting event, our experiences in life are even more so. Art has traditionally concerned itself with capturing these ordinary experiences, especially the more pleasurable ones. This is one reason we all photograph family get-togethers. In painting, such depictions of everyday life are called **genre** paintings. Auguste Renoir's *The Luncheon of the Boating Party* (Fig. 57) depicts an afternoon gathering on the terrace of a restaurant near Chatou on the banks of the Seine north of Paris. So "real" is the scene that we can identify with some certainty many of the people in it. Standing at the left, with his back to the river is Alphonse Fornaise, son of the restaurant's proprietor. The woman seated below him, about to kiss the little dog, is Renoir's

future wife, Aline Charigot. The lushness of Renoir's color, and the almost tangible quality of his impressionist brushwork, lend the painting an almost sensual reality. When the painting was first exhibited in 1882, one critic captured its spirit with particular accuracy: "It is a charming work," he wrote, "full of gaiety and spirit, its wild youth caught in the act, radiant and lively, frolicking at high noon in the sun, laughing at everything, seeing only today and mocking tomorrow. For them eternity is in their glass, in their boat, and in their songs."

The implicit theme of this painting is that the charming people it depicts have transformed ordinary experience into something special, something beautiful. They have turned ordinary life into "the good life." One of the

Fig. 58 Edouard Manet, *Asparagus,* **1880.**
Oil on canvas, 6¼ × 8¼ in. Musée d'Orsay, Paris. Reunion des Musées Nationaux. Art Resource, New York.

purposes of art is to make everyday objects and events more pleasurable or beautiful, and one of the most extraordinary instances of this in the history of art is Edouard Manet's tiny painting *Asparagus*, a single spear painted in 1880 (Fig. 58). Manet sent the picture as a gift to Charles Ephrussi, who had purchased another small still life, *Bunch of Asparagus*, paying Manet rather more than the asking price. Accompanying the gift was a note from Manet: "This one was missing from your bunch."

Nothing could be more trivial, but nothing in its triviality more masterfully painted. The asparagus spear sits very near the viewer in the foreground of the painting, at a slight angle to a vast expanse of tabletop extending behind it, almost the same color as the asparagus spear but just a degree grayer. The spear itself is painted with surprising hints of color—both red and green—and with a looseness of brushwork that suggests Manet's sensual engagement with his subject. Even the abbreviated signature, scrawled in the top right of the painting, a completely anti-traditional placement, declares the immediacy of Manet's involvement with his subject matter.

But why such a degree of engagement with so slight a subject? White asparagus is one of the great delicacies of European cuisine. It is grown underground, so as to prevent any chlorophyll from greening the spear, and its

Fig. 59 Kane Kwei (Teshi tribe, Ghana, Africa), *Coffin Orange, in the Shape of a Cocoa Pod*, ca. 1970.
Polychrome wood, 34 × 105½ × 24 in. The Fine Arts Museums of San Francisco. Gift of Vivian Burns, Inc., 74.8.

season is short, a few weeks in late spring. White asparagus is, in short, a sign of the good life. And this single spear, sitting on the table, evokes all the sensual appetites of Parisian society.

In the West, we are used to approaching everyday objects made in African, Oceanic, Native American, or Asian cultures in museums as "works of art." But in their cultures of origin, such objects might be sacred tools that provide divine insight and inspiration. Or they might serve to define family and community relationships, establishing social order and structure. Or they might document momentous events in the history of a people. Or they might serve a simple utilitarian function, such as a pot to carry water or a spoon to eat with, or, as in the case of the work by Kane Kwei of Ghana, illustrated here (Fig. 59), the object might be a coffin to bury someone in. Trained as a carpenter, Kwei first made a decorative coffin for a dying uncle, who asked him to produce one in the shape of a boat. In Ghana, coffins possess a ritual significance, celebrating a successful life, and Kwei's coffins delighted the community. Soon he was making fish and whale coffins for fishermen, hens with chicks for women with large families, Mercedes Benz coffins for the wealthy, and cash crops for farmers, such as the 8½-foot cocoa bean coffin illustrated here. In 1974, an enterprising San

Fig. 60 Coconut Grater, Kapingamarangi, Caroline Islands, 1954.
Wood, shell blade attached with sennet. Height, 19 in. Private collection.

Francisco art dealer brought examples of Kwei's work to the United States, and today the artist's large workshop makes coffins for both funerals and the art market.

Another purely practical piece that transcends its functionality is a coconut grater from Micronesia (Fig. 60). Practically speaking, one sits on the back of the horse-like form and grates the coconut across the serrated blade on the top of the animal's head so that it falls into a bowl below. But the practicality of the "tool" is almost irrelevant. Its streamlined form, its almost austere simplicity, is beautiful in its own right.

Fig. 61 *Karaori* kimono, Middle Edo Period, Japan, c. 1700.
Brocaded silk, 60 in. long. Tokyo National Museum.

Perhaps the object upon which cultures lavish their attention most is clothing. Clothing serves many more purposes than just protecting us from the elements: It announces the wearer's taste, self-image, and, perhaps above all, social status. The *Karaori* kimono illustrated here (Fig. 61) was worn by a male performer who played the part of a woman in Japanese *Noh* theater. In its sheer beauty, it announced the dignity and status of the actor's character. Made of silk, brocaded with silver and gold, each panel in the robe depicts autumn grasses, flowers, and leaves. Thus the kimono is more an **aesthetic** object than a func-

tional one—that is, it is conceived to stimulate a sense of beauty in the viewer.

Almost all of us apply, or would like to apply, this aesthetic sense to the places in which we live. We decorate our walls with pictures, choose apartments for their visual appeal, ask architects to design our homes, plant flowers in our gardens, and seek out well-maintained and pleasant neighborhoods. We want city planners and government officials to work with us to make our living space more appealing.

Public space is particularly susceptible to aesthetic treatments. The great Gothic

churches of the late Middle Ages were, like the stained glass that adorned them, conceived to move the congregation's aesthetic, as much as their spiritual, sense. One of the most beautiful of these churches is the tiny chapel of Sainte Chapelle (Fig. 62), in the heart of Paris, near the great Notre Dame Cathedral. Built by the king to house religious relics he had purchased, including the Crown of Thorns and a piece of the original Cross, it was literally conceived as a giant jewel box, its windows sparkling like jewels themselves.

In fact, aesthetic considerations can sometimes lead to functional disaster, as is the case with Danish architect Jorn Utzon's Sydney Opera House (Fig. 63). Design flaws led Utzon eventually to resign from the project due to huge cost overruns, and the building's interior, which includes an opera hall, a theater, an exhibition area, a cinema, a chamber music hall, and restaurants, has never been suitable for opera. Still, the building is a source of great civic pride, and its sail-like roof is the city's landmark.

Fig. 62 Interior of Sainte Chapelle, Paris, 1243–1248.
Photo: Marvin Trachtenberg.

Fig. 63 Jorn Utzon, The Sydney Opera House, Sydney, Australia, completed 1973.
Photo: Robert Frerck/Woodfin Camp & Associates.

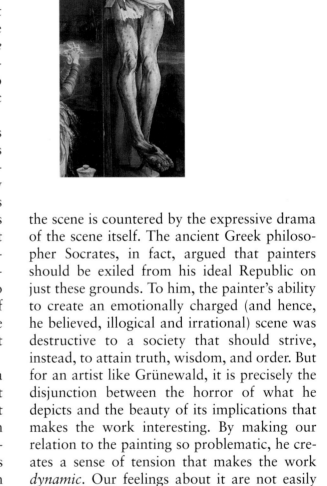

Fig. 64 Matthias Grünewald, *Crucifixion* (detail), from the *Isenheim Altarpiece*, c. 1512–1515.

Oil on paper, height 117½ in. Musée Unterlinden, Colmar. Erich Lessing/Art Resource, New York.

For many people, the main purpose of art is to satisfy our *aesthetic* sense, our desire to see and experience the beautiful. But as Robert Motherwell's representation of "the struggle between life and death" in his *Elegy to the Spanish Republic* demonstrates, art often represents other truths, other realities that seem to have little to do with a purely aesthetic response to the world.

The central *Crucifixion* panel of Matthias Grünewald's *Isenheim Altarpiece* (Fig. 64) is one of the most tragic and horrifying depictions of Christ on the cross ever painted. Many people cannot bear to look at it. Rigor mortis has set in, Christ's body is torn with wounds and scars, his flesh is a greenish gray, his feet are mangled, and his hands are stiffly contorted in the agony of death. The painting portrays suffering, pure and simple. It causes us to ask some difficult questions. Can the ugly itself ever be art? Can the ugly be made, by the artist, to appear beautiful, and if so, does that cause us to ignore the reality of the situation?

Grünewald painted this altarpiece for a hospital chapel, and it was assumed that patients would find solace in knowing that Christ had suffered at least as much as they. In this painting, the ugly and horrible are transformed into art, not least of all because, as Christians believe, resurrection and salvation await the Christ after his suffering. The line that runs down Christ's right side is, in fact, the edge of a double door that opens to reveal the Annunciation and the Resurrection behind. In the latter, Christ's body has been transformed into a pure, unblemished white, his hair and beard are gold, and his wounds are rubies.

Grünewald's *Crucifixion* shows how beauty can arise out of horror. The horror of the scene is countered by the expressive drama of the scene itself. The ancient Greek philosopher Socrates, in fact, argued that painters should be exiled from his ideal Republic on just these grounds. To him, the painter's ability to create an emotionally charged (and hence, he believed, illogical and irrational) scene was destructive to a society that should strive, instead, to attain truth, wisdom, and order. But for an artist like Grünewald, it is precisely the disjunction between the horror of what he depicts and the beauty of its implications that makes the work interesting. By making our relation to the painting so problematic, he creates a sense of tension that makes the work *dynamic*. Our feelings about it are not easily resolved. The painting demands our active response.

From a certain point of view, the experience of such dynamic tension is itself pleasing, and it is the ability of works of art to create and sustain such moments that many people value most about them. That is, many people find such moments *aesthetically* pleasing. The work of art may not itself be beautiful, but it

triggers a higher level of thought and awareness in the viewer, and the viewer experiences this intellectual and imaginative stimulus—this higher order of thought—as a form of beauty in its own right.

The *vanitas* tradition of still life painting is specifically designed to induce in the spectator a higher order of thought. *Vanitas* is the Latin term for "vanity," and *vanitas* paintings, especially popular in Northern Europe in the seventeenth century, remind us of the vanity, or frivolous quality, of human existence. One ordinarily associates the contemplation of the normal subjects of still life paintings—flowers, food, books, and so on, set on a tabletop—with the enjoyment of the pleasurable things in life. The key element in a *vanitas* painting, however, is the presence of a human skull among these objects. The skull reminds the viewer that the material world—the world of still life—is fleeting, and that death is the end of all things. Such a reminder is called a *momento mori*—literally a "reminder of death." In Philippe de Champaigne's *Vanitas* (Fig. 65), the skull reminds us that the other elements in the painting are themselves short-lived. The hourglass embodies the quick passage of time. The cut flower will quickly fade, its petals dropping to the tabletop, its beauty temporary and conditional. Even the light in the room will soon disappear as darkness falls. Nevertheless, the *vanitas* is not about death, it is about the right way to live. It reminds the viewer that the material world is not as longlasting as the spiritual, and that spiritual well-being is of greater importance than material wealth.

Robert Mapplethorpe's *Self-Portrait* of 1988 (Fig. 66) purposefully invokes these same themes, but with a certain irony. Mapplethorpe means to draw an analogy between his own face and the skull that tops the cane he holds. We are invited to see death in his face. When this self-portrait was taken, Mapplethorpe was HIV-positive. Soon after, in the spring of 1989, he died of AIDS. Mapplethorpe frankly acknowledges the vanity of his lifestyle in the *Self-Portrait*. He accepts death as the price of his pleasure, turning the *vanitas* tradition on its head. But he also means the *Self-Portrait* to be read as a mirror—as all photography is in some sense a mirror—a mirror that he holds up to us. He means us to see ourselves in its light.

Fig. 65 Philippe de Champaigne (1602–1674), *Still Life* or *Vanitas* (tulip, skull, and hour glass). Oil on panel, 11¼ × 14¾ in. Musée des Tesse, Le Mans, France. Photo Giraudon/Art Resource, New York.

Fig. 66 Robert Mapplethorpe, *Self-Portrait*, 1988.
© 1988 Estate of Robert Mapplethorpe.

Pablo Picasso's Les Demoiselles d'Avignon

Not long after finishing his portrait of Gertrude Stein (Fig. 54), Picasso began working on a large canvas, nearly eight feet square, that would come to be considered one of the first major paintings of the modern era—and one of the least beautiful—*Les Demoiselles d'Avignon* (Fig. 69). The title, chosen not by Picasso but by a close friend, literally means "the young ladies of Avignon," but its somewhat tongue-in-cheek reference is specifically to the prostitutes of Avignon Street, the red-light district of Barcelona, Spain, Picasso's hometown. We know a great deal about Picasso's process as he worked on the canvas from late 1906 into the early summer months of 1907, not only because many of his working sketches survive but also because the canvas itself has been submitted to extensive examination, including X-ray analysis. This reveals early versions of certain passages, particularly the figure at the left and the two figures on the right, which lie under the final layers of paint.

Fig. 67 Pablo Picasso, *Medical Student, Sailor, and Five Nudes in a Bordello* (Study for *Les Demoiselles d'Avignon*), Paris/early 1907. Charcoal and pastel, 18½ × 25 in. Oeffentliche Kunstsammlung, Kupferstichkabinett Basel. Photo: Oeffentliche Kunstsammlung, Martin Buhler. © 2003 Estate of Pablo Picasso/Artists Rights Society (ARS), New York.

An early sketch (Fig. 67) reveals that it was originally conceived to include seven figures—five prostitutes, a sailor seated in their midst, and, entering from the left, a medical student carrying a book. Picasso probably had in mind some anecdotal or narrative idea contrasting the dangers and joys of both work and pleasure, but he soon abandoned the male figures. By doing so, he involved the viewer much more fully in the scene. No longer does the curtain open up at the left to allow the medical student to enter. Now the curtain is opened by one of the prostitutes as if she were admitting us, the audience, into the bordello. We are implicated in the scene.

And an extraordinary scene it is. Picasso seems to have willingly abdicated any traditional aesthetic sense of beauty. There is nothing enticing or alluring here. Of all the nudes, the two central ones are the most traditional, and their facial features, particularly their brows and oval eyes, are closely related to Gertrude Stein's in his portrait of her. But their bodies are composed of a series of long lozenge shapes, hard angles, and only a few traditional curves. It is unclear whether the second nude from the left is standing or sitting, or possibly even lying down. (In the early drawing, she is clearly seated.) Picasso seems to have made her position in space intentionally ambiguous.

Fig. 68 Pablo Picasso, *Study for the Crouching Demoiselle*, 1907. Gouache on paper, 24¾ × 18⅞ in. Musée Picasso, Paris. Réunion des Musées Nationaux/© 2003 Estate of Pablo Picasso/ Artists Rights Society (ARS), New York.

We know, through X-rays, that all five nudes originally looked like the central two. We also know that sometime after he began painting *Les Demoiselles*, Picasso visited the Trocadero, now the Museum of Man, in Paris and saw in its collection of African sculpture, particularly African masks, an approach to the representation of the human face that was extraordinarily powerful. As in his portrait of Gertrude Stein, the masks freed him from representing exactly what his subjects looked like and allowed him to represent his *idea* of them instead.

That idea is clearly ambivalent. Picasso probably saw in these masks something of the same "fear and darkness" that Kenneth Clark would find in them sixty years later in his book *Civilisation* (see the discussion of the African masks on pages 28–29). But it is also clear that he found something liberating in them. They freed him from a slavish concern for accurate representation, and they allowed him to create a much more emotionally charged scene than he would have otherwise been able to accomplish. Rather than offering us a single point of view, he offers us many, both literally and figuratively. The painting is about the ambiguity of experience.

Nowhere is this clearer than in the squatting figure in the lower right hand corner of the painting. She seems twisted around on herself in the final version, her back to us, but her head impossibly turned to face us, her chin resting on her grotesque, clawlike hand. We see her, in other words, from both front and back. (Notice, incidentally, that even the nudes in the sketch possess something of this "double" point of view: their noses are in profile though they face the viewer.) But this crouching figure is even more complex. An early drawing of her (Fig. 68) reveals that her face was originally conceived as a headless torso. What would become her hand is originally her arm. What would become her eyes were her breasts. And her mouth would begin as her belly button. Here we are witness to the extraordinary freedom of invention that defines all of Picasso's art.

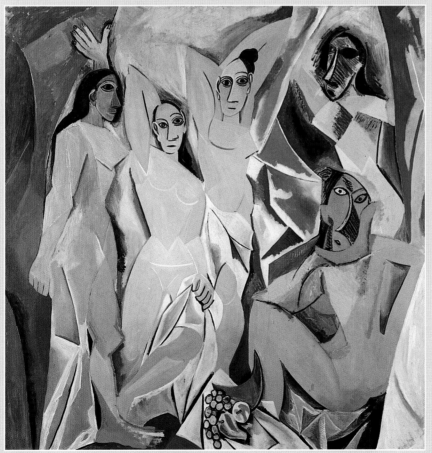

**Fig. 69 Pablo Picasso,
Les Demoiselles d'Avignon, 1907.**
Oil on canvas, 8 ft. × 7 ft. 8 in.
Collection, Museum of Modern Art, New York.
Acquired through the Lillie P. Bliss Bequest.
Photograph © 1999 The Museum of Modern Art,
New York. Licensed by Scala-Art Resource, New York.
© 2003 Estate of Pablo Picasso/Artists
Rights Society (ARS), New York.

THE CRITICAL PROCESS:

Thinking about the Themes of Art

At the time of his death and for long afterward, Mapplethorpe was probably the world's most notorious photographer, known to the general public chiefly for his photographs of sadomasochistic and homoerotic acts. Known as the "X Portfolio," these photographs were the focus of a continuing Congressional debate, headed by Senator Jesse Helms of North Carolina, over funding of the National Endowment for the Arts, which partially funded their scheduled exhibition at the Corcoran Gallery in Washington, D.C. the summer after Mapplethorpe's death. Many of these same photographs were seized, a year after his death, when they were exhibited at the Cincinnati Arts Center, as police arrested the Center's director, Dennis Barrie, for pandering and the use of a minor in pornography.

In the midst of these controversies, the remainder of Mapplethorpe's work was ignored. The "X Portfolio" was meant to be seen, for instance, in conjunction with a "Y Portfolio," a series of still lifes of flowers. Mapplethorpe's many stunningly beautiful flower photographs, such as *Parrot Tulip* (Fig. 70), take on a special poignancy in relation to his other work. In what way is this photograph not merely a still life? In what particular ways does it acknowlege the *vanitas* tradition? You might want to consider more than just the vase and flower. What about the lighting? What does it suggest? How does it compare to Philippe de Champaigne's *Vanitas*? Assuming, as well, that Mapplethorpe does have an interest in erotic, even pornographic imagery, how does this image reflect or represent that aspect of his mind? What, all told, contributes to the aesthetic beauty of this image? What tensions are created in the collision of erotic and *vanitas* themes?

Fig. 70 Robert Mapplethorpe, *Parrot Tulip*, 1985.
© 1985 Estate of Robert Mapplethorpe.

CHAPTER 4

SEEING THE VALUE IN ART

ART AND ITS RECEPTION

ART, POLITICS, AND PUBLIC SPACE
Three Public Sculptures

WORKS IN PROGRESS
Guillermo Gómez-Peña's *Temple of Confessions*

The "Other" Public Art

THE CRITICAL PROCESS
Thinking about the Value of Art

A t the end of Chapter 3, we used Robert Mapplethorpe's *Parrot Tulip* to suggest the many complex meanings that works of art can have. Mapplethorpe's photography raises key questions about the **value** of art—not its monetary worth, but its intrinsic value to the individual and to society as a whole. When the Corcoran Gallery decided not to exhibit Mapplethorpe's work in the summer of 1989, fearing that to do so would be to jeopardize continued Congressional funding of the National Endowment for the Arts, the show quickly moved to a smaller Washington gallery, Project for the Arts, where nearly fifty thousand people visited it in twenty-five days. After leaving Washington, the exhibition ran without incident in both Hartford, Connecticut, and Berkeley, California. And as mentioned in Chapter 3, the show drew record crowds in Cincinnati, at least in part because people wanted to decide for themselves whether the work was "criminally obscene" as the county sheriff alleged. The Cincinnati Arts Center, the Robert Mapplethorpe Foundation, and the Mapplethorpe

estate together countered the sheriff's action by filing suit to determine whether the photographs were obscene under Ohio state law. "We want a decision on whether the work as a whole has serious artistic value," they stated.

And it is, of course, the question of *artistic* value that confronts us. The monetary value of the works was, at least, confirmed. *The New York Times* reported that the national publicity surrounding the exhibition had notably increased the prices of Mapplethorpe's work. And its popularity with the public seemed established—the Mapplethorpe Foundation was realizing significant new dollars from the sale of books, T-shirts, and posters. But do monetary value and popularity determine the artistic value of the works?

Senator Jesse Helms certainly didn't think that Mapplethorpe's works possessed artistic

Are you going to let politics kill Art?

Art should be supported by government and protected from politics.

Until now that has been the enlightened principle that has guided all legislation affecting the Arts in America.

Art must live free to survive.

That is why it is crucial that every friend of the Arts send a message to Washington right now.

There is still time for cool heads and common sense to prevail over the Helms amendment to the appropriations bill for the National Endowment for the Arts.

But the Arts desperately need your help now. Today.

It is with a sense of the greatest urgency that we ask you to write to the people in Congress who will be meeting in the next few days in a crucial conference between the Appropriations Subcommittees of both Houses to resolve differences in the National Endowment for the Arts legislation.

The names and addresses of the Congressional people to contact are listed below.

You are probably aware of the controversy that inspired the devastating amendment by Senator Jesse Helms. In a July 28 editorial, entitled "The Helms Process," the New York Times wisely urged Congress to protect the legislation that insulates art from politics. It observed:

"The Helms process would drain art of creativity, controversy – of life... and would plunge one esthetic question after another into the boiling bath of politics. That's unlikely to be good for politics; it would surely be fatal to Art."

Don't let moral panic and political pressure kill the Arts.

Don't assume that "someone else" will fight this battle for you.

Write, call, fax, or telegram the Congressional leaders listed below *now* and urge them to delete the Helms provisions from the conference report on H.R. 2788.

Trustees of the Whitney Museum of American Art

Fig. 71 *Are you going to let politics kill Art?* Whitney Museum of American Art Advertisement,
The New York Times, Sept. 7, 1989.
Courtesy of the Trustees of the Whitney Museum of American Art.

Fig. 78 Etienne-Jules Marey, *Man Walking in Black Suit with White Stripe Down Sides*, 1886.
Collection Musée Marey, Beaune, France. Photo: Jean-Claude Couval.

Muybridge had used a trip-wire device in an experiment commissioned by California governor Leland Stanford to settle a bet about whether there were moments in the stride of a trotting or galloping horse when it was entirely free of the ground. As a result of Muybridge's photographs, Marey began to use the camera himself, using models dressed in a black suits with white points and stripes (Fig. 79) that allowed him to study, in images created out of a rapid succession of photographs, the flow of their motion. These images, called "chrono-photographs," literally "photographs of time," (Fig. 78) are startlingly like Duchamp's painting. "In one of Marey's books," Duchamp later explained, "I saw an illustration of how he indicated [movement] . . . with a system of dots delimiting the different movements. . . . That's what gave me the idea for the execution of [the] *Nude*."

Marey, Muybridge, and Duchamp had all embarked, we can now see, on the same path, a path that led to the invention of the motion picture. On December 28, 1895, at the Grand Café on the Boulevard des Capucines in Paris, the Lumière brothers, who knew Marey and his work well, projected motion pictures of a baby being fed its dinner, a gardener being doused by a hose, and a train racing directly at the viewers, causing them to jump from their seats. Duchamp's vision had already been confirmed, but the public had not yet learned to see it.

Fig. 79 Etienne-Jules Marey, *Man in Black Suit with White Stripe Down Side of Chronophotograph Motion Experiment*, 1883.
Collection Musée Marey, Beaune, France. Photo: Jean-Claude Couval.

A more recent example of the same phenomenon, of a public first rejecting and then coming to understand and accept a work of art, is Maya Lin's *Vietnam Memorial* in Washington, D. C. (Fig. 80). Lin's work was selected from a group of more than 1,400 entries in a national competition. At the time her proposal was selected, Lin was twenty-two years old, a recent graduate of Yale University where she had majored in architecture.

Many people at first viewed the monument as an insult to the memory of the very soldiers to whom it was supposed to pay honor. Rather than rise in majesty and dignity above the Washington Mall, like the Washington Monument or the Jefferson Memorial, it descends below earth level in a giant V, over two hundred feet long on each side. It represents nothing in particular, unlike the monument to the planting of the flag on the hill at Iwo Jima, which stands in Arlington National Cemetery, directly across the river. If Lin's memorial commemorates the war dead, it does so only abstractly.

And yet, this anti-monumental monument has become the most visited site in Washing-ton. In part, people recognize that it symbolizes the history of the Vietnam War itself, which began barely perceptibly, like the gentle slope that leads down into the V, then deepened and deepened in crisis, to end in the riveting drama of the American withdrawal from Saigon. Though technically over, the war raged on for years in the nation's psyche, while at the same time a slow and at times almost imperceptible healing process began. To walk up the gentle slope out of the V symbolizes for many this process of healing. The names of the 58,000 men and women who died in Vietnam are chiseled into the wall in the order in which they were killed. You find the name of a loved one or a friend by looking it up in a register. As you descend into the space to find that name, or simply to stare in humility at all the names, the polished black granite reflects your own image back at you, as if to say that your life is what these names fought for.

Like Manet's *Luncheon* and Duchamp's *Nude*, Lin's piece was misunderstood by the public. But unlike either, it was designed for public space. As we have seen, the public as a

Fig. 80 Maya Ying Lin, *Vietnam Memorial*, Washington, D. C., 1982.
Polished black granite, length 492 ft. Woodfin Camp & Associates.

Fig. 81 Alexander Calder, *La Grand Vitesse*, 1969.
Painted steel plate, height 43 ft., width 55 ft. Calder Plaza, Vandenberg Center, Grand Rapids, Michigan.

whole is a fickle audience, and the fate of art in public places can teach us much about how and why we, as a culture, value art.

ART, POLITICS, AND PUBLIC SPACE

A certain segment of the public has always sought out art in galleries and museums. But as a general rule, (except for statues of local heroes mounted on horseback in the public square—of interest mainly to pigeons), the public could ignore art if they wished. In 1967, when Congress first funded the National Endowment for the Arts, that changed. An Arts in Public Places Program was initiated, quickly followed by state and local programs nationwide that usually required 1% of the cost of new public buildings to be dedicated to purchasing art to enhance their public spaces. Where artists had before assumed an interested, self-selected audience, now everyone was potentially their audience. And like it or not, artists were thrust into an activist role—their job, as the NEA defined it, to educate the general public about the value of art.

The Endowment's plan was to expose the nation's communities to "advanced" art, and the Arts in Public Places Program was conceived as a mass-audience art appreciation course. Time and again, throughout its history, it commissioned pieces that the public initially resisted but learned to love. Alexander Calder's *La Grand Vitesse* (Fig. 81) in Grand Rapids, Michigan, was the first piece commissioned by the Program. The selection committee was a group of four well-known outsiders, including New York painter Adolph Gottlieb and Gordon Smith, director of the Albright-Knox Art Gallery in Buffalo, N.Y., and three local representatives, giving the edge to the outside experts, who were, it was assumed, more knowledgeable about art matters than their local counterparts. In the case of *La Grand Vitesse*, the public reacted negatively to the long organic curves of Calder's praying mantis-like forms but soon adopted the sculpture as a civic symbol and a source of civic pride. The NEA and its artists were succeeding in teaching the public to value art for art's sake.

Figs. 82 & 83 Carl Andre, *Stone Field Sculpture*, Hartford, Connecticut, 1977.
36 glacial boulders, overall 51 × 290 ft. Collection: City of Hartford, Connecticut.
Courtesy Paula Cooper Gallery, New York. © Carl Andre/Licensed by VAGA, New York.

Three Public Sculptures

To value art for art's sake is to value it as an aesthetic object, to value the beauty of its forms rather than its functional practicality or its impact on social life. The NEA assumed, however, that teaching people to appreciate art would enhance the social life of the nation. Public art, the Endowment believed, would make everyone's life better by making the places in which we live more beautiful, or at least more interesting. The three public sculptures considered in this section have all tested this hypothesis.

Carl Andre's *Stone Field Sculpture* (Figs. 82 and 83), was commissioned in 1977 by the Arts in Public Places Program. Designed for a triangular public green at the corner of Gold and Main Streets in downtown Hartford, Connecticut, it offers a particularly clear example of how the community came to appreciate a work of art that it at first regarded as a frivolous waste of tax dollars. The work consists of thirty-six boulders, ranging in weight from one thousand pounds to eleven tons, placed in eight rows,

beginning with one boulder in the first row and increasing by one boulder in each subsequent row. The largest boulder is situated at the narrowest end of the green and the row containing the eight smallest boulders is at the other end. The stones themselves are uncut, natural boulders from a sand and gravel pit in nearby Bristol, Connecticut. About a third of them are Connecticut sandstone, the same material used in many Hartford buildings, and the rest are granite, basalt, schist, gneiss, and serpentine.

Many people in Hartford felt that the work hardly qualified as art at all. They were doubly incensed that money had been spent on it at a time when the jobless rate was very high. For example, the Republican candidate for mayor at the time called it "another slap in the face for the poor and elderly." Residents in the apartment tower across the street called meetings to discuss having the boulders removed. "There was a lot of real hostility during the installation," Andre told *The New Yorker* magazine. "People would come up and start screaming at me—really screaming. People from all social and economic classes. I was quite startled by the vehemence." But as people came more and

more to understand Andre's intentions—and the issue was constantly before them in the press—they began to change their minds.

In the first place, Andre wanted to create a tranquil space that would parallel, both emotionally and physically, the 300-year-old graveyard of Center Church alongside it. He also wanted to juxtapose human time—Center Church's first minister, appointed in 1633, was the great Puritan preacher Thomas Hooker—with the far vaster scale of geological time embodied in the rocks. He saw the site as facilitating a sort of dialogue between gravestones and quarry stones, as the meeting place of human history and natural time. "What I really hate," he said, "is to see a piece of abstract art in a public space that's nothing more than a disguised man-on-horseback. That just doesn't interest me at all." He thinks of his work, instead, in terms of movement in and around the work. "My idea of a piece of sculpture is a road," he has said. "We don't have a single point of view for a road at all, except a moving one, moving along it. Most of my works—certainly the successful ones—have been ones that are in a way causeways—they cause you to make your way along them or around them. . . . There should be no one place, nor even group of places . . . where you should be." By activating the viewer physically, Andre believes his work will activate the viewer imaginatively. To his way of thinking, this is a better kind of public sculpture, no longer just aesthetically pleasing but intellectually compelling.

Richard Serra's controversial *Tilted Arc* (Fig. 84) received an entirely different reception. When it was originally installed in 1981 in Federal Plaza in lower Manhattan, there was only a minor flurry of negative reaction. However, beginning in March 1985, William Diamond, newly appointed Regional Administrator of the General Services Administration, which had originally commissioned the piece, began an active campaign to have it removed. At the time, nearly everyone believed that the vast majority of people working in the Federal Plaza complex despised the work. In fact, of the approximately 12,000 employees in the complex, only 3,791 signed the petition to have it removed, while nearly as many—3,763—signed a petition to save it. Yet the public perception was that the piece was "a

Fig. 84 Richard Serra, *Tilted Arc*, 1981.
Cor-Ten steel, 12 ft. × 120 ft. × 2½ in. Installed Federal Plaza, New York City. Destroyed by the U.S. Government, 3/15/89. Artists Rights Society, Inc.

scar on the plaza" and "an arrogant, nose-thumbing gesture," in the words of one observer. During the night of March 15, 1989, against the artist's vehement protests and after he had filed a lawsuit to block its removal, the sculpture was dismantled and its parts stored in a Brooklyn warehouse. It has subsequently been destroyed.

From Serra's point of view, *Tilted Arc* was destroyed when it was removed from Federal Plaza. He had created it specifically for the site, and once removed, it lost its reason for being. In Serra's words: "Site-specific works primarily engender a dialogue with their surroundings. . . . It is necessary to work in opposition to the constraints of the context, so that the work cannot be read as an affirmation of questionable ideologies and political power." Serra *intended* his work to be confrontational. It was political. He had assumed the role of the artist as *analyst*. That is, he felt that Americans were

divided from their government, and the Arc divided the plaza in the same way. Its tilt was ominous—it seemed ready to topple over at any instant. Serra succeeded in questioning political power probably more dramatically than he ever intended, but he lost the resulting battle. He made his intentions known and understood, and the work was judged as fulfilling those intentions. But those in power judged his intentions negatively, which is hardly surprising, considering that Serra was challenging their very position and authority.

One of the reasons that the public has had difficulty, at least initially, accepting so many of the public art projects that have been funded

by both the NEA and Percent-for-art programs is that they have not found them to be aesthetically pleasing. The negative reactions to Andre's boulders and Serra's arc are typical. If art must be beautiful, then neither work is evidently art. And yet, as the public learned what each piece meant, many came to value the works, not for their beauty but for their insight, for what they revealed about the places they were in. Serra's work teaches us a further lesson about the value of art. Once public art becomes activist, promoting a specific political or social agenda, there are bound to be segments of the public that disagree with its point of view.

A classic example is Michelangelo's *David* (Fig. 85). Today it is one of the world's most famous sculptures, considered a masterpiece of Renaissance art. But it did not meet with universal approval when it was first displayed in Florence, Italy, in 1504. The sculpture was originally commissioned three years earlier, when Michelangelo was twenty-six years old, by the Opera del Duomo ("Works of the Cathedral"), a group founded in the thirteenth century to look after the Florence cathedral and to maintain works of art. It was to be a public piece, designed for outdoor display in the Piazza della Signoria, the plaza where public political meetings took place on a raised platform called the *arringhiera* (from which the English word "harangue" derives). Its political context, in other words, was clear. It represented David's triumph over the tyrant Goliath and was meant to symbolize Republican Florence, the city's freedom from foreign and papal domination and from the rule of the Medici family as well.

The *David* was itself, as everyone in the city knew, a sculptural triumph in its own right. It was carved from a giant sixteen-foot-high block of marble that had been quarried forty years earlier. Not only was the block riddled with cracks, forcing Michelangelo to bring all his skills to bear, but earlier sculptors, including Leonardo da Vinci, had been offered the problem stone and refused.

When the *David* was finished in 1504, it was moved out of the Opera del Duomo at eight in the evening. It took forty men four days to move it the six hundred yards to the Piazza della Signoria. It required another twenty days to raise it onto the *arringhiera*.

The entire time its politics hounded it. Each night, stones were hurled at it by supporters of the Medici, and guards had to be hired to keep watch over it. Inevitably, a second group of citizens objected to its nudity, and before its installation a skirt of copper leaves was prepared to spare the general public any possible offense. The skirt is today long gone. By the time the Medici returned to power in 1512, the *David* was a revered public shrine, and it remained in place until 1873, when it was replaced by a copy and moved to the Opera del Duomo to protect it from a far greater enemy than the Medici, the natural elements themselves. Michelangelo's *David* suggests another lesson about the value of art. Today, we no longer value the sculpture for its politics but rather for its sheer aesthetic beauty and accomplishment. It teaches us how important aesthetic issues remain, even in the public arena.

The "Other" Public Art

Public art, as these last three examples make clear, has been associated particularly with sculptural works. Whatever social issues or civic pride they may symbolize, however, they are not active agents of change.

Still, there are other fully activist kinds of public art that are designed to have direct impact on our lives. For example, during the winter of 1987-88, an estimated 70,000 people were homeless in New York City alone. Artist Krzysztof Wodiczko, who had fled Poland in 1984 and had lived in the United States for only four years, was appalled at the situation, and while he felt that "the fact that people are compelled to live on the streets is unacceptable," he also proposed to do something about it. Given the failure of the city's shelter system, he asked himself, "What can we do for individuals struggling for self-sufficiency on the steets today?" His solution was a vehicle for the homeless (Figs. 86 & 87). As ingenoius as the vehicle itself is, providing a level of safety and creature comforts on the streets, Wodiczko's project is also motivated by more traditional issues. He draws attention to what the viewer has failed, or refuses, to see, and thus attempts "to create a bridge of empathy between homeless individuals and observers."

Fig. 86 (above right) Krzysztof Wodiczko, *Homeless Vehicle*, 1988.
Preliminary drawing showing vehicle in washing, sleeping, and resting position (day). Courtesy of the Artist and Gallery Lelong, New York.

Fig. 87 (right) Krzysztof Wodiczko, *Homeless Vehicle* in New York City, 1988–1989.
Color photograph. Courtesy of the Artist and Gallery Lelong, New York.

Guillermo Gómez-Peña's
Temple of Confessions

Fig. 88 Guillermo Gómez-Peña and Coco Fusco, *Two Undiscovered Amerindians Visit London*, May 1992. Site-specific performance, London, England. Photo: Peter Barker.

Fig. 89 Guillermo Gómez-Peña, *The Cruci-fiction Project,* 1994. Site-specific performance, Marin headlands, California. Photo: Victor Zaballa. Courtesy Headlands Center for the Arts.

n his work, Mexican artist and activist Guilliermo Gómez-Peña has chosen to address what he considers to be the major political question facing North America—relations between the United States and

Mexico. For him, the entire problem is embodied in the idea of the "border." As the border runs from the Gulf of Mexico up the Rio Grande, it has a certain geographical reality, but as it extends west from Texas, across the bottom of New Mexico, Arizona, and California, its arbitrary nature becomes more and more apparent until, when it reaches the Pacific Ocean between San Diego and Tijuana, it begins to seem patently absurd. Gómez-Peña's work dramatizes how the geographical pseudo-"reality" of the border allows us, in the United States, to keep out what we do not want to see. The "border" is a metaphor for the division between ourselves and our neighbors, just as the difference in our national languages, English and Spanish, bars us from understanding one another. Gómez-Peña's work is an ongoing series of what he calls

"border crossings," purposeful transgressions of this barrier.

Gómez-Peña asks his audience in the United States to examine their own sense of their cultural superiority. He laces all his performances with Spanish in order to underscore to his largely English-speaking audience that he, the Mexican, is bilingual, and they are not. In one of his most famous pieces, *Two Undiscovered Amerindians* (Fig. 88), a collaboration with Coco Fusco, he and Fusco dressed as recently discovered, wholly uncivilized "natives" of the fictitious island of Guatinaui in the middle of the Gulf of Mexico. At places such as the Walker Art Center in Minneapolis, Columbus Plaza in Madrid, Spain, and in London, England, they performed, in their own words, "authentic and traditional tasks, such as writing on a laptop computer, watch-

ing television, sewing voodoo dolls and doing exercise." Audience members could pay for "authentic" dances or for Polaroid snapshots. To the artists' astonishment, nearly half of the audience members assumed that they were real, and huge numbers of people didn't find the idea of supposed natives locked in a cage as part of an "art" or "anthropological" exhibit objectionable or even unusual. The project pointed out just how barbaric the assumptions of Western culture sometimes are.

Since 1994, Gómez-Peña has been collaborating with Roberto Sifuentes. In *The Crucifiction Project* (Fig. 89), the two, dressed as Mexican stereotypes as a migrant worker and a lowrider, crucified themselves on two twelve-by-eight-foot wooden crosses to protest immigration policy. In an artists' statement they identified themselves as modern-day versions of Dimas and Gestas, the two small-time thieves who were crucified along with Jesus Christ. Over three hundred audience members watched them suffer for nearly three hours until, finally, someone took it upon themselves to set them free.

Another ongoing performance and installation work is titled *The Temple of Confessions* (Fig. 90). Gomez-Peña and Sifuentes exhibit themselves, for five-to-seven hours a day, inside Plexiglass booths. Sifuentes's arms and face are painted with tattoos, his bloody T-shirt is riddled with bullet holes. He shares his booth with 50 cockroaches, a four-foot iguana, and what appear to be real weapons and drug paraphernalia. In his own booth, Gómez-Peña sits on a toilet (or wheelchair), dressed as what he calls a "curio shop shaman." Hundreds of souvenirs hang from his chest and waist. He shares his box with live crickets, stuffed animals, tribal musical instruments, and a giant ghetto blaster. A violet neon light frames the entire altar and a highly "techno" soundtrack plays constantly.

In front of each booth, there is a church kneeler with a microphone to allow audience members to confess their "intercultural fears and desires." At least a third of all visitors eventually do so. Gómez-Peña describes the effect: "Emotions begin to pour forth from both sides. Some people cry, and in doing so, they make me cry. Some express their sexual desire for me. Others spell their hatred, their contempt, and their fear. . . . The range goes from confessions of extreme violence and racism toward Mexicans and other people of color, to expressions of incommensurable ten-

Fig. 90 Guillermo Gómez-Peña and Roberto Sifuentes, *The Temple of Confessions*, 1994.
Site-specific performance, Detroit Institute of the Arts, 1994. Photo: Dirk Bakker.

derness and solidarity with us. Some confessions are filled with guilt, or with fear of invasion, violence, rape, and disease. Others are fantasies about wanting to be Mexican or Indian, or vice versa: Mexicans and Latinos suffused in self-hatred wanting to be Anglo, Spanish, or 'blond.'" At night, after each performance, Sifuentes and Gómez-Peña listen to tapes of all the confessions of the day. The most revealing ones are edited and incorporated into the installation soundtrack.

Fig. 91 Suzanne Lacy and Leslie Labowitz, *In Mourning and in Rage,* 1977.
Photo: Susan R. Mogul.

coverage of the performance, an elaborately staged event conceived to be both visually powerful and politically telling. Ten women stepped from a hearse wearing veils draped over structures that, headress-like, made each figure seven feet tall. Representing the ten victims of the Hillside Strangler, a serial killer then on the loose in Los Angeles, each of the figures, in turn, addressed the media. They linked the so-called Strangler's crimes to a national climate of violence against women and the sensationalized media coverage that supports it. As Lacy and Labowitz have explained: "The *art* is in making it compelling; the *politics* is in making it clear. . . . *In Mourning and in Rage* took this culture's trivialized images of mourners as old, powerless women and transformed them into commanding seven-foot-tall figures angrily demanding an end to violence against women." To maximize the educational and emotional impact of the event, the performance itself was followed up by a number of talk show appearances and activities organized in conjunction with a local rape hot line program.

This model for political art represents the end of Lacy's spectrum of possible roles for the artist that opened this chapter. On the day of *In Mourning and in Rage*'s performance in 1977, the artists assumed an activist role, engaging the public and the press in a confrontational way. It is worth remembering,

Another example of this activist direction in art is the collaborative performance piece created by Suzanne Lacy and Leslie Labowitz, *In Mourning and in Rage* (Fig. 91), which was performed in December 1977 outside the Los Angeles City Hall to protest violence against women in America's cities. It was timed to coincide with a Los Angeles city council meeting. Lacy and Labowitz wanted to ensure media

Fig. 92 Group Material, *Group Material Installation View (AIDS Timeline),* 1989.
Courtesy University of California, Berkeley Art Museum. Photo by Benjamin Blackwell.

CHAPTER 5

LINE

VARIETIES OF LINE
Outline and Contour Line

Implied Line

QUALITIES OF LINE
Expressive Line

WORKS IN PROGRESS
Vincent Van Gogh's *The Sower*

Analytic or Classical Line

WORKS IN PROGRESS
Hung Liu's *Three Fujins*

Line and Cultural Convention

WORKS IN PROGRESS
J.-A.-D. Ingres's *The Turkish Bath*

THE CRITICAL PROCESS
Thinking about Line

The painting at the left, Paul Cézanne's *The Basket of Apples* (Fig. 94), is a still life, but it is also a complex arrangement of visual elements: lines and shapes, light and color, space, and, despite the fact that it is a "still" life, time. Upon first encountering the painting, most people sense immediately that it is full of what appear to be visual "mistakes." The edges of the table, both front and back, do not line up. The wine bottle is tilted sideways, and the apples appear to be spilling forward, out of

Fig. 96 Pablo Picasso, *Pitcher, Candle, and Casserole,* 1945.
Oil on canvas, 32¼ × 41¾ in. Musée National d'Art Moderne, Centre National
d'Art et de Culture Georges Pompidou, Paris.
© 2003 Estate of Pablo Picasso/Artists Rights Society (ARS), New York.
Superstock, Inc.

static, to engage the imagination of the viewer. He has taken the visual elements of line, space, and texture and has deliberately manipulated them as part of his **composition**, the way he has chosen to organize the canvas. As we begin to appreciate how the visual elements routinely function—the topic of this and the next four chapters—we will better appreciate how Cézanne manipulates them to achieve the wide variety of effects in this still life.

VARIETIES OF LINE

One of the most fundamental elements of art is **line**. If you take pencil to paper, you can draw a straight line or a curved one. Straight lines can be vertical, horizontal, or diagonal. Curved lines can be circular, or oval (or segments of circles and ovals), or they can be freeform. Lines can abruptly change direction, in an angle or a curve. They seem to possess direction—they can rise or fall, head off to the left or to the right, disappear in the distance. Lines can divide one thing from another, or they can connect things together. They can be thick or thin, long or short, smooth or agitated. Almost all types of line are apparent in Jean Tinguely's work from his portfolio of prints, *La Vittoria* (Fig. 95). Tinguely's frenzied image is an explosion of lines, each playing off the others in a manner as odd, and as full of imaginative possibility, as the wrench, in the print's upper left, which turns a butterfly.

the basket, onto the white napkin, which in turn seems to project forward, out of the picture plane. Indeed, looking at this work, one feels compelled to reach out and catch that first apple as it rolls down the napkin's central fold and falls into our space.

However, Cézanne has not made any mistakes at all. Each decision is part of a strategy designed to give back life to the "still life"— which in French is called *nature morte*—"dead nature." He wants to animate the picture plane, to make its space *dynamic* rather than

Outline and Contour Line

Another important feature of line is that it indicates the edge of two- or three-dimensional shapes or forms. This edge can be indicated either directly, by means of an actual **outline**, as in Picasso's *Pitcher, Candle, and Casserole* (Fig. 96), or indirectly, as in Richard Diebenkorn's *Untitled* drawing (Fig. 97). In Picasso's painting, each of the objects on the table, and the table itself, is established by *actual* black outlines drawn at their edges. Picasso has then filled in each of the outlined areas with large fields of color. Unlike Picasso, Diebenkorn has not drawn lines in order to indicate the edges of his figure, such as her arm or the crossed leg under her dress. Rather, it is as if each line surrounds and establishes a volume. This is perhaps clearest in the lines that establish the model's left leg and hip, which do not define a flat shape but rather the fullness and recession of her anatomy. From the point of view of the artist, there are no actual lines in this work, even though, perceptually, they are quite apparent. There are only volumes that make lines *appear* to us as they curve away. We call these **contour lines**.

Implied Line

Another variety of line that depends upon perception is *implied*. We perceive **implied lines** even though they neither exist in or mark the edge of our visual field. We visually "follow," for instance, the line indicated by a pointing finger. If someone nods toward us, we recognize the direction of that nod, the line of communication thus established between us. Movement also creates implied lines, as we saw in Chapter 4 in the photographs of Eadweard Muybridge and Etienne-Jules Marey (Figs. 77-79). In his *Untitled* drawing (Fig. 98), Keith Haring draws actual lines to indicate the motion of waving hands and jumping dogs. Haring began his career as a graffiti artist in the New York City subways and made his work available to a large audience through a retail outlet called the Pop Shop. Though Haring died of AIDS in 1990, the Pop Shop still sells Haring-designed posters, T-shirts, refrigerator magnets, radios, buttons, Swatch watches, and other items. The piece reproduced here is typical of Haring's work. Deceptively simple in its outlines, it is not just a "fun" line drawing. It is meant to represent the fatal shooting of John Lennon. Lennon's assassin is only one in an endless line of hyenas, a hideous all-consuming public that believes it has the right to enter into any star's heart and soul.

Fig. 99 Alexander Calder, *Dots and Dashes*, 1959.

Collection of Peter and Beverly Lipman. Whitney Museum of Art.

Alexander Calder's mobiles (Fig. 99), composed of circular disks and wing-shaped discs that spin around their points of balance on arched cantilevers, are designed to create a sense of virtual volume as space is filled out by implied line. The sequence of photographs of *Dots and Dashes* (Fig. 100) clearly reveals how Calder's sculpture changes as it moves. The lines generated here are equivalent, in Calder's mind, to the lines created by a dancer moving through space.

Dashes in motion, 1959.

ical Mobiles by Jean Lipman,

ey Museum of American Art.

ts Society (ARS), New York.

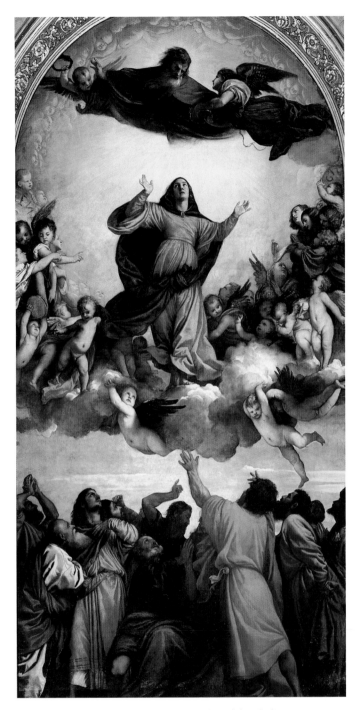

Fig. 101 Titian, *Assumption and Consecration of the Virgin*, c. 1516–1518.
Oil on wood, 22½ × 11⅘ ft.
Santa Maria Gloriosa dei Frari, Venice. Scala/Art Resource, New York.

Fig. 102 Line analysis of Titian,
Assumption and Consecration of the Virgin.
c. 1516–1518.
Oil on wood, 22½ × 11⅘ ft.
Santa Maria Gloriosa dei Frari, Venice.
Scala/Art Resource, New York.

One of the most powerful kinds of implied line is a function of *line of sight*, the direction the figures in a given composition are looking. In his *Assumption and Consecration of the Virgin* (Fig. 101), Titian ties together the three separate horizontal areas of the piece—God the Father above, the Virgin Mary in the middle, and the Apostles below—by implied lines that create simple, interlocking, symmetrical triangles (Fig. 102) that serve to unify the worlds of the divine and the mortal.

QUALITIES OF LINE

Line delineates form and shape, by means of outline and contour line. Implied lines also create a sense of movement and direction. But line also possesses certain intellectual, emotional, and expressive qualities.

In a series of six works entitled *Drawing Lesson, Part I, Line*, Pat Steir has created what she calls "a dictionary of marks," derived from

the ways in which artists whom she admires employ line. Each pair of works represents a particular intellectual, emotional, or expressive quality of line. One pair, of which Figure 103 at the left is an example, refers to the work of Rembrandt, particularly to the kinds of effects Rembrandt achieved in works like *The Three Crosses* (Fig. 104). The center square of Steir's piece is a sort of "blow-up" of Rembrandt's basic line; the outside frame shows the wide variety of effects achieved by Rembrandt as he draws this line with greater or lesser density. Rembrandt's lines seem to envelop the scene, shrouding it in a darkness that moves in upon the crucified Christ like a curtain closing upon a play or a storm descending upon a landscape. Rembrandt's line—and Steir's too—becomes more charged emotionally as it becomes denser and darker.

A second pair of Steir's "drawing lessons" is even more emotionally charged. In the center of Figure 105 is a dripping line, one of the basic "signatures" of contemporary abstract painting. It indicates the presence of the artist's brush in front of the canvas. Surrounding it is a series of gestures evocative of Vincent van Gogh. Of the swirling turmoil of line that makes up *The Starry Night* (Fig. 106),

(above) Pat Steir,
Part I, Line #1, 1978.
from a portfolio of 7

Fig. 104 (right) Rembrandt van Rijn,
The Three Crosses, 1653.
Etching, 15¼ × 17¾ in.
© The British Museum.

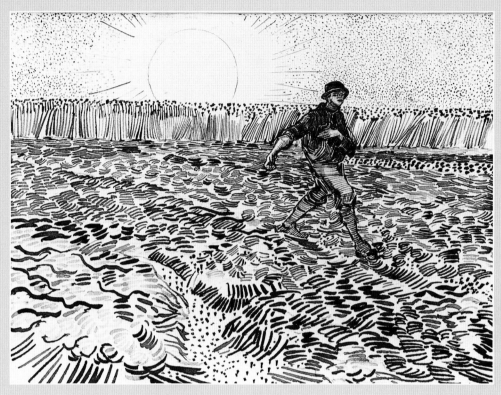

Fig. 109 Vincent van Gogh, *The Sower*, 1888.
Drawing. Pencil, reed pen, brown and black ink on wove paper, 9⅝ × 12½ in.
Amsterdam: Van Gogh Museum (Vincent van Gogh Foundation).

yellow and green, the ground violet and orange." This plan succeeded (Fig. 108). Each area of the painting now contained color that connected it to the opposite area, green to violet and orange to yellow.

The sower was, for van Gogh, the symbol of his own "longing for the infinite," as he wrote to Bernard, and having finished the painting, he remained, in August, still obsessed with the image. "The idea of the *Sower* continues to haunt me all the time," he wrote to Theo. In fact, he had begun to think of the finished painting as a study that was itself a preliminary work leading to a drawing (Fig. 109). "Now the harvest, the Garden, the Sower . . . are sketches after painted studies. I think all these ideas are good," he wrote to Theo on August 8, "but the painted studies lack clearness of touch. That is [the] reason why I felt it necessary to draw them."

In the drawing, sun, wheat, and the sower himself are enlarged, made more monumental. The house and tree on the left have been eliminated, causing us to focus more on the sower himself, whose stride is now wider and who seems more intent on his task. But it is the clarity of van Gogh's line that is especially astonishing. Here we have a sort of anthology of line types: short and long, curved and straight, wide and narrow. Lines of each type seem to group themselves into bundles of five or ten, and each bundle seems to possess its own direction and flow, creating a sense of the tilled field's uneven but regular furrows. It is as if, wanting to represent his longing for the infinite, as it is contained at the moment of the genesis of life, sowing the field, van Gogh himself returns to the most fundamental element in art—line itself.

Fig. 110 Sol LeWitt, *Lines from Four Corners to Points on a Grid*, 1976.
Chalk on four painted walls. Installation, Museum of Modern Art, New York, 1978.
Collection: The Whitney Museum of American Art, New York.
Photo: John Weber Gallery, New York. © 2003 Sol LeWitt/Artists Rights Society (ARS), New York.

Analytic or Classical Line

Sol LeWitt, whose work is the source, inciden-
~~of Steir's *Drawing*~~

van Gogh's (Figs. 107, 108, and 109). LeWitt's
line is *analytical* where van Gogh's is
expressive. LeWitt's **analytic line** is precise,
controlled, mathematically rigorous, logical,
and rationally organized, where van Gogh's
expressive line is imprecise, emotionally
charged, and almost chaotic. One seems a
product of the mind, the other of the heart.

A measure of the removal of LeWitt's art
from personal expression is that very often
LeWitt does not even draw his own lines. The
works are usually generated by museum staff
according to LeWitt's instructions. If a museum
"owns" a LeWitt, it does not own the actual

wall drawing but only the instructions on how
to make it. As a result, LeWitt's works are tem-
porary, but they are always resurrectable. *Lines
~~from Four Corners to Points on a Grid~~ (Fig.
~~making it are in the Whitney's collection—but~~
it was "borrowed" by the Museum of Modern
Art for the installation illustrated here. Since
LeWitt often writes his instructions so that the
staff executing the drawing must make their
own decisions about the placement and
arrangement of the lines, the work changes
from appearance to appearance.

In LeWitt's drawing, the geometry of the
room's architecture, with its strong sense of the
vertical, the horizontal, and the right angle, helps
lend the work a sense of mathematical precision
and regularity. But it is probably the **grid**, the
pattern of vertical and horizontal lines crossing

Fig. 114 Eugène Delacroix, *Study for The Death of Sardanapalus*, 1827–1828.
watercolor, and pencil, 10¼ × 12½ in. Cabinet des Dessins, Musée du Louvre, Paris. Cliché des Musées Nationaux, Paris. © Photo R.M.N.-SPADEM.

Fig. 115 Eugène Delacroix, *The Death of Sardanapalus*, 1828.
Oil on canvas, 153½ × 195 in. Cabinet des Dessins, Musée du Louvre, Paris. Cliché des Musées Nationaux, Paris. © Photo R.M.N.-SPADEM.

Hung Liu's Three Fujins

Born in Changchun, China, in 1948, the year that Chairman Mao forced the Nationalist Chinese off the mainland to Taiwan, painter Hung Liu lived in China until 1984. Beginning in 1966, during Mao's Cultural Revolution, she worked for four years as a peasant in the fields. Successfully "reeducated" by the working class, she returned to Beijing where she studied, and later taught, painting of a strict Russian Social Realist style—propaganda portraits of Mao's new society that employed a strict, classical line. But this way of drawing and painting, in its clear linear style, constricted Hung Liu's artistic sensibility. In 1980, she applied for a passport to study painting in the United States, and in 1984 her request was granted. An extraordinarily independent spirit, raised and educated in a society that values social conformity above individual identity, Liu depends as a painter on the interplay between the line she was trained to paint, and a new, freer line more closely aligned to Western abstraction but tied to ancient Chinese traditions as well.

During the Cultural Revolution, Liu had begun photographing peasant families, not for herself, but as gifts for the villagers. She has painted from photographs ever since, particularly archival photographs that she has discovered on research trips back to China in both 1991 and 1993. "I am not copying photographs," she explains. "I release information from them. There's a tiny bit of information there—the photograph was taken in a very short moment, maybe ¹⁄₁₀₀ or ¹⁄₅₀ of a sec- ... give me an excuse ... int from a ... ide it. For example, the disfigured feet of the woman ... *Virgin/Vessel* (Fig. 116) are the result of tradi... Chinese foot-binding. Unable to walk, even uppe... women were forced into prostitution after Mao's Revolution confiscated their material possessions and left them without servants to transport them. In the painting, the woman's body has become a sexual vessel, like the one in front of her. She is completely isolated and vulnerable.

Three Fujins (Fig. 117) is also a depiction of women bound by the system in which they live. The Fujins were concubines in the royal court at the end of the nineteenth century. Projecting in front of each of them is an actual birdcage, purchased by Liu in San Francisco's Chinatown, symbolizing the

Fig. 116 Hung Liu, *Virgin/Vessel*, 1990.
Oil on canvas, broom, 72 × 48 in. Collection Bernice and Harold Steinbaum. © Hung Liu. Courtesy Bernice Steinbaum Gallery, Miami, FL.

Fig. 120 Jean-Auguste-Dominique Ingres, *Jupiter and Thetis*, 1811.
Oil on canvas, 130⅝ × 101¼ in.
Musée Granet, Aix-en-Provence. Erich Lessing/Art Resource, New York.

Line is, in summation, an extremely versatile element. Thick or thin, short or long, straight or curved, line can outline shapes and forms, indicate the contour of a volume, and imply direction and movement. Lines of sight can connect widely separated parts of a composition. Depending on how it is employed, line can seem extremely intellectual and rational or highly expressive and emotional. It is, above all, the artist's most basic tool.

How would you describe the use of line in Robert Mapplethorpe's photograph of *Lisa Lyon* (Fig. 121), winner of the First World Women's Bodybuilding Championship in Los Angeles in 1979? Does Lyon present herself to the viewer in classical or romantic terms? How does the photograph subvert or contest conventional representations of the female figure? Is Lyon closer to Ingres's *Jupiter* or his *Thetis*? To the Greek *Zeus* or the Praxiteles *Aphrodite*? What are the implications of this reversal of expectations?

soft as the folds of the drapery covering her lower body, but she is much smaller than the giant god at whose feet she kneels. The grand and indifferent Jupiter, like the vertical and horizontal lines that define him, is the personification of reason and power—the male—while Thetis is the embodiment of the sensual and the submissive—the female.

While conventional representations of the male and female nude carry with them recognizably sexist implications—man as strong and rational, woman as weak and given to emotional outbursts—it should come as no surprise that these conventions are fundamental to the representation of the human figure in Western art. The biases of our culture are, naturally, reflected in our art, even in the most fundamental of art's formal elements—line.

Fig. 121 Robert Mapplethorpe, *Lisa Lyon*, 1980.
© 1982 Estate of Robert Mapplethorpe.

J.-A.-D. Ingres's The Turkish Bath

Probably no painter more thoroughly explored the expressive qualities of the curve as it relates to the female body than Jean-Auguste-Dominique Ingres. As early as 1808, in his *The Valpinçon Bather* (Fig. 122) Ingres inaugurated a series of studies and finished paintings on the theme of women alone, either in isolation or in the harem, sometimes accompanied by a slave. The series culminated over half a century later in the famous circular painting, *The Turkish Bath* (Fig. 123), which can be usefully thought of as the final statement in a career-long work in progress.

All of these works are notable for the liberties that Ingres has taken with the female anatomy, and *The Valpinçon Bather* is no exception. They were even criticized, in their day, as a sign of Ingres's incompetence. Just as in *Jupiter and Thetis*, where it is difficult to imagine the relation between Thetis's lithe arms and tiny feet and her giant but rounded hips and buttocks (rounded, one supposes, to accentuate her "feminine" aspect), it is equally hard to imagine just where the *Valpiçon Bather*'s right leg might be positioned beneath her in order to fall, as it does, behind the left leg. It seems oddly disengaged from the body proper. Ingres is, apparently, not entirely interested in anatomy. Rather, he seems to submit the body to the demands of his composition, the leg disappearing into the coiled sheet, just as the left arm disappears into the robe, directly above.

In *The Turkish Bath*, the oddity of this leg has been cured. The woman playing the guitar with her back to the viewer is clearly modeled on the earlier painting. But now her legs are tucked beneath her, and her left arm is extended to the neck of the guitar in a line that parallels both her upper left leg and the painting's rounded edge. Furthermore, by extending her arm, Ingres reveals the rounded curve of her breast, further echoing the shape of the frame, as does the curved shape of her turban, hair, and forehead.

In fact, the whole painting consists of a series of circles within circles, leaving the rectilinear frame of the earlier works behind. Of particular interest is the reclining nude on the right, whose gaze, unlike any other in the

Fig. 122 Jean-Auguste-Dominique Ingres, *Bathing Woman (Baigneuse de Valpinçon)*, 1808. Oil on canvas, 57¼ × 38¼ in. Louvre, Paris. Erich Lessing/Art Resource, New York.

painting, seems to engage the viewer. She is composed as a series of rounded shapes, from her eyes and mouth, to her face as a whole, her necklace, her breasts, her belly. She echoes, in her recumbent position, the standing nude at the far side of the pool. A drawing (Fig. 124) reinforces Ingres's intention to submit her form to his circular scheme. Here she possesses three arms, two on her right side. Clearly Ingres is experimenting with the arm's position. By raising it above her head, he not only encircles her face, framing it, but silhouettes her breast against the figures behind her, emphasizing its curvilinear form.

As Ingres sacrifices, or controls, female anatomy to meet the demands of his circular design, the sexist implications of his work become clear. The painting celebrates

Fig. 123 Jean-Auguste-Dominique Ingres, *The T[...]* [...]62.
Oil on canvas, Louvre, Paris. Giraudon/Art Resour[...]

the five senses—touch (the t[...] fondling each other in the f[...] smell (the perfume held by [...] figure on the right), taste (the tra[...] he foreground), sound (the g[...] ve all, sight. For though women [...] hese works, from the world o[...] thoroughly submitted to the [...] east of all Ingres's own. Intent on painting a purely female space, his painting is almost entirely freed of the male grid as well. But, in the architecture of the room, especially in the rectangular design of the floor, the male frame that surrounds and controls these women asserts itself, like the ominous presence of the sultan himself.

Fig. 124 Jean-Auguste-Dominique Ingres, *La Femme aux Trois Bras* (study *for The Turkish Bath*), c. 1859.
Musée Ingres, Montauban. © Photo R.M.N./Art Resource, New York.

CHAPTER 6

SPACE

SHAPE AND MASS

THREE-DIMENSIONAL SPACE

TWO-DIMENSIONAL SPACE

LINEAR PERSPECTIVE

WORKS IN PROGRESS
Rubens's *The Kermis*

SOME OTHER MEANS OF REPRESENTING SPACE

DISTORTIONS OF SPACE AND FORESHORTENING

MODERN EXPERIMENTS AND NEW DIMENSIONS

THE CRITICAL PROCESS
Thinking about Space

We live in a physical world whose properties are familiar, and together with line, space is one of the most familiar. It is all around us, all the time. We talk about outer space—the space outside our world—and "inner" space—the space inside our own minds. We cherish our own "space." We give "space" to people or things that scare us. But in the twentieth century, space has become a more and more contested issue. Since Einstein, we have come to recognize that the space in which we live is fluid. It takes place in time. We have developed new kinds of space as well—the space of mass media, the Internet, the computer screen, "virtual reality," and cyberspace. All these new kinds of space result, as we shall see, in new media for artists. But first, we need to define some elementary concepts of shape and mass.

SHAPE AND MASS

A **shape** is flat. In mathematical terms, a shape is a two-dimensional *area*, that is, its boundaries can be measured in terms of height and width. A **mass**, on the other hand, is a solid that occupies a three-dimensional *volume*. It must be measured in terms of height, width, and depth. Though mass also implies density and weight, in the simplest terms, the difference between shape and mass is the difference between a square and a cube, a circle and a sphere.

Donald Sultan's *Lemons, May 16, 1984,* (Fig. 125) is an image of three lemons, but it consists of a single yellow shape on a black ground nearly eight feet square. To create the image, Sultan covered vinyl composite tile with tar. Then he drew the outline of the lemons, scraped out the area inside the outline, filled it with plaster, and painted the plaster area yellow. The shape of the three lemons is created not only by the outline Sultan drew but also by the contrasting colors and textures, black and yellow, tar and plaster.

Martin Puryear's *Self* (Fig. 126) is a sculptural mass standing nearly six feet high. Made of wood, it looms out of the floor like a giant basalt outcropping, and it seems to satisfy the other implied meanings of mass—that is, it seems to possess weight and density as well as volume. "It looks as though it might have been created by erosion," Puryear has said, "like a rock worn by sand and weather until the angles are all gone. . . . It's meant to be a visual notion of the self, rather than any particular self—the self as a secret entity, as a secret, hidden place." And in fact, it does not possess the mass it visually announces. It is actually very lightweight, built of thin layers of wood over a hollow core. This hidden, almost secret fragility is the "self" of Puryear's title.

One of the most interesting things about Sultan's *Lemons* is that, though it is completely flat, it implies three-dimensional space. We tend to read the painting from the bottom to the top—the left-hand lemon as closest to us and the top lemon as farthest away—although it is simple enough to imagine any one of the lemons as lying on top of the other two. But the point is that the instant

Fig. 125 Donald Sultan, *Lemons, May 16, 1984*, 1984.
Latex, tar on vinyl tile over wood, 97 in. × 97½ in.
Virginia Museum of Fine Arts, Richmond. Gift of the Sydney and Frances Lewis Foundation.
Photo: Katherine Wetzel. © 1996 Virginia Museum of Fine Arts.

Fig. 126 Martin Puryear, *Self*, 1978.
Polychromed red cedar and mahogany, 69 × 48 × 25 in.
Joslyn Art Museum, Omaha, Nebraska.

Fig. 127 Rubin vase.

we place any shape on a ground, a sense of space is activated. In Figure 127, the black vase seems to sit on a white ground. When, conversely, we look at the white as shape and the black as ground, our perceptual experience of the same space is radically altered. What was the foreground vase becomes the background space, and we see two faces peering at each other. Such **figure-ground reversals** help us recognize how our perceptual experience fundamentally depends on our recognition of the spatial relationships between an object and what lies beside and behind it.

THREE-DIMENSIONAL SPACE

The world that we live in (our homes, our streets, our cities), has been carved out of **three-dimensional space**. A building surrounds empty space in such a way as to frame it or outline it. Walls shape the space they contain, and rooms acquire a sense of volume and form. In 1986, architect Gae Aulenti transformed a nineteenth-century Parisian railroad station into the new home for late-nineteenth- and early-twentieth-century art, the now famous Musée d'Orsay (Fig. 128). Aulenti maintained the space defined by the architecture of the original station, with its arched 100-foot ceiling stretching to a length of 150 yards, but across the bottom of this space he carved new cubical and rectilinear gallery rooms. The sculptural quality of these rooms is underscored by the way in which their lines are echoed in the benches and actual sculptures that fill the central walkway through the space. The massive presence of all these new forms stands in marked contrast to the airiness of the original building, but these new spaces also lend the building a sense of monumentality and solidity, a dignity befitting the works of art they contain.

Barbara Hepworth's *Two Figures* (Fig. 129) consists of two standing vertical masses that occupy three-dimensional space in a manner similar to standing human forms. Into each of these figures she has carved **negative shapes** or **negative spaces**, so called because they are empty spaces that acquire a sense of volume

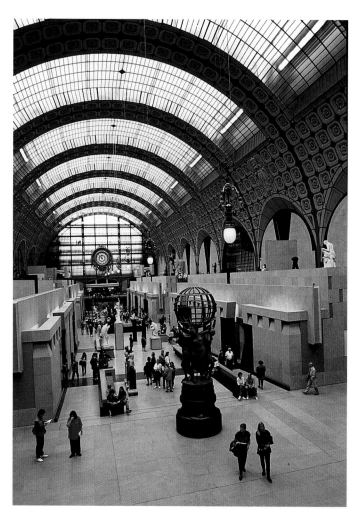

Fig. 128 Musée d'Orsay, Paris, interior, main floor, Gae Aluenti, architect, 1986.

John Brooks/Liaison Agency Inc./Getty Images.

Fig. 129 Barbara Hepworth, *Two Figures,* 1947–1948.
Elmwood and white paint, 38 × 17 in.
Collection Frederick R. Weisman Art Museum, University of Minnesota,
Minneapolis. Girft of John Rood Sculpture Collection.

and form by means of the outline or frame that surrounds them, like the rooms in the Musée d'Orsay. Hepworth has painted these negative spaces white. Especially in the left-hand figure, the negative shapes suggest anatomical features: the top round indentation suggests a head, the middle hollow a breast, and the bottom hole a belly, with the elmwood wrapping around the figure like a cloak.

The negative space formed by the bowl of the ceremonial spoon of the Dan people native to Liberia and the Ivory Coast (Fig. 130) likewise suggests anatomy. Nearly a foot in length and called the "belly pregnant with rice," the bowl represents the generosity of the most hospitable woman of the clan, who is known as the *wunkirle*. The *wunkirle* carries this spoon at festivals, where she dances and sings. As *wunkirles* from other clans arrive, the festivals become competitions, each woman striving to give away more than the others. Finally, the most generous *wunkirle* of all is proclaimed, and the men sing in her honor. The spoon represents the power of the imagination to transform an everyday object into a symbolically charged container of social good.

Fig. 130 Feast-making spoon, Liberia/Ivory Coast, Dan, 20th century.
Wood and iron, height 24¼ in. The Seattle Art Museum.
Gift of Katherine C. White and the Boeing Company, 81.17.204.
Photo: Paul Macapia.

Fig. 131 Richard Diebenkorn, *Woman in Chaise*, 1965.
Crayon and gouache, 17 × 12½ in. Signed and dated lower left: RD65.
Yale University Art Gallery. Gift of Richard Brown Baker, B.A., 1935.

TWO-DIMENSIONAL SPACE

While sculptors and architects define forms out of empty three-dimensional space, painters begin with an empty canvas, a two-dimensional space. **Two-dimensional space** is flat, possessing height and width, but no depth. A sense of depth, of three dimensions, can be achieved only by means of *illusion*.

In Richard Diebenkorn's *Woman in Chaise* (Fig. 131), the untouched white ground of the paper—also called the **reserve**—is surrounded by drawing in crayon and gouache so that it seems to stand forward from the paper itself to become the woman's blouse, face, arm, and leg, the scarf in her hair, the rail of the chaise longue, and even the flowers behind her. As in the figure-ground reversal discussed at the beginning of this section, we no longer read the drawing's white space as background, but rather as illuminated forms. Diebenkorn allows the whiteness of the paper to represent the intensity of light falling on the woman as she sits in the sun. The figure-ground reversal creates an illusion. Our eyes read the whiteness as representing the elements of the composition, but it is literally the whiteness of the paper that we see.

There are many ways to create the illusion of deep space on the flat surface of the paper or canvas, and most are used simultaneously. For example, we recognize that objects close to us appear larger than objects farther away, creating a change in **scale**. Objects closer to the viewer **overlap** and cover other objects behind them. Both a change in scale and overlapping inform the creation of the space in Caspar David Friedrich's *Woman in Morning Light* (Fig. 132). The woman looking out at the rising sun is *literally* larger than the mountains in the "distance," and she blocks out our view of the sun, overlapping it. But we do not think of her as a giant. We simply recognize that she is closer than the mountain to the surface of the painting, which is called the **picture plane**. Her position is, in fact, similar to our own as viewers, and together we look out on the new day with all its possibility and promise.

Fig. 132 Caspar David Friedrich,
Woman in Morning Light, 1818.
Oil on canvas, 8¾ × 11¾ in.
Museum Folkwang, Essen, Germany.

LINEAR PERSPECTIVE

The lines emanating from Friedrich's sun evoke certain principles of perspective, one of the most convincing means of representing three-dimensional space on a two-dimensional surface. **Perspective** is a system, known to the Greeks and Romans but not mathematically codified until the Renaissance, that, in simplest terms, allows the picture plane to function as a window through which a specific scene is presented to the viewer. In **one-point linear perspective** (Fig. 133), lines are drawn on the picture plane in such a way as to represent parallel lines receding to a single point on the viewer's horizon, called the **vanishing point**. As the two examples in Figure 133 make clear, when the vanishing point is directly across from the viewer's **vantage point**, the recession is said to be **frontal**. If the vanishing point is to one side or the other, the recession is said to be **diagonal**.

To judge the effectiveness of linear perspective as a system capable of creating the illusion of real space on a two-dimensional surface, we need only look at an example of a work painted before linear perspective was fully understood and then compare it to works in which the system is successfully employed. In 1228, just two years after the death of St. Francis, a basilica was built in his honor in Assisi, Italy. The greatest painters of the day were

Fig. 133 One-point linear perspective
Left: frontal recession, street level. Right: diagonal recession, elevated position.

sought out to decorate it. The laws of perspective would not be worked out for nearly two hundred years, but in a series of twenty-eight frescoes depicting the life of St. Francis, often thought to be the work of Giotto, we can witness an artist attempting to grasp the principles intuitively. Notice how, in the scene *St. Francis Renouncing His Earthly Possessions* (Fig. 134), the feet of St. Francis, standing on the right with the halo, seem unnaturally close to the building behind him. Notice also how the column supporting the building on the far right seems to descend into the head of his follower. In fact, if we draw perspective lines along the major elements of this building (Fig. 135), we can see that they fly off in any number of directions and never come together at a common vanishing point. Thus, the space of this painting seems unrealistic and artificial.

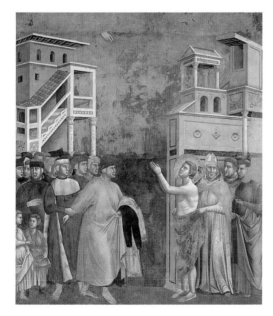

Fig. 134 Assisi, Upper Church of S. Francesco,
Giotto and pupils, *St. Francis Renouncing his Earthly Possessions,*
c. 1295–1330. Fresco.
© Canali Photobank, Capriolo, Italy.

Fig. 135 Assisi, Upper Church of S. Francesco, Giotto and pupils,
perspective analysis of *St. Francis Renouncing his Earthly Possessions,*
c. 1295–1330. Fresco.
© Canali Photobank, Capriolo, Italy.

Fig. 136 Leonardo da Vinci, *The Last Supper*, c. 1495–1498.
Mural (oil and tempera on plaster), 15 ft. 1⅛ in. × 28 ft. 10½ in.
Refectory, Monastery of Santa Maria delle Grazie, Milan, Italy. Alinari/Art Resource, New York.

Fig. 137 Leonardo da Vinci,
perspective analysis of *The Last Supper*, c. 1495–1498.
Mural (oil and tempera on plaster), 15 ft. 1⅛ in. × 28 ft. 10½ in.
Refectory, Monastery of Santa Maria delle Grazie, Milan, Italy. Alinari/Art Resource, New York.

By way of contrast, the space of Leonardo da Vinci's famous depiction of *The Last Supper* (Fig. 136) is completely convincing. Leonardo employs a fully frontal one-point perspective system, as the perspective analysis shows (Fig. 137). This system focuses our attention on Christ, since the perspective lines appear almost as rays of light radiating from Christ's head. *The Last Supper* itself is a wall painting created in the refectory—dining hall—of the

Monastery of Santa Maria delle Grazie in Milan, Italy. Because the painting's architecture appears to be continuous with the actual architecture of the refectory, it seems as if the world outside the space of the painting is organized around Christ as well. Everything in the architecture of the painting and the refectory draws our attention to Him. His gaze controls the world.

The complex illusion of real space that perspective makes possible is evident in Gustave Caillebotte's *Place de l'Europe* (Fig. 138). Two (and even more) vanishing points organize a complex array of parallel lines emanating from the intersection of the five Paris streets depicted (Fig. 139). More than one vanishing point—that is, **two-point linear perspective** (Fig. 140)—help to create a more lively composition, in part because the perspective recedes in several diagonal directions from the viewer, rather than frontally, as in Leonardo's *The Last Supper*. Caillebotte nevertheless imposes order on this scene by dividing the canvas into four equal rectangles formed by the vertical lamp post and the horizon line.

Fig. 139 Gustave Caillebotte,
Perspective analysis of *Place de l'Europe on a Rainy Day*, 1876–1877.

Oil on canvas, 83½ × 108¾ in. Charles H. and Mary F. S. Worcester Collection.

1964.336. Photograph © 1999 The Art Institute of Chicago,

Fig. 140 Two-point linear perspective.

Fig. 142 Pieter Brueghel the Elder, frontal recession of
The Wedding Dance, c. 1566.

Oil on panel, 46⅞ × 61¹³⁄₁₆ in.
City of Detroit Purchase. Photograph © 1998 Detroit Institute of Arts
30.734.

painters of their day, reveals the difference in
effect created by frontal and diagonal reces-
sions of space. The vanishing point in Pieter
Brueghel's 1566 *The Wedding Dance* (Fig.
141) is on the horizon, directly across from the
viewer, though the viewer's position is surpris-
ingly high, as if looking down on the scene
from a tree. Despite the confusion of the fes-
tivities, the painting is composed of a number
of greater and lesser equilateral triangles, each
pointing toward the horizon. Not only do the
dancing couples raise their arms in triangular
gestures, but the entire foreground group
forms a large triangular shape with its apex at
the central female figure at the base of the tree,
her back arched, her bodice thrust forward,
and her head back. Particularly on the left,
across the open space between the dance group
and the others, the figures are arranged along a
diagonal parallel to the foreground group. In a
manner appropriate to the theme—marriage

Fig. 143 Peter Paul Rubens, *The Kermis*, c. 1635.
Oil on panel, 58⅝ × 102¾ in. Musée du Louvre, Paris. Scala/Art Resource, New York.

Fig. 144 Peter Paul Rubens, diagonal recession.
Musée du Louvre, Paris. Scala/Art Resource, N…

and dance—the scene is balanced along its central axis (Fig. 142).

In contrast, in his *The Kermis* (Fig. 143), probably painted in the early 1630s, Peter Paul Rubens positions his vanishing point at the end of a diagonal that disappears somewhere off-canvas to the right of the church steeple in the distance, in the direction that the couple on the far right seems amorously headed (Fig. 144). Here, children drink beer, men brawl, others have passed out, and every male hand seems intent on clutching some

unprotected and fo… …he female anatomy. Rather than … …e, the painting is ribald, unbalan… …teetering with drink itself. Where Brue… …s painting celebrates marriage, and is almost perfectly balanced, Rubens's work celebrates something less civilized, something closer to raw appetite and pure sexuality, and the painting seems to move to the right, to a space beyond vision. Rubens, it could be said, paints our feelings, and nothing, he suggests, could be less balanced, less rational.

Peter Paul Rubens's The Kermis

Fig. 145 Peter Paul Rubens, *Studies for a Kermis*, c. 1631.
Pen and brown ink over black chalk, traces of red chalk, 19¾ × 22¹⁵⁄₁₆ in. © British Museum.

When or why Rubens decided to paint his *The Kermis*—literally the celebration of a saint's feast day—is unknown, but many of its themes are related to a painting of a *Peasant Dance*

by his contemporary, Adriaen Brouwer, purchased by Rubens in 1631, one of seventeen separate paintings by Brouwer owned by Rubens. Like *The Kermis*, Brouwer's *Peasant Dance* is marked by a diagonal recession toward a church steeple in the distance, a central tree, and an inn set to one side of the composition (Brouwer's work survives today only in a drawn copy made in 1659). It does seem clear that Rubens, who was painter to the Spanish king, was intent on acknowledging his connection to Pieter Brueghel (Brueghel's son, Jan, was, like Brouwer, a colleague and friend) in particular and to his Flemish roots in general.

Two sets of drawings for the final painting survive, both on the same sheet, front and back (or *recto* and *verso*, in traditional terminology). The first (Fig. 145) delineates, in a strong diagonal, peasants seated at a table. Many of the elements of this

early study survive in the final painting, particularly the drunken men asleep at the table, though in the final painting, Rubens has lowered his point of view. At the far left of the drawing, at the near end of the table, two men appear to be exchanging a tankard of ale, as if the one in paying the other. In the final painting, the exchange between these two is far less amicable. Indeed, they seem to be fighting over their beer. One element in the drawing seems to have been abandoned altogether. In the middle right are two scenes of drunken figures being helped to their feet under the gaze of a stern, and seemingly sober, woman. Apparently, Rubens chose to abandon this moral commentary.

On the back side of this drawing is another set of studies for the dancing figures in the final painting (Fig. 146). In contrast to Pieter Brueghel's dancing couples (see Fig. 141), who only

Fig. 146 Peter Paul Rubens, *Studies of a Dancing Couple*, c. 1631.
Pen and brown ink over black chalk (verso of Fig. 145). 19¾ × 22¹⁵⁄₁₆ in. © British Museum.

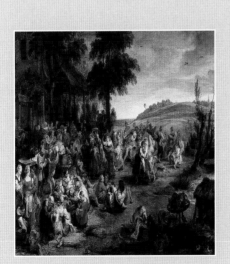

Fig. 147 Peter Paul Rubens,
detail of *The Kermis*, c. 1635.
Musée du Louvre, Paris. Scala/Art Resource, New York.

touch hands if they touch at all, these pairs coil around each other in a close embrace. Rubens is apparently searching for just the right combination of dancelike movement and sexual embrace, and these are studies for the pair highlighted in the right center of the painting (Fig. 147). He seems to have discovered what he wanted in the mass of figures, executed hastily on top of one another, in the lower left of the drawing, with a final version in front of the quick diagonal sketches. The embrace is the same, but reversed in the painted version. Rubens turns the figures around, and draws them as they will finally appear, in a more finished drawing at the top right. Why have them face this way and not the other? Quite evidently so that the woman's body, falling as it does beneath her partner's kiss, caught in the circle of his arms, bends toward and into the diagonal composition of the painting as a whole.

SOME OTHER MEANS OF REPRESENTING SPACE

Linear perspective creates the illusion of three-dimensional space on a two-dimensional surface. Other systems of projecting space, however, are available. These so-called **axonometric projections** (Fig. 148), employed by architects and engineers, have the advantage of translating space in such a way that the distortions of scale common in linear perspective are eliminated. In axonometric projections, all lines remain parallel rather than receding to a common vanishing point, and all sides of the object are at an angle to the picture plane. There are three types of axonometric projection: **isometric**, **dimetric**, and **trimetric**. In the first, all the measurements—height, width, and depth—are to the same scale: for instance, each inch might represent one foot. In dimetric projection, two of the measurements maintain the same scale, while the third is reduced, often by half. Figure 148 is an example of dimetric projection, its height employing a smaller scale than its width and depth. In trimetric projection all three measurements use different scales.

Another related type of projection commonly found in Japanese art is **oblique projection**. As in axonometric projection, the sides of the object are parallel, but in this system, one face is parallel to the picture plane as well. The same scale is utilized for height and width, while depth is reduced. This hanging scroll (Fig. 149) depicts, in oblique perspective, the three sacred Shinto-Buddhist shrines of Kumano, south of Osaka, Japan. The shrines are actually about eighty miles apart: the one at the bottom of the scroll high in the mountains of the Kii Peninsula in a cypress forest, the middle one on the eastern coast of the peninsula, and the top one near a famous waterfall that can be seen to its right. In addition to oblique projection, the artist employs two other devices to give a sense of spatial depth as well. As is common in traditional perspective, each shrine appears smaller the farther away it is. But spatial depth is also indicated here by **position**—the farther away the shrine, the *higher* it is in the composition.

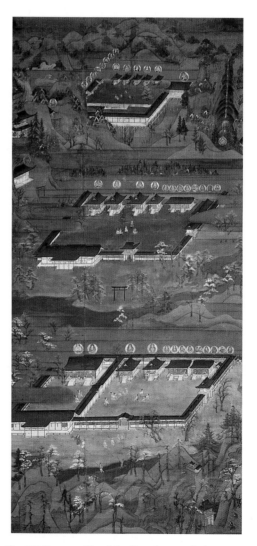

Fig. 149 *Kumano Mandala*, Kamakura period, c. 1300.
Hanging scroll, ink and color on silk, 52¼ × 24¼ in.
© 1999 The Cleveland Museum of Art.
John L. Severance Fund, 1953.16.

Fig. 148 Theo van Doesburg and Cornelius van Eesteren,
Color Construction, Project for a private house, 1923.
Gouache and ink on paper, Sheet: 22½ × 22½ in.
The Museum of Modern Art, New York. Edgar J. Kaufmann, Jr. Fund.
Photograph © 1999 The Museum of Modern Art, New York.
Licensed by Scala-Art Resource, New York. © 2003 Artist's Rights Society
(ARS), New York/Beeldrecht, Amsterdam.

Fig. 150 George Barker, *Sunset–Niagara River (no. 609)*, c. 1870–1875.
Stereograph. International Museum of Photography at George Eastman House, Rochester, NY.

Fig. 151 Photographer unknown, *Man with Big Shoes*, c. 1890.
Stereograph. Library of Congress.

DISTORTIONS OF SPACE AND FORESHORTENING

The space created by means of linear perspective is closely related to the space created by photography, the medium we accept as representing "real" space with the highest degree of accuracy. The picture drawn in perspective and the photograph both employ a *monocular*, that is, one-eyed, point of view that defines the picture plane as the base of a pyramid, the apex of which is the single lens or eye. Our actual vision, however, is *binocular*. We see with both eyes. If you hold your finger up before your eyes and look at it first with one eye closed and then with the other, you will readily see that the point of view of each eye is different. Under most conditions, the human organism has the capacity to synthesize these differing points of view into a unitary image.

In the nineteenth century, the stereoscope was invented precisely to imitate binocular vision. Two pictures of the same subject, taken from slightly different points of view, were viewed through the stereoscope, one by each eye. The effect of a single picture was produced, with the appearance of depth, or relief, a result of the divergence of the point of view. As George Barker's stereoscope of the *Niagara River* (Fig. 150) makes clear, the difference between the two points of view is barely discernible if we are looking at relatively distant objects. But if we look at objects that are nearby, as in the stereoscopic view of the *Man with Big Shoes* (Fig. 151), then the difference is readily apparent.

Fig. 152 Albrect Dürer, *Draftsman Drawing a Reclining Nude*.
Woodcut, second edition, 3 × 8½ in. One of 138 woodcuts and diagrams in *Underweysung der Messung, mit dem Zirkel und richtscheyt* (*Teaching of Measurement with Compass and Ruler*). Horatio Greenough Curtis Fund, Museum of Fine Arts, Boston.

Fig. 153 Phillip Pearlstein, *Model on Dogon Chair, Legs Crossed*, 1979.
Watercolor, 29½ × 49¼ in. Robert Miller Gallery, New York.

Fig. 154 Andrea Mantegna, *The Dead Christ*, c. 1501.
Tempera on canvas, 26 × 30 in. Brera Gallery, Milan. Nimatallah/Art Resource, New York.

Painters can make up for such distortions in ways that photographers cannot. If the artist portrayed in Dürer's woodcut (Fig. 152) were to draw exactly what he sees before his eyes, he would end up with a composition not unlike that achieved by Phillip Pearlstein in his watercolor (Fig. 153), a nude whose feet and calves are much larger than the rest of her body. Pearlstein is deliberately painting exactly what he sees, in order to draw our attention to certain formal repetitions and patterns in the figure. Note, for instance, the way that the shape of the nearest foot repeats the

shape of the shadowed area beneath the model's buttocks and thigh. But Andrea Mantegna was not interested at all in depicting *The Dead Christ* (Fig. 154) with disproportionately large feet. Such a representation would make comic or ridiculous a scene of high seriousness and consequence. It would be *indecorous*. Thus, Mantegna has employed **foreshortening** in order to represent Christ's body. In foreshortening, the dimensions of the closer extremities are adjusted in order to make up for the distortion created by the point of view.

MODERN EXPERIMENTS AND NEW DIMENSIONS

As we saw in the Pearlstein watercolor, modern artists often intentionally violate the rules of perspective to draw the attention of the viewer to elements of the composition other than its *verisimilitude*, or the apparent "truth" of its representation of reality. In other words, the artist seeks to draw attention to the act of imagination that created the painting, not its overt subject matter. In his large painting *Harmony in Red* (Fig. 155), Henri Matisse has almost completely eliminated any sense of three-dimensionality by uniting the different spaces of the painting in one large field of uniform color and design. The wallpaper and the table-cloth are made of the same fabric. Shapes are repeated throughout: the spindles of the chairs and the tops of the decanters echo one another, as do the maid's hair and the white foliage of the large tree outside the window. The tree's trunk repeats the arabesque design on the table-cloth directly below it. Even the window can be read in two ways: it could, in fact, be a window opening to the world outside, or it could be the corner of a painting, a framed canvas lying flat against the wall. In traditional perspective, the picture frame functions as a window. Here the window has been transformed into a frame.

What one notices most of all in Cézanne's *Mme. Cézanne in a Red Armchair* (Fig. 156) is its very lack of spatial depth. Although the arm of the chair seems to project forward on the right, on the left the painting is almost totally flat. The blue flower pattern on the wallpaper seems to float above the spiraled end of the arm, as does the tassel that hangs below it, drawing the wall far forward into the composition. The line that establishes the bottom of the baseboard on the left seems to ripple on through Mme. Cézanne's dress. But most of all, the assertive vertical stripes of that dress, which appear to rise straight up from her feet parallel to the picture plane, deny Mme. Cézanne her lap. It is almost as if a second, striped vertical plane lies between her and the viewer. By this means Cézanne announces that it is not so much the accurate representation of the figure that interests him as it is the *design* of the canvas and the activity of painting itself, the play of its pattern and color.

Fig. 155 Henri Matisse, *Harmony in Red (The Red Room)*, 1908–1909.
Oil on canvas, 70⅞ × 86⅝ in. The Hermitage, St. Petersburg. George Roos/Art Resource, New York.
© 2003 Succession H. Matisse, Paris/ Artists Rights Society (ARS), New York.

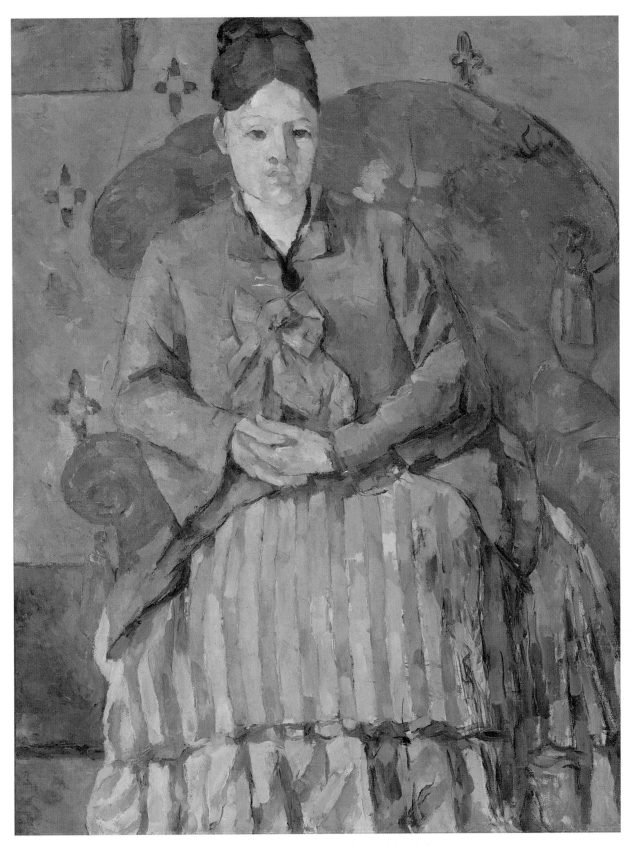

Fig. 156 Paul Cézanne, *Mme. Cézanne in a Red Armchair*, 1877.
Oil on canvas, 28½ × 22 in.
Museum of Fine Arts, Boston. Bequest of Robert Treat Paine 2nd. 44.77.6.

THE CRITICAL PROCESS

Thinking about Space

The history of modern art has often been summarized as the growing refusal of painters to represent three-dimensional space and the resulting emphasis placed on the two-dimensional space of the picture plane. While modern art diminished the importance of representing "real" space in order to draw attention to other types of reality, recent developments in video and computer technologies have begun to make it possible to create artificial environments that the viewer experiences as real space. Variously known as **cyberspace**, **hyperspace**, or **virtual reality**, these spaces are becoming increasingly realistic. The viewer "enters" one such space by donning a set of goggles containing two small video monitors, one in front of each eye (Fig. 157). Created in 1993 with a grant from the Art and Virtual Environment Project at the Banff Centre for the Arts in Banff, Canada, Michael Scroggins and Stewart Dickson's *Topological Slide* (Fig. 158) allows the viewer/participant to slide down a non-Euclidean mathematical model through a hole that descends hypothetically to infinity. The image sequence reproduced here shows the rider's point of view in one side of the head-

Fig. 157 Michael Scroggins and Stewart Dickson, *Topological Slide*, 1993.
The Banff Centre for the Arts. Photo: Cheryl Bellows.

mounted display as the rider slides down the virutal space of *Topological Slide*. The larger, composite image shows the rider, standing on the slide's tilting platform, as if immersed in the virtual space of the image.

In this technology, traditional distinctions about the nature of space begin to collapse. As a result, our sense of space is today open to redefinition, a redefinition perhaps as fundamental as that which occurred in the fifteenth century when the laws of linear perspective were finally codified. How would you speak of this space? In what ways is it two-dimensional? In what ways is it three-dimensional? What are the implications of our seeming to move in and through a two-dimensional image? What would you call such new spaces? Electronic space? Four-dimensional space? What possibilities do you see for such spaces?

Fig. 158 Michael Scroggins and Stewart Dickson, *Topological Slide*, 1993.
Digital images courtesy Michael Scroggins © 1999 Michael Scroggins.

CHAPTER 7

LIGHT AND COLOR

The manipulation of perspective systems is by no means the only way that space is created in art. Light is at least as important to the rendering of space. For instance, light creates shadow, and thus helps to define the contour of a figure or mass. Our experience of color is itself a direct function of light. In 1666, Sir Isaac Newton

Fig. 159 Ishihara "Test for Color Deficiency."
Courtesy Kanehara & Co., Ltd.
Offered exclusively in the USA by Graham-Field Inc., Bay Shore, NY.

demonstrated that objects appear to be a certain color because they absorb and reflect different parts of the visible spectrum. In the simplest terms, when light strikes an object that appears blue, the object has absorbed all the colors of the spectrum but wavelengths of blue. If it appears yellow-green—or chartreuse—it has screened out all but yellow and green wavelengths. Color is essential in defining shape and mass. It allows us, for instance, to see a red object against a green one, and thus establish their relation in space. So-called "color-blind" people (who actually can see colors, just not those that most of us see) cannot detect, for reasons that are not entirely understood, one or both of the numerals in Figure 159. Interestingly, if you were to photocopy this pattern of dots, the numerals would not be visible. The machine, like the eye of the color-blind person, reads the light brown and light red dots as if they were the same, and the dark brown and red dots as if they were the same. Because they are unable to see some shapes overlapping others, color-blind people experience spatial relationships differently than the rest of us, but their difficulty helps demonstrate how important color—and, by extension, light—is to our experience of space.

Fig. 160 Le Corbusier, Notre-Dame-du-Haut at Ronchamp (interier), Ronchamp, France, 1950–1955.
Explorer. Photo Researchers, Inc. © 2003 Artists Rights Society (ARS), New York/ADAGP, Paris/FLC.

LIGHT

Since natural light helps us to define spatial relationships, it stands to reason that artists are interested in manipulating it. By doing so, they can control our experience of their work. Architects, particularly, must concern themselves with light. Interior spaces demand lighting, either natural or artificial, and our experience of a given space can be deeply affected by the quality of its light.

One of the most dramatically lit spaces in all modern architecture is Le Corbusier's church of Notre-Dame-du-Haut at Ronchamp in eastern France (Fig. 160). The light is admitted through narrow stained-glass windows on the exterior southern wall, but as the window boxes expand through the thick wall, the light broadens into wide shafts that possess an unmistakable spiritual quality. The effect is one of extraordinary beauty.

Obviously, not all artists are able to utilize light as fully as architects. But, especially if they are interested in representing the world, they must learn to imitate the effects of light in their work. Before turning to a discussion of color—the most complex effect of light—we need to consider some of the more general ways in which the properties of light are utilized in art.

Atmospheric Perspective

For Leonardo da Vinci, representing the effects of light was at least as important as perspective in creating believable space. The effect of the atmosphere on the appearance of elements in a landscape is one of the chief preoccupations of his *Notebooks*, and it is fair to say that Leonardo is responsible for formulating the "rules" of what we call **atmospheric** or **aerial perspective**. Briefly, these rules state that the quality of the atmosphere (the haze and relative humidity) between us and large objects, such as mountains, changes their appearance. Objects farther away from us appear less distinct, often cooler or bluer in color, and the contrast between light and dark is reduced.

Clarity, precision, and contrast between light and dark dominate the foreground elements in Leonardo's *Madonna of the Rocks* (Fig. 161). The Madonna's hand extends over the head of the infant Jesus in an instance of almost perfect perspectival foreshortening. Yet perspective has

Fig. 161 Leonardo da Vinci, *Madonna of the Rocks*, c. 1495–1508. Oil on panel, 75 × 47 in. National Gallery, London. Scala/Art Resource, New York.

little to do with the way in which we perceive the distant mountains over the Madonna's right shoulder. We assume that the rocks in the far distance are the same brown as those nearer us, yet the atmosphere has changed them, making them appear blue. We know that of these three distant rock formations, the one nearest us is on the right, and the one farthest away is on the left. Since they are approximately the same size, if they were painted with the same clarity and the same amount of contrast between light and dark, we would be unable to place them spatially. We would see them as a horizontal wall of rock, parallel to the picture plane, rather than as a series of mountains, receding diagonally into space.

Fig. 162 J. M. W. Turner, *Rain, Steam, and Speed—The Great Western Railway*, 1844.
Oil on canvas, 33¾ × 48 in. Clore Collection, Tate Gallery, London. Erich Lessing/Art Resource, New York.

By the nineteenth century, aerial perspective had come to dominate the thinking of landscape painters. A painting like *Rain, Steam, and Speed—The Great Western Railway* (Fig. 162) certainly employs linear perspective: we stare over the River Thames across the Maidenhead Bridge, which was completed for the railway's new Bristol and Exeter line in 1844, the year Turner painted the scene. But the space of this painting does not depend upon linear perspective. Rather, light and atmosphere dominate it, creating a sense of space that in fact overwhelms the painting's linear elements in luminous and intense light. Turner's light is at once so opaque that it conceals everything behind it and so deep that it seems to stretch beyond the limits of vision. Describing the power of Rembrandt's

The Mill (Fig. 163) in a lecture delivered in 1811, Turner praised such ambiguity: "Over [the Mill] he has thrown that veil of matchless color, that lucid interval of Morning dawn and dewy light on which the Eye dwells . . . [and he] thinks it a sacrilege to pierce the mystic shell of color in search of form." With linear perspective one might adequately describe physical reality—a building, for instance—but through light one could reveal a greater spiritual reality.

The dominance of light over line, fully developed in Turner's work, had begun to assert itself in painting as early as the late Renaissance. When compared to Leonardo's classical rendering of the scene (Fig. 136), painted almost exactly one hundred years earlier, Tintoretto's version of *The Last Supper*

(Fig. 164) seems much more expressive. It is, in large part, the dramatic play of light and dark in the painting that contributes to this expressivity. As in Leonardo's mural, Tintoretto's *The Last Supper* places Christ in the center of the composition. But where the perspective system employed by Leonardo is used to focus our attention on Christ, it is light that draws our attention to His actions in the Tintoretto.

The heavenly light surrounding Christ contrasts dramatically with the darkness of the rest of the composition. Christ, in fact, is offering bread to the disciples, and in so doing performs the Eucharist of the Mass, symbolically offering them His body as nourishment. This purely spiritual act contrasts with the gluttonous worldly activity going on in the foreground, where a dog gnaws at a bone and a cat searches for leftovers. Light here symbolizes the spiritual world, and darkness our earthly home.

Fig. 163 Rembrandt van Rijn, *The Mill*, 1645–1648.
Oil on canvas, 34½ × 41⅝ in.
Widener Collection, © 1999 Board of Trustees, National Gallery of Art, Washington, DC.

Fig. 164 Tintoretto, *The Last Supper*, 1592–1594.
Oil on canvas, 12 × 18⅔ ft. San Giorgio Maggiore, Venice. Scala/Art Resource, New York.

Fig. 165 Pierre Paul Prud'hon, *Study for La Source*, c. 1801.
Black and white chalk, 21¾ × 15¼ in.
© Sterling and Francine Clark Art Institute, Williamstown, Massachusetts.

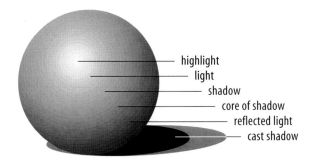

highlight
light
shadow
core of shadow
reflected light
cast shadow

Fig. 166 A sphere represented by means of modeling.

Chiaroscuro

One of the chief tools employed by artists of the Renaissance to render the effects of light is **chiaroscuro**. In Italian, the word *chiaro* means "light," and the word *oscuro* means "dark." Thus, the word *chiaroscuro* refers to the balance of light and shade in a picture, especially its skillful use by the artist in representing the gradual transition around a curved surface from light to dark. The use of chiaroscuro to represent light falling across a curved or rounded surface is called **modeling**.

In his *Study for La Source* (Fig. 165), Pierre Paul Prud'hon has employed the techniques of chiaroscuro to model his figure. Drawing on blue tinted paper, he has indicated shadow by means of charcoal and has created the impression of light with white chalk. The *reserve*—or

the tinted paper upon which the drawing is made—functions as the light area. Thus, Prud'hon leaves all of the normally lit areas of the model's body, as it were, "blank"—they are not drawn upon.

The basic types of shading and light employed in chiaroscuro can be observed in Figure 166. **Highlights**, which directly reflect the light source, are indicated by white, and the various degrees of shadow are noted by darker and darker areas of black. There are three basic areas of shadow: the **penumbra**, which provides the transition to the **umbra**, the core of the shadow, and the **cast shadow**, the darkest area of all. Finally, areas of reflected light, cast indirectly on the table on which the sphere rests, lighten the underside of shadowed surfaces. The effect can be seen on the underside of the model's left thigh in the Prud'hon drawing.

In her *Judith and Maidservant with the Head of Holofernes* (Fig. 167), Artemisia Gentileschi heightens the drama inherent in the conflict between light and dark, taking the technique of chiaroscuro to a new level. One of the most important painters of her day, Gentileschi utilizes a technique that came to be known as **tenebrism**, from the Italian *tenebroso*, meaning murky. Competing against the very deep shadows of the painting are dramatic spots of light. Based on the tale in the book of Judith in the Bible in which the noble Judith seduces the invading general Holofernes and then kills him, thereby saving her people from destruction, the painting is larger than lifesize. Its figures are heroic, illuminated in a strong artificial spotlight, and modeled in both their physical features and the folds of their clothing with a skill that lends them astonish-

ing spatial reality and dimension. Not only does Judith's outstretched hand cast a shadow across her face, suggesting a more powerful, revealing source of light off canvas to the left, it invokes our silence. Like the light itself, danger lurks just off-stage. If Judith is to escape, even we must remain still. Gentileschi represents a woman of heroic stature in a painting of heroic scale, a painting that dominates, even controls, the viewer.

Hatching and Cross-hatching

Other techniques used to model figures include hatching and cross-hatching. Employed especially in ink-drawing and printmaking, where the artist's tools do not readily lend themselves to creating shaded areas, hatching and cross-hatching are linear methods of modeling. **Hatching** is an area of closely spaced parallel lines, or hatches. The closer the spacing of the lines, the darker the area.

If you look closely, you will see that Prud'hon has employed black hatches to deepen the shadows of his *Study for La Source*. They are especially evident along the figure's left thigh and upper left arm. Hatching can also be seen in Michelangelo's *Head of a Satyr* (Fig. 168), at the top and back of the satyr's head and at the base of his neck. But in Michelangelo's drawing, it is through cross-hatching that the greatest sense of volume and form in space is achieved. In **cross-hatching** one set of hatches is crossed at an angle by a second, and sometimes a third, set. The denser the lines, the darker the area. The hollows of the satyr's face are tightly cross-hatched. In contrast, the most prominent aspects of the satyr's face, its highlights at the top of his nose and on his cheekbone, are almost completely free of line. Michelangelo employs line to create a sense of volume not unlike that achieved in the sphere modeled in Figure 166.

Fig. 167 Artemisia Gentileschi,
Judith and Maidservant with the Head of Holofernes, c. 1625.
Oil on canvas, 72½ × 55¾ in.
Gift of Mr. Leslie H. Green. 52.253. Photograph © 1984 Detroit Institute of Arts.

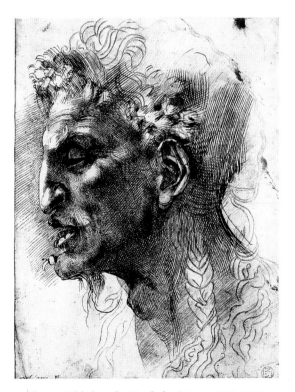

Fig. 168 Michelangelo, *Head of a Satyr*, c. 1520–1530.
Pen and ink over chalk, 10⅝ × 7⅞ in.
Musée du Louvre, Paris. Giraudon/Art Resource, New York.

Mary Cassatt's In the Loge

Painted in 1879, the year she first exhibited with the Impressionists, Mary Cassatt's *In the Loge (At the Francais, A Sketch)* (Fig. 170) is a study in the contrast between light and dark,

as becomes evident when we compare the final work to a tiny sketch, a study perhaps made at the scene itself (Fig. 169). In the sketch, Cassatt divides the work diagonally into two broad zones, the top left bathed in light, the lower right dominated by the woman's black dress. As the drawing makes clear, this diagonal design is softened by Cassatt's decision to fit her figure into the architectural curve of the loge itself, so that the line running along the railing, then up her arm, continues around the line created by her hat and its strap in a giant compositional arch. Thus the woman's face falls into the zone of light, highlighted by her single diamond earring, and cradled, as it were, in black.

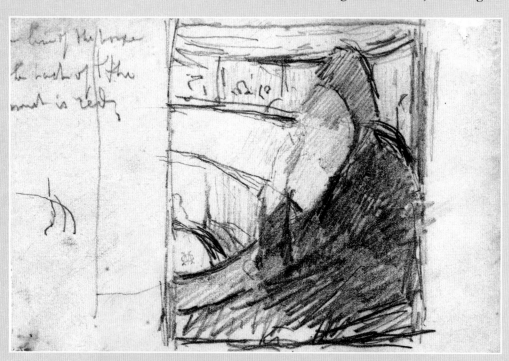

Fig. 169 Mary Stevenson Cassatt, Study for painting *In the Loge*, 1880.
Pencil, 4 × 6 in. Gift of Dr. Hans Schaeffer. Courtesy, Museum of Fine Arts, Boston. 55.28.

In the final painting, the strict division between light and dark has been somewhat modified, particularly by the revelation of the woman's neck between the hat's strap and her collar, creating two strong light-and-dark diagonals. A sort of angularity is thus introduced into the painting, emphasizing the horizontal quality of the woman's profile and gaze as she stares out at the other loges through her binoculars, at an angle precisely 90° from our point of view.

Across the way, a gentleman, evidently in the company of another woman, leans forward out of his box to stare through his own binoculars in the direction of the woman in black. He is in the

Fig. 174 Thomas Cole, *The Oxbow (Connecticut River near Northhampton)*, 1836.
Oil on canvas, 51½ × 76 in. The Metropolitan Museum of Art, Gift of Mrs. Russell Sage.

civilized valley floor on the right. Here, bathed in serene sunlight, are cultivated fields, hillsides cleared of timber, and farmhouses from whose chimneys rise gentle plumes of smoke. The Connecticut River itself flows in a giant arc that reinforces the pastoral tranquility of the scene.

The painting embodies many of the themes that Cole's contemporaries, the authors Washington Irving and James Fenimore Cooper, expressed in such classics as Irving's "Rip Van Winkle," and Cooper's Leatherstocking novels. In 1826, a decade before this painting, Cole himself described a storm in the Catskills, the mountains of Eastern New York and Western Connecticut:

> In one of my many mountain rambles I was overtaken by a thunderstorm. . . . As it advanced, huge masses of vapour were seen moving across the deep blue. . . . The deep gorge below me grew darker, and the general gloom more awful: terrific clouds gathered in their black wings upon the hollow, hushed and closer . . . squadrons of vapour rolled in,—shock succeeded shock,—thunderbolt fell on thunderbolt,—peal followed peal,—waters dashed on every crag from the full sluices of the sky. . . . All at once, a blast, with the voice and temper of a hurricane, swept up through the gulf, and lifted with magical swiftness the whole mass of clouds high into the air. . . . A flood of light burst forth from the west and jeweled the whole broad bosom of the mountain. The birds began to sing, and I saw, in a neighboring dell, the blue smoke curling up quietly from a cottage chimney.

The power of Cole's description rests on the same tension between light and dark as his painting. It is, in fact, as if *The Oxbow* captures the very moment with which his narrative ends. The artist's umbrella juts out across the river from the rock at the right. And just below it, to the left, is Cole himself, now at work at his easel. The furious forces of nature have moved on, and the artist "captures" the scene just as civilization would "tame" the wild.

Fig. 175 J. M. W. Turner, *Shade and Darkness—The Evening of the Deluge*, 1843.
Oil on canvas, 30½ × 30½ in. Clore Collection, Tate Gallery, London/Art Resource, New York.

Fig. 176 J. M. W. Turner, *Light and Colour (Goethe's Theory)—Morning After the Deluge—Moses Writing the Book of Genesis*, 1843.
Oil on canvas, 30½ × 30½. Clore Collection, Tate Gallery, London/Art Resource, New York.

We have only to think of the Bible, and the first lines of the Book of Genesis, which very openly associates the dark with the bad and the light the good to understand how thoroughly the tension between light and dark dominates Western thought:

> *In the beginning God created the heaven and the earth. And the earth was without form, and void; and darkness was upon the face of the deep. And the Spirit of God moved upon the face of the waters. And God said, Let there be light: and there was light. And God saw the light, that it was good: and God divided the light from the darkness.*

In the history of art, this association of light or white with good and darkness or black with evil was first fully developed in the late eighteenth- and early nineteenth-century color theory of the German poet and dramatist Johann Wolfgang von Goethe. For Goethe, colors were not just phenomena to be explained by scientific laws. They also had moral and religious significance, existing halfway between the goodness of pure light and the damnation of pure blackness. In heaven there is only pure light, but the fact that we can experience color—which, according to the laws of optics,

depends upon light mixing with darkness—promises us at least the hope of salvation.

J. M. W. Turner was deeply impressed with Goethe's color theory and illustrated it in a pair of paintings executed late in life, though he is certainly accepting darkness here in a way that Goethe did not, recognizing that his painting depends on an equal give-and-take between light and darkness. *Shade and Darkness* (Fig. 175) is dominated by blues, grays, and browns, while *Light and Colour* (Fig. 176) is alive with reds and yellows. In the first, the figures are all passive, sleeping, or dead. In the second, bathed in an almost pure white light, and barely recognizable at the top center of the painting, Moses writes the words from Genesis quoted above. Figures swirl around him as if life itself is being born out of the vortex.

Although this opposition between dark and light is taken for granted in our culture, many people of color, with reason, find such thinking offensive. They are especially offended by the use of the term *value* to describe gradations of light and dark, so that black is "low" and white is "high" in value. Like Goethe's theory, the term *value* entered art discourse in the late eighteenth century, the first instance of its use in English being in the lectures of Sir Joshua Reynolds, with whom

Turner probably studied at the Royal Academy between 1789 and 1792. Since then, artists and art historians alike use the term as part of a specialized descriptive vocabulary that, in itself, would seem to be at the farthest remove from issues of race and the relative "worth" of human beings. It is nevertheless clear that since Biblical times, Western culture has tended to associate blackness with negative qualities and whiteness with positive ones, and it is understandable why people might take offense at this usage. For this reason, this book uses the word **key** instead of **value**, substituting the musical metaphor for the moral and economic one.

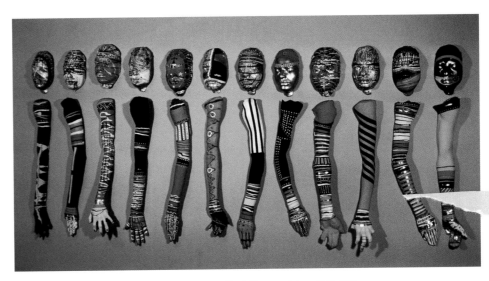

Fig. 177 Ben Jones, *Black Face and Arm Unit*, 1971.
Plaster and paint, 1971 New Jersey State Museum Collection Purchase, FA 1984.92 A-X.

If for Goethe blackness is not merely the absence of color but the absence of good, for African-Americans blackness is just the opposite. In poet Ted Wilson's words:

> *Mighty drums echoing the voices*
> *of Spirits. . . .*
> *these sounds are rhythmatic*
> *The rhythm of vitality,*
> *The rhythm of exuberance*
> *and the rhythms of Life*
> *These are the sounds of blackness*
> *Blackness—the presence of all color.*

Ben Jones's *Black Face and Arm Unit* (Fig. 177) is in many ways the visual equivalent of Wilson's poem. Cast lifesize from actual hands and arms, the twelve-part piece literally embodies an essential blackness. Adorning this essence are a series of bands, decorations, and scarifications (patterns made by scarring), reminiscent of the facial decorations evident in some of the most ancient African sculpture. The brass head of an *oni*, or king, illustrated here (Fig. 178), dates from the thirteenth century C.E. The parallel striations create a sense of rhythm and exuberance, and it is as if in the striations that decorate Jones's arms and faces we hear the voices of this Nigerian spirit.

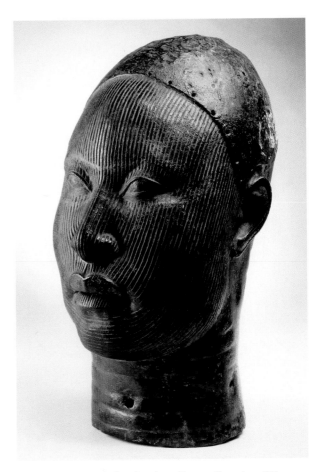

Fig. 178 Head of a King, from Ife, c. 13th century C.E.
Brass, height 11 11/16 in. Museum of Ife Antiquities, Ife, Nigeria.
© 1985 Dirk Bakker, Detroit, MI.

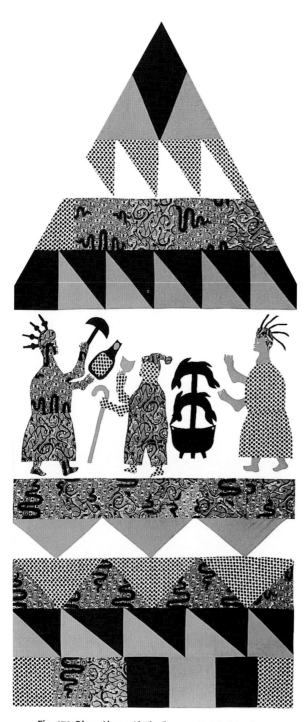

Fig. 179 Okun Akpan Abuje (born c. 1900), Nigerian, Funerary shrine cloth, commissioned in the late 1970s.
Cotton, dye 135¾ × 60¼.
Museum Purchase 84-6-9.
Photograph: Frank Khoury. National Museum of African Art/ Smithsonian Institution.

Another, more contemporary example of Nigerian art, a funeral cloth (Fig. 179) commissioned by a collector in the late 1970s, similarly illustates the limits of white Western assumptions about the meaning of light and dark, black and white. The cloth is the featured element of a shrine, called a *nwomo*, constructed of bamboo poles to commemorate the death of a member of Ebie-owo, a Nigerian warriors' association. A deceased elder, wearing a woolen hat, is depicted in the center of this cloth. His eldest daughter, at the left, pours liquor into his glass. The woman on the right wears the hairdo of a mourning widow. She is cooking two dried fish for the funeral feast.

But the dominant colors of the cloth—red, black, and white—are what is most interesting. While in the West we associate black with funerals and mourning, here it signifies life and the ancestral spirits. White, on the other hand, signifies death. Though red is the color of blood, it is meant to inspire the warrior's valorous deeds.

COLOR

Both the ambiguity of Goethe's color theory and the example of the Nigerian funeral cloth make clear that, of all the formal elements, color is perhaps the most complex. Not only do different colors mean different things to different people and cultures, but our individual perception of a given color can change as its relationship to other colors changes. The human eye may be able to distinguish as many as ten million different colors, but we have nowhere near that many words to differentiate among them. Different cultures, furthermore, tend to emphasize different ranges of color. Although apparently able to distinguish visually between green and blue, many cultures do not possess different words for them. The Maoris of New Zealand regularly employ over one hundred words for what most of us would simply call "red." Color is so complex that no one—neither scientists, nor artists, nor theoreticians such as Goethe—has ever fully explained it to everyone's satisfaction.

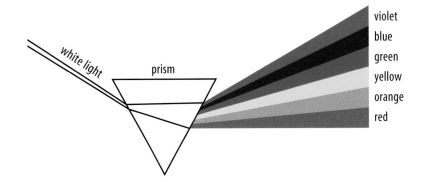

Fig. 180 Colors separated by a prism.

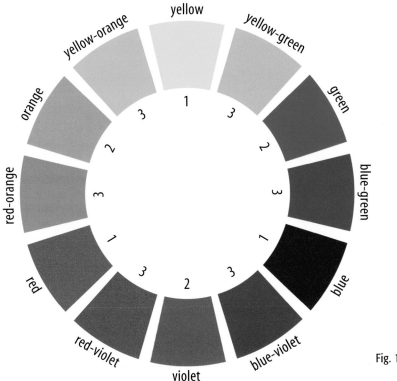

Fig. 181 Conventional color wheel.

Basic Color Vocabulary

As we have said, color is a direct function of light. Sunlight passed through a prism breaks into bands of different colors, in what is known as the **spectrum** (Fig. 180). By reorganizing the visible spectrum into a circle, we have what is recognized as the conventional **color wheel** (Fig. 181). The three **primary colors**—red, yellow, and blue (designated by the number 1 on the color wheel)—are those that, in theory at least, cannot be made by any mixture of the other colors. Each of the **secondary colors**—orange, green, and violet (designated by the number 2)—is a mixture of the two primaries that it lies between. Thus, as we all learn in elementary school, green is made by mixing yellow and blue. The **intermediate colors** (designated by the number 3) are mixtures of a primary and a neighboring secondary. If we mix the primary yellow with the secondary orange, for instance, the result is yellow-orange.

Fig. 182 Color mixtures of reflected pigment—subtractive process.

Fig. 183 Color mixtures of refracted light—additive process.

As we have already noted in our discussion of tint and shade, each primary and secondary color of the visible spectrum is called a hue. Thus all shades and tints of red—from pink to deep maroon—are said to be of the same red hue, though they are different keys of that hue. One of the more complex problems presented to us by color is that the primary and secondary hues change depending upon whether we are dealing with *refracted* light or *reflected* pigment. The conventional color wheel illustrated on the previous page demonstrates the relationship among the various hues as reflected pigment. When we mix pigments, we are involved in a **subtractive** process (Fig. 182). That is, in mixing two primaries, the secondary that results is of a lower key and seems duller than either of the original two primaries, because each given primary absorbs a different range of

white light. Thus when we combine red and yellow, the resulting orange absorbs twice the light of either of its source primaries taken alone. Theoretically, if we combined all the pigments, we would absorb all light and end up with black, the absence of color altogether.

Refracted light, on the other hand, works in a very different manner. With refracted light, the primary colors are red-orange, green, and blue-violet. The secondaries are yellow, magenta, and cyan. When we mix light, we are involved in an **additive** process (Fig. 183). That is, if we mix two primaries of colored light, the resulting secondary is higher in key and seems brighter than either primary. Our most common exposure to this process occurs when we watch television. This is especially apparent on a large screen monitor, where yellow, if viewed close up, can be seen to result from the overlapping of many red and green dots. In the additive color process, as more and more colors are combined, more and more light is added to the mixture, and the colors that result are brighter than either source taken alone. As Newton discovered, when the total spectrum of refracted light is recombined, white light results.

Color is described first by reference to its hue (red), then to its relative key or value (pink or maroon) and also by its **intensity** or **saturation** (bright pink). Intensity is a function of a color's relative brightness or dullness. One lowers the intensity of a hue by adding to it either gray or the hue opposite it on the color wheel (in the case of red, we would add green). Intensity may also be reduced by adding **medium**—a liquid that makes paint easier to manipulate—to the hue.

There is perhaps no better evidence of the psychological impact a change in intensity can make than to look at the newly restored frescoes of the Sistine Chapel at the Vatican in Rome, painted by Michelangelo between 1508 and 1512 (Figs. 184 and 185). Restoration was begun in 1980 and has just been completed. The process was relatively simple. A solvent called AB 57, mixed with a fungicide and antibacterial agent, and a cellulose gel so that it would not drip from the ceiling, was painted onto a small section of the fresco with a bristle brush. The AB 57 mixture was allowed to sit for three minutes, and then it was removed with a sponge

and water which also removed the grime. The process was repeated in the dirtiest areas. The entire operation was documented in great detail by the Nippon Television Network of Japan, which funded the entire restoration project.

Restorers have discovered that the dull, somber hues always associated with Michelangelo were not the result of his **palette**, that is, the range of colors he preferred to use, but of centuries of accumulated dust, smoke, grease, and varnishes made of animal glue painted over the ceiling by earlier restorers. The colors are in fact much more saturated and intense than anyone had previously supposed. Some experts in fact find them so intense that they seem, beside the golden tones of the unrestored surface, almost garish. As a result, there has been some debate about the merits of the cleaning. But, in the words of one observer: "It's not a controversy. It's culture shock."

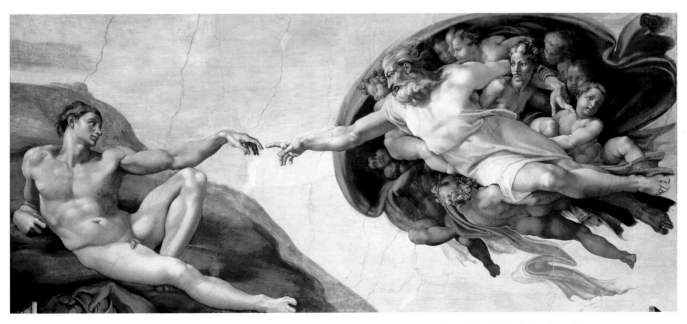

Figs. 184 & 185 Michelangelo, *The Creation of Adam* (top unrestored, bottom restored), ceiling of the Sistine Chapel, 1508–1512.
Fresco. The Vatican, Rome. Unrestored image Scala/Art Resource, New York. Restored image 1989 © Nippon TV, Tokyo.

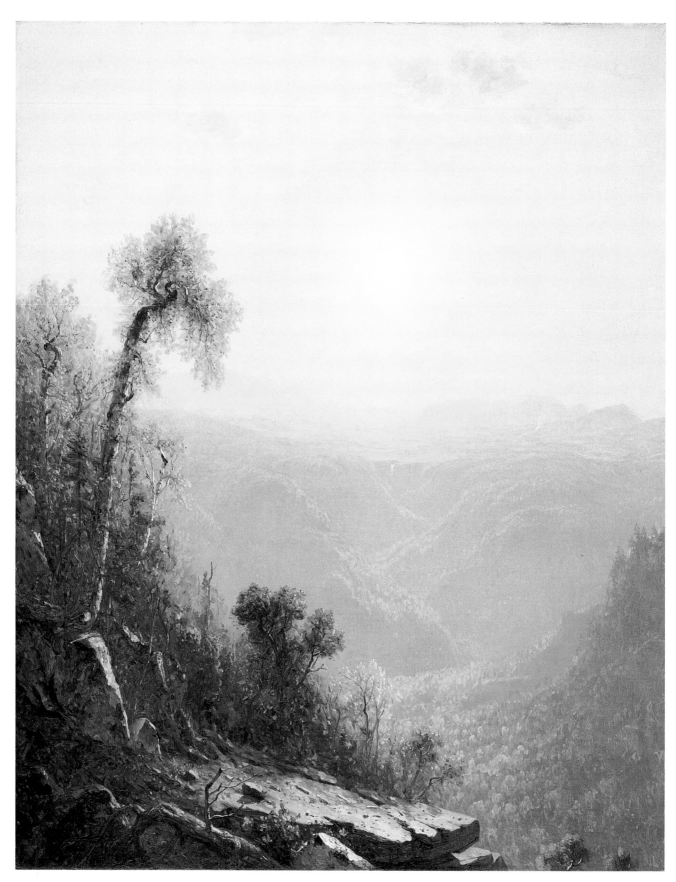

Fig. 186 Sanford R. Gifford, *October in the Catskills*, 1880.
Oil on canvas, 36⁵/₁₆ × 29³/₁₆ in. Los Angeles County Museum of Art.
Gift of Mr. And Mrs. Charles C. Shoemaker, Mr. and Mrs. J. Douglas Pardee, and Mr. and Mrs. John McGreevey. M77.141. Photograph © 2002 Museum Associates/LACMA..

they appear alone. This effect, known as **simultaneous contrast,** is due to the physiology of the eye. If, for example, you stare intensely at the color red for about thirty seconds, and then shift your vision to a field of pure white, you will see not red, but a variety of green. Physiologically, the eye supplies an **afterimage** of a given hue in the color of its complement. This effect can be experienced in Leon Golub's *Mercenaries III* (Fig. 188). Based on news photos, Golub's painting attempts, in his words, to "have a sense of the contemporaneity of events. They are poised to be almost physically palpable, a tactile tension of events." The almost neon, electric red and and green of the canvas clash dramatically. The color seems as explosive as the situation Golub depicts.

In his *A Sunday on La Grande Jatte* (Fig. 189), George Seurat has tried to *harmonize* his complementary colors rather than create a sense of tension with them. With what almost amounts to fanaticism, Seurat painted this giant canvas with thousands of tiny dots, or points, of pure color in a process that came to be known as *pointillism.* Instead of mixing color on the palette or canvas, he believed that the eye of the perceiver would be able to mix colors optically. He strongly believed that if he placed complements side by side—particularly orange and blue in the shadowed areas of the painting—that the intensity of the color would be dramatically enhanced. But to Seurat's dismay, most viewers found the painting "lusterless" and "murky." This is because there is a rather limited zone in which the viewer does in fact optically mix the pointillist dots. For most viewers, Seurat's

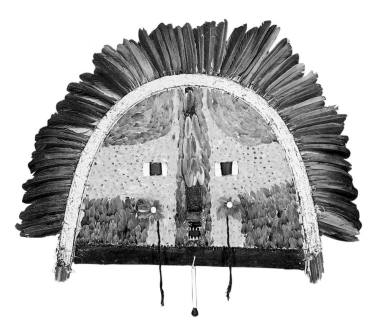

Fig. 191 *Cara Grande* feather mask, Tapirapé, Rio Tapirapé, Brazil, c. 1960. Height 31 in. National Museum of the American Indian/Smithsonian Institution.

painting works from about six feet away—closer, and the painting breaks down into abstract dots, farther away, and the colors muddy, turning almost brown.

One of the more vexing issues that the study of color presents is that the traditional color wheel really does not adequately describe true complementary color relations. For instance, the afterimage of red is not really green, but blue-green. In 1905, Albert Munsell created a color wheel based on five, rather than three, primary hues: yellow, green, blue, violet, and red (Fig. 190). The complement of each of these five is a secondary. Munsell's color wheel accounts for what is, to many eyes, one of the most powerful complementary color schemes, the relation between yellow and blue-violet. The Brazilian feather mask, known as a *Cara Grande* (Fig. 191), illustrates this contrast. The mask is worn during the annual Banana Fiesta in the Amazon basin; it is almost three feet tall. It is made of wood and is covered with pitch to which feathers are attached. The brilliantly colored feathers are not dyed, but are the natural plumage of tropical birds, and the intensity of their color is heightened by the simultaneous contrast between yellow and blue-violet, which is especially apparent at the outer edge of the mask.

Fig. 190 Munsell color wheel.

Chuck Close's Stanley

Chuck Close's 1981 oil painting *Stanley* (Fig. 193) might best be described as "layered" pointillism (refer to Fig. 189). Like all of his paintings, the piece is based on a photograph.

Fig. 192 Chuck Close, *Stanley* (large version), 1980–81, detail.
Oil on canvas, 108 × 84 in. Purchased with funds contributed by Mr. and Mrs. Barrie M. Damson, 1981. 81.2839.
The Solomon R. Guggenheim Museum, New York.
Photo: David Heald. © The Solomon R. Guggenheim Foundation, New York (FN 2839).

Close's working method is to overlay the original photograph with a grid. Then he draws a grid with the same number of squares on a canvas. Close is not so much interested in representing the person whose portrait he is painting, as he is in reproducing, as accurately as possible, the completely abstract design that occurs in each square of the photo's grid. In essence, Close's large paintings—*Stanley* is nearly eight feet high and six feet wide—are made up of thousands of little square paintings, as the detail (Fig. 192) makes clear. Each of these "micro"-paintings is composed as a small target, an arrangement of between two, three, or four concentric circles. Viewed up close, it is hard to see anything but the design of each square of the grid. But as the viewer moves farther away, the design of the individual squares of the composition dissolves, and the sitter's features emerge with greater and greater clarity.

In an interview conducted by art critic Lisa Lyons for an essay that appears in the book *Chuck Close*, published by Rizzoli International in 1987, Close describes his working method in *Stanley* at some length, comparing his technique to, of all things, the game of golf:

Artists working with either analogous or complementary color schemes choose to limit the range of their color selection. In his painting *Filàs for Sale* (Fig. 194), Charles Searles has rejected such a *closed* or *restricted palette*, in favor of an *open palette*, in which he employs the entire range of hues in a wide variety of keys and intensities. Such a painting is **polychromatic**. The painting depicts a Nigerian marketplace and was inspired by a trip Searles took to Nigeria, Ghana, and Morocco in 1972. "What really hit me," Searles says, "is th... art is in the people. The way the peo... themselves, dressed, decorate... became the art to me, like a ... of *filàs*, or brightly patter... pies the right foreground confusion and turmoil ... place is mirrored in the swirl of the variously

colored textile patterns. Each pattern has its own color scheme—yellow arcs against a ser... violet dots, for instance, in the swatc... just above the pile of hats—but a... ~ to create an almost disorienting ... ~ move-ment and activity.

Color in Repres... ...nal Art

There are ...
... ...erent ways of using color in
... ...al art. The artist can employ
r... ...
..., represent perceptual color, create an
...l mix like Seurat, or simply use color
...bitrarily. The green tree and the red brick building in Stuart Davis's *Summer Landscape* (Fig. 195) are examples of **local color**, or the color of objects viewed close up in even lighting conditions. Local color is the color we "know" an object to be, in the way that we know a

especially concerned with rendering such **perceptual colors**. Monet painted his landscapes outdoors, in front of his subject—**plein-air painting** is the technical term, the French word for "open air"—so as to be true to the optical colors of the scene before him. He did not paint a grainstack yellow simply because he knew hay to be yellow. He painted it in the colors that natural light rendered it to his eyes. Thus this *Grainstack* (Fig. 196) is dominated by reds, with afterimages of green flashing throughout.

The Impressionists' attempt to render the effects of light by representing *perceptual reality* is different than Seurat's attempt to reproduce light's effects by means of **optical color mixing**. Monet mixes color on the canvas. Seurat expects color to mix in your own eye. He put two hues next to each other, creating a third, new hue in the beholder's eye. Seurat's experiments were carried farther by his student Paul Signac. Signac recognized that Seurat's dots had been too small to be read legibly from

Fig. 196 Claude Monet, *Grainstack (Sunset)*, 1891.
Oil on canvas, 28⅞ × 36½ in. Museum of Fine Arts, Boston. Juliana Cheney Edwards Collection. 25.112.

banana is yellow or a fire truck is red. But we are also aware that as the effects of light and

Fig. 198 Pierre Bonnard, *The Terrace at Vernon*, c. 1920–1939.
Oil on canvas, 57¹¹/₁₆ × 76½ in. The Metropolitan Museum of Art, New York. Gift of Mrs. Frank Jay Gould, 1968 (68.1).
Photograph © 1980 The Metropolitan Museum of Art. © 2003 Artists Rights Society (ARS), New York/ADAGP, Paris.

insisted that his style be known as *divisionism*—the painter, he wrote, "does not paint with *dots*, he *divides*." That is, the optical mix is created by the practice of dividing the paint on the canvas by means of separate, unmixed strokes of different pigments. Depending on the nature of each stroke—depending, that is, on such variables as its hue, intensity, and size—a whole range of effects could be

glow, or even turn muddy and pale.

Artists sometimes choose to paint things in colors that are not "true" to either their optical or local colors. Bonnard's painting *The Terrace at Vernon* (Fig. 198) is an example of the expressive use of **arbitrary color**. No tree is "really" violet, and yet this large foreground tree is. The woman at the left holds an apple, but the apple

is as orange as her dress. Next to her, a young woman carrying a basket seems almost to disappear into the background, painted, as she is, in almost the same hues as the landscape (or is it a hedge?) behind her. At the right, another young woman in orange reaches above her head, melding into the ground around her. Everything in the composition is sacrificed to Bonnard's interest in the play between warm and cool colors, chiefly orange and violet or blue-violet, which he uses to flatten the composition, so that fore-, middle-, and backgrounds all seem to coexist in the same space. "The main subject," Bonnard would explain, "is the surface which has its color, its laws, over and above those of the objects." He sacrifices both the local and optical color of things to the arbitrary color scheme of the composition.

Sonia Delaunay's Electric Prism

With her husband Robert Delaunay, whom she married in 1910, Sonia Delaunay-Terk was one of the founders of modern abstract painting. Together in Paris, in the first decades of the twentieth century, they explored what their poet friend, Guillaume Apollinaire, called "the beautiful fruit of light," the colors of the modern world. In the work of both artists, these colors assumed the shape of disks. Robert called these *Simultaneous Disks* (Fig. 199), and they were based on his own notions about the simultaneous contrast of colors. He sought, in the paintings, to balance complements in giant color wheels. Sonia was less scientific in her approach to the design. Electric streetlight, which was still a relatively new phenomenon, transfixed her. "Robert, our friends and I met at the St. Michel fountain at the bottom of Boulevard Saint-Michel," she would later recall. "The halos of the new electric lights made colors and shades turn and vibrate, as if as yet unidentified objects fell out of the sky around us."

Reacting to this new light, in the summer of 1913, Delaunay began to make what she called "simultaneous dresses" (Fig. 200). Apollinaire described such a dress for the readers of the *Mercure de France*, a Paris newspaper: "A purple dress, wide purple and green belt, and under the jacket, a bodice divided into brightly colored zones, delicate or faded where the following colors are mixed—antique rose, yellow-orange, blue, scarlet, etc., appearing on different materials." Imprinted on a dress, Delaunay's colors became dynamic. They moved as the body moved.

The poet Blaise Cendrars was so inspired by Sonia's color sense that he asked her to illustrate his long prose poem *The Prose of the Transsiberian*. The printed poem, with its illustrations, is 81¾ inches high, and end to end, its total edition of 150 added up to the height of the Eiffel Tower.

Fig. 199 Robert Delaunay, *Premier disque (First Disk),* 1912.
Oil on canvas, 53 in. diameter
Christie's Images Ltd. 1999.

Fig. 200 Sonia Delaunay in a Simultaneous dress, 1914.
Collection du Centre Georges Pompidou.
Musée National d'Art Moderne, Paris.

CHAPTER 8

OTHER FORMAL ELEMENTS

TEXTURE
Actual Texture
Visual Texture

PATTERN

TIME AND MOTION

WORKS IN PROGRESS
Jackson Pollock's *Number 29, 1950*

THE CRITICAL PROCESS
Thinking about the Formal Elements

To this point, we have discussed some of the most important of the formal elements—line, space, light, and color—but several other elements employed by artists can contribute significantly to an effective work of art. **Texture** refers to the surface quality of a work. **Pattern** is a repetitive motif or design. And **time** and **motion** can be introduced into a work of art in a variety of ways. A work can *suggest* the passing of time by telling a story, for instance, in a sequence of panels or actions. It can create the *illusion* of movement, optically, before the eye. Or the work can *actually* move, as Alexander Calder's mobiles do (see Figures 99 and 100), or as video and film do.

Fig. 205 Michelangelo, *Pietà*, 1501.
Marble, height 6 ft. 8½ in. Vatican, Rome. Alinari/Art Resource, New York.

TEXTURE

Texture is the word we use to describe the work of art's ability to call forth certain *tactile* sensations and feelings. It may seem rough or smooth, as course as sandpaper or as fine as powder. If it seems slimy, like a slug, it may repel us. If it seems as soft as fur, it may make us want to touch it. In fact, most of us are compelled to touch what we see. It is one of the ways we come to understand our world. That's why signs in museums and galleries saying "Please Do Not Touch" are so necessary: If, for example, every visitor to the Vatican in Rome had touched the marble body of Christ in Michelangelo's *Pietà* (Fig. 205), the rounded, sculptural forms would have been reduced to utter flatness long ago.

Actual Texture

Marble is one of the most tactile of all artistic mediums. Confronted with Michelangelo's almost uncanny ability to transform marble into lifelike form, we are virtually compelled to reach out and confirm that Christ's dead body is made of hard, cold stone and not the real, yielding flesh that the grieving Mary seems to hold in her arms. Even the wound on his side, which Mary almost touches with her own hand, seems real. The drapery seems soft, falling in gentle folds. The visual experience of this work defies what we know is materially true. Beyond its emotional content, part of the power of this work derives from the stone's extraordinary texture, from Michelangelo's ability to make stone come to life.

Another actual texture that we often encounter in art is paint applied in a thick, heavy manner. Each brushstroke is not only evident but seems to have a "body" of its own. This textural effect is called **impasto**. Joan Snyder is known for the expressive impasto of her

Fig. 206 Joan Snyder, *Sea Moons*, 1989.
Oil and velvet on linen, 11¼ × 19½ in. Courtesy of Robert Miller Gallery, New York.

Fig. 207 Manuel Neri, *Mujer Pegada Series No. 2*, 1985–1986.
Bronze with oil-based enamel, 70 × 56 × 11 in. Courtesy Charles Cowles Gallery, New York. Photo: M. Lee Fatheree.

abstract "stroke" paintings of the late 1960s. Recently, Snyder has begun to use this brushstroke in landscape paintings done on a ground of red or black velvet. *Sea Moons* (Fig. 206), for example, consists of a canvas draped with a swath of black velvet. The thick impasto of the sea sweeps up from the canvas across the bottom of the hanging fabric; a night sky, dotted with van Gogh-like moons and stars, descends across the painting like a shroud. The shift in texture, from paint to velvet, differentiates space. The line between sea and sky, heaven and earth, is underscored by this shift in texture.

In Manuel Neri's bronze sculpture from the *Mujer Pegada Series* (Fig. 207), the actual texture of the bronze is both smooth, where it

implies the texture of skin on the figure's thigh, for instance, and rough, where it indicates the "unfinished" quality of the work. It is as if Neri can only begin to capture the whole woman who is his subject, as she emerges half-realized from the sheet of bronze. Our sense of the transitory nature of the image, its fleeting quality, is underscored by the enamel paint that Neri has applied in broad, loosely gestural strokes to the bronze. This paint adds yet another texture to the piece, the texture of the brushstroke. This brushstroke helps, in turn, to emphasize the work's two-dimensional quality. It is as if Neri's three-dimensional sculpture is attempting to escape the two-dimensional space of the wall, to escape, that is, the space of painting.

Fig. 208 Max Ernst, *Europe After the Rain*, 1940–1942.
Oil on canvas, 21⁹/₁₆ × 58³/₁₆ in. Wadsworth Atheneum, Hartford.
The Ella Gallup Sumner and Mary Catlin Sumner Collection Fund. ©2003 Artists Rights Society (ARS), New York/ADAGP, Paris.

Visual Texture

Visual texture appears to be actual but is not. Like the representation of three-dimensional space on a two-dimensional surface, a visual texture is an illusion. If we were to touch the painting above, *Europe After the Rain* (Fig. 208), it would feel primarily smooth, despite the fact that it seems to possess all sorts of actual surface texture, bumps and hollows of fungus-like growth.

Fig. 209 William A. Garnett, *Erosion and Strip Farms*, 1951.
Gelatin-silver print, 15⁹/₁₆ × 19½ in. Museum of Modern Art, New York, Purchase.
Licensed by Scala-Art Resource, New York. Copy Print.
© 1999 Museum of Modern Art, New York.

The painting is by Max Ernst, the inventor of a technique called *frottage*, from the French word *frotter*, "to rub." By putting a sheet of paper over textured surfaces, especially floorboards and other wooden surfaces, and then rubbing a soft pencil across the paper, he was able to create a wide variety of textural effects. He would then arrange these textures into visions of surrealistic "forests" and fantastic landscapes.

William Garnett's stunning aerial view of strip farms stretching across an eroding landscape (Fig. 209) is a study in visual texture. The plowed strips of earth contrast dramatically with the strips that have been left fallow. And the predictable, geometric textures of the farmed landscape also contrast with the irregular veins and valleys of the unfarmed and eroded landscape in the photograph's upper left.

The evocation of visual textures is, in fact, one of the primary tools of the photographer. When light falls across actual textures, especially *raking* light, or light that illuminates the surface from an oblique angle, the resulting patterns of light and shadow emphasize the texture of the surface. In this way, the Garnett photograph reveals the most subtle details of the land surface. But remember, the photograph itself is smooth and flat, and its textures are therefore *visual*. The textures of its subject, revealed by the light, are *actual* ones.

Fig. 210 Anatolia Konya "Lotto" rug, 16th century.
Wool, 6 ft. 9 in. × 4 ft. 1 in. Philadelphia Museum of Art,
The Joseph Lees Williams Memorial Collection. 1955-65-9.

PATTERN

The textures of the landscape in Garnett's photograph reveal themselves as a pattern of light and dark stripes. Any formal element that repeats itself in a composition—line, shape, mass, color, or texture—creates a recognizable **pattern**.

The carpet illustrated here (Fig. 210) was probably made in Anatolian Turkey in the sixteenth century, and its design may have originated among Asian nomads. The pattern, a repetitive interlace of lines and shapes, was apparently based on a widely available master plan, and it rarely changed. It developed as a court design in central Turkey and subsequently spread through exportation to Europe, where it was copied by local manufacturers in Spain, Flanders, England, and Italy, as well as in North Africa and India.

In its systematic and repetitive use of the same motif or design, pattern is an especially important *decorative* tool. Throughout history,

decorative patterns have been applied to utilitarian objects, such as this rug, in order to make them more pleasing to the eye. Early manuscripts, for instance, such as the page reproduced here from the eighth-century *Lindisfarne Gospels* (Fig. 211), were *illuminated*, or elaborately decorated with drawings, paintings, and large capital letters, to beautify the sacred text. This page represents the ways in which Christian imagery—the cross—and earlier pre-Christian pagan motifs came together in the early Christian era in the British Isles. The simple design of the traditional Celtic cross, found across Ireland, is almost lost in the checkerboard pattern and the interlace of fighting beasts with spiraling tails, extended necks, and clawing legs that borders the page. These beasts are examples of the pagan *animal style*, which consists of intricate, ribbonlike traceries of line that suggest wild and fantastic beasts. The animal style was used not only in England but also in Scandanavia, Germany, and France.

Because decorative pattern is associated with the beautifying of utilitarian objects in the crafts, with folk art, and with "women's work" such as quilt-making, it has not been

Fig. 211 Cross page from the *Lindisfarne Gospels*, c. 700.
13½ × 9¼ in. British Library/Bridgeman Art Library.

held in the highest esteem among artists. But since the early 1980s, as the value of "women's work" has been rethought, and as the traditional "folk" arts of other cultures have come to be appreciated by the Western art world, its importance in art has been reassessed by many.

Of all the artists working with pattern and decoration, Miriam Schapiro has perhaps done the most to legitimate pattern's important place in the arts. Schapiro creates what she calls "femmages," a bilingual pun, contracting the French words *femme* and *hommage*, "homage to woman," and the English words "female" and "image." "I wanted to explore and express," Schapiro explains, "a part of my life which I had always dismissed—my homemaking, my nesting." In her monumental

Fig. 212 Miriam Schapiro, *Night Shade*, 1986.
Acrylic and fabric collage on canvas, 48 × 96 in. Private Collection. © Miriam Schapiro.

Fig. 213 Kim McConnel, *Miracle*, 1980.
Acrylic on cotton with metallic paint, 93 × 123 in.
Courtesy Holly Solomon Gallery, New York. Photo: D. James Dee. (HSG#: KM-0239).

created a collage web of paint, containing pebbles, shells, sand, sections of wire mesh, marbles, and pieces of colored plastic.

Namuth's photographs and films teach us much about Pollock's working method. Pollock longed to be completely involved in the process of painting. He wanted to become wholly absorbed in the work. As he had written in a short article called "My Painting," published in 1947, "When I am *in* my painting, I'm not aware of what I'm doing . . . the painting has a life of its own. I try to let it come through. It is only when I lose contact with the painting that the result is a mess. Otherwise there is pure harmony, an easy give and take, and the painting comes out well."

In Namuth's photographs and films, we witness Pollock's absorption in the work. We see the immediacy of his gesture as he flings paint, moving around the work, the paint tracing his path. He worked on the floor, in fact, in order to heighten his sense of being in the work. "I usually paint on the floor," he says in Namuth's film. "I feel more at home, more at ease in a big area, having a canvas on the floor, I feel nearer, more a part of a painting. This way I can walk around it, work from all four sides and be *in* the painting." We also see in Namuth's images, something of the speed with which Pollock worked. According to Namuth, when Pollock was painting, "his movements, slow at first, gradually became faster and more dancelike." In fact, the traceries of line on the canvas are like choreographies, complex charts of a dancer's movement. In Pollock's words, the paintings are

Fig. 219 Jackson Pollock, *No. 29, 1950.*
Oil on canvas, expanded steel, string, glass, and pebbles on glass, 48 × 72 in.
National Gallery of Canada, Ottawa. Purchased 1968.
© 2003 Pollock-Krasner Foundation/Artists Rights Society (ARS) New York.

energy and motion
made visible—
memories arrested in space.

Namuth was disturbed by the lack of sharpness and the blurred character in some of his photographs, and he did not show them to Pollock. "It was not until years later," Namuth admitted, "that I understood how exciting these photographs really were." At the time, though, his inability to capture all of Pollock's movement led him to the idea of making a film. "Pollock's method of painting suggested a moving picture," he would recall, "the dance around the canvas, the continuous movment, the drama."

Some art works are created precisely to give us the *illusion* of movement. In **Optical Painting,** or "Op Art" as it is more popularly known, the physical characteristics of certain formal elements—line and color particularly—are subtly manipulated to stimulate the nervous system into thinking it perceives movement. Bridget Riley's *Drift 2* (Fig. 220) is a large canvas that seems to wave and roll before our eyes even though it is stretched taut across its support. One of Riley's earliest paintings was an attempt to find a visual equivalent to heat. She had been crossing a wide plain in Italy: "The heat off the plain was quite incredible—it shattered the topographical structure of it and set up violent color vibrations. . . . The important thing was to bring about an equivalent shimmering sensation on the canvas." In *Drift 2*, we encounter not heat, but wave action, as though we were, visually, out at sea.

Other works of art, of course, do *actually* move. Often driven by motors, such works are examples of **kinetic** art. Alexander Calder's mobiles, such as *Dots and Dashes* (see Figs. 99 & 100), are an example. One of the most fas-

cinating of kinetic sculptors was Jean Tinguely, who dedicated his career to making large machines out of the refuse of industrial culture. On the rainy evening of March 7, 1960, he set in motion a machine in the sculpture garden of the Museum of Modern Art in New York (Fig. 221). The piece sputtered, stalled, started up again. A big balloon inflated over the mass of pulleys and gears. A player piano began to play. Fire erupted, the piano burned, stink bombs exploded, and a small, wheeled machine was released and, all aflame, careened toward the audience, chasing a TV cameraman up a ladder. A fireman, in attendance as a safety precaution, was eventually summoned, and to the robust boos of the audience, finally doused the flames with a fire extinguisher. The piece—or the event, actually—was entitled *Homage to New York*. Asked what he thought of it, one critic replied, with tongue in cheek, "It's the end of civilization as we know it," which is something of what Tinguely himself must have felt. In modern day New York, he seems to say, creative energy is mechanical, self-destructive—and entirely amusing.

Fig. 220 Bridget Riley, *Drift 2*, 1966.
Acrylic on canvas, 91½ × 89½ in. The Albright-Knox Art Gallery, Buffalo, NY. Gift of Seymour H. Knox, 1967.

Fig. 221 Jean Tinguely, *Homage to New York*, March 7, 1960.
Museum of Modern Art, New York. Licensed by Scala-Art Resource, New York. Photo: David Gahr. ©2003 Artists Rights Society (ARS), New York/ADAGP, Paris.

Fig. 222 Edwin S. Porter, *The Great Train Robbery*, 1903.
Kobal Collection.

Fig. 223 Walt Disney, *Steamboat Willie*, 1928.
Kobal Collection. ©Disney Enterprises, Inc.

Fig. 224 Apollo XI Astronaut Neil Armstrong Stepping onto the Moon, July 20, 1969.
Courtesy of NASA.

The spatial and the temporal have been most successfully combined in the twentieth century in the arts of film and video. In 1903, Edwin S. Porter released the ground-breaking film *The Great Train Robbery*, the first narrative-action-chase scene in the history of the cinema, which ended with the shockingly direct act of the bandit turning to fire his gun into the audience (Fig. 222). Fifteen minutes in length, the film opened in 1905 at John P. Harris's Nickelodeon in Pittsburgh, the first theater in the United States devoted to the showing of movies, where it played to packed houses. Within months, thousands of "nickelodeons" were springing up across the continent as millions of people rushed to experience "moving pictures." By the late 1920s, Walt Disney had perfected the animated cartoon, and Mickey Mouse had become an American institution (Fig. 223). Hollywood was making over 450 movies a year by 1936, and the average American saw two films a week.

After World War II, this thirst for the moving image was satisfied as much by television, the first medium in history to bring the primary image directly into the viewer's home. Many early television shows were actually "live"—that is, the show was broadcast live, before a live studio audience, without any taping or even tape delay. The directness, immediacy, and realism of the television image (further heightened by the rise of the color monitor, which began to have a real impact in the late 1950s) have made it, at least seemingly, the most *realistic* of media. Though its images are constantly manipulated, and its stage space almost totally artificial (notice how many television "families" sit on the same side of the kitchen table, facing the camera), we accept it as "real." When 400 million people watched Neil Armstrong step onto the moon in July 1969 (Fig. 224), only the most die-hard skeptics distrusted what they saw. It is fair to say, in fact, that television has shrunk the world. In 1985, one-third of the world's population—approximately 1.6 billion people—watched the Live Aid Telethon together.

Time and motion in television are very different from time and motion in video art, as Bill Viola's *Room for St. John of the Cross* (Fig. 225) demonstrates. Like film, television is made of sequences of "shots"—close-ups (showing head

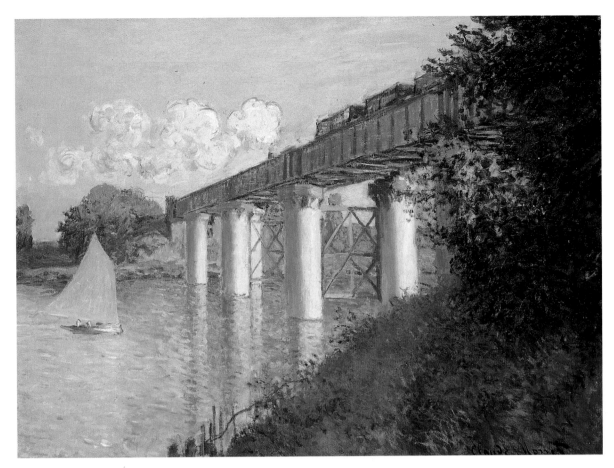

Fig. 264 Claude Monet, *The Railroad Bridge at Argenteuil*, 1874.
Oil on canvas, 21⅘ × 29⅖ in. The John G. Johnson Collection, Philadelphia Museum of Art. J#1050.

THE CRITICAL PROCESS

Thinking about the Principles of Design

By way of concluding this part of the book, let's consider how the various elements and principles inform a particular work, Monet's *The Railroad Bridge at Argenteuil* (Fig. 264). Line comes into play here in any number of ways. How would you describe Monet's use of line? Is it classical or expressive? Two strong diagonals—the near bank and the bridge itself—cross the picture. What architectural element depicted in the picture echoes this structure? Now note the two opposing directional lines in the painting—the train's and the boat's. In fact, the boat is apparently tacking against a strong wind that blows from right to left, as the smoke coming from the train's engine indicates. Where else in the painting is this sense of opposition apparent? Consider the relationships of light to dark in the composition and the com-

plementary color scheme of orange and blue that is especially utilized in the reflections and in the smoke above. Can you detect opposing and contradictory senses of symmetry and asymmetry? What about opposing focal points?

What appears at first to be a simple landscape view, upon analysis reveals itself to be a much more complicated painting. In the same way, what at first appears to be a cloud becomes, rather disturbingly, a cloud of smoke. Out of the dense growth of the near bank, a train emerges. Monet seems intent on describing what larger issues here? We know that when Monet painted it, the railroad bridge at Argenteuil was a new bridge. How does this painting capture the dawn of a new world, a world of opposition and contradiction that in many ways mirrors the tensions in Thomas Cole's *Course of Empire* series (Figs. 40–44)? Can you make a case that almost every formal element and principle of design at work in the painting supports this reading?

Fig. 265 Jan Vermeer, *The Allegory of Painting (The Painter and His Model as Klio)*, 1665–1666.
Oil on canvas, 48 × 40 in.
Cat. 395, Inv. 9128. Kunsthistorisches Museum, Vienna Austria.
© Photograph by Erich Lessing. Art Resource, New York.

The Fine Arts Media

LEARNING HOW ART IS MADE

CHAPTER 10

DRAWING

DRAWING AS AN ART

DRAWING MATERIALS

WORKS IN PROGRESS
Raphael's *Alba Madonna*

Dry Media

WORKS IN PROGRESS
Beverly Buchanan's *Shackworks*

Liquid Media

Innovative Drawing Media

THE CRITICAL PROCESS
Thinking about Drawing

In Jan Vermeer's *The Allegory of Painting* (Fig. 265), a stunning variety of media are depicted. The artist, his back to us, is depicted painting his model's crown, but the careful observer can detect, in the lower half of the canvas, the white chalk lines of his preliminary drawing. A tapestry has been pulled back at the left, and a beautifully crafted chandelier hangs from the ceiling. A map on the back wall illustrates the art of cartography. The model herself is posed above a sculpted mask, which lies on the table below her gaze. As the muse of history, she holds a book in one hand, representing writing and literature, and a trumpet, representing music, in the other.

Fig. 266 Workshop of Pollaiuolo (?), *Youth Drawing,* late-15th century.
Pen and ink with wash on paper, 7⅝ × 4½ in.
© The British Museum.

In Part III we will study all of the various media, but we turn our attention first to drawing, perhaps the most basic medium of all. Drawing has many purposes, but chief among them is preliminary study. Through drawing, artists can experiment with different approaches to their compositions. They illustrate, for themselves, what they are going to do. And, in fact, illustration is another important purpose of drawing. Before the advent of the camera, illustration was the primary way that we recorded history, and today it provides visual interpretations of written texts, particularly in children's books. Finally, because it is so direct, recording the path of the artist's hand directly on paper, artists also find drawing to be a ready-made means of self-expression. It is as if, in the act of drawing, the soul or spirit of the artist finds its way to paper.

DRAWING AS AN ART

The young man in this picture (Fig. 266) seems to be doing the most ordinary thing in the world—drawing. We think of drawing as an everyday activity that everyone, artists and ordinary people, does all the time. You doodle on a pad; you throw away the marked-up sheet and start again with a fresh one. Artists often make dozens of sketches before deciding on the composition of a major work. But people have not always been able or willing to casually toss out marked-up paper and begin again. Before the late fifteenth century, paper was costly.

Look closely at Figure 266. The young man shown here is sketching on a wooden tablet that he would sand clean after each drawing. The artist who drew him at work, however, worked in pen and ink on rare, expensive paper. This work thus represents a transition point in Western art—the point at which artists began to draw on paper before they committed their idea to canvas or plaster.

Until the late fifteenth century, drawing was generally considered a student medium. Copying a master's work was the means by which a student learned the higher art of painting. Thus, in 1493, the Italian religious zealot Savonarola outlined the ideal relation between student and master: "What does the pupil look

Each of the materials in Vermeer's work—painting, drawing, sculpture, tapestry, even the book and the trumpet—represent what we call a **medium.** The history of the various media used to create art is, in essence, the history of the various **technologies** that artists have employed. These technologies have helped artists both to achieve their desired effects more readily and to discover new modes of creation and expression. A technology, literally, is the "word" or "discourse" (from the Greek *logos*) about a "techne" (from the Greek word for art, which in turn comes from the Greek verb *tekein,* "to make, prepare, or fabricate"). A medium is, in this sense, a *techne,* a means for making art.

for in the master? I'll tell you. The master draws from his mind an image which his hands trace on paper and it carries the imprint of his idea. The pupil studies the drawing, and tries to imitate it. Little by little, in this way, he appropriates the style of his master. That is how all natural things, and all creatures, have derived from the divine intellect." Savonarola thus describes drawing as both the banal, everyday business of beginners and also as equal in its creativity to God's handiwork in nature. For Savonarola, the master's idea is comparable to "divine intellect." The master is to the student as God is to humanity. Drawing is, furthermore, autographic: it bears the master's imprint, his style.

By the end of the fifteenth century, then, drawing had come into its own. It was seen as embodying, perhaps more clearly than even the finished work, the artist's personality and creative genius. As one watched an artist's ideas develop through a series of preparatory sketches, it became possible to speak knowingly about the creative process itself. By the time Giorgio Vasari wrote his famous *Lives of the Painters* in 1550, the tendency was to see in drawing the foundation of Renaissance painting itself. Vasari had one of the largest collections of fifteenth-century—or so-called *quattrocento*—drawings ever assembled, and he wrote as if these drawings were a dictionary of the styles of the artists who had come before him.

In the *Lives* he recalls how, in 1501, crowds rushed to see Leonardo's *Virgin and Child with St. Anne and Infant St. John*, a **cartoon** (from the Italian *cartone*, meaning "paper"), a drawing done to scale for a painting or a fresco. "The work not only won the astonished admiration of all the artists," Vasari reported, "but when finished for two days it attracted to the room where it was exhibited a crowd of men and women, young and old, who flocked there, as if they were attending a great festival, to gaze in amazement at the marvels he had created." Though this cartoon apparently does not survive, we can get some notion of it from the later cartoon illustrated here (Fig. 267). Vasari's account, at any rate, is the earliest recorded example we have of the public actually admiring a drawing.

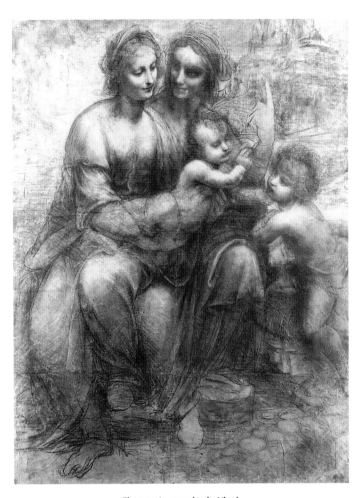

Fig. 267 Leonardo da Vinci,
Virgin and Child with St. Anne and Infant St. John, c. 1505–1507.
Black chalk, 55¾ × 41 in. The National Gallery, London.

The two works shown here illustrate why drawing merits serious consideration as an art form in its own right. In Leonardo's *Study for a Sleeve* (Fig. 268), witness the extraordinary fluidity and spontaneity of the master's line. In contrast to the stillness of the resting arm (the hand, which is comparatively crude, was probably added later), the drapery is portrayed as if it were a whirlpool or vortex. The directness of the medium, the ability of the artist's hand to move quickly over paper, allows Leonardo to bring this turbulence out. Through the intensity of his line, Leonardo imparts a degree of emotional complexity to the sitter, which is revealed in the part as well as in the whole. But the drawing also reveals the movements of the artist's own mind. It is as if the still sitter were at odds with the turbulence of the artist's imag-ination, an imagination that will not hold still whatever its object of contemplation.

Movement, in fact, fascinated Leonardo. And nothing obsessed him more than the movement of water, in particular the swirling forms of the Deluge (Fig. 269), which he celebrated in a series of sixteen drawings depicting the great flood that would come at the end of the world. It is as if, even in this sleeve, we are witness to the artist's fantastic preoccupation with the destructive forces of nature. We can see it also in his famous notebooks, where he instructs the painter how to represent a storm:

> *O what fearful noises were heard throughout the dark air as it was pounded by the discharged bolts of thunder and lightning that violently shot through it to strike whatever opposed their course. O how many you might have seen covering their ears with their hands in abhorrence at the uproar. . . . O how much weeping and wailing! O how many terrified beings hurled themselves from the rocks! Let there be shown huge branches of great oaks weighed down with men and borne through the air by the impetuous winds. . . . You might see herds of horses, oxen, goats and sheep, already encircled by the waters and left marooned on the high peaks of the*

Fig. 268 Leonardo da Vinci,
***Study for a Sleeve*, c. 1510–1513.**
Pen, lampblack, and chalk, 3⅛ × 6¾ in.
The Royal Collection ©1992 Her Majesty Queen Elizabeth II.

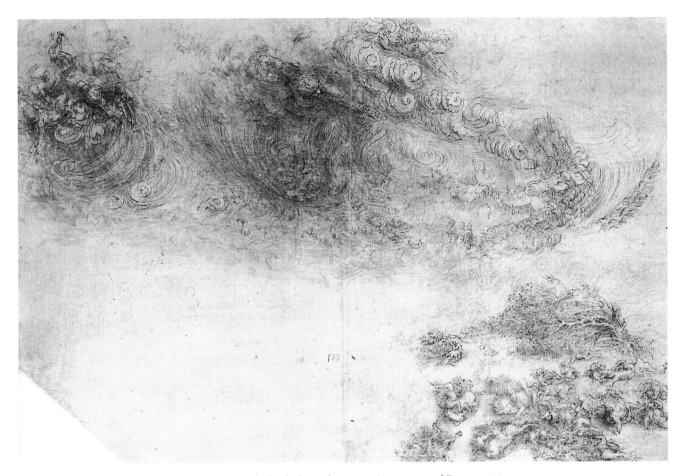

Fig. 269 Leonardo da Vinci, *Hurricane over Horsemen and Trees*, c. 1518.
Pen and ink over black chalk, 10¼ × 16⅛ in. The Royal Collection ©1992 Her Majesty Queen Elizabeth II.

mountains. Now they . . . huddled together with those in the middle clambering on top of the others, and all scuffling fiercely amongst themselves. . . . The air was darkened by the heavy rain that, driven aslant by the crosswinds and wafted up and down through the air, resembled nothing other than dust, differing only in that this inundation was streaked through by the lines drops of water make as they fall.

Because we can see in the earlier drawing of the sleeve a fascination with swirling line that erupts in the later drawings of the Deluge, we feel we know something important not only about Leonardo's technique but about what drove his imagination. More than any other reason, this was why, in the sixteenth century, drawings began to be preserved by artists and, simultaneously, collected by connoisseurs, experts on and appreciators of fine art.

DRAWING MATERIALS

Just as the different fine arts media produce different kinds of images, different drawing materials produce different effects as well. Drawing materials are generally divided into two categories—dry media and liquid media. The dry media—metalpoint, chalk, charcoal, graphite, and pastel—consist of coloring agents—or **pigments**—that are sometimes ground or mixed with substances that hold the pigment together called **binders**. Binders, however, are not necessary if the natural pigment—for instance, charcoal made from vine wood heated in a hot kiln until only the carbon charcoal remains—can be applied directly to the surface of the work. In liquid media, pigments are suspended in liquid binders, like the ink in Leonardo's drawing of the hurricane. The liquid ink flows much more easily onto Leonardo's surface than the dry chalk below it.

Raphael's Alba Madonna

Figs. 270 and 271 Raphael (1483–1520), *Studies for The Alba Madonna* **(recto and verso), c. 1511.**
Left: red chalk; right: red chalk and pen and ink, both 16⅝ × 10¾ in. Musée des Beaux Arts, Lille France. (left) RMN, (right) Giraudon/Art Resource, New York.

n a series of studies for *The Alba Madonna* (Fig. 272), the great Renaissance draughtsman Raphael demonstrates many of the ways that artists utilize drawings to plan the final work. It is as if Raphael,

in these sketches, had been instructed by Leonardo himself. We do know, in fact, that when Raphael arrived in Florence in 1504, he was stunned by the freedom of movement and invention that he discovered in Leonardo's drawings. "Sketch subjects quickly," Leonardo admonished his students. "Rough out the arrangement of the limbs of your fig-

ures and first attend to the movements appropriate to the mental state of the creatures that make up your picture rather than to the beauty and perfection of their parts."

In the studies illustrated here, Raphael worked on both sides of a single sheet of paper (Figs. 270 and 271). On one side he has drawn a male model from life, and posed him

as the Madonna. In the sweeping cross-hatching below the figure in the sketch, one can already sense the circular format of the final painting, as these lines rise and turn up the arm and shoulder and around to the model's head. Inside this curve is another, rising from the knee bent under the model up across his chest to his neck and face. Even the folds of the drapery under his extended arm echo this curvilinear structure.

On the other side of the paper, all the figures present in the final composition are included. The major difference between this and the final painting is that infant St. John offers up a bowl of fruit in the drawing and Christ does not yet carry a cross in his hand. But the circular format of the final painting is fully realized in this drawing. A hastily drawn circular frame encircles the group (outside this frame, above it, are first ideas for yet another Madonna and Child, and below it, in the bottom right corner, an early version of the Christ figure for this one). The speed and fluency of this drawing's execution is readily apparent, and if the complex facial expressions of the final painting are not yet indicated here, the emotional tenor of the body language is. The postures are both tense and relaxed. Christ seems to move away from St. John even as he turns toward him. Mary reaches out, possibly to comfort the young saint, but equally possibly to hold him at bay. Raphael has done precisely as Leonardo directed, attending to the precise movements and gestures that will indicate the mental states of his subjects in the final painting.

Fig. 272 Raphael, *The Alba Madonna*, c. 1510.
Oil on panel transferred to canvas, diameter 37¼ in.; framed: 54 × 53½ in.
Andrew W. Mellon Collection, © 1999 Board of Trustees,
National Gallery of Art, Washington, DC.
Photograph by José A. Naranjo.

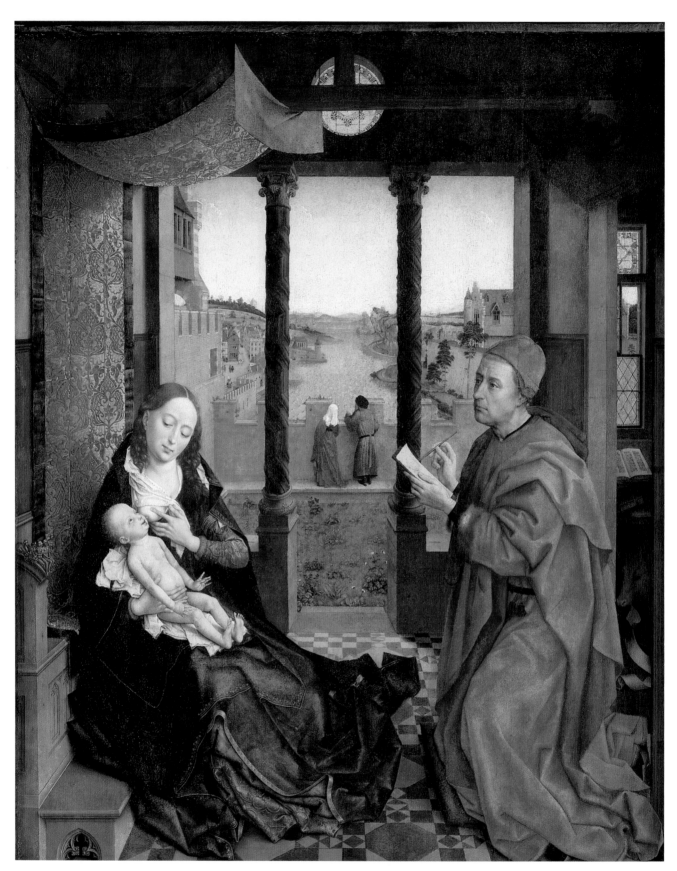

Fig. 273 Rogier van der Weyden, *St. Luke Painting the Virgin and Child*, c. 1435.
Oil on panel, 54⅛ × 43⅝ in. Museum of Fine Arts, Boston. Gift of Mr. and Mrs. Henry Lee Higginson. 93.153

Dry Media

Metalpoint One of the most common tools used in drawing in late fifteenth- and early sixteenth-century Italy was **metalpoint**. A *stylus* (point) made of gold, silver, or some other metal is applied to a sheet of paper prepared with a mixture of powdered bones (or lead white) and gumwater (when the stylus was silver, as it often was, the medium was called **silverpoint**). Sometimes pigments other than white were added to this preparation in order to color the paper. When the metalpoint is applied to this ground, a chemical reaction results, and line is produced.

Rogier van der Weyden's *St. Luke Painting the Virgin and Child* (Fig. 273), actually depicts St. Luke drawing with metalpoint on parchment. The figure of St. Luke is believed to be a self-portrait of Rogier himself. Probably executed for the chapel of the Painters Guild in Brussels, of which Rogier was the head, the painting is, then, a compendium of the artist's craft, and represents the entire process of making a painting, from drawing to finished product. The painting, incidentally, is indebted to Jan van Eyck's *The Madonna of Chancellor Rolin* (see Fig. 344), which was painted six years earlier. Van der Weyden's painting reverses van Eyck's composition; its format is more vertical than van Eyck's, and it is considerably simpler in its details.

A metalpoint line, which is pale gray, is very delicate, and cannot be widened by increasing pressure upon the point. To make a thicker line, the artist must switch to a thicker point. Often, the same stylus would have a fine point on one end and a blunt one on the other, as does St. Luke's in the van der Weyden. Since a line cannot be erased without resurfacing the paper, drawing with metalpoint requires extreme patience and skill. Raphael's metalpoint drawing of *Paul Rending His Garments* (Fig. 274) shows this skill. Shadow is rendered here by means of careful hatching. At the same time, a sense of movement and energy is evoked not only by the directional force of these parallels, but also by the freedom of Raphael's outline, the looseness of the gesture even in this most demanding of formats. The highlights in the drawing are known as **heightening**, and are created by applying an

Fig. 274 Raphael, *Saint Paul Rending His Garments*, c. 1514–1515.
Metalpoint heightened with white gouache on lilac-gray prepared paper, 9¹⁄₁₆ × 4¹⁄₁₆ in.
The J. Paul Getty Museum, Los Angeles, CA. (84.GG.919)
© The J. Paul Getty Museum.

Fig. 275 Fra Bartolommeo,
Study for a Prophet Seen from the Front, 1499–1500.
Black chalk, heightened with white chalk, on brown prepared paper, 11⅝ × 8⅝ in.
Museum Boimans Van Beuningen, Rotterdam, The Netherlands.

opaque white to the design after the metalpoint lines have been drawn.

Chalk and Charcoal Metalpoint is a mode of drawing that is chiefly concerned with **delineation**—that is, with a descriptive representation of the thing, seen through an outline or contour drawing. Effects of light and shadow are essentially "added" to the finished drawing by means of hatching or heightening. With the softer media of chalk and charcoal, however, it is much easier to give a sense of the *volumetric*—that is, of three-dimensional form—through modulations of light and dark. While some degree of hatching is visible in Fra Bartolommeo's *Study for a Prophet Seen from the Front* (Fig. 275), the primary impression is not one of linearity or two-dimensionality. Instead, the artist uses *chiaroscuro* to realize the three-dimensional form of the figure in space (see Chapter 7).

By the middle of the sixteenth century, artists used natural chalks, derived from red ocher hematite, white soapstone, and black carbonaceous shale, which were fitted into holders and shaved to a point. With these chalks, it became possible to realize gradual transitions from light to dark, either by adjusting the pressure of one's hand or by merging individual strokes by gently rubbing over a given area with a finger, cloth, or eraser. Charcoal sticks are made from burnt wood, and the best are made from hardwood, especially vines. They can be either hard or soft, sharpened to so precise a point that they draw like a pencil, or held on their sides and dragged in large bold gestures across the surface of the paper.

In her charcoal drawing of a *Banana Flower* (Fig. 276), Georgia O'Keeffe achieves a sense of volume and space comparable to that realized by means of chalk. Though she is noted for her stunning oil paintings of flowers, this is a rare example in her work of a colorless flower composition. O'Keeffe's interest here is in creating three-dimensional space with a minimum of means, and the result is a study in light and dark in many ways comparable to a black-and-white photograph.

Because of its tendency to smudge easily, charcoal was not widely used during the Renaissance except in **sinopie**, tracings of the outlines of compositions drawn on the wall before the paint-

ing of frescoes. Such *sinopie* have come to light only recently, as the plaster supports for frescoes have been removed for conservation purposes. Drawing with both charcoal and chalk requires a ~~with *tooth*~~—a rough surface to which the ~~Today, charcoal drawings can~~ ~~drawing synthetic~~ resin **fixatives** over the finished work.

In the hands of modern artists, charcoal has become one of the more popular drawing media, in large part because of its expressive directness and immediacy. In her *Self-Portrait, Drawing* (Fig. 277), Käthe Kollwitz has revealed the extraordinary expressive capabilities of charcoal as a medium. Much of the figure was realized by dragging the stick up and down in sharp angular gestures along her arm from her chest to her hand. It is as if this line, which mediates between the two much more carefully rendered areas of hand and face, embodies the dynamics of her work. This area of raw drawing literally connects her mind to her hand, her intellectual and spiritual capacity to her technical facility. It embodies the power of the imagination. She seems to hold the very piece of charcoal that has made this mark sideways between her fingers. She has rubbed so hard, and with such fury, that it has almost disappeared.

Fig. 276 Georgia O'Keeffe, *Banana Flower,* **1933.**
Charcoal and black chalk on paper, 21¾ × 14¾ in.
The Museum of Modern Art, New York. Given anonymously (by exchange).
Photograph © 1999 Museum of Modern Art, New York. Licensed by Scala-Art Resource, New York.
©2003 The Georgia O'Keeffe Foundation/Artists Rights Society (ARTS), New York.

Fig. 277 Käthe Kollwitz, *Self-Portrait, Drawing,* **1933.**
Charcoal on brown laid Ingres paper (Nagel 1972 1240). 18¾ × 25 in.
Rosenwald Collection. © 1999 Board of Trustees, National Gallery of Art, Washington, DC. 1943. 3.5217/
© 2003 Artists Rights Society (ARS), New York.

Graphite Graphite, a soft form of carbon similar to coal, was discovered in 1564 in Borrowdale, England. As good black chalk became more and more difficult to obtain, the lead **pencil**—graphite enclosed in a cylinder of soft wood—increasingly became one of the most common of all drawing tools. It became even more popular during the Napoleonic Wars early in the nineteenth century. Then, because supplies of English graphite were cut off from the continent, the Frenchman Nicholas-Jacques Conté invented, at the request of Napoleon himself, a substitute for imported pencils that became known as the **Conté crayon** (not to be confused with the so-called Conté Crayons marketed today, which are made with chalk). Conté substituted clay for some of the graphite. This technology was quickly adapted to the making of pencils generally. Thus the relative hardness of the pencil could be controlled—the less graphite, the harder the pencil—and a greater range of lights (hard pencils) and darks (soft pencils, employing more graphite) became available.

Georges Seurat's Conté crayon studies (Fig. 278) indicate the powerful range of tonal effects afforded by the new medium. As Seurat presses harder, in the lower areas of the composition depicting the shadows of the orchestra pit, the coarsely textured paper is filled by the crayon. Above, pressing less firmly, Seurat creates a sense of light dancing on the surface of the stage. Where he has not drawn on the surface at all—across the stage and on the singer's dress—the glare of the white paper is almost as intense as light itself.

Vija Celmin's *Untitled (Ocean)* (Fig. 279) is an example of a highly developed photorealist graphite drawing. A little larger than a sheet of legal paper, the drawing is an extraordinarily detailed rendering of ocean waves seen from the Venice Pier in Venice, California. This is one of a long series of drawings based on small 3½ × 5-inch photographs. Celmins used a pencil of differing hardness for each drawing in the series, exploring the range of possibilities offered by the medium.

Graphite drawings can be erased, and erasure itself can become an important element in the composition. In 1953, a young Robert Rauschenberg, just at the beginning of his career, was thinking about the possibility of

Fig. 278 Georges Pierre Seurat, *Café Concert*, c. 1887–1888.
Conté crayon with white heightening on Ingres paper, 12 × 9¼ in.
Museum of Art, Rhode Island School of Design.
Gift of Mrs. Murray S. Danforth. Photography by Cathy Carver. 42.210.

Fig. 279 Vija Celmins, *Untitled (Ocean)* (Venice, California), 1970.
Pencil on paper, 14⅛ × 18⅞ in.
The Museum of Modern Art, New York. Mrs. Florence M. Schoenborn Fund. Licensed by Scala-Art Resource, New York.
Photograph © 2000 Museum of Modern Art, New York.

Fig. 280 Larry Rivers, *Willem de Kooning*, 1961.
Pencil on paper, 10¾ × 10 in.
Founders Society Purchase, Director's Discretionary Fund. 64.63.
Photograph © 1993 The Detroit Institute of Arts/© Larry Rivers/
Licensed by VAGA, New York, NY.

Fig. 281 Willem de Kooning, *Seated Woman*, 1952.
Pastel and pencil on cut and pasted paper, 12 × 9½ in.
The Museum of Modern Art, The Lauder Foundation Fund. Licensed by Scala-
Art Resource, New York.
Photograph © 1996 Museum of Modern Art, New York/
© Artists Rights Society (ARS), New York.

making an entire drawing by erasing. He told Willem de Kooning, a generation older than himself and an established abstract expressionist painter, about his musings. "I'd been trying with my own drawings, and it didn't work, because that was only 50 percent of what I wanted to get. I had to start with something that was 100 percent art, which mine might not be; but his work was definitely art." De Kooning reluctantly agreed to give Rauschenberg a drawing to erase. "It was a drawing done partly with a hard line, and also with grease pencil, and ink, and heavy crayon. It took me a month, and about forty erasers, to do it." The result is not easy to reproduce. It is a white sheet of paper with a faint shadow of its original gestures barely visible on it.

Larry Rivers's full figure of Willem de Kooning (Fig. 280) is a more traditional homage of a younger artist to his mentor, but it too is concerned with erasure. Rivers has described the process and the rationale behind it:

I tend to erase it, erase it, erase it, keep trying, erase, keep trying, erase, and finally . . . well, let the observer make up more

than I can represent. . . . This drawing is in the tradition of those kinds of work in which the history of the work became part of the quality of the work. De Kooning's work is full of that. His whole genre is that. His work is all about sweeping away, putting in . . . struggle, struggle, struggle and poof—masterpiece!

What Rivers says about de Kooning's work is evident if we consider one of the master's own drawings (Fig. 281), itself a study for a famous series of paintings of women, executed between 1950 and 1953. One can see that the drawing has been erased, smudged out, and drawn over. Part of the comic effect of the drawing is the result of the fact that the proportions of the woman are odd, her breasts too big, her eyelashes huge, her head too small for the torso. In fact, this work probably began as two separate drawings—de Kooning cut the head off another drawing and pasted it to the top of this one—putting in and sweeping away, as Rivers described his process.

Fig. 282 Edgar Degas, *After the Bath, Woman Drying Herself*, c. 1889–1890.
Pastel on paper, 26⅝ × 22¾ in. Courtauld Institute Galleries, London.

Pastel The color in de Kooning's drawing is the result of **pastel**, which is essentially a chalk medium with colored pigment and a nongreasy binder added to it. Pastels come in sticks the dimension of an index finger and are labeled soft, medium, and hard, depending on how much binder is incorporated into the medium—the more binder the harder the stick. Since the pigment is, in effect, diluted by increased quantities of binder, the harder the stick, the less intense its color. This is why we tend to associate the word "pastel" with pale, light colors. Although the harder sticks are much easier to use than the softer ones, some of the more interesting effects of the medium can only be achieved with the more intense colors of the softer sticks. The lack of binder in pastels makes them extremely fragile. Before the final drawing is fixed, the marks created by the chalky powder can literally fall off the paper, despite the fact that, since the middle of the eighteenth century, special ribbed and tex-

tured papers have been made that help hold the medium to the surface.

Of all artists who have ever used pastel, perhaps Edgar Degas was the most proficient and inventive. He was probably attracted to the medium because it was more direct than painting, and its unfinished quality seemed particularly well suited to his artistic goal of capturing the reality of the contemporary scene. According to George Moore, a friend of Degas's who began his career as a painter in Paris but gave it up to become an essayist and novelist, Degas's intention in works such as *After the Bath, Woman Drying Herself* (Fig. 282) was to show "a human figure preoccupied with herself—a cat who licks herself; hitherto, the nude has always been represented in poses which presuppose an audience, but these women of mine are honest and simple folk, unconcerned by any other interests than those involved in their physical condition. . . . It is as if you looked through a keyhole." It is disturbing that Degas is so comfortable in his position as voyeur, and that he assumes that his model possesses little or no intelligence. His comparison of his model to a cat is demeaning. But he is also to be admired for giving up the academic studio pose.

And his use of his medium is equally unconventional, incorporating into the "finished" work both improvised gesture and a loose, sketchlike drawing. Degas invented a new way to use pastel, building up the pigments in successive layers. Normally, this would not have been possible because the powdery chalks of the medium would not hold to the surface. But Degas worked with a fixative, the formula for which has been lost, that allowed him to build up layers of pastel without affecting the intensity of their color. Laid on the surface in hatches, these successive layers create an optical mixture of color that shimmers before the eyes in a virtually abstract design.

The American painter Mary Cassatt met Degas in Paris in 1877, and he became her artistic mentor. Known for her pictures of mothers and children, Cassatt learned to use the pastel medium with an even greater freedom and looseness than Degas. In this drawing of *Young Mother, Daughter, and Son* (Fig. 283), one of Cassatt's last works, the gestures

of her pastel line again and again exceed the boundaries of the forms that contain them, and loosely drawn, arbitrary blue strokes extend across almost every element of the composition.

The owner of this work, Mrs. H. O. Havemeyer, Cassatt's oldest and best friend, saw in works such as this one an almost virtuoso display of "strong line, great freedom of technique and a supreme mastery of color." When Mrs. Havemeyer organized a benefit exhibition of Cassatt's and Degas's works in New York in 1915, its proceeds to be donated to the cause of woman's suffrage, she included works such as this one because Cassatt's freedom of line was, to her, the very symbol of the strength of women and their equality to men. Seen beside the works by Degas, it would be evident that the pupil had equaled, and in many ways surpassed, the achievement of Degas himself.

Fig. 283 Mary Cassatt, *Young Mother, Daughter, and Son***, 1913.**
Pastel on paper, 43¼ × 33¼ in.
Memorial Art Gallery of the University of Rochester, Marion Stratten Gould Fund.

Beverly Buchanan's Shackworks

Pastels are an extremely fragile medium, but they can be combined with oil to make pastel oilsticks that not only flow more easily onto the surface of the drawing but adhere to the surface more

Fig. 284 Beverly Buchanan, *Ms. Mary Lou Furcron's House, deserted*, 1989. Ektacolor print, 16 × 20 in. Courtesy Steinbaum Krauss Gallery, New York.

Fig. 285 Beverly Buchanan, *Richard's Home*, 1993. Oil crayon on wood and mixed media, 78 × 16 × 21 in. Photo: Adam Reich. Collection: of Bernice and Harold Steinbaum. Courtesy Steinbaum Krauss Gallery, New York.

readily. Pastel oilstick drawings are central to the art of Beverly Buchanan, whose work is about the makeshift shacks that dot the Southern landscape near her home in Athens, Georgia.

Beginning in the early 1980s, Buchanan started photographing these shacks, an enterprise she has carried on ever since (Fig. 284). "At some point," she says, "I had to realize that for me the structure was related to the people who built it. I would look at shacks and the ones that attracted me always had something a little different or odd about them. This evolved into my having to deal with [the fact that] I'm making portraits of a family or person."

Buchanan soon began to make drawings and sculptural models of the shacks. Each of these models tells a story. This legend, for instance, accompanies the sculpture of *Richard's Home* (Fig. 285):

Some of Richard's friends had already moved north, to freedom, when he got on the bus to New York. Richard had been "free" for fifteen years and homeless now for seven. . . . After eight years as a foreman, he was "let go." He never imagined it would be so hard and cruel to look for something else. Selling his blood barely fed him. At night, dreams took him back to a childhood of good food, hard work, and his Grandmother's yard of flowers and pinestraw and wood. Late one night, his cardboard house collapsed during a heavy rain. Looking down at a soggy heap, he heard a voice, like thunder, roar this message through his brains, RICHARD GO HOME!

Buchanan's sculpture does not represent the collapsed cardboard house in the North, but Richard's new home in the South. It is not just a ramshackle

Fig. 286 Beverly Buchanan, *Monroe County House with Yellow Datura*, 1994.
Oil pastel on paper, 60 × 79 in. Photo: Adam Reich. Collection of Bernice and Harold Steinbaum. Courtesy Steinbaum Krauss Gallery, New York.

symbol of poverty. Rather, in its improvisational design, in its builder's determination to use whatever materials are available, to make something of nothing, as it were, the shack is a testament to the energy and spirit of its creator. More than just testifying to Richard's will to survive, his shack underscores his creative and aesthetic genius.

Buchanan's oilstick drawings such as *Monroe County House with Yellow Datura* (Fig. 286) are embodiments of this same energy and spirit. In their use of expressive line and color, they are almost abstract, especially in the fields of color that surround the shacks. Their distinctive scribble-like marks are based on the handwriting of Walter Buchanan, Beverly Buchanan's great-uncle

and the man who raised her. Late in his life he suffered a series of strokes, and before he died he started writing letters to family members that he considered very important. "Some of the words were legible," Buchanan explains, "and some were in this kind of script that I later tried to imitate. . . . What I thought about in his scribbling was an interior image. It took me a long time to absorb that. . . . And I can also see the relation of his markings to sea grasses, the tall grasses, the marsh grasses that I paint." The pastel oilstick is the perfect tool for this line, the seemingly untutored rawness of its application mirroring the haphazard construction of the shacks. And it results in images of great beauty, as beautiful as the shacks themselves.

Fig. 287 Elisabetta Sirani,
The Holy Family with a Kneeling Monastic Saint, c. 1660.
Pen and brown ink, black chalk, on paper, 10⅜ × 7⅜ in.
Private collection. Photo courtesy of Christie's, London.

Liquid Media

Pen and Ink During the Renaissance, after the invention of paper, most drawings were made with iron-gall ink, which was made from a mixture of iron salts and an acid obtained from the nutgall, a swelling on an oak tree caused by disease. The characteristic brown color of most Renaissance pen and ink drawings results from the fact that this ink, though black at application, browns with age.

The quill pen used by most Renaissance artists, which was most often made from a goose or swan feather, allows for far greater variation in line and texture than is possible with a metalpoint stylus or even with a pencil. As we can see in this drawing by Elisabetta Sirani (Fig. 287), one of the leading artists in Bologna during the seventeenth century, the line can be thickened or thinned, depending on the artist's manipulation of the flexible quill and the absorbency of the paper (the more absorbent the paper, the more freely the ink will flow through its fibers). Diluted to a greater or lesser degree, ink also provides her with a more fluid and expressive means to render light and shadow than the elaborate and tedious hatching that was necessary when using stylus or chalk. Drawing with pen and ink is fast and expressive. Sirani, in fact, displayed such speed and facility in her compositions that, in a story that most women will find familiar, she was forced to work in public in order to demonstrate that her work was her own and not done by a man.

In this example from Jean Dubuffet's series of drawings *Corps de Dame* (Fig. 288) ("corps" means both a group of women and the bodies of women), the whorl of line, which ranges from the finest hairline to strokes nearly a half-inch thick, defines a female form, her two small arms raised as if to ward off the violent gestures of the artist's pen itself. Though many see Dubuffet's work as misogynistic—the product of someone who hates women—it can also be read as an attack on academic figure drawing, the pursuit of formal perfection and beauty that has been used traditionally to justify drawing from the nude. Dubuffet does not so much render form as flatten it, and in a gesture that insists on the modern artist's liberation from traditional techniques and values, his use of pen and ink threatens to transform drawing into scribbling, conscious draftsmanship into automatism, that is, unconscious and random automatic marking. In this, his work is very close to surrealist experiments designed to make contact with the unconscious mind.

Wash and Brush When ink is diluted with water and applied by brush in broad, flat areas,

Fig. 288 Jean Dubuffet, *Corps de Dame*, June–December 1950.
Pen, reed pen, and ink, 10⅝ × 8⅜ in. The Museum of Modern Art, New York. The Jean and Lester Avnet Collection. Licensed by Scala-Art Resource, New York.
Photograph © 2000 Museum of Modern Art, New York/©2003 Artists Rights Society (ARS), New York/ADAGP, Paris.

Fig. 289 Giovanni Battista Tiepolo,
The Adoration of the Magi, **c. 1740s.**
Pen and brown wash over graphite sketch, 11³⁄₅ × 8¹⁄₅ in.
Iris & B. Gerald Cantor Center for Visual Arts at Stanford University. 1950.392. Mortimer C. Leventritt Fund.

Fig. 290 Rembrandt van Rijn, *A Sleeping Woman*, c. 1660–1669.
Brush drawing in brown ink and wash, 9⅝ × 8 in.
The British Museum, London. Marburg/Art Resource, New York.

Drawing with a brush is a technique with a long tradition in the East, perhaps because the brush is used there as a writing instrument. Chinese calligraphy requires that each line in a written character begin very thinly, then broaden in the middle and taper again to a point. The soft brushtip allows calligraphers to control the width of their line. Thus, in the same gesture, a line can move from broad and sweeping to fragile and narrow, and back again. Such ribbons of line are extremely expressive. In his depiction of the Tang poet Li Bo (Fig. 291), Liang Kai juxtaposes—contrasts—the quick strokes of diluted ink that form the robe with the fine, detailed brushwork of his face. This opposition contrasts the fleeting materiality of the poet's body—as insubstantial as his chant, which drifts away on the wind—with the enduring permanence of his poetry.

the result is called a **wash**. Tiepolo's *Adoration of the Magi* (Fig. 289) is essentially three layers deep. Over a preliminary graphite sketch is a pen and ink drawing, and over both, Tiepolo has laid a brown wash. The wash serves two purposes here. First, it helps to define volume and form by adding shadow. But it also creates a visual pattern of alternating light and dark elements that help to make the drawing much more dynamic than it would otherwise be. As we move from right to left across the scene, deeper and deeper into its space, this alternating pattern leads us to a central moment of light, which seems to flood from the upper right, falling on the infant Jesus himself.

Many artists prefer to draw with a brush. It affords them a sense of immediacy and spontaneity, as Rembrandt's brush drawing of *A Sleeping Woman* (Fig. 290) makes clear. The work seems so spontaneous, so quick and impetuous, that one can imagine Rembrandt drawing the scene quickly, so as not to wake the woman. And the drawing possesses an equally powerful sense of intimacy. It is as if the ability to draw this fast is the result of knowing very well who it is one draws.

Fig. 291 Liang Kai,
The Poet Li Bo Walking and Chanting a Poem,
Southern Song Dynasty, c. 1200.
Hanging scroll, ink on paper, 31¾ × 11⅞ in.
Tokyo National Museum, Japan.

Innovative Drawing Media

Drawing is by its nature an exploratory medium. It invites experiment. Taking up a sheet of heavy prepainted paper, Henri Matisse was often inspired, beginning in the early 1940s, to cut out a shape in the paper with a pair of wide-open scissors, using them like a knife to carve through the paper. "Scissors," he says, "can acquire more feeling for line than pencil or charcoal." Sketching with the scissors, Matisse discovered what he considered to be the essence of a form. Cut-outs, in fact, dominated Matisse's artistic production from 1951 until his death in 1954. In this *Venus* (Fig. 292), the figure of the goddess is revealed in the negative space of the composition. It is as if the goddess of love—and hence love itself—were immaterial. In the blue positive space to the right we discover the profile of a man, as if love springs, fleetingly, from his very breath.

Walter De Maria's *Las Vegas Piece* (Fig. 293) is a "drawing" made in 1969 in the central Nevada desert with the six-foot blade of a bulldozer. The photograph shows one side of a square that is one-half mile on each side. Two

Fig. 292 Henri Matisse, *Venus,* 1952.
Paper collage on canvas, 39⅞ × 30⅛ in. Ailsa Mellon Bruce Fund. © 1999 Board of Trustees,
National Gallery of Art, Washington, DC. © 2003 Succession H. Matisse, Paris/Artists Rights Society (ARS) New York.

Fig. 296 Pietro da Cortona, *Study for a Figure Group in the Ceiling of the Palazzo Barberini*, c. 1623.
Pen and brown ink on ivory laid paper, 4⅓ × 5⅞ in.
Iris and B. Gerald Cantor Center for Visual Arts at Stanford University; Mortimer C. Leventritt Fund, 1977.12.

immediacy that revealed significant details about the artist's personality and style.

What, in particular, tells you that Cortona's drawing was thought of as a work of art in its own right? This drawing is executed in pen and ink. How does Cortona take advantage of this medium? How, furthermore, does Cortona's drawing reflect his temperament? It may help you to know that Cortona was commissioned by the Barberini to paint a fresco on the ceiling of the reception chamber of their palace celebrating the life of the Barberini pope, Urban VIII, and this drawing is a "first-idea" sketch for a group of figures at the base of a scene extoling the great benefits and prosperity brought to Rome under Barberini rule. Comparing the sketch to the final painting (Fig. 297), what important differences can you see? In what ways is the drawing even more exuberant than the final painting?

Fig. 297 Pietro da Cortona, *Justice, Abundance, and Charity, Hercules Killing Harpies*, c. 1633.
Detail of ceiling Fresco, Palazzo Barberini, Rome, Italy.
Alinari/Art Resource, New York.

CHAPTER 11

PRINTMAKING

The medium of printmaking originated in the West very soon after the appearance of the first book printed with movable type, the Gutenberg Bible (1450–1456). At first, printmaking was used almost exclusively as a mode of illustration for books. In post-medieval Western culture, prints not only served to codify and regularize scientific

knowledge, which depends on the dissemination of exact reproductions, but they were fundamental to the creation of our shared visual culture.

This illustration for *The Nuremberg Chronicle* (Fig. 298) was published in 1493 by one of the first professional book publishers in history, Anton Koberger. Appearing in two editions, one in black-and-white, and another much more costly edition with hand-colored illustrations, *The Nuremberg Chronicle* was intended as a history of the world. A best-seller in its day, it contained over 1,800 pictures, though only 654 different blocks were employed. Forty-four images of men and women were repeated 226 times to represent different famous historical characters, and depictions of many different cities utilized the same woodcut.

For centuries, prints were primarily used in books, but since the nineteenth century, and increasingly since World War II, the art world has witnessed what might well be called an explosion of prints. The reasons for this are many. For one thing, the fact that prints exist in multiple numbers seemed to many artists absolutely in keeping with an era of mass production and distribution. The print allows the contemporary artist, in an age increasingly dominated by the mass media and mechanical modes of reproduction, such as photography, to investigate the meaning of mechanically reproduced imagery itself. An even more important reason is that the unique work of art—a painting or a sculpture—has become, during the twentieth century, too expensive for the average collector, and the size of the purchasing public has, as a consequence, diminished considerably. Far less expensive than unique paintings, prints are an avenue through which artists can more readily reach a wider audience.

A **print** is defined as a single **impression,** or example, of a multiple **edition** of impressions, made on paper from the same **matrix,** the master image on the working surface. As collectors have come to value prints more and more highly, the somewhat confusing concept of the **original print** has come into being. How, one wonders, can an image that exists in multiple be considered "original"? By and large, an original print consists of an image that the artist alone has created, and that has been printed by the artist or under the artist's supervision. Since the late nineteenth century, artists have signed and numbered each impression—for example, the number 3/35 at the bottom of a print means that this is the third impression in an edition of thirty-five. Often the artist reserves a small number of additional **proofs**—trial impressions made before the final edition is run—for personal use. These are usually designated "AP," meaning "artist's proof." After the edition is made, the original plate is destroyed or canceled by incising lines across it. This is done to protect the collector against a misrepresentation about the number of prints in a given edition.

Today, prints provide many people with aesthetic pleasure. There are five basic processes of printmaking—relief, intaglio, lithography, silkscreen, and monotype—and we will consider them all in this chapter.

Fig. 298 Hartmann Schedel, *The Nuremberg Chronicle*: *Venice*, 1493.
Woodcut, illustration size approx. 10 × 20 in. The Metropolitan Museum of Art, New York. Rogers Fund, 1921. (21.36.145).

RELIEF PROCESSES

The term **relief** refers to any printmaking process in which the image to be printed is raised off the background in reverse. Common rubber stamps utilize the relief process. If you have a stamp with your name on it, you will know that the letters of your name are raised off it in reverse. You press the letters into an ink pad, and then to paper, and your name is printed right side up. All relief processes rely on this basic principle.

Woodcut

The earliest prints, such as the illustrations for *The Nuremberg Chronicle*, were **woodcuts**. A design is drawn on the surface of a wood block, and the parts that are to print white are cut or gouged away, usually with a knife. This process leaves the areas that are to be black elevated. A black line is created, for instance, by cutting away the block on each side of it. This elevated surface is then rolled with a relatively viscous ink, thick and sticky enough that it will not flow into the hollows (Fig. 299). Paper is then rolled through a press directly against this inked and raised surface.

The woodcut print offers the artist a means of achieving great contrast between light and dark, and as a result, dramatic emotional effects. In the twentieth century, the expressive potential of the medium was recognized, particularly by the German Expressionists. In Emile Nolde's *Prophet* (Fig. 300), we do not merely sense the pain and anguish of the prophet's life, the burden that prophecy entails,

Fig. 300 Emile Nolde, *Prophet*, 1912.
Woodcut (Schiefler/Mosel 1996 [W] 110 only) image: 12⅝ × 8⅞ in.;
sheet: 15¾ × 13⁵⁄₁₆ in. Rosenwald Collection,
©1999 Board of Trustees, National Gallery of Art, Washington, DC. 1943.3.6698.

but we feel the portrait emerging out of the very gouges Nolde's knife made in the block.

European artists became particularly interested in the woodblock process in the nineteenth century through their introduction to the Japanese woodblock print. Woodblock printing

printed image

ink

negative areas
cut away

paper

block

ink

Fig. 299 Relief-printing technique.

had essentially died as an art form in Europe as early as the Renaissance, but not long after Commodore Matthew C. Perry's arrival in Japan in July 1853, ending 215 years of isolation from the rest of the world, Japanese prints flooded the European market, and they were received with enthusiasm. Part of their attraction was their exotic subject matter, but artists were also intrigued by the range of color in the prints, their subtle and economical use of line, and their novel use of pictorial space.

Artists such as Edouard Manet, Edgar Degas, and Mary Cassatt were particularly influenced by Japanese prints. But the artist most enthusiastic about Japanese prints was Vincent van Gogh. He owned prints by the hundreds, and on numerous occasions he copied them directly. *Japonaiserie: The Courtesan (after Kesai Eisen)* (Fig. 302) is an example. The central figure in the painting is copied from a print by Kesai Eisen that van Gogh saw on the cover of a special Japanese number of *Paris Illustré* published in May 1886 (Fig. 301). All the other elements of the painting are derived from other Japanese prints, except perhaps the boat at the very top, which appears Western in conception. The frogs were copied from Yoshimaro's *New Book of Insects,* and both the cranes and the bamboo stalks are derived from prints by Hokusai, whose *Great*

Wave Off Kanagawa we saw in Chapter 9 (Fig. 251). Van Gogh's intentions in combining all these elements become clear when we recognize that the central figure is a courtesan (her tortoiseshell hair ornaments signify her profession), and that the words *grue* (crane) and *grenouille* (frog) were common Parisian words for prostitutes. Van Gogh explained his interest in Japanese prints in a letter of September 1888: "Whatever one says," he wrote, "I admire the most popular Japanese prints, colored in flat areas, and for the same reasons that I admire Rubens and Veronese. I am absolutely certain that this is no primitive art."

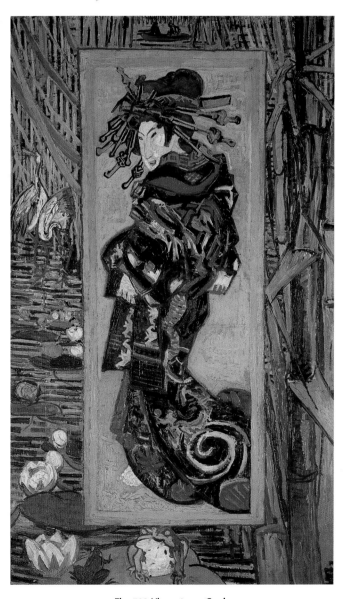

Fig. 302 Vincent van Gogh,
Japonaiserie: The Courtesan (after Kesai Eisen), 1887.
Oil on canvas, 41⅜ × 24 in. Amsterdam, van Gogh Museum (Vincent van Gogh Foundation).

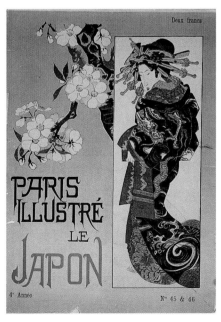

Fig. 301 "Le Japon,"cover of *Paris Illustré,* May 1886.
©Amsterdam, van Gogh Museum (Vincent van Gogh Foundation).

Utamaro's Studio

Most Japanese prints are examples of what is called *ukiyo-e,* or "pictures of the transient world of everyday life." Inspired in the late seventeenth century by a Chinese manual on the art of painting entitled *The Mustard-Seed Garden,* which contained many wood-cuts in both color and black-and-white, *ukiyo-e* prints were commonplace in Japan by the middle of the eighteenth century. Between 1743 and 1765, Japanese artists developed their distinctive method for color printing from multiple blocks.

The subject matter of these prints is usually concerned with the pleasures of contemporary life—hairdos and wardrobes, daily rituals such as bathing, theatrical entertainments, life in the Tokyo brothels, and so on, in endless combination. Utamaro's depiction of *The Fickle Type,* from his series *Ten Physiognomies of Women* (Fig. 303) embodies the sensuality of the world that the *ukiyo-e* print so often reveals. Hokusai's views of the eternal Mount Fuji in *The Great Wave Off Kanagawa,* (Fig. 251), which we have already studied in connection with their play with questions of scale, were probably conceived as commentaries on the self-indulgence of the genre of *ukiyo-e* as a whole. The mountain—and by extension, the values it stood for, the traditional values of the nation itself—is depicted in these works as transcending the fleeting pleasures of daily life.

Traditionally, the creation of a Japanese print was a team effort, and the publisher, the designer (such as Utamaro), the carver, and the printer were all considered essentially equal in the creative process. The head of the project was the publisher, who often conceived of the ideas for the prints, financing individual works or series of works that the public would, in his estimation, be likely to buy. Utamaro's depiction of his studio in a publisher's establishment (Fig. 304) is a *mitate,* or fanciful picture. Each of the workers in the studio is a pretty girl—hence, the print's status as a *mitate*—and they are engaged, according to the caption on the print in "making the famous Edo [present day Tokyo] color prints." Utamaro depicts himself at the right, dressed in women's clothing and holding a finished

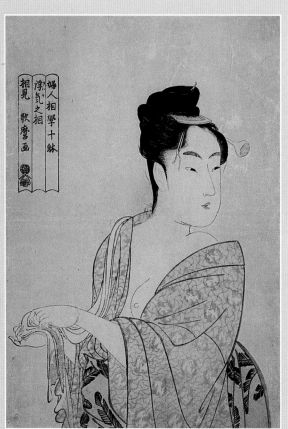

Fig. 303 Kitagawa Utamaro, *The Fickle Type,* from the series *Ten Physiognomies of Women,* c. 1793. Woodcut, 14 × 9⅞ in. Art Resource, New York.

Fig. 304 Kitagawa Utamaro, *Utamaro's Studio*,
Eshi . . . dosa-hiki (the three primary steps in producing a print from drawing to glazing), c. 1790.
From the series Edo meibutsu nishiki-e kosaku, ink and color on paper.
Oban triptych, 24¾ × 9⅝ in. Published by Tsuruya Kiemon.
Clarence Buckingham Collection, 1939.2141. Photograph ©1999, The Art Institue of Chicago. All Rights Reserved.

print. His publisher, also dressed as a woman, looks on from behind his desk. On the left of the triptych is a depiction of workers preparing paper. They are **sizing** it—that is, brushing the surface with an astringent crystalline substance called alum that reduces the absorbency of the paper so that ink will not run along its fibers—then hanging the sized prints to dry. The paper was traditionally made from the inside of the bark of the mulberry tree mixed with bamboo fiber, and, after sizing, it was kept damp for six hours before printing.

In the middle section of the print, the block is actually prepared. In the foreground, a worker sharpens her chisel on a stone. Behind her is a stack of blocks with brush drawings made by Utamaro stuck face down on them with a weak rice-starch dissolved in water. The woman seated at the desk in the middle rubs the back of the drawing to remove several layers of fiber. She then saturates what remains with oil until it becomes transparent. At this point, the original drawing looks as if it were drawn on the block.

Next the workers carve the block, and we can see here large white areas being chiseled out of the block by the woman seated in the back. Black-and-white prints of this design are made and then returned to the artist, who indicates the colors for the prints, one color to a sheet. The cutter then carves each sheet on a separate block. The final print is, in essence, an accumulation of the individually colored blocks, requiring a separate printing for each color.

Wood Engraving

By the late nineteenth century, woodcut illustration had reached a level of extraordinary refinement. Illustrators commonly employed a method known as **wood engraving**. Wood engraving is a "white-line" technique in which the fine, narrow grooves cut into the block do not hold ink. The grainy end of a section of wood—comparable to the rough end of a 4 × 4—is utilized instead of the smooth side of a board, as it is in woodcut proper. The end grain can be cut in any direction without splintering, and thus extremely delicate modeling can be achieved by means of careful hatching in any direction.

The wood engraving below (Fig. 305) was copied by a professional wood engraver from an original sketch, executed on the site, by American painter Thomas Moran (his signature mark, in the lower left corner, is an "M" crossed by a "T" with an arrow pointing downward). It was used to illustrate Captain J. W. Powell's 1875 *Exploration of the Colorado River of the West*, a narrative of the first exploration of the Colorado River canyon from Green River, in Wyoming, to the lower end of the Grand Canyon. The wood engravings of Moran's work—together with a number of paintings executed by him from the same sketches—were America's first views of the great western canyonlands.

Fig. 305 *Noon-Day Rest in Marble Canyon,* from *Exploration of the Colorado River of the West* by J. W. Powell, 1875.
Plate 25 opposite page 75. Wood engraving after an original sketch by Thomas Moran, 6½ × 4⅜ in. Courtesy Colorado Historical Society. 978.06/P871eS.

Fig. 306 Paul Gauguin, *Watched by the Spirit of the Dead (Manao Tupapau)*, c. 1891–1893.
Woodcut, printed in black on endgrain boxwood, composition: 8¹⁄₁₆ × 14 in.
The Museum of Modern Art, New York. Lillie P. Bliss Collection. Licensed by Scala-Art Resource, New York. Photograph © 1999 Museum of Modern Art, New York.

The French artist Paul Gauguin detested the detailed effects achievable in wood engraving. He felt they made the print look more like a photograph than a woodcut. He considered his own wood engravings interesting because, he said, they "recall the primitive era."

Gauguin gave up the detailed linear representation achieved by expert cutting, and opted instead to compose with broad, bold, purposely coarse gestures. Whereas in a traditional woodcut the surface of the block would be cut away, leaving black line on a predominantly white surface, Gauguin chose to leave large areas of surface uncut so that they would print in black. In a purposefully unrefined example of the wood engravers' method, he would scratch raggedly across this black surface to reveal form by means of white line on black. Every detail of Gauguin's print, *Watched by the Spirit of the Dead* (Fig. 306), reveals the presence of the artist at work—poking, gouging, slicing, scraping, and scratching into the block.

Linocut

Color can also be added to a print by creating a series of different blocks, one for each different color, each of which is aligned with the others in a process known as **registration**. In 1959, Picasso, working with linoleum instead of wood, simplified the process. This **linocut**, as it is called, is made from one linoleum block. After each successive stage of carving is com-

pleted, the block is printed. An all-yellow run of the print below (Fig. 307) was first made from an uncarved block. Picasso then cut into the linoleum, hollowing out the areas that now appear yellow on the print, so that they would not print again. Then he printed in blue. The blue area was then hollowed out, the plate reprinted again, in violet, and so on, through red, green, and finally black.

Fig. 307 Pablo Picasso, *Luncheon on the Grass,* after Edouard Manet, 1962.
Linoleum cut. One block printed in black, green red, violet, blue, and yellow; Arches paper.
Edition: 50. Sheet: 24³⁄₈ × 29⁵⁄₈ in. Image: 20⁷⁄₈ × 25¹⁄₄ in.
The Metropolitan Museum of Art, New York. The Mr. and Mrs. Charles Kramer Collection,
Gift of Mr. and Mrs. Charles Kramer, 1979 (1979.620.50).
Photograph © 1983 The Metropolitan Museum of Art/
©2003 Estate of Pablo Picasso/Artists Rights Society (ARS), New York.

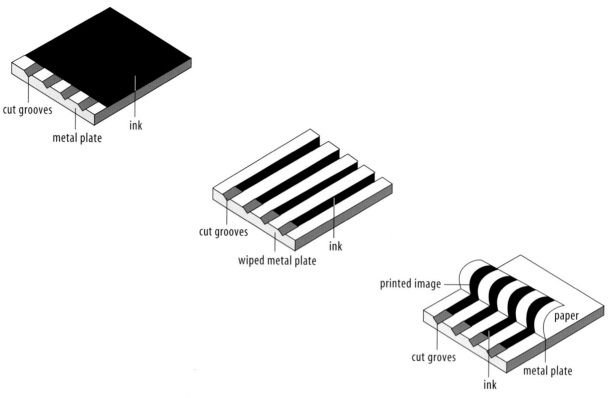

Fig. 308 Intaglio printmaking technique, general view.

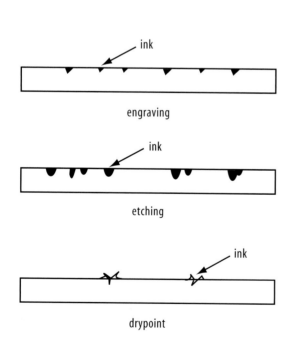

Fig. 309 Intaglio printmaking techniques, side views.

INTAGLIO PROCESSES

Relief processes rely on a *raised* surface for printing. With the **intaglio** process, on the other hand, the areas to be printed are *below* the surface of the plate. *Intaglio* is the Italian word for "engraving," and the method itself was derived from engraving techniques practiced by goldsmiths and armorers in the Middle Ages. In general, intaglio refers to any process in which the cut or incised lines on the plate are filled with ink (Figs. 308 and 309). The surface of the plate is wiped clean, and a sheet of dampened paper is pressed into the plate with a very powerful roller so that the paper picks up the ink in the depressed grooves. Since the paper is essentially pushed into the plate in order to be inked, a subtle but detectable elevation of the lines that result is always evident in the final print. Modeling and shading are achieved in the same way as in drawing, by hatching, cross-hatching, and often **stippling**—where, instead of lines, dots are employed in greater and greater density the deeper and darker the shadow.

Fig. 310 After J. M. W. Turner, *Snow Storm: Steamboat off a Harbor's Mouth (1842)*, 1891.
Engraving on steel. © The British Museum, London.

Engraving

Engraving is accomplished by pushing a small V-shaped metal rod, called a **burin**, across a metal plate, usually of copper or zinc, forcing the metal up in slivers in front of the line. These slivers are then removed from the plate with a hard metal scraper. Depending on the size of the burin used and the force with which it is applied to the plate, the results can range from almost microscopically fine lines to ones so broad and coarse that they can be felt with a finger tip.

Line engravings were commonly used to illustrate books and reproduce works of art in the era before the invention of photography, and for many years after. We know, for instance, Raphael's painting *The Judgement of Paris* only through Marcantonio Raimondi's engraving after the original (Fig. 75). Illustrated here is an engraving done on a steel plate (steel was capable of producing many more copies than either copper or zinc) of J. M. W. Turner's painting *Snow Storm: Steamboat off a Harbor's Mouth* (Fig. 310). The anonymous engraver captures the play of light and dark in the original by using a great variety of lines of differing width, length, and density.

Etching

Etching is a much more fluid and free process than engraving and is capable of capturing something of the same sense of immediacy as the sketch. As a result, master draughtsmen, such as Rembrandt, readily took to the medium. It satisfied their love for spontaneity of line. Yet the medium requires, in addition, the utmost calculation and planning, an ability to manipulate chemicals that verges, especially in Rembrandt's greatest etchings, on wizardry, and a certain willingness to risk losing everything in order to achieve the desired effect.

Creating an etching is a twofold process, consisting of a drawing stage and an etching stage. The metal plate is first coated with an acid-resistant substance called a **ground**, and this ground is drawn upon. If a hard ground is chosen, then an etching needle is required to break through the ground and expose the plate. Hard grounds are employed for finely detailed linear work. Soft grounds, made of tallow or petroleum jelly, can also be utilized, and virtually any tool, including the artist's finger, can be used to expose the plate. The traditional soft-ground technique is often called *crayon* or *pen-*

Albrecht Dürer's Adam and Eve

Figs. 311 and 312 Albrecht Dürer, *Adam and Eve,* First state and Second state, 1504.
Engraving, each 9⅞ × 7⅝ in. Graphische Sannlung, Albertina, Wien.

O ne of the greatest of the early masters of the intaglio process was Albrecht Dürer. Trained in Nuremberg from 1486 to 1490, he was the godson of Anton Koberger, publisher of *The Nuremberg*

Chronicle. As an apprentice in the studio of Michael Wolgemut, who was responsible for many of the major designs in the *Chronicle,* Dürer may, in fact, have carved several of the book's woodcuts. By the end of the century, at any rate, Dürer was recognized as the preeminent woodcut artist of the day, and he had mastered the art of engraving as well.

Dürer's engraving of *Adam and Eve* (Fig. 313) is one of his finest. It is also the first of his works to be "signed" with the artist's char-

acteristic tablet, including his Latinized name and the date of composition, here tied to a bough of the tree above Adam's right shoulder. Two of Dürer's trial proofs (Figs. 311 and 312) survive, providing us the opportunity to consider the progress of Dürer's print. The artist pulled each of these **states,** or stages in the process, so that he could consider how well his incised lines would hold ink and transfer it to paper, as well as to see the actual image, since on the plate it is reversed. In the

white areas of both states we can see how Dürer outlined his entire composition with lightly incised lines. In the first state, all of the background has been incised, except for the area behind Eve's left shoulder. Adam himself is barely realized. Dürer has only just begun to define his leg with hatching and cross-hatching. In the second state, Adam's entire lower body and the ground around his left foot have been realized.

Notice how hatching and cross-hatching serve to create a sense of real volume in Adam's figure.

The print is rich in iconographical meaning. The cat at Eve's feet—a symbol of deceit, and perhaps sexuality as well—suggests not only Eve's feline character but, as it prepares to pounce on the mouse at Adam's feet, Adam's susceptibility to the female's wiles. The parrot perched over the sign is the embodiment of both wisdom and language. It contrasts with the evil snake that Eve is feeding. Spatially, then, the parrot and its attributes are associated with Adam, the snake and its characteristics with Eve. An early sixteenth-century audience would have immediately understood that the four animals on the right were

Fig. 313 Albrecht Dürer, *Adam and Eve*, 1504.
Engraving, 9⅞ × 7⅝ in. The Metropolitan Museum of Art, New York. Fletcher Fund, 1919 (19.73.1).

intended to represent the four *humors*, the four bodily fluids thought to make up the human constitution. The elk represents melancholy (black bile), the cat, anger and cruelty (yellow bile), the rabbit, sensuality (blood), and the ox, sluggishness or laziness (phlegm). The engraving technique makes it possible for Dürer to realize this wealth of detail.

cil manner because the final product so closely resembles pencil and crayon drawing. In this technique, a thin sheet of paper is placed on top of the ground and is drawn on with a soft pencil or crayon. When the paper is removed, it lifts the ground where the drawing instrument was pressed into the paper.

Whichever kind of ground is employed, the drawn plate is then set in an acid bath, and those areas that have been drawn are eaten into, or *etched*, by the acid. The undrawn areas of the plate are, of course, unaffected by the acid. The longer the exposed plate is left in the bath, and the stronger the solution, the greater the width and depth of the etched line. The strength of individual lines or areas can be controlled by removing the plate from the bath and **stopping out** a section by applying a varnish or another coat of ground over the etched surface. The plate is then resubmerged in the bath. The stopped-out lines will be lighter than those that are again exposed to the acid. When the plate is ready for printing, the ground is removed with solvent, and the print is made in the intaglio method.

Rembrandt's *The Angel Appearing to the Shepherds* (Fig. 314) is one of the most fully realized etchings ever printed, pushing the medium to its very limits. For this print, Rembrandt

Fig. 314 Rembrandt van Rijn, *The Angel Appearing to the Shepherds*, 1634.
Etching, 10¼ × 8½ in. Rijksmuseum, Amsterdam.

altered the usual etching process. Fascinated by the play of light and dark, he wanted to create the feeling that the angel, and the light associated with her, was emerging *out* of the darkness. Normally, in etching, the background is white, since it is unetched and there are no lines on it to hold ink. Here Rembrandt wanted a black background, and he worked first on the darkest areas of the composition, creating an intricately crosshatched landscape of ever-deepening shadow. Only the white areas bathed in the angel's light remained undrawn. At this point, the plate was placed in acid and bitten as deeply as possible. Finally, the angel and the frightened shepherds in the foreground were worked up in a more traditional manner of etched line on a largely white ground. It is as if, at this crucial moment of the New Testament, when the angel announces the birth of Jesus, Rembrandt reenacts, in his manipulation of light and dark, the opening scenes of the Old Testament—God's pronouncement in Genesis, "Let there be light."

The dynamic play between dark and light achieved by Rembrandt would be used to great expressive effect in the work of the German artist Käthe Kollwitz. Kollwitz, renowned for the quality of her graphic work, chose as her artistic subject matter the poor and downtrodden, especially mothers and children. Deliberately avoiding the use of color in her work, she preferred the sense of emotional conflict and opposition that could be realized in black and white.

In 1914, at the beginning of World War I, Kollwitz's son Peter was killed. The drama of the battle between the life-giving mother and the forces of death that we witness in *Death, Woman and Child* (Fig. 315) painfully foreshadows her own tragedy. It is hard to say just whose hand is reaching around the child's throat—the mother's or death's. What is clear, however, is that in the dark and deeply inked shadow created where the mother presses her child's forehead hard against her own face, is expressed a depth of feeling and compassion virtually unsurpassed in the history of art.

Drypoint

A third form of intaglio printing is known as **drypoint**. The drypoint line is scratched into the copper plate with a metal point that is pulled across the surface, not pushed as is the case in

Fig. 315 Käthe Kollwitz, *Death, Woman and Child*, 1910.
Etching, printed in dark brown, plate: 16⅛ × 16³⁄₁₆ in.
The Museum of Modern Art, New York. Gift of Mrs. Theodore Boettger. Licensed by Scala-Art Resource, New York. Photograph © 1999 Museum of Modern Art, New York/ ©2003 Artists Rights Society (ARS), New York.

engraving. A ridge of metal, called a **burr**, is pushed up along each side of the line, giving a rich, velvety, soft texture to the print when inked, as is evident in Mary Cassatt's *The Map* (Fig. 316). The softness of line generated by the drypoint process is especially appealing. Because this burr quickly wears off in the printing process, it is rare to find a drypoint edition of more than twenty-five numbers, and the earliest numbers in the edition are often the finest.

Fig. 316 Mary Cassatt, *The Map* (*The Lesson*), 1890.
Drypoint, 6³⁄₁₆ × 9³⁄₁₆ in. Joseph Brooks Fair Collection, 1933.537.
Photograph © 1999 The Art Institute of Chicago. All rights reserved.

Fig. 317 Prince Rupert, *The Standard Bearer*, 1658.
Mezzotint. The Metropolitan Museum of Art,
New York. Harris Brisbane Dick Fund, 1933 (32.52.32).

Mezzotint and Aquatint

Two other intaglio techniques should be mentioned, mezzotint and aquatint. **Mezzotint** is, in effect, a negative process. That is, the plate is first ground all over using a sharp, curved tool called a **rocker**, leaving a burr over the entire surface that, if inked, would result in a solid black print. The surface is then lightened by scraping away the burr to a greater or lesser degree. One of the earliest practitioners of the mezzotint process was Prince Rupert, son of Elizabeth Stuart of the British royal family and Frederick V of Germany, who learned the process from its inventor in 1654. Rupert is credited, in fact, with the invention of the rocking tool used to darken the plate. His *Standard Bearer* (Fig. 317) reveals the deep blacks from which the image has been scraped.

Like mezzotint, **aquatint** relies for its effect not on line but on tonal areas of light and dark. Invented in France in the 1760s, the method involves coating the surface of the plate with a porous ground through which acid can penetrate. Usually consisting of particles of resin or powder, the ground is dusted onto the plate,

then set in place by heating it until it melts. The acid bites around each particle into the surface of the plate, creating a sandpaperlike texture. The denser the resin, the lighter the tone of the resulting surface. Line is often added later, usually by means of etching or drypoint.

Jane Dickson's *Stairwell* (Fig. 318) is a pure aquatint, printed in three colors, in which the roughness of the method's surface serves to underscore the emotional turmoil and psychological isolation embodied in her subject matter. "I'm interested," Dickson says, "in the ominous underside of contemporary culture that lurks as an ever present possibility in our lives. . . . I aim to portray psychological states that everyone experiences." In looking at this print, one can almost feel the acid biting into the plate, as if the process itself is a metaphor for the pain and isolation of the figure leaning forlornly over the bannister.

Fig. 318 Jane Dickson, *Stairwell*, 1984.
Aquatint on Rives BFK paper, 35¾ × 22¾ in.
Mount Holyoke College Art Museum. The Henry Rox Memorial Fund
for the Acquisition of Works by Contemporary Women Artists.

Fig. 319 Edouard Manet, *The Races (Les courses)*, 1865.
Lithograph (Harris 1970 41.only) 14⅝ × 20½ in. Rosenwald Collection, © 1999 Board of Trustees, National Gallery of Art, Washington, DC.
1943.3.9084 (B-11151). Photo: Dean Beasom.

LITHOGRAPHY

Lithography—meaning, literally, "stone writing"—is the chief **planographic print-making process,** meaning that the printing surface is flat. There is no raised or depressed surface on the plate to hold ink. Rather, the method depends on the fact that grease and water don't mix.

The process was discovered accidentally by a young German playwright named Alois Senefelder in the 1790s in Munich. Unsuccessful in his occupation, Senefelder was determined to reduce the cost of publishing his plays by writing them backwards on a copper plate in a wax and soap ground and then etching the text. But with only one good piece of copper to his name, he knew he needed to practice writing backwards on less expensive material, and he chose a smooth piece of Kelheim limestone, the material used to line the Munich streets and abundantly available. As he was practicing one day, his laundry woman arrived to pick up his clothes and, with no paper or ink on the premises, he jotted down what she had taken on the prepared limestone slab. It dawned on him to bathe the stone with nitric acid and water, and when he did so, he found that the acid had etched the stone and left his writing raised in relief above its surface.

Recognizing the commercial potential of his invention, he abandoned playwrighting to perfect the process. By 1798, he had discovered that if he drew directly on the stone with a greasy crayon, and then treated the entire stone with nitric acid, water, and gum arabic (a very tough substance obtained from the acacia tree that attracts and holds water), then ink would stick to the grease drawing but not to the treated and dampened stone. He also discovered that the acid and gum arabic solution did not actually *etch* the limestone. As a result, the same stone could be used again and again. The essential processes of lithography had been invented.

Possibly because it is so direct a process, actually a kind of drawing on stone, lithography has been the favorite printmaking medium of nineteenth- and twentieth-century artists. The gestural freedom it offers the artist, the sense of spontaneity and immediacy that can be captured in its line, is readily apparent in Edouard Manet's *The Races* (Fig. 319). More than a simple sketch of the event, the print is

almost abstract, a whirl of motion and line that captures the furious pace of the race itself.

In the hands of Honoré Daumier, who turned to lithography to depict actual current events, the feeling of immediacy that the lithograph could inspire was most fully realized. From the early 1830s until his death in 1872, Daumier was employed by the French press as an illustrator and political caricaturist. Recognized as the greatest lithographer of his day, Daumier did some of his finest work in the 1830s for the monthly publication *L'Association Mensuelle,* each issue of which contained an original lithograph. His famous print *Rue Transnonain* (Fig. 320) is direct reportage of the outrages committed by government troops during an insurrection in the Parisian workers' quarters. He illustrates what happened in a building at 12 rue Transnonain on the night of April 15, 1834, when police, responding to a sniper's bullet that had killed one of their number and had appeared to originate from the building, revenged their colleague's death by slaughtering everyone inside. The father of a family, who had evidently been sleeping, lies dead by his bed, his child crushed beneath him, his dead wife to his right and an elder parent to his left. The foreshortening of the scene draws us into the lithograph's visual space, making the horror of the scene all the more real.

While lithography flourished as a medium throughout the twentieth century, it has enjoyed a marked increase in popularity since the late 1950s. In 1957 Tatyana Grosman established Universal Limited Art Editions (ULAE) in West Islip, New York. Three years later, June Wayne founded the Tamarind Lithography Workshop in Los Angeles with a

Fig. 320 Honoré Daumier, *Rue Transnonain, April 15, 1834,* 1834.
Lithograph, 11½ × 17⅝ in. The Charles Derring Collection, 1953.530

Fig. 321 Elaine de Kooning, *Lascaux #4*, 1984.
Lithograph on Arches paper, sheet: 15 × 21 in.
Printed by John Hutcheson at Mount Holyoke College. Mount Holyoke College Art Museum. South Hadley, Massachusetts.
Gift of the Mount Holyoke College Printmaking Workshop.

grant from the Ford Foundation. While Grosman's primary motivation was to make available to the best artists a quality printmaking environment, one of Wayne's primary purposes was to train the printers themselves. Due to her influence, workshops sprang up across the country, including Gemini G.E.L. in Los Angeles, Tyler Graphics in Mount Kisco, New York, Landfall Press in Chicago, Cirrus Editions in Los Angeles, and Derrière l'Etoile in New York. In 1987, an exhibition of prints by women artists which was inspired by Nancy Campbell's founding of the Mount Holyoke College Printmaking Workshop in 1984 was held at the Mount Holyoke College Art Museum. Elaine de Kooning was the first resident artist at this workshop, and the series of prints she created there, one of which is reproduced here (Fig. 321), was inspired by the prehistoric cave drawings at Lascaux, France (see Chapter 18, "The Ancient World"). The medium of lithography allows de Kooning to use to best advantage the broad painterly gesture that she developed as an abstract expressionist painter in the 1950s and 1960s. In these prints she develops a remarkable tension between what might be called "the present tense" of her gesture, the sense that we can feel the very motion of her hand, and the "past tense" of her chosen image, the timelessness and permanence of the drawings at Lascaux.

June Wayne's Knockout

Fig. 322 June Wayne, *Stellar Roil, Stellar Winds 5*, 1978.
Lithograph, 11 × 9¼ in. (image). 18¾ × 14¾ in. (paper).
© June Wayne/Licensed by VAGA, New York, NY.

Fig. 323 June Wayne, *Wind Veil, Stellar Winds 3*, 1978.
Lithograph, 11⅛ × 9⅝ in. (image). 18¾ × 14¾ in. (paper).
© June Wayne/Licensed by VAGA, New York, NY.

One of the great innovators of the lithographic process in the last 50 years has been June Wayne, founder of the Tamarind Lithography Workshop. She founded the workshop because

lithography was, in 1960, on the verge of extinction, like "the great white whooping crane," she says. "In all the world there were only 36 cranes left, and in the United States there were no master printers able to work with the creative spectrum of our artists. The artist-lithographers, like the cranes, needed a protected environment and a concerned public so that, once rescued from extinction, they could make a go of it on their own." By 1970, Wayne felt that lithography had been saved, and she arranged for Tamarind to move to the University of New Mexico, where it remains, training master printers and bringing artists to Albuquerque to work with them.

Wayne still lives and works in the original Tamarind Avenue studio in Los Angeles.

"Every day," she says, "I push lithography and it reveals something new." With Edward Hamilton, who was trained at Tamarind and who was her personal printer for fourteen years, beginning in 1974, Wayne has continually discovered new processes. She is inspired by the energy made visible in Leonardo da Vinci's *Deluge* drawings (see Fig. 269), and she is equally inspired by modern science and space exploration—in her own words, by "the ineffably beautiful but hostile wilderness of astrophysical space." She regularly visits the observatory at Mount Palomar above Los Angeles, she is acquainted with leading physicists and astronauts, and she routinely reviews the images returned to earth by unmanned space probes. In 1975, experimenting with

zinc plates and liquid tusche, she discovered that the two oxidized when combined and that the resultant textures created patterns reminiscent of skin, clusters of nebulae, magnetic fields, solar flares, or astral winds. In prints such as *Stellar Roil* (Fig. 322) and *Wind Veil* (Fig. 323), she felt that she was harnessing in the lithographic process the same primordial energies that drive the universe.

A long-time feminist, who sponsored the famous "Joan of Art" seminars in the 1970s, designed to help women understand their professional possibilities, Wayne has turned her attention, in her 1996 print *Knockout* (Fig. 324), to a scientific discovery with implications about sexual politics. In November 1995, *The New York Times* reported that scientists had discovered that a brain chemical, nitric oxide, which plays a significant role in human strokes, also controls aggressive and sexual behavior in male mice. Experiments in mice had indicated that by blocking the enzyme responsible for producing nitric oxide, incidence of stroke can be reduced by 70 percent. But in the course of experiments on so-called "knockout" mice, from whom the gene responsible for the enzyme had been genetically eliminated, scientists found that the male mice would fight until the dominant one in any cage would kill the others. Furthermore, paired with females, the male mice were violently ardent. "They would keep trying to mount the female no matter how much she screamed," according to the *Times*. It would appear, then, that nitric oxide curbs aggressive and sexual appetites, and it also appears that this function is sex-specific. Female mice lacking the same gene show no significant change in behavior.

Fig. 324 June Wayne, *Knockout*, 1996.
Lithograph, 28¼ × 35⅜ in. (image). Bleed (paper).
© June Wayne/Licensed by VAGA, New York, NY.

It is, of course, dangerous to extrapolate human behavior from the behavior of rodents, but from a feminist point of view, the implications of this discovery are enormous. The study suggests that male violence may in fact be genetically coded. *Knockout* is, in this sense, a feminist print, and Wayne's choice of a printer underscores this—Judith Solodkin of Solo Impression, Inc. in New York, the first woman trained at Tamarind to become a master printer.

Knockout is an explosion of light, its deep black inks accentuating the whiteness of the paper, the shattered white bands piercing the darkness like screams of horror. At the bottom, three crouching spectators look on as a giant mouse, perhaps a product of genetic engineering, attacks a human victim.

Fig. 325 Robert Rauschenberg, *Accident*, 1963.
Lithograph on paper, 41 × 29 in. In the Collection of The Corcoran Gallery of Art,
Gift of the Women's Committee. ©Robert Rauschenberg/Licensed by VAGA, New York, NY.

Robert Rauschenberg's *Accident* (Fig. 325), printed at Universal Limited Art Editions in 1963, represents the spirit of innovation and experiment found in so much contemporary printmaking. At first, Rauschenberg, a post-abstract expressionist painter who included everyday materials and objects in his canvases, was reluctant to undertake printmaking. "Drawing on rocks," as he put it, seemed to him archaic. But Grosman was insistent that he try his hand at making lithographs at her West Islip studio. "Tatyana called me so often that I figured the only way I could stop her was to go out there," Rauschenberg says. He experimented with pressing all manner of materials down on the stone in order to see if they con-

tained enough natural oil to leave an imprint that would hold ink. He dipped zinc cuts of old newspaper photos in **tusche**—a greasing liquid, which also comes in a hardened, crayonlike form, made of wax, tallow, soap, shellac, and lampblack, and which is the best material for drawing on a lithographic stone. *Accident* was created with these tusche-dipped zinc cuts.

As the first printing began, the stone broke under the press, and Rauschenberg was forced to prepare a new version of the piece on a second stone. Only a few proofs of this second state had been pulled when it, too, broke, an almost unprecedented series of catastrophes. It turned out that a small piece of cardboard lodged under the press's roller was causing

uneven pressure to be applied to the stones. Rauschenberg was undaunted. He dipped the broken chips of the second stone in tusche, set the two large pieces back on the press, and lay the chips beneath them. Then, with great difficulty, his printer, Robert Blackburn, printed the edition of twenty-nine plus artist's proofs. *Accident* was awarded the grand prize at the Fifth International Print Exhibition in Ljubljana, Yugoslavia, in 1963. Says Grosman: "Bob is always bringing something new, some new discovery" to the printmaking process.

SILKSCREEN PRINTING

Silkscreens are more formally known as **serigraphs,** from the Greek *graphos,* "to write," and the Latin *seri,* "silk." Unlike other printmaking media, no expensive, heavy machinery is needed to make a serigraph, though, as in the case of printing Lorna Simpson's *The Park* (Fig. 21), elaborate serigraphy studios such as Jean Noblet's in New York do exist. The principles used are essentially the same as those required for stenciling, where a shape is cut out of a piece of material and that shape is reproduced over and over on other surfaces by spreading ink or paint over the cutout. In serigraphy proper, shapes are not actually cut out. Rather, the fabric—silk, or more commonly today, nylon and polyester—is stretched tightly on a frame, and a stencil is made by painting a substance such as glue across the fabric in the areas where the artist does not want ink to pass through to the paper. Alternately, special films can be cut out and stuck to the fabric, or tusche can be utilized. This last allows the artist a freedom of drawing that is close to the lithographic process. The areas that are left uncovered are those that will print. Silkscreen inks are very thick, so that they will not run beneath the edge of the cutout, and must be pushed through the open areas of the fabric with the blade of a tool called a *squeegee.*

Serigraphy is the newest form of printmaking, though related stencil techniques were employed in textile printing in China and Japan as early as C.E. 550. Until the 1960s, serigraphy was used primarily in commercial printing, especially by the advertising industry. In fact, the word "serigraphy" was coined in 1935 by the curator of the Philadelphia Museum of Fine Arts in order to differentiate the work of artists

Fig. 326 Claes Oldenburg, *Design for a Colossal Clothespin Compared to Brancusi's Kiss,* 1972. Silkscreen, 21½ × 13⅞ in. Philadelphia Museum of Art: From the Friends of the Philadelphia Museum of Art.

using the silkscreen in creative ways from that of their commercially oriented counterparts.

In the 1960s, serigraphy became an especially popular medium for Pop artists. Claes Oldenburg's *Design for a Colossal Clothespin Compared to Brancusi's Kiss* (Fig. 326) takes advantage of the fact that photographs can be transferred directly to the screen. The print compares his own giant clothespin to Brancusi's famous sculpture *The Kiss,* not merely to underscore their formal similarity—and it is striking—but, with tongue in cheek, to lend his own design the status of Brancusi's modern masterpiece. The print not only celebrates, with intentional irony, the commonplace and our culture's ability to monumentalize virtually anything, but also makes fun of art criticism's tendency to regard art in formal terms alone, the logic that might lead one to see the Brancusi and the clothespin in the same light.

MONOTYPES

There is one last kind of printmaking for us to consider, one that has much in common with painting and drawing. However, **monotypes** are generally classified as a kind of printmaking because they utilize both a plate and a press in the making of the image. Unlike other prints, however, a monotype is a unique image. Once it is printed, it can never be printed again.

In monotypes, the artist forms an image on a plate with printer's ink or paints, and the image is transferred to paper under pressure, usually by means of an etching press. Part of the difficulty and challenge of the process is that if a top layer of paint is applied over a bottom layer of paint on the plate, when printed, the original bottom layer will be the top layer and vice versa. Thus the foreground elements of a composition must be painted first on the plate, and the background elements over them. The process requires considerable planning.

Native American artist Fritz Scholder is a master of the medium. Scholder often works in series. Whenever he lifts a full impression of an image, a "ghost" of the original remains on the plate. He then reworks that ghost, revising and renewing it to make a new image. Since each print is itself a surprise—the artist never knows until the image is printed just what the work will look like—and since each print leaves a "ghost" that will spur him to new discoveries, the process is one of perpetual discovery and renewal. His *Dream Horse* monotypes, of which Figure 327 is

Fig. 327 Fritz Scholder, *Dream Horse G*, 1986.
Monotype, 30 × 22 in. Courtesy of the artist, Fritz Scholder.

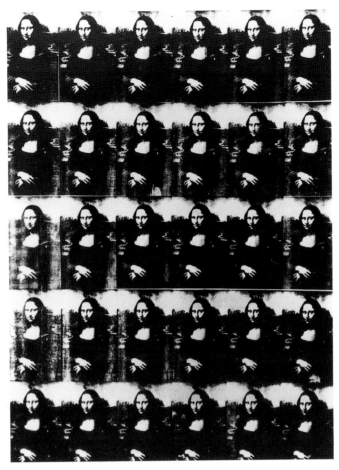

Fig. 328 Andy Warhol, *30 Are Better than One*, 1963.
Silkscreen ink and synthetic polymer paint on canvas, 110 × 82 in.
©2003 The Andy Warhol Foundation for the Visual Arts, Inc./Artists Rights Society (ARS), New York.

an example, are symbolic of this process. The artist figuratively "rides" the horse, and its image, on his continuing imaginative journey.

Scholder's process is, in another sense, a summation of the possibilities of printmaking as a whole. As new techniques have been invented—from the relief processes to those of intaglio, to lithography, silkscreen printing, and the monotype—the artist's imagination has been freed to discover new means of representation and expression. The variety of visual effects achievable in printmaking is virtually unlimited.

THE CRITICAL PROCESS

Thinking about Printmaking

Like Claes Oldenburg, Andy Warhol is a Pop artist who recognized in silkscreen printing, possibilities not only for making images but for commenting on art and art history in general. In his *30 Are Better than One* (Fig. 328), Warhol reproduces Leonardo da Vinci's famous *Mona Lisa* thirty times. What does Warhol's work share with Oldenburg's *Design for a Colossal Clothespin* (Fig. 326)? What do both share with the engraving of J. M. W. Turner's *Snow Storm* (Fig. 310)? What is the work's attitude toward the idea of the "original," and how does that idea relate to printmaking as a whole? Why, in your opinion, does Warhol believe that "thirty are better than one"? You may find it useful to consider the fact that Warhol called his studio "the Factory." In this light, how is the idea of "reproduction" affected? Finally, at about the same time he made this print, Warhol made a series of portraits of Marilyn Monroe, who died tragically in 1963. Is Marilyn, like Mona Lisa, "just" another image? What does it mean to be an "image"?

CHAPTER 12

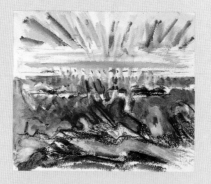

PAINTING

ENCAUSTIC

FRESCO

WORKS IN PROGRESS
Michelangelo's *Libyan Sybil*

TEMPERA

OIL PAINTING

WORKS IN PROGRESS
Milton Resnick's *U + Me*

WATERCOLOR

GOUACHE

SYNTHETIC MEDIA

COMPUTER-GENERATED PAINTING

THE CRITICAL PROCESS
Thinking About Painting

Early in the fifteenth century, a figure known as *La Pittura*—literally, "the picture"—began to appear in Italian art (Fig. 329). As art historian Mary D. Garrard has noted, the emergence of the figure of *La Pittura*, the personification of painting, could be said to announce the cultural arrival of painting as an art. In the Middle Ages, painting was never included among the liberal arts—those areas of knowledge that were thought to develop general intellectual capacity—which included rhetoric, arithmetic, geometry, astrology, and music. While the liberal arts were understood to involve

inspiration and creative invention, painting was considered merely a mechanical skill, involving, at most, the ability to copy. The emergence of *La Pittura* announced that painting was finally something more than mere copywork, that it was an intellectual pursuit equal to the other liberal arts, all of which had been given similar personification early in the Middle Ages.

In her *Self-Portrait as the Allegory of Painting* (Fig. 330), Artemisia Gentileschi presents herself as both a real person and as the personification of *La Pittura*. Iconographically speaking, Gentileschi may be recognized as *La Pittura* by virtue of the pendant around her neck that symbolizes *imitation*. And Gentileschi can imitate the appearance of things very well. She presents us a portrait of herself as she really looks. Still, in Renaissance terms, imitation means more than simply copying appearances; it is the representation of nature as seen by and through the artist's imagination. On the one hand, Gentileschi's multicolored garment alludes to her craft and skill as a copyist—she can imitate the effects of color—but on the other hand, her unruly hair stands for the imaginative frenzy of the artist's temperament. Thus, in this painting, she portrays herself both as a real woman and as an idealized personification of artistic genius, possessing all the intellectual authority and dignity of a Leonardo or a

Michelangelo. Though in her time it was commonplace to think of women as intellectually inferior to men—"women have long dresses and short intellects" was a popular saying—here Gentileschi transforms painting from mere copywork, and transforms her own possibilities as a creative person in the process.

Nevertheless, from the earliest times, one of the major concerns of painting in the Western world has been representing the appearance of things in the natural world. There is a famous story told by the historian Pliny about a contest between the Greek painters Parrhasius and Zeuxis as to who could make the most realistic image:

> *Zeuxis produced a picture of grapes so dexterously represented that birds began to fly down to eat from the painted vine. Whereupon Parrhasius designed so lifelike*

Fig. 330 Artemisia Gentileschi, *Self-Portrait as the Allegory of Painting*, 1630.
Oil on canvas, 35¼ × 29 in.
The Royal Collection © Her Majesty Queen Elizabeth II.

Fig. 329 Giorgio Vasari, *The Art of Painting*, 1542.
Fresco of the vault of the Main Room. Arezzo, Casa Vasari.
Canali Photobank, Capriolo, Italy.

*a picture of a curtain that Zeuxis, proud of
the verdict of the birds, requested that the
curtain should now be drawn back and the
picture displayed. When he realized his
mistake, with a modesty that did him
honor, he yielded up the palm, saying that
whereas he had managed to deceive only
birds, Parrhasius had deceived an artist.*

This tradition, which views the painter's task
as rivaling the truth of nature, has survived to
the present day.

In the late Middle Ages, Dante wrote in the
Purgatory section of his *Divine Comedy* about
the painters Cimabue and Giotto: "Once,
Cimabue was thought to hold the field / In
painting; now it is Giotto's turn." If we com-
pare altarpieces painted by both artists (Figs.
331 and 332), Giotto's only thirty years after
Cimabue's, we can readily see that Giotto's is
the more "realistic." However, this is not the
realism to which we have since grown accus-
tomed in, for instance, photography. For one
thing, Giotto's Madonna and Child are far
larger than the angels, raising all sorts of prob-
lems of scale. To early Renaissance eyes, how-
ever, Giotto's painting was a significant
"advance" over the work of Cimabue. It is
possible, for instance, to feel the volume of the
Madonna's knee in Giotto's altarpiece, to sense
actual bodies beneath the draperies that clothe
his models. The neck of Cimabue's Madonna
is a flat surface, while the neck of Giotto's
Madonna is modeled and curves round
beneath her cape. Cimabue's Madonna is chin-
less, her nose almost rendered in profile; the
face of Giotto's Virgin is far more sculptural, as
if real bones lie beneath her skin.

By this measure, the more faithful to nature
a painting is, the more accurately it represents
the real world, the greater is its aesthetic value.
But if this were all there was to painting, then
abstraction would be of little or no value.
However, there are many types and styles of
painting for which truth to nature is not of
paramount importance. Think of modern
abstract art. Even during the Renaissance, the
concept of imitation, or **mimesis**, involved the
creation of representations that transcended
mere appearance, that implied the sacred or
spiritual essence of things. This is the truth
Gentileschi sought to reveal.

Painting, in other words, can outstrip phys-
ical reality, leave it behind, even when it is fully
representational. It need not simply point at
what it represents. It can suggest at least as
much, and probably more, than it portrays.
Another way to say this is that painting can be
understood in terms of its **connotation** as well
as its **denotation**. What a painting denotes is
clearly before us: both Cimabue and Giotto
have painted a Madonna and Child sur-
rounded by angels. But what these paintings

connote is something else again. To a thir-teenth- or fourteenth-century Italian audience, both altarpieces would have been understood as depicting the ideal of love that lies between mother and child and, by extension, the greater love of God for mankind. The meaning, then, of these altarpieces exists on many levels. And although the relative realism of Giotto's painting is what secures its place in art history, its *didactic* function—that is, its ability to teach, to elevate the mind, in this case, to the contemplation of salvation—was at least as important to its original audience. Its truth to nature was, in fact, probably inspired by Giotto's desire to make an image with which its audience could readily identify.

In this chapter, we will consider the art of painting. We will pay particular attention to how its various media developed in response to artists' desire to imitate reality and express themselves more and more fluently. But before we begin our discussion of these various painting media, we should be familiar with a number of terms that all the media share, and which are crucial to understanding how paintings are made.

From prehistoric times to the present day, the painting process has remained basically the same. As in drawing, artists use **pigments**, or powdered colors, suspended in a **medium** or **binder** that holds the particles of pigment together. The binder protects the pigment from changes and serves as an adhesive to anchor the pigment to the **support**, or the surface on which the artist paints—a wall, a panel of wood, a sheet of paper, or a canvas. Different binders have different characteristics. Some dry more quickly than others. Some create an almost transparent paint, while others are *opaque*—that is, they cannot be seen through. The same pigment used in different binders will look different because of the differing degrees of each binder's transparency.

Since most supports are too absorbent to allow the easy application of paint, artists often *prime* (pre-treat) a support with a paint-like material called a **ground**. Grounds also make the support surface smoother or more uniform in texture. Many grounds, especially white grounds, increase the brightness of the final picture.

Finally, artists use **solvent** or **vehicle**, a thinner that enables the paint to flow more readily and that also cleans brushes. All water-based paints use water for a vehicle. Other paints, such as oil-based paints, require a different thinner—turpentine in the case of oil paint.

Fig. 332 Giotto, *Madonna and Child Enthroned*, c. 1310. Tempera on panel, 10 ft. 8 in. × 6 ft. 8¼ in. Galleria degli Uffizi, Florence.

Fig. 333 Faiyum, *Mummy Portrait of a Man*, c. 160–170 C.E.
Encaustic on wood, 14 × 18 in.
Albright-Knox Art Gallery, Buffalo, NY. Charles Clifton Fund, 1938.

Each painting medium has unique characteristics and has flourished at particular historical moments. Though many have been largely abandoned as new media have been discovered—media that allow the artist to create a more believable image or that are simply easier to use—almost all continue to be used to some extent, and older media, such as encaustic and fresco, sometimes find fresh uses in the hands of contemporary artists.

ENCAUSTIC

Encaustic, made by combining pigment with a binder of hot wax, is one of the oldest painting media. It was widely used in classical Greece, most famously by Polygnotus, but very few paintings from that period survive. (The contest between Zeuxis and Parrhasius was probably conducted in encaustic.) The Hellenistic Greeks used it as well.

Most of the surviving encaustic paintings come from Faiyum in Egypt which, in the second century C.E., was a thriving Roman province about 60 miles south of present-day Cairo. The Faiyum paintings are funeral portraits, which were attached to the mummy cases of the deceased, and they are the only indication we have of the painting techniques used by the Greeks. A transplanted Greek artist may, in fact, have been responsible for *Mummy Portrait of a Man* (Fig. 333), though we cannot be sure.

What is clear, though, is the artist's remarkable skill with the brush. The encaustic medium is a demanding one, requiring the painter to work quickly so that the wax will stay liquid. Looking at *Mummy Portrait of a Man,* we notice that while the neck and shoulders have been rendered with simplified forms, which gives them a sense of strength that is almost tangible, the face has been painted in a very naturalistic and sensitive way. The wide, expressive eyes and the delicate modeling of the cheeks make us feel that we are looking at a "real" person, which was clearly the artist's intention.

The extraordinary luminosity of the encaustic medium has led to its revival in recent years. Of all contemporary artists working in the medium, no one has perfected its use more than Jasper Johns, whose encaustic *Three Flags* (Fig. 10) we saw in Chapter 1.

Fig. 334 *Still Life with Eggs and Thrushes,* Villa of Julia Felix, Pompeii, before C.E. 79.
Fresco, 35 × 48 in. National Museum, Naples. Scala/Art Resource, New York.

FRESCO

Wall painting was practiced by the ancient Egyptians, Greeks, and Romans, as well as by Italian painters of the Renaissance. The preferred medium was **fresco**, in which pigment is mixed with limewater (a solution containing calcium hydroxide, or slaked lime), and then applied to a lime plaster wall that is either still wet or hardened and dry. If the paint is applied to a wet wall, the process is called ***buon fresco*** (Italian for "good" or "true fresco"), and if applied to a dry wall, ***fresco secco,*** or "dry fresco." In *buon fresco,* the wet plaster absorbs the wet pigment, and the painting literally becomes part of the wall. The artist must work quickly, plastering only as much wall as can be painted before it dries, but the advantage of the process is that it is extremely durable. In *fresco secco,* on the other hand, the pigment is combined with binders such as egg yolk, oil, or wax, and applied separately, at virtually any pace the artist desires. As a result, the artist can render an object with extraordinary care and meticulousness. The disadvantage of the *fresco secco* technique is that moisture can creep in

between the plaster and the paint, causing the paint to flake off the wall. This is what happened to Leonardo da Vinci's *Last Supper* in Milan, which has peeled away to such a tragic degree that the image has almost disappeared, though it is today being carefully restored.

In the eighteenth century, many frescoes were discovered at Pompeii and nearby Herculaneum, where they had been buried under volcanic ash since the eruption of Mt. Vesuvius in C.E. 79. A series of still life paintings was unearthed in the years 1755–1757 that proved so popular in France that they led to the renewed popularity of the still life genre. This *Still Life with Eggs and Thrushes* (Fig. 334), from the Villa of Julia Felix, is particularly notable, especially the realism of the dish of eggs, which seems to hang over the edge of the painting and push forward into our space. The fact that all the objects in the still life have been painted lifesize adds to the work's sense of realism.

One of the most remarkable frescoes to survive Roman times is a wall-size rendering of a garden, found in the Villa of Livia, wife of the Emperor Augustus, in Prima Porta near

Fig. 335 (above) *Garden*, Villa of Livia, Prima Porta,
near Rome, late 1st century B.C.E.
Fresco, height 10 ft. Museo delle Terme, Rome. Scala/Art Resource, New York.

Fig. 336 (right) Giotto, *Lamentation*, c. 1305.
Fresco, approx. 70 × 78 in. Arena Chapel, Padua, Italy. Scala/Art Resource, New York.

Rome (Fig. 335). Not unlike certain back-lighted beer advertisements of rushing mountain streams commonly found in taverns today, the painting is designed to "open" the closed room to the out-of-doors, lending it the airiness and light of a cool summer evening. The artist is attempting to render an illusionistic, that is, realistic, space by means of both linear and atmospheric perspective.

This goal of creating the illusion of reality dominates fresco painting from the early Renaissance in the fourteenth century through the Baroque period of the late seventeenth century. It is as if painting at the scale of the wall invites, even demands, the creation of "real" space. In one of the great sets of frescoes of the early Renaissance, painted by Giotto in the Arena Chapel in Padua, Italy, this realist impulse is especially apparent.

The Arena Chapel was designed, possibly by Giotto himself, especially to house frescoes, and it contains thirty-eight individual scenes that tell the stories of the lives of the Virgin and Christ. In the *Lamentation* (Fig. 336), the two crouching figures with their backs to us extend into our space in a manner similar to the bowl of eggs in the Roman fresco. Here, the result is

to involve us in the sorrow of the scene. As the hand of the left-most figure cradles Christ's head, it is almost as if it were our own. One of the more remarkable aspects of this fresco, however, is the placement of its focal point—Christ's face—in the lower left-hand corner of the composition, at the base of the diagonal formed by the stone ledge. Just as the angels in the sky above seem to be plummeting toward the fallen Christ, the tall figure on the right leans forward in a sweeping gesture of grief that mimics their descending flight.

The fresco artists' interest in illusionism culminated in the Baroque ceiling designs of the late seventeenth century. Among the most remarkable of these is *The Glorification of St.*

Fig. 337 Fra Andrea Pozzo, *The Glorification of Saint Ignatius*, 1691–1694.
Ceiling fresco. Nave of Sant' Ignazio, Rome. Scala/Art Resource, New York.

Ignatius (Fig. 337), which Fra Andrea Pozzo painted for the church of Sant' Ignazio in Rome. Standing in the nave, or central portion of the church, and looking upward, the congregation had the illusion that the roof of the church had been removed, revealing the glories of Heaven. A master of perspective, about which he wrote an influential treatise, Pozzo realized his effects by extending the architecture in paint one story above the actual windows in the vault. St. Ignatius, the founder of the Jesuit order, is shown being transported on a cloud toward the waiting Christ. The foreshortening of the many figures, becoming ever smaller in size as they rise toward the center of the ceiling, greatly adds to the realistic, yet awe-inspiring effect.

Michelangelo's Libyan Sibyl

On May 10, 1506, Michelangelo received an advance payment from Pope Julius II to undertake the task of frescoing the ceiling of the Sistine Chapel at the Vatican in Rome. By the end of July, a scaffolding had been erected. By September 1508, Michelangelo was painting, and for the next four and one-half years, he worked almost without interruption on the project.

According to Michelangelo's later recounting of the events, Julius had originally envisioned a design in which the central part of the ceiling would be filled by "ornaments according to custom" (apparently a field of geometrical ornaments) surrounded by the twelve apostles in the twelve spandrels. Michelangelo protested, assuring Julius that it would be "a poor design" since the apostles were themselves "poor too." Apparently convinced, the pope then freed Michelangelo to paint anything he liked. Instead of the apostles, Michelangelo created a scheme of twelve Old Testament prophets alternating with twelve sibyls, or women of classical antiquity said to possess prophetic powers. The center of the ceiling would be filled with nine scenes from Genesis.

Fig. 338 Michelangelo Buonarroti, *Studies for the Libyan Sibyl*, c. 1510.
Red chalk, 11⅜ × 8⁷⁄₁₆ in.
The Metropolitan Museum of Art, Joseph Pulitzer Bequest, 1924 (24.197.2).
Photograph © 1995 The Metropolitan Museum of Art, New York.

As the scaffolding was erected, specially designed by the artist so that he could walk around and paint from a standing position, Michelangelo set to work preparing hundreds of drawings for the ceiling. These drawings were then transferred to full-size cartoons, which would be laid up against the moist surface of the fresco as it was prepared, their outlines traced through with a stylus. None of these cartoons, and surprisingly few drawings, has survived.

One of the greatest, and most revealing, of the surviving drawings is a study for the Libyan Sibyl (Fig. 338). Each of the sibyls holds a book of prophecy—though not Christian figures, they prophesy the revelation of the New Testament in the events of the Old Testament that they surround. The Libyan Sibyl (Fig. 339) is the last sibyl that Michelangelo would paint. She is positioned next to the *Separation of Light from Darkness*, the last of the central panels, positioned directly over the

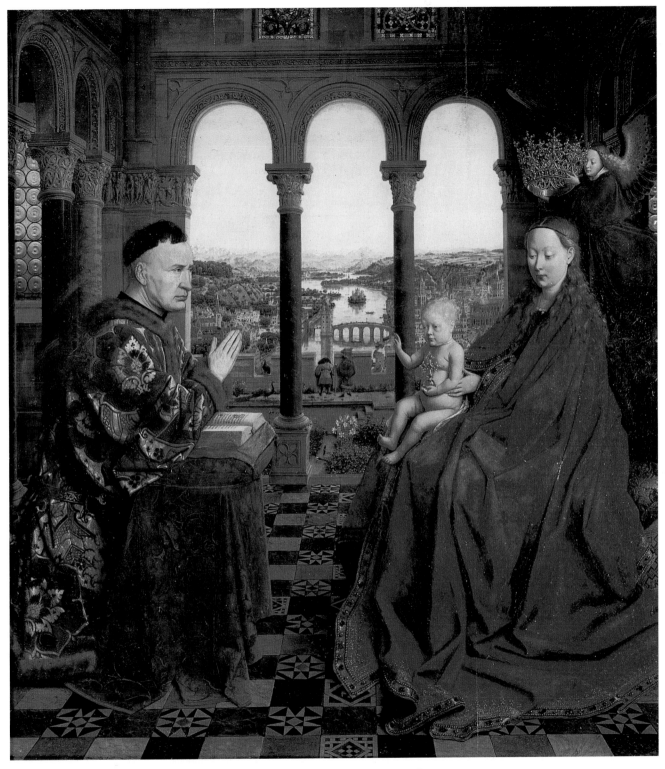

Fig. 344 Jan van Eyck, *The Madonna of Chancellor Rolin*, c. 1433–1434.
Oil on panel, 26 × 24¾ in. Musée du Louvre, Paris. Scala/Art Resource, New York.

In 1608, the Netherlands freed itself of Spanish rule and became, by virtue of its almost total dominance of world trade, the wealthiest nation in the world. By that time, artists had become extremely skillful at representing these material riches—with the medium of oil paint. One critic has called the Dutch preoccupation with still life "a dialogue between the newly affluent society and its material possessions." In a painting such as Jan de Heem's *Still Life with Lobster* (Fig. 345), we are witness to the remains of a most extravagant meal, most of which has been left uneaten. This luxuriant and conspicuous display of wealth is deliberate. Southern fruit in a cold climate is a luxury, and the peeled lemon, otherwise untouched, is a sign of almost wanton consumption. And though we might want to read into this image our own sense of its decadence, for de Heem the painting was more a celebration, an invita-

tion to share, at least visually and thus imaginatively, in its world. The feast on the table was a feast for the eyes.

The ability to create such a sense of tactile reality is a virtue of oil painting that makes the medium particularly suitable to the celebration of material things. By painting a **glaze** over the surface of the painting, consisting of thin films of transparent color, the artist creates a sense of luminous materiality. Light penetrates this glaze, bounces off the opaque underpainting beneath, and is reflected back up through the glaze. Painted objects thus seem to reflect light as if they were real, and the play of light through the painted surfaces gives them a sense of tangible presence.

The more real a painting appears to be, the more it is said to be an example of *trompe l'oeil*, a French phrase meaning "deceit of the eye." It is precisely painting's ability to deceive

Fig. 345 Jan Davidsz. de Heem, *Still Life with Lobster*, late 1640s.
Oil on canvas, 25⅛ × 33¼ in.
Toledo Museum of Art, Toledo, Ohio. Purchased with funds from the Libbey Endowment. Gift of Edward Drummond Libbey.

paint could record and trace the artist's presence before the canvas. In the swirls and dashes of paint that make up Susan Rothenberg's *Biker* (Fig. 347), we can detect a cyclist charging through a puddle or a stream straight at us, water splashing up from the bike's tires. A windswept tree reaches into the painting from the right, like a claw ready to bring the biker down. The biker himself seems disembodied. All we can see of him is his head and his right arm, which reaches up to his brow as if to shade his eyes. Rothenberg's paint seems to want to capture the image and at the same time reject it. It is as if the artist's hand, caught in the act of painting a figure, rejects reality (representation) and insists on abstraction. We feel, in other words, that Rothenberg has been moved by something she has seen, but that she can express it only through the expressive agitation of her brushwork and the glimmering beauty of her color. As in Kathë Kollwitz's *Self-Portrait* (Fig. 277), the power of the artist's imagination is embodied in the artist's gesture.

Fig. 346 René Magritte, *Euclidean Walks*, 1955.
Oil on canvas, 64 × 51½ in. The Minneapolis Institute of Arts.
© 2003 C. Hersovici, Brussels/Artists Rights Society (ARS), New York.

the eye, to substitute itself for reality, that is the subject of René Magritte's *Euclidean Walks* (Fig. 346). Here a painting-within-a-painting is set in front of a window so that it hides, but exactly duplicates, the scene outside. The painting confuses the interior of the room with the exterior landscape, and by analogy, the world of the mind with the physical world outside it. In Magritte's words, this is "how we see the world: we see it as being outside ourselves even though it is only a mental representation of it that we experience inside ourselves." The artificial nature of this superficially *trompe-l'oeil* scene is underscored by the way in which the shape of the tower is identical to the shape of the avenue that recedes to a distant vanishing point. A painting is, after all, a mental construction, an artificial reality, not reality itself.

If oil painting exists in the mind and for the mind it need not necessarily reflect the world outside it. Virtually since its inception, oil painting's *expressive* potential has also been recognized. Much more than in fresco, where the artist's gesture was lost in the plaster, and much more than in tempera, where the artist was forced to use brushes so small that gestural freedom was absorbed by the scale of the image, oil

Fig. 347 Susan Rothenberg, *Biker*, 1985.
Oil on canvas, 74 × 69½ in. Collection: Museum of Modern Art, New York. Licensed by Scala-Art Resource, New York.
Fractional gift of Paine Webber Group, Inc., 1986.
© 2003 Susan Rothenberg/Artists Rights Society (ARS), NY.

Fig. 348 Pat Passlof, *Dancing Shoes,* 1998.
Oil on canvas, 80 × 132 in. Courtesy of the artist and Elizabeth Harris Gallery, New York.

Where Rothenberg begins with the thing seen, Pat Passlof begins with abstraction. Her painting *Dancing Shoes* (Fig. 348), like many of her larger paintings, began with leftover paint from a smaller work, which she distributed in odd amounts over the surface of the eleven-foot canvas. The painting developed as a predominantly yellow field that threatened, even with its syncopation of darker, loosely rectangular medium yellow shapes, to flatten out. In response to these yellow shapes, Passlof added Sap Green blocks of color, so dark that they read as black. These immediately animated the surface, creating an uneven choreography of short leaps and intervals across the painting's surface that at first glance seems to fit into a grid but reveals itself to be much freer, the space between elements lengthening itself out across the canvas with a greater and greater sense of abandon.

Many of Passlof's attitudes about painting were developed working with New York painters such as Willem de Kooning, whom she first met when she attended Black Mountain College in North Carolina in 1948 and who, soon after, introduced her to her husband,

Milton Resnick (see Figs. 350 and 351). At the time, de Kooning was in the process of creating a more and more abstract art. In paintings like his *Door to the River* (Fig. 349) there is no reference to visual reality at all. He has described the subject matter of this painting, and others like it, as a mixture of raw sensations: "landscapes and highways and sensations of that, outside the city—with the feeling of going to the city or coming from it." What we feel here, especially, is energy, the energy of the city translated into the energy of painting itself.

From de Kooning, Passlof learned to appreciate, in his words, "a leap of space," a sense of discontinuity or displacement between elements in a composition that creates a sense of surprise, excitement, and even a degree of existential trembling, as if we are about, at each moment, to step into the void. It is, perhaps, this leap that *Dancing Shoes* so successfully exploits, as each "step" or block in the composition stands in surprising relation to the next, not as an impossible "next move," but not in the rhythm of a natural pace either. It is as if, in looking at the painting, we can hear the syncopation of its jazz beat.

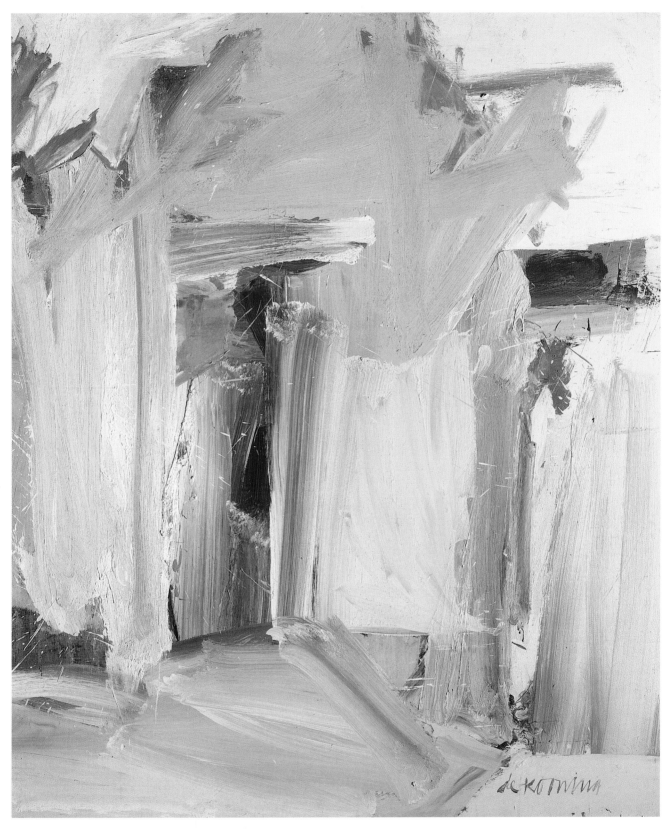

Fig. 349 Willem de Kooning, *Door to the River*, 1960.
Oil on canvas, 80 × 70 in. Collection: Whitney Museum of American Art. Purchase, with funds from the Friends of the Whitney Museum of American Art. (60.63).
© 2003 Willem de Kooning Revocable Trust/Artists Rights Society (ARS), New York.

Milton Resnick's U + Me

Fig. 350 Milton Resnick's *U + Me* in progress.
Left: July 25, 1995. Right: July 26, 1995.

On July 25, 1995, abstract expressionist painter Milton Resnick began five new large paintings. They would sum up, he hoped, what he had learned over the years as a painter. He had left home in his late teens to become an artist, lived through the heyday of abstract expressionist painting in New York, where, as one of the leaders of what would come to be known as the New York School, he had worked together with Willem de Kooning, Jackson Pollock, and Franz Kline, and had continued to work up to the present, longer than any of his contemporaries. These new paintings would take him full circle, back to his beginnings and forward again into the present. And it was, in fact, beginnings that would lend the new paintings their theme—Genesis, the first book of the Bible, Adam and Eve, the Garden of Eden, the Tree of the Knowledge of Good and Evil, and the serpent, Satan. Pat Passlof, Resnick's wife and fellow painter, suggested that the figures in the new work had a more general significance as well, that they were "you and me." The name stuck, though modified to *U + Me,* because, Resnick says, "it's easier to write."

On July 25, he painted on all five canvases in his Eldridge Street studio in Chinatown, a two-story brick-walled space with large windows that had been, in the first decades of this century, a Jewish synagogue. He begins without a plan, and without preliminary drawing, with nothing but a brushmark and a feeling about where he's going. "This feeling doesn't have to be physical," he says, "but it has to be as if I come at you and you're frightened. That's the feeling. It's like if you have a glass and there's something in it and it's a kind of funny color. And someone says, 'Drink it.' And you say, 'What's in it?' And they say, 'Drink it or else!' And so you have to drink it. So that's the feeling. I'm going to drink something, and I don't know what's going to happen to me."

Pictured on these pages is one of the *U + Me* paintings at three different stages in its development—two studio photographs taken on each of the first two days, July 25 and July

In the early 1950s, Helen Frankenthaler gave up the gestural qualities of the brush loaded with oil paint and began to stain raw, unprimed canvas with greatly thinned oil pigments, soaking color into the surface in what has been called an art of "stain-gesture." Her technique soon attracted a number of painters, Morris Louis among them, who were themselves experimenting with Magna, a paint made from **acrylic** resins—materials used to make plastic—mixed with turpentine. Staining canvas with oil created a messy, brownish "halo" around each stain or puddle of paint, but Louis quickly realized that the "halo" disappeared when he stained canvas with Magna, the paint and canvas really becoming one.

At almost exactly this time, researchers in both Mexico and the United States discovered a way to mix acrylic resins with water, and by 1956, water-based acrylic paints were on the market. These media were inorganic and, as a result, much better suited to staining raw canvas than turpentine or oil-based media, since no chemical interaction could take place that might threaten the life of the painting.

Louis's *Blue Veil* (Fig. 357) consists of multicolored translucent washes of acrylic paint thinned to the consistency of watercolor. Inevitably, Frankenthaler gave up staining her canvases with oil and moved to acrylic in 1963. With this medium, she was able to create such intensely atmospheric paintings as *Flood* (Fig. 358). Working on the floor and pouring paint directly on canvas, the artist was able to make the painting seem spontaneous, even though it is quite large. "A really good picture," Frankenthaler says, "looks as if it's happened at once. . . . It looks as if it were born in a minute." This sense of spontaneity manifests itself as a sort of aggressive good humor in the giant poured pieces of Lynda Benglis (Fig. 359). Her liquid rubber materials find their own form as they spill, not onto canvas, but directly onto the floor, creating what might be called "soft" painting.

COMPUTER-GENERATED PAINTING

As David Hockney's drawing executed with Quantel's "paint" program suggests (see Fig. 295), the computer offers artists many new possibilities for making art. One of the most

Fig. 359 Lynda Benglis, *Contraband*, 1969.
Poured pigmented latex, 33 ft. 9 in. × 9 ft. × 1 in.
Courtesy Paula Cooper Gallery, New York, and Cheim & Reed, New York.
© Lynda Benglis/Licensed by VAGA, New York.

Fig. 360 Harold Cohen, *Meeting on Gauguin's Beach*, 1988.
Oil on canvas, 90 × 68 in. Photo: Becky Cohen.

interesting experiments has been conducted by painter Harold Cohen at the Center for Research and Computing in the Arts at the University of California, San Diego. For the past quarter-century, Cohen has been developing a computer program and robot named AARON which is capable of generating unique paintings on canvas (Fig. 360). Each night AARON's memory generates four or five possibilities for new paintings, and then the next day, Cohen picks one and AARON paints it. AARON makes preliminary drawings on canvas, chooses and mixes colors, paints with brushes, and even cleans up after itself.

AARON does not see. It relies on a sophisticated repertoire of characteristics that allows it to "choose" among various aspects of plants, human figures, and colors and put them together in a "composition." "Plants exist for AARON," as Cohen explains "in terms of their size, the thickness of limbs with respect to height, the rate at which limbs get thinner with respect to spreading, the degree of branching, the angular spread where branching occurs, and so on." AARON possesses like knowledge of the human figure. Cohen realizes, however, that AARON asks us some very difficult questions: "If what AARON is making is not art, what is it exactly, and in what ways, other than its origin, does it differ from the 'real thing.' If it is not thinking, what exactly is it doing?"

THE CRITICAL PROCESS

Thinking about Painting

In this chapter, we have considered all of the painting media—encaustic, fresco, tempera, oil paint, watercolor, gouache, and acrylic paints—and we have discussed not only how these media are used but why artists have favored them. One of the most important factors in the development of new painting media has always been the desire of artists to represent the world more and more faithfully. But representation is not the only goal of painting. In Artemesia Gentileschi's *Self-Portrait* at the beginning of this chapter, she is not simply representing the way she looks but also the way she feels. In her hands, paint becomes an *expressive* tool. Some painting media—oil paint, watercolor, and acrylics—are better suited to expressive ends than others

the work proceeds. Modeling, construction, and assemblage are additive processes. Casting, in which material in a liquid state is poured into a mold and allowed to harden, has additive aspects, but as we shall see, it is in many ways a process of its own. Earthworks often utilize both additive and subtractive processes.

In addition to these processes, there are three basic ways in which we experience sculpture in three-dimensional space—as relief, in the round, and as an environment. If you recall the process for making wood-block prints, which is described in Chapter 11, you will quickly understand that the raised portion of a woodblock plate stands out in relief against the background. The woodblock plate is, in essence, a carved relief sculpture, a sculpture that has three-dimensional depth but is meant to be seen from only one side.

Among the great masters of relief sculpture were the Egyptians, who often decorated the walls of their temples and burial complexes with intricate raised relief sculpture, most of which was originally painted. One of the best preserved of these is the so-called "White Chapel," built by Senwosret I in about 1930 B.C.E. at Karnak, Thebes, near the modern city of Luxor in the Nile River valley. Like many great archeological finds it has survived, paradoxically, because it was destroyed. In this case, 550 years after its construction, King Amenhotep III dismantled it and and used it as filling material for a monumental gateway for his own temple at Karnak. Archeologists have thus been able to reconstruct it almost whole. The scene here (Fig. 362) is a traditional one, showing the Senwosret I in the company of two Egyptian dieties surrounded by hieroglyphics, the pictorial Egyptian writing system. On the left is Amun, the chief god of Thebes, recognizable by the two plumes that form his headdress and by his erect penis. In the middle, leading Senwosret, is Atum, the creator god. By holding the hieroglyph *ankh* (a sort of cross with a rounded top) to Senwosret I's nose, he symbolically grants him life.

Like the Egytpians, the Greeks used the sculptural art of relief as a means to decorate and embellish the beauty of their great archi-

Fig. 362 Senwosret I led by Atum to Amun-Re, from the White Chapel at Karnak, Thebes. c. 1930 B.C.E. Limestone, raised relief, H. 13 ft. 6 in. Scala/Art Resource, New York.

Fig. 363 *Maidens and Stewards*, fragment of the *Panathenaic Procession*, from the east frieze of the Parthenon, Acropolis, Athens, 438–432 B.C.E.
Marble, H. approx. 43 in. Musée du Louvre, Paris. Marburg/Art Resource, New York.

Fig. 364 *Atlas Bringing Herakles the Golden Apples*, from the Temple of Zeus, Olympia, c. 470–456 B.C.E.
Marble, H. 63 in.
Archaeological Museum, Olympia. Alinari/Art Resource, New York.

tectural achievements. Forms and figures carved in relief are spoken of as done in either **low relief** or **high relief**. (Some people prefer the French terms, *bas-relief* and *haut-relief*.) The very shallow depth of the Egyptian raised reliefs is characteristic of low relief, though technically any sculpture that extends from the plane behind it less than 180° is considered low relief. High relief sculptures project forward from their base by at least half their depth, and often several elements will be fully in the round. Thus, even though it possesses much greater depth than the Eygptian raised relief at Karnak, the fragment from the **frieze**, or sculptural band, on the Parthenon called the *Maidens and Stewards* (Fig. 363), projects only a little distance from the background, and no sculptural element is detached entirely from it. It is thus still considered low relief. By contrast, *Atlas Bringing Herakles the Golden Apples* (Fig. 364), from the Temple of Zeus at Olympia, is an example of high relief. Here, the figures project from the background at least half their circumference, and other elements, like the left arm of Atlas, the right-hand figure, float free.

Of the two, the relief from the Temple of Zeus is the simpler and more direct in carving style. It depicts the moment in the story of Her-

akles when the giant Atlas returns from the Hesperides with the Golden Apples of immortality. In Atlas's absence, Herakles had assumed the giant's normal task of holding up the heavens on his back, assisted by a pillow that rests upon his shoulders. In the relief, his protectress, Athena, the goddess of wisdom, helps Herakles to support the weight of the sky so that he can exchange places with Atlas. The frontality of Athena's body is countered by the pure profile of her face, a profile repeated in the positioning of both Herakles and Atlas. Compared to the Egyptian relief sculpture at Karnak, where the head and legs are in profile, and the body squarely frontal, the frieze from Olympia seems highly naturalistic. Still, the composition of this relief is dominated by right angles, and as a result, it is stiff and rigid, as if the urge to naturalism, realized, for instance, in the figure of Herakles, is as burdened by tradition as Herakles is himself weighed down.

The naturalism of the Parthenon frieze is much more fully developed. Figures overlap one another and are shown in three-quarter view, making the space seem far more natural and even deeper than that at Olympia, though it is, in fact, much shallower. The figures themselves seem almost to move in slow procession, and the garments they wear reveal real flesh and limbs beneath them. The carving of this drapery invites a play of light and shadow that further activates the surface, increasing the sense of movement.

Perhaps because the human figure has traditionally been one of the chief subjects of sculpture, movement is one of the defining characteristics of the medium. Even in relief sculptures it is as if the figures want to escape the confines of their base. Sculpture **in-the-round** literally demands movement. It is meant to be seen from all sides, and the viewer must move around it. Giovanni da Bologna's *The Rape of the Sabine Women* (Fig. 365) is impossible to represent in a single photograph. As its figures rise in a spiral, the sculpture changes dramatically as the viewer walks around it and experiences it from each side. It is in part the horror of the scene that lends the sculpture its power, for as it draws us around it, in order to see more of what is happening, it involves us both physically and emotionally in the scene it depicts.

Fig. 365 Giovanni da Bologna,
The Rape of the Sabine Women, completed 1583.
Marble, height 13 ft. 6 in.
Loggia dei Lanzi, Florence. Alinari/Art Resource, New York.

Figs. 366 and 367 David Smith, *Blackburn: Song of an Irish Blacksmith*, frontal view above; profile view at right, 1949–1950.
Steel and bronze, 46¼ × 49¾ × 24 in.
Wilhelm Lehmbruck Museum, Duisburg, Germany.
© Estate of David Smith/Licensed by VAGA, New York, NY.

Looked at from different points of view, David Smith's *Blackburn: Song of an Irish Blacksmith* (Figs. 366 and 367) appears to be two entirely different works of art. The frontal view is airy and open, the work seeming to float in space like a series of notes and chords, while the profile view reveals the sculpture as densely compacted, a confusing jumble of forms from which two seem to want to escape, one at the top left, the other on the extreme right. The frontal view is almost symmetrical, the profile view radically asymmetrical.

The viewer is even more engaged in the other sculptural media we will discuss in this chapter—environments. An **environment** is a sculptural space into which you can physically enter either indoors, where it is generally referred to as an **installation**, or out-of-doors, where its most common form is that of the **earthwork**. With these terms in mind—relief sculpture, sculpture in-the-round, and environments—we can now turn to the specific methods of making sculpture.

CARVING

Carving is a subtractive process in which the material being carved is chipped, gouged, or hammered away from an inert, raw block of material. Wood and stone are the two most common carving materials. Both materials present problems for the artist to solve. Sculptors who work in wood must pay attention to the wood's grain, since wood will only split in the direction it grew. To work "against the grain" is to risk destroying the block. Sculptors who work in stone must take into account the different characteristics of each type of stone. Sandstone is gritty and coarse, marble soft and

crystalline, granite dense and hard. Each must be dealt with differently. For Michelangelo, each stone held within it the secret of what it might become as a sculpture. "The best artist," he wrote, "has no concept which some single marble does not enclose within its mass. . . . Taking away . . . brings out a living figure in alpine and hard stone, which . . . grows the more as the stone is chipped away." But carving is so difficult that even Michelangelo often failed to realize his concept. In his *"Atlas" Slave* (Fig. 368), he has given up. The block of stone resists Michelangelo's desire to transform it, as if refusing to release the figure it holds enslaved within. Yet, arguably, the power of Michelangelo's imagination consists in his willingness to leave the figure unrealized. Atlas, condemned to bearing the weight of the world on his shoulders forever as punishment for challenging the Greek gods, is literally held captive in the stone.

Nativity (Fig. 369), by the Taos, New Mexico-born Hispanic sculptor Patrocinio Barela, is carved out of the aromatic juniper tree that grows across the arid landscape of the Southwest. Barela's forms are clearly dependent on the original shape of the juniper itself. The lines of his figures, verging on abstraction, follow the natural contours of the wood and its grain. The group of animals at the far left, for instance, are supported by a natural fork in the branch that is incorporated into the sculpture. The human figures in Barela's work are closely related to *santos*, images of the saints. Those who carve *santos* are known as *santeros*. Both have been an important part of Southwestern Hispanic culture since the seventeenth century, serving to give concrete identity to the abstractions of Catholic religious doctrine. By choosing to work in local wood, Barela ties the local world of the everyday to the universal realm of religion, uniting material reality and the spiritual.

Fig. 368 Michelangelo, *"Atlas" Slave,* c. 1513–1520.
Marble, 9 ft. 2 in. Accademia, Florence. Nimatallah/Art Resource, New York.

Fig. 369 Patrocinio Barela, *Nativity*, c. 1966.
Juniper wood, H. tallest figure 33 in. Private collection.

Fig. 370 *Pair Statue of Mycerinus and His Queen, Kha-merer-nebty II,*
Dynasty IV, c. 2548–2530 B.C.E.
Giza, Valley Temple of Mycerinus. Graywackle, height 54½ in.
Harvard-Museum Expedition. Courtesy Museum of Fine Arts, Boston.

leg, allowing his right leg to relax completely. This youth, then, begins to move—we see him shift his weight to his left foot to take a step in one of the earliest examples of the principle of **ponderation**, or weight shift. The sculpture begins to be animated, to portray not just the figure but its movement. It is as if the stone has begun to come to life. Furthermore, the *Kouros* is much more anatomically correct than his Egyptian forebear. In fact, by the fifth century B.C.E., the practice of medicine had established itself as a respected field of study in Greece, and anatomical investigations were commonplace. At the time that the *Kouros* was sculpted, the body was an object of empirical study, and its parts were understood to be unified in a single, flowing harmony.

This flowing harmony was further developed by Praxiteles, without doubt the most famous sculptor of his day. In works such as

This desire to unify the material and the spiritual worlds has been a goal of sculpture from the earliest times. In Egypt, for example, larger-than-lifesize stone funerary figures (Fig. 370) were carved to bear the **ka,** or individual spirit, of the deceased into the eternity of the afterlife. The permanence of the stone was felt to guarantee the *ka*'s immortality. For the ancient Greeks, only the gods were immortal. What tied the world of the gods to the world of humanity was beauty itself, and the most beautiful thing of all was the perfectly proportioned, usually athletic male form.

Egyptian sculpture was known to the Greeks as early as the seventh century B.C.E., and Greek sculpture is indebted to it, but the Greeks quickly evolved a much more realistic, or *naturalistic* style. In other words, compared with the rigidity of the Egyptian figures, this *Kouros*, or youth (Fig. 371), is both more at ease and more lifelike. Despite the fact that his feet have been lost, we can see that the weight of his body is on his left

Fig. 371 *Kouros* (also known as the *Kritios Boy*), c. 480 B.C.E.
Marble statue, height 36 in. Acropolis Museum, Athens. (Inv. no. 698).

Hermes with the Infant Dionysius (Fig. 372), he shifted the weight of the body even more dynamically, so that Hermes's weight falls on his right foot, raising his right hip. This shift in weight is countered by a turn of the shoulders, so that the figure stands in a sort of S-curve. Known as **contrapposto,** or counter-balance, this pose became a favorite in the Renaissance, as artists strove to achieve greater and greater naturalistic effects.

Such naturalism is perhaps nowhere more fully realized in Greek sculpture than in the grouping *Three Goddesses* (Fig. 373) on the east pediment, or triangular roof gable, of the Parthenon. Though actually freestanding when seen from the ground, as it is displayed today in the British Museum, with the wall of the pediment behind them, Aphrodite, the goddess of beauty, her mother Dione, and Hestia, the goddess of the hearth, would have looked as if they had been carved in high relief. As daylight shifted across the surface of their bodies, it is easy to imagine the goddesses seeming to move beneath the swirling, clinging, almost transparent folds of cloth, as if brought to life by light itself.

Fig. 372 Praxiteles, *Hermes and Dionysus*, c. 330 B.C.E.
Marble, height 7 ft. 1 in. National Archeological Museum, Athens, Greece.
Scala/Art Resource, New York.

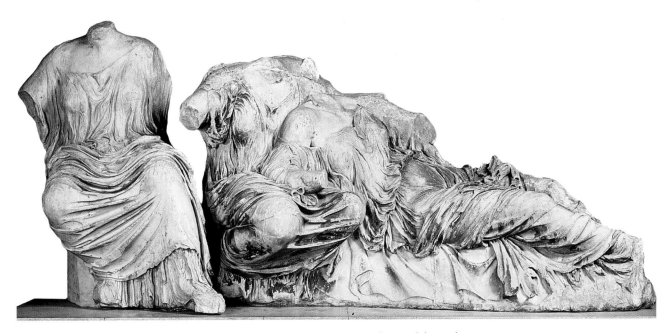

Fig. 373 *Three Goddesses*, from the east pediment of the Parthenon,
Acropolis, Athens, c. 438–432 B.C.E.
Marble, over-lifesize. British Museum, London. London/Bridgeman Art Library.

Jim Sardonis's Reverence

Stone is a symbol of permanence, and of all stones, black granite is one of the hardest and most durable. Thus, in 1988, when sculptor Jim Sardonis chose the stone out of which to carve his tribute to the whale, *Reverence* (Fig. 375), black granite seemed the most suitable medium. Not only was its color close to that of the whales themselves, but the permanence of the stone stood in stark contrast to the species' threatened survival. Sardonis wanted the work to have a positive impact. He wanted it to help raise the national consciousness about the plight of the whale, and he wanted to use the piece as a means to raise funds for both the Environmental Law Foundation and the National Wildlife Federation, organizations that both actively engaged in wildlife conservation efforts.

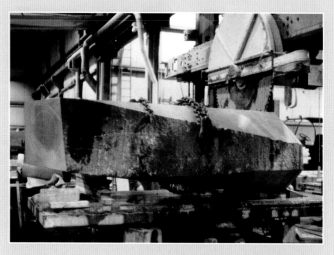

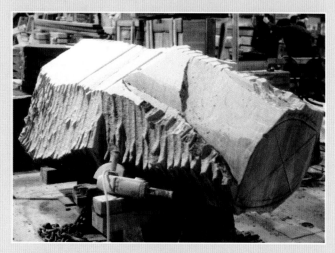

Fig. 374 Jim Sardonis's *Reverence* in progress, 1988–1989.
Photos Courtesy of the artist.

The idea for the sculpture first came to Sardonis in a dream—two whale tales rising out of the sea. When he woke he saw the sculpture as rising out of the land, as if the land was an imaginary ocean surface. And, surprisingly, whales were not unknown to the area. In 1849, while constructing the first railroad between Rutland and Burlington, Vermont, workers unearthed a mysterious set of bones near the town of Charlotte. Buried nearly ten feet below the surface in a thick blue clay, they were ultimately determined to be the bones of a "beluga" or "white" whale, an animal that inhabits arctic and subarctic marine waters. Because Charlotte is far inland (over 150 miles from the nearest ocean), early naturalists were at a loss to explain the bones of a marine whale buried beneath the fields of rural Vermont. But the Charlotte whale was preserved in the sediments of the Champlain Sea, an arm of the ocean that extended into the Champlain Valley for 2,500 years following the retreat of the glaciers 12,500 years ago.

Sculptures of the size that Sardonis envisioned are not easily realized without financial backing. A local developer, who envisioned the piece installed at the entrance of a planned motel and conference center supported the idea, and Sardonis was able to begin. The piece would require more space, and more complicated equipment, than Sardonis had available in

his own studio, so he arranged to work at Granite Importers, an operation in Barre, Vermont, that could move stones weighing twenty-two and fourteen tons respectively and that possessed diamond saws as large as eleven feet for cutting the stones.

Sardonis recognized that it would be easier to carve each tail in two pieces, a tall vertical piece and the horizontal flukes, so he began by having each of the two stones cut in half by the eleven-foot saw. Large saws roughed out the shapes, and then Sardonis began to work on the four individual pieces by hand (see Fig. 374). As a mass, such granite is extremely hard, but in thin slabs, it is relatively easy to break away. The sculptor's technique is to saw the stone, in a series of parallel cuts, down to within two to six inches of the final form, then break each piece out with a hammer. This "cut-and-break" method results in an extremely rough approximation of the final piece that is subsequently realized by means of smaller saws and grinders.

When the pieces were finally assembled, they seemed even larger to Sardonis than he had imagined. But as forms, they were just what he wanted: As a pair, they suggest a relationship that extends beyond themselves to the rest of us. The name of the piece, *Reverence*, sug-

Fig. 375 Jim Sardonis, *Reverence*, 1989.
Beside Interstate 89, south of Burlington, Vt. Photo Courtesy of the artist.

gests not only a respect for nature, but a respect tinged with awe, not only for the largest mammals on the planet, but for the responsibility we all share in protecting all of nature. The whale, as the largest creature, becomes a symbol for all species and for the fragility and interconnection of all life on earth.

The project had taken almost a year, and by mid-summer 1989, the site at the prospective conference center was being prepared. Though the pair of forms were installed, when funding for the conference center fell through, they were moved to a new site, just south of Burlington, Vermont, on Interstate 89, where they overlook the Champlain Valley.

MODELING

When you pick up a handful of clay, you almost instinctively know what to do with it. You smack it with your hand, pull it, squeeze it, bend it, pinch it between your fingers, roll it, slice it with a knife, and shape it. Then you grab another handful, repeat the process, and add it to the first, building a form piece by piece. These are the basic gestures of the addi-

tive process of **modeling**, in which a pliant substance, usually clay, is molded.

Clay, a natural material found worldwide, has been used by artists to make everything from pots to sculptures since the earliest times. Its appeal is largely due to its capacity to be molded into forms that retain their shape. Once formed, the durability of the material can be ensured by firing it—that is, baking it—at

Fig. 376 Robert Arneson, *Case of Bottles*, 1964.
Glazed ceramic (stoneware) and glass, 10½ × 22 × 15 in. Collection: Santa Barbara Museum of Art.
Gift of Mr. and Mrs. Stanley Sheinbaum. © Estate of Robert Arneson/Licensed by VAGA, New York, NY.
Courtesy of George Adams Gallery, NY.

Fig. 377 Tomb of Emperor Shih Huang Ti, 221–206 B.C.E.
Painted ceramic figures, lifesize. Photo: An Keren/PPS. Photo Researchers, Inc.

temperatures normally ranging between 1200 and 2700 degrees Fahrenheit in a **kiln**, or oven, designed especially for the process. This causes it to become hard and waterproof. We call all works made of clay **ceramics**.

Robert Arneson's *Case of Bottles* (Fig. 376) is a ceramic sculpture. The rough handmade quality of Arneson's work, a quality that clay lends itself to especially well, contrasts dramatically with his subject matter, mass-produced consumer products. He underscores this contrast by including in the case of Pepsi a single real 7-Up bottle. He has even allowed the work to crack by firing it too quickly. The piece stands in stark defiance to the assembly line.

Throughout history, the Chinese have made extraordinary ceramic works, including the finest porcelains of fine, pure white clay. We tacitly acknowledge their expertise when we refer to our own "best" dinner plates as "china." But the most massive display of the Chinese mastery of ceramic art was discovered in 1974 by well diggers who accidentally drilled into the tomb of Shih Huang Ti, the first emperor of China (Fig. 377). In 221 B.C.E., Shih Huang Ti united the country under one rule and imposed order, establishing a single code of law and requiring the use of a single language. Under his rule, the Great Wall was built, and construction of his tomb required a force of over 700,000 men. Shih was buried near the central Chinese city of Xian, or Ch-in (the origin of the name China), and his tomb contained more than 6,000 lifesize, and extraordinarily life-like, ceramic figures of soldiers and horses, immortal bodyguards for the emperor. More recently, clerks, scribes, and other court figures have been discovered, as well as a set of magnificent bronze horses and chariots. Compared to Arneson's rough work, the figures created by the ancient Chinese masters are incredibly refined, but between the two of them we can see how versatile clay is as a material.

Fig. 378 Henry Moore, *Draped Reclining Figure*, 1952–1953.
Bronze, 40⅞ × 66⅝ × 34⅛ in. Hirshhorn Museum and Sculpture Garden, Smithsonian Institution;
Gift of Joseph H. Hirshhorn, 1966. Reproduced by permission of the Henry Moore Foundation.

CASTING

When the sculptor Henry Moore visited Greece in 1951, he was immediately enthralled by the use of drapery in classical sculpture. "Drapery can emphasize the tension in a figure," he wrote, "For where the form pushes outwards such as on the shoulders, the thighs, the breasts, etc., it can be pulled tight across the form (almost like a bandage)." Moore's *Draped Reclining Figure* (Fig. 378) was inspired by what he saw in Greece. "Although static," he said, "this figure is not meant to be in slack repose, but, as it were, alerted."

Moore's work is cast in bronze, a metal made by mixing copper and tin. **Casting** is an invention of the Bronze Age (beginning approximately 2500 B.C.E.), when it was first utilized to make various utensils by simply pouring liquid bronze into open-faced molds. The technology is not much more complicated than that of a gelatin mold. You pour gelatin into the mold

Fig. 379 *Girl Running*, Greece, probably Sparta, c. 500 B.C.E.
Height 4½ in. British Museum, London. Marburg/Art Resource, New York.

and let it harden. When you remove the gelatin, it is shaped like the inside of the mold. Small figures made of bronze are similarly produced by making a simple mold of an original modeled form, filling the mold with bronze, and then breaking the mold away. The early Greek *Girl Running* (Fig. 379) is a small, solid, cast-bronze figure almost certainly made by this most straightforward of bronze-casting methods.

As the example of gelatin demonstrates, bronze is not the only material that can be cast. In the kingdom of Benin, located in southern Nigeria, on the coastal plain west of the Niger River, brass casting reached a level of extraordinary accomplishment as early as the late fourteenth century. Brass, which is a compound composed of copper and zinc, is similar to bronze but contains less copper and is yellower in color. When, after 1475, the people of Benin began to trade with the Portuguese for copper and brass, an explosion of brass casting

occurred. Shown below is a brass head of an Oba dating from the eighteenth century (Fig. 380). The Oba is the king of a dynasty. When an Oba dies, one of the first duties of the new Oba is to establish an altar commemorating his father and to decorate it with newly cast brass heads. The heads are not portraits. Rather, they are generalized images that emphasize the king's coral-bead crown and high bead collar, the symbols of his authority. The head has a special significance in Benin ritual. According to British anthropologist R. E. Bradbury, the head "symbolizes life and behavior in this world, the capacity to organize one's actions in such a way as to survive and prosper. It is one's Head that 'leads one through life.' . . . On a man's Head depends not only his own wellbeing but that of his wives and children. . . . At the state level, the welfare of the people as a whole depends on the Oba's Head which is the object of worship at the main event of the state ritual year."

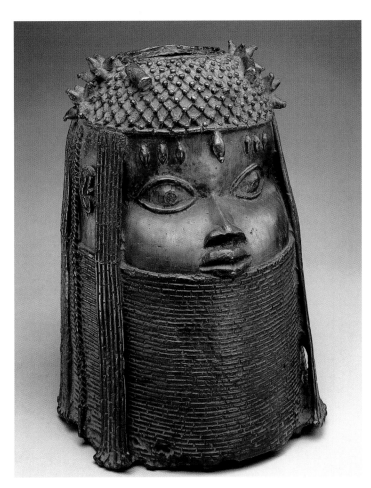

Fig. 380 African, Nigeria, Edo; Court of Benin, *Head of an Oba*, **18th century.**
Brass, iron, Height 13⅛ in. The Metropolitan Museum of Art, Gift of Mr. and Mrs. Klaus G. Perls, 1991.
(1991.17.2) Photograph © 1991 The Metropolitan Museum of Art.

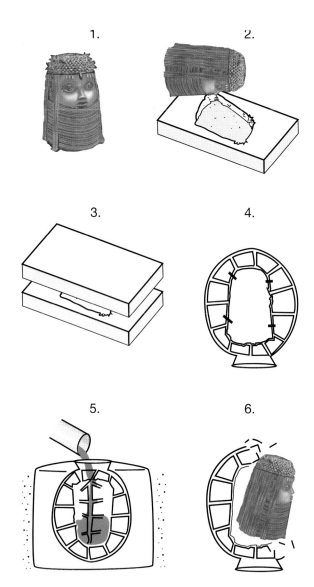

1.

2.

3.

4.

5.

6.

Fig. 381 The Lost-Wax Casting Process

A positive model (1), often created with clay, is used to make a negative mold (2). The mold is coated with wax, the wax shell is filled with a cool fireclay, and the mold is removed (3). Metal rods, to hold the shell in place, and wax rods, to vent the mold, are then added (4). The whole is placed in sand, and the wax is burned out (5). Molten bronze is poured in where the wax used to be. When the bronze has hardened, the whole is removed from the sand and the rods and vents are removed (6).

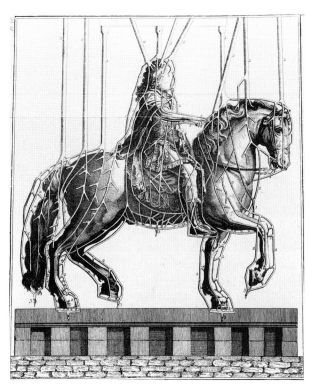

Fig. 382 *Casting a Large Equestrian Statue, I.*
Denis Diderot, *Recuil de Planches, sur le Sciences, les Arts liberaux, et les arts mechaniques*, Paris, 1767–1772 , Vol 8, Plate 4.
(Arents Coll. S0713) Arents Collections, The New York Public Library, Astor, Lenox and Tilden Foundations.

The Oba head is an example of one of the most enduring, and one of the most complicated processes for casting metal. The **lost-wax** method, also known as *cire-perdue*, was perfected by the Greeks if not actually invented by them. Because metal is both expensive and heavy, a technique had to be developed to create hollow images rather than solid ones. The diagram to the left (Fig. 381) schematizes the process in simplified terms, while the illustrations of the method on these two pages and the following (Figs. 382–384) give some indication of its actual complexity. From the *Encyclopedia of Science, the Liberal Arts, and the Mechanical Arts*, compiled in the eighteenth century by the French encyclopedist, art critic, dramatist, and writer Denis Diderot, these latter images depict the casting process of a mounted figure of the French king, Louis XIV, which was actually erected in Paris in 1699.

In the lost-wax method, the sculpture is first modeled in some soft, pliable material, such as clay, wax, or plaster in a putty state. This model looks just like the finished sculpture, but, of course, the material of which it is

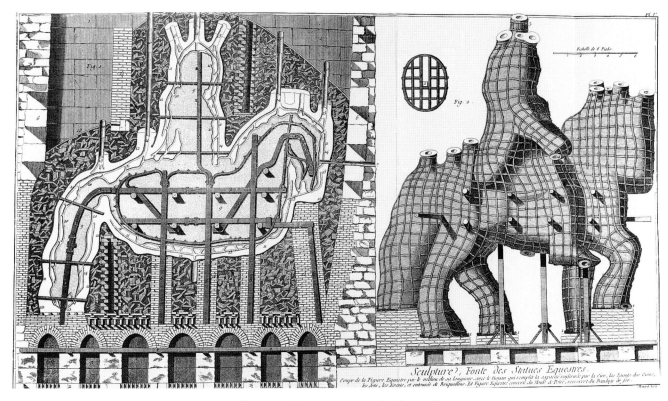

Fig. 383 *Casting a Large Equestrian Statue, II.*
Denis Diderot's *Recuil de Planches, sur le Sciences, les Arts liberaux, et les arts mechaniques*, Paris, 1767–1772 , Vol 8, Plate 5.
(Arents Coll. S0713) Arents Collections, The New York Public Library, Astor, Lenox and Tilden Foundations.

composed is nowhere near as durable as metal. As the process proceeds, this core is at least theoretically disposable, though many sculptors, including Auguste Rodin (see Fig. 259), retained them for possible re-casting.

A mold is then made of the model (today, synthetic rubber is most commonly used to make this mold), and when it is removed, we are left with a *negative* impression of the original—in other words, something like a gelatin mold of the object. Molten wax is then poured or brushed into this impression to the thickness desired for the final sculpture—about an eighth of an inch. The space inside this wax lining is filled with an **investment**—a mixture of water, plaster, and powder made from ground-up pottery. The mold is then removed, and we are left with a wax casting, identical to the original model, that is filled with the investment material. Rods of wax are then applied to the wax casting. They stick out from it like giant hairs. They will carry off melted wax during baking and will eventually provide channels through which the molten bronze will be poured. Figure 382 depicts the

wax model of the statue of Louis XIV surrounded by a latticework of wax channels. Note how the channels descend from the top, where the bronze will eventually be poured. The statue's surface is a thin layer of wax supported by the investment. Bronze pins have been driven through the wax into the investment in order to hold investment, casting, and channels in place.

This wax cast, with its wax channels, is now ready to be covered with an outer mold of investment. In the left panel of Figure 383, we see a cutaway of the wax cast surrounded by the investment. When this outer mold cures, it is then baked in a kiln at a temperature of 1500° F, with the wax replica inside it. The wax rods melt, providing channels for the rest of the wax to run out as well—hence the term *lost-wax*. A thin space where the wax once was now lies empty between the inner core and the outer mold, the separation maintained by the bronze pins. The right hand side of Figure 383 shows the burned-out mold ready to be lowered into the casting pit, its exterior reinforced by iron bands.

Fig. 384 *Casting a Large Equestrian Statue, III*.
Denis Diderot's *Recuil de Planches, sur le Sciences, les Arts liberaux, et les arts mechaniques*, Paris, 1767–1772, Vol 8, Plates 4 and 5.
(Arents Coll. S0713) Arents Collections, The New York Public Library, Astor, Lenox and Tilden Foundations.

Fig. 385 Henry Moore, *Draped Torso*, 1953.
Bronze, height 35 in. Ferens Art Gallery: Hull City Museums and Art Galleries, Hull, England.

In Figure 384, the bronze pour is about to take place. The casting pit is located beneath the foundry floor, where the mold is encased in sand. The large box in the background is the furnace, where the bronze is melted. Molten bronze is poured into the *casting gate*, the large opening in the top of the mold directly in front of the furnace, filling the cavity where the wax once was. Hence, many people refer to casting as a **replacement** method—bronze replaces wax. When the bronze has cooled, the mold and the investment are removed, and we are left with a bronze replica of the wax form complete with the latticework of rods. The rods are cut from the bronze cast and the surface smoothed and finished.

Large pieces such as Moore's *Draped Reclining Figure* (Fig. 378) must be cast in several pieces and then welded together. Bronze is so soft and malleable that the individual pieces can easily be joined in either of two ways: pounded together with a hammer, the procedure used in Greek times, or welded, the more usual procedure today. Finally, the shell is reassembled to form a perfect hollow replica of the original model. In fact, when Moore saw the torso part of his *Draped Reclining Figure*, cast separately from the rest, he was struck by what he called "its completeness and impressiveness just as a thing in its own right." Thus, after the *Draped Reclining Figure* was completed, he had a wax version of the figure's torso made, and he reworked it, alternately modeling and carving it until it looked appropriately poised in an upright position. The resulting work, *Draped Torso* (Fig. 385), looks like a piece of medieval body armor, and it is, in fact, possible that the process of making body armor might have suggested to the Greeks that the living human body could be used to create molds for cast bronze sculptures, such as the magnificent Zeus we described in Chapter 5 (Fig. 118).

Contemporary sculptor Tom Morandi does, in fact, use living humans to cast his aluminum sculptures (Fig. 386). At the Oregon State Department of Human Resources in Salem, Oregon, he asked for volunteers from among the department's employees to submit themselves to the somewhat claustrophobic process of having their entire bodies, including clothing, serve as the original cores for the casts. Molds

were literally fitted to the sub-jects' faces, hands, and clothed bodies. Because they are cast from aluminum and are thus very light-weight, Morandi was able to hang the sculptures from pillars at the second-story level of the building's lobby. They serve to elevate everyday work and everyday people to the con-dition of art. Morandi's sculp-tures both dignify the work of the Department of Human Resources, and honor it.

ASSEMBLAGE

Many of the same thematic concerns that we saw in Michelangelo's *"Atlas" Slave* (Fig. 368) are at work in David Hammons's *Spade with Chains* (Fig. 387). Both specifically address the issue of enslave-ment. By means of **assemblage**—creating a sculpture by compiling objects taken from the environment—Hammons has combined "found" materials, a common spade and a set of chains, into a face that recalls an African mask. The piece represents a wealth of trans-formations. Just as Michelangelo could see in the raw block of stone the figure within, Ham-mons can see, in the most common materials of everyday life, the figures of his world. This transformation of common materials into art is a defining characteristic of assemblage. As a process, assemblage evokes the myth of the phoenix, the bird that, consumed by fire, is reborn out of its own ashes. That rebirth, or rejuvenation, is also expressed at a cultural level in Hammons's work. The transformation of the materials of slave labor—the spade and the chain—into a mask is an affirmation of the American slave's African heritage. The richness of this transformation is embodied in the dou-ble meaning of the word "spade"—at once a racist epithet and the appropriate name of the object in question. But faced with this image, it is no longer possible, in the words of a com-mon cliché, to "call a spade a spade." The piece literally liberates us from that simple and reductive possibility.

Fig. 386 Tom Morandi, *Work*, 1995.
Three of eleven figures, cast aluminum, lifesize.
Human Resources Building, Salem, Oregon. Photo Courtesy of the artist.

Fig. 387 David Hammons, *Spade with Chains*, 1973.
Spade, chains, 24 × 10 × 5 in.
Courtesy Jack Tilton Gallery, New York. Photo: Dawoud Bey

Fig. 388 H. C. Westermann, *Memorial to the Idea of Man If He Was an Idea*, 1958. Two views, door opened and closed.
Pine, bottle caps, cast-tin toys, glass, metal, brass, ebony, and enamel, 56½ × 38 × 14¼ in. Museum of Contemporary Art, Chicago,
Gift of Susan and Lewis Manilow (1993.34). © MCA, Chicago 1993.34. Estate of H. C. Westermann/Licensed by VAGA, New York.

To the degree that they are composed of separately cast pieces later welded together, works like Moore's *Draped Reclining Figure* (Fig. 378) and Morandi's *Work* (Fig. 386), might themselves seem to be assemblages. But it is better to think of them as *constructions*— works in which the artist forms all of the parts that are put together rather than finding the parts in the world. On the other hand, H. C. Westermann's *Memorial to the Idea of Man If He Was an Idea* (Fig. 388) is assembled from a number of found parts, including bottle caps and cast-tin toys, in addition to its carefully crafted wooden construction. Westermann is an artist whose work comments constantly on Western "values," especially those that have led to such conflicts as the Korean and Vietnam Wars, the first of which he fought in. The figure's war-like nature is emphasized by the fortress that forms the top of its head, and its

"resemblance" to the United States is underscored by its red, white, and blue color scheme. Westermann's "Idea of Man" is also a recognizable image of the one-eyed cyclops Polyphemus of Homeric myth, the giant who captures Odysseus and his men on their way home from the notoriously futile Trojan War. In order to escape Polyphemus, who feasts on humans (note the figure gesturing helplessly in the cyclops's mouth), Odysseus and his men blind him, then escape by hanging from the underbellies of sheep as Polyphemus rages after them. The two toys inside Westermann's "war chest" re-enact this, a cast-tin headless baseball player swinging his bat at a wooden trapeze artist hanging from the top of the interior space. In the bottom half of the "war chest," a black Death Ship sinks into a sea of bottle caps, symbolizing the economic forces that lead to war. Even Westermann's own initials,

inscribed in bottlecaps on the inside of the door, serve less as a signature than an ironic commentary on the destructive role of the ego in realizing any "idea of man."

Another assemblage, Clyde Connell's *Swamp Ritual* (Fig. 389), is fabricated of parts from rusted-out tractors and machines, discarded building materials and logs, and papier-mâché made from the classified sections of the *Shreveport Journal and Times*. The use of papier-mâché developed out of Connell's desire to find a material capable of binding the wooden and iron elements of her work. By soaking the newsprint in hot water until its ink began to turn it a uniform gray, and then mixing it with Elmer's Glue, she was able to create a claylike material possessing, when dry, the texture of wasps' nests or rough gray stone.

Connell developed her method of working very slowly, over the course of about a decade, beginning in 1959 when, at age fifty-eight, she moved to a small cabin on Lake Bistineau, seventeen miles southeast of Shreveport, Louisiana. She was totally isolated. "Nobody is going to look at these sculptures," she thought. "Nobody was coming here. It was just for me because I wanted to do it. . . . I said to myself, 'I'm just going to start to make sculpture because I think it would be great if there were sculptures here under the trees.' "

In the late 1960s, Connell, by then in her late sixties, discovered the work of another assembler of nontraditional materials, the much younger artist Eva Hesse, who died at age thirty-four in 1970 (see the Works in Progress spread on the following two pages). Hesse's work is marked by its use of the most outlandish materials—rope, latex, rubberized cheesecloth, fiberglass, and cheap synthetic fabrics—which she used in strangely appealing, even elegant, assemblages. Connell particularly admired Hesse's desire to make art in the face of all odds. She sensed in Hesse's work an almost obstinate insistence on *being:* "No matter what it was," she said about Hesse's work, "it looked like it had life in it." Connell wanted to capture this sense of life in her own sculpture—what she calls Hesse's "deep quality." In *Swamp Ritual,* the middle of Connell's figure is hollowed out, creating a cavity filled with stones. Rather than thinking of this space in sexual terms—as a womb, for instance—it is,

Fig. 389 Clyde Connell, *Swamp Ritual*, 1972.
Mixed media, 81 × 24 × 22 in.
Collection: Tyler Museum of Art, Tyler, Texas.
A gift from Atlantic Richfield Company.

in Connell's words, a "ritual space" in which she might deposit small objects from nature. "I began to think about putting things in there, of having a gathering place, not for mementos but for things you wanted to save. The ritual place is an inner sanctuary. . . . Everybody has this interior space."

Eva Hesse's Contingent

Fig. 390 Eva Hesse, *Study for Contingent*, 1969.
Pencil on paper, 8¼ × 11 in. ©Estate of Eva Hesse.
Courtesy The Robert Miller Gallery, New York. Private Collection.
Photo: Afira Hagihara.

Fig. 391 Eva Hesse, *Test Piece for Contingent*, 1969.
Latex over cheesecloth, 144 × 44 in.
Collection: Naomi Spector and Stephen Antonakos Private Collection.
©Estate of Eva Hesse. Courtesy The Robert Miller Gallery, New York.

Between September 1965 and her death in May 1970, Eva Hesse completed over 70 sculptural works. *Contingent* (Fig. 392) is one of the last four pieces she made. For most of the last two years

of her life she was ill, suffering from the effects of a brain tumor that was not diagnosed until April 1969. Clyde Connell's admiration for her work is partly a response to Hesse's heroic insistence on making art in the face of her illness and, to use Connell's word, infusing it with "life." But it is also a result of Hesse's feminist sensibilities, for Hesse was a feminist long before the Women's Movement of the early 1970s. "A woman is side-tracked by all her feminine roles," she wrote in 1965.

"She's at a disadvantage from the beginning. . . . She also lacks the conviction that she has the 'right' to achievement. . . . [But] we want to achieve something meaningful and to feel our involvements make of us valuable thinking persons." *Contingent* embodies Hesse's personal strength.

Hesse's first ideas for the piece took the form of drawing (Fig. 390). "I always did drawings," Hesse said, "but they were always separate from the sculpture. . . . They were

just sketches. . . . [A drawing] is just a quickie to develop it in the process rather than working out a whole model in small and following it—that doesn't interest me." In the drawing, it appears as if Hesse initially conceived of the piece as hanging against the wall, but by the time she was fabricating it, she had turned it sideways, as her "test piece" (Fig. 391) shows.

The final work consists of eight cheesecloth and fiberglass sheets that catch light in different ways, producing different colors, an effect almost impossible to capture in a photograph. The sheets seem at once to hang ponderously and to float effortlessly away. Hesse's catalogue statement for the first exhibition of the piece at Finch College in the fall of 1969 speaks eloquently of her thinking about the work:

Began somewhere in November-December, 1968.
Worked.
Collapsed April 6, 1969. I have been very ill.
Statement.
Resuming work on piece,
have one complete from back then. . . .
Piece is in many parts.
Each in itself is a complete statement. . . .
textures, coarse, rough, changing.

see through, not see through, consistent, inconsistent.
they are tight and formal but very ethereal. sensitive. fragile. . . .
not painting, not sculpture. it's there though. . . .
non, nothing,
everything, but of another kind, vision, sort. . . .
I have learned anything is possible. I know that.
that vision or concept will come through total risk,
freedom, discipline.
I will do it.

Fig. 392 Eva Hesse, *Contingent*, 1969.
Reinforced fiberglass and latex over cheesecloth, height each of 8 units, 114–118 in.; width each of 8 units, 36–48 in.
Collection: National Gallery of Australia, Canberra. ©Estate of Eva Hesse. Courtesy The Robert Miller Gallery, New York.

Fig. 393 Nancy Holt, *Sun Tunnels*, Great Basin Desert, Utah, 1973–1976.
Four tunnels, each 18 ft. long × 9 ft. 4 in. diameter; each axis 86 ft. long.
Nancy Holt/Licensed by VAGA, New York, NY/Courtesy John Weber Gallery, New York.

Fig. 394 Nancy Holt, *Sun Tunnels*, Great Basin Desert, Utah, 1973–1976.
Four tunnels, each 18 ft. long × 9 ft. 4 in. diameter; each axis 86 ft. long.
Nancy Holt/Licensed by VAGA, New York, NY/
Courtesy John Weber Gallery, New York.

EARTHWORKS

The larger a work, the more our visual experience of it depends on multiple points of view. Since the late 1960s, one of the focuses of modern sculpture has been the creation of large-scale out-of-doors environments, generally referred to as **earthworks**. We have already seen several examples. Both Christo's *Umbrellas* (Figs. 1 and 2) and Robert Smithson's *Spiral Jetty* (Fig. 6) are classic examples of the medium, as is Walter de Maria's *Las Vegas Piece* (Fig. 293). As the lines drawn on the landscape in Nazca, Peru, indicate, (Fig. 294) humans have set out to sculpt the landscape, and to impose sculpture into the landscape, since the earliest times.

Nancy Holt's *Sun Tunnels* (Figs. 393 and 394) consists of four twenty-two-ton concrete tunnels aligned with the rising and setting of the sun during the summer and winter sol-

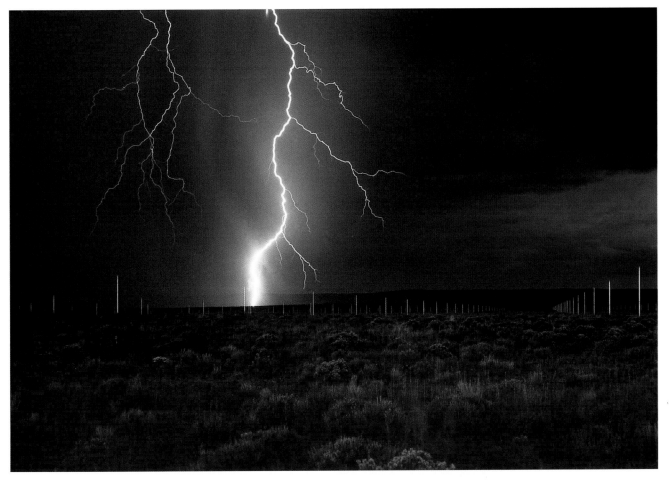

Fig. 395 Walter de Maria, *Lightning Field*, near Quemado, New Mexico, 1977.
Stainless-steel poles, average H. 20 ft. 7½ in.; overall dimensions 5,280 × 3,300 ft.
All reproduction rights reserved: ©Dia Center for the Arts. Photo: John Cliett.

stices. The holes cut into the walls of the tunnels duplicate the arrangement of the stars in four constellations—Draco, Perseus, Columba, and Capricorn—and the size of each hole is relative to the magnitude of each star. The work is designed to be experienced on site, imparting to viewers a sense of their own relation to the cosmos. "Only 10 miles south of *Sun Tunnels*," Holt writes, "are the Bonneville Salt Flats, one of the few areas in the world where you can actually see the curvature of the earth. Being part of that kind of landscape . . . evokes a sense of being on this planet, rotating in space, in universal time."

In an isolated region near the remote town of Quemado, New Mexico, Walter de Maria has created an environment entitled *Lightning Field* (Fig. 395). Consisting of 400 steel poles laid out in a grid over nearly one square mile of desert, the work is activated between three and thirty times a year by thunderstorms that cross the region. At these times, lightning jumps from pole to pole across the grid in a stunning display of pyrotechnics, but the site is equally compelling even in the clearest weather.

Visitors to the *Lightning Field* are met in Quemado and driven to the site, where they are left alone for one or two nights in a comfortable cabin at its edge. De Maria wants visitors to his environment to experience the space in relative isolation and silence, to view it over a number of hours, to see the stainless-steel poles change as the light and weather change, to move in and out of the grid at their leisure. He wants them to experience the infinite, to have some sense, posed in the vastness around them, of limitless freedom and time without end.

When artists manipulate the landscape at the scale of De Maria, it becomes clear that their work has much in common with landscape design in general, from golf courses to parks to landfills. Indeed, part of the power of their work consists in the relationship they establish and the tension they embody between the natural world and civilization. A series of interventions conceived by sculptor Karen McCoy for Stone Quarry Hill Art Park in Cazenovia, New York, including the grid made of arrowhead leaf plants in a small pond, illustrated here (Figs. 396 and 397), underscores this. The work was guided by a concern for land use and was designed to respond to the concerns of local citizens who felt their rural habitat was fast becoming victim to the development and expansion of nearby Syracuse, New York. Thus McCoy's grid purposefully evokes the orderly and regimented forces of civilization, from the fence rows of early white settlers to the street plans of modern suburban developers, but it represents these forces benignly. The softness and fragility of the grid's flowers, rising delicately from the quiet pond, seem to argue that the acts of man can work at one with nature, rather than in opposition to it.

Figs. 396 and 397 Karen McCoy, *Considering Mother's Mantle*, Project for Stone Quarry Hill Art Park, Cazenovia, NY, 1992.
View of gridded pond made by transplanting arrowhead leaf plants, 40 × 50 ft., and detail (bottom). Photos Courtesy of the artist.

THE CRITICAL PROCESS
Thinking About Sculpture

Anthony Caro's *Early One Morning* (Figs. 398 and 399) is made of sheet metal, I-beams, pipe, and bolts. Through the materials of which it is made, the materials of contemporary industrial construction, it boldly declares itself separate from the natural world, the exact opposite of a work like Karen McCoy's. What other elements contribute to this feeling? Consider, for one thing, that Caro did not think of this work in any context other than an interior room. "I prefer to think of my sculptures indoors," he says. Why would *Early One Morning* lose much of its force outside, in a sculpture garden, for instance? Granted how different it is from McCoy's piece, what does it have in common with her work? What do you make of the title? Think particularly about the experience of viewing it. You might find it

Figs. 398 and 399 Anthony Caro, *Early One Morning*, 1962 (two views).
Painted metal, 114 × 244 × 132 in. Tate Gallery, London.
Art Resource, New York. © Anthony Caro/Licensed by VAGA, New York, NY.

useful as well to compare it to David Smith's *Blackburn: Song of the Irish Blacksmith* (Figs. 366 and 367). (In the early sixties, when this piece was made, Caro was deeply influenced by Smith.) How would you describe each of the two views of the piece as depicted here? Not only is the work an assemblage of disparate elements, but our visual experience of it is itself an assemblage, a construction of multiple points of view. Still, it is not choatic. What unifies it?

For all that it shares with Smith's *Blackburn*, Caro's *Early One Morning* is fundamentally different. Smith's work is figurative, or at least anthropomorhic—that is, it is human-like. How would you describe Caro's? What is the relation of each piece to the ground? Caro's work does not rest on a base, while Smith's does. What difference does this make? Think of the base as a kind of altar, upon which the sculpture rests. By losing it, what does Caro gain?

CHAPTER 14

OTHER THREE-DIMENSIONAL MEDIA

CRAFT MEDIA
Ceramics

WORKS IN PROGRESS
Peter Voulkos's *X-Neck*

Glass
Fiber
Metal
Wood

MIXED MEDIA

Collage

WORKS IN PROGRESS
Hannah Höch's *Cut with the Kitchen Knife*

Installation
Performance Art

WORKS IN PROGRESS
Goat Island's *How Dear to Me the Hour When Daylight Dies*

THE CRITICAL PROCESS
Thinking about Other Three-Dimensional Media

We ended our consideration of two-dimensional media in Chapter 12 with Lynda Benglis's *Contraband* (Fig. 359), a painting that spills off the wall and escapes across the floor. In a similar way, Marcia Gygli King's *Springs Upstate* (Fig. 400), travels even further into three-dimensional space. *Springs Upstate* is half

Fig. 400 Marcia Gygli King, *Springs Upstate*, 1990–1992.
Oil on canvas, mixed media frame, 6 ft. × 9 ft. × 10 ft. 6 in. painting, 9 ft. × 5 ft. × 7 in. scuptural projection.
Courtesy of the artist. Photo: Allan Finkelman.

painting, half sculpture. The stream and boulders on the floor and the frame of the painting itself, are created with carved styrofoam that is covered with epoxy and fiberglass. King's painting leaves two-dimensional space behind and embraces three dimensions. It moves off the wall and into our space. As we will see in this chapter, this movement of art into the room, and then out of the room and into our lives, is one of the defining characteristics of many contemporary art forms, from collage to performance art.

But to begin this chapter, we turn to a discussion of the many so-called "craft" media—ceramics, glass, and fiber in particular—which have traditionally been distinguished from the fine arts because they are employed to make functional objects, from the utensils we eat with to the clothes we wear. In the hands of a skilled artist, however, these media can be employed to make objects that are not only of great beauty but that must be appreciated as sculptures in their own right.

Fig. 401 Pablo Picasso (1881–1973), *Meed.*
Museum of Fine Arts, Moscow, Russia. Photo © SuperStock, Inc.
© 2003 Estate of Pablo Picasso/Artists Rights Society (ARS), New York.

CRAFT MEDIA

In the previous chapter, we considered the traditional methods of making sculpture. But on more than one occasion, we have discussed works that take advantage of media not associated so much with the fine arts as with the traditional crafts. Robert Arneson's ceramic *Case of Bottles* (Fig. 376) is a case in point, and so is Eva Hesse's fiber piece *Contingent* (Fig. 392). The line between the arts and the crafts is a fine one. **Craft** refers to expert handiwork, or work done by hand. And yet artists are expert with their hands. How is it that we don't call their work "craft" as well? Indeed, many artists would feel insulted if you complimented their work as being finely crafted. These artists feel that a craft must be

functional. That is, a craft object is something that can be used to satisfy our everyday needs. But the distinction between craft and artwork is not that clear-cut. For example, even if you poured wine out of Picasso's ceramic pitcher (Fig. 401), you would never call it craft. It is a work of art. Perhaps the only meaningful distinction we can draw between art and craft is this: if a work is primarily made to be used, it is craft, but if it is primarily made to be seen, it is art. However, the artist's intention may be irrelevant. If you buy an object because you enjoy looking at it, then whatever its usefulness, it is, for you at least, a work of art.

Ceramics

As we saw in the previous chapter, **ceramics** are objects that are formed out of clay and then hardened by **firing**, or baking in a very hot oven, called a kiln. Ceramic objects are generally either flat and relief-like (think of a plate or a square of tile), or hollow, like cast sculpture (think of a pitcher). Unlike metal casts, the hollowness of ceramic objects is not a requirement of weight or cost as much as it is of utility (ceramic objects are made to hold things), and of the firing process itself. Solid clay pieces tend to hold moisture deep inside where it cannot easily evaporate, and during firing, as this moisture becomes superheated, it can cause the object to explode. In order to make hollow ceramic objects, a number of techniques have been developed.

Some types of ceramics are actually cast, like bronze or brass. Liquid clay is poured into a mold, fired, and hardened. As we will see in Chapter 17, "Design," mass-manufactured earthenware dishes, such as most of us eat on daily, are produced in this way. But most ceramic objects are created by one of three other means—*slab construction, coiling,* or *throwing* on a potter's wheel. Pieces made by any one of these techniques are then **glazed**—painted with a material that turns glassy when heated—and fired.

Koetsu's tea bowl named *Amagumo (Rain Clouds)* (Fig. 402) is an example of **slab construction.** Clay is rolled out flat, rather like a pie crust, and then shaped by hand. The tea bowl has a special place in the Japanese tea cer-

emony, the Way of the Tea. In small tea rooms specifically designed for the purpose and often decorated with calligraphy on hanging scrolls or screens, the guest was invited to leave the concerns of the daily world behind and enter a timeless world of ease, harmony, and mutual respect. Koetsu was an accomplished tea master. At each tea ceremony, the master would assemble a variety of different objects and utensils used to make tea, together with a collection of painting and calligraphy. Through this ensemble the master expressed his artistic sensibility, a sensibility shared with his guest, so that guest and host collaborated to make the ceremony itself a work of art.

This tea bowl, shaped perfectly to fit the hand, was made in the early seventeenth century at one of the "Six Ancient Kilns," the traditional centers of wood-fired ceramics in Japan. These early kilns, known as *anagama*, were narrow, underground tunnels, dug out following the contour of a hillside. The pit was filled with pottery, and heat moved through the tunnel from the firebox at the lower end to the chimney at the upper end. The firing would take an average of seven days, during which temperatures would reach 2500°F. The coloration that distinguished these pieces results from wood ash in the kiln melting and fusing into glass on the pottery. The simplicity of these wood-fired pieces appealed to the devotee of the tea ceremony, and often tea masters

such as Koetsu named their pieces after the accidental effects of coloration achieved in firing. The most prized effect is a scorch, or *koge*, when the firing has oxidized the natural glass glaze completely, leaving only a gray-black area. Such a *koge* forms the "rain clouds" on Koetsu's tea bowl.

María Martinez's black jar (Fig. 403) is an example of a second technique often used in ceramic construction, **coiling**, in which the clay is rolled out in long, ropelike strands that are coiled on top of each other and then smoothed. This pot is a specific example of a technique developed by María and her husband Julián in about 1919. The red clay pot is smothered in a dung-fueled bonfire during firing and then painted with black-on-black designs.

Fig. 402 (left) Hon'ami Koetsu (1558–1637),
Tea Bowl Named Amagumo,
Momoyama or early Edo period.
3½ × 4⁹⁄₁₀ in.
Mitsui Bunko, Museum, Tokyo.

Fig. 403 (above) Santana and Adam Martinez (Native American),
Jar, San Ildefonso Pueblo, New Mexico, c. 1939.
Blackware, 11⅛ × 13 in. (H. × D.).
The National Museum of Women in the Arts.
Gift of Wallace and Wilhelmina Holladay.

Fig. 404 Pottery Wheel-Throwing. *Craft and Art of Clay.*
Courtesy of Lawrence King Publishing Ltd.

Fig. 405 Euthymides, *Revelers,* Vulci, c. 510–500 B.C.E.
H. approx. 24 in. Staatliche Antikensammulungen, Munich, Germany.

Native American cultures relied on coiling techniques, whereas peoples of most other parts of the world used the potter's wheel. Egyptian potters employed a wheel by about 4000 B.C.E., and their basic invention has remained in use ever since. The ancient Greeks became particularly skillful with the process. The **potter's wheel** is a flat disk attached to a flywheel below it, which is kicked by the potter (or driven by electricity in modern times), thus making the upper disk turn. A slab of clay, from which air pockets have been removed by slamming it against a hard surface, is centered on the wheel (see Fig. 404). As the slab turns, the potter pinches the clay between fingers and thumb, sometimes utilizing both hands at once, and pulls it upward in a round, symmetrical shape, making it wider or narrower as the form demands and shaping both the inside and outside simultaneously. The most skilled potters apply even pressure on all sides of the pot as it is thrown. The Greek amphora, or two-handled vase, known as *Revelers* (Fig. 405), is a thrown pot designed to store provisions such as wine, oil, or honey. An inscription on its bottom taunts the maker's chief competitor— "Euphronios never did anything like it," it reads—indicating the growing self-consciousness of the Greek artist, the sense that he was producing not just a useful object but a thing of beauty.

There are three basic types of ceramics. **Earthenware**, made of porous clay and fired at low temperatures, must be glazed if it is to hold liquid. **Stoneware** is impermeable to water because it is fired at high temperatures, and it is commonly used for dinnerware today. Finally, **porcelain**, fired at the highest temperatures of all, is a smooth-textured clay that becomes virtually transluscent and extremely glossy in finish during firing. The first true porcelain was made in China during the T'ang Dynasty (C.E. 618–906). By the time of the Ming Dynasty (1368–1644), the official kilns at Chingtehchen had become a huge industrial center, producing ceramics for export. Just as the Greek artist painted his revelers on the red-orange amphora, Chinese artists painted elaborate designs onto the glazed surface of the the porcelain. Originally, Islam was the primary market for the distinctive blue-and-white patterns of Ming porcelain (Fig. 406), but as trade with Europe increased, so too did Europe's demand for Ming design.

The export trade flourished even after the Manchus overran China in 1644, establishing the Ch'ing Dynasty, which lasted into the twentieth century. This had a profound effect

Fig. 407 Vase, Qing Dynasty, Kangxi period, late 17th–early 18th century.
Vase decorated with birds among flowering branches.
Porcelain painted in overglaze *Famille verte* enamels and gilt, height 18 in.
The Metropolitan Museum of Art, New York. Bequest of John D. Rockefeller, Jr., 1960.
(61.200.66). Photograph © 1980 The Metropolitan Museum of Art.

Fig. 406 Plate, Ming Dynasty, late 16th–early 17th century,
Kraakporselein, probably from the Ching-te Chen kilns.
Porcelain, painted in underglaze blue. D. 14¼ in.
The Metropolitan Museum of Art, New York. Rogers Fund, 1916 (16.13).
Photograph © 1980 The Metropolitan Museum of Art.

on Chinese design. The Chingtehchen potters quickly began to make two grades of ware, one for export and a finer "Chinese taste" ware for internal, royal use. They also became dedicated to satisfying European taste. As a result, consistency and standardization of product were of chief concern.

One of the more beautiful Ch'ing Dynasty porcelains is this remarkable *famille verte* vase (Fig. 407), so-called because the palette of enamel paints used is marked by its several distinctive shades of green. Here birds, rocks, and flowers create a sense of the vibrancy of nature itself.

By the end of the eighteenth century, huge workshops dominated the Chinese porcelain industry, and by the middle of the nineteenth century, the demands of mass production for trade, throughout China, led to the same lack of creative vitality so common in Western mass manufacturing.

Peter Voulkos's X-Neck

Fig. 408 Peter Voulkos, *Untitled*, 1988.
Monotype, 50 × 35 in. Collection: Deborah Scripps, San Francisco.
Photo: Schopplein Studio. © Peter Voulkos.

Fig. 409 Peter Voulkos, *Pyramid of the Amphora*, 1985.
Paper collage with pushpins, 52 × 37 in.
Collection: Bruce C. and Monica Reeves, Alameda, CA.
Photo: Schopplein Studio. © Peter Voulkos.

n 1976, a young American ceramic artist by the name of Peter Callas built the first traditional Japanese *anagama*, or wood-burning kiln, in the United States in Piermont, New York. Three years later,

California artist Peter Voulkos was regularly firing his work in Callas's kiln. Voulkos's work is particularly suited to the wood-firing process, in which the artist must give up control of his work and resign himself to the accidental effects that result from submitting the work to a heat of 2500°F over the course of a seven-day firing. His "stacks," giant bottle-like pyramids of clay that average about 250 pounds, are so named because Voulkos liter-ally stacks clay cylinders one on top of the other to create his form. Before they are quite dry, he gouges them, draws on them with var-ious tools, and drags through the clay in giant sweeps across the form's surface. Then he fires it in the *anagama*. Anything can happen in the firing. Depending on such factors as how the pieces in the kiln are stacked, the direction of the flame, where ash is deposited on the surface of the work, how a section

near a flame might or might not melt, and undetectable irregularities in the clay itself, each stack will turn out differently. The Japanese call this "controlled accident." For Voulkos, it is the source of excitement in the work, "the expectancy of the unknown" that is fundamental to the process.

This interest in the possibilities of the accidental evidences itself in other ways in Voulkos's work. In many of his works, including both the untitled monotype reproduced here (Fig. 408) and the *X-Neck* stack (Fig. 410), a ragged "x" seems to be the focus of the piece. The "x" is, of course, a standard signature for those who cannot write, the signature of an absolute novice in the art of calligraphy. As was pointed out in the catalogue to Voulkos's 1995 retrospective exhibition, the "x" is also a reference to the Zen practice of *shoshin,* which means "beginner's mind." It is Voulkos's way of keeping in touch with what the Zen master Shunryu Suzuki describes as "the limitless potential of original mind, which is rich and sufficient within itself. For in the beginner's mind there are many possibilities; in the expert's mind there are few."

The form of the stacks of clay, however, is not accidental. It is a direct reference to the pyramid form, not only to the pyramids of ancient Egypt, but also those of ancient Mexican Aztec and Mayan cultures. For Voulkos, the pyramid represents the mystery of the unknown. In utilizing this form, Voulkos makes contact between the ancient and the modern, between himself and the forces that have driven the human race for centuries. His collage, *Pyramid of the Amphora* (Fig. 409), has the stepped sides of a Mexican pyramid. On such structures, men and women were once sacrificed to the gods, their heads cut off, their hearts cut out. Red blood seems to flow across Voulkos's work. Even the tears in the paper and the pins pushed into the surface reflect this violence, and Voulkos's own manner of working with clay, the almost primitive violence of his approach to the material, is underscored by the collage. His stacks make contact with the most elemental of emotions, our most intense, but human, feelings.

Fig. 410 Peter Voulkos, *X-Neck*, 1990.
Woodfired stoneware stack, height 34½ in. × diameter 21 in.
Private collection. Photo: Schopplein Studio, Berkeley, CA.
© 1997 Peter Voulkos.

Fig. 411 Mosaic glass bowl, fused and slumped, Roman, 25 B.C.E.–50 C.E.
Height 4½ in. Victoria & Albert Museum, London/Art Resource, New York.

Glass

Since ancient times, glassware was made either by forming the hot liquid glass, made principally of silica, or sand, on a core or by casting it in a mold. The invention of glassblowing techniques late in the first century B.C.E. so revolutionized the process that, in the Roman world, glassmaking quickly became a major industry. To blow glass, the artist dips the end of a pipe into molten glass and then blows through the pipe to produce a bubble. While it is still hot, the bubble is shaped and cut.

This glass bowl (Fig. 411) was probably made near Rome in the second half of the first century C.E., before glassblowing took hold. It is made of opaque chips of colored glass. These chips expanded and elongated in the oven as they were heated over a core ceramic form. As the glass chips melted, they fused together and fell downward over the form, creating a decorative patchwork of dripping blobs and splotches. By the time this vase was made, demand for glass was so great that many craftsmen had moved from the Middle East to Italy to be near the expanding European markets.

Today, the Pilchuck Glass School in Washington State is one of the leading centers of glassblowing in the world, surpassed only by the traditional glassblowing industry of Venice, Italy. Dale Chihuly, one of Pilchuck's cofounders, has been instrumental in transforming the medium from its utilitarian purposes into more sculptural ends. As one of his drawings for his "basket" series makes clear (Fig. 412), he is interested in the interplay of line and space, in creating a web of interlaced line and transparent form. These works are not "baskets" per se, but rather sculpted containers that hold other sculpted forms within them. Inspired by having seen a group of Indian baskets in a museum storage room sagging under their own weight, works such as Chihuly's *Alabaster Basket Set* (Fig. 413) sag, bulge, push against, and flow into one another as if still in their liquid state. His work demonstrates another quality of glass—the way it is animated by light. At once reflective and transparent, the surface is dynamic, constantly transformed, as both the light and the viewer's point of view changes.

Fig. 412 Dale Chihuly, *Alabaster Basket* (Drawing), 1986.
Graphite, colored pencil, and watercolor on paper, 30 × 22 in.
Courtesy of Dale Chihuly. Photo: Claire Garotte.

Fig. 413 Dale Chihuly, *Alabaster Basket Set with Oxblood Lip Wraps*, Oct. 1991.
Glass, 18 × 27 × 21 in. Courtesy of Dale Chihuly. Photo: Claire Garoutte.

Fiber

We do not usually think of fiber as a three-dimensional medium. However, fiber arts are traditionally used to fill three-dimensional space, in the way that a carpet fills a room or that clothing drapes across a body. In the Middle Ages, tapestry hangings such as *The Unicorn in Captivity* on the left (Fig. 414) were hung on the stone walls of huge mansions and castles to soften and warm the stone. Fiber is an extraordinarily textural medium, and as a result, it has recently become an increasingly favored medium for sculpture.

But all fiber arts, sculptural or not, trace their origins back to **weaving**, a technique for constructing fabrics by means of interlacing horizontal and vertical threads. The vertical threads—called the **warp**—are held taut on a loom or frame, and the horizontal threads—the **weft** or **woof**—are woven loosely over and under the warp. A **tapestry** is a special kind of weaving in which the weft yarns are of several colors and the weaver manipulates the colors to make a design as intricate as *The Unicorn in Captivity.*

Fig. 414 *The Hunt of the Unicorn. VII: The Unicorn in Captivity*,
Franco-Flemish, 16th Century, c. 1500.
Silk and wool, silver and silver-gilt threads, 12 ft. 1 in. × 8 ft. 3 in.
©The Metropolitan Museum of Art, New York, Gift of John D. Rockefeller, Jr.
The Cloisters Collection, 1937. (37.80.6).
Photograph © 1993 The Metropolitan Museum of Art.

Fig. 415 Embroidered *rumal*, late-18th century.
Muslin and colored silks. V & A Picture Library.

In **embroidery**, a second traditional fiber art, the design is made by needlework. From the early eighteenth century onward, the town of Chamba was one of the centers of the art of embroidery in India. It was known, particularly, for its *rumals*, embroidered muslin textiles that were used as wrappings for gifts (Fig. 415). If an offering was to be made at a temple, or if gifts were to be exchanged between families of a bride and groom, an embroidered *rumal* was always used as a wrapping.

The composition of the Chamba *rumals* is consistent. A floral border encloses a dense series of images, first drawn in charcoal and then embroidered, on a plain white muslin background. For a wedding gift, as in the *rumal* illustrated here, the designs might depict the wedding itself. The designs were double-darned, so that an identical scene appeared on both sides of the cloth. Because of its location in the foothills and mountains of the Himalayas, offering relief from the heat of the Indian plains, the region around Chamba was a favorite summer retreat for British colonists, and its embroidery arts became very popular in nineteenth-century England.

One of the most important textile designers of this century was Anni Albers. The wall hanging at the right (Fig. 416) was done on a twelve-harness loom, each harness capable of supporting a four-inch band of weaving. Consequently, Albers designed a forty-eight-inch-wide grid composed of twelve of the four-inch-wide units. Each unit is a vertical rectangle, variable only in its patterning, which is either solid or striped. The striped rectangles are themselves divided into units of twelve alternating stripes. Occasional cubes are formed when two rectangles of the same pattern appear side by side.

Anni Albers regarded such geometric play as rooted in nature. Inspired by reading *The Metamorphosis of Plants,* by Johann Wolfgang von Goethe, the eighteenth-century German poet and philosopher, she was fascinated by the way a simple basic pattern could generate, in nature, infinite variety. There is, in the design here, no apparent pattern in the occurrence of solid or striped rectangles or in the colors employed in them. This variability of particular detail within an overall geometric scheme is, from Albers's point of view, as natural and as inevitable as the repetition itself.

Fig. 416 Anni Albers, Wall Hanging, 1926.
Silk (two-ply weave), 72 × 48 in.
Courtesy The Busch-Reisinger Museum, Harvard University Art Museums, Association Fund. Photo: Michael Nedzweski.
©President and Fellows of Harvard College, Harvard University. BR48.132.
© 2003 the Josef and Anni Albers Foundation/Artists Rights Society (ARS), New York.

Fig. 417 Magdalena Abakanowicz, *Backs in Landscape*, 1978–1981.
Eighty sculptures of burlap and resin molded from plaster casts, over-lifesize. ©Magdalena Abakanowicz/Licensed by VAGA, New York/
Marlborough Gallery, New York. Photo ©1982 Dirk Bakker, Detroit, MI.

It was in the hands of Magdalena Abakanowicz, however, that fiber became, in this century, a tool of serious artistic expression, freed of any associations with utilitarian crafts. In the early 1970s, using traditional fiber materials such as burlap and string, Abakanowicz began to make forms based on the human anatomy (Fig. 417). She presses these fibers into a plaster mold, creating a series of multiples that, though generally uniform, are strikingly different piece to piece, the materials lending each figure an individual identity.

As we have already seen in the discussion of the Lotto rug in Chapter 8 (Fig. 210), and as Anni Albers's work also demonstrates, pattern and repetition have always played an important role in textile design. Abakanowicz brings new meaning to the traditional functions of repetitive pattern. These forms, all bent over in

prayer, or perhaps pain, speak to our condition as humans, our spiritual emptiness—these are hollow forms—and our mass anxiety.

The textile wrappings also remind us of the traditional function of clothing—to protect us from the elements. Here, huddled against the sun and rain, each figure is shrouded in a wrap that seems at once clothing and bandage. It is as if the figures are wounded, cold, impoverished, homeless—the universal condition. As Abakanowicz reminds us, "It is from fiber that all living organisms are built—the tissues of plants, and ourselves. Our nerves, our genetic code, the canals of our veins, our muscles. We are fibrous structures. Our heart is surrounded by the coronary plexus, the plexus of most vital threads. Handling fiber, we handle mystery. . . . When the biology of our body breaks down, the skin has to be cut so as to give access

to the inside, later it has to be sewn, like fabric. Fabric is our covering and our attire. Made with our hands, it is a record of our souls."

Metal

Perhaps the most durable of all craft media is metal, and as a result, it has been employed for centuries to make vessels for food and drink, tools for agriculture and building, and weapons for war. We have discussed traditional metal-casting techniques in Chapter 13, but it is worth remembering that Chinese artisans had developed a sophisticated bronze-casting technique as early as the 16th century B.C.E., many centuries before the advent of the lost-wax technique in the West. The Chinese apparently constructed two piece "sandwich" molds that did not require wax to hold the two sides apart. For an example, see Chapter 18, The Ancient World, Figure 599.

Over the years, metals, especially gold and silver, have been most lavishly used in the creation of jewelry. The Persian griffin bracelet illustrated here (Fig. 418) was discovered in 1877 as part of the Oxus Treasure, named after the river in Soviet Central Asia where it was found. The griffin is a mythological beast, half eagle, half lion, that symbolized vigilance and courage and was believed by the Persians to guard the gold of India, and the story associated with the discovery of this bracelet is indeed one of heroism and courage. Originally sold to Muslim merchants, the Oxus treasure was soon stolen by bandits, who were intent on dividing the loot evenly by melting it down. Captain F. C. Burton, a British officer in Pakistan, heard of the robbery, rescued the treasure, and returned it to the merchants, asking only that he be given the griffin bracelet illustrated here as his reward. He subsequently donated it to the Victoria and Albert Museum. Considered one of the most beautiful works of jewelry ever made, the bracelet was originally inlaid with colored stones. The minute detail of the griffins—especially the feathers on wings and necks, as well as the clawed feet—must have suggested, inlaid with stone, the finest Asian silk drapery.

The Oxus treasure was almost surely a royal horde, and throughout history, the most elaborate metal designs have always been commissioned by royalty. In 1539, Benvenuto

Fig. 418 Griffin bracelet, from the Oxus treasure, c. 500–400 B.C.E.
Gold and stones, diameter 5 in.
British Musem, London. The Bridgeman Art Library.

Fig. 419 Benvenuto Cellini, *Saliera (saltcellar), Neptune (sea), and Tellus (earth)*, 1540–1543.
Gold, nielo work, and ebony base, height 10¼ in.
Kunsthistorisches Museum, Vienna. Erich Lessing/Art Resource, New York.

Cellini designed a *Saltcellar* (Fig. 419) for Francis I of France. Made of gold and enamel, this is actually a functional salt and pepper shaker. Salt is represented by the male figure, Neptune, god of the sea, and hence overlord of the sea's salt. Pepper is the provenance of Earth, represented by the female figure, because pepper comes from the earth. Along the base of the saltcellar is a complex array of allegorical figures depicting the four seasons and the four parts of the day, embodying both seasonal festivities and the daily meal schedule.

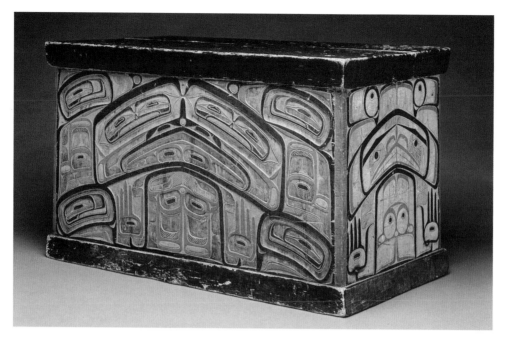

Fig. 420 Heiltsuk, *Bent-Corner Chest (Kook)*, c. 1860.
Yellow and red cedar, and paint, 21¼ × 35¾ × 20½ in. The Seattle Art Museum.
Gift of John H. Hauberg and John and Grace Putnam. Photo: Paul Macapia.

Fig. 421 Antoni Gaudí, Oak armchair for the Casa Calvet, 1904.
Museo Gaudi, Barcelona, Spain. The Bridgeman Art Library.

Wood

Because it is so easy to carve, and because it is so widely available, artisans have favored wood as a medium throughout history. Yet, because it is organic material, wood is also extremely fragile, and few wood artifacts survive from ancient cultures.

Of all woods, cedar, native to the Northwest American coast, is a particular favorite of Native American artists in that region because of its relative impermeability to weather, its resistance to insect attack, and its protective, aromatic odor. Chests such as this Heiltsuk example (Fig. 420) were designed to contain family heirlooms and clan regalia and were opened only on ceremonial occasions. Often such a chest also served as the ceremonial seat of the clan leader, who sat upon it, literally supported by his heritage.

Wood has also been a favorite, even preferred, material for making furniture, and in the hands of accomplished artists, a piece of furniture can be transformed into a work of art in its own right. Spanish architect Antoni Gaudí thought that the furniture decorating a house should be integrated with the house itself. His elaborate, organic architectural designs (see Fig. 559) thus demanded organic furniture design. This chair (Fig. 421), designed for the Casa Calvet in Barcelona, is at once

shoulder rests an exotic dancer with the head of General Field Marshall Friedrich von Hindenburg. Below them are other generals, and behind Wilhelm, a photograph of people waiting in line at a Berlin employment office.

The upper left focuses on Albert Einstein, out of whose brain Dada slogans seem to burst, as if the Theory of Relativity, overturning traditional phsyics as it did, was a proto-Dada event. In the very center of the collage is a headless dancer, and above her floats the head of printmaker Kathë Kollwitz. To the right of her are the words, "Die grosse Welt dada," and then, farther down, "Dadaisten"— "the great dada World" and "Dadaists." Directly above these words are Lenin, whose head tops a figure dressed in hearts, and Karl Marx, whose head seems to emanate from a machine. Raoul Hausmann stands just below in a diver's suit. A tiny picture of Höch herself is situated at the bottom right, partially on the map of Europe that depcicts the progress of women's enfranchisement. To the left, a figure stands above the crowd shouting "Tretet Dada bei"—"Join Dada."

Fig. 424 Hannah Höch, *Cut with the Kitchen Knife*, 1919.
Collage, 44⅞ × 35⁷/₁₆ in.
Staatliche Museen zu Berlin, Preussischer Kulturbesitz
Nationalgalerie/NG57/61. Photo: Jorg P. Anders, Berlin.
© 2003 Artists Rights Society (ARS), New York/VG Bild-Kunst, Bonn.

The complexity of Höch's composition is obvious, but in its ability to capture both a sense of liberation and oppression, pleasure and pain, it is emotionally complex as well. Finally, the title suggests that it is not just photographs that have been cut with the kitchen knife, but the self, and the body politic.

Fig. 425 Robert Rauschenberg, *Monogram*, 1959.
Freestanding combine: oil, fabric, wood, on canvas and wood, rubber heel, tennis ball, metal plaque, hardware, stuffed Angora goat, rubber
tire, mounted on four wheels, 42 × 63¼ × 64½ in. © Robert Rauschenberg/Licensed by VAGA, New York, NY.

The movement of the two-dimensional into the three-dimensional that is suggested by collage is nowhere more forcefully stated than in the work of Robert Rauschenberg. Rauschenberg's work literally moves "off the wall"—the title of Calvin Tomkins's biography of the artist. There is probably no better example of this than *Monogram* (Fig. 425), a combine-painting, or high-relief collage, that Rauschenberg worked on over a five-year period from 1955 to 1959.

The composer John Cage once defined Rauschenberg's combine-paintings as "a situation involving multiplicity." They are a kind of collage, but more lenient than other collages about what they will admit into their space. They will, in fact, admit anything, because unity is not something they are particularly interested in. They bring together objects of diverse and various kinds and simply allow them to coexist beside one another in the same space. In Rauschenberg's words, "A pair of

socks is no less suitable to make a painting with than wood, nails, turpentine, oil and fabric." Nor, apparently, is a stuffed Angora goat.

Rauschenberg discovered the goat in a second-hand office furniture store in Manhattan. The problem it presented, as Tomkins has explained, was how "to make the animal look as if it belonged in a painting." In its earliest recorded state (Fig. 426) the goat is mounted on a ledge in profile in the top half of a six-foot painting. It peers over the edge of the painting and casts a shadow on the wall. Compared to later states of the work, the goat is integrated into the two-dimensional surface, or as integrated as an object of its size could be.

In the second state (Fig. 427), Rauschenberg brings the goat off its perch and sets it on a platform in front of another combine-painting, this one nearly ten feet high. Now it seems about to walk forward into our space, dragging the painting behind it. Rauschenberg has also placed an automobile tire around the

goat's mid-section. This tire underscores its volume, its three-dimensionality.

But Rauschenberg was not happy with this design either. Finally, he put the combine painting flat on the floor, creating what he called a "pasture" for the goat. Here Rauschenberg manages to accomplish what seems logically impossible: the goat is at once fully contained within the boundaries of the picture frame and totally liberated from the wall. Painting has become sculpture.

The close connection between collage and sculpture is evident when we consider Louise Nevelson's *Sky Cathedral* (Fig. 428). The piece is a giant assemblage of wooden boxes, woodworking remnants and scraps, and found objects, such as a bowling pin. It is entirely frontal and functions like a giant high-relief altarpiece—hence its name—transforming and elevating its materials to an almost spiritual dimension. The real accomplishment here—and it is substantial—is that Nevelson has been able to make a piece of almost endless variety appear unified and coherent. Both its grid structure and the repetition of forms and shapes help accomplish this, but the work's overall black color does the most of all. Black, Nevelson has explained, "means totality. It means: contains all. . . . Because black encompasses all colors. Black is the most aristocratic color of all. The only aris-

Fig. 428 Louise Nevelson, *Sky Cathedral*, 1958.
Assemblage: wood construction painted black,
11 ft. 3½ in. × 10 ft. ¼ in. × 18 in.
The Museum of Modern Art, New York. Gift of Mr. and Mrs. Ben Mildwoff.
Photograph ©1999 Museum of Modern Art, New York. Licensed by Scala-Art Resource, New York. ©2003 Estate of Louise Nevelson, Artists Rights Society (ARS), New York.

tocratic color. . . . I have seen things that were transformed into black, that took on just greatness. I don't want to use a lesser word." It is this transformation of everyday things into greatness that defines not only Nevelson's *Sky Cathedral* but collage as a whole.

Fig. 429 Judy Pfaff, *Rock/Paper/Scissor*, 1982.
Mixed media installation at the Albright-Knox Art Gallery, September 1982.
Albright-Knox Art Gallery, Buffalo, NY.

Fig. 430 Gaho Taniguchi, *Plant Body*, 1987.
Installation at Spiral Garden, Wacoal Art Center, Tokyo. Soybeans, millet, rice, rope, straw
mats, urethane, metal mesh, clay, 14 ft. 6¾ in. × 26 ft. 9 in.
Spiral Garden, Tokyo/PPS.

Installation

Collage is an inclusive medium. It admits anything and everything into its world. However, not everything that might be admitted into a collage can sit comfortably on a wall. We have already seen how collage begins to move into the space of the room. Judy Pfaff's *Rock/Paper/Scissor* (Fig. 429) completely escapes the wall, spilling out into the gallery as a whole. The piece insists on its lack of unity. It defiantly refuses to be classified. It even manages to ignore the unified architectural space of the gallery itself, turning it into a chaotic clutter of line, form, and color. The architecture of the room virtually disintegrates before our eyes.

This play with the predictable forms of interior architectural space is typical of installation art. Gaho Taniguchi's *Plant Body* (Fig. 430) is designed to transform interior space entirely. It is inspired by the ancient Japanese art of flower arranging, *ikebana*. The philosophy behind *ikebana* stresses the notion of *mono no aware*, a sense of the poignancy of things, an attitude and feeling that can be traced back to early forms of Japanese Zen

Figs. 431 & 432 Eleanor Antin, stills from *Minetta Lane–A Ghost Story*, 1995.
Mixed media installation. Above: Actors Amy McKenna and Joshua Coleman.
Right: Artist's window with Miriam. Courtesy of the artist and Ronald Feldman Fine Arts, New York.

Buddhism. Both the ephemeral nature of the flower arrangement and the short life of the flower bear witness to the fact that all things beautiful must pass. *Ikebana,* then, seeks to capture the vanishing moment, and by doing this, to celebrate the continual cycle of birth, death, and renewal.

Taniguchi was trained in the art of *ikebana,* and in *Plant Body,* she has implanted soybeans, rice, millet, straw, and rootlike rope into a surface of dried clay that seems barely to cling to the wall of the gallery. A sort of room-size live ceramic sculpture, the piece compresses the time of the seasons, from the wetness of the time when the seeds are planted to the hard dry soil of the harvest. The installation embodies, in interior space, the entire agricultural cycle.

More recently, installations have incorporated film and video in the sculptural or architectural setting. Eleanor Antin's 1995 *Minetta Lane—A Ghost Story* consists of a recreation of three buildings on an actual New York, Greenwich Village street that runs for two blocks between MacDougal Street and Sixth Avenue. In the late 1940s and early 1950s, it was the site of a low-rent artists' community,

and Antin seeks to recreate the boehemian scene of that lost world. For the installation, Antin prepared three narrative films, transferred them onto video disc, and back-projected them onto tenement windows of the reconstructed lane. The viewer, passing through the scene, thus voyeuristically sees in each window what transpires inside. In one window (Fig. 431), a pair of lovers sport in a kitchen tub. In a second (Fig. 432), an abstract expressionist painter is at work. And in a third, an old man tucks in his family of caged birds for the night. These characters are the ghosts of a past time, but their world is inhabited by another ghost. A little girl, who is apparently invisible to those in the scene but clearly visible to us, paints a giant "X" across the artist's canvas and destroys the relationship of the lovers in the tub. She represents a destructive force that, in Antin's view, is present in all of us. The little girl is to the film's characters as they are to us. For the artist, the lovers, and the old man represent the parts of us that we have lost—like our very youth. They represent ideas about art, sexuality, and life, that, despite our nostalgia for them, no longer pertain.

Performance Art

One of the innovators of performance art was Allan Kaprow, who in the late 1950s "invented" what he called **Happenings**, which he defined as "assemblages of events per-

Fig. 433 Jackson Pollock, *Full Fathom Five*, 1947.
Oil on canvas with nails, tacks, buttons, key, coins, cigarettes, matches, etc., 50⅞ × 30⅛ in. Collection: Museum of Modern Art, New York. Gift of Peggy Guggenheim.
© 1999 The Museum of Modern Art. Licensed by Scala-Art Resource, New York.
© 2003 Pollock-Krasner Foundation/Artists Rights Society (ARS), New York.

Fig. 434 Allan Kaprow, *Household*, 1964.
Licking jam off a car hood, near Ithaca, New York. Sol Goldberg/Cornell University Photography.

formed or perceived in more than one time and place. . . . A Happening . . . is art but seems closer to life." It was, in fact, the work of Jackson Pollock that inspired Kaprow to invent the form. The inclusiveness of paintings such as *Full Fathom Five* (Fig. 433)—it contains nails, tacks, buttons, a key, coins, cigarettes, matches, and other things buried in the paint that swirls across its surface—gave Kaprow the freedom to bring everything, including the activity of real people acting in real time, into the space of art. "Pollock," Kaprow wrote in 1958, "left us at the point where we must become preoccupied with and even dazzled by the space and objects of our everyday life, either our bodies, clothes, rooms, or, if need be, the vastness of Forty-Second Street. . . . Objects of every sort are materials for the new art: paint, chairs, food, electric and neon signs, smoke, water, old socks, a dog, movies, a thousand other things will be discovered by the present generation of artists. . . . The young artist of today need no longer say, 'I am a painter,' or 'a poet' or 'a dancer.' He is simply an 'artist.' All of life will be open to him."

In the Happening *Household* (Fig. 434), there were no spectators, only participants, and the event was choreographed in advance by Kaprow. The site was a dump near Cornell University in Ithaca, New York. At 11 A.M. on the day of the Happening, the men who were participating built a wooden tower of trash, while the women built a nest of saplings and string. A smoking, wrecked car was towed onto the site, and the men covered it with strawberry jam. The women, who had been screeching inside the nest, came out to the car and licked the jam as the men destroyed their nest. Then the men returned to the wreck, and slapping white bread over it, began to eat the jam themselves. As the men ate, the women destroyed their tower. Eventually, as the men took sledge hammers to the wreck and set it on fire, the animosity between the two groups began to wane. Everyone gathered round and watched until the car was burned up, and then left quietly. What this Happening means, precisely, is not entirely clear, but it does draw attention to the violence of relations between men and women in our society and the frightening way in which violence can draw us together as well as drive us apart.

One of the most interesting and powerful performance artists was Joseph Beuys, who died in 1985. Beuys created what he preferred to call "actions." These were designed to reveal what he believed to be the real function of art—teaching people to be creative so that, through their creativity, they might change contemporary society. As he put it, "The key to changing things is to unlock the creativity in every man. When each man is creative, beyond right and left political parties, he can revolutionize time." Beuys's aims may have been didactic, but they were, nevertheless, almost always expressed in hauntingly poetic and moving images. In 1974, Beuys performed, at the René Block Gallery in Manhattan, a three-day piece, entitled *I Like America and America Likes Me* (Fig. 435). He had refused to visit the United States until it pulled out of Vietnam, and this performance not only celebrated his first visit to the country, but addressed the still unhealed wounds of the Vietnam War, which had so divided the American people. When Beuys arrived at Kennedy International Airport, he was met by medical attendants, wrapped in gray felt, and driven by ambulance to the gallery, where, lying on a stretcher, he was placed behind a chain-link fence to live for three days and nights with a live coyote.

The coyote was comparable to the Native American in Beuys's eyes, a mammal subject to the same attack and persecution as they had been. For Beuys, the settling (or, rather, conquest) of the American West was a product of the same imperialist mentality that had led to the Vietnam War. The felt fabric in which Beuys wrapped himself is his most characteristic medium. It refers to his own rescue by Tartar tribesmen in the Crimea during World War II. After Beuys's plane crashed in a driving snowstorm, the Tartars restored him to health by covering his body with fat and wrapping him in felt. Thus wrapped in felt, Beuys introduced himself as an agent of healing into the symbolic world of the threatened coyote.

Man and coyote quickly developed a sort of mutual respect, mostly ignoring one another. About thirty times over the course of the three days, however, Beuys would imitate the coyote's every movement for a period of one or two hours, so that the two moved in a strangely harmonious "dance" through the gallery space. Often, when Beuys moved into a corner to smoke, the coyote would join him. For many viewers, Beuys's performance symbolized the possibilities for radically different "types" to coexist in the same space.

Fig. 435 Joseph Beuys, *I Like America and America Likes Me*, 1974.
Courtesy Ronald Feldman Fine Arts, New York. Photograph © Caroline Tisdall. ©2003 Artists Rights Society (ARS), New York/VG Bild-Kunst, Bonn.

Goat Island's
How Dear to Me the Hour When Daylight Dies

Figs. 436 and 437 Goat Island, *How Dear to Me the Hour When Daylight Dies*, 1995–1996.
Images from video documentation of work in progress, January 20, 1996. Courtesy Goat Island.

Goat Island's work is collaborative in nature. The group's four performers, and its director, Lin Hixson, all contribute to the writing, choreography, and conceptual aspects of each work.

Founded in 1987, the group has to date created five performance events, the last of which is *How Dear to Me the Hour When Daylight Dies,* which premiered in Glasgow, Scotland, in May 1996, and then subsequently toured across Scotland and England.

In each piece, the troupe focuses on five major concerns: (1) they try to establish a conceptual and spatial relationship with the audience by treating the performance space, for instance, as a parade ground or a sporting arena; (2) they utilize movement in a way that is demanding to the point of exhaustion; (3) they incorporate personal, political, and social issues into the work directly through spoken text; (4) they stage their performances in nontheatrical spaces within the community, such as gyms or street sites; and (5) they seek to create striking visual images that encapsulate their thematic concerns.

The subject matter of their works is always eclectic, an assemblage of visual images, ideas, texts, physical movements, and music, that often have only the most poetic connection to each other. *How Dear to Me the Hour When Daylight Dies* began with their desire to share an intense group experience. To that end, in July 1994, the troupe traveled to Ireland to participate in the massive Croagh Patrick pilgrimage, a grueling four-hour climb up a mountain on the western seacoast near Westport, County Mayo, to a tiny church at the summit, where St. Patrick spent forty days and forty nights exorcising the snakes from Ireland. Eleven days before the pilgrimage, on July 20, the father of Greg and Timothy McCain, two members of the troupe who have subsequently moved on to other endeavors, died in Indianapolis. The elder McCain had seen every Goat Island

piece, some of them three times. The pilgrimage thus became not only an act of faith and penance, but one of mourning.

How Dear to Me begins with the troup performing a sequence of hand gestures, silently, thirty times, that evokes for them the memory of Mr. McCain (Fig. 436). The minimal exertion of these gestures contrasts dramatically with the intense physicality of the pilgrimage. But both actions, the hand movements and the pilgrimage, are acts of memory. And memory is, in turn, the focus of the next set of images in the performance.

Matthew Goulish plays the part of Mr. Memory, a sort of traveling sideshow character who claimed to commit to memory fifty new facts a day and who could answer virtually any question posed to him by an audience. After he answers a series of questions, the troupe breaks into a long dance number (Fig. 437). As all four perform this arduous and complex dance in absolute synchronous movement, it becomes clear that it is, at once, another version of the pilgrimage—the same physical exercise performed year after year, again and again—and an exercise in collaborative and communal memory, as each member of the troupe remembers just what movement comes next in the dance sequence.

After the dance, Mr. Memory is asked, "Who was the first woman to fly across the Atlantic Ocean?" The answer is Amelia Earhart, and, at that, Karen Christopher dons a flying cap and becomes Amelia Earhart herself. The mystery surrounding Earhart's death in the South Pacific in World War II is evoked, the mystery of her death is symbolic of the mystery of all death. In Figure 438, right, we witness the transformation of Christopher from her Earhart character into Mike Walker, "the world's fattest man,"

Fig. 438 Goat Island, *How Dear to Me the Hour When Daylight Dies*, 1995–1996.
Image from video documentation of work in progress, January 20, 1996. Courtesy Goat Island.

who in 1971 weighed 1,187 pounds. This transformation was necessitated by the discovery, during rehearsals, that Christopher was diabetic and would, as a result, need to eat during the course of each performance. The image of the three men carrying her emphasizes not only her weight but the gravity of her situation.

Many more images and ideas collide in the course of this one-and-one-half-hour performance, too many to outline here; but this gives a sense of the remarkable energy, power, and inventiveness of Goat Island's collaborative and open-ended process.

BY GEORGE BRECHT, CLAUS BREMER, EARLE BROWN, JOSEPH BYRD, JOHN CAGE, DAVID DEGENER, WALTER DEMARIA, HENRY FLYNT, YOKO ONO, DICK HIGGINS, TOSHI ICHIYANAGI, TERRY JENNINGS DENNIS, DING DONG, RAY JOHNSON, JACKSON MAC LOW, RICHARD MAXFIELD, ROBERT MORRIS, SIMONE MORRIS, NAM JUNE PAIK, TERRY RILEY, DITER ROT, JAMES WARING, EMMETT WILLIAMS, CHRISTIAN WOLFF, LA MONTE YOUNG, LA MONTE YOUNG - EDITOR,

Fig. 439 George Maciunas, title pages of *An Anthology*, edited by La Monte Young, 1963.
The Gilbert and Lila Silverman Fluxus Collection, Detroit.
© La Monte Young and Jackson Mac Low. Photo: Jon Hendricks.

Performance art, it should be clear, exceeds limits of the visual sense to which we normally think of art as primarily appealing. As a result, it tends to be interdisciplinary, often combining elements not only of drama and poetry, but of music and dance as well. One of the major advocates of such an eclectic approach in the early 1960s was a loosely knit group of European, Japanese, Korean, Canadian, and American artists, many of whom trained first as musicians, which came to be identified by the name of Fluxus. Beuys often associated himself with the group, but more directly involved were people such as avant-garde musician La Monte Young, George Brecht, Dick Higgins, an accomplished assemblage artist, poet Jackson Mac Low, Yoko Ono, and, on occasion, John Lennon of the Beatles.

The composer John Cage's classes at the New School in New York were a catalyst for the group. Many of Cage's students began to investigate the implications of compositions such as his *4'33"* in their own work. The composition *4'33"* is literally four minutes and 33 seconds of silence, during which the audience becomes aware that all manner of noise in the room, incidental and otherwise, is, in the context of the piece, "music."

Thus Jackson Mac Low created poetry of chance-derived nouns and verbs improvised upon by the performer. La Monte Young's *X for Henry Flynt* required the performer to play an unspecified sound, or group of sounds, in a distinct and consistent rythmic pattern for as long as the performer wished, which, in Young's own performance, consisted of 600-odd beats on a frying pan. Dick Higgins's *Winter Carol* consisted of everyone going outdoors to listen to the snow fall for a specified amount of time. Events such as this were soon organized into Fluxus "concerts," events that admitted anything, including the audience's outrage. One of the first collections of Fluxus-like work, which served as something of a model for these concerts, was a publication called *An Anthology,* collected by La Monte Young and designed by George Maciunas. The innovative graphic design of its six title pages (Fig. 439), and its willingness to accept almost everything—even "anti-art"—as art are indicative of the inclusiveness of the movement as a whole.

Perhaps the most successful of the multimedia performance artists has been Laurie Anderson, who not only performs before large enthusiastic audiences in essentially commercial rock concert settings, but has successfully marketed both films and recordings of her work as well. Her performances—the most ambitious of which is the seven-hour, four-part, two-evening *United States* (Fig. 440)—involve a wide variety of technological effects. An electronic harmonizer lends her voice a deep male resonance that she describes as "the Voice of Authority . . . a corporate voice, a kind of 'Newsweekese.'" A "black box" delays, alters, and combines tapes of her voice so that she sounds like a chorus. Her "violin" is actually a tape playback head and her "bow" a strip of prerecorded audiotape that is

transmitted as she draws it, at various speeds, in long or short sweeps, across the head.

These audio effects are matched by equally sophisticated choreography, lighting changes, and a wealth of complex visual imagery that inundates the audience in wave after wave of Americana. Anderson's performances wander through the psychological and emotional terrain of the United States, not so much in an effort to understand it as in submission to the impossibility of ever understanding it. "I mean my mouth is moving," she admits in *United States,* "but I don't really understand what I'm saying." It is as if she has no real voice of her own, only the voice of technology. She is not so much a person, a performer, as an assemblage, fabricated out of the American scene.

THE CRITICAL PROCESS

Thinking about Other
Three-Dimensional Media

If it seems slightly odd that this chapter should conclude with discussion of a group of works that verge on becoming theater, you need only reflect back to where our discussion of three-dimensional media began. As a medium, sculp-ture is, by and large, more active than painting. We passively stand before a painting. But we walk around sculpture—or through it, in the case of earthworks—and it changes with our point of view. Even when we consider sculp-ture in relief, it is as if the scenes depicted in it are trying to emerge or escape from the con-fines of two-dimensionality.

One of the great myths that helps us to understand the power of sculpture is the story of Pygmalion. According to legend, Pygmalion fell in love with a statue of Venus that he him-self had carved. When he prayed that he might have a wife as beautiful as the image he had created, to his amazement, the statue came to life as his wife, Galatea. The story embodies the "liveliness" of all three-dimensional media, their tendency to move off the wall and actively engage us, not just imaginatively but physically as well. By modeling, carving, cast-ing, and assembling, we create objects that enter our world, share our space, even con-front us. When we work with clay or glass or fiber, we make things that we can physically use. Three-dimensional media engage our lives, just as collage engages the realities of the world around it by admitting such things as the news into the space of art. And as the space of art

Fig. 440 Laurie Anderson, *United States Part II*, 1980.
Photo: Paula Court. Sean Kelly Gallery, New York.

Fig. 441 Ann Hamilton, *a round*, May 7–September 12, 1993.
Installation at the Power Plant, Toronto, Canada. Wrestling dummies, canvas floor, circular hand knitting.
Courtesy Sean Kelly Gallery, New York. Photo: Cheryl O'Brien.

opens up, as room-size installations and then as performance, it literally comes to life like Galatea herself.

Consider Ann Hamilton's installation '*a round*' (Fig. 441). Hamilton conceives of projects that relate directly to their site. '*a round*' was commissioned by a contemporary art space in Toronto, Canada, called the Power Plant, a former storage area on the Toronto docks. It consisted of 1,200 human-shaped cotton bags, wrestling dummies, cut and sewn industrially, and filled, manually, with sawdust, and piled around the walls, suggesting the transformation of the human into the commodity. The floor was covered with canvas, like a boxing ring, and at the top of two massive pillars, also covered in canvas, were two mechanized leather punching bags which periodically burst into motion, disrupting the silence (hence the work's title). Between them, an extraordinary length of white yarn was stretched in a wide horizontal band, which, during the course of the installation, was gradually unraveled by a seated woman knitting a white shawl in isolation in the middle of the room.

What is sculptural about this space? What about the work is related to the so-called craft media? What is more performance oriented? What about the space could be described as masculine? What about it could be defined as feminine? It should help you to know that Hamilton was trained, as an undergraduate, in textile design, and as a graduate student, in sculpture. "Cloth," Hamilton has said, "like human skin, is a membrane that divides an interior from an exterior. It both reveals and conceals. . . . In its making, individual threads of warp are crossed successively by individual threads of weft. Thus cloth is an accumulation of many gestures of crossing." What "crossings can you detect in the work? Can you say how, for instance, the ritualized activity of sewing, or so-called "piece work," relate to the ritualized violence of sport? (Remember the saying, "what goes around comes around.") Or what about the tension between "live" and mechanized activity? How does the wall of "dummies" function as a sort of skin in its own right? These are just a few of the questions that this mysterious, but evocative installation provokes.

CHAPTER 15

THE CAMERA ARTS

Thus far in Part III we have discussed the two-dimensional media—drawing, print-making, and painting—and the three-dimensional media—sculpture, the craft media, and new, mixed-media forms. Now we turn to the camera arts, the media that allow the artist to explore the fourth dimension—time.

The images that come from still, motion-picture, and video cameras are, first and foremost, informational. Cameras record the world around us, and the history of the camera is a history of technologies that record our world with ever-increasing sophistication and expertise. Photography began with still images, then added motion. To the silent moving image was added sound. To the "talkie" was added color. And film developed in its audience a taste for "live" action, a taste satisfied by live television transmission, video images that allow us to view anything happening in the world as

Fig. 442 Walker Evans,
Roadside Store between Tuscaloosa and Greensboro, Alabama, 1936.
Library of Congress. Photo: Walker Evans.

it happens. The history of the camera arts is thus a history of increasing immediacy and verisimilitude, or semblance to the truth. In this chapter, we will survey that history, starting with still photography, moving to film, and, finally, to video. Our focus will be on these media as works of *art*.

PHOTOGRAPHY

Like collage, photography is, potentially at least, an inclusive rather than an exclusive medium. You can photograph anything you can see. According to artist Robert Rauschenberg,

whose combine-paintings we studied in the last chapter (Fig. 425), "The world is essentially a storehouse of visual information. Creation is the process of assemblage. The photograph is a process of instant assemblage, instant collage." Walker Evans's photograph *Roadside Store between Tuscaloosa and Greensboro, Alabama* (Fig. 442) is an example of just such "instant collage." Evans's mission as a photographer was to capture every aspect of American visual reality, and his work has been called a "photographic equivalent to the Sears, Roebuck catalog of the day." But the urge to make such instant visual assemblages—to capture a moment in time—is as old as the desire to represent the world accurately. We begin our discussion of photography by considering the development of the technology itself, and then we will consider the fundamental aesthetic problem photography faces, the tension between form and content, the tension between the way a photograph is formally organized as a composition and what it expresses or means.

Early History

The word *camera* is the Latin word for "room." And in fact, by the sixteenth century, a darkened room, called a *camera obscura*, was routinely used by artists to copy nature accurately. The scientific principle employed is essentially the same as that used by the camera today. A small hole on the side of a light-tight room admits a ray of light that projects a scene, upside down, directly across from the hole onto a semitransparent white scrim. The *camera*

Fig. 443 Camera Obscura.
Engraving. Courtesy George Eastman House.

obscura depicted here (Fig. 443) is a double one, with images entering the room from both sides. It is also portable, allowing the artist to set up in front of any subject matter.

But working with the *camera obscura* was a tedious proposition, even after small portable dark boxes came into use. The major drawback of the *camera obscura* was that while it could capture the image, it could not preserve it. In 1839, that problem was solved, simultaneously in England and France, and the public was introduced to a new way of representing the world.

In England, William Henry Fox Talbot presented a process for fixing negative images on paper coated with light-sensitive chemicals, a process which he called **photogenic drawing** (Fig. 444). In France, a different process, which yielded a positive image on a polished metal plate, was named the **daguerreotype** (Fig. 445), after one of its two inventors, Louis Jacques Mandé Daguerre (Joseph Nicéphore Niépce had died in 1833, leaving Daguerre to perfect the process and garner the laurels). Public reaction was wildly enthusiastic, and the French and English press faithfully reported every development in the greatest detail.

Fig. 444 William Henry Fox Talbot,
***Mimosoidea Suchas, Acacia*, c. 1839.**
Photogenic drawing. Fox Talbot Collection, National Museum of Photography, London. Film & Television/Science & Society Picture Library.

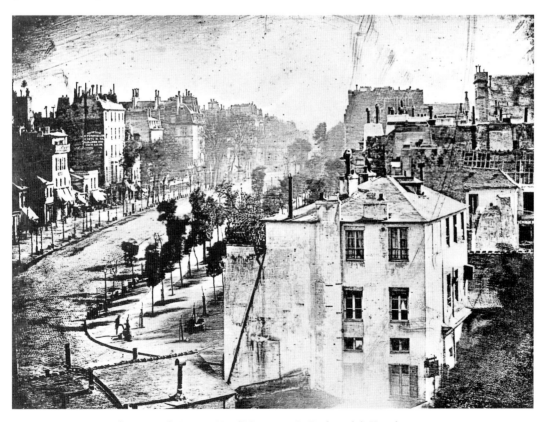

Fig. 445 Louis Jacques Mandé Daguerre, *Le Boulevard du Temple*, 1839.
Daguerreotype. Bayerisches National Museum, Munich.

Fig. 446 Richard Beard, *Maria Edgeworth*, 1841.
Daguerreotype, 2⅛ × 1¾ in. Courtesy of the National Portrait Gallery, London.

When he saw his first daguerreotype, the French painter Paul Delaroche is reported to have exclaimed, "From now on, painting is dead!" Delaroche may have overreacted, but he nevertheless understood the potential of the new medium of photography to usurp painting's historical role of representing the world. In fact, photographic portraiture quickly became a successful industry. As early as 1841, a daguerreotype portrait could be had in Paris for fifteen francs. That same year in London, Richard Beard opened the first British portrait studio, bringing a true sense of showmanship to the process. One of his first customers, the novelist Maria Edgeworth (Fig. 446), described having her portrait done at Beard's in a breathless letter dated May 25, 1841: "It is a wonderful mysterious operation. You are taken from one room into another upstairs and down and you see various people whispering and hear them in neighboring passages and rooms unseen and the whole apparatus and stool on a high platform under a glass dome casting a snapdragon blue light making all look like spectres and the men in black gliding about. . . ."

In the face of such a "miracle," the art of portrait painting underwent a rapid decline. Of the 1,278 paintings exhibited at the Royal Academy in London in 1830, more than 300 were miniatures, the most popular form of the portrait; in 1870, only 33 miniatures were exhibited. In 1849 alone, 100,000 daguerreotype portraits were sold in Paris. Not only had photography replaced painting as the preferred medium for portraiture, it had democratized the genre as well, making portraits available not only to the wealthy, but to the middle class, and even, with some sacrifice, to the working class.

The daguerreotype itself had some real disadvantages as a medium, however. In the first place, it required considerable time to prepare, expose, and develop the plate. Iodine was vaporized on a copper sheet to create light-sensitive silver iodide. The plate then had to be kept in total darkness until the camera lens was opened to expose it. At the time Daguerre first made the process public in 1839, imprinting an image on the plate took from eight to ten minutes in bright summer light. His own view of the Boulevard du Temple (Fig. 445) was exposed for so long that none of the people in the street, moving about their business, has left any impression on the plate, save for one solitary figure at the lower left, who is having his shoes shined. By 1841, the discovery of so-called chemical "accelerators" had made it possible to expose the plate for only one minute, but a sitter could not move in that time for fear of blurring the image. The plate was finally developed by suspending it face down in heated mercury, which deposited a white film over the exposed areas. The unexposed silver iodide was dissolved with salt. The plate then had to be rinsed and dried with the utmost care.

An even greater drawback of the daguerreotype was that it could not be reproduced. Utilizing paper instead of a metal plate, Fox Talbot's photogenic process made multiple prints a possibility. Talbot quickly learned that he could reverse the negative image of the photogenic drawings by placing sheets of sensitized paper over them and exposing both again to sunlight. Talbot also discovered that sensitized paper, exposed for even a few seconds, held a *latent* image that could be brought out and developed by dipping the paper in gallic acid. This **calotype** process is the basis of modern photography.

In 1843, Talbot made a picture, which he called *The Open Door* (Fig. 447), that convinced him that the calotype could not only document the world as we know it, but it could become a work of art in its own right. When he published this calotype in his book *The Pencil of Nature*, the first book of photographs ever produced, he captioned it as follows: "A painter's eye will often be arrested where ordinary people see nothing remarkable. A casual gleam of sunshine, or a shadow thrown across his path, a time-withered oak, or a moss-covered stone may awaken a train of thoughts and feelings, and picturesque imaginings." For Talbot, at least, painters and photographers saw the world as one.

In 1850, the English sculptor Frederick Archer introduced a new **wet-plate collodion** photographic process that was almost universally adopted within five years. In a darkened room, he poured liquid collodion—made of pyroxyline dissolved in alcohol or ether—over a glass plate bathed in a solution of silver nitrate. The plate had to be prepared, exposed, and developed all within fifteen minutes and while still wet. The process was cumbersome, but the exposure time was short and the rewards were quickly realized. On her forty-ninth birthday, in 1864, Julia Margaret Cameron, the wife of a highly placed British civil servant and friend to many of the most famous people of her day, was given a camera and collodion-processing equipment by her daughter and son-in-law. "It may amuse you, Mother, to photograph," the accompanying note said.

Cameron, who was a friend of Sir John Herschel, the scientist with whom Fox Talbot had most often consulted, became one of the greatest of all portrait photographers. She set up a studio in a chicken coop at her home on the Isle of Wight, and over the course of the next ten years, convinced almost everyone she knew to pose for her. Commenting on her photographs of famous men like Herschel himself (Fig. 448), she wrote in her *Annals of My Glass House*, "When I have had such men before my camera, my whole soul has endeavored to do its duty towards them in recording faithfully the greatness of the inner man as well as the features of the outer man. The photograph thus taken has been almost the embodiment of a prayer."

Fig. 447 William Henry Fox Talbot, *The Open Door*, 1843.
Calotype. Fox Talbot Collection, National Museum of Photography, London.
Film & Television/Science & Society Picture Library.

Fig. 448 Julia Margaret Cameron, *Sir John Herschel*, April 1867.
Albumen print, 12¾ × 10¼ in.
Gift of Mrs. J. D. Cameron Bradley, Courtesy Museum of Fine Arts, Boston.

More than anything else, the ability of the portrait photographer to expose, as it were, the "soul" of the sitter led the French government to give photography the legal status of art as early as 1862. But from the beginning, photography served a *documentary* function as well—it recorded and preserved important events. At the outbreak of the American Civil War, in 1861, Matthew Brady spent the entirety of his considerable fortune to outfit a band of photographers to document the war. When Brady insisted that he owned the copyright for every photograph made by anyone in his employ, whether or not it was made on the job, several of his best photographers quit, among them Timothy O'Sullivan (Fig. 449). One of the first great photojournalists, O'Sullivan is reported to have photographed calmly during the most horrendous bombardments, twice having his camera hit by shell fragments.

After the war, O'Sullivan packed his photography wagon, laden with glass plates, chemicals, and cameras, and joined Clarence King's Survey of the Fortieth Parallel in order to document a landscape few Americans had ever seen: the rugged, sometimes barren terrain stretching along the Fortieth Parallel between Denver, Colorado and Virginia City, Nevada. Hired to record the geological variety of the region, O'Sullivan quickly realized that on the two-dimensional surface of the photograph, the landscape yielded sometimes stunningly beautiful formal plays of line and texture. In his view of the Green River canyon (Fig. 450), brush dots the landscape in small, isolated flecks that create an almost dimensionless space, especially on the right. A geological upthrust, through which the river has apparently cut its way, sweeps up from the left, ending abruptly at the picture's center, almost reminding us of the broad brushwork of an abstract expressionist canvas.

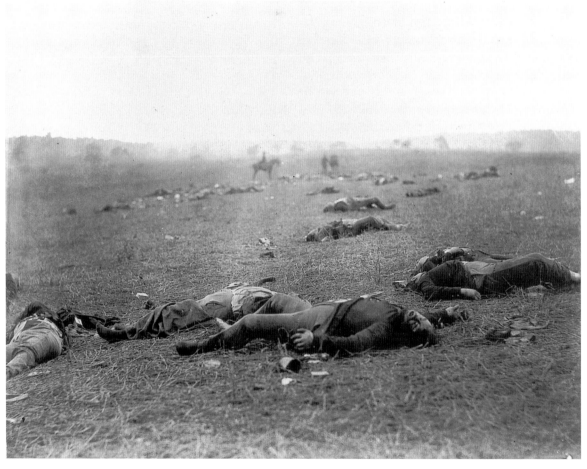

Fig. 449 Timothy O'Sullivan, *Harvest of Death, Gettysburg, Pa.*, 1863.
Collodion print. International Museum of Photography at George Eastman House, Rochester, NY.

Fig. 450 Timothy O'Sullivan, *Green River (Colorado)*, c. 1868.
Collodion print, 8 × 10 in. Library of Congress.

Form and Content

It might be said that every photograph is an abstraction, a simplification of reality that substitutes two-dimensional for three-dimensional space, an instant of perception for the seamless continuity of time, and, in black-and-white work at least, the gray scale for color. By emphasizing formal elements over representational concerns, as O'Sullivan seems to have done in his picture of the Green River canyon, the artist further underscores this abstract side of the medium. One of the greatest sources of photography's hold on the popular imagination lies in this ability to aestheticize the everyday—to reveal as beautiful that which we normally take for granted. In his photograph, *From the Shelton, New York* (Fig. 451), Alfred Stieglitz has transformed the three-dimensional space of the picture into a two-dimensional design of large, flat black-and-white shapes. By heightening the contrast between light and dark, and almost completely eliminating middle-register grays, Stieglitz deemphasizes the literal content of his photograph and creates, instead, what he called "an affirmation of light. . . . Each thing that arouses me is perhaps but a variation on the theme of how black and white maintain a living equilibrium."

Fig. 451 Alfred Stieglitz, *From the Shelton, New York*, 1931.
Silver gelatin print, 9⁹/₁₆ × 7⁹/₁₆ in.
© 1999 National Gallery of Art, Washington, DC. Alfred Stieglitz Collection.

Fig. 452 Charles Sheeler,
Criss-Crossed Conveyors–Ford Plant, 1927.
Gelatin silver print, 10 × 8 in. (9⅜ × 7½ in.)
The Lane Collection, Courtesy Museum of Fine Arts, Boston.

The geometric beauty of Stieglitz's work deeply influenced Charles Sheeler, who was hired by Henry Ford to photograph the new Ford factory at River Rouge in the late 1920s (Fig. 452). Sheeler's precise task was to aestheticize Ford's plant. His photographs, which were immediately recognized for their artistic merit and subsequently exhibited around the world, were designed to celebrate industry. They revealed, in the smokestacks, conveyors, and iron latticework of the factory, a grandeur and proportion not unlike that of the great Gothic cathedrals of Europe.

Even when the intention is not to aestheticize the subject, as is often true in photojournalism, the power of the photograph will come from its ability to focus our attention on that from which we would normally avert our eyes. The impact of Eddie Adams's famous photograph of Brigadier General Nguygen Ngoc Loan summarily executing the suspected leader of a Vietcong commando unit in Saigon, South Vietnam, February 1, 1968 (Fig. 453), lies in its sheer matter-of-factness. The photograph not only records the immediacy of death and the cold, ruthless detachment of its agent, it is

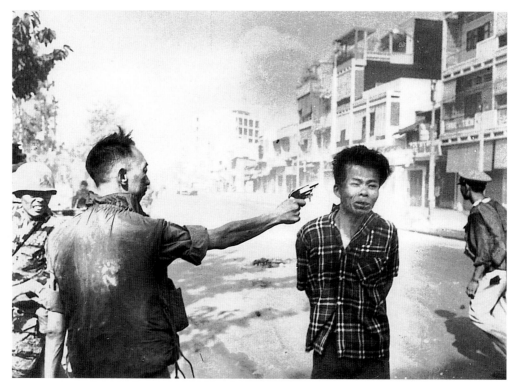

Fig. 453 Brigadier General Nguygen Ngoc Loan summarily executing the
suspected leader of a Vietcong commando unit, Saigon, South Vietnam, February 1, 1968.
AP/Wide World Photos.

unrelenting in its insistence on what might be called the "truth factor" of the photographic image. This *really* happened, and the photograph became, like Abraham Zapruder's film of John F. Kennedy's assassination or the television coverage of Jack Ruby shooting Lee Harvey Oswald, an icon of the political and moral ambiguity of the age.

Both Sheeler and Adams's photographs depend on much more sophisticated photographic equipment and film than was available to early practitioners like O'Sullivan. Since the day in 1888 when Kodak introduced the hand-held camera, the technological advances have been staggering. But technological advances have not effaced the medium's primary concern with the tension and distance between form and content—between the photographic object, which exists out of time in aesthetic space, and the real event, the content, which takes place in both historical time and actual space.

Talking about the ways in which he arrives at the photographic image, Henri Cartier-Bresson has described the relation between form and content in the following terms:

> We must place ourselves and our camera in the right relationship with the subject, and it is in fitting the latter into the frame of the viewfinder that the problems of composition begin. This recognition, in real life, of a rhythm of surfaces, lines, and values is for me the essence of photography. . . . We compose almost at the moment of pressing the shutter. . . . Sometimes one remains motionless, waiting for something to happen; sometimes the situation is resolved and there is nothing to photograph. If something should happen, you remain alert, wait a bit, then shoot and go off with the sensation of having got something. Later you can amuse yourself by tracing out on the photo the geometrical pattern, or spatial relationships, realizing that, by releasing the shutter at that precise instant, you had instinctively selected an exact geometrical harmony, and that without this the photograph would have been lifeless.

Thus, in looking at this photograph (Fig. 454), we can imagine Cartier-Bresson walking down a street in Athens, Greece, one day in

Fig. 454 Henri Cartier-Bresson, *Athens*, 1953.
Magnum Photos, Inc.

1953, and coming across the second-story balcony with its references to the classical past. Despite the doorways behind the balcony, the second story appears to be a mere facade. Cartier-Bresson stops, studies the scene, waits, and then spies two women walking up the street in his direction. They pass beneath the two female forms on the balcony above, and, at precisely that instant, he releases the shutter. Cartier-Bresson called this "the decisive moment." Later, in the studio, the parallels and harmonies between street and balcony, antiquity and the present moment, youth and age, white marble and black dresses, stasis and change—all captured in this photograph—become apparent to him, and he prints the image.

Fig. 455 Margaret Bourke-White, *At the Time of the Louisville Flood*, 1937.
Black-and-white photograph, *Life Magazine* ©TimePix.

These same conflicts between the ideal and the real animate Margaret Bourke-White's *At the Time of the Louisville Flood* (Fig. 455). Far less subtle than Cartier-Bresson's image, Bourke-White juxtaposes the dream of white America against the reality of black American lives. The dream is a flat, painted surface, the idealized space of the advertising billboard. In front of it, real people wait, indifferent in their hunger.

Bourke-White shot the scene in January 1937, on assignment for *Life* magazine. The Ohio River had flooded, inundating Louisville, Kentucky, and killing or injuring more than nine hundred people. Bourke-White flew into the city on the last flight before the airfield was flooded out. She hitchhiked on rowboats that were delivering food packages and searching for survivors. She shot photos of the churning river from a raft. *Life* ran *At the Time of the Louisville Flood* as its lead in a story featuring Bourke-White's photographs.

Life magazine, which started publication in November 1936, was conceived as a photojournalistic enterprise—heavy on pictures, light on words—and it became one of the primary outlets for American photography for the next thirty years. According to Bourke-White, it taught photographers an important lesson: "Pictures can be beautiful, but must tell facts too." Photographs have to balance form and content. But whatever *Life*'s emphasis on content, the

magazine still provided an enormous opportunity for creative work. "I could almost feel the horizon widening and the great rush of wind sweeping in," Bourke-White wrote of its arrival on the scene, "this was the kind of magazine that could be anything we chose to make it . . . everything we could bring to bear would be swallowed up in every piece of work we did."

Color Photography

Black-and-white photography lends itself so well to investigating the relation between opposites, in large part because, as a formal tool, it depends so much on the tension between black and white. In color photography, this formal tension is lost, but for many photographers, color creates more complex interplays between form and content. Early in his career, Joel Meyerwitz worked mostly in black-and-white, but since the mid-1970s, in a continuing series of photographs taken at Cape Cod, in Massachusetts, he has changed to color (Figs. 456 and 457). As he explained in 1977,

> When I committed myself to color exlusively, it was a response to a greater need for description. [Color] makes everything more interesting. Color suggests more things to look at, new subjects for me. Color suggests that light itself is a subject. In that sense, the work here on the Cape is about light. Look. Black and white taught me about a lot of interesting things. . . . Black and white shows how things look when they're stripped of color. We've accepted that that's the way things are in a photograph for a long time because that's all we could get. That's changed now. We have color and it tells us more. There's more content! The form for the content is more complex, more interesting to work with.

The sensibility here is very close to that of Claude Monet as he worked on the series of Grainstack paintings in the late 1880s and early 1890s. From picture to picture, the view remains the same, but the mood of the scene shifts as dramatically as the change from day to night and calm to storm.

Fig. 456 Joel Meyerwitz, *Bay/Sky,* 1984.
(B/S Plate 30). Courtesy of Joel Meyerwitz.

Fig. 457 Joel Meyerwitz, *Bay/Sky, Provincetown,* 1984.
(B/S Plate 8). Courtesy of Joel Meyerwitz.

The color shifts in these two Meyerwitz photographs are so subtle that only in seeing them side by side do we recognize the complexity of color that they reveal. In other photographs taken at Cape Cod, Meyerwitz takes advantage of more dynamic color contrasts, especially complementary color schemes that create much the same kind of tension that we

Fig. 458 Joel Meyerwitz, *Porch, Provincetown,* 1977.
(Lightning bolt, C/L Plate 7). Courtesy of Joel Meyerwitz.

discover in black-and-white work. In *Porch, Provincetown* (Fig. 458), the deep blue sky, lit up by a bolt of lightning, contrasts dramatically with the hot orange electric light emanating from the interior of the house. Here we have a perfect example of what Cartier-Bresson described as "the decisive moment." By releasing the shutter at this precise instant, Meyerwitz not only captures the contrasting colors of the scene, but he underscores the tension between the peacefulness of the porch and the wildness of the night in the contrast between the geometry of the house and the jagged line of the lightning bolt itself.

The rise of color photography in the 1960s coincides with the growing popularity of color television. On February 17, 1961, when NBC first aired all of its programs in color, only one

percent of American homes possessed color sets. By 1969, thirty-three percent of American homes had color TVs, and today they command almost one hundred percent of the market. The advent of the Polaroid camera and film and inexpensive color processing for Kodak film both contributed to a growing cultural taste for color images. In fact, the Polaroid SX-70 system, which offered instant processing in the camera, was quickly taken up by artists of all kinds as the perfect tool for experimenting with light and color. Lucas Samaras, a sculptor interested in manipulating commonplace objects and environments in order to disorient the viewer, quickly saw the potential of the SX-70 process. His series of *Photo Transformations* (Fig. 459) are self-portraits that explore almost every facet of his

personality, as if the camera captures a magical and Surrealist world beneath the surface of reality. In these works, his own image becomes the commonplace object that he transforms into something unique and strange.

Digital Photography

In the last few years, digital technologies have been introduced into the world of photography, rendering film obsolete and transforming photography into a highly manipulable medium. German photographer Andreas Gursky utilizes digital technologies to present his vision of a world dominated by high-tech industries who view the marketplace as the ultimate "image." By creating photographs as large as sixteen feet wide, Gursky immerses us in this corporate vision, a literal panorama of commerce. In *99 Cent* (Fig. 460), he saturates our view with a wild field of undeniably attractive color. As literally "full" as the image is, emotionally—and spiritually—it remains empty, a view into our own human isolation. Digitally, Gursky has eliminated all atmospheric perspective, and he has no doubt emphasized the color saturation of the scene,

Fig. 459 Lucas Samaras, *Photo Transformation*, 1974.
SX-70 Polaroid, 3 × 3 in. Photo: Ellen Page Wilson.
Photo Courtesy of PaceWildensteinMacGill.

but if the scene is technically "inauthentic," the viewer must ask just how "authentic" anything in the world of "99 Cent" shopping really is.

Fig. 460 Andreas Gursky, *99 Cent,* 1999.
Cibachrome print mounted on Plexiglass in artist's frame, 81½ × 132⅝ in. Collection: The Broad Art Foundation.

Fig. 461 Fernand Léger, *Ballet Mécanique*, 1924.
Courtesy The Humanities Film Collection,
Center for the Humanities, Oregon State University.
© 2003 Artists Rights Society (ARS), New York/ADAGP, Paris.

FILM

As we saw in Chapter 4, almost as soon as photography was invented, people sought to extend its capacities to capture motion. Eadweard Muybridge captured the locomotion of animals (Fig. 77) and Etienne-Jules Marey the locomotion of human beings (Fig. 78) in sequences of rapidly exposed photos. It was, in fact, the formal revelations of film that first attracted artists to it. As forms and shapes repeated themselves in time across the motion picture screen, the medium seemed to invite the exploration of rhythm and repetition as principles of design. In his 1924 film *Ballet Mécanique* (Fig. 461), the Cubist painter Fernand Léger chose to study a number of different images—smiling lips, wine bottles, metal discs, working mechanisms, and pure shapes such as circles, squares, and triangles. By repeating the same image again and again at separate points in the film, Léger was able to create a visual rhythm that, to his mind, embodied the beauty—the ballet—of machines and machine manufacture in the modern world.

Assembling a film, the process of editing, is a sort of linear collage, as the Léger plainly shows. Although the movies may seem true to life, as if they were occurring in real time and space, this effect is only an illusion, accomplished by means of the editing. **Editing** is the process of arranging the sequences of a film after it has been shot in its entirety. It is perhaps not coincidental that as film began to come into its own in the second decade of the twentieth century, collage, constructed by cutting and pasting together a variety of fragments, was itself invented.

The first great master of editing was D. W. Griffith who, in *The Birth of a Nation* (Fig. 462) essentially invented the standard vocabulary of filmmaking. Griffith desired to create visual variety in the film by alternating between and among a repertoire of **shots**, each one a continuous sequence of film frames. A **full shot** shows the actor from head to toe, a **medium shot** from the waist up, a **close-up** the head and shoulders, and an **extreme close-up** a portion of the face. The image of the battle scene reproduced here is a **long shot**, a shot that takes in a wide expanse and many characters at once. Griffith makes use of another of his techniques in this shot as well—the edge of

the film is blurred and rounded in order to focus the attention of the viewer on the scene in the center. This is called an **iris shot**.

Related to the long shot is the **pan**, a name given to the panoramic vista, in which the camera moves across the scene from one side to the other. Griffith also invented the **traveling shot**, in which the camera moves back to front or front to back. In editing, Griffith combined these various shots in order to tell his story. Two of his more famous editing techniques are cross-cutting and flashbacks. The **flashback**, in which the editor cuts to narrative episodes that are supposed to have taken place before the start of the film, is now standard in film practice, but it was an entirely original idea when Griffith first utilized it. **Cross-cutting** is an editing technique meant to create high drama. The editor moves back and forth between two separate events—such as someone in jeopardy and the hero fighting his way to the rescue—in ever shorter sequences, the rhythm of shots eventually becoming furiously paced. Griffith borrowed these techniques of fiction writing to tell a visual story in film.

One of the other great innovators of film editing was the Russian filmmaker Sergei Eisenstein. Eisenstein did his greatest work in Bolshevik Russia after the 1917 revolution, in a newly formed state whose leader, Vladimir Lenin, had said, "Of all the arts, for us the cinema is the most important." In this atmosphere, Eisenstein created what he considered a revolutionary new use of the medium. Rather than concentrating on narrative sequencing, he sought to create a shock in his film that would ideally lead the audience to perception and knowledge. He called his technique **montage**—the sequencing of widely disparate images to create a fast-paced, multifaceted image. In the famous "Odessa Steps Sequence" of his 1925 film *Battleship Potemkin,* four frames of which are reproduced here (Fig. 463), Eisenstein utilized 155 separate shots in four minutes and twenty seconds of film, an astonishing rate of 1.6 seconds per shot. The movie is based on the story of an unsuccessful uprising against the Russian monarchy in 1905, and the sequence depicts the moment when the crowd pours into the port city of Odessa's harbor to welcome the liberated ship *Potemkin.* Behind them, at the top of the steps leading down to the pier, sol-

Fig. 462 D. W. Griffith, battle scene from *The Birth of a Nation*, 1915.
Museum of Modern Art. Film Stills Archive.

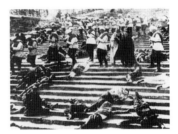
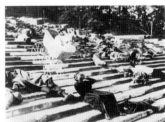

Fig. 463 (a–d) Sergei Eisenstein, *Battleship Potemkin*, 1925.
Goskino. Courtesy of The Kobal Collection.

diers appear, firing on the crowd. In the scene, the soldiers fire, a mother lifts her dead child to face the soldiers, women weep, a baby carriage careens down the steps. Eisenstein's "image" is all of these shots combined and more. "The strength of montage resides in this," he wrote, "that it involves the creative process—the emotions and mind of the spectator . . . assemble the image."

The thrust of Eisenstein's work is to emphasize action and emotion through enhanced time sequencing. Just the opposite

Fig. 464 Andy Warhol, film still from *Empire*, 1964
© 2003 The Andy Warhol Foundation for the Visual Arts/
Artists Rights Society (ARS), New York.

The Popular Cinema

However interesting Warhol's film might be on an intellectual level, it is not the kind of film that most audiences would appreciate. Audiences expect a narrative, or story, to unfold, characters with whom they can identify, and action that thrills their imaginations. In short, they want to be entertained. After World War I, American movies dominated the screens of the world like no other mass media in history, precisely because they entertained audiences so completely. And the name of the town where these entertainments were made became synonymous with the industry itself—Hollywood.

The major players in Hollywood were Fox and Paramount, the two largest film companies, followed by Universal and Metro-Goldwyn-Mayer (M-G-M). With the introduction of sound into the motion picture business in 1926, Warner Brothers came to the forefront as well. In addition, a few well-known actors, notably Douglas Fairbanks, Mary Pickford, and Charlie Chaplin, maintained control over the financing and distribution of their own work by forming their own company, United Artists. Their ability to do so, despite the power of the other major film companies, is testimony to the power of the **star** in Hollywood.

The greatest of these stars was Charlie Chaplin who, in his famous role of the tramp, managed to merge humor with a deeply sympathetic character who could pull the heartstrings of audiences everywhere. In *The Gold Rush* (Fig. 465), an eighty-minute film made in 1925, much of it filmed on location near Lake Tahoe in the Sierra Nevada mountains of California, he portrayed the abysmal conditions faced by miners working in the Klondike gold fields during the Alaska gold rush of 1898. One scene in this movie is particularly poignant—and astonishingly funny: together with a fellow prospector, Big Jim, a starving Charlie cooks and eats, with relish and delight, his old leather shoe.

The Gold Rush is a silent film, but a year after it was made, Warner Brothers and Fox were busy installing speakers and amplification systems in theaters as they perfected competing sound-on-film technologies. On October 6, 1927, the first words of synchronous speech

effect is created by Andy Warhol. Warhol equates, in the words of one critic, "reel" time with "real" time. Many of Warhol's films are the visual equivalent of John Cage's *4'33"* (discussed in the last chapter in connection with performance art), which consists of four minutes and thirty-three seconds of silence. In *Empire* (1964) (Fig. 464), Warhol filmed the Empire State Building for eight straight hours, through the afternoon and evening, with a stationary camera set up on the 44th floor of the Time-Life building. To view either film is to understand the idea of *duration* in terms one might never before have experienced. In a darkened theater, where there is relatively little other visual stimulus, the viewer's attention is soon drawn beyond the screen to other elements in the surrounding environment. The slightest movement or sound in the theater becomes interesting in itself. The drama in these films, in fact, lies in the audience's reaction in real time to the monotony of the image.

uttered by a performer in a feature film were spoken by Al Jolson in *The Jazz Singer*: "Wait a minute. Wait a minute. You ain't heard nothing yet." By 1930, the conversion to sound was complete.

For the next decade, the movie industry produced films in a wide variety of **genres**, or narrative types—comedies, romantic dramas, war films, horror films, gangster films, and musicals. By 1939, Hollywood had reached a zenith. Some of the greatest films of all time date from that year, including the classic western *Stagecoach*, starring John Wayne, *Gone with the Wind*, starring Vivien Leigh and Clark Gable, and *Mr. Smith Goes to Washington*, starring Jimmy Stewart. But perhaps the greatest event of the year was the arrival of twenty-four-year-old Orson Welles in Hollywood. Welles had made a name for himself in 1938 when a Halloween night radio broadcast of H. G. Wells's novel *War of the Worlds* convinced many listeners that Martians had invaded New Jersey. Gathering the most talented people in Hollywood around him, he produced, directed, wrote, and starred in *Citizen Kane*, the story of a media baron modeled loosely on newspaper publisher William Randolph Hearst. Released in 1941 to rave reviews, the film utilized every known trick of the filmmaker's trade, with high-angle and low-angle shots (Fig. 466), a wide variety of editing effects, including dissolves between scenes, and a narrative technique, fragmented and consisting of different points of view, unique to film at the time. All combined to make a work of remarkable total effect that still stands as one of the greatest achievements of American popular cinema.

The year 1939 also marked the emergence of color as a major force in the motion picture business. The first successful full-length Technicolor film had been *The Black Pirate*, starring Douglas Fairbanks, released in 1926, but color was considered an unnecessary ornament, and audiences were indifferent to it. With the release of *Gone with the Wind*, however, with its four hours of color production, audiences reacted differently. And when, in the *Wizard of Oz* (Fig. 467), Dorothy arrives in a full-color Oz, having been carried off by a tornado from a black-and-white Kansas, the magical transformation of color became stunningly evident.

Fig. 465 Charlie Chaplin, in *The Gold Rush*, 1925.
United Artists. Courtesy The Kobal Collection.

Fig. 466 Orson Welles as Kane campaigning for governor, in *Citizen Kane*, 1941.
RKO. Courtesy The Kobal Collection.
CITIZEN KANE © Turner Entertainment Co. All Rights Reserved.

Fig. 467 Judy Garland, as Dorothy, sees the yellow brick road in *The Wizard of Oz*, 1939. MGM/Courtesy Kobal.
The Wizard of Oz © 1939 Turner Entertainment Co. All Rights Reserved.

Fig. 468 Five stills from "The Sorcerer's Apprentice," in *Fantasia*, 1940.
© Disney Enterprises, Inc.

Meanwhile, Walt Disney had begun to create feature-length animated films in full color. The first was *Snow White and the Seven Dwarfs*, in 1937, which was followed, in 1940, by both *Pinocchio* and *Fantasia* (Fig. 468). **Animation**, which means "bringing to life," was suggested to filmmakers from the earliest days of the industry when it became evident that film itself was a series of "stills" animated by their movement in sequence. Obviously, one could draw these stills as well as photograph them. But in order for motion to appear seamless, and not jerky, literally thousands of drawings need to be executed for each film, up to twenty-four per second of film time. "The Sorcerer's Apprentice" section of *Fantasia* was conceived as a vehicle to reinvigorate the stock Disney cartoon character of Mickey Mouse. Donning the sorcerer's cap, Mickey commands a broom to do all his work for him, and the Disney animators soon multiplied and accelerated the broom's every move into a virtual army of whirling dervishes. As a film, *Fantasia* is itself an experiment in animation, an anthology of human fantasy freed of the constraints of reality, somewhat more successful than the experiment of the sorcerer's apprentice.

In the years after World War II, the idea of film as a potential art form resurfaced, especially in Europe. Fostered in large part by international film festivals, particularly in Venice and Cannes, this new "art cinema" brought directors to the fore, seeing themselves as the *auteurs*, or "authors," of their works. Chief among these was the Italian director Federico Fellini, whose film about the decadent lifestyle of 1960s Rome, *La Dolce Vita*, earned him an international reputation. Close on his heels was the Swedish director Ingmar Bergman and the French "New Wave" directors Jean-Luc Godard and Alain Resnais. By the end of the 1960s, Hollywood had lost its hold on the film industry, and most films had become international productions.

A famous example is the first English-language film by the Italian director Michelangelo Antonioni, *Blow-Up*, winner of the 1966 Cannes Film Festival. It is the story of a fashion photographer, played by David Hemmings, who in processing a series of photographs he has taken in a London park becomes convinced that he has unwittingly recorded a mur-

der. He blows up his photographs into larger and larger images (Fig. 469), hoping to see a mysterious figure off in the woods holding, he thinks, a gun, but as he blows up the photographs, they are reduced to abstract patterns of dots. The movie is, in essence, an essay on the "truth" of photography.

In the late 1970s, Hollywood regained its control of the popular cinema with the unqualified success of George Lucas's *Star Wars* (Fig. 470) in 1977. In many ways an anthology of stunning special effects, the movie had made over $200 million even before its highly successful twentieth-anniversary re-release in 1997, and it inaugurated an era of "blockbuster" Hollywood attractions, including *E.T.*, *Titanic*, and *Harry Potter and the Sorcerer's Stone*.

Fig. 469 David Hemmings as the photographer, in *Blow-Up*, directed by Michelangelo Antonioni, 1966.

Fig. 470 *Star Wars: Episode IV–A New Hope*, directed by George Lucas, 1977.

Fig. 471 Nam June Paik, *TV Buddha*, 1974–1982.
Mixed media, 55 × 115 × 36 in. Photo: Peter Moore ©Estate of Peter Moore/Licensed by VAGA, New York, NY.

VIDEO

One of the primary difficulties faced by artists who wish to explore film as a medium is the sheer expense of using it. The more sophisticated a film is in terms of its camera work, lighting, sound equipment, editing techniques, and special effects, the more expensive it is to produce. With the introduction in 1965 of the relatively inexpensive hand-held video camera, the Sony Portapak, artists were suddenly able to explore the implications of seeing in time. Video is not only cheaper than film but it is also more immediate—that is, what is seen on the recorder is simultaneously seen on the monitor. While **video art** tends to exploit this immediacy, commercial television tends to hide it, by attempting to make videotaped images look like film.

Nam June Paik, originally a member of the Fluxus group (see p. 318), was one of the first people in New York to buy a Portapak. Since the late 1950s, he has been making video installations, exploring the limits and defining characteristics of the medium. His *TV Buddha* (Fig. 471), for example, perpetually contemplating itself on the screen, is a self-contained version of Warhol's exercises in filmic duration. The work is deliberately and playfully ambiguous. It includes an inanimate stone sculpture shown "live" on TV. It is both peacefully meditative and mind-numbingly boring, simultaneously an image of complete wholeness and absolute emptiness. It represents, in short, the best and worst of TV.

The playfulness that Paik employs in *TV Buddha* is equally evident in the wordplay that underlies his *TV Bra for Living Sculpture* (Fig. 472), a literal realization of the "boob tube." The piece is a collaborative work, executed with the avant-garde musician Charlotte Moor-

man. Soon after Paik's arrival in New York in 1964, he was introduced to Moorman by the composer Karlheinz Stockhausen. Moorman wanted to perform a Stockhausen piece called *Originale*, but the composer would grant permission only if it was done with the assistance of Paik, who had performed the work many times. Paik's role was to cover his entire head with shaving cream, sprinkle it with rice, plunge his head into a bucket of cold water, and then accompany Moorman's cello on the piano as if nothing strange had occurred. So began a long collaboration. Like all of Paik's works, *TV Bra's* humor masks a serious intent. For Paik and Moorman, it was an attempt "to humanize the technology . . . and also stimulate viewers . . . to look for new, imaginative, and humanistic ways of using our technology." *TV Bra*, in other words, is an attempt to rescue the boob tube from mindlessness.

The clichéd mindlessness of commercial television has been hilariously investigated in a vast number of short videos by William Wegman. In one, called *Deodorant*, the artist simply sprays an entire can of deodorant under one armpit while he extols its virtues. The video, which is about the same length as a normal television commercial, is an exercise in consumerism run amok. In *Rage and Depression* (Fig. 473), Wegman sits smiling at the camera as he speaks the following monologue:

> *I had these terrible fits of rage and depression all the time. It just got worse and worse and worse. Finally my parents had me committed. They tried all kinds of therapy. Finally they settled on shock. The doctors brought me into this room in a straight jacket because I still had this terrible, terrible temper. I was just the meanest cuss you could imagine and when they put this cold, metal electrode, or whatever it was, to my chest, I started to giggle and then when they shocked me, it froze on my face into this smile and even though I'm still incredibly depressed—everyone thinks I'm happy. I don't know what I'm going to do.*

Wegman completely undermines the authority of visual experience here. What our eyes see is an illusion. He implies that we can never trust what we see, just as we should not trust television's objectivity as a medium.

Fig. 472 Nam June Paik,
TV Bra for Living Sculpture, 1969.
Performance by Charlotte Moorman with television sets and cello.
Photo: Peter Moore © The Estate of Peter Moore/
Licensed by VAGA, New York, NY.

Fig. 473 William Wegman,
Still from *Rage and Depression*, Reel 3, 1972–1973.
Video, approx. 1 min. Courtesy of the artist.

Bill Viola's The Greeting

When video artist Bill Viola first saw a reproduction of Jacopo Pontormo's 1528 painting *The Visitation* (Fig. 475), he knew that he had to do something with it. Asked to be the American representative at the 1995 Venice Biennale, perhaps the oldest and most prestigious international arts festival, he decided to see if he could create a piece based on Pontormo's painting for the exhibition. He intended to convert the entire United States Pavilion into a series of five independent video installations, which he called, as a whole, "Buried Secrets." By "buried secrets" he meant to refer to our emotions, which have for too long lain hidden within us. "Emotions," he says, "are precisely the missing key that has thrown things out of balance, and the restoration to their right place as one of the higher orders of the mind of a human being cannot happen fast enough."

What fascinated Viola about Pontormo's painting was, first of all, the scene itself. Two women meet each other in the street. They embrace as two other women look on. An instantaneous knowledge and understanding seems to pass between their eyes. The visit, as told in the Bible by Luke (I:36–56), is of the Virgin Mary to Elizabeth. Mary has just been told by the angel Gabriel: "You shall conceive and bear a son, and you shall give him the name Jesus," the moment of the Annunciation. In Pontormo's painting, the two women, one just pregnant with Jesus, the other six months pregnant, after a lifetime of barrenness, with the child who would grow to be John the Baptist, share each other's joy. For Viola, looking at this work, it is their shared intimacy—that moment of contact in which the nature of their relationship is permanently changed—that most fascinated him. Here was the instant when we leave the isolation of ourselves and enter into social relations with others. Viola decided that he wanted to recreate this encounter, to try and capture in a medium such as film or video—media that can depict the passing of time—the emotions buried in the moment of greeting itself.

Fig. 474 Bill Viola, sketch for *The Greeting Set*, 1995.
Courtesy of Bill Viola Studio.

In order to re-create the work, Viola turned his attention to other aspects of the composition. He was particularly interested in how the piece depicted space. There seemed to him to be a clear tension between the deep space of the street behind the women and the space occupied by the women themselves. He made a series of sketches of the hypothetical street behind the women (Fig. 474); then, working with a set designer, recreated it. The steep, odd perspective of the buildings had to fit into a twenty-foot-deep sound stage. He discovered that if he filled the foreground with four women, as in the Pontormo painting, much of the background

Fig. 475 Jacopo da Pontormo, *The Visitation*, 1528.
Oil on canvas, 79½ × 61⅜ in. Pieve di S. Michele, Carmignano, Italy.
©Canali Photobank, Capriolo, Italy.

Fig. 476 Bill Viola, *The Greeting*, 1995.
Video/sound installation exhibition, *Buried Secrets*.
United States Pavilion, Venice Biennale 1995
commissioner, Marilyn Zeitlin. Arizona
State University Art Museum, Tempe, Arizona.
© Bill Viola Studio. Photo: Roman Mensing.

would be lost. Furthermore, the fourth woman in the painting presented dramatic difficulties. Removed from the main group as she is, there was really little for her to do in a re-creation of the scene involving live action.

A costume designer was hired; actors auditioned and then rehearsed. On Monday, April 3, 1995, on a sound stage in Culver City, California, Viola shot *The Greeting*. He had earlier decided to shoot the piece on film, not video, because he wanted to capture every nuance of the moment. On an earlier project, he had utilized a special high-speed 35-millimeter camera that was capable of shooting an entire role of film in about forty-five seconds at a rate of 300 frames per second. The camera was exactly what he needed for this project. The finished film would run for over ten minutes. The action it would record would last for forty-five seconds.

"I never felt more like a painter," Viola says of the piece. "It was like I was moving

color around, but on film." For ten slow-motion minutes, the camera never shifts its point of view. Two women stand talking on a street, and a third enters from the left to greet them. An embrace follows (Fig. 476).

Viola knew, as soon as he saw the unedited film, that he had what he wanted, but questions still remained. How large should he show the piece? On a table monitor, or larger-than-life size, projected on a wall? He could not decide, but at the last minute decided to project it. On the day of the Venice Biennale opening, he saw it in its completed state for the first time, and for the first time since filming it, he saw it with the other key element in video—sound. It seemed complete as it never had before. Gusts of wind echo through the scene. Then the woman in red leans across to the other and whispers, "Can you help me? I need to talk with you right away." Joy rises to their faces. Their emotions surface. The wind lifts their dresses, and they are transformed.

Fig. 477 Bruce Nauman,
Live/Taped Video Corridor and Performance Corridor, 1968–1970.
Video installation. Collection of Giuseppe Panza di Biumo, Milan.
© 2003 Bruce Nauman/Artists Rights Society (ARS), New York/ADAGP, Paris.

In *Live/Taped Video Corridor and Performance Corridor* (Fig. 477), artist Bruce Nauman mounted a closed-circuit video camera on the ceiling of a narrow corridor and placed two TV monitors at its end. In the top monitor, a video tape of the empty corridor continually plays; in the bottom one, viewers watch themselves enter the space. The act of entering disrupts the empty corridor and the black screen. It is as if the viewer becomes a performer in front of the camera, committing an act of aggression upon the space.

Video art has been used with particular effectiveness in installations such as Nauman's. At the end of Chapter 8, we discussed a video installation by Bill Viola to sum up the ways in which all the formal elements come into play (Figs. 225 & 226). Another of his installations, *Stations* (Fig. 478), consists of five video projections focusing on the human body submerged in water. Five cloth screens, three of which are visible in this reproduction, are suspended from the ceiling of a large, dark open space. A polished granite slab lies flat on the floor underneath each screen. The projections of the floating bodies are upside down, causing their reflections on the polished granite below to appear rightside up. Underwater sounds can be heard near each screen. The images slowly

Fig. 478 Bill Viola, *Stations,* 1994.
Video/sound installation. Commissioned by the Bohen Foundation for the inaugural opening of the American Center, Paris.
© Bill Viola Studio. Photo by Charles Duprat.

drift out of the frame and then, suddenly, plunge into the water. Water, for Viola, is a kind of tangible space. In it, the body's relation to space becomes clear. The piece strips away the viewer's sense of gravity. Nothing is what it seems here. The reflecting pools are granite, up becomes down, to fall is to rise. The installation positions us somewhere between the dream state, our memory of birth, and the soul's flight from the body after death.

In his video installation *Crux* (Figs. 479 and 480), made in the mid-1980s, Gary Hill transforms the traditional imagery of the Crucifixion. The installation consists of five television monitors mounted on a wall in the shape of a cross. Hill shot the piece on a deserted island in the middle of the Hudson River in New York. Attached to his body were five video cameras, one on each shin facing his feet, one braced in front of his face and pointed directly back at him, and one on each arm aimed at his hands, which he extended out from his body. On his back, he carried all the necessary recording equipment and power packs. The cameras recorded his barefooted

trek across the island, through the woods and an abandoned armory, to the river's edge. The twenty-six-minute journey captures all the agony and pain of Christ's original ascent of Golgotha, as he carried his own cross to the top of the hill where he was crucified. But all we see of Hill's walk are his two bruised and stumbling feet, his two hands groping for balance, and his exhausted face. The body that connects them is absent, a giant blank spot on the gallery wall. This absence not only suggests the disappearance of Christ's body after the Resurrection, but it is also the "crux" of the title. A "crux" is a cross, but it is also a vital or decisive point ("the crux of the matter"), or something that torments by its puzzling nature. By eliminating his body, Hill has discovered a metaphor for the soul—that puzzling energy which is spiritually present but physically absent.

As forms of art, film and video are not the same as the movies and television. Film and video art seek to do more than merely entertain. They seek to discover new possibilities in their mediums, to transcend, in fact, the limitations inherent in producing work for the

Fig. 479 Gary Hill, *Crux*, 1983–1987.
Five-channel video/sound installation. Five color monitors, five-channel synchronizer, three amplifiers, five speakers, five laser disk players, and five laser disks.
Full installation shot by Mark B. McLoughlin. Courtesy Donald Young Gallery, Chicago.

Fig. 480 Gary Hill, *Crux*, 1983–1987.
Five-channel video/sound installation.
Five color monitors, five-channel synchronizer, three amplifiers, five speakers, five laser disk players, and five laser disks.
Production shot at
Bannerman's Island by Ularn Curjel.
Courtesy Donald Young Gallery, Chicago.

Fig. 481 Sakino Hokusai, *Shunshuu Ejiri,* from the series *Thirty-Six Views of Mount Fuji,* 1831.
Oban yoko. The Japan Uklyoe Museum.

corporate film industry and the commercial networks. Photography, too, has its commercial and journalistic side. It is an inherently informational medium, but it transcends that limitation—its ability to record the facts—by presenting its content in a formally beautiful or interesting way. Obviously, there are great commercial and journalistic photographs just as there are great commercial films and even television shows. But what separates the *art* of photography, film, and video from mainstream production is the *aesthetic* sense. When a photograph or a film or a video triggers a higher level of thought and awareness in the viewer, when it stimulates the imagination, then it is a work of art.

THE CRITICAL PROCESS
Thinking About the Camera Arts

Jeff Wall's *A Sudden Gust of Wind* (Fig. 482) is a large, back-lit photographic image modeled on a nineteenth-century Japanese print by Hokusai, *Shunshuu Ejiri* (Fig. 481), from the series *Thirty-Six Views of Mount Fuji,* which also includes *The Great Wave of Kanagawa* (Fig. 251). Wall's interest lies, at least in part, in the transformations contemporary culture has worked on traditional media. Thus his billboard-like photograph creates a scene radically different from the original. What sorts of transformations can you describe? Con-

Fig. 482 Jeff Wall, *A Sudden Gust of Wind (After Hokusai),* **1993.**
Fluorescent light and display case 90³/₁₆ in. × 148⁷/₁₆ in. Tate Gallery, London/Art Resource, New York.

sider, first of all, the content of Wall's piece. What does it mean that businessmen inhabit the scene rather than Japanese in traditional dress? How has the plain at Ejiri—considered one of the most beautiful locations in all of Japan—been translated by Wall? And though Hokusai indicates Fuji with a simple line drawing, why has Wall eliminated the mountain altogether? (Remember, Fuji is, for the Japanese, a national symbol, and is virtually held in spiritual reverence.)

But perhaps the greatest transformation of all is from the print to the photograph. Wall's format, in fact, is meant to invoke cinema, and the scene is anything but the result of some chance photographic encounter. Wall employed professional actors, staged the scene carefully, and shot it over the course of nearly five months. The final image, in fact, consists of fifty separate pieces of film spliced together through digital technology to create a completely artificial but absolutely realistic scene. For Wall, photography has become "the perfect synthetic technology," as conducive to the creation of propaganda as art. What is cinematic about this piece? What does this say about the nature of film as a medium—not only photographic film but motion picture film? Where does "truth" lie? Can we—indeed, should we—trust what we see? If we can so easily create "believeable" imagery, what are the possibilities for belief itself? And, perhaps most important of all, why must we, engaged in the critical process, consider not just the image itself, but the way the image is made, the artistic process?

Fig. 483 Philip Johnson and John Burgee, College of Architecture, University of Houston, 1983–1985.
Photo: Richard Payne, FAIA.

The Visual Arts
in Everyday Life
RECOGNIZING THE ART OF DESIGN

CHAPTER 16

ARCHITECTURE

TOPOGRAPHY

TECHNOLOGY
Load-bearing Construction
Post-and-Lintel
Arches and Domes
Cast-iron Construction
Frame Construction
Steel-and-Reinforced-Concrete Construction

WORKS IN PROGRESS
Frank Lloyd Wright's *Fallingwater*

COMMUNITY LIFE

WORKS IN PROGRESS
Mierle Laderman Ukeles's *Fresh Kills Landfill Project*

THE CRITICAL PROCESS
Thinking about Architecture

The building that houses the College of Architecture at the University of Houston (Fig. 483), designed by architects Philip Johnson and John Burgee, is a sort of history of Western architecture from the Greeks to the present. Resting on its top is a Greek temple. The main building below is reminiscent of Italian country villas of the Renaissance. The entire building was inspired by an eighteenth-century plan for a House of Education designed by Claude-Nicolas Ledoux (Fig. 484) for a proposed utopian community at Chaux, France, that never came into being. And the building

Fig. 484 Claude-Nicolas Ledoux, House of Education, 1773–1779.
Courtesy of The Library of Congress.

Fig. 485 Philip Johnson and John Burgee, College of
Architecture, University of Houston, interior, 1983–1985.
Photo: Richard Payne, FAIA.

itself is distinctly postmodern in spirit—it revels in a sense of discontinuity between its parts. One has the feeling that the Greek temple fits on the building's roof about as well as a maraschino cherry would on a scoop of potato salad.

In this chapter, we will consider how our built environment has developed—how we have traveled, in effect, from Greek temples and Anasazi cliff dwellings to skyscrapers and postmodernist designs. We will see that the "look" of our buildings and our communities depends on two different factors and their interrelation—**topography**, or the distinct landscape characteristics of the local site, and **technology**, the materials and methods available to a given culture. Johnson and Burgee's design for the College of Architecture at the University of Houston takes advantage of many of the technologies developed over the centuries, but at first glance, it seems to ignore the local topography altogether. However, when we consider its interior (Fig. 485), we can see that the cool atrium space that lies under the colonnade on the roof offers a respite from the hot Texas sun. The site has had a considerable influence on the design. Thus the key to understanding and appreciating architecture always involves both technology and topography. We will consider topography first.

TOPOGRAPHY

The built environment reflects the natural world and the conception of the people who inhabit it of their place within the natural scheme of things. A building's form might echo the world around it, or it might contrast with it—but, in each case, the choices builders make reveal their attitudes toward the world around them.

The architecture of the vast majority of early civilizations was designed to imitate natural forms. The significance of the pyramids of Egypt (Fig. 486) is the subject of much debate, but their form may well derive from the image of the god Ra, who in ancient Egypt was symbolized by the rays of the sun descending to earth. A text in one pyramid reads: "I have trodden these rays as ramps under my feet." As

Fig. 486 Pyramids of Mycerinus (c. 2470 B.C.E.), Chephren (c. 2500 B.C.E.), and Cheops (c. 2530 B.C.E.).
Original height of Pyramid of Cheops 480 ft., length of each side at base 755 ft. SuperStock, Inc.

one approached the mammoth pyramids, covered in limestone to reflect the light of the sun, the eye was carried skyward to Ra, the Sun itself, who was, in the desert, the central fact of life. In contrast, the pyramidlike structures of Mesopotamia, known as **ziggurats** (Fig. 487), are flatter and wider than their Egyptian counterparts, as if imitating the shape of the foothills that lead up to the mountains. The Sumerians believed that the mountaintops were not only the source of precious water, but the dwelling place of the gods. The ziggurat was constructed as an artificial mountain in which a god could reside.

Fig. 487 Ziggurat, Ur, c. 2100 B.C.E.
Fired brick over mudbrick core, 210 × 150 ft. at base. Hirmer Fotoarchive.

Fig. 488 Mesa Verde, Spruce Tree House, c. 1200–1300 C.E.
Courtyard formed by restoration of the roofs over two underground kivas. John Deeks/Photo Researchers, Inc.

The Anasazi cliff dwelling known as Spruce Tree House (Fig. 488), at Mesa Verde National Park in southwestern Colorado, reflects a similar relation between humans and nature. The Anasazi lived in these cliffside caves for hundreds, perhaps thousands, of years. The cave not only provided security, but to live there was to be closer to the people's origin and, therefore, to the source of their strength. For unknown reasons, the Anasazi abandoned their cliff dwellings in about 1300 C.E. One possible cause was a severe drought that lasted from 1276 to 1299. It is also possi-

ble that disease, a shortened growing season, or warfare with Apache and Shoshone tribes caused the Anasazi to leave the highland mesas and migrate south into Arizona and New Mexico.

At the heart of the Anasazi culture was the **kiva**, a round, covered hole in the center of the communal plaza in which all ceremonial life took place. The roofs of two underground kivas on the north end of the ruin have been restored. They are constructed of horizontally laid logs built up to form a dome with an access hole (Fig. 489). The people utilized these roofs as a common area. Down below, in the enclosed kiva floor, was a *sipapu,* a small, round hole symbolic of the Anasazi creation myth, which told of the emergence of the Anasazi's ancestors from the depths of the earth. In the parched Southwestern desert country it is equally true that water, like life itself, also seeps out of small fissures in the earth. Thus, it is as if the entire Anasazi community, and everything necessary to its survival, emerges from mother earth.

Fig. 489 Cribbed roof construction of a kiva.
After a National Park Service pamphlet.

TECHNOLOGY

The structure of the kiva's roof represents a technological innovation of the Anasazi culture. Thus, while it responds directly to the topography of the place, it also reflects the *technology* available to the builder. The basic technological challenge faced by architecture is to construct upright walls and put a roof over the empty space they enclose. Walls may employ one of two basic structural systems: the **shell system**, in which one basic material provides both the structural support and the outside covering of the building, and the **skeleton-and-skin** system, which consists of a basic interior frame, the skeleton, that supports the more fragile outer covering, the skin.

In a building that is several stories tall, the walls or frame of the lower floors must also support the weight of the upper floors. The ability of a given building material to support weight is thus a determining factor in how high the building can be. The walls or frame also support the roof. The span between the elements of the supporting structure—between, for instance, stone walls, columns, or steel beams—is determined by the tensile strength of the roof material. **Tensile strength** is the ability of a building material to span horizontal distances without support and without buckling in the middle. The greater the tensile strength of a material, the wider its potential span. Almost all technological advances in the history of architecture depend on either the invention of new ways to distribute weight or the discovery of new materials with greater tensile strength. We begin our survey with the most basic technology and move forward to the most advanced.

Load-bearing Construction

The simplest method of making a building is to make the walls **load-bearing**—make the walls themselves bear the weight of the roof. One does this by piling and stacking any material—stones, bricks, mud and straw—right up to roof level. Many load-bearing structures, such as the pyramids or the ziggurats we have already seen, are solid almost all the way through, with only small open chambers inside them. Though the Anasazi cliff dwelling contains more livable space than a pyramid or a

ziggurat, it too is a load-bearing construction. The kiva is built of adobe bricks—bricks made of dried clay—piled on top of one another, and the roof is built of wood. The complex roof of the kiva spans a greater circumference than would be possible with just wood, and it supports the weight of the community in the plaza above. This is achieved by the downward pressure exerted on the wooden beams by the stones and fill on top of them above the outside wall, which counters the tendency of the roof to buckle.

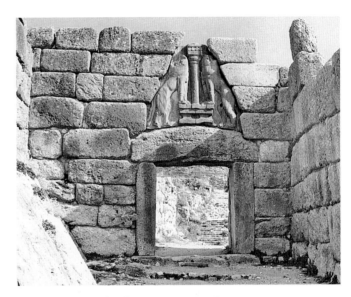

Fig. 490 The Lion Gate, Mycenae, Greece, 1250 B.C.E.
Hirmer Fotoarchiv.

Post-and-Lintel

The walls surrounding the Lion Gate at Mycenae in Greece (Fig. 490) are load-bearing construction. But the gate itself represents another form of construction, post-and-lintel. **Post-and-lintel construction** consists of a horizontal beam supported at each end by a vertical post or a wall. In essence, the downward force of the horizontal bridge holds the vertical posts in an upright position, and conversely, the posts support the stone above in a give-and-take of directional force and balance. So large are the stones used to build this gate—both the length of the **lintel** and the total height of the post-and-lintel structure are roughly thirteen feet—that later Greeks believed it could only have been built by the mythological race of one-eyed giants, the Cyclops.

Post-and-lintel construction is fundamental to all Greek architecture. As can be seen in the Basilica at Paestum (Fig. 491), the columns, or posts, supporting the structure were placed relatively close together. This was done for a practical reason: If stone lintels, especially of marble, were required to span too great a distance, they were likely to crack and eventually collapse. Each of the columns in the Basilica is made of several pieces of stone, called *drums*. Grooves carved in the stone, called **fluting**, run the length of the column and unite the individual drums into a single unit. Each column tapers dramatically toward the top and slightly toward the bottom, an architectural feature known as **entasis**. Entasis deceives the eye and makes the column look absolutely vertical. It also gives the column a sense of almost human musculature and strength. The columns suggest the bodies of human beings, holding up the roof like miniature versions of the giant Atlas, who carried the world on his shoulders.

The values of the Greek city-state were embodied in its temples. The temple was usually situated on an elevated site above the city—an *acropolis*, from *akros*, meaning "top," of the *polis*, "city"—and was conceived as the center of civic life. Its **colonnade**, or row of columns set at regular intervals around the building and supporting the base of the roof, was constructed according to the rules of geometry and embodied cultural values of equality and proportion. So consistent were the Greeks in developing a generalized architectural type for their temples that it is possible to speak of them in terms of three distinct architectural types—the Doric, the Ionic, and the Corinthian, the last of which was rarely used by the Greeks themselves but later became the standard order in Roman architecture (Fig. 492). In ancient times, the heavier Doric order was considered masculine, and the more graceful Ionic order feminine. It is true that the Ionic order is slimmer and much lighter in feeling than the Doric.

Fig. 491 Corner of the Basilica, Paestum, Italy, c. 550 B.C.E.
Canali Photobank.

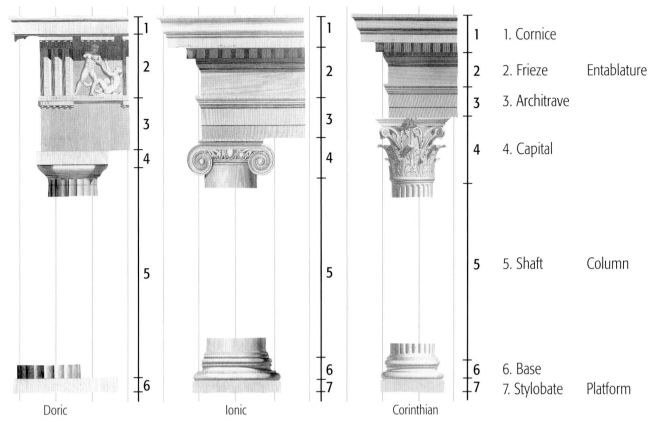

1. Cornice	
2. Frieze	Entablature
3. Architrave	
4. Capital	
5. Shaft	Column
6. Base	
7. Stylobate	Platform

Doric Ionic Corinthian

Fig. 492 The Greek orders, from James Stuart, *The Antiquities of Athens*, London, 1794.
Courtesy of The Library of Congress.

The vertical design, or **elevation**, of the Greek temple is composed of three elements—the **platform**, the **column**, and the **entablature**. The relationship among these three units is referred to as its **order**. The Doric, the earliest and plainest of the three, is utilized in the Basilica at Paestum. The Ionic is later, more elaborate, and organic, while the Corinthian is more organic and decorative still. The elevation of each order begins with a platform, the **stylobate**. The column in the Doric order consists of two parts, the **shaft** and the **capital**, to which both the Ionic and Corinthian orders add a base. The orders are most quickly distinguished by their capitals. The Doric capital is plain, marked only by a subtle outward curve. The Ionic capital is much more elaborate and is distinguished by its scroll. The temple of Athena Nike (Fig. 493) is the oldest Ionic temple on the Acropolis in Athens. The Corinthian capital is decorated with stylized acanthus leaves. The entablature consists of three parts, the **architrave**, or weight-bearing and weight-distributing element, the decorated **frieze**, and the **cornice**.

Fig. 493 Temple of Athena Nike, Acropolis, Athens, 427–424 B.C.E.
Vanni/Art Resource, New York.

Arches and Domes

The geometrical order of the Greek temple suggests a conscious desire to control the natural world. So strong was this impulse that their architecture seems defiant in its belief that the intellect is superior to the irrational forces of nature. We can read this same impulse in Roman architecture—the will to dominate the site. Though the Romans made considerable use of colonnades—rows of columns—they also perfected the use of the arch (Fig. 494), an innovation that revolutionized the built environment. They recognized that the arch would allow them to make structures with a much larger span than was possible with post-and-lintel construction. Made of wedge-shaped stones, called *voussoirs,* each cut to fit into the semicircular form, an arch is not stable until the **keystone**, the stone at the very top, has been put into place. At this point, equal pressure is exerted by each stone on its neighbors, and the scaffolding that is necessary to support the arch while it is under construction can be removed. The arch supports itself, with the weight of the whole transferred downward to the posts. A series of arches could be made to span a wide canyon with relative ease. One of the most successful Roman structures is the Pont du Gard (Fig. 495) , an aqueduct used to carry water from the distant hills to the Roman

Fig. 494 Arch.

Fig. 495 Pont du Gard, near Nîmes, France. Late 1st century B.C.E.
Joelle Burrows.

Fig. 496 Barrel vault (top) and groined vault (bottom) construction.

Fig. 497 The Colosseum (aerial view), Rome, 72–80 C.E.
Italian Government Travel Office.

Fig. 498 Barrel-vaulted gallery, ground floor of the Colosseum, Rome.
Scala/Art Resource.

compound in Nîmes, France. Still intact today, it is an engineering feat remarkable not only for its durability, but, like most examples of Roman architecture, for its incredible size.

With the development of the **barrel**, or *tunnel vault* (Fig. 496, top), which is essentially an extension in depth of the single arch by lining up one arch behind another, the Romans were able to create large, uninterrupted interior spaces. The strength of the vaulting structure of the Roman Colosseum (Figs. 497 and 498) allowed more than fifty thousand spectators to be seated in it. The Colosseum is an example of an *amphitheater* (literally meaning a "double theater"), in which two semicircular theaters are brought face to face, a building type invented by the Romans to accommodate large crowds. Built for gladiatorial games and other "sporting" events, including mock naval battles and fights to the death between humans and animals, the Colosseum is constructed both with barrel vaults and with **groined vaults** (Fig. 496, bottom), the latter created when two barrel vaults are made to meet at right angles. These vaults were made possible by the Roman invention of concrete. The Romans discovered

that if they added volcanic aggregate, such as that found near Naples and Pompeii, to the concrete mixture, it would both set faster and be stronger. The Colosseum is constructed of these concrete blocks, held together by metal cramps and dowels. They were originally covered with stone and elaborate stucco decorations.

Fig. 499 Interior, Pantheon, 117–125 B.C.E.
Giovanni Paolo Panini, Interior of the Pantheon, Rome, c. 1734.
Oil on canvas, 50½ × 39 in. Samuel H. Kress Collection.
© 1999 Board of Trustees, National Gallery of Art, Washington, DC.

Even though their use of concrete had been forgotten, the architectural inventions of the Romans provided the basis for building construction in the Western world for nearly 2,000 years. The idealism, even mysticism, of the Pantheon's vast interior space, with its evocation of the symbolic presence of Jupiter, found its way into churches as the Christian religion came to dominate the West. Large congregations could gather beneath the high barrel vaults of churches, which were constructed on Roman architectural principles. Vault construction in stone was employed especially in Romanesque architecture—so called because it utilized so many Roman methods and architectural forms. The barrel vault at St. Sernin, in Toulouse, France (Figs. 500 and 501) is a magnificent example of Romanesque architecture. The plan of this church is one of great symmetry and geometric simplicity (Fig. 502). It reflects the Romanesque preference for rational order and logical development. Every measurement is based on the central square at the **crossing**, where the two **transepts**, or side wings, cross the length of the **nave**, the central aisle of the church used by the congregation, and the **apse**, the semicircular projection at the end of the

The Romans were also the first to perfect the **dome**, which takes the shape of a hemisphere, sometimes defined as a continuous arch rotated 360 degrees on its axis. Conceived as a temple to celebrate all their gods, the Roman Pantheon (Fig. 499)—from the Greek words *pan* ("every") and *theos* ("god")—consists of a 142-foot-high dome set on a cylindrical wall 140 feet in diameter. Every interior dimension appears equal and proportionate, even as its scale overwhelms the viewer. The dome is concrete, which was poured in sections over a huge mold supported by a complex scaffolding. Over twenty feet thick where it meets the walls—a point called the **springing**—the dome thins to only six feet at the circular opening, thirty feet in diameter, at the dome's top. Through this *oculus* (Latin for "eye"), the building's only source of illumination, worshipers could make contact with the heavens. As the sun shone through it, casting a round spotlight into the interior, it seemed as if the eye of Jupiter, king of the gods, shone upon the Pantheon walls.

Fig. 500 Interior view of nave, St. Sernin,
Toulouse, France, c. 1080–1120.
Marburg/Art Resource, New York.

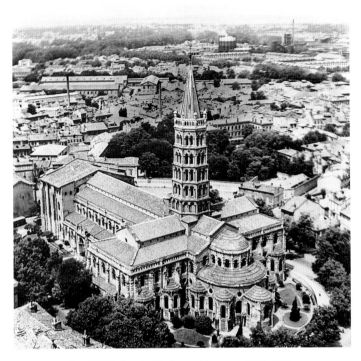

Fig. 501 St. Sernin, Toulouse, France, c. 1080–1120.
French Government Tourist Office.

Fig. 502 Plan, St. Sernin.

church that is topped by a Roman half-dome. Each square in the aisles, for instance, is one-quarter the size of the crossing square. Each transept extends two full squares from the center. The tower that rises over the crossing, incidentally, was completed in later times and is taller than it was originally intended to be.

The immense interior space of the great Gothic cathedrals, which arose throughout Europe beginning in about C.E. 1150, culminates this direction in architecture. A building such as the Pantheon, with a thirty-foot hole in its roof, was simply impractical in the severe climates of northern Europe. As if in response to the dark and dreary climate outside, the interior of the Gothic cathedral rises to an incredible height, lit by stained-glass windows that transform a dull day with a warm and richly radiant light. The enormous interior space of Amiens Cathedral (Fig. 503), with an interior height of 142 feet and a total interior surface of over 26,000 square feet, leaves any viewer in awe. At the center of the nave is a complex maze, laid down in 1288, praising the three master masons who built the complex, Robert de Luzarches, and Thomas and Renaud de Cormont, who succeeded in creating the largest Gothic cathedral ever built in northern Europe.

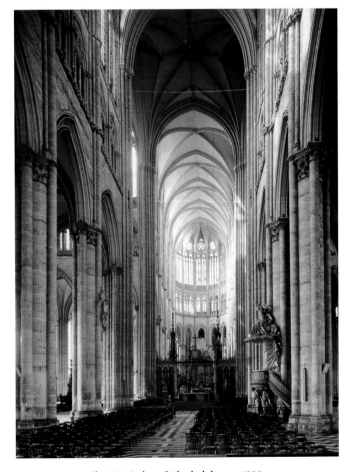

Fig. 503 Amiens Cathedral, begun 1220.
Scala/Art Resource, New York.

Fig. 505 Flying buttresses, Notre-Dame, Paris.
Jim Bryson/Photo Researchers, Inc.

Fig. 504 Pointed arch.

Fig. 506 Flying buttress.

The great height of the Gothic cathedral's interior space is achieved by means of a system of pointed, rather than round, arches. The height of a rounded arch is determined by its width, but the height of a **pointed arch** (Fig. 504) can readily be extended by straightening the curve of the sides upward to a point, the weight descending much more directly down the wall. By utilizing the pointed arch in a scheme of groined vaults, the almost ethereal space of the Gothic cathedral, soaring upward as if toward God, is realized.

All arches tend to spread outward, creating a risk of collapse, and early on, the Romans learned to support the sides of the arch to counteract this *lateral thrust*. In the great French cathedrals, the support was provided by building a series of arches on the outside whose thrusts would counteract the outward force of the interior arches. Extending inward from a series of columns or *piers*, these **flying buttresses** (Figs. 505 and 506), so named because they lend to the massive stone architecture a sense of lightness and flight, are an aesthetic response to a practical problem. Together with the stunning height of the nave allowed by the pointed arch, the flying buttresses reveal the desire of the builder to elevate the cathedral above the humdrum of daily life in the medieval world. The cathedral became a symbol not only of the divine, but of the human ability to exceed, in

art and in imagination, our own limitations and circumstances.

Cast-iron Construction

Until the nineteenth century, the history of architecture was determined by innovations in the ways the same materials—mostly stone—could be employed. In the nineteenth century, a material that had been known for thousands of years, but never employed in architecture, absolutely transformed the built environment—iron. Wrought iron, which Hector Guimard used to construct his entrance for the Paris Métro (Fig. 507) in 1900, was soft and flexible, and, when heated, it could be easily turned and twisted into the plantlike forms evident in Guimard's structure. But engineers discovered that by adding carbon to iron, they could create a much more rigid and strong material, **cast iron.** The French engineer Gustave Eiffel used cast iron in his new *lattice beam* construction technique, which produces structures of the maximum rigidity with the minimum weight by exploiting the way in which girders can be used to brace one another in three dimensions.

The most influential result was the Eiffel Tower (Fig. 508), designed as a monument to industry and the centerpiece of the international Paris Exposition of 1889. Nearly 1,000 feet high, and at that time the tallest structure in the world by far, the Tower posed a particular problem—how to build a structure of such a height, yet one that could resist the wind. Eiffel's solution was simple but brilliant: Construct a skeleton, an open lattice-beam framework that would allow the wind to pass through it. Though it served for many years as a radio tower—on July 1, 1913, the first signal transmitted around the world was broadcast from its top, inaugurating the global electronic network—the tower was essentially useless, nothing more than a monument. Many Parisians hated it at first, feeling that it was a blight on the skyline, but by the early years of the twentieth century it had become the symbol of Paris itself, probably the most famous structure in the world. Newspapers jokingly held contests to "clothe" it. But most important, it demonstrated the possibility of building to very

Fig. 507 Hector Guimard, Paris Métro entrance, 1900.
H. Roger-Viollet, Paris. Getty Images Inc.

Fig. 508 Gustave Eiffel, Eiffel Tower, 1887–1889.
Seen from Champs de Mars. Height of tower 1,051 ft.
Alain Evrard/Globe Press. Photo Researchers, Inc.

great height without load-bearing walls. The tower gave birth to the skeleton-and-skin system of building. And the idea of designing "clothes" to cover such a structure soon became a reality.

Fig. 510 Model of Old St. Peter's Basilica, Rome, c. 333–390.

Fig. 509 Wood-frame construction.

Frame Construction

The role of iron and steel in changing the course of architecture in the nineteenth century cannot be underestimated—and we will consider steel in even more detail in a moment—but two more humble technological innovations had almost as significant an impact, determining the look of our built environment down to the present day. The mass production of the common nail, together with improved methods and standardization in the process of milling lumber, led to a revolution in home building techniques.

Lumber cannot easily support structures of great height, but it is perfect for domestic architecture. In 1833, in Chicago, the common **wood-frame** house (Fig. 509), a true skeleton-and-skin building method, was introduced. Sometimes called *balloon-frame* construction, because early skeptics believed houses built in this manner would explode like balloons, the method is both inexpensive and

relatively easy. A framework skeleton of, generally, 2 × 4-inch beams is nailed together. Windows and doors are placed in the wall using basic post-and-lintel design principles, and the whole is sheathed with planks, clapboard, shingles, or any other suitable material. The roof is somewhat more complex, but as early as the construction of Old St. Peter's Basilica in Rome in the fourth century C.E. (Fig. 510), the basic principles were in use. The walls of St. Peter's were composed of columns and arches made of stone and brick, but the roof was wood. And notice the angled beams supporting the roof over the aisles. These are elementary forms of the **truss**, prefabricated versions of which most home builders today use for the roofs of their houses. One of the most rigid structural forms in architecture, the truss (Fig. 511) is a triangular framework that, because of its rigidity, can span much wider areas than a single wooden beam.

Fig. 511 Truss.

Fig. 512 Christian Gladu, *The Birch,* The Bungalow Company, North Town Woods, Bainbridge Island, Washington, 1998.
Photo Courtesy of The Bungalow Company.

This form of building is, of course, the foundation of American domestic architecture. Early in the twentieth century, it formed the basis of a wide-spread "bungalow" style of architecture, which has enjoyed a revival in the last decade (Figs. 512 and 513). It became popular when furniture designer Gustav Stickley began publishing bungalow designs in his magazine *The Craftsman.* From the beginning, the bungalow was conceived as a form of domestic architecture available to everyone. Like Stickley's furniture, which he thought of as "made" for bungalows, it was democratic. It embodied, from Stickley's point of view "that plainness which is beauty." The hand-hewn local materials—stone and shingles—employed in the construction tied the home to its natural environment. And so did its porches, which tied the interior to the world outside, and which, with their sturdy, wide-set pillars, bespoke functional solidity. By the late 1920s, as many as 100,000 stock plans had been sold by both national architectural companies and local lumber and building firms, and across America, bungalows popped up everywhere. In the popular imagination, the word "bungalow" was synonymous with "quality."

Fig. 513 Christian Gladu, *The Birch,* The Bungalow Company, North Town Woods, Bainbridge Island, Washington, 1998.
Photo Courtesy of The Bungalow Company.

Steel-and-Reinforced-Concrete Construction

It was in Chicago that frame construction began, and it was Chicago that most impressed C. R. Ashbee, a representative of the British National Trust, when he visited America in 1900: "Chicago is the only American city I have seen where something absolutely distinctive in the aesthetic handling of material has been evolved out of the Industrial system." A young architect named Frank Lloyd Wright impressed him most, but it was Wright's mentor, Louis Sullivan, who was perhaps most responsible for the sense of vitality that Ashbee was responding to.

In 1870, fire had destroyed much of downtown Chicago, providing a unique opportunity for architects to rebuild virtually the entire core of the city. For Sullivan, the foremost problem that the modern architect had to address was how the building might transcend the "sinister" urban conditions out of which, of necessity, it had to rise. Most urban buildings were massive in appearance. Henry Hob-

son Richardson's Marshall Field Wholesale Store (Fig. 514), built after the fire, is a good example. Although Richardson employed a skeletal iron framework within the building to support its interior structure, its thick walls carried their own weight, just as stone walls had for centuries. Richardson's genius lay in his ability to lighten this facade by means of the three- and two-story window arcades running from the second through the sixth floors. But from Sullivan's point of view, the building still appeared to squat upon the city block rather than rise up out of the street to transcend its environment.

For Sullivan, the answer lay in the development of steel construction techniques, combined with what he called "a system of ornament." A fireproof steel skeletal frame, suggested by wood-frame construction, freed the wall of load-bearing necessity and opened it both to ornament and to large numbers of exterior windows. The horizontality of Richardson's building was replaced by a vertical emphasis as the building's exterior lines echoed the upward sweep of the steel skeleton.

Fig. 514 H. H. Richardson, Marshall Field Wholesale Store, Chicago, 1885–1887.
Photo Courtesy of the Art Institute of Chicago.

As a result, the exterior of the tall building no longer seemed massive; rather, it might rise with an almost organic lightness into the skies.

The building's real identity depended on the ornamentation that could now be freely distributed across its facade. Ornament was, according to Sullivan, "spirit." The inorganic, rigid, and geometric lines of the steel frame would flow, through the ornamental detail that covered it, into "graceful curves," and angularities would "disappear in a mystical blending of surface." Thus, at the top of Sullivan's Bayard Building (Fig. 515)—a New York, rather than a Chicago, building—the vertical columns that rise between the windows blossom in an explosion of floral decoration.

Such ornamentation might seem to contradict completely the dictum for which Sullivan is most famous—"Form follows function." If the function of the urban building is to provide a well-lighted and ventilated place in which to work, then the steel frame structure and the abundance of windows on the building's facade make sense. But what about the ornamentation? How does it follow from the structure's function? Isn't it simply an example of purposeless excess?

Down through the twentieth century, Sullivan's original meaning has largely been forgotten. He was not promoting a notion of design akin to the sense of practical utility that can be discovered in, for instance, a Model T Ford. For Sullivan, "the function of all functions is the Infinite Creative Spirit," and this spirit could be revealed in the rhythm of growth and decay that we find in nature. Thus the elaborate, organic forms that cover his buildings were intended to evoke the Infinite. For Sullivan, the primary function of a building was to elevate the spirit of those who worked in it.

Almost all of Sullivan's ornamental exuberance seems to have disappeared in the architecture of Frank Lloyd Wright, whom many consider the first truly modern architect. But from 1888 to 1893, Wright worked as chief draftsman in Sullivan's Chicago firm, and Sullivan's belief in the unity of design and nature can still be understood as instrumental to Wright's work. In an article written for the *Architectural Record* in 1908, Wright emphasized that "a sense of the organic is indispensable to an architect," and as early as the 1890s,

Fig. 515 Louis H. Sullivan, Bayard (Condict) Building, New York, 1897–1898.
Schles/Art Resource, New York.

Figs. 516 and 517 Frank Lloyd Wright,
left: photo of wild flowers; right: ornamental detail;
both in William C. Gannett, *The House Beautiful*, 1896–1897.
The Frank Lloyd Wright Archives.

he was routinely "translating" the natural and the organic into what he called "the terms of building stone." In the ornamental detail Wright designed for William C. Gannett's book *The House Beautiful*, Wright literally transformed the organic lines of his own photograph of some wildflowers into a geometric design dominated by straight lines and rectangular patterns (Figs. 516 and 517).

The ultimate expression of Wright's intentions is the so-called Prairie House, the most notable example of which is the Robie House in Chicago, designed in 1906 and built in 1909 (Fig. 518). Although the house is contemporary in feeling—with its wide overhanging roof extending out into space, its fluid, open interiors, and its rigidly geometric lines—it was, from Wright's point of view, purely "organic" in conception.

Wright spoke of the Prairie House as "of" the land, not "on" it, and the horizontal sweep of the roof and the open interior space reflect the flat expanses of the Midwestern prairie landscape. The **cantilever**, a horizontal form supported on one end and jutting out into space on the other, was made possible by newly invented steel-and-reinforced-concrete con-

Fig. 518 Frank Lloyd Wright, Robie House, exterior, Chicago, 1909.
Esto Photographics Inc. Photo: Ezra Stoller.

struction techniques. Under a cantilevered roof, one could be simultaneously both outside and protected. The roof thus ties together the interior space of the house and the natural world outside. Furthermore, the house itself was built of materials—brick, stone, and wood, especially oak—native to its surroundings.

The architectural innovations of Wright's teacher, Louis Sullivan, led directly to the skyscraper. It is the sheer strength of steel that makes the modern skyscraper a reality. Structures with stone walls require thicker walls on the ground floor as they rise higher. A sixteen-story building, for instance, would require ground-floor walls approximately six feet thick. But the steel cage, connected by concrete floors, themselves reinforced with steel bars, overcomes this necessity. The simplicity of the resulting structure can be seen clearly in French architect Le Corbusier's 1914 drawing for the Domino Housing Project (Fig. 519). The design is almost infinitely expandable, both sideways and upward. Any combination of windows and walls can be hung on the frame. Internal divisions can be freely designed in an endless variety of ways, or, indeed, the space can be left entirely open. Even the stairwell can be moved to any location within the structural frame.

In 1932, Alfred H. Barr, Jr., a young curator at the Museum of Modern Art in New York City, who would later become one of the most influential historians of modern art, identified Le Corbusier as one of the founders of a new "International Style." In an exhibition on "Modern Architecture," Barr wrote: "Slender steel posts and beams, and concrete reinforced by steel have made possible structures of skeletonlike strength and lightness. The modern architect working in the new style conceives of his building . . . as a skeleton enclosed by a thin light shell. He thinks in terms of volume—of space enclosed by planes and surfaces—as opposed to mass and solidity. This principle of volume leads him to make his walls seem thin flat surfaces by eliminating moldings and by making his windows and doors flush with the surface."

Taking advantage of the strength of concrete-and-steel construction, Le Corbusier lifted his houses on stilts (Fig. 520), thus creating, out of the heaviest of materials, a sense of

Fig. 519 Le Corbusier, Perspective drawing for Domino Housing Project, 1914.
© 2003 Artists Rights Society (ARS), New York/ADAGP, Paris/FLC.

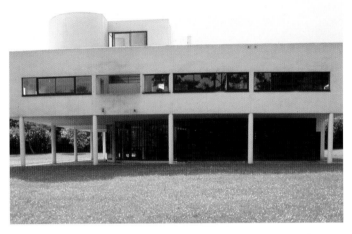

Fig. 520 Le Corbusier and Jeanneret, Villa Savoye, Poissy-sur-Seine, France, 1928–1930.
Photo: Anthony Scibilia. Art Resource, New York.

lightness, even flight. The entire structure is composed of primary forms (that is, rectangles, circles, and so on). Writing in his first book, *Towards a New Architecture*, translated into English in 1925, Le Corbusier put it this way, "Primary forms are beautiful forms because they can be clearly appreciated."

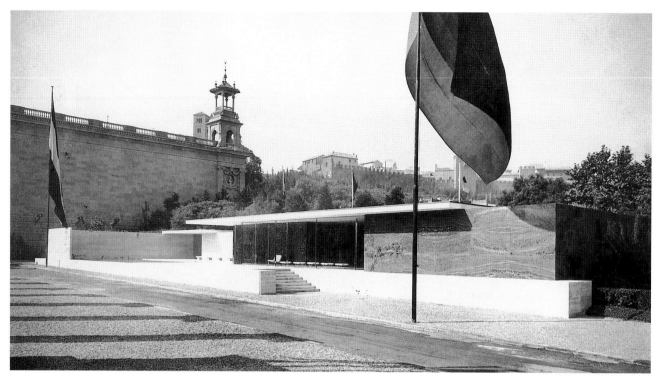

Fig. 521 Ludvig Miës van der Rohe, German Pavilion, International Exposition, Barcelona, Spain, 1928–1929.
Photo Courtesy of Miës van der Rohe Archive, The Museum of Modern Art, New York. Licensed by Scala-Art Resource, New York.
© 2003 Artists Rights Society (ARS), New York.

Fig. 522 Ludvig Miës van der Rohe,
German Pavilion, International Exposition, Barcelona, Spain.
Floor plan, final scheme. Made for publication 1929
Ink, pencil on paper, 22½ × 38½ in.
The Miës van der Rohe Archive, The Museum of Modern Art, New York.
Gift of the architect. Licensed by Scala-Art Resource, New York.
© 1999 The Museum of Modern Art, New York/
© 2003 Artists Rights Society (ARS), New York.

For Barr, Ludvig Miës van der Rohe was the other great innovator of the International Style. His German Pavilion for the 1929 International Exposition in Barcelona (Fig. 521) was considered by Barr to be one of the most important buildings of the day. As the floor plan (Fig. 522) makes clear, Miës wanted most of all to open the space of architecture. The bands of marble walls and sheets of glass held between stainless steel poles extend back from the entry steps under a daringly cantilevered roof. The back wall encloses, but only barely, a large pool, visible in the lower left of the floor plan, that reflects both building and sky. As a result, as the visitor climbs the short set of stairs approaching the pavilion, the entire structure seems to shimmer in light. Built to showcase the German marble industry, the perfectly proportioned and immaculate building shines like a jewel.

Miës's Farnsworth House (Fig. 523), which was built in 1950, likewise opens itself to its surroundings. At once an homage to Le Corbusier's Villa Savoye and a reincarnation of the architect's own German Pavilion, the house is virtually transparent—both opening itself out into the environment and inviting it in.

But the culmination of Le Corbusier's steel-and-reinforced-concrete Domino plan is the so-called International Style skyscraper, the most notable of which is the Seagram

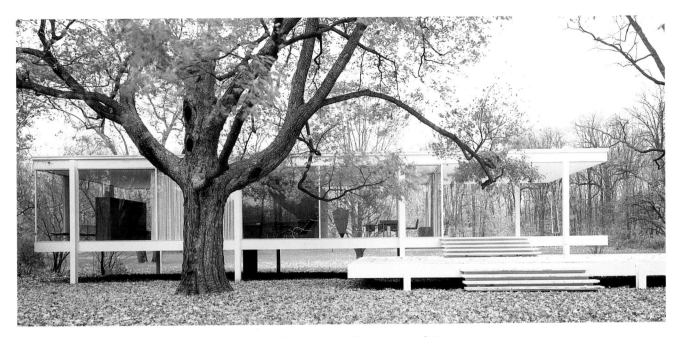

Fig. 523 Ludvig Miës van der Rohe, Farnsworth House,
Fox River, Plano, Illinois, 1950.
Bill Hedrich/Hedrich-Blessing.

Fig. 524 Miës van der Rohe and Philip Johnson,
Seagram Building, New York City, 1958.
Photo: Ezra Stoller ©Esto. All rights reserved.
Esto Photographics, Inc. © 2003 Artists Rights Society (ARS), New York/
VG Bild-Kunst, Bonn.

Building in New York City (Fig. 524), a collaboration between Miës van der Rohe and Philip Johnson. Johnson is the architect whose design for the College of Architecture at the University of Houston opened this chapter and who, in 1932, had written the foreword to Barr's "Modern Architecture" catalogue. The **International Style** is marked by its austere geometric simplicity, and the design solution presented by the Seagram Building is extremely elegant. The exposed structural *I-beams* (that is, steel beams that seen in cross-section look like the capital letter "I") are finished in bronze to match the amber-tinted glass sheath. At the base, these exterior beams drop, unsheathed, to the courtyard, creating an open-air steel colonnade around a recessed glass lobby. New York law requires that buildings must conform to a "setback" restriction: buildings that at ground level occupy an entire site must stagger-step inward as they rise in order to avoid "walling-in" the city's inhabitants. But the Seagram Building occupies less than one-half its site, and as a result, it is free to rise vertically out of the plaza at its base. At night, the lighted windows activate the building's exterior, and by day, the surface of the opaque glass reflects the changing world around the building.

Fig. 525 Philip Johnson, Glass House, New Canaan, Connecticut, 1949.
Photo: Ezra Stoller ©Esto. All rights reserved. Esto Photographics, Inc.

Johnson's collaboration with Miës on the Seagram Building indicates his admiration for the older architect, but perhaps his greatest homage to Miës is his own home, built in 1949 in New Canaan, Connecticut (Fig. 525). Johnson's goal, and the goal of the International Style, was to speak a language of beauty so universal that it would, inevitably, appeal to all. The house defines this language as the language of simple primary forms in harmony with their surroundings. The glass block rises directly out of the surrounding space and opens, through its glass walls, into it. Except for the central round brick cylinder containing toilet and bath, the practical side of living in a transparent glass house has been almost entirely ignored. It is a pure aesthetic statement, meant to be considered only as a thing of beauty. In Johnson's own words, "If the business of getting the house to run well takes precedence over your artistic invention the result won't be architecture at all; merely an assemblage of useful parts."

Rejecting the International Style's emphasis on primary geometric forms, the architec-ture of Eero Saarinen demonstrates how steel-and-reinforced-concrete construction can be utilized in other ways. Probably his two most successful buildings are airline terminals that were completed after his death in 1961. The TWA terminal at Kennedy International Airport in New York (Figs. 526 and 527), designed in 1956, is defined by a contrast between the openness provided by the broad expanses of window and the sculptural mass of the reinforced-concrete walls and roof. What results is a constant play of light and shadow throughout the space. The exterior—two huge concrete wings that appear to hover above the runways—is a symbolic rendering of flight. Washington's Dulles International Airport (Fig. 528), designed in 1959, is much larger than the TWA terminal. Concrete piers hold a vast canopy in place so that the roof appears to be a giant wing, soaring in space. The air-traffic control tower, rising behind the terminal like a floating Chinese pagoda, underscores the international character of both the building and the cosmopolitan city it serves.

Figs. 526 (left) and 527 (middle) Eero Saarinen,
TWA Terminal, Kennedy International Airport, New York, 1962.
Photo: Ezra Stoller ©Esto. All rights reserved. Esto Photographics, Inc.

Fig. 528 (bottom) Eero Saarinen,
Dulles International Airport, Chantilly, Virginia, 1962.
Photo: Ezra Stoller ©Esto. All rights reserved. Esto Photographics, Inc.

Frank Lloyd Wright's Fallingwater

Fig. 529 Frank Lloyd Wright, drawing for *Fallingwater*, Kaufmann House, Bear Run, Pennsylvania, 1936.
15⅜ × 27¼. The Frank Lloyd Wright Archives. Frank Lloyd Wright drawings are Copyright © 1997 The Frank Lloyd Wright Foundation, Scottsdale, AZ.
© 2003 Artists Rights Society (ARS), New York.

Fallingwater (Fig. 530), Frank Lloyd Wright's name for the house he designed for Edgar and Lillian Kaufmann in 1935, is arguably the most famous modern house in the world. Edgar Kaufmann was owner of Kaufmann's Store in Pittsburgh, the largest ready-made men's clothing store in the country, and his son had begun to study with Wright in 1934. In November of that year, Wright first visited the site. There are no known design drawings until the following September. Writing a few years before about his own design process, Wright stated that the architect should "conceive the building in the imagination, not on paper but in the mind, thoroughly—before touching paper. Let it live there—gradually taking more definite form before committing it to the draughting board. When the thing lives for you, start to plan it with tools. Not before. . . . It is best to cultivate the imagination to construct and complete the building before working on it with T-square and triangle."

The first drawings were done in two hours when Kaufmann made a surprise call to Wright and told him he was in the neighborhood and would like to see something. Using a different colored pencil for each of the house's three floors on the site plan,

Wright completed not only a floor plan, but a north-south cross section and a view of the exterior from across the stream (Fig. 529). The drawings were remarkably close to the final house.

Wright thought of the house as entirely consistent with his earlier Prairie Houses. It was, like them, wedded to its site, only the site was markedly different. The reinforced concrete cantilevers mirrored the natural cliffs of the hillside down and over which the stream, Bear Run, cascades. By the end of 1935, Wright had opened a quarry on the site to extract local stone for the construction.

Meanwhile, the radical style of the house had made Kaufmann nervous. He hired engineers to review Wright's plan, and they were doubtful that reinforced concrete could sustain the eighteen-foot cantilevers that Wright proposed. When Kaufmann sent the engineers' reports to Wright, Wright told him to return the plans to him "since he did not deserve the house." Kaufmann apologized for his lack of faith, and work on the house proceeded.

Still, the contractor and engineer didn't trust Wright's plans for reinforcing the concrete for the cantilevers, and before the first slab was poured, they put in nearly twice as much steel as Wright had called for. As a result, the main cantilever droops to this day. Wright was incensed that no one trusted his calculations. After the first slab was set, but still heavily braced with wooden framing (Fig. 531), Wright walked under the house and kicked a number of the wooden braces out.

The house, finally, is in complete harmony with its site. "I came to see a building," Wright wrote in 1936, as the house was nearing completion, "primarily . . . as a broad shelter in the open, related to vista; vista without and vista within. You may see in these various feelings, all taking the same direction, that I was born an American, child of the ground and of space."

Fig. 530 Frank Lloyd Wright, *Fallingwater*, Kaufmann House, Bear Run, Pennsylvania, 1936.
M.E. Warren/Photo Researchers, Inc.

Fig. 531 *Fallingwater Scaffolding*, architect: Frank Lloyd Wright
From the Fallingwater Collection at the Avery Architectural and Fine Arts Library, Columbia University in the City of New York.
© 2003 Artists Rights Society (ARS), New York.

COMMUNITY LIFE

However lovely we find the Seagram Building, the uniformity of its grid-like facade, in the hands of less skillful architects, came to represent, for many, the impersonality and anonymity of urban life. The skyscraper became, by the 1960s, the embodiment of conformity and mediocrity in the modern world. Rather than a symbol of community, it became a symbol of human anonymity and loneliness.

Nevertheless, the idea of community remains a driving impulse in American architecture and design. Richard Meier's Atheneum (Fig. 532), in New Harmony, Indiana, is a tribute to this spirit. New Harmony is the site of two of America's great utopian communities. The first, Harmonie on the Wabash (1814–1824), was founded by the Harmony Society, a group of Separatists from the German Lutheran Church. In 1825, Robert Owen, Welsh-born industrialist and social philosopher,

bought their Indiana town and the surrounding lands for his own utopian experiment. Owen's ambition was to create a more perfect society through free education and the abolition of social classes and personal wealth. World-renowned scientists and educators settled in New Harmony. With the help of William Maclure, the Scottish geologist and businessman, they introduced vocational education, kindergarten, and other educational reforms.

Meier's Atheneum serves as the Visitors Center and introduction to historic New Harmony. It is a building oriented, on the one hand, to the orderly grid of New Harmony itself, and, on the other, to the Wabash River, which swings at an angle to the city. Thus, the angular wall which the visitor sees on first approaching the building points to the river, and the uncontrollable forces of nature. The glass walls and the vistas they provide serve to connect the visitor to the surrounding landscape. But overall, the building's formal struc-

Fig. 532 Richard Meier, Atheneum, New Harmony, Indiana, 1979.
Digital imaging project. Photo © Mary Ann Sullivan, sullivanm@bluffton.edu

Fig. 533 Frederick Law Olmsted and Calvert Vaux, Central Park, aerial view, New York City, 1857–1887.
Steve Proehl/Getty Images, Inc.

ture recalls Le Corbusier's Villa Savoye (Fig. 520) and the "International Style" as a whole. It is this tension between man and nature upon which all "harmony" depends.

Since the middle of the nineteenth century, there have been numerous attempts to incorporate the natural world into the urban context. New York's Central Park (Fig. 533), designed by Frederick Law Olmsted and Calvert Vaux after the city of New York acquired the 840-acre tract of land in 1856, is an attempt to put city-dwelling humans back in touch with their roots in nature. Olmsted developed a system of paths, fields, and wooded areas modeled after the eighteenth-century gardens of English country estates. These estate gardens *appeared* wholly natural, but they were in actuality extremely artificial, with man-made lakes, carefully planted forests, landscaped meadows, meandering paths, and fake Greek ruins.

Olmsted favored a park similarly conceived, with, in his words, "gracefully curved lines, generous spaces, and the absence of sharp corners, the idea being to suggest and imply leisure, contemplativeness and happy

tranquility." In such places, the rational eighteenth-century mind had sought refuge from the trials of daily life. Likewise, in Central Park, Olmsted imagined the city dweller escaping the rush of urban life. "At every center of commerce," he wrote, "more and more business tends to come under each roof, and, in the progress of building, walls are carried higher and higher, and deeper and deeper, so that now 'vertical railways' [elevators] are coming in vogue." For Olmsted, both the city itself and neoclassical Greek and Roman architectural features in the English garden offer geometries—emblems of reason and practicality—to which the "gracefully curved" lines of the park and garden stand in counterpoint.

So successful was Olmsted's plan for Central Park that he was subsequently commissioned to design many other parks, including South Park in Chicago and the parkway system of the City of Boston, Mont Royal in Montreal, and the grounds at Stanford University and the University of California at Berkeley. But he perhaps showed the most foresight in his belief that the growing density of the city demanded

Fig. 534 Olmsted, Vaux & Co., landscape architects,
General plan of Riverside, Illinois, 1869.
Frances Loeb Library, Graduate School of Design, Harvard University.

Fig. 535 Los Angeles Freeway Interchange.
Photo Courtesy of California Division of Highways, Sacramento.

the growth of what would later become known as the *suburb*, a residential community lying outside but within commuting distance of the city. "When not engaged in business," Olmsted wrote, "[the worker] has no occasion to be near his working place, but demands arrangements of a wholly different character. Families require to settle in certain localities which minister to their social and other wants, and yet are not willing to accept the conditions of town-life . . . but demand as much of the luxuries of free air, space and abundant vegetation as, without loss of town-privileges, they can be enabled to secure." As early as 1869, Olmsted laid out a general plan for the city of Riverside, Illinois, one of the first suburbs of Chicago (Fig. 534), which was situated along the Des Plaines River. The plan incorporated the railroad as the principle form of transportation into the city. Olmsted strived to create a communal spirit by subdividing the site into small "village" areas linked by drives and walks, all situated near common areas that were intended to have "the character of informal village greens, commons and playgrounds."

Together with Forest Hills in New York, Llewellyn Park in New Jersey, and Lake Forest, also outside of Chicago, Olmsted's design for Riverside set the standard for suburban development in America. The pace of that development was steady but slow until the 1920s, when suburbia exploded. During that decade, the suburbs grew twice as fast as the central cities. Beverly Hills in Los Angeles grew by 2,500 percent, and Shaker Heights outside of Cleveland by 1,000 percent. The Great Depression and World War II slowed growth temporarily, but by 1950, the suburbs were growing at a rate ten times that of the cities. Between 1950 and 1960, American cities grew by six million people or 11.6 percent. In that same decade, the suburban population grew by nineteen million, a rate of 45.6 percent. And, for the first time, some cities actually began to lose population: the populations of both Boston and St. Louis declined by thirteen percent.

There were two great consequences of this suburban emigration: first, the development of the highway system, aided as well by the rise of the automobile as the primary means of transportation, and second, the collapse of the financial base of the urban center itself. As early as

Fig. 536 Leonardo da Vinci, *Map of the River Arno and Proposed Canal*, c. 1503–1504.
Pen and ink over black chalk with washes, pricked for transfer, 13³/₁₆ × 19 in.
The Royal Collection ©1992 Her Majesty Queen Elizabeth II.

1930, there were 800,000 automobiles in Los Angeles—two for every five people—and the city quite consciously decided not to spend public monies on mass transit but to support instead a giant freeway system (Fig. 535). The freeways essentially overlaid the rectilinear grid of the city's streets with continuous, streamlined ribbons of highway. Similarly, in 1940, the State of Pennsylvania opened a turnpike that ran the length of the state. Public enthusiasm was enormous, and traffic volume far exceeded expectations. That same year, the first stretches of the Pasadena Freeway opened. Today it is estimated that roads and parking spaces for cars occupy between sixty and seventy percent of the total land area of Los Angeles.

However, not only automobiles but also money—the wealth of the middle-class—drove down these highways, out of the core city and into the burgeoning suburbs. The cities were faced with discouraging and destructive urban decline. Most discouraging of all was the demise

of the **infrastructure**, the systems that deliver services to people—water supply and waste removal, energy, transportation, and communications. The infrastructure is what determines the quality of city life. Artists such as Leonardo da Vinci have always been concerned with the quality of life, and, as a result, with the infrastructure. His plan for a canal on the Arno River (Fig. 536), which anticipates the route followed by the modern *autostrada*, or freeway, would have given the city of Florence access to the sea. If we think about many of the works of art we have studied in this chapter, we can recognize that they were initially conceived as part of the infrastructure of their communities. For example, the Pont du Gard (Fig. 495) is a water supply aqueduct. The Paris Métro and the suspension bridges made possible by steel eased the difficulty of transportation in their communities. Public buildings such as temples, churches, and cathedrals provide places for people to congregate. Even skyscrapers are integral

Mierle Laderman Ukeles's
Fresh Kills Landfill Project

Maintenance has been one of the major themes of Mierle Ukeles's multidisciplinary art. Her seminal 1969 *Manifesto for Maintenance Art* announced her belief that art can

reveal, even transform, the discontinuity between society's promise of freedom for all and the unequal effects arising from our need to survive. Survival, she argues, has for too long led to gender, class, and race-based disinfranchisements. If earth is to be our "common home," these inequities must be addressed; her own personal situation fueled her thinking. "I

Fig. 537 Mierle Laderman Ukeles, *Fresh Kills Landfill, daily operation.*
Courtesy Ronald Feldman Fine Arts, Inc., New York

am an artist. I am a woman. I am a wife. (Random order)," she wrote. "I do a hell of a lot of washing, cleaning, cooking, renewing, supporting, preserving, etc. Also (up to now separately) I 'do' Art. Now I will simply do these maintenance things, and flush them up to consciousness, exhibit them, as Art."

In the first place, Ukeles wanted to challenge the notion of service work—i.e., "women's work"—and make it public. In her 1973 piece *Wash*, she scrubbed the sidewalk in front of A. I. R. Gallery in Soho, New York, on her hands and knees, with a bucket of water, soap, and rags. In taking personal responsibility for maintaining the "cleanliness" of the area for five hours, she immediately wiped out any tracks made by those innocently passing by, following them, rag in hand, erasing their footsteps right up to the point of brushing the backs of their heels. The often unstated power-based "social contract" of maintenance was made visible.

The city, she realized, was the ideal site for investigating the idea of maintenance. Maintenance of the city's infrastructure is an invisible process that is absolutely vital, and bringing the invisible to light is one of the artist's primary roles. For her *I Make Maintenance Art One Hour Every Day*, a 1976 project for a branch of the Whitney Museum of American Art located in New York's Chemical Bank Building, Ukeles invited the 300-person maintenance staff in the building, most of whom work invisibly at night, to designate one hour of their normal activities on the job as art, while she inhabited the building for seven weeks documenting their selections and exhibiting them daily.

Soon after, Ukeles became the unsalaried artist-in-residence for the New York City Department of Sanitation. In New York, the collection, transportation, and disposal of waste occurs twenty-four hours a day, every day of the year but Christmas. Her first piece was *Touch Sanitation*, a performance artwork in which, after one and one-half year's preparatory research, she spent eleven months creating a physical portrait of New York City as "a living entity" by facing and shaking the hand of each of the Department's eighty-five hundred employees, saying "Thank you for keeping New York City alive," and walking thousands of city miles with them. She spent four more years creating an exhibition documenting this journey.

Her most ambitious project for the Department is as Artist of the Fresh Kills Landfill on Staten Island (Figs. 537 and 538), an ongoing collaboration in redesign, begun in 1977, with no end in sight. Landfills, she points out, are the city's largest remaining open spaces, and the Fresh Kills Landfill, at three thousand acres, is the largest in the United States. She was designated to be part of a team that was to remediate, reshape, transform, and recapture the landfill as healed public space after its closure in 2001. But the events of history intervened in 2002, when Fresh Kills reopened as the repository for the bulk of the material recovered from the World Trade Center disaster of 9/11.

One area of her mega-project is based on re-envisioning the four images of earth that have yielded four traditions of creation. In each, the earth is imaged as female, often as seen by males. Earth as ancient mother, seen in sacred earth mounds, forever nourishes us and sustains us, producing in us an attitude of reverence

Fig. 538 Mierle Laderman Ukeles, *Fresh Kills Landfill, aerial view.*
Courtesy Ronald Feldman Fine Arts, Inc., New York.

and devotion. Earth as virgin is, as seen in early Americans' landscape painting as a virtually unin-habited boundless territory, is, she says, "forever fresh and young . . . available for the taking, pro-ducing in us (males) lust and acquisitiveness." Earth as wife is "enticingly wild and equally kempt . . . thoroughly domesticated because adequately husbanded." For her, the perfect image of earth as wife is the artificial wilderness of English landscape and Olmsted. Finally, there is the earth as old sick whore, once free and bountiful and endlessly available, then wasted, used up, dumped, and abandoned. To treat the earth as whore is to pretend that "one has no responsibility for one's actions." In Ukeles's plan for Fresh Kills Landfill, she asks, "Can we utilize the beauty of rever-ence, devotion, awe, craft, science, technology, and love that yielded the first three traditions while eliminating what has been essentially the obsession with domination and control that comes inevi-tably when one sex has rapacious power over the other, a power that pollutes all four traditions? Or can we simply un-gender our image of earth, so that we can re-invent our entire relationship, to create a new open interdependency in a more free and equal way?" After 9/11, these questions res-onate even more powerfully than before.

Fig. 539 Baltimore, Inner Harbor.
Gary Cralle/Getty Images, Inc.

Fig. 540 Magic Kingdom Park®, Walt Disney World® Resort, Florida.
©Disney Enterprises, Inc.

parts of the urban infrastructure, providing centralized places for people to work. As the infrastructure collapses, businesses close down, industries relocate, the built environment deteriorates rapidly, and even social upheaval can follow. To this day, downtown Detroit has never recovered from the 1967 riots and the subsequent loss of jobs in the auto industry in the mid-1970s. Block after block of buildings that once housed thriving businesses lie decayed and unused.

As early as the 1950s, Boston and Baltimore began working to revitalize the core areas of their cities. At first, both tried to develop the downtowns by attracting office and corporate headquarters to the areas. Led by the Baltimore developer James Rouse, both cities turned their attention to redesigning their port areas (Fig. 539). Rouse restored old warehouse and market buildings to create multiple-use environments of boutiques, restaurants and bars, hotels, upscale residential areas, and major tourist attractions, such as aquariums and tall-masted schooners.

Figs. 541 and 542 Charles Moore, *Piazza d'Italia*, New Orleans, 1976–1979.

Baltimore's Inner Harbor and Boston's Quincy Market and Boston Waterfront projects were huge undertakings—the Baltimore project covers 250 acres and cost $260 million—but marked economic benefits were almost immediately realized. The idea was to create an essentially theatrical space in the heart of the city, a downtown area of spectacle and glamour that would attract not only suburbanites (and their dollars) back into the city on a weekly or monthly basis, but tourists as well. Today, Baltimore's Inner Harbor attracts more than twenty-two million visitors a year, of whom seven million are tourists, roughly comparable to the number who visit Walt Disney World in Florida. It is, in fact, Walt Disney World, with its Main Street, U.S.A. (Fig. 540), that provides the model for the new inner city—an arena of wholesome family entertainment, notably free of crime and drugs, thronging with happy people having a good time and spending money. Walt Disney World may be an imaginary kingdom, but it functions in the contemporary imagination like a continuous World's Fair, a Tomorrowland projection of how we would like the real world to appear.

THE CRITICAL PROCESS

Thinking about Architecture

One of the most interesting examples of a downtown revitalization project is Charles Moore's design for the *Piazza d'Italia* in New Orleans (Figs. 541 and 542). Intended to honor Italian immigrants of New Orleans and to serve as the gateway to a new group of urban buildings behind it, the plaza and fountain are composed of a compendium of styles, referencing virtually the entire history of architecture. How many orders of column can you detect? Some you can probably name, but others are unique and original. What styles or periods of architectural history do these last evoke? Some of the columns are fluted and made of marble. Others are smooth and made of stainless steel. What is the effect of this transformation? Consider some of the other materials. How do they contrast? And what about color? What is the effect of the colored lighting and neon? At the end of Chapter 9, we discussed the idea of *postmodernism*. How does this idea help us understand Moore's *Piazza d'Italia*?

CHAPTER 17

DESIGN

DESIGN, CRAFT, AND FINE ART

THE ARTS AND CRAFTS MOVEMENT

ART NOUVEAU

ART DECO

THE AVANT-GARDES

THE BAUHAUS

STREAMLINING

THE FORTIES AND FIFTIES

CONTEMPORARY DESIGN

WORKS IN PROGRESS
Fred Wilson's *Mining the Museum*

THE CRITICAL PROCESS
Thinking about Design

During the 1920s in the United States, many people who had once described themselves as involved in the graphic arts, the industrial arts, the craft arts, or the arts allied to architecture—even architects themselves—began to be referred to as *designers*. They were seen as serving industry. They could take any object or product—a shoe, a chair, a book, a poster, an automobile, or a building—and make it appealing,

and thereby persuade the public to buy it or a client to build it. In fact, design is so intimately tied to industry that its origins as a profession can be traced back only to the beginnings of the industrial age.

DESIGN, CRAFT, AND FINE ART

On May 1, 1759, in Staffordshire, England, a twenty-eight-year-old man by the name of Josiah Wedgwood opened his own pottery manufacturing plant. With extraordinary foresight, Wedgwood chose to make two very different kinds of pottery; one he called "ornamental ware" (Fig. 543), the other "useful ware" (Fig. 544). The first were elegant handmade luxury items, the work of highly skilled craftsmen. The second were described in his catalogue as "a species of earthenware for the table, quite new in appearance . . . manufactured with ease and expedition, and consequently cheap." This new

Fig. 544 Wedgwood Queen's Ware kitchen ware, c. 1850
Courtesy Wedgwood Museum, Barlaston, Staffordshire, England.

earthenware was made by machine. Until this moment, almost everything people used was handmade, and thus unique. With the advent of machine mass-manufacturing, the look of the world changed forever.

Wedgwood's business illustrates very clearly how the art of design has been differentiated from, on the one hand, the traditional **crafts** and, on the other, the so-called *fine arts*, like painting or sculpture. As we said in Chapter 14, when we speak of crafts, we are generally referring to *handmade* objects created by highly skilled artisans to serve useful functions. Designers are different from craftspeople in that they often have nothing to do with the actual making of the object, which is produced by mechanical means. A craft object is one-of-a-kind, and in order for it to sell, only one person needs to like it. But designers create objects that are multiples. Their job is to make objects attractive to as large a public as possible. Thus, they must appeal to the whims of fashion.

In these terms, craftspeople and fine artists have more in common with one another than with designers. They both equally share a hands-on relation to the objects they make. Wedgwood's ornamental ware, upon which he himself often worked, is more craft than is his useful ware, which was mechanically produced. In fact, Wedgwood's ornamental ware is aesthetic in its intention and was meant to be received as an object of fine art. But his useful ware was meant to be used daily, on the table. Another way of

Fig. 543 Josiah Wedgwood, *Apotheosis of Homer Vase*, 1786.
Blue Jasper ware, height 18 in. Courtesy Wedgwood Museum, Barlaston, Staffordshire, England.

Fig. 545 Josiah Wedgwood, copy of *Portland Vase*, c. 1790.
Black Jasper ware, Height 10 in.
Courtesy Trustees Wedgwood Museum, Barlaston, Staffordshire, England.

original, made around 25 B.C.E in Rome, is a cameo deep blue (virtually black) glass vase that the Dowager Duchess of Portland purchased in 1784 for her private museum. The duchess died within a year of her purchase, and her entire estate was auctioned off, but the vase stayed in the family when the third Duke of Portland bought it in June 1786. It was subsequently lent to Wedgwood so that he might copy it, and he contracted to sell a number of these copies to a group of "gentlemen" subscribers.

It took Wedgwood four years to reproduce the vase successfully. He was able to match the deep blue-black of the original, but the ornamental ware for which he is best known is generally of a much lighter blue, as pictured on the previous page. Some fifty numbered and unnumbered first-edition copies of the Portland vase survive, and the factory has continued to produce editions over the years, most recently in 1980 for the 250th anniversary of Josiah's birth.

But Wedgwood's success as a manufacturer did not depend on such "ornamental" wares of refined taste and elegance. Rather his "useful" ware supported his business. His cream-colored earthenware (dubbed Queen's Ware because the English royal family quickly became interested in it), was made by casting liquid clay in molds instead of by throwing individual pieces and shaping them by hand. Designs were chosen from a pattern book (Fig. 546) and printed by mechanical means directly on the pottery. Because Wedgwood could mass-produce his earthenware both quickly and efficiently, a reliable, quality tableware was made available to the middle-class markets of Europe and America.

putting this is to say that the word "ornamental" serves, in Wedgwood's usage, to remove the object from the ordinary, to separate it from the "useful," to lend it the status of art.

Though the Wedgwood factory has continued to produce various kinds of ornamental ware, Wedgwood's copy of the Portland Vase (Fig. 545) was his crowning achievement. The

Fig. 546 First Wedgwood pattern book with border designs for Queen's Ware, 1774–1814.
Courtesy Trustees Wedgwood Museum, Barlaston, Staffordshire, England.

Fig. 547 (left) Joseph Paxton,
Crystal Palace, Great Exposition, London, 1851.
1,848 ft. long, 408 ft. wide.
Marburg/Art Resources, New York.

Fig. 548 (below) Philip Webb,
The Red House, Bexley Heath, UK, 1859.
Photo: Charlotte Wood.

THE ARTS AND CRAFTS MOVEMENT

During the first half of the nineteenth century, as mass production became more and more the norm in England, the quality and aesthetic value of mass-produced goods declined. In order to expose England to the sorry state of modern design in the country, Henry Cole, a British civil servant who was himself a designer, organized the Great Exposition of 1851. The industrial production on exhibit demonstrated, once and for all, just how bad the situation was. Almost everyone agreed with the assessment of Owen Jones: "We have no principles, no unity; the architect, the upholsterer, the weaver, the calico-painter, and the potter, run each their independent course; each struggles fruitlessly, each produces in art novelty without beauty, or beauty without intelligence."

The building that housed the exhibition in Hyde Park was an altogether different proposition. A totally new type of building, which became known as the Crystal Palace (Fig. 547), it was designed by Joseph Paxton, who had once served as gardener to the Duke of Devonshire and had no formal training as an architect. Constructed of more than 900,000 square feet of glass set in prefabricated wood and cast iron, it was three stories tall and measured 1,848 by 408 feet. It required only nine months to build, and it hailed in a new age in construction. As one architect wrote at the time, "From such beginnings what glories may be in reserve. . . . We may trust ourselves to dream, but we dare not predict."

Not everyone agreed. A. W. N. Pugin, who had collaborated on the new Gothic-style Houses of Parliament, called the Crystal Palace a "glass monster," and the essayist and reformer John Ruskin, who likewise had championed a return to a preindustrial Gothic style in his book *The Stones of Venice*, called it a "cucumber frame." Under their influence, William Morris, a poet, artist, and ardent socialist, dedicated himself to the renewal of English design through the renewal of medieval craft traditions. In his own words: "At this time, the revival of Gothic architecture was making great progress in England. . . . I threw myself into these movements with all my heart; got a friend [Philip Webb] to build me a house very medieval in spirit . . . and set myself to decorating it." Built of traditional red brick, the house was called the Red House (Fig. 548), and nothing could be further in style from the Crystal Palace. Where the latter reveals itself to be the product of manufacture—engineered out of prefabricated, factory-made parts and assembled, with minimal cost, by unspecialized workers in a matter of a few months—the former is a purposefully rural, even archaic building that rejects the industrial spirit of Paxton's Palace. It signaled, Morris hoped, a return to craft traditions in which workers were intimately tied to the design and manufacture of their products from start to finish.

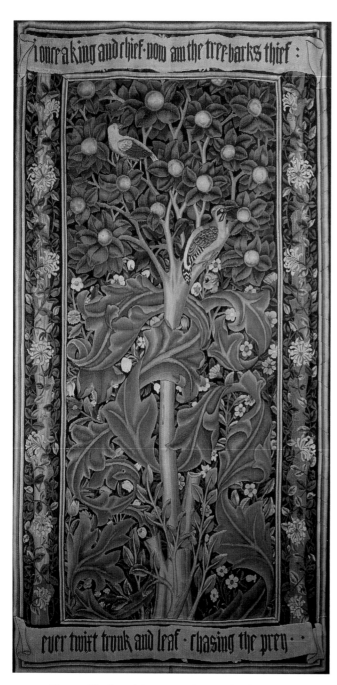

Fig. 549 Morris and Company, *The Woodpecker*, 1885.
Wool tapestry designed by Morris. William Morris Gallery, Walthamstow, England.

Morris longed to return to a handmade craft tradition for two related reasons. He felt that the mass manufacturing process alienated workers from their labor, and he also missed the quality of handmade items. Industrial laborers had no stake in what they made, and thus no pride in their work. The result, he felt, was both shoddy workmanship and unhappy workers.

As a result of the experience of building the Red House and attempting to furnish it with objects of a medieval, handcrafted nature, a project that was frustrated at every turn, Morris decided to take matters into his own hands. In 1861 he founded the firm that would become Morris and Company. It was dedicated "to undertake any species of decoration, mural or otherwise, from pictures, properly so-called, down to the consideration of the smallest work susceptible of art beauty." To this end, the company was soon producing stained glass, painted tiles, furniture, embroidery, table glass, metalwork, chintzes, wallpaper, woven hangings, tapestries, and carpets.

In his designs, Morris constantly emphasized two principles, simplicity and utility. However, it is difficult, at first glance, to see "simplicity" in work such as *The Woodpecker* (Fig. 549). For Morris, however, the natural and organic were by definition simple. Thus the pattern possesses, in Morris's words, a "logical sequence of form, this *growth* looks as if it could not have been otherwise." Anything, according to Morris, "is beautiful if it is in accord with nature." "I must have," he said, "unmistakable suggestions of gardens and fields, and strange trees, boughs, and tendrils."

Morris's desire for simplicity—"simplicity of life," as he put it, "begetting simplicity of taste"—soon led him to create what he called "workaday furniture," the best examples of which are the company's line of Sussex rush-seated chairs (Fig. 550). Such furniture was meant to be "simple to the last degree" and to appeal to the common man. As Wedgwood had done one hundred years earlier, Morris quickly came to distinguish this "workaday" furniture from his more costly "state furniture," for which, he wrote, "we need not spare ornament . . . but [may] make them as elaborate and elegant as we can with carving or inlaying or paintings; these are the blossoms of

the art of furniture." A sofa designed by Morris's friend, the painter Dante Gabriel Rossetti, and displayed by Morris and Company at the International Exhibition of 1862 (Fig. 551), is the "state" version of the Sussex settee. Covered in rich, dark green velvet, each of the three panels in the back contains a personification of Love, hand-painted by Rossetti. As Morris's colleague Walter Crane put it: "The great advantage . . . of the Morrisian method is that it leads itself to either simplicity or splendor. You might be almost plain enough to please Thoreau, with a rush bottomed chair, piece of matting, and oaken trestle-table; or you might have gold and luster gleaming from the sideboard, and jeweled light in your windows, and walls hung with rich arras tapestry."

By the 1870s, embroidered wall hangings were among the most popular items produced by Morris and Company. At first, Morris's wife, Jane, headed a large group of women, some of whom worked for the company full-time and others who worked more occasionally. In 1885, his daughter May, then twenty-three years old, took over management of the embroidery section.

Fig. 550 Morris and Company, Sussex rush-seated chairs.
William Morris Gallery, London.

Fig. 551 Dante Gabriel Rossetti, Sofa, 1862.
Wood, upholstered in velvet, width 74⅞ in. Fitzwilliam Museum, Cambridge, England.

For a quarter of a century, until about 1910, May Morris trained many women in the art of embroidery at her Hammersmith Terrace workshops, and many designs attributed to her father after 1885 are actually her own (apparently, she thought it important, at least from a commercial point of view, to give her father the credit).

The bed hangings below were designed by her in 1916 for a lady's bedroom, "in which elaboration and luxury have been purposefully avoided" (Fig. 552). Shown at the Arts and Crafts Exhibition in London in the same year, the embroidery work was done by May Morris, the teacher Mary Newill, and Newill's students at the Birmingham School of Art. The fact that most of the women who worked for Morris and Company were relegated to the embroidery division demonstrates the rigidity of sex roles in English society at the turn of the century. Nevertheless, May Morris, a successful businesswoman, author, and lecturer, was an important

role model for the women of her day. In 1907, she helped to found the Women's Guild of Art, the purpose of which was to provide a "centre and a bond for the women who were doing decorative work and all the various crafts."

William Morris claimed that his chief purpose as a designer was to elevate the circumstances of the common man. "Every man's house will be fair and decent," he wrote, "all the works of man that we live amongst will be in harmony with nature . . . and every man will have his share of the *best*." But common people were in no position to afford the elegant creations of Morris and Company. Unlike Wedgwood, whose common, "useful" ware made the most money for the firm, it was the more expensive productions—the state furniture, tapestries, and embroideries—that kept Morris and Company financially afloat. Inevitably, Morris was forced to confront the inescapable conclusion that to handcraft an object made it prohibitively expensive. With resignation and probably no small regret, he came to accept the necessity of mass manufacture.

In the United States, Gustav Stickley's magazine *The Craftsman,* first published in 1901 in Syracuse, New York, was the most important supporter of the Arts and Crafts tradition. The magazine's self-proclaimed mission was "to promote and to extend the principles established by [William] Morris," and its first issue was dedicated exclusively to Morris. Likewise, the inaugural issue of *House Beautiful,* published in Chicago in 1896, included articles on Morris and the English Arts and Crafts movement. Stickley, recognizing the expense of Morris's handcrafted furniture and the philosophical dilemma that Morris faced in continuing to make it, accepted the necessity of machine manufacturing his own work. Massive in appearance, lacking ornamentation, its aesthetic appeal depended, instead, on the beauty of its wood, usually oak (Fig. 553).

By the turn of the century, architect Frank Lloyd Wright was also deeply involved in furniture design. Like Morris before him, Wright felt compelled to design furniture for the interiors of his Prairie Houses that matched the design of the building as a whole (Fig. 554). Though geometric, his designs were rooted in nature (see Figs. 516 and 517). "It is quite impossible," Wright wrote, "to consider the

Fig. 552 May Morris, Bed Hangings, 1916.
Wool crewel on linen, cotton lined, 76¾ × 54 in.
Collection: Cranbrook Art Museum, Gift of George G. Booth.
Photo: R. H. Hensleigh. Accession number CAM 1955.402.

Fig. 553 Gustav Stickley, settee
(for the Craftsman Workshops), 1909.
Oak and leather, back 38 × 71⁷/₁₆ × 22 in.; seat 19 × 62 in.
Gift of Mr. and Mrs. John J. Evans, Jr., 1971.748
© 1999 The Art Institute of Chicago, all rights reserved.

Fig. 554 Frank Lloyd Wright, Robie House, dining room
with original furniture designed by Wright, 1909.
Courtesy Frank Lloyd Wright Archives, Scottsdale, Arizona.
© 2003 Artists Rights Society (ARS), New York.

building as one thing, its furnishings another and its setting and environment still another. The Spirit in which these buildings are conceived sees these all together at work as one thing." The table lamp designed for the Lawrence Dana House in Springfield, Illinois (Fig. 555) is meant to reflect the dominant decorative feature of the house—a geometric rendering of the sumac plant that is found abundantly in the neighboring Illinois countryside, chosen because the site of the house itself was particularly lacking in vegetation. Given a very large budget, Wright designed 450 glass panels and 200 light fixtures for the house that are variations on the basic sumac theme. Each piece is unique and individually crafted.

The furniture designs of Morris, Stickley, and Wright point out the basic issues that design faced in the twentieth century. The first dilemma, to which we have been paying particular attention, was whether the product should be handcrafted or mass-manufactured. But formal issues have arisen as well. If we compare Wright's designs to Morris's, we can see that they use line completely differently. Even though both find the source of their forms in nature, Wright's forms are rectilinear and geometric, Morris's curvilinear and organic. Both believed in "simplicity," but the word meant different things to the two men. Morris, as we have seen, equated simplicity with the natural. Wright, on the other hand, designed furniture for his houses because, he said, "simple things . . . were nowhere at hand.

A piece of wood without a moulding was an anomaly, plain fabrics were nowhere to be found in stock." To Wright, simplicity meant plainness. The history of design continually confronts the choice between the geometric and the organic. The major design movement at the turn of the century, Art Nouveau, chose the latter.

Fig. 555 Frank Lloyd Wright, Table lamp, Susan Lawrence Dana House, 1903.
Bronze, leaded glass. Photo: Douglas Carr.
Courtesy The Dana-Thomas House, The Illinois Historic Preservation Agency.
© 2003 Artists Rights Society (ARS), New York.

Fig. 556 Louis Comfort Tiffany, Tiffany Studios,
Water-lily table lamp, c. 1904–1915.
Leaded Favrile glass and bronze, height 26½ in.
The Metropolitan Museum of Art, New York. Gift of Hugh J. Grant, 1974
(1974.214.15ab). Photograph ©1984 The Metropolitan Museum of Art.

Fig. 557 Louis Comfort Tiffany, Tiffany Glass & Decorating Co.
(1893–1902), Corona, New York, *Peacock Vase*, c. 1893–1896.
Favrile glass, height 14⅛ in.; width 11½ in. The Metropolitan Museum
of Art, New York. Gift of H. O. Havemeyer, 1896 (96.17.10). Photograph
© 1987 The Metropolitan Museum of Art

ART NOUVEAU

The day after Christmas in 1895, a shop opened in Paris named the Galeries de l'Art Nouveau. It was operated by one S. Bing, whose first name was Siegfried, though art history has almost universally referred to him as Samuel, perpetuating a mistake made in his obituary in 1905. Bing's new gallery was a success, and in 1900, at the Universal Exposition in Paris, he opened his own pavilion, Art Nouveau Bing. By the time the Exposition ended, the name **Art Nouveau** had come to designate not merely the work he displayed but a decorative arts movement of international dimension.

Bing had visited the United States in 1894. The result was a short book titled *Artistic Culture in America,* in which he praised American architecture, painting, and sculpture, but most of all its arts and crafts. The American who

fascinated him most was the glassmaker Louis Comfort Tiffany, son of the founder of the famous New York jewelry firm, Tiffany and Co. The younger Tiffany's work inspired Bing to create his new design movement, and Bing contracted with the American to produce a series of stained glass windows designed by such French artists as Henri de Toulouse-Lautrec and Pierre Bonnard. Because oil lamps were at that very moment being replaced by electric lights—Thomas Edison had startled the French public with his demonstration of electricity at the 1889 International Exhibition—Bing placed considerable emphasis on new, modern modes of lighting. From his point of view, a new light and a new art went hand in hand. And Tiffany's stained-glass lamps (Fig. 556), backlit by electric light, brought a completely new sense of vibrant color to interior space.

Even more than his stained glass, Bing admired Tiffany's iridescent Favrile glassware, which was named after the obsolete English word for handmade, "fabrile." The distinctive feature of this type of glassware is that nothing of the design is painted, etched, or burned into the surface. Instead, every detail is built up by the craftsperson out of what Tiffany liked to call "genuine glass." In the vase illustrated in Fig. 557, we can see many of the design characteristics most often associated with Art Nouveau, from the wavelike line of the peacock feathers to the self-conscious asymmetry of the whole. In fact, the formal vocabulary of Art Nouveau could be said to consist of young saplings and shoots, willow trees, buds, vines—anything organic and undulating, including snakes and, especially, women's hair. The Dutch artist Jan Toorop's advertising poster for a peanut-based salad oil (Fig. 558) flattens the long, spiraling hair of the two women preparing salad into a pattern very like the elaborate wrought-iron grillwork also characteristic of Art Nouveau design. Writing about Bing's installation at the the 1900 Universal Exposition, one writer described Art Nouveau's use of line this way: "[In] the encounter of the two lines . . . the ornamenting art is born—an indescribable curving and whirling ornament, which laces and winds itself with almost convulsive energy across the surface of the [design]!"

The organic, curvilinear qualities of Art Nouveau easily lent themselves to the development of an intensely personal and expressive style. In the hands of a master, such as the Spanish architect Antoni Gaudí, a level of formal invention was achieved that constitutes one of the most important artistic expressions of the period. Gaudí's Church of the Sagrada Familia (Fig. 559) is a twisting, spiraling, almost fluid mass of forms. In the architect's hands, masonry has been transformed into some pliable, natural material that seems as infinitely manipulable as his fantastic imagination is large.

Yet, for many, Art Nouveau seemed excessively subjective and personal, especially for public forms such as architecture. In Vienna, particularly, where Art Nouveau had flourished under the banner of the *Jugendstil*—literally, "the style of youth"—the curvilinear and

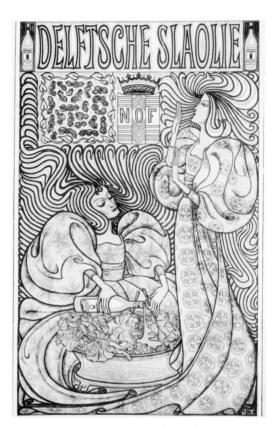

Fig. 558 Jan Toorop, poster for *Delftsche Slaolie* (Salad Oil), 1894.
Dutch advertisement poster. Scala/Art Resource, New York.

Fig. 559 Antoni Gaudí, Church of the Sagrada Familia, 1883–1926.
Spanish National Tourist Office.

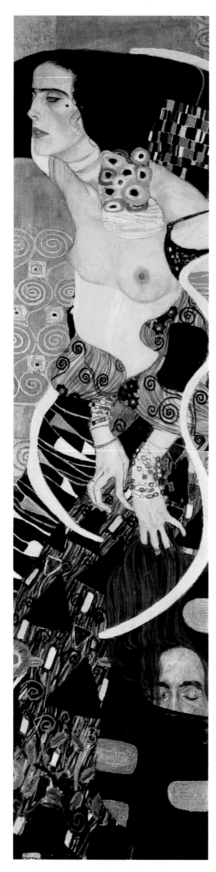

organic qualities of Art Nouveau gave way to symmetry and simple geometry. Consider, for instance, the Palais Stoclet in Brussels (Fig. 561), designed by the Viennese architect Josef Hoffman. The exterior is starkly white and geometrical, and quite plain. But the interior is luxurious. Hoffman ringed the walls of the dining room, for instance, in marble inlaid with mosaics of glass and semiprecious stones including onyx and malachite designed by the Viennese painter Gustav Klimt. The theme of the mosaics is openly sexual. They were designed in the same spirit as paintings such as his *Salomé*, illustrated here (Fig. 560), which depicts a decadent society woman as if she were a temptress. For Hoffman, the interior of the house was private space, a place where fantasy and emotion could have free reign. Through the example of buildings like the Palais Stoclet, Art Nouveau became associated with an interior world of aristocratic wealth, refinement, and even emotional abandon, but it was also a style that realized the necessity of presenting, in its exteriors, a public face of order, simplicity, and control. In other words, the type of geometric and rectilinear design practiced by Frank Lloyd Wright began to find favor, and by the Exposition Internationale des Arts Décoratifs et Industriels Modernes—the International Exposition of Modern Decorative and Industrial Arts—in Paris in 1925, it held sway.

Fig. 560 Gustav Klimt, *Salomé*, 1909.
Oil on canvas, 70⅛ × 18⅛ in. Galleria d'Arte Moderna, Venice.
Scala/Art Resource, New York.

Fig. 561 Josef Hoffman, Palais Stoclet, Brussels, Belgium, 1905–1911.
Foto Marburg/Art Resource, New York.

ART DECO

The Exposition Internationale des Arts Décoratifs et Industriels Modernes was planned as early as 1907, during the height of Art Nouveau, but logistical problems—especially the outbreak of World War I—postponed it for almost twenty years. A very influential event, the exposition was the most extensive international showcase of the style of design then called *Art Moderne* and, since 1968, better known as **Art Deco.**

Not only did individual designers build their own exhibition spaces, but all of the great French department stores, as well as the leading French manufacturers, built lavish pavilions as well. Throughout, the emphasis was on a particularly French sense of fashionable luxury. There was no evidence anywhere of the practical side of design—no concern with either utility or function. The cabinet designed by the French furniture company Süe et Mare (Fig. 562) is typical of the most elaborate form of the Art Deco style featured at the 1925 exposition. Made of ebony, the preferred wood of Art Deco designers because it was extremely rare and, therefore, expensive, and inlaid with mother-of-pearl, abalone, and silver, the cabinet is extraordinarily opulent. This richness of materials, together with the slightly asymmetrical and organic floral design of the cabinet door, link the piece to the earlier style of Art Nouveau.

But there was another type of Art Deco that, while equally interested in surface decoration, preferred more up-to-date materials—chrome, steel, and Bakelite plastic—and sought to give expression to everyday *"moderne"* life. The *Skyscraper Bookcase* by the American designer Paul T. Frankl (Fig. 563), made of maple wood and Bakelite, is all sharp angles that rise into the air, like the brand-new skyscrapers that were beginning to dominate America's urban landscape.

Fig. 563 Paul T. Frankl, *Skyscraper Bookcase*, 1925–1930.
Maple wood and bakelite, height 79⅞ in.; width 34⅜ in.; depth 18⅞ in.
The Metropolitan Museum of Art, New York, Purchase, Theodore R.
Gamble, Jr. Gift, in honor of his mother, Mrs. Theodore Robert
Gamble, 1982 (1982.30ab).

Fig. 562 Louis Süe and Andre Mare, *Cabinet,* 1927.
Ebony, mother-of-pearl, silver, height 61⅞; width 35⅜; depth 15¾ in.
Virginia Museum of Fine Arts, Richmond.
Gift of Sydney and Frances Lewis Foundation.
Photo: Katherine Wetel © Virginia Museum of Fine Arts.

Fig. 564 (left) Edouardo Garcia Benito,
cover illustration, *Vogue*, May 25, 1929.
©1929 Vogue/Condé Nast Publications, Inc.
Illustration by Edouard Garcia Benito.

Fig. 565 (right) Unidentified illustrator,
Corset, *Vogue*, October 25, 1924.
Courtesy of Vogue/Condé Nast Publications Inc.

This movement toward the geometric is perhaps the defining characteristic of Art Deco. Even the leading fashion magazines of the day reflect this in their covers and layouts. In Edouardo Benito's *Vogue* magazine cover (Fig. 564), we can see an impulse toward simplicity and rectilinearity comparable to Frankl's bookcase. The world of fashion embraced the new geometric look. During the 1920s, the boyish silhouette became increasingly fashionable. The curves of the female body were suppressed (Fig. 565), and the waistline disappeared in tubular, "barrel"-line skirts. Even long, wavy hair, one of the defining features of Art Nouveau style, was abandoned, and the schoolboyish "Eton crop" became the hairstyle of the day.

THE AVANT-GARDES

At the 1925 Paris Exposition, one designer's pavilion stood apart from all the rest, not because it was better than the others, but because it was so different. As early as 1920, a French architect by the name of Le Corbusier had written in his new magazine *L'Esprit Nouveau* (The New Spirit) that "decorative art, as opposed to the machine phenomenon is the final twitch of the old manual modes; a dying

thing." He proposed a *"Pavillon de l'Esprit Nouveau"* (Pavilion of the New Spirit) for the exposition that would contain "only standard things created by industry in factories and mass-produced; objects truly of the style of today."

To Le Corbusier, to make expensive, hand-crafted objects, such as the cabinet by Süe et Mare (Fig. 562), amounted to making antiques in a contemporary world. From his point of view, the other designers at the 1925 exposition were out of step with the times. The modern world was dominated by the machine, and though designers had shown disgust for machine manufacture ever since the time of Morris and Company, they did so at the risk of living forever in the past. "The house," Le Corbusier declared, "is a machine for living."

Le Corbusier's "new spirit" horrified the exposition's organizers, and, accordingly, they gave him a parcel of ground for his pavilion between two wings of the Grand Palais, with a tree, which could not be removed, growing right in the middle of it. Undaunted, Le Corbusier built right around the tree, cutting a hole in the roof to accommodate it (Fig. 566). The pavilion was built of concrete, steel, and glass, and its walls were plain white. So distressed were Exposition officials that they ordered a high fence to be built completely around the site in order to hide it from public view. Le Corbusier appealed to the Ministry of Fine Arts, and finally the fence was removed. "Right now," Le Corbusier announced in triumph, "one thing is sure: 1925 marks the decisive

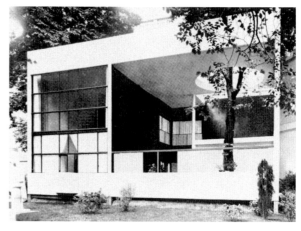

Fig. 566 Le Corbusier, Pavillon de l'Esprit Nouveau.
Exposition Internationale des Arts Décoratifs et
Industriels Modernes, Paris, 1925.
Copyrighted from: Le Corbusier, *My Work*.
(London: Architectural Press, 1960), p. 72.

turning point in the quarrel between the old and the new. After 1925, the antique lovers will have virtually ended their lives, and productive industrial effort will be based on the 'new.' "

The geometric starkness of Le Corbusier's design had been anticipated by developments in the arts that began to take place in Europe before World War I. A number of new **avant-garde** (from the French meaning "advance guard") groups had sprung up, often with radical political agendas, and dedicated to overturning the traditional and established means of art-making through experimental techniques and styles.

One of the most important was the **De Stijl** movement in Holland. De Stijl, which is Dutch for "The Style," took its lead, like all the avant-garde styles, from the painting of Picasso and Braque, in which the elements of the real world were simplified into a vocabulary of geometric forms. The De Stijl artists, chief among them Mondrian (see Fig. 731), simplified the vocabulary of art and design even further, employing only the primary colors—red, blue, and yellow—plus black and white. Their design relied on a vertical and horizontal grid, often dynamically broken by a curve or a circle or a diagonal line. Rather than enclosing forms, their compositions seemed to *open* out into the space surrounding them.

Gerrit Rietveld's famous chair (Fig. 567) is a summation of these De Stijl design principles. The chair is designed *against*, as it were, the traditional elements of the armchair. Both the arms and the base of the chair are insistently locked in a vertical and horizontal grid. But the two planes that function as the seat and the back seem almost to float free from the closed-in structure of the frame. Rietveld dramatized their separateness from the black grid of frame by painting the seat blue and the back red.

Rietveld's Schröder House, built in 1925, is an extension of the principles guiding his chair design. The interior of the box-shaped house is completely open in plan. The view represented here (Fig. 568) is from the living and dining area toward a bedroom. Sliding walls can shut off the space for privacy, but it is the sense of openness that is most important to Rietveld. Space implies movement. The more open the space, the more possibility for movement in it. Rietveld's design, in other words, is meant to immerse its occupants in a dynamic situation

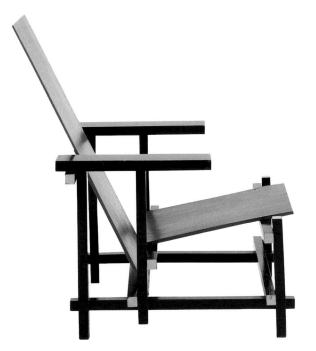

Fig. 567 Gerrit Rietveld, *Red and Blue Chair*, c. 1918.
Wood, painted, height 34⅛; width 26; depth 26½ in.; seat height: 13 in.
Museum of Modern Art, New York. Gift of Philip Johnson.
Licensed by Scala-Art Resource, New York.
Photograph © 1999 Museum of Modern Art, New York/
© 2003 Artists Rights Society (ARS), New York.

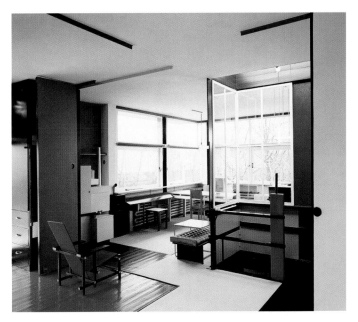

Fig. 568 Gerrit Rietveld, First floor, 1987, view of the stairwell/landing and the living-dining area. In the foreground is the Red and Blue Chair. Rietveld Schröderhlis, 1924, Utrecht, The Netherlands. c/o Stichting Beedldrect, Anstelveen.
Collection: Centraal Museum Utrecht/Rietveld-Schröder Archive. Photo: Ernst Moritz, The Hague. © 2003 Artists Rights Society (ARS), New York.

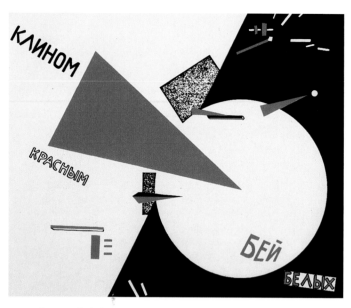

Fig. 569 El Lissitzky, *Beat the Whites with the Red Wedge*, 1919.
Lithograph. Collection: Stedelijk Van Abbemuseum, Eindhoven, Holland.
© 2003 Artists Rights Society (ARS), New York/VG Bild-Kunst, Bonn.

that might, idealistically, release their own creative energies.

This notion of dynamic space can also be found in the work of the Russian **Constructivists**, who worked in the new postrevolutionary Soviet state and who dreamed of uniting art and everyday life through mass-production and industry. The artist, they believed, should "go into the factory, where the real body of life is made." They believed, especially, in employing nonobjective formal elements in functional ways. El Lissitzky's design for the poster *Beat the Whites with the Red Wedge* (Fig. 569), for instance, is a formal design with propagandistic aims. It presents the "Red" Bolshevik cause as an aggressive red triangle attacking a defensive and static "White" Russian circle. Although the elements employed are starkly simple, the implications are disturbingly sexual—as if the Reds are male and active, while the Whites are female and passive—and the sense of aggressive action, originating both literally and figuratively from "the left," is unmistakable.

This same sense of geometrical simplification can be found in Alexander Rodchenko's design for a catalogue cover for the Russian exhibition at the 1925 Paris Exposition (Fig. 570). Rodchenko had designed the interiors and furnishings of the Workers' Club, which was included in the Soviet exhibit at the Exposition, and the cover design echoes and embodies his design for the Club. The furniture, as Rodchenko described it, emphasized "simplicity of use, standardisation, and the necessity of being able to expand or contract the numbers of its parts." It was painted in only four colors—white, red, grey, and black—alone or in combination, and employed only rectilinear geometric forms. Chairs could be stacked and folded, tables could serve as screens and display boards if turned on their sides, and everything was moveable and interchangeable.

Perhaps nowhere has the dynamism of Russian Constructivism been more powerfully expressed than in Vladimir Tatlin's visionary *Monument to the Third International* (Fig. 571). Though it was never constructed, Tatlin did make a large-scale model of the *Monument* for the U.S.S.R. pavilion at the 1925 Paris Exposition, and its affinities to Le Corbusier's Pavillon de l'Esprit Nouveau were noticed immediately. With its skeletal steel frame deliberately reminiscent of the Eiffel Tower, the *Monument* was intended to eclipse that Paris landmark and to become, at about 1,300 feet tall, the highest building in the world. The spiraling open-work construction was to have

Fig. 570 Alexander Rodchenko, *L'Art Décoratif, Moscow-Paris*, 1925.
Design for catalog cover, Russian section, Exposition International des Arts Decoratifs et Industriel, Paris, 1925.
Rodchenko Archive, Moscow, Russia. Scala/Art Resource, New York.
Estate of Alexander Rodchenko/Licensed by VAGA, New York, NY.

contained three monumental glass elements—a cube, a pyramid, and a cylinder, the essential forms of the Constructivist vocabulary—that would revolve on their axes at different speeds, one at a revolution of once per year, the second once a month, and the third once a day. The geometric forms were also intended to house the administrative, political, cultural, and scientific offices of the Communist International. For Tatlin, the spiral represented the inevitable advance of humanity under communism, the revolutionist's dream of never-ending progress toward a utopian workers' paradise.

Le Corbusier's l'Esprit Nouveau pavilion and Tatlin's *Monument* were not the only examples of the new rigorously geometric design sensibility at the 1925 Paris Exposition. The French abstract painter Sonia Delaunay also made a contribution in the form of daily fashion shows. Every evening during the run of the exposition, Delaunay dressed 20 models in her new geometric designs and paraded them through the grounds. Writing in the magazine *Surrealisme* in 1925, Claire Goll described the new dynamic Delaunay woman: "The black, white and red stripe runs down her almost like a new meander, giving her movements her own rhythm. And when she goes out, she slips into the delightful mole-coat, which is covered with wool embroidery, so it looks almost woven, and its lines filled in nuances of brown, rusty red and violet. When she has friends visiting, she wears an afternoon gown, in which a gaudy triangle cheerfully recurs. But in the evening she wears the coat that is worthy of the moon and that was born of a poem." For the exposition, Delaunay transposed the design of her motoring ensemble onto a Citroën B-12 roadster (Fig. 572). Here, Delaunay announces, is the design for a new machine age.

Fig. 571 (above right) Vladimir Tatlin,
Model for Monument to the Third International, **1919–1920.**
Original model destroyed; reconstruction 1968.
Wood, iron, and glass with motor, height 15 ft. 5 in. Moderna Museet, Stockholm.
© Estate of Vladimir Tatlin/Licensed by VAGA, New York, NY.

Fig. 572 (right) Models wearing Sonia Delaunay designs with a Delaunay-customized Citroën B-12.
From *Maison de la Mode*, 1925.
L & M Services.

Fig. 573 Marcel Breuer, *Armchair,* model B3, late 1927 or early 1928.
Chrome-plated tubular steel with canvas slings, height 28⅛ × width 30¼ × depth 27¾ in.
Museum of Modern Art, New York. Gift of Herbert Bayer. Photograph Licensed by Scala-Art Resource, New York. © 1999 Museum of Modern Art, New York.

THE BAUHAUS

At the German pavilion at the 1925 Paris Exposition, one could see a variety of new machines designed to make the trials of everyday life easier—for instance, an electric washing machine and an electric armoire in which clothes could be tumble-dried. When asked who could afford such things, Walter Gropius, who in 1919 had founded a school of arts and crafts in Weimar, Germany, known as the **Bauhaus,** replied, "To begin with, royalty. Later on, everybody."

Like Le Corbusier, Gropius saw in the machine the salvation of humanity. And he thoroughly sympathized with Le Corbusier, whose major difficulty in putting together his Pavillon de l'Esprit Nouveau had been the unavailability of furniture that would satisfy his desire for "standard things created by industry in factories and mass-produced; objects truly of the style of today." Ironically, at almost exactly that moment, Marcel Breuer, a furniture designer working at Gropius's Bauhaus, was doing just that.

In the spring of 1925, Breuer purchased a new bicycle, manufactured out of tubular steel by the Adler company. Impressed by the bicycle's strength—it could easily support the weight of two riders—its lightness, and its apparent indestructibility, Breuer envisioned furniture made of this most modern of materials. "In fact," Breuer later recalled, speaking of the armchair that he began to design soon after his purchase (Fig. 573), "I took the pipe dimensions from my bicycle. I didn't know where else to get it or how to figure it out."

The chair is clearly related to Rietveld's *Red and Blue Chair* (Fig. 567), consisting of

two diagonals for seat and back set in a cubic frame. It is easily mass-produced—and, in fact, is still in production today. But its appeal was due, perhaps most of all, to the fact that it looked absolutely new, and it soon became an icon of the machine age. Gropius quickly saw how appropriate Breuer's design would be for the new Bauhaus building in Dessau. By early 1926, Breuer was at work designing modular tubular-steel seating for the school's auditorium, as well as stools and side chairs to be used throughout the educational complex. As a result, Breuer's furniture became identified with the Bauhaus.

But the Bauhaus was much more. In 1919, Gropius was determined to break down the barriers between the crafts and the fine arts and to rescue each from its isolation by training craftspeople, painters, and sculptors to work on cooperative ventures. There was, Gropius said, "no essential difference" between the crafts and the fine arts. There were no "teachers" either; there were only "masters, journeymen, and apprentices." All of this led to what Gropius believed was the one place where all of the media could interact and all of the arts work cooperatively together. "The ultimate aim of all creative activity," Gropius declared, "is the building," and the name itself is derived from the German words for building (*Bau*) and house (*Haus*).

We can understand Gropius's goals if we look at Herbert Bayer's design for the cover of the first issue of *Bauhaus* magazine, which was published in 1928 (Fig. 574). Each of the three-dimensional forms—cube, sphere, and cone—casts a two-dimensional shadow. The design is marked by the letter forms Bayer employs in the masthead. This is Bayer's Universal Alphabet, which he created to eliminate what he believed to be needless typographical flourishes, including capital letters. Bayer, furthermore, constructed the image in the studio and then photographed it, relying on mechanical reproduction instead of the handcrafted, highly individualistic medium of drawing. The pencil and triangle suggest that any drawing to be done is mechanical drawing, governed by geometry and mathematics. Finally, the story on the cover of the first issue of *Bauhaus* is concerned with architecture, to Gropius the ultimate creative activity.

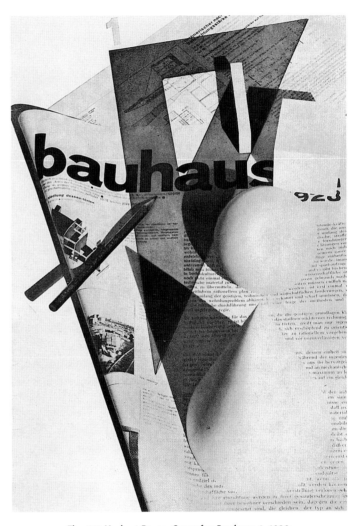

Fig. 574 Herbert Bayer, Cover for *Bauhaus 1*, 1928.
Photomontage. Photo: Bauhaus–Archiv, Berlin.
© VG Bild-Kunst, Bonn, Germany.
© 2003 Artists Rights Society (ARS), New York/BG Bild-Kunst, Bonn.

Fig. 575 Burlington Northern Co.Burlington *Zephyr #9900*, 1934.
Photo Courtesy of Burlington Northern & Santa Fe Railway Co.

STREAMLINING

Even as the geometry of the machine began to dominate design, finding particular favor among the architects of the International Style (see Chapter 16), in the ebb and flow between the organic and the geometric that dominates design history, the organic began to flow back into the scene as a result of advances in scientific knowledge. In 1926, the Daniel Guggenheim Fund for the Promotion of Aeronautics granted $2.5 million to the Massachusetts Institute of Technology, the California Institute of Technology, the University of Michigan, and New York University to build wind tunnels. Designers quickly discovered that by eliminating extraneous detail on the surface of a plane, boat, automobile, or train, and by rounding its edges so that each subform merged into the next by means of smooth transitional curves, air would flow smoothly across the surface of the machine. Drag would thereby be dramatically reduced, and the machine could move faster with less expenditure of energy. "Streamlining" became the transportation cry of the day.

The nation's railroads were quickly redesigned to take advantage of this new technological information. Since a standard train engine would expend 350 horsepower more than a streamlined one operating at top speed, at 70 to 110 mph, streamlining would increase pulling capacity by 12 percent. It was clearly economical for the railroads to streamline.

At just after five o'clock on the morning of May 26, 1934, a brand new streamlined train called the Burlington *Zephyr* (Fig. 575) departed Union Station in Denver bound for Chicago. Normally, the 1,015-mile trip took twenty-six hours, but this day, averaging 77.61 miles per hour and reaching a top speed of 112 miles per hour, the *Zephyr* arrived in Chicago in a mere thirteen hours and five minutes. The total fuel cost for the haul, at 5¢ per gallon, was only $14.64. When the train arrived later that same evening at the Century of Progress Exposition on the Chicago lakefront, it was mobbed by a wildly enthusiastic public. If the railroad was enthralled by the streamlined train's efficiency, the public was captivated by its speed. It was, in fact, through the mystique of speed that the Burlington Railroad meant to recapture dwindling passenger revenues. Ralph Budd, president of the railroad, deliberately chose not to paint the *Zephyr's* stainless steel sheath. To him it signified "the motif of speed" itself.

But the *Zephyr* was more than its sheath. It weighed one-third less than a conventional train, and its center of gravity was so much lower that it could take curves at 60 miles per hour that a normal train could only negotiate at 40. Because regular welding techniques severely damaged stainless steel, engineers had invented and patented an electric welding process to join its stainless steel parts. All in all, the train became the symbol of a new age. After its trips

to Chicago, it traveled more than thirty thousand miles, visiting 222 cities. Well over two million people paid a dime each to tour it, and millions more viewed it from the outside. Late in the year, it became the feature attraction of a new film, *The Silver Streak*, a somewhat improbable drama about a high-speed train commandeered to deliver iron lungs to a disease-stricken Nevada town.

Wind-tunnel testing had revealed that the ideal streamlined form most closely resembled a teardrop. A long train could hardly achieve such a shape—at best it resembled a snake. But the automobile offered other possibilities. The first production-model streamlined car was the Chrysler *Airflow* (Fig. 576), which abandoned the teardrop ideal and adopted the look of the new streamlined trains. (It is pictured here with the 1934 Union Pacific *Streamliner.*) The man who inspired Chrysler to develop the automobile was Norman Bel Geddes. Bel Geddes was a poster and theatrical designer when he began experimenting, in the late 1920s, with the design of planes, boats, automobiles, and trains—things he thought of as "more vitally akin to life today than the theatre." After the stock market crash in 1929, his staff of twenty engineers, architects, and draftsmen found themselves with little or nothing to do, so Bel Geddes turned them loose on a series of imaginative projects, including the challenge to dream up some way to transport "a thousand luxury lovers from New York to Paris fast. Forget the limitations." The specific result was his *Air Liner Number 4* (Fig. 577), designed with the assistance of Dr. Otto Koller, a veteran airplane designer. With a wingspan of 528 feet, Bel Geddes estimated that it could carry 451 passengers and 115 crew members from Chicago to London in forty-two hours. Its passenger decks included a dining room, game deck, solarium, barber shop and beauty salon, nursery, and private suites for all on board. Among the crew were a nursemaid, a physician, a masseuse and a masseur, wine stewards, waiters, and an orchestra.

Although Bel Geddes insisted that the plane could be built, it was the theatricality and daring of the proposal that really captured the imagination of the American public. Bel Geddes was something of a showman. In November 1932, he published a book titled *Horizons* that included most of the experimental designs

Fig. 576 Chrysler *Airflow* 4-door sedan, 1934.
Chrysler Historical Collection, Detroit, Michigan.

he and his staff had been working on since the stock market collapse. It was wildly popular. And its popularity prompted Chrysler to go forward with the *Airflow*. Walter P. Chrysler hired Bel Geddes to coordinate publicity for the new automobile. In one ad, Bel Geddes himself, tabbed "America's foremost industrial designer," was the spokesman, calling the *Airflow* "the first sincere and authentic streamlined car . . . the first *real* motor car." Despite this, the car was not a success. Though it drew record orders after its introduction in January 1934, the company failed to reach full production before April, by which time many orders had been withdrawn, and serious production defects were evident in those cars the company did manage to get off the line. The *Airflow* attracted more than eleven thousand buyers in 1934, but by 1937 only forty-six hundred were sold, and Chrysler dropped the model.

Fig. 577 Norman Bel Geddes, with Dr. Otto Koller, *Air Liner Number 4*, 1929.
Norman Bel Geddes Collection, Theatre Arts Collection, Harry Ransom Humanities Research Center, The University of Texas at Austin, by permission of Edith Lutyens Bel Geddes, Executrix.

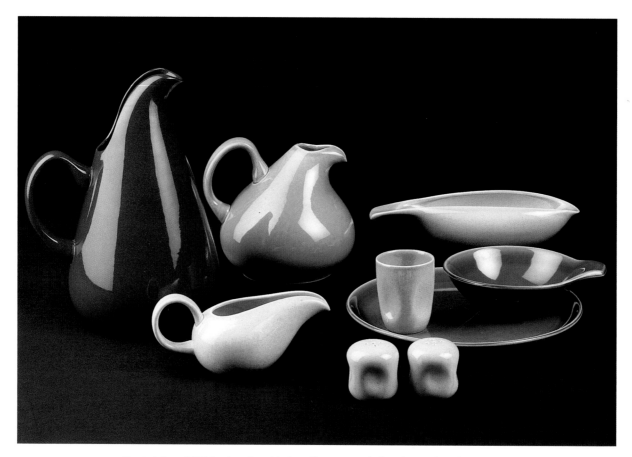

Fig. 578 Russel Wright, American Modern dinnerware, designed 1937, introduced 1939.
Glazed earthenware. Department of Special Collections, Russell Wright papers. Syracuse University Library.

Fig. 579 Staubsauger, *Champion* vacuum cleaner, Type OK, Holland, late 1930s.
© Photo Bungartz/Die Neue Sammlung, Staatliches Museum für Angewandte Kunst, Munich.

However, streamlining had caught on, and other designers quickly joined the rush. One of the most successful American designers, Raymond Loewy, declared that streamlining was "the perfect interpretation of the modern beat." To Russel Wright, the designer of the tableware illustrated here (Fig. 578), streamlining captured the "American character." It was the essence of a "distinct American design." Almost overnight, European designers began employing streamlining in their own product design, as evidenced by a Dutch chromium-plated vacuum cleaner from the late 1930s (Fig. 579). Suddenly, to be modern, a thing had to be streamlined. Even more important, to be streamlined was to be distinctly American in style. Thus, to be modern was to be American, an equation that dominated industrial and product design worldwide through at least the 1960s.

Fig. 580 Installation view of the exhibition
Organic Design in Home Furnishings.
Museum of Modern Art, New York. September 24–November 9, 1941.
Licensed by Scala-Art Resource, New York.
Photo Courtesy Museum of Modern Art, New York.

THE FORTIES AND FIFTIES

The fully organic forms of Russel Wright's "American Modern" dinnerware announce a major shift in direction away from design dominated by the right angle and toward a looser, more curvilinear style. This direction was further highlighted when, in 1940, the Museum of Modern Art held a competition titled "Organic Design in Home Furnishings." The first prize in that competition was awarded jointly to Charles Eames and Eero Saarinen, both young instructors at the Cranbrook Academy of Art in Michigan. Under the direction of the architect Eliel Saarinen, Eero's father, Cranbrook was similar in many respects to the Bauhaus, especially in terms of its emphasis on interdisciplinary work on architectural environments. It was, however, considerably more open to experiment and innovation than the Bauhaus, and the Eames-Saarinen entry in the Museum of Modern Art competition was the direct result of the elder Saarinen encouraging his young staff to rethink entirely just what furniture should be.

All of the furniture submitted to the show by Eames and Saarinen (Fig. 580) used molded plywood shells in which the wood veneers were laminated to layers of glue. The resulting forms almost demand to be seen from more than a single point of view. The problem, as Eames wrote, "becomes a sculptural one." The furniture was very strong, comfortable, and reasonably priced. Because of the war, production and dis-

Fig. 581 Charles and Ray Eames, side chair, model DCM, 1946.
Molded ash plywood, steel rods, and rubber shock mounts,
height 28¾ × width 19½ × depth 20 in.
Museum of Modern Art, New York. Gift of Herman Miller Furniture Company.
Licensed by Scala-Art Resource, New York.
Photograph © 1999 Museum of Modern Art, New York.

tribution were necessarily limited, but in 1946, the Herman Miller Company made five thousand units of a chair Eames designed with his wife, Ray Eames, also a Cranbrook graduate (Fig. 581). Instantly popular and still in production today, the chair consists of two molded-plywood forms that float on elegantly simple steel rods. The effect is amazingly dynamic: the back panel has been described as "a rectangle about to turn into an oval," and the seat almost seems to have molded itself to the sitter in advance.

Eero Saarinen took the innovations he and Eames had made in the "Organic Design in Home Furnishings" competition in a somewhat different direction. Unlike Eames, who in his 1946 chair had clearly abandoned the notion of the one-piece unit as impractical, Saarinen continued to seek a more unified

design approach, feeling that it was more economical to stamp furniture from a single piece of material in a machine. His *Tulip Pedestal Furniture* (Fig. 582) is one of his most successful solutions. Saarinen had planned to make the pedestal chair entirely out of plastic, in keeping with his unified approach, but he discovered that a plastic stem would not take the necessary strain. Forced, as a result, to make the base out of cast aluminum, he nevertheless painted it the same color as the plastic in order to make the chair appear of a piece.

The end of World War II heralded an explosion of new American design, particularly attributable to the rapid expansion of the economy, as twelve million military men and women were demobilized. New home starts rose from about 200,000 in 1945 to 1,154,000 in 1950. These homes had to be furnished, and new products were needed to do the job. Passenger car production soared from 70,000 a year in 1945 to 6,665,000 in 1950, and in the following ten years, Americans built and sold more than fifty-eight million automobiles. In tune with the organic look of the new furniture design, these cars soon sported fins, suggesting both that they moved as gracefully as fish and that their speed was so great that they needed stabilizers. The fins were inspired by the tail fins on the U.S. Air Force's P-38 "Lightning" fighter plane, which Harley Earl, chief stylist at General Motors, had seen during the war. He designed them into the 1948 Cadillac as an aerodynamic symbol. But by 1959, when the craze hit its peak, fins no longer had anything to do with aerodynamics. As the Cadillac (Fig. 583) made clear, it had simply become a matter of the bigger the better.

In many ways, the Cadillac's excess defines American style in the 1950s. This was the decade that brought the world fast food (both the McDonald's hamburger and the TV dinner), Las Vegas, *Playboy* magazine, and a TV in almost every home. But there were, in the 1950s, statements of real elegance. One of the most notable was the graphic design of the Swiss school, notably that of Armin Hofmann. Recognizing, in his words, that "the whole of sensory perception has been shifted by the photographic image," he freely incorporated photographs into his poster designs. Like Saarinen in his air terminal designs (Figs. 526–528), Hofmann emphasized finding a symbolic form or image appropriate to the content of his message. The poster for the ballet *Giselle* (Fig. 584) immediately conveys the idea of dance. It does this through the studied contrast between light and dark, between the blurred, speeding form of the dancer and the static clarity of the type, between, finally, the geometry of the design and the organic movement of the body. By these means, Hofmann arrives at a synthesis of the competing stylistic forces at work in the history of modern design.

Fig. 582 Eero Saarinen, *Tulip Pedestal Furniture*, 1955–1957.
Chairs: plastic seat, painted metal base; tables: wood or marble top, plastic laminate base.
Saarinen Collection designed by Eero Saarinen in 1956 and 1957. Courtesy Knoll Inc.

Fig. 583 General Motors 1959 Cadillac Fleetwood.
General Motors Media Archives.

CONTEMPORARY DESIGN

One way to view the evolution of design since 1960 is to recognize a growing tendency to accept the splits between the organic and the geometric and the natural and the mechanical that dominate its history as not so much an either/or situation as a question of both/and. In its unification of competing and contrasting elements, Hofmann's graphic design anticipates this synthesis. So, indeed, does the Eames chair, with its contrasting steel-support structure and molded plywood seat and back.

But, as we suggested in the earlier discussion of postmodernism, the contemporary has been marked by a willingness to incorporate anything and everything into a given design. This is not simply a question of the organic versus the geometric. It is, even more, a question of the collisions of competing cultures of an almost incomprehensible diversity and range. On our shrinking globe, united by television and the telephone, by the fax machine and the copier, e-mail, and the World Wide Web, and especially by increasingly interdependent economies, we are learning to accept, perhaps faster than we realize, a plurality of styles.

What we mean when we speak of the stylistic pluralism of contemporary design is clear if we compare a traditional corporate identity package with a conspicuously postmodern one. Although the Coca-Cola bottle has changed

Fig. 584 Armin Hofmann, *Giselle,* 1959.
Offset lithograph, 50¾ × 35⅝ in.
Courtesy Reinhold-Brown Gallery, New York.

Fred Wilson's Mining the Museum

Fred Wilson is a contemporary museum curator who has transformed the problem of exhibition design by exposing the cultural, political, and socioeconomic assumptions that underlie the modern museum space. Traditionally, museums have tried to create coherent, even homogeneous, spaces in which to view exhibitions. The "white room" effect is one such design principle—that is, the walls of the space are uniform and white so as not to detract from the work on the walls. Even when more elaborate design ideas come into play—for instance, when an architectural setting is recreated in order to reconstruct the original era or setting of the works on display—the principle of an intellectually coherent space, one which helps the viewer to understand and contextualize the work, predominates.

Wilson believes that this traditional curatorial stance has caused most museums to "bury" or ignore works that do not fit easily into the dominant "story" that the museum tells. In 1992, The Contemporary, a museum exhibiting in temporary spaces in Baltimore, Maryland, arranged for Wilson to install an exhibition at the Maryland Historical Society. Wilson saw it as an opportunity to reinterpret the Historical Society's collection and present a larger story about Maryland history than the museum was used to telling.

Wilson begins all of his projects with a research phase—in this case, into the history of Baltimore and the people who lived there. "When I go into a project," he says, "I'm not looking to bring something to it. I'm responding more than anything else. You can still get a very personal emotional response from a situation or an individual who lived a hundred years ago. It's connecting over time that I'm responding to." In the archives and collections of the museum, Wilson was able to discover a wealth of material that the museum had never exhibited, not least of all because it related to a part of Maryland history that embarrassed and even shamed many viewers—the reality of slavery. Wilson brought these materials to light by juxtaposing them with elements of the collection that viewers were used to seeing.

Behind a "punt gun" ostensibly used for hunting game birds on Chesapeake Bay, he placed reward notices for runaway slaves. A document discovered in the archives, an

Fig. 585 Nicholas Carroll Estate Inventory, MS 2634, c. 1812.
Manuscripts Division, Maryland Historical Society Library.
Maryland Historical Society, Baltimore, Maryland.

Fig. 586 (left) and 587 (below)
Mining the Museum, 1922.
Installation details,
Fred Wilson, artist/curator.
Left: Whipping post and chairs for
Cabinetmaking 1820–1960.
Below: Silver Vessels and Slave
Shackles for *Metalwork*.
Photos: Jeff D. Goldman
© Contemporary Museum.

inventory of the estate of one Nicholas Carroll (Fig. 585), lists all his slaves and animals together with their estimated value. What jars the contemporary reader is the fact that least valuable of all, valued at a mere one dollar, is the "negro woman Hannah seventy-three years of age." Even the "old Mule called Coby" is worth five times as much. In the middle of a display of silver repoussé objects made by Maryland craftsmen in the early 1800s (Fig. 587), Wilson placed a set of iron slave shackles, underscoring the fact that Maryland's luxury economy was built on slavery. Similarly, in a display of Maryland cabinetmaking, he placed a whipping post (Fig. 586), which was used until 1938 in front of the Baltimore city jail, and which the museum had ignored for years, storing it with its collection of fine antique cabinets.

But Wilson was equally struck by what was missing from the museum's collection. While the museum possessed marble busts of Henry Clay, Napoleon Bonaparte, and Andrew Jackson, none of whom had any particular impact on Maryland history, it possessed no busts of three great black Marylanders, Harriet Tubman, Frederick

Douglass, and the astronomer and mathematician Benjamin Banneker. Thus, at the entrance to the museum, across from the three marble busts in the museum's collection, he placed three empty pedestals, each identified with the name of its "missing" subject.

"Objects," Wilson says, "speak to me." As an artist, curator, and exhibition designer, Wilson translates what these objects say to him for all of us to hear. "I am trying to root out . . . denial," he says. "Museums are afraid of what they will bring to the surface and how people will feel about issues that are long buried. They keep it buried, as if it doesn't exist, as though people aren't feeling these things anyway, instead of opening that sore and cleaning it out so it can heal."

Fig. 592 Ettore Sottsass, *Casablanca* cabinet, 1981.
Laminate print. Production: Memphis srl, Milano.

important than function. His *Casablanca* cabinet (Fig. 592) does indeed function as a cabinet, but it is primarily a visual statement. As one Memphis designer has put it: "Industry must face up to a new strategy of production, no longer . . . seemingly objective (and substantially anonymous), but personal and subjective. . . . From high-tech to high-touch."

Thinking about Design

Consumer spaces—from boutiques to restaurants, from arcades to malls—have increasingly appealed to this highly personal and subjective sense of taste. An interesting example is English architect Nigel Coates's Caffè Bongo in Toyko, Japan (Fig. 593). It is, in a sense, "disposable" architecture, made to appeal to the taste of the moment—but what a plurality of tastes! It also captures what Coates thinks of as a key quality of contemporary urban experience: "the imprint of one reality on another." How many different "realities" can you discover here? What design style does the airplane wing that runs across the top of the bar suggest? What about the statuary that rests on top of the wing? What order of column is incorporated into the back wall and rear entrance? What style does the brickwork evoke (if "style" is even the right word)? What about the steel I-beams? What is the effect of bending them, and supporting them with tilted steel columns? What, finally, does this space reveal about Coates's attitude toward the idea of stability and permanence as values in art and design?

Fig. 593 Nigel Coates, Caffè Bongo interior (1986), Parco department store, Tokyo, Japan.
Photo by Edward Valentine Hames, © Branson Coates Architecture.

Fig. 586 (left) and 587 (below)
Mining the Museum, 1922.
Installation details,
Fred Wilson, artist/curator.
Left: Whipping post and chairs for
Cabinetmaking 1820–1960.
Below: Silver Vessels and Slave
Shackles for *Metalwork*.
Photos: Jeff D. Goldman
© Contemporary Museum.

inventory of the estate of one Nicholas Carroll (Fig. 585), lists all his slaves and animals together with their estimated value. What jars the contemporary reader is the fact that least valuable of all, valued at a mere one dollar, is the "negro woman Hannah seventy-three years of age." Even the "old Mule called Coby" is worth five times as much. In the middle of a display of silver repoussé objects made by Maryland craftsmen in the early 1800s (Fig. 587), Wilson placed a set of iron slave shackles, underscoring the fact that Maryland's luxury economy was built on slavery. Similarly, in a display of Maryland cabinetmaking, he placed a whipping post (Fig. 586), which was used until 1938 in front of the Baltimore city jail, and which the museum had ignored for years, storing it with its collection of fine antique cabinets.

But Wilson was equally struck by what was missing from the museum's collection. While the museum possessed marble busts of Henry Clay, Napoleon Bonaparte, and Andrew Jackson, none of whom had any particular impact on Maryland history, it possessed no busts of three great black Marylanders, Harriet Tubman, Frederick Douglass, and the astronomer and mathematician Benjamin Banneker. Thus, at the entrance to the museum, across from the three marble busts in the museum's collection, he placed three empty pedestals, each identified with the name of its "missing" subject.

"Objects," Wilson says, "speak to me." As an artist, curator, and exhibition designer, Wilson translates what these objects say to him for all of us to hear. "I am trying to root out . . . denial," he says. "Museums are afraid of what they will bring to the surface and how people will feel about issues that are long buried. They keep it buried, as if it doesn't exist, as though people aren't feeling these things anyway, instead of opening that sore and cleaning it out so it can heal."

Fig. 588 Coca-Cola Contour bottle.
Coke, Coca-Cola, the Dynamic Ribbon device, and the design of the Coca-Cola Contour bottle are trademarks of The Coca-Cola Company. Used with permission.

Fig. 589 MTV: MUSIC TELEVISION logo.
Artwork provided courtesy of MTV: Music Television and all related titles, characters, and logos are trademarks owned by MTV Networks, a division of Viacom International, Inc. All Rights Reserved.

over the course of time, the 1957 redesign of the bottle (Fig. 588) makes it slightly more streamlined and sleeker than earlier versions and changes the embossed lettering to white paint. The script logo itself has remained constant almost since the day Dr. John Pemberton first served the concoction on May 8, 1886, at Jacob's Pharmacy in downtown Atlanta, Georgia. Coke claims that today more than 90 percent of the world's men, women, and children easily recognize the bottle.

By contrast, the Music Television Network, MTV, and the designers of Swatch watches, the Swiss husband and wife team Jean Robert and Käti Durrer, conceive of their design identities as kinetic, ever-changing variations on a basic theme (Figs. 589 and 591). In recent years, both the television and music industries have increasingly turned from producing shows and recordings designed to appeal to the widest possible audience to a concentration on appealing to more narrowly defined, specialized audiences. Television learned this lesson with the series "St. Elsewhere," which had very low overall ratings, but which attracted large numbers of married, young, upper-middle-class professionals—yuppies—with enough disposable income to attract, in turn, major advertising accounts.

In light of this situation, it is no longer necessary to standardize a corporate identity. It may not even be desirable. Illustrated here, in Figure 591, are eight of the approximately three hundred watch designs produced by Robert and Durrer between 1983 and 1988, which were inspired by a variety of cultures— from Japanese to Native American—and styles. Each watch is designed to allow the wearer's unique individuality to assert itself. "In 1984," Robert and Durrer recall, "we saw a gentleman sitting in the back of his Rolls Royce. We couldn't help noticing a Swatch on his wrist. That showed us how great the breakthrough had been."

Nothing is perhaps more representative of the change from a uniform design sensibility to a pluralist vision than the poster on the next page by graphic designers April Greiman and Jayme Odgers (Fig. 590). Greiman, in all her work, likes to juxtapose opposites. In this collaboration with Odgers, the trapezoidal form of the design makes the top of the poster appear to move back into space away from the

Fig. 590 April Greiman and Jayme Odgers,
moving announcement for Douglas W. Schmidt, 1980.
Four-color offset and silkscreen, trapezoidal poster,
top 17 in., bottom 21 in., height 24 in. Courtesy April Greiman.

bottom, as if it were simultaneously two-
and three-dimensional. In the words of
one critic, "Her designs make opposites
play on a common field: East/West,
Stability/Change, Order/Randomness
. . . Tension/Balance, Technical/Tribal
. . . Classic/Eclectic, Cerebral/Sen-
sual, New Wave/No Wave."

The development of this plural-
ist design vision has been aided
and abetted by a widespread reac-
tion in the design community
against the "good taste" aes-
thetic of mass consumption.
One of the chief figures in this
movement has been the Ital-
ian Ettore Sottsass, who
designed Olivetti's first
electronic typewriter in
1958. In the mid-1970s,
Sottsass spearheaded an
Italian-based international design
cooperative known as "Memphis." For
Sottsass, personal expression takes precedence
over mass appeal, and appearance is more

Fig. 591 Jean Robert and Käti Durrer, Swatch watches, 1983–1988.
Courtesy Swatch AG, Biel, Switzerland.

Fig. 592 Ettore Sottsass, *Casablanca* cabinet, 1981.
Laminate print. Production: Memphis srl, Milano.

important than function. His *Casablanca* cabinet (Fig. 592) does indeed function as a cabinet, but it is primarily a visual statement. As one Memphis designer has put it: "Industry must face up to a new strategy of production, no longer . . . seemingly objective (and substantially anonymous), but personal and subjective. . . . From high-tech to high-touch."

THE CRITICAL PROCESS

Thinking about Design

Consumer spaces—from boutiques to restaurants, from arcades to malls—have increasingly appealed to this highly personal and subjective sense of taste. An interesting example is English architect Nigel Coates's Caffè Bongo in Toyko, Japan (Fig. 593). It is, in a sense, "disposable" architecture, made to appeal to the taste of the moment—but what a plurality of tastes! It also captures what Coates thinks of as a key quality of contemporary urban experience: "the imprint of one reality on another." How many different "realities" can you discover here? What design style does the airplane wing that runs across the top of the bar suggest? What about the statuary that rests on top of the wing? What order of column is incorporated into the back wall and rear entrance? What style does the brickwork evoke (if "style" is even the right word)? What about the steel I-beams? What is the effect of bending them, and supporting them with tilted steel columns? What, finally, does this space reveal about Coates's attitude toward the idea of stability and permanence as values in art and design?

Fig. 593 Nigel Coates, Caffè Bongo interior (1986), Parco department store, Tokyo, Japan.
Photo by Edward Valentine Hames, © Branson Coates Architecture.

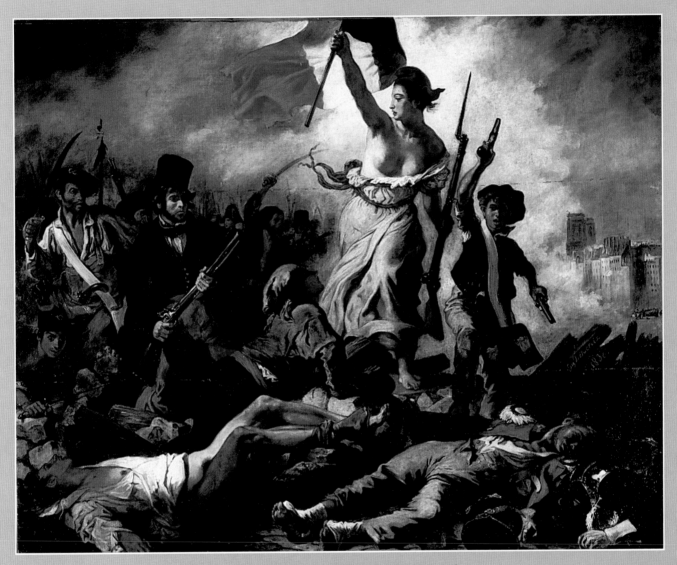

Fig. 594 Eugène Delacroix, *Liberty Leading the People*, 1830.
Oil on canvas, 8 ft. 6⅜ in. × 10 ft. 8 in.
Musée du Louvre, Paris. Giraudon/Art Resource.

The Visual Record

PLACING THE ARTS IN HISTORICAL CONTEXT

CHAPTER 18

THE ANCIENT WORLD

THE EARLIEST ART

SUMERIAN CULTURE

EGYPTIAN CIVILIZATION

WORKS IN PROGRESS
Drawing in Ancient Egypt

AEGEAN CIVILIZATIONS

GREEK ART

ROMAN ART

DEVELOPMENTS IN ASIA

The following chapters are designed to help place the works of art so far discussed in *A World of Art* into a broader historical context. The brief chronological survey and illustrations trace the major developments and movements in art from the earliest to the most recent times. To help you place the illustrations in these and earlier chapters in context, we have listed some important contemporaneous historical events across the tops of the pages. We will see how the history of art is inextricably tied to these broader cultural developments and in many ways reflects them.

Modern humans
arrive in Europe
40,000 BCE

15,000 BCE

22,000 BCE
Height of last
glacial advance in Europe

Fig. 596 *Horses*, Chauvet, Ardèche Gorge, France, c. 30,000 B.C.E.
Corbis/Sygma. Photo: Jean Clottes/Miniterie de la Culture.

Fig. 595 *Venus of Willendorf*,
Lower Austria, c. 25,000–20,000 B.C.E.
Limestone, height 4½ in. Naturhistorisches Museum, Vienna.

THE EARLIEST ART

It is not until the emergence of modern humans, *Homo sapiens,* in the Paleolithic Era, that we find artifacts that might be called works of art. The word "Paleolithic" derives from the Greek *palaios,* "old," and *lithos,* "stone," and refers to the use of stone tools, which represent a significant advance beyond the flint instruments used by Neanderthal people. With these tools, works of art could be fashioned. The earliest of these, representing animals and women, are small sculptural objects, that serve no evident practical function. Found near Willendorf, Austria, the so-called *Venus of Willendorf* (Fig. 595) is probably a fertility figure, judging from its exaggerated breasts, belly, and genitals, and lack of facial features. We know little about it, and we can only guess at its significance. Many

sculptures of this kind are highly polished, a result of continuous handling.

The scale of these small objects is dwarfed by the paintings that have been discovered over the course of the last 125 years in caves concentrated in southern France and northern Spain. In 1996, at Chauvet cave in the Ardèche Gorge in southern France, new drawings were discovered that have been carbon-dated to approximately 30,000 B.C.E. These drawings (Fig. 596) are so expertly rendered, including the use of modeling and even a sense of recessive space, that our sense of prehistoric art has completely changed. Whereas before, we believed that as prehistoric peoples became increasingly sophisticated, their art gained in comparable sophistication, these drawings, the earliest ever found, suggest that prehistoric peoples possessed, at least potentially, the same level of skill as anyone ever has. They suggest as well that the ability to represent reality accurately is not so much a matter of intellectual or cultural sophistication as it is a function of the desire or need of a culture for such images.

15,000 BCE
Cave paintings in
France and Spain

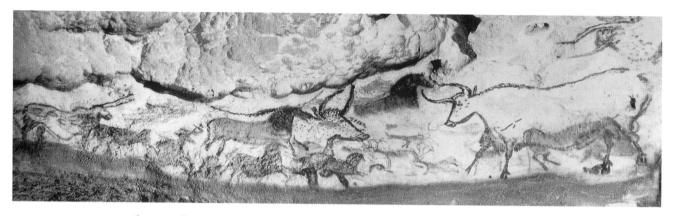

Fig. 597 Hall of Bulls, Lascaux (Dordogne), France (Upper Paleolithic, c. 15,000–10,000 B.C.E.)
Approximately lifesize. Colorfoto Hans Hinz, Basel, Switzerland.

Fig. 598 Houses and shrines at Çatal Hüyük, Turkey, c. 6000 B.C.E.
Schematic reconstruction after J. Mellart.

One of the most magnificent of these caves was discovered at Lascaux, in the Dordogne region of France, near the city of Montignac, in 1940, when a dog belonging to some local boys fell into a hole. These drawings at Lascaux (Fig. 597) were done with chunks of red and yellow ocher that was mixed with something like animal fat as a medium. Many flat stones have been discovered that served as palettes for mixing colors. We can only guess at the signficance of these works, but perhaps they had something to do with hunting, drawn to invoke success in an upcoming hunt or to encourage the return of large herds to the region.

As the Ice Age waned, around 8000 B.C.E., humans began to domesticate animals and cultivate food grains, practices that started in the Middle East and spread slowly across Greece and Europe for the next six thousand years, reaching Britain last. Gradually, Neolithic—or New Stone Age—peoples abandoned temporary shelters for permanent structures built of wood, brick, and stone. Crafts—pottery and weaving, in particular—began to flourish. Religious rituals were regularized in shrines dedicated to that purpose. Remains of highly developed Neolithic communities have been discovered at Jericho, which reached a height of development around 7500 B.C.E. in modern-day Jordan, and at Çatal Hüyük, a community that developed in Turkey about one thousand years later. Jericho was built around a freshwater spring, vital to life in the near-desert conditions of the region, and was surrounded by huge walls for protection. Çatal Hüyük (Fig. 598) was a trade center with a population of about ten thousand people. First excavated between 1961 and 1965, this village was built of mud bricks and timber. There were no streets, only courtyards, and people passed between houses via the rooftops.

Neolithic society developed most quickly in the world's fertile river valleys. By 4000 B.C.E., urban societies had developed on the Tigris and Euphrates rivers in Mesopotamia and on the

4000 BCE
Beginnings of
agriculture in China

Fig. 599 Five-eared *ding* with dragon pattern, c. 1200 B.C.E.
Bronze: height 48 in.; diameter at mouth, 32¾ in.
Chunhua County Cultural Museum. Art Resource, New York.

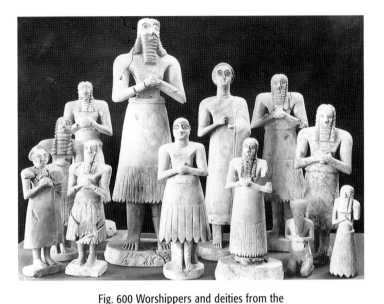

Fig. 600 Worshippers and deities from the
Abu Temple, Tell Asmar, Iraq, c. 2900–2600 B.C.E.
Limestone, alabaster, and gypsum, height of tallest figure, 30 in.
Excavated by the Iraq Expedition of the Oriental Institute of the University of Chicago,
February 13, 1934. Courtesy Oriental Institute of the University of Chicago.

Nile River in Egypt. Similarly complex urban communities were flourishing by 2200 B.C.E. in the Indus and Ganges valleys of India and, by 2000 B.C.E., in the Huang Ho and Yangtze valleys of China (see map on p. 417). Excavations begun at Anyang in northern China in 1928, have revealed the existence of what is known as the Shang dynasty, which ruled China from about 1766 to 1122 B.C.E. The great art form of the Shang dynasty was the richly decorated bronze vessel (Fig. 599), made by a casting technique as advanced as any ever used. This vessel was created to hold food during ceremonies dedicated to the worship and memory of ancestors. Many Shang vessels are decorated with symmetrical animal forms, often mythological, and the symmetrical animal mask that decorates this one is typical of the bronze work of the period.

SUMERIAN CULTURE

Between 4000 and 3000 B.C.E., irrigation techniques were developed on the Tigris and Euphrates rivers in Mesopotamia. A complex society emerged, one credited, for instance, with both the invention of the wheel and the invention

of writing. By the time they were finally overrun by other peoples in 2030 B.C.E., the Sumerians had developed schools, libraries, and written laws. Ancient Sumeria consisted of a dozen or more cities, each with a population of between ten thousand and fifty thousand, and each with its own reigning deity. Each of the local gods had the task of pleading the case of their particular community with the other gods, who controlled the wind, the rain, and so on. The tallest figure in the collection of Sumerian figures above (Fig. 600) is Abu, the Sumerian god of vegetation. Next to him is a mother goddess. The smaller statues represent worshippers and are stand-ins for actual persons, enabling worshippers, at least symbolically, to engage in continuous prayer and devotion. Eyes were considered by the Sumerians to be the "windows to the soul," which explains why the staring eyes in these sculptures are so large. Communication with the god occurred in a *ziggurat*, a stepped temple, which rose high in the middle of the city (see Fig. 487). An early Mesopotamian text calls the ziggurat "the bond between heaven and earth."

4000 BCE

Sumerians brew beer
from barley
3000–2500 BCE

3100 BCE
Egypt united in the
Early Dynastic Period

Fig. 601 *Palette of King Narmer* (front and back), Hierakonpolis,
Upper Egypt, c. 3000 B.C.E.
Slate, height 25 in. Egyptian Museum, Cairo. Hirmer Fotoarchiv.

EGYPTIAN CIVILIZATION

At about the same time that Sumerian culture developed in Mesopotamia, Egyptian society began to flourish along the Nile River. As opposed to Sumeria, which was constantly threatened by invasion, Egypt was protected on all sides by sea and desert, and cherished the ideals of order, stability, and endurance; these ideals are reflected in its art.

Egyptian culture was dedicated to providing a home for the *ka*, that part of the human being that defines personality and that survives life on earth after death. The enduring nature of the *ka* required that artisans decorate tombs with paintings that the spirit could enjoy after death. Small servant figures might be carved from wood to serve the departed in the afterlife. The *ka* could find a home in a statue of the deceased. Mummification—the preservation of the body by treating it with chemical solutions and then wrapping it in linen—provided a similar home, as did the elaborate coffins in which the mummy was placed. The pyramids (see Fig. 486) were, of course, the largest of the resting places designed to house the *ka*.

The enduring quality of the *ka* accounts for the unchanging way in which, over the centuries, Egyptian figures, especially the pharaohs,

Fig. 602 *King Chephren,* Giza, Egypt, c. 2530 B.C.E.
Diorite, height 66⅛ in. Egyptian Museum, Cairo. Hirmer Fotoarchiv.

were represented. A canon of ideal proportions was developed that was almost universally applied. The figure is, in effect, fitted into a grid. The feet rest on the bottom line of the grid, the ankles are placed on the first horizontal line, the knee on the sixth, the navel on the thirteenth (higher on the female), elbows on the fourteenth, and the shoulders on the nineteenth. These proportions are utilized in the *Palette of King Narmer* (Fig. 601)—called a "palette" because eye make-up was prepared on it. The tablet celebrates the victory of Upper Egypt, led by King Narmer, over Lower Egypt, in a battle that united the country. Narmer is depicted holding an enemy by the hair, ready to

Great Sphinx and
Pyramids of Giza
2500 BCE

2000 BCE

2000 BCE
Epic of Gilgamesh
written in Mesopotamia

Cradles of Civilization

Areas of earliest civilization

△ Pleistocene sites

— Present-day boundaries in color

IRAQ Present-day national place names in color

finish him off. On the other side, he is seen reviewing the beheaded bodies of his foes. Narmer's pose is typical of Egyptian art. The lower body is in profile, his torso and shoulders full front, his head in profile again, though a single eye is portrayed frontally.

The rigorous geometry governing Egyptian representation is apparent in the statue of Khafre (Fig. 602). Khafre's frontal pose is almost as rigid as the throne upon which he sits. It is as if he had been composed as a block of right angles. The conventions of representation do not apply, however, to the face itself. Great care was taken in the realistic depiction of individual facial features, and, architecture aside, portraiture may be considered one of the greatest accomplishments of Egyptian art.

4000 BCE

Bronze Age
city-states in China
1766 BCE

1500 BCE
Earliest Vedic hymns
written in India

Fig. 604 Painted chest, tomb of Tutankhamen, Thebes, c. 1350 B.C.E.
Length approx. 20 in. Egyptian Museum, Cairo. Bolton Picture Library.

Fig. 603 *Queen Nefertiti*, Tell el Amarna, c. 1365 B.C.E.
Painted limestone, height 19⅝ in. Agyptisches Museum, Berlin.
Bildarchiv Preussischer Kulturbesitz.

For a brief period, in the fourteenth century B.C.E., under the rule of the Emperor Akhenaten, the realism of Egyptian portraiture was extended to the figure as a whole. Akhenaten declared an end to traditional Egyptian religious practices, relaxing especially the long-standing preoccupation with the *ka*. The Egyptians turned their attention to matters of life instead of death, and a sense of naturalistic form developed in their art that, until this time, could be seen only in representations of people of lower rank, such as entertainers. For the first time, Egyptian art showed a taste for the curved form and for a softness of contour, rather than the harshly rigid geometries of the Egyptian canon of proportion. Nowhere is the beauty of this new style more evident than in the famous bust of Akhenaten's queen, Nefertiti (Fig. 603). Both the graceful curve of her neck and her almost completely relaxed look make for a stunningly naturalistic piece of work.

The reason we know this style so well today is because it has survived in the only unplundered Egyptian tomb whose contents have come down to us. The tomb of Akhenaten's successor, Tutankhamen, the famous "King Tut," was discovered at Thebes in 1922. Among the thousands of artifacts recovered at that time was the tomb of King Tut himself, which consists of three coffins, one set within the other. The innermost coffin is made of 243 pounds of beaten gold inlaid in lapis lazuli, turquoise, and carnelian. The scene of the young king hunting, on a painted chest from the tomb (Fig. 604) shows Tutankhamen as larger than life in traditional heirarchical scale. Nevertheless, the sense of movement and action, and the abandonment of the traditional ground line in the wild chaos of the animals on the right, shows the influence of the freer Akhenaten style.

Drawing in Ancient Egypt

For the ancient Egyptians, drawing was not only a preparatory medium—a design tool in the service of painting, sculpture, and architecture. It was also a self-sufficient medium that has survived in the form of papyrus illustrations (papyrus being a flat, paperlike material made from a water plant native to the Nile Valley), as well as in designs on pots, bowls, and other ceramic objects. Yet it is on what is known as *ostraka* that the majority of Egyptian drawings have come down to us.

Ostraka are limestone flakes upon which draftsmen made preparatory sketches (papyrus was too costly for such work). These sketches are often of the highest quality, and are similar in purpose to the cartoons for frescoes prepared by Renaissance painters in the West over two thousand years later. Most of the *ostraka* known to us come from a village called Deir el Medina, which was built to house the artisans who decorated the royal tombs in nearby Thebes. They date from the period of the New Kingdom, during which Tutankhamen ruled, and they reflect the loose curvilinear style of his court.

The equipment used by the Egyptian artist consisted of a palette and pen case like the one depicted here, which is decorated with a head drawn in profile on its reverse side (Fig. 605). The depressions in the palette held cakes of pigment, the two most common being red ocher and black, which was obtained from soot. Rushes were used to create

Fig. 606 Acrobatic dancer, Ramsside, c. 1305–1080 B.C.E.
Ink on limestone, 4⅛ × 6⅝ in. Egyptian Museum, Turin, Italy.

the pens. The rush was chiseled to a point, and then flattened to a greater or lesser degree depending on the width of line the artist wished to use. The pen was then dipped in water, the wet nib mixed with pigment, and the artist was ready to draw.

The *ostraka* above (Fig. 606) depicts one of the acrobatic dancers who were part of most religious ceremonies. Dancers such as this one even participated in funeral rituals. It is believed that their purpose was to create a mood of intense physical activity. Reporting on his Egyptian Expedition of 1925–1927, N. de Garis Davies wrote in the *Bulletin of the Metropolitan Museum of Art* that such acrobatic dancing was designed to help spectators and participants "reach a physical rhapsody, a throbbing emotion, which . . . must be induced by the sight of rapid physical action and the sound of strong monotonous rhythm." Notice that in this drawing, the dancer's large loop earring defies the laws of gravity, suggesting that the artist drew the body first, and then turned the *ostraka* upside down to draw the head.

Fig. 605 Pen case of Amenmes. Dynasty XVII, c. 1305–1196 B.C.E.
Wood, 15⅞ × 3 in. Musée du Louvre, Paris; Cliché des Musées Nationaux–Paris © R. M. N.

Emperor Hammurabi's code of law
imposed in Mesopotamia
c. 1750 BCE

Fig. 607 *Snake Goddess* or *Priestess*, c. 1600 B.C.E.
Faience, height 11⅝ in. Archeological Museum, Heraklion, Crete.
Nimatallah/Art Resource, New York.

The Akhenaten style did not survive long in Egypt. Soon after King Tut's death, traditional religious practices were reestablished, and a revival of the old style of art, with its unrelentingly stiff formality, quickly followed. For the next one thousand years, the Egyptians maintained the conventions and formulas that their forefathers had initiated in the first half of the third millennium B.C.E.

AEGEAN CIVILIZATIONS

The Egyptians had significant contact with other civilizations in the eastern Mediterranean, particularly with the Minoan civilization on the island of Crete and with Mycenae on the Greek Peloponnesus, the southern peninsula of Greece. The origin of the Minoans is unclear—they may have arrived on the island as early as 6000 B.C.E.—but their culture reached its peak between 1600 and 1400 B.C.E. The chief deity of Minoan culture was a fertility goddess represented in several different forms. As she appears here (Fig. 607), her bare breasts indicate female fecundity, while the snakes she carries are associated with male fertility. Nothing like her has been discovered in any other culture.

The so-called *"Toreador"* fresco (Fig. 608), from the Minoan palace at Knossos, does not actually depict a bullfight, as its title suggests. Instead, a youthful acrobat can be seen vaulting over the bull's back as one maiden holds the animal's horns and another waits to catch him. The similarity between this image and the Egyptian *ostraka* on the preceeding page demonstrates how much contact took place between the Minoans and the Egyptians. Both, at any rate, valued the activity, grace, and agility of athletes, something that the later Greeks, in founding the Olympic Games, also valued highly.

In Minoan culture, the bull was an animal of sacred significance. Legend has it that the wife of King Minos, after whom the culture takes its name, gave birth to a creature half-human and half-bull, that was the *Minotaur.* Minos had a giant labyrinth, or maze, constructed to house the creature, to whom Athenian youths and maidens were sacrificed until it was killed by the hero Theseus. The legend of the labyrinth probably arose in response to the intricate design of the palaces built for the Minoan kings.

It is unclear why Minoan culture abruptly ended in approximately 1450 B.C.E. Great earthquakes and volcanic eruptions may have

Aryan peoples migrate
to northwest India
c. 1500 BCE

c. 1500 BCE
Rise of Olmec civilization
on Gulf Coast of Mexico

c. 1200 BCE
Decline of Mycenean
and Minoan civilizations

Fig. 608 *The "Toreador" fresco*, Knossos, Crete, c. 1500 B.C.E.
Height including upper border approx. 24½ in. Art Resource, New York. Photo: Nimatallah.

destroyed the civilization, or perhaps it fell victim to the warlike Mycenaeans from the mainland, whose culture flourished between 1400 and 1200 B.C.E. Theirs was a culture dominated by military values. In the *The Warrior Vase* (Fig. 609) we see Mycenaean soldiers marching to war, perhaps to meet the Dorian invaders who destroyed their civilization soon after 1200 B.C.E. The Dorian weapons were made of iron and therefore were superior to the softer bronze Mycenaean spears. It is this culture, immortalized by Homer in the *Iliad* and the *Odyssey*, that sacked the great Trojan city of Troy. The Mycenaeans built stone fortresses on the hilltops of the Peloponnesus, a peninsula forming part of the Greek mainland. They buried their dead in so-called beehive tombs, which, dome-shaped, were full of gold and silver, including masks of the royal dead, a burial practice similar to that of the Egyptians.

Fig. 609 *The Warrior Vase*, Mycenae, c. 1200 B.C.E.
Height approx. 14 in. National Museum, Athens. Scala/Art Resource, New York.

1200 BCE

Rule of the
Hebrew King, David
960–933 BCE

c. 1000 BCE
Agriculture practiced in village
communities in American Southwest

c. 800 BCE
Homer writes
Iliad and *Odyssey*

Fig. 610 The Acropolis today, viewed from the southwest, Athens, Greece.
Greek National Tourism Organization.

GREEK ART

The rise of the Greek city-state, or *polis*, marks the moment when Western culture begins to celebrate its own human strengths and powers—the creative genius of the mind itself—over the power of nature. The Western world's gods now became personified, taking human form and assuming human weaknesses. Though immortal, they were otherwise versions of ourselves, no longer angry beasts or natural phenomena such as the earth, the sun, or the rain.

In about 1200 B.C.E., just after the fall of Mycenae, the Greek world consisted of various tribes separated by the geographical features of the peninsula, with its deep bays, narrow valleys, and jagged mountains. These tribes soon developed into independent and often warring city-states, with their own constitutions, coinage, and armies. We know that in 776 B.C.E. these feuding states declared a truce in order to hold the first Olympic games, a moment so significant that the Greeks later took it as the starting point of their history.

The human figure celebrated in athletic contests is the most important subject of Greek art as well. Only during the short reign of Pharaoh Akhenaten, in Egypt (Fig. 603), had there been such concern to depict the human form in a realistic manner. By the fifth century B.C.E., this interest in humanity was reflected throughout Greek culture. The philosopher Plato developed theories not only about social and political relations but about education and aesthetic pleasure. The physician Hippocrates systematically studied human disease, and the historian Herodotus, in his account of the Persian Wars, began to chronicle human history. Around 500 B.C.E., in Athens, all free male citizens were included in the political system, and democracy—from *demos*, meaning "people," and *kratia*, meaning "power"—was born. It was not quite democracy as we think of it today: Slavery was considered natural, and women were excluded from political life. Nevertheless, the concept of individual freedom was cherished.

The values of the Greek city-state were embodied in its temples. The temple was usually situated on an elevated site above the city, and the **acropolis**, from *akros*, meaning "top," and *polis*, "city," was conceived as the center of civic life. The crowning achievement of Greek architecture is the complex of buildings on the Acropolis in Athens (Fig. 610), which was built to replace those destroyed by the Persians in 480 B.C.E. Construction began in about 450 B.C.E., under the leadership of the great Athen-

Poet Sappho of Lesbos **c. 610–580 BCE**	Confucius in China **551–479 BCE**	**400 BCE**

594 BCE
Solon's code of laws in Athens

5th century BCE
Drama of Sophocles, Euripides, Aristophanes.
Historical writings of Herodotus, Thucydides

Ancient Greece

Athenian Empire, 450 BCE

ian statesman, Pericles. The central building of the new complex, designed by Ictinus and Callicrates, was the Parthenon, dedicated to the city's namesake, Athena Parthenos, the goddess of wisdom. A Doric temple of the grandest scale, it is composed entirely of marble. At its center was an enormous ivory and gold statue of Athena, sculpted by Phidias, who was in charge of all the ornamentation and sculpture for the project. The Athena is long since lost, and we can imagine his achievement only by considering the sculpture on the building's pediment (see Fig. 373) and its friezes, all of which reflect Phidias's style and may be his design.

400 BCE

Conquests of
Alexander the Great
336–323 BCE

Ch'in Emperor unites
all of China
221 BCE

C. 300 BCE
Mexican sun temple
built at Teotihuacán

Fig. 611 *Nike,* from the balustrade
of the Temple of Athena Nike, c. 410–407 B.C.E.
Marble, height 42 in. Acropolis Museum, Athens. Alinari/
Art Resource, New York.

Fig. 612 Unknown artist, perhaps a pupil of Lysippos,
Statue of a Victorious Athlete, Greek,
last quarter of the 4th century B.C.E.
Bronze, 59⅝ in. The J. Paul Getty Museum, Malibu, California. (77.AB.30).

The Phidian style is marked by its naturalness. The human figure often assumes a relaxed, seemingly effortless pose, or it may be caught in the act of movement, athletic or casual. In either case, the precision with which the anatomy has been rendered is remarkable. The relief of *Nike* (Fig. 611), goddess of victory, from the balustrade of the Temple of Nike (see Fig. 493) is a perfect example of the Phidian style. As Nike bends to take off her sandal, the drapery both reveals and conceals the body beneath. Sometimes appearing to be transparent, sometimes dropping in deep folds and hollows, it contributes importantly to the sense of reality conveyed by the sculpture. It is as if we can see the body literally push forward out of the stone and press against the drapery.

The Greek passion for individualism, reason, and accurate observation of the world continued on even after the disastrous defeat of Athens in the Peloponnesian War in 404 B.C.E., which led to a great loss of Athenian power. In 338 B.C.E., the army of Philip, King of Macedon, conquered Greece, and after Philip's death two years later, his son, Alexander the Great, came to power. Because Philip greatly admired Athenian culture, Alexander was educated by

the philosopher Aristotle, who persuaded the young king to impose Greek culture throughout his empire. **Hellenism,** or the culture of Greece, thus came to dominate the Western world. The court sculptor to Alexander the Great was Lysippos, known to us only through later Roman copies of his work. The *Statue of a Victorious Athlete* (Fig. 612), recently discovered in the Adriatic Sea, captures the body in its fleeting movements with such naturalness—the Lysippic ideal—that some scholars feel it may be the work of the master himself.

In the sculpture of the fourth century B.C.E., we discover a graceful, even sensuous, beauty marked by *contrapposto* and three-dimensional

Rome rules entire western
Mediterranean after defeat of Carthage
146 BCE

CE **100**

206 BCE
Former Han Dynasty
in China begins

44–14 BCE
End of Roman Republic;
rule of Augustus

Fig. 613 *Nike of Samothrace*, c. 190 B.C.E.
Marble, height approx. 8 ft. Musée du Louvre, Paris. Hirmer Fotoarchiv.

Fig. 614 *The Laocoön Group*, Roman copy, perhaps after
Agesander, Athenodorus, and Polydorus of Rhodes, 1st century C.E.
Marble, height 7 ft. The Vatican Museum, Rome.

realism (see Figs. 119 and 372). The depiction of physical beauty becomes an end in itself, and sculpture increasingly seems to be more about the pleasures of seeing than anything else. At the same time, artists strove for an ever greater degree of realism, and in the sculpture of the Hellenistic Age, we find an increasingly animated and dramatic treatment of the figure. The *Nike of Samothrace* (Fig. 613) is a masterpiece of Hellenistic realism. The goddess has been depicted as she alights on the prow of a victorious war galley, and one can almost feel the wind as it buffets her, and the surf spray that has soaked her garment so that it clings revealingly to her torso.

The swirl of line that was once restricted to drapery overwhelms the entire composition of *The Laocoön Group* (Fig. 614), in which Laocoön, a Trojan priest, and his two sons are overwhelmed by serpents sent by the sea-god Poseidon. We are caught in the midst of the the Trojan War. The Greeks have sent the Trojans a giant wooden horse as a "gift." Inside it are Greek soldiers, and Laocoön suspects as much. So Poseidon, who favors the Greeks, has chosen to silence Laocoön forever. So theatrical is the group that to many eyes it verges on melodrama, but its expressive aims are undeniable. The sculptor is no longer content simply to represent the figure realistically; sculpture must convey emotion as well.

509 BCE
Foundation of
Roman Republic

Fig. 615 *Mars from Todi*, early 4th century B.C.E.
Bronze, height 56 in. Vatican Museums, Rome. Giraudon/Art Resource, New York.

Fig. 616 *She-Wolf*, c. 500 B.C.E.
Bronze, height 33½ in. Museo Capitolino, Rome. Alinari/
Art Resource, New York.

ROMAN ART

Although the Romans conquered Greece (in 146 B.C.E.), like Philip of Macedon and Alexander, they regarded Greek culture and art as superior to any other. Thus, like the Hellenistic Empire before it, the Roman Empire possessed a distinctly Greek character. The Romans imported thousands of original Greek artworks and had them copied in even greater numbers. In fact, much of what we know today about Greek art, we know only through

Roman copies. The Greek gods were adapted to the Roman religion, Jupiter bearing a strong resemblance to Zeus, Venus to Aphrodite, and so on. The Romans used the Greek architectural orders in their own buildings and temples, preferring especially the highly decorative Corinthian order. Many, if not most, of Rome's artists were of Greek extraction, though they were "Romanized" to the point of being indistinguishable from the Romans themselves.

Roman art derives, nevertheless, from at least one other source. Around 750 B.C.E., at about the same time the Greeks first colonized the southern end of the Italian peninsula, the Etruscans, whose language has no relation to any known tongue, and whose origin is somewhat mysterious, established a vital set of city-states in the area between present-day Florence and Rome. Little remains of the Etruscan cities, which were destroyed and rebuilt by Roman armies in the second and third centuries B.C.E., and we know the Etruscans' culture largely through their sometimes richly decorated tombs. At Veii, just north of Rome, the Etruscans established a sculptural center that gave them a reputation as the finest metalworkers of the age. They traded widely, and from the sixth century on, a vast array of bronze objects, from statues to hand mirrors, were made for export. Etruscan art was influ-

Fig. 617 *Marcus Agrippa with imperial family* (south frieze),
detail of the *Ara Pacis*, 13–9 B.C.E.
Marble, height 5 ft. 3 in. Museum of the Ara Pacis, Rome.
Scala/Art Reource, New York.

Fig. 618 *Odysseus in the Land of the Lestrygonians,*
from a Roman patrician house, 50–40 B.C.E.
Fresco, height 60 in. Vatican Library, Rome. Scala/Art Resource, New York.

enced by the Greeks, as the lifesize portrait of a young man dressed as the god of war, *Mars from Todi* (Fig. 615), makes clear.

The Romans traced their ancestry to the Trojan prince Aeneas, who escaped after the sack of Troy and who appears in Homer's *Iliad*. The city of Rome itself was founded early in Etruscan times—in 753 B.C.E., the Romans believed—by Romulus and Remus, twins nurtured by a *She-Wolf* (Fig. 616). Though Romulus and Remus are Renaissance additions to the original Etruscan bronze, the image served as the totem of the city of Rome from the day on which a statue of a she-wolf, possibly this very one, was dedicated on the Capitoline Hill in Rome in 296 B.C.E. The she-wolf reminded the Romans of the fiercely protective loyalty and power of their motherland.

Beginning in the fifth century B.C.E., Rome dedicated itself to conquest and created an empire that included all areas surrounding the Mediterranean and that stretched as far north as present-day England. By the time the Romans conquered Greece, their interest in the accurate portrayal of human features was long established, and Hellenistic art only supported this tendency. But where the Greeks had sought

to idealize their figures, to render them perfectly proportioned and beautiful to the eye, the Romans preferred absolute realism. The *Ara Pacis* (Fig. 617), or "Altar of Peace," was built by the Emperor Augustus to celebrate the peace he had brought to Rome. It depicts three generations of his actual family. In this section, Augustus's grandson, Gaius Caesar, stands between Augustus's wife, Livia, and his son-in-law, Marcus Agrippa, the little boy looking up reverentially at his grandmother. Such realism is prototypically Roman.

In painting, the Romans were dedicated to a similar *verism*, or truth to nature. They had still lifes and illusionistic "window views" painted in fresco on the walls of their villas (see Figs. 334 and 335). Atmospheric perspective was commonplace, and three-dimensional effects were achieved by means of *chiaroscuro*. The illusionistic landscape above (Fig. 618) portrays a moment from Homer's *Odyssey,* in which the Lestrygonians hurl rocks at Odysseus's fleet.

The perfection of the arch and dome and the development of structural concrete were, as we have seen in Part IV, the Romans' major architectural contributions. But they were

Romans destroy the
Hebrew Temple in Jerusalem
CE 70

CE 30
Crucifixion of Jesus

CE 180
Pax Romana begins
to break down

Fig. 620 Bechetti, *Reconstruction of the Roman Forum, Northern Part*.
Watercolor. Superintendent of Architecture, Rome. Scala/Art Resource, New York.

Fig. 619 Attributed to Apollodorus, *Column of Trajan*, 113 C.E.
Marble, height originally 128 ft.; length of frieze approx. 625 ft., Rome.
Alinari/Art Resource.

extraordinary monument builders. Many of their triumphal arches still stand across Europe. One remarkable symbol of their power is the *Column of Trajan* (Fig. 619). Encircled by a spiraling band of relief sculpture 50 inches high and, if it were unwound and stretched out, 625 feet long, the column details the Emperor Trajan's two successful campaigns in present-day Hungary and Romania in the first century B.C.E. The 150 separate episodes celebrate not only military victories, but Rome's civilizing mission as well.

As the empire solidified its strength under the Pax Romana—150 years of peace initiated by the Emperor Augustus in 27 B.C.E.—a succes-

sion of emperors celebrated the glory of the empire in a variety of elaborate public works and monuments, including the Colosseum and the Pantheon (see Figs. 497 and 499). The most extravagant architectural expression of the Roman state was the Forum Romanum, the political center of Rome. At the time represented in this imaginary reconstruction (Fig. 620), around the first century C.E., Rome's population approached one million. Most of its inhabitants lived in apartment buildings surrounding the Forum area. An archival record indicates that, at this time, there were only 1,797 private homes in the city. The Etruscans had developed the site as a marketplace, but in a plan developed by Julius Caesar and implemented by Augustus, the Forum became the symbol of Roman power and grandeur, paved in marble and dominated by colonnaded public spaces, temples, basilicas, and state buildings such as the courts, the archives, and the Curia, or senate house.

Though Rome became extraordinarily wealthy, the empire began to falter after the death of the emperor Marcus Aurelius in C.E. 180. Invasions of Germanic tribes from the north, Berbers from the south, and Persians from the east wreaked havoc upon the Empire's economic, administrative, and military structure. By the time the Emperor Constantine decided to move the capital to Byzantium in C.E. 323—renaming it Constan-

313
Constantine gives Christianity
favored status in Roman Empire

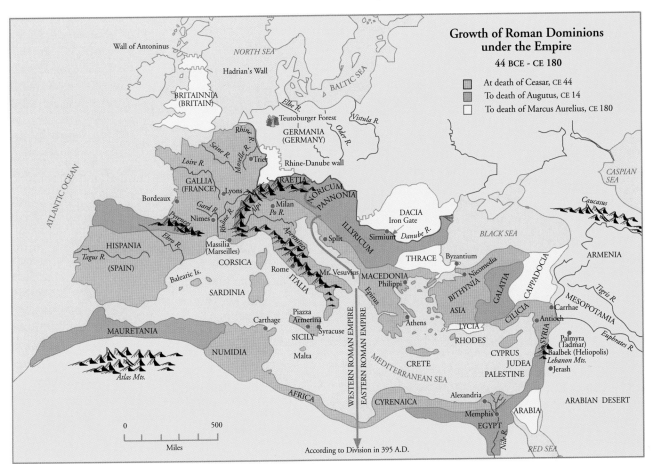

**Growth of Roman Dominions
under the Empire**

44 BCE - CE 180

At death of Ceasar, CE 44
To death of Augutus, CE 14
To death of Marcus Aurelius, CE 180

tinople, today's Istanbul—the empire was hopelessly divided, and the establishment of the new capital only underscored the division.

DEVELOPMENTS IN ASIA

Meanwhile, in Asia, the early artistic traditions developed during the Shang dynasty in China, particularly the casting of bronze (see Fig. 599), were continued. Even as the Roman Empire began to disintegrate, bronze casting in China reached new heights of subtlety and elegance. An example is *Flying Horse Poised on One Leg on a Swallow* (Fig. 621). It is perfectly balanced—almost impossibly so, defying gravity itself—so that it seems to have stolen the ability to fly from the bird beneath its hoof.

Fig. 621 *Flying Horse Poised on One Leg on a Swallow*, from a tomb at Wuwei, Kansu, Late Han dynasty, 2nd century C.E.
Bronze, height 13½ in.; length 17¾ in.
The Exhibition of the Archeological Finds of the People's Republic of China.
Erich Lessing/Art Resource, New York.

Cyrus the Great establishes
the Iranian Empire in Persia
539 BCE

Life of Socrates
469–399 BCE

600 BCE

C. 500–200 BCE
Rise of Taoist and legalist schools
of thought in China

Fig. 622 *Ritual Disc with Dragon Motif (Pi)*, Eastern Zhou
Dynasty, Warring States period, 4th–3rd century B.C.E.
Jade, diameter 6½ in. The Nelson-Atkins Museum of Art, Kansas City,
Missouri (Purchase: Nelson Trust) 33-81.

Though the traditions of bronze casting remained strong, that part of the world developed no less turbulently than the West. By the sixth century B.C.E., the Chinese empire had begun to dissolve into a number of warring feudal factions. The resulting political and social chaos brought with it a powerful upsurge of philosophical and intellectual thought that focused on how to remedy the declining social order. In the context of this debate, Confucius, who died in 479 B.C.E., ten years before the birth of Socrates, introduced the idea that high office should be obtained by merit, not birth, and that all social institutions, from the state to the family, should base their authority on loyalty and respect, not sheer might. At the same time, the Taoists developed a philosophy based on the universal principle, or Tao—the achievement by the individual of a pure harmony with nature (for an image embodying the Tao in a later Chinese painting, see Fig. 4).

The jade *Pi,* or disc (Fig. 622), illustrated here symbolizes the desire of the Chinese to unify their country. Made sometime between the sixth and third centuries B.C.E., the disc is decorated with a dragon and a phoenix, which are today commonly found in the context of the Chinese wedding ceremony, hanging together as a pair over the table at the wedding feast. The tradition goes back to a time when the ancient peoples of China were united in an historic alliance between those from western China, who worshiped the dragon, and those from eastern China, who worshiped the phoenix. This particular disc was found in a tomb, probably placed there because the Chinese believed that jade preserved the body from decay.

Peace lasted in China from 221 B.C.E., when Shih Huang Ti, the first emperor of Ch'in, whose tomb was discussed in Chapter 13 (Fig. 377), united the country under one rule. This lasted until the end of the Han dynasty in C.E 220, when China once again endured a 400-year period of disorder and instability. The Han restored Confucianism to prominence. We know through surviving literary descriptions that the Han emperors built lavish palaces, richly decorated with wall paintings. In one of the few imperial Han tombs to have been discovered, that of the Emperor Wu Ti's brother and his wife, both bodies were dressed in suits made of more than two thousand jade tablets sewn together with gold wire. The prosperity of the Han dynasty was due largely to the expansion of trade, particularly the export of silk. The silk-trading routes reached all the way to Imperial Rome.

Elsewhere in Asia, the philosophy of Buddha, "The Enlightened One," was taking hold. Born as Siddhartha Gautama around 537 B.C.E., Buddha achieved *nirvana*—the release from worldly desires that ends the cycle of death and reincarnation and begins a state of permanent bliss. He preached a message of self-denial and meditation across northern India, attracting converts from all levels of Indian society. The religion gained strength for centuries after Buddha's death and finally became

Kushite Empire of Africa
reaches its pinnacle
c. 250 BCE

200 BCE

c. 256–206 BCE
Original Great Wall
of China built

Fig. 623 The Great Stupa, Sanchi, India. Begun 3rd century B.C.E., with later additions.
Brick and rubble, originally faced with painted and gilded stucco, with rails of white stone. Four by Five/Superstock, Inc.

institutionalized in India under the rule of Asoka (273–232 B.C.E.). Deeply saddened by the horrors of war, and believing that his power rested ultimately in religious virtue and not military force, Asoka became a great patron of the Buddhist monks, erecting some eighty-four thousand shrines, called *stupas*, throughout India, all elaborately decorated with sculpture and painting. The *stupa* is literally a burial mound, dating from prehistoric times, but by the time the Great Stupa at Sanchi was made (Fig. 623)—it is the earliest surviving example of the form—it had come to house important relics of Buddha himself or the remains of later Buddhist holy persons. This *stupa* is made of rubble, piled on top of the original shrine, which has been faced with brick to form a hemispherical dome that symbolizes the earth

itself. A railing—in this case, made of white stone and clearly visible in this photograph—encircles the sphere. Ceremonial processions moved along the narrow path behind this railing. Pilgrims would circle the *stupa* in a clockwise direction on another wider path, at ground level, retracing the path of the sun, thus putting themselves in harmony with the cosmos and symbolically walking the Buddhist Path of Life around the World Mountain.

All the ancient centers of civilization underwent wars, conquests, and dramatic cultural changes. And all produced great philosophers, great art, and great writing, much of which we still find current and useful today. All were organized around religion, and with the dawn of the Christian era, religion continued to play a central role in defining culture.

CHAPTER 19

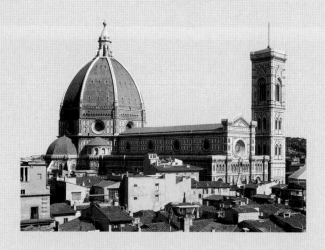

THE CHRISTIAN ERA

EARLY CHRISTIAN AND BYZANTINE ART

CHRISTIAN ART IN NORTHERN EUROPE

ROMANESQUE ART

GOTHIC ART

DEVELOPMENTS IN ISLAM AND ASIA

Our study of the ancient world—from ancient fertility statues, to the Egyptian *ka*, to the rise of Buddhism—shows how powerful religion can be in setting the course of culture, and the advent of Christianity in the Western world makes this abundantly clear. So powerful was the Christian story, that even the common calendar changed. From the 6th century on, time was recorded in terms of years "B.C." (before Christ) and years "A.D." (*anno Domini*, the year of Our Lord, meaning the year of his birth). Today, usage has changed somewhat—the preferred terms, as we have used them in this text, are B.C.E. (before the common era) and C.E. (the common era)—but the world's calendar remains Christian.

Camels first used for
trans-Saharan transport
c. 200

Augustine writes
The City of God
426

CE 550

c. 300
End of the Olmec
civilization

c. 400–500
Germanic tribes
invade Rome

Fig. 624 Basilica di S. Apollinaire in Classe,
the former port of Ravenna, Italy, 533–549.
Alinari/Art Resource, New York.

Fig. 625 Santa Costanza, Rome, c. 354 C.E.
Interior view. Alinari/Art Resource, New York.

EARLY CHRISTIAN AND BYZANTINE ART

Christianity spread through the Roman world at a very rapid pace, in large part due to the missionary zeal of St. Paul. By C.E. 250, fully sixty percent of Asia Minor had converted to the religion, and when the Roman Emperor Constantine legalized Christianity in the Edict of Milan in C.E. 313, Christian art became imperial art. The classical art of Greece and Rome emphasized the humanity of its figures, their corporeal reality. But the Christian God was not mortal and could not even be comfortably represented in human terms. Though His Son, Jesus, was human enough, the mystery of both his Virgin Birth and his rising from the dead most interested early Christian believers. The world that the Romans had celebrated on their walls in fresco—a world of still lifes and landscapes—was of little interest to Christians, who were more concerned with the spiritual and the heavenly than with their material surroundings.

Constantine chose to make early Christian places of worship as unlike classical temples as possible. The building type that he preferred was the rectangular **basilica**, which the Romans had used for public buildings, especially courthouses. The original St. Peter's in Rome, constructed circa C.E. 333–390 but destroyed in the sixteenth century to make way for the present building, was a basilica (see Fig. 510). Sant' Apollinaire (Fig. 624), in Ravenna, Italy, is one of the earliest Christian basilicas to have survived intact. As at St. Peter's, wooden trusses support the gable roof of this essentially rectangular structure.

Equally important for the future of Christian religious architecture was Santa Costanza (Fig. 625), the small mausoleum built circa C.E. 354 for the tomb of Constantine's daughter, Constantia. Circular in shape and topped with a dome supported by a barrel vault, the building defines the points of the traditional Greek cross, which has four equal arms. Surrounding the circular space is a passageway known as an **ambulatory** that was used for ceremonial processions.

The circular form of Santa Costanza appears often in later Byzantine architecture. By the year 500, most of the western empire, traditionally Catholic, had been overrun by

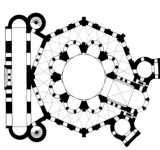

Fig. 626 San Vitale, Ravenna, 526–547 C.E.
Exterior view and floor plan. Alinari/Art Resource, New York.

barbarian forces from the north. When the Emperor Justinian assumed the throne in Constantinople in 527, he dreamed of restoring the lost empire. His armies quickly recaptured the Mediterranean world, and he began a massive program of public works. At Ravenna, Italy, at one time the imperial capital, Justinian built San Vitale (Fig. 626), a new church modeled on the churches of Constantinople. Although the exterior is octagonal, the interior space is essentially circular, like Santa Costanza before it. Only in the altar and the apse, which lie to the right of the central domed area in the floor plan, is there any reference to the basilica structure that dominates western church architecture. Considering that Sant' Apollinaire was built at virtually the same time and in virtually the same place, there is some reason to believe that San Vitale was conceived as a political and religious statement, an attempt to persuade the people of the Italian peninsula to give up their Catholic ways and to adopt the Orthodox point of view—that is, to reject the leadership of the Church by the pope.

Sant' Apollinaire and San Vitale share one important feature. The facades of both are very plain, more or less unadorned local brick. Inside, however, both churches are elaborately decorated with marble and glittering mosaics. At St. Vitale two elaborate **mosaics**—small stones or pieces of tile arranged in a pattern—face each other on the side walls of the apse, one depicting Theodora, the wife of Justinian

(Fig. 627), and the other Justinian himself (Fig. 628). Theodora had at one time been a circus performer, but she became one of the emperor's most trusted advisors, sharing with him a vision of a Christian Roman Empire. In the mosaic, she carries a golden cup of wine, and Justinian, on the opposite wall, carries a bowl containing bread. Together they are bringing to the Church an offering of bread and wine for the celebration of the Eucharist. The haloed Justinian is to be identified with Christ, surrounded as he is by twelve advisors, like the Twelve Apostles. And the haloed Theodora, with the three Magi bearing gifts to the Virgin and newborn Christ embroidered on the hem of her skirt, is to be understood as a figure for Mary. In this image, Church and state become one and the same.

These mosaics bear no relation to the naturalism that dominated Greek and Roman culture. Here, the human figures are depicted wearing long robes that hide the musculature and cause a loss of individual identity. Although each face has unique features—some of Justinian's attendants, for example, are bearded, while others are not, and the hairstyles vary—all have identical wide-open eyes, curved brows, and long noses. The feet of the figures turn outward, as if to flatten the space in which they stand. They are disproportionately long and thin, a fact that lends them a heavenly lightness. And they are motionless, standing before us without gesture, as if eternally still. The Greek ideal of sculpture in the round, with its sense of the body caught in an intensely personal, even private moment—Nike taking off her sandal, for instance, or Laocoön caught in the intensity of his torment—is gone. All sense of drama has been removed from the idea of representation.

Mosaics are made of small pieces of stone called *tesserae*, from the Greek word *tesseres*, meaning "square." In Hellenistic Rome, they were a favorite decorative element, used because of their durability, especially to embellish villa floors. But the Romans rarely used mosaic on their walls, where they pre-

Birth of Mohammed
c. 570

First book printed
in China
600

CE 600

597
Pope Gregory sends Augustine
to Christianize Britain

607
Japan begins sending
embassies to China

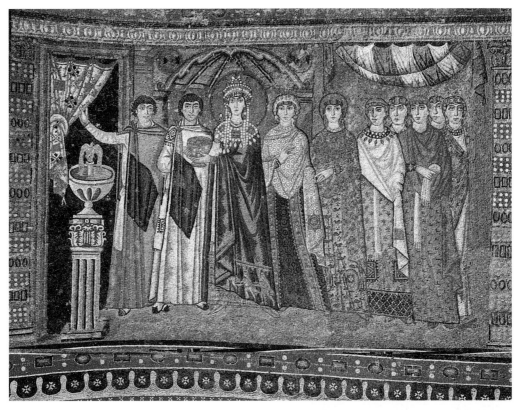

Fig. 627 (above) *Theodora and Her Attendants*, c. 547.
Mosaic, sidewall of the apse, San Vitale. Scala/Art Resource, New York.

Fig. 628 (right) San Vitale, interior view,
looking into the apse at *Justinian and His Attendants*, c. 547.
Canali Photobank.

ferred the more refined and naturalistic effects that were possible with fresco. For no matter how skilled the mosaic artist, the naturalism of the original drawing would inevitably be lost when the small stones were set in cement.

The Byzantine mosaic artists, however, had little interest in naturalism. Their intention was to create a symbolic, mystical art, something for which the mosaic medium was perfectly suited. Gold *tesserae* were made by sandwiching gold leaf between two small squares of glass, and polished glass was also used. By setting the *tesserae* unevenly, at slight angles, a shimmering and transcendent effect was realized, which was heightened by the light from the church's windows.

Sung Dynasty in China
600

Charlemagne comes
to the throne
768

CE 600

607
Flowering of court literature
in Heian Japan

800
City of Machu Picchu
built in Peru

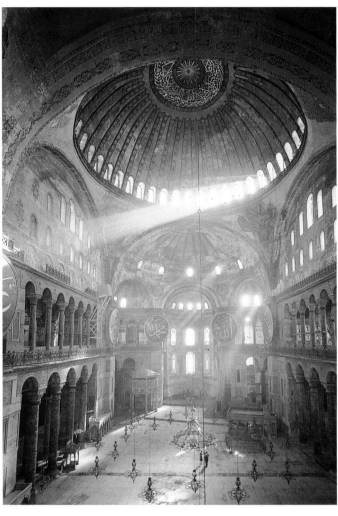

Fig. 629 Anthemius of Tralles and Isidorus of Miletus,
Hagia Sophia, Istanbul, 532–537. Interior view.
Erich Lessing/Art Resource, New York.

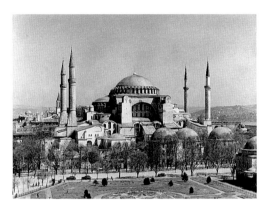

Fig. 630 Anthemius of Tralles and Isidorus of Miletus,
Hagia Sophia, Istanbul, and plan 532–537.
Pearson Education/PH College.

Justinian attached enormous importance to architecture, believing that nothing better served to underscore the power of the emperor. The church of Hagia Sophia, meaning "Holy Wisdom," was his imperial place of worship in Constantinople (Figs 629 and 630). The huge interior, crowned by a dome, is reminiscent of the circular, central plan of Ravenna's San Vitale, but this dome is abutted at either end by half-domes that extend the central core of the church along a longitudinal axis reminiscent of the basilica, with the apse extending in another smaller half-dome out one end of the axis. These half-domes culminate in arches that are repeated on the two sides of the dome as well. The architectural scheme is, in fact, relatively simple—a dome supported by four **pendentives**, the curved, inverted triangular shapes

c. 1000–1500
Inca civilization in
South America

that rise up to the rim of the dome between the four arches themselves. This dome-on-pendentive design was so enthusiastically received that it became the standard for Byzantine church design.

Many of the original mosaics that decorated Hagia Sofia, Justinian's magnificent church in Constantinople, were later destroyed or covered over. During the eighth and ninth centuries, Iconoclasts, meaning "image-breakers," who believed literally in the Bible's commandment against the worship of "graven" images, destroyed much Byzantine art. Forced to migrate westward, Byzantine artists discovered Hellenistic naturalism and incorporated it into later Byzantine design. The mosaic of Christ from Hagia Sophia (Fig. 631) is representative of that later synthesis.

Though only a few of the original mosaics have been restored, and later mosaics were few in number, the light in the interior is still almost transcendental in feeling, and one can only imagine the heavenly aura when gold and glass reflected the light that entered the nave through the many windows that surround it. In Justinian's own words: "The sun's light and its shining rays fill the temple. One would say that the space is not lit by the sun without, but that the source of light is to be found within, such is the abundance of light. . . . The scintillations of the light forbid the spectator's gaze to linger on the details; each one attracts the eye and leads it on to the next. The circular motion of one's gaze reproduces itself to infinity. . . . The spirit rises toward God and floats in the air."

Justinian's reign marked the apex of the early Christian and Byzantine era. By the seventh century, barbarian invaders had taken control of the western empire, and the new Muslim empire had begun to expand to the east. Reduced in area to the Balkans and Greece, the Byzantine empire nevertheless held on until 1453 when the Turks finally captured Constantinople and renamed it Istanbul, converting Hagia Sophia into a mosque.

Fig. 631 *Christ*, from *Deësis* mosaic, 13th century.
Hagia Sophia, Istanbul. Erich Lessing/Art Resource, New York.

Death of St. Patrick
in Ireland
461

Justinian comes to the throne
of Byzantium
527

CE 400

c. 450
Angles, Saxons, and Jutes
invade England

476
Last Roman emperor
dethroned

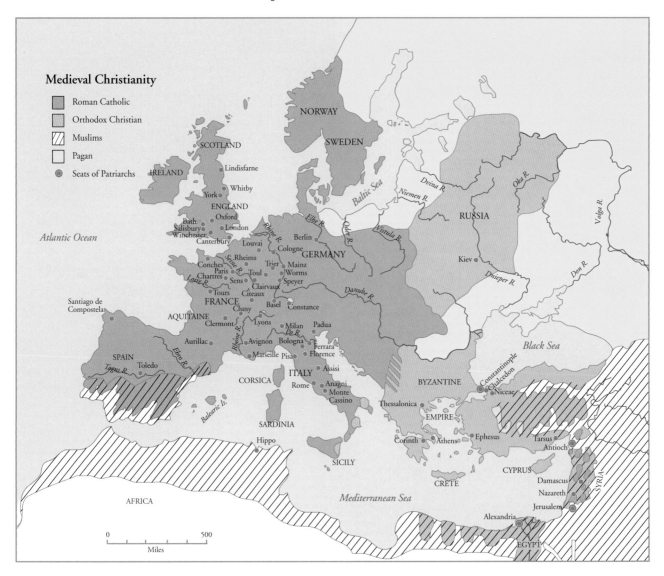

Medieval Christianity

- Roman Catholic
- Orthodox Christian
- Muslims
- Pagan
- Seats of Patriarchs

CHRISTIAN ART IN NORTHERN EUROPE

Until the year 1000, the center of Western civilization was located in the Middle East, at Constantinople. In Europe, tribal groups with localized power held sway: the Lombards in what is now Italy, the Franks and the Burgundians in regions of France, and the Angles and Saxons in England. Though it possessed no real political power, the Papacy in Rome had begun to work hard to convert the pagan tribes and to reassert the authority of the Church. As early as 496, the leader of the Franks, Clovis, was baptized into the Church. Even earlier (c. 430), St. Patrick had undertaken an evangelical mission to Ireland, establishing monasteries and quickly converting the native Celts. These new monasteries were designed to serve missionary as well as educational functions. At a time when only priests and monks could read and write, the sacred texts they produced came to reflect native Celtic designs. These designs

c. 600
Slave trade between sub-Saharan
Africa and Mediterranean begins

7th century
Anglo-Saxon epic
Beowulf is composed

Fig. 632 Hinged clasp from the Sutton Hoo burial ship, 7th century.
Gold with garnets, mosaic, glass, and filigree.
British Museum, London. Bridgeman Art Library.

are elaborately decorative, highly abstract, and contain no naturalistic representation. Thus, Christian art fused with the native traditions, which employed the so-called *animal style*. Some of the best examples of this animal style, such as the hinged clasp above (Fig. 632), have been found at Sutton Hoo, north of present-day London, in the grave of an unknown 7th-century East Anglian king. At the round end of each side of the hinge are animal forms, and the entire clasp is covered with intricate traceries of lines and bands.

In 597, Gregory the Great, the first monk to become pope, sent an emissary, later known as Saint Augustine of Canterbury, on a mission to convert the Anglo-Saxons. This mission brought Roman religious and artistic traditions into direct contact with Celtic art, and slowly but surely, Roman culture began to dominate the Celtic-Germanic world. The difficulties that the artist trained in the linear Celtic tradition faced in coping with the naturalistic tradi-

Fig. 633 *St. Matthew* from the *Lindisfarne Gospels*, c. 700.
Approx. 11 × 9 in. British Library, London. Bridgeman Art Library.

tions of Roman art are evident in the painting of Saint Matthew above (Fig. 633), copied from an earlier Italian original. Here, the image is flat, the figure has not been modeled, and the perspective is completely askew. It is pattern—and the animal style—that really interests the artist, not accurate representation.

CE 700

Cluny monastery founded
910

Rise of Inca Empire
in South America
c. 1000

c. 800–1000
England and Europe invaded
by Vikings, Magyars, and Muslims

980s
Russia converted
to Christianity

Fig. 634 *St. Matthew* from the
Gospel Book of Charlemagne, c. 800–810.
13 × 10 in. Kunsthistorisches Museum, Vienna.
Marburg/Art Resource, New York.

Fig. 635 Capital with relief
representing the Third Tone
of Plainsong, from the choir,
Abbey Church of
St. Pierre, Cluny.
Musée Lapidaire du Farinier, Cluny,
France. Giraudon/
Art Resource, New York.

page, demonstrates the impact of Roman realism on Northern art. Found in Charlemagne's tomb, this illustration looks as if it could have been painted in classical Rome.

ROMANESQUE ART

After the dissolution of the Carolingian state in the ninth and tenth centuries, Europe disintegrated into a large number of small feudal territories. The emperors were replaced by an array of rulers of varying power and prestige who controlled smaller or larger *fiefdoms* (areas of land worked by persons under obligation to the ruler) and whose authority was generally embodied in a chateau or castle surrounded by walls and moats. Despite this atomization of political life, a recognizable style that we have come to call **Romanesque** developed throughout Europe beginning in about 1050. Although details varied from place to place, certain features remained constant for nearly two hundred years.

Romanesque architecture is characterized by its easily recognizable geometric masses—rectangles, cubes, cylinders, and half-cylinders. The wooden roof that St. Peter's Basilica had utilized was abandoned in favor of fireproof stone and masonry construction, apparently out of bitter experience with the invading nomadic tribes, who burned many of the churches of Europe in the ninth and tenth centuries. Flat roofs were replaced by vaulted ceilings. By structural necessity, these were supported by massive walls that often lacked windows sufficient to provide adequate lighting. The churches were often built along the roads leading to pilgrimage centers, usually monasteries that housed Christian relics, and they had to be large enough to accommodate large crowds of the faithful. For instance, St. Sernin, in Toulouse, France (Figs. 501 and 502) was on the pilgrimage route to Santiago de Compostela, in Spain, where the body of St. James was believed to rest.

When Charlemagne (Charles, or Carolus, the Great) assumed leadership of the Franks in 771, this process of Romanization was assured. At the request of the Pope, Charlemagne conquered the Lombards, becoming their King, and on Christmas Day, 800, he was crowned Holy Roman Emperor by Pope Leo III at St. Peter's Basilica in Rome. The fusion of Germanic and Mediterranean styles that reflected this new alliance between Church and state is known as **Carolingian art**, a term referring to the art produced during the reign of Charlemagne and his immediate successors.

Charlemagne was intent on restoring the glories of Roman civilization. He actively collected and had copied the oldest surviving texts of the classical Latin authors. He created schools in monasteries and cathedrals across Europe in which classical Latin was the accepted language. A new script, with Roman capitals and new lowercase letters, the basis of modern type, was introduced. A second depiction of St. Matthew (Fig. 634), executed one hundred years after the one on the previous

Conquest of England
by the Norman French
1066

Beginning of
First Crusade
1096

1135

1054
Schism between Latin and Greek
Christian churches

1071
The fork is introduced to Europe
by a Byzantine princess

Fig. 636 Reconstruction of the third Abbey Church
of St. Pierre, Cluny, France, c. 1085–1130.
Marburg/Art Resource, New York.

Fig. 637 Gislebertus, *Last Judgment*, tympanum and lintel,
west portal, Cathedral, Autun, France, c. 1125–1135.
Stone, approx. 12 ft. 6 in. × 22 ft. Marburg/Art Resource, New York.

Thanks in large part to Charlemagne's emphasis on monastic learning, monasteries had flourished ever since the Carolingian period, many of them acting as feudal landlords as well. The largest and most powerful was Cluny, near Mâcon, France (Fig. 636). Until the building of the new St. Peter's in Rome, the church at Cluny was the largest in the Christian world. It was 521 feet in length, and its nave vaults rose to a height of 100 feet. The height of the nave was made possible by the use of pointed arches. The church was destroyed in the French Revolution, and only part of one transept survives.

The Benedictine order at Cluny stressed the intellectual life, the study of music, and the pursuit of the arts. A Corinthian capital (Fig. 635), one of ten that survives from the original Abbey Church at Cluny, shows the continued importance of Roman art even in a Christian context. The almond-shaped inset hollowed into the acanthus leaves, contains a figure playing a lyre, underscoring the importance of the arts in the Clunaic order. Surviving examples such as this demonstrate how richly decorated Cluny was.

With the decline of Hellenistic Rome, the art of sculpture had largely declined in the West, but in the Romanesque period it began to reemerge. Certainly the idea of educating the masses in the Christian message through architectural sculpture on the facades of the pilgrimage churches contributed to the art's rebirth. The most important sculptural work was usually located on the **tympanum** of the church, the semicircular arch above the lintel on the main door. It often showed Christ with His Twelve Apostles. Another favorite theme was the Last Judgment, full of depictions of sinners suffering the horrors of hellfire and damnation. To the left of Gislebertus's *Last Judgment* at Autun, France (Fig. 637), the blessed arrive in heaven, while on the right, the damned are seized by devils. Combining all manner of animal forms, the monstrosity of these creatures recalls the animal style of the Germanic tribes.

1137

Rise of Chivalric poetry
written in the vernacular
12th century

1100
Third Pueblo period
in American Southwest

12th and 13th centuries
Growth of trade and towns
as trading centers

Fig. 638 Chartres Cathedral, 1145–1220.
© Marvin Trachtenberg.

GOTHIC ART

The great era of **Gothic** art begins in 1137 with the rebuilding of the choir of the abbey church of St. Denis, located just outside Paris. Abbot Suger of St. Denis saw his new church as both the political and the spiritual center of a new France, united under King Louis VI. Although he was familiar with Romanesque architecture, which was then at its height, Suger chose to abandon it in principle. The Romanesque church was difficult to light, because the structural need to support the nave walls from without meant that windows had to be eliminated. Suger envisioned something different. He wanted his church flooded with light as if by the light of Heaven itself. The new St. Denis, he wrote, "will shine with the wonderful and uninterrupted light of the most luminous windows, pervading the interior beauty [of the church]." For Suger, this light was deeply the-

ological in meaning. "Marvel not at the gold and the expense but at the craftsmanship of the work," he wrote. "Bright is the noble work; but, being nobly bright, the work should brighten the minds, so that they may travel, through the true light, to the True Light where Christ is the true door."

St. Denis contains many Romanesque features, notably a choir and an apse surrounded by an arcaded ambulatory. But instead of creating separate chapels behind the ambulatory, as was customary, the ambulatory and chapel areas were merged into a continuous open space. This space consists of seven wedge-shaped areas, articulated by columns and arches, that fan out from the center of the apse (Fig. 639). The stained-glass windows at the back of each wedge fill the entire wall area, admitting a relatively large amount of light into the church. Thus filled with light, the walls

St. Francis of Assisi
1182–1226

Granting of Magna Carta
by King John of England
1215

1250

1209
Founding of
Cambridge University

Fig. 639 St. Denis, near Paris, 1140–1144.
© Marvin Trachtenberg.

Fig. 640 Choir of Cologne Cathedral,
Germany, 13th and 14th centuries.
Caisse Nationale des Monuments Historique et des Sites.

seem to disappear. Supported by the buttress system, the interior stonework was made to appear almost fragile, even weightless, especially where it framed the stained glass.

What made all of this possible was the flying buttress, which we have already discussed in Chapter 16 (Figs. 505 and 506). With this unique combination of pointed arches, groined vaults, and flying buttresses, the architect of the Gothic church was able to vault the central nave to an extraordinary height. Chartres Cathedral is a good example (Fig. 638). To this day, its spires dominate the countryside and can be seen for miles around.

The Gothic style spread rapidly throughout Europe, though each particular region modified it to suit local tastes and conditions. In Germany's Cologne Cathedral (Fig. 640), the width of the nave has been narrowed to such a degree that the vaults seem to rise higher than they actually do. The cathedral was not finished until the nineteenth century, though built strictly in accordance with thirteenth-century plans. The stonework is so slender, incorporating so much glass into its walls, that the effect is one of almost total weightlessness.

1250

Dante Alighieri
1265–1320

Aztecs arrive
in the Valley of Mexico
c. 1325

c. 1300
Dante writes
The Divine Comedy

Fig. 641 Florence Cathedral (Santa Maria del Fiore), begun by Arnolfo de Cambio, 1296; dome by Filippo
Brunelleschi, 1420–1436.
Scala/Art Resource.

The Gothic style in Italy is unique. For instance, the exterior of Florence Cathedral (Fig. 641) is hardly Gothic at all. It was, in fact, designed to match the dogmatically Romanesque octagonal Baptistry that stands in front of it. But the interior space is completely Gothic in character. Each side of the nave is flanked by an arcade that opens almost completely into the nave by virtue of four wide pointed arches. Thus nave and arcade become one, and the interior of the cathedral feels more spacious than any other. Nevertheless, rather than the mysterious and transcendental feelings evoked by most Gothic churches, Florence Cathedral produces a sense of tranquility and of measured, controlled calm.

The Gothic style in architecture inspired an outpouring of sculptural decoration. There was, for one thing, much more room for sculp-

ture on the facade of the Gothic church than had been available on the facade of the Romanesque church. There were now three doors where there had been only one before, and doors were added to the transepts as well. The portal at Reims (Fig. 642), which notably substitutes a stained-glass rose window for the Romanesque tympanum and a pointed for a round arch, is sculpturally much lighter than, for instance, the tympanum at Autun, France (see Fig. 637). The elongated bodies of the Romanesque figures are distributed in a very shallow space. In contrast, the sculpture of the Gothic cathedral is more naturalistic. The proportions of the figures are more natural, and the figures assume more natural poses as well. The space they occupy is deeper—so much so that they appear to be fully realized sculpture in-the-round, freed of the wall behind them.

1347–1349
The Black Death kills
two-fifths of Europe's people

1492
Columbus's first voyage
to the New World

Fig. 643 *Annunciation* and *Visitation,*
detail, west portal, Reims Cathedral, c. 1225–1245.
Giraudon/Art Resource, New York.

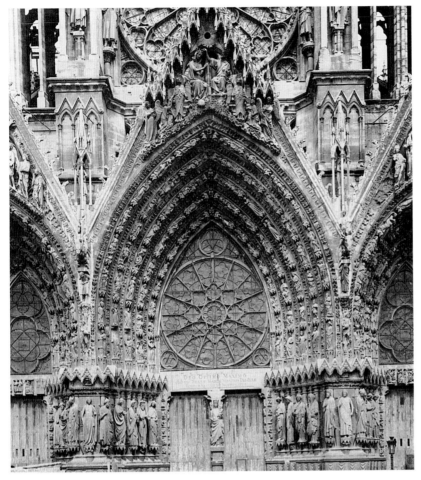

Fig. 642 Central portal of the west facade of Reims Cathedral, c. 1225–1290.
Giraudon/Art Resource, New York.

Fig. 644 Giovanni Pisano, *The Nativity,*
detail of pulpit, Pisa Cathedral, 1302–1310.
Marble. Alinari/Art Resource, New York.

Most important of all, many of the figures seem to assert their own individuality, as if they were actual persons. The generalized "types" of Romanesque sculpture are beginning to disappear. The detail of figures at the bottom of the Reims portal (Fig. 643) suggests that each is engaged in a narrative scene. The angel on the left smiles at the more somber Virgin. The two at the right seem about to step off their pedestals. What is most remarkable is that the space between the figures is bridged by shared emotion, as if feeling can unite them in a common space. The Renaissance is about to dawn, as we can witness in Giovanni Pisano's Nativity for the Pisa Cathedral (Fig. 644). Pisano sets the figures in this relief loose from their architectural mooring by situating them in a landscape. Notice, particularly, how the sheep below the tree on the right seem to come toward us as they graze down the hillside. The Virgin is, realistically speaking, too large, showing the continued influence of medieval hierarchies, but Pisano has nevertheless given expression to his naturalistic impulses.

Chapter 19 *The Christian Era* **445**

644–656
Koran text established

732
Farthest point of Muslim
advances in Western Europe

Fig. 646 Interior of the sanctuary of the mosque at Córdoba,
Spain, 786–987.
Werner Forman/Art Resource, New York.

Fig. 645 Great Mosque at Samarra, Iraq, 648–852.
Marburg/Art Resource, New York.

DEVELOPMENTS
IN ISLAM AND ASIA

In 1096, Pope Urban II declared the First Crusade to liberate Jerusalem from the control of the Muslims. Ever since the Prophet Mohammed had fled Mecca for Medina in 622, the Muslim empire had expanded rapidly. By 640, Mohammed's successors, the Caliphs, had conquered Syria, Palestine, and Iraq. Two years later, they defeated the army of Byzantium at Alexandria, and, by 710, they had captured all of northern Africa and had moved into Spain. They advanced north until 732, when Charles Martel, grandfather of Charlemagne, defeated them at Poitiers, France. But

the Caliphs' foothold in Europe remained strong, and they did not leave Spain until 1492. Even the Crusades failed to reduce their power. During the First Crusade, fifty thousand men were sent to the Middle East, where they managed to hold Jerusalem and much of Palestine for a short while. The Second Crusade, in 1146, failed to regain control, and in 1187, the Muslim warrior Saladin reconquered Jerusalem. Finally, in 1192, Saladin defeated King Richard the Lion-Hearted of England in the Third Crusade.

The major architectural form of Islam was the mosque. Now ruined, the mosque at Samarra was once the largest in the Islamic world. Its single **minaret** (Fig. 645), or tower, modeled on the ziggurats of ancient Mesopotamia, stood before the entrance, opposite the *mihrab* on the *qibla* wall. The *mihrab* is symbolic of the spot in Mohammed's house at Medina where he stood to lead communal prayers. The *qibla* wall faces in the direction of Mecca, the holy site toward which all Muslims turn in prayer. The minaret overlooked a ten-acre wooden roof supported by 464 columns arranged in aisles around an open center court. With its 36 piers and 514 columns, the mosque at Córdoba (Fig. 646) gives us some sense of

Islam penetrates
sub-Saharan Africa
1000–1100

Turks capture Jerusalem
1071

1100

1055
Turks capture Baghdad

Fig. 647 Kandariya Mahadeva Temple, Khajuraho, India, 10th–11th century.
George Holton/Photo Researchers, Inc.

Fig. 648 Wall relief, Kandariya
Mahadeva Temple, Khajuraho, India,
10th–11th century.
George Holton/Photo Researchers, Inc.

what Samarra might once have looked like. Between 786 and 987, it was enlarged seven times, showing the versatility of its construction method. All Muslim design is characterized by a visual rhythm realized through symmetry and repetition of certain patterns and motifs, a rhythm clearly evident in the interior of the Córdoba mosque.

As early as 1500 B.C.E., Aryan tribesmen from northern Europe invaded India, bringing a religion that would have as great an impact on the art of India as Islam had on the art of the Middle East. The Vedic traditions of the light-skinned Aryans, written in religious texts called the *Vedas,* allowed for the development of a class system based on racial distinctions. Status in one of the four classes—the priests (Brahmans), the warriors and rulers (kshatriyas), the farmers and merchants (vaishayas), and the serfs (shudras)—was determined by birth, and one could escape one's caste only through reincarnation. Buddhism, which began about 563 B.C.E., was in many ways a reaction against the Vedic caste system, allowing for salvation by means of individual self-denial and meditation, and it gained many followers.

The Hindu religion, which evolved from the Vedic tradition, has myriad gods, headed by the trinity of Brahma, Vishnu, and Shiva. Brahma is the creator of the cosmos, who contains all things. Hindu temples were designed to capture the rhythms of the cosmos, of Brahma. Completed only a few years before the great Romanesque cathedrals of Europe, the main tower at Kandariya (Fig. 647) is like a mountain peak, showing the summit of the paths one must follow to attain salvation. The entirety is covered by intricate reliefs representing the gods, stories from Hindu tradition, and erotic encounters (Fig. 648). The pleasures of erotic love were understood as reflecting the pleasures of the eventual union with the god, and carnal love was seen as an aspect of spiritual love. The achievement of sexual bliss was thus considered to be one of the many paths of virtue leading to redemption. Indeed, the Hindu gods usually incorporate all aspects of the human personality.

Meanwhile, in Europe, the naturalistic impulses evident in the facade of Reims Cathedral (Fig. 643) and in Pisano's *Nativity* (Fig. 644) were asserting themselves ever more forcefully. A new era, marked by a rebirth of classical values, was about to unfold.

Chapter 19 *The Christian Era* **447**

THE RENAISSANCE THROUGH THE BAROQUE

THE EARLY RENAISSANCE

THE HIGH RENAISSANCE

ART IN CHINA

PRE-COLUMBIAN ART IN MEXICO

MANNERISM

THE BAROQUE

Just when the Gothic era ended and the Renaissance began is by no means certain. In Europe, toward the end of the thirteenth century, a new kind of art began to appear, at first in the South, and somewhat later in the North. By the beginning of the fifteenth century, this new era, marked by a revival of interest in arts and sciences that had been lost since antiquity, was firmly established. We have come to call this revival the **Renaissance**, meaning "rebirth."

English defeat French in
Battle of Agincourt
1415

Beginning of
Age of Exploration
1420

1420

early 15th century
Gunpowder first used in Europe

The Gothic era has been called a long overture to the Renaissance, and we can see, perhaps, in the sculptures at Reims Cathedral (Fig. 643), which date from the first half of the thirteenth century, the beginnings of the spirit that would develop into the Renaissance sensibility. These figures are no longer archetypical and formulaic representations; they are almost real people, displaying real emotions. This tendency toward more and more naturalistic representation in many ways defines Gothic art, but it is even more pronounced in Renaissance art. If the figures in the Reims portal seem about to step off their columns, Renaissance figures actually do so. By the time of the Limbourg Brothers' early fifteenth-century manuscript illumination for *Les Très Riches Heures du Duc de Berry* (Fig. 649), human beings are represented, for the first time since classical antiquity, as casting actual shadows upon the ground. The architecture is also rendered with some measure of perspectival accuracy. The scene is full of realistic detail, and the potential of landscape to render a sense of actual space, evident in the earlier Pisano *Nativity*, is fully realized.

THE EARLY RENAISSANCE

The Renaissance is, perhaps most of all, the era of the individual. As early as the 1330s, the poet and scholar Petrarch had conceived of a new Humanism, a philosophy that emphasized the unique value of each person. Petrarch believed that the birth of Christ had ushered in an "age of faith," which had blinded the world to learning and thus condemned it to darkness. The study of classical languages, literature, history, and philosophy—what we call the "humanities"—could lead to a new enlightened stage of history. People should be judged, Petrarch felt, by their actions. It was not God's will that determined who they were and what they were capable of; rather, glory and fame were available to anyone who dared to seize them.

Fig. 649 The Limbourg Brothers, *October,*
from *Les Très Riches Heures du Duc de Berry*, 1413–1416.
Musée Condé, Chantilly. Giraudon/Art Resource, New York.

Treaty of Troyes grants
French throne to the English king
1420

—1420—

15th century
Compass and navigation
charts come into use

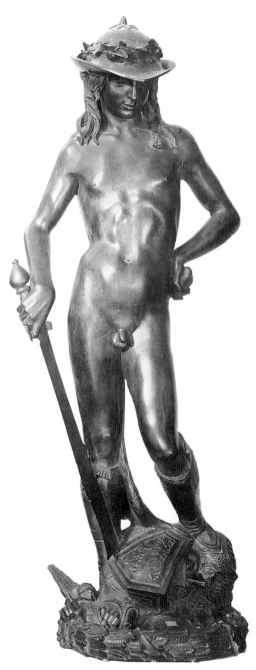

Fig. 650 Donatello, *David*, c. 1425–1430.
Bronze, height 62¼ in.
Museo Nazionale del Bargello, Florence. Alinari/Art Resource, New York.

Writing in 1485, the philosopher Giovanni Pico della Mirandola—Pico, as he is known—addressed himself to every ordinary (male) person: "Thou, constrained by no limits, in accordance with thine own free will . . . shalt ordain for thyself the limits of thy nature. We have set thee at the world's center . . . [and] thou mayst fashion thyself in whatever shape thou shalt prefer." Out of such sentiments were born not only the archetypical Renaissance geniuses—men like Michelangelo and Leonardo—but also Niccolò Machiavelli's wily and pragmatic Prince, for whom the ends justify any means, and the legendary Faust, who sold his soul to the devil in return for youth, knowledge, and magical power.

Under the leadership of the extraordinarily wealthy and beneficent Medici family—with first Cosimo de' Medici and, subsequently, his grandson, Lorenzo the Magnificent, assuming the largest roles—the city of Florence became the cultural center of the early Renaissance. The three leading innovators of the arts in fifteenth-century Florence—the painter Masaccio, who died in 1428 at the age of twenty-seven, having worked only six short years; the sculptor Donatello, and the architect Filippo Brunelleschi—were already firmly established by the time Cosimo assumed power in 1434. Brunelleschi was the inventor of geometric, linear perspective, a system he probably developed in order to study the ruins of ancient Rome. In 1420, he accepted a commission to design and build a dome over the crossing of the Florence Cathedral (see Fig. 641). The result, which spans a space 140 feet wide, was a major technological feat. But above all, his sense of measure, order, and proportion defined his sensibility—and that of the Italian Renaissance as a whole. Brunelleschi's God is a reasonable one, not the mysterious force that manifests itself in the ethereal light of the Gothic cathedral.

Donatello had traveled to Rome in 1402 with his friend Brunelleschi. The Greek and Roman statuary he studied there greatly influenced his own work, which reflects the classi-

15th century
Incidence of syphillis
increases in Europe

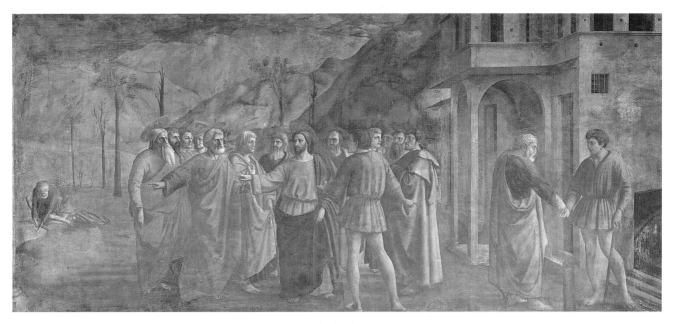

Fig. 651 Masaccio, *The Tribute Money*, c. 1427.
Fresco. Brancacci Chapel, Santa Maria del Carmine, Florence. Scala/Art Resource, New York.

cal interest in the human body in motion and in articulating that body through the use of drapery. The first lifesize nude sculpture since antiquity, Donatello's *David* (Fig. 650) is posed in perfectly classical ***contrapposto*** (see Fig. 372). But the young hero—almost antiheroic in the youthful fragility of his physique—is also fully self-conscious, his attention turned, in what appears to be full-blown self-adoration, upon himself as an object of physical beauty.

Masaccio, fifteen years younger than Donatello and twenty-four years younger than Brunelleschi, learned from them both, translating Donatello's naturalism and Brunelleschi's sense of proportion into the art of painting. In his *The Tribute Money* (Fig. 651), painted around 1427, Christ's disciples, especially St. Peter, wonder whether it is proper to pay taxes to the Roman government when, from their point of view, they owe allegiance to Christ, not Rome. But Christ counsels them to separate their earthly affairs from the spiritual obligations—"Render therefore unto Cae-

sar the things which are Caesar's; and unto God the things that are God's"(Matthew 22:21). To that end, Christ tells St. Peter and the other disciples that they will find the coin necessary to pay the imperial tax collector, whose back is to us, in the mouth of a fish. At the left, St. Peter extracts the coin from the fish's mouth, and, at the right, he pays the required tribute money to the tax collector. The figures here are modeled by means of chiaroscuro in a light that falls upon the scene from the right (notice their cast shadows). We sense the physicality of the figures beneath their robes; the landscape is rendered through atmospheric perspective; the building on the right is rendered in a one-point perspective scheme, with a vanishing point behind the head of Christ. All of these artistic devices are in themselves innovations; together, they constitute one of the most remarkable achievements in the history of art, an extraordinary change in direction from the flat, motionless figures of the Middle Ages toward a fully realistic representation.

Turks conquer Constantinople,
Hagia Sofia becomes a mosque
1453

1440

1453
Gutenberg prints
the Mazarin Bible

1455–85
War of the Roses
in England

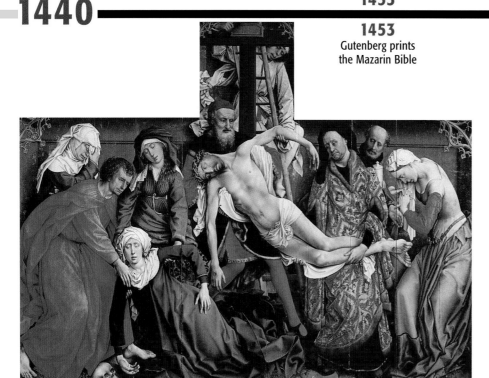

Fig. 652 Rogier van der Weyden,
Deposition, c. 1435–1438.
Oil on wood, 7 ft. 1⅝ in. × 8 ft. 7⅛ in.
Museo del Prado, Madrid. Scala/Art
Resource, New York.

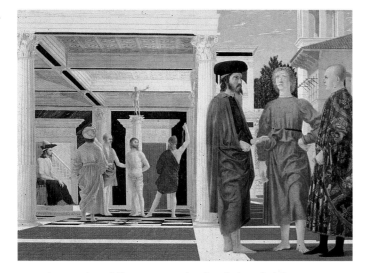

Fig. 653 Piero della Francesca, *The Flagellation of Christ*, c. 1451.
Tempera on wood, 32¾ × 23⅓ in.
Palazzo Ducale, Galleria Nazionale delle Marche, Urbino. Scala/Art Resource, New York.

In the North of Europe, in Flanders particularly, a flourishing merchant society promoted artistic developments that in many ways rivaled those of Florence. The Italian revival of classical notions of order and measure was, for the most part, ignored in the North. Rather, the Northern artists were deeply committed to rendering believable space in the greatest and most realistic detail. The *Mérode Altarpiece,* executed by Robert Campin (see Fig. 343), is almost exactly contemporary with Masaccio's *Tribute Money,* but in the precision and clarity of its detail—in fact, an explosion of detail—it is radically different in feel. The chief reason for the greater clarity is, as we discussed in Part III, a question of medium. Northern painters developed oil paint in the first half of the fourteenth century. With oil paint, painters could achieve dazzling effects of light on the surface of the painting—as opposed to the matte, or nonreflective, surface of both fresco and tempera. These effects recall, on the one hand, the Gothic style's emphasis on the almost magical light of the stained-glass window. In that sense, the effect achieved seems transcendent. But it also lends the depicted objects a sense of material reality, and thus caters to the material desires of the North's rising mercantile class.

If we compare Rogier van der Weyden's *Deposition* (Fig. 652) to Piero della Francesca's *The Flagellation of Christ* (Fig. 653), the differences between the northern, Flemish, and the southern, Italian, sensibilities become evident. Virtually a demonstration of the rules of linear perspective, Piero's scene depicts Pontius Pilate

Cosimo de' Medici founds
the Platonic Academy
1462

Lorenzo the Magnificent
rules in Florence
1469–1492

1480

1472
Dante's *Divine Comedy*
is printed

1478
Spanish Inquisition
begins

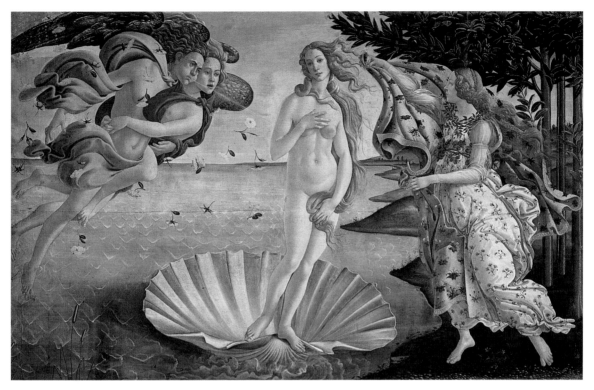

Fig. 654 Sandro Botticelli, *The Birth of Venus*, c. 1482.
Tempera on canvas, 5 ft. 8⅞ in. × 9 ft. 1⅞ in. Galleria degli Uffizi, Florence. Scala/Art Resource, New York.

watching as executioners whip Christ. Although it is much more architecturally unified, the painting pays homage to Masaccio's *Tribute Money*. Emotionally speaking, Rogier's *Deposition* has almost nothing in common with Piero's *Flagellation*. It is as if Piero has controlled the violence of his emotionally charged scene by means of mathematics, while Rogier has emphasized instead the pathos and human feeling that pervades his scene of Christ being lowered from the cross. While Piero's composition is essentially defined by a square and a rectangle, with figures arranged in each in an essentially triangular fashion, Rogier's composition is controlled by two parallel, deeply expressive, and sweeping curves, one defined by the body of Christ and the other by the swooning figure below him. Next to the high drama of Rogier's painting, Piero's seems almost static, but the understated brutality of Christ's flagellation in the background of Piero's painting is equally compelling.

THE HIGH RENAISSANCE

When Lorenzo de' Medici assumed control of his family in 1469, Florence was still the cultural center of the Western world. Lorenzo's predecessor had founded the Platonic Academy of Philosophy, where the artist Sandro Botticelli studied a brand of Neoplatonic thought that transformed the philosophic writings of Plato almost into a religion. According to the Neoplatonists, in the contemplation of beauty, the inherently corrupt soul could transform its love for the physical and material into a purely spiritual love of God. Thus, Botticelli uses mythological themes to transform his pagan imagery into a source of Christian inspiration and love. His *Birth of Venus* (Fig. 654), the first monumental representation of the nude goddess since ancient times, represents innocence itself, a divine beauty free of any hint of the physical and the sensual. It was this form of beauty that the soul, aspiring to salvation, was expected to

1480

Population of Europe
begins to increase
late 15th century

Bartolomeu Dias
rounds the Cape of Good Hope
1488

1483
Russians cross the Urals
into Asia

1492
Muslim Spain
falls to Christians

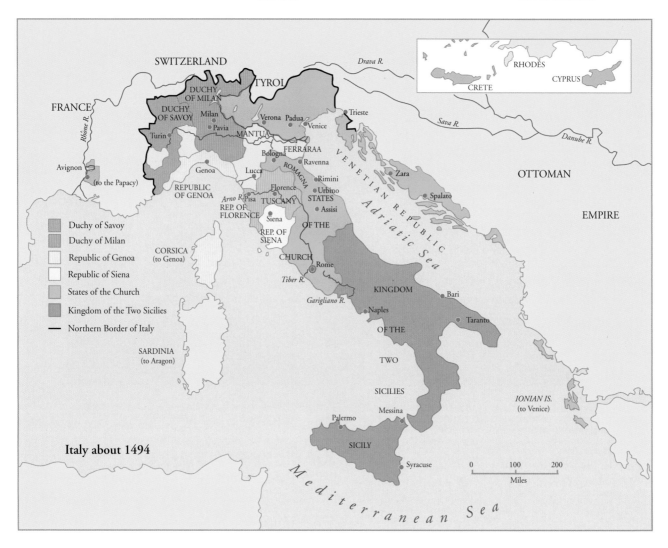

Italy about 1494

contemplate. But such meanings were by no means clear to the uninitiated, and when the Dominican monk Girolamo Savonarola denounced the Medicis as pagan, the majority of Florentines agreed. In 1494, the family was banished.

Still, for a short period at the outset of the sixteenth century, Florence was again the focal point of artistic activity. The three great artists of the High Renaissance—Leonardo, Michelangelo, and Raphael—all lived and worked in the city. As a young man, Michelangelo had been a member of Lorenzo de' Medici's circle, but with the Medicis' demise in

1494, he fled to Bologna. He returned to Florence seven years later to work on a giant piece of marble left over from an abandoned commission. Out of this, while still in his twenties, he carved his monolithic *David* (Fig. 85).

Leonardo, some 23 years older than Michelangelo, had left Florence as early as 1481 for Milan. There he offered his services to the great Duke of Milan, Ludovico Sforza, first as a military engineer and, only secondarily, as an architect, sculptor, and painter. His drawing of *A Scythed Chariot, Armored Car, and Pike* (Fig. 655), is indicative of his work for Sforza. "I will make covered vehicles," he wrote to the duke,

Vasco da Gama reaches
India by sea
1497

Portuguese dominate
the East Coast of Africa
1506

1510

c. **1500**
Rise of modern
European nation-states

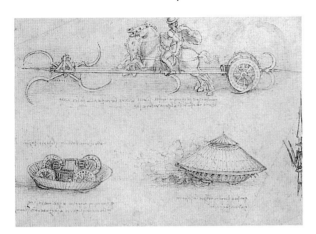

Fig. 655 Leonardo da Vinci,
A Scythed Chariot, Armored Car, and Pike, c. 1487.
Pen and ink and wash, 6¾ × 9¾ in. The British Museum, London.

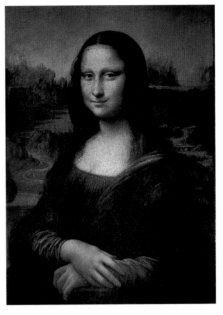

Fig. 656 Leonardo da Vinci, *Mona Lisa*, c. 1503–1505.
Oil on wood, 30¼ × 21 in.
Musée du Louvre, Paris. Erich Lessing/Art Resource, New York.

"which will penetrate the enemy and their artillery, and there is no host of armed men so great that they will not be broken down by them." The chariot in the drawing is equipped with scyths to cut down the enemy, and the armored car, presented in an upside down view as well as scooting along in a cloud of dust, was to be operated by eight men. But Leonardo's work for Sforza was not limited to military operations. From 1495 to 1498, he painted his world famous fresco *The Last Supper* (Fig. 136), which many consider to be the first painting of the High Renaissance, in Santa Maria delle Grazie, a monastic church under the protection of the Sforza family. Leonardo left Milan soon after the French invaded in October 1499, and by April he had returned to Florence, where he concentrated his energies on a lifesize cartoon for *Virgin and Child with St. Anne and Infant St. John* (see Fig. 267). This became so famous that throngs of Florentines flocked to see it. At about this time he also painted the *Mona Lisa* (Fig. 656). Perhaps a portrait of the wife of the Florentine banker Zanobi del Giocondo, the painting conveys a psychological depth that has continued to fascinate viewers up to the present day. Its power derives, at least in part, from a manipulation of light and shadow that imparts a blurred imprecision to the sitter's

features, lending her an aura of ambiguity and mystery. This interest in the pyschology, not just the physical looks, of the sitter is typical of the Renaissance imagination.

When Raphael, twenty-one years old, arrived in Florence in 1504, he discovered Leonardo and Michelangelo locked in a competition over who would get the commission to decorate the city council chamber in the Palazzo Vecchio with pictures celebrating the Florentine past. Leonardo painted a Battle of Anghiari and Michelangelo a Battle of Cascina, neither of which survives. We know the first today only by reputation and early drawings. A cartoon survived well into the seventeenth century and was widely copied, most faithfully by Peter Paul Rubens. Of the Michelangelo we know very little. What is clear, however, is that the young Raphael was immediately confronted by the cult of genius that in many ways has come to define the High Renaissance. Artists of genius and inspiration were considered different from everyone else, and guided in their work by an insight that,

The Prince written by
Niccoló Machiavelli
1513

Martin Luther posts his
ninety-five theses
1517

1510

1517
Spain authorizes slave trade between
West Africa and New World colonies

1519–22
First circumnavigation
of the world

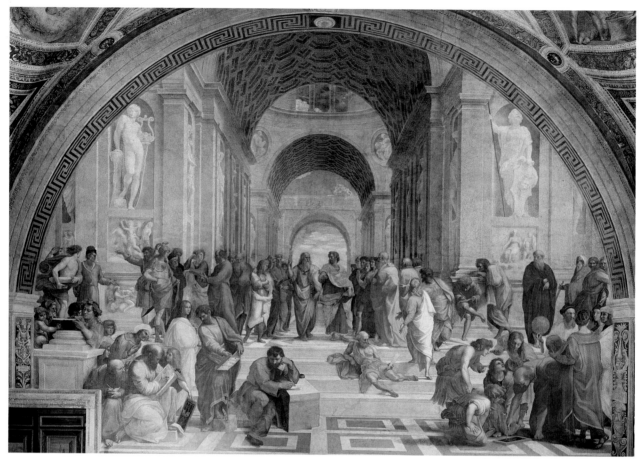

Fig. 657 Raphael, *The School of Athens*, 1510–1511.
Fresco. Stanza della Segnatura, Vatican Palace, Rome. Scala/Art Resource, New York.

according to the Neoplatonists was divine in origin. The Neoplatonists believed that the goals of truth and beauty were not reached by following the universal rules and laws of classical antiquity—notions of proportion and mathematics. Nor would fidelity to visual reality guarantee beautiful results; in fact, given the fallen condition of the world, quite the opposite was more likely, as Leonardo's studies of the faces of his fellow citizens had demonstrated (see Fig. 30). Instead, the artist of genius had to rely on subjective and personal intuition—what the Neo-platonists called the "divine frenzy" of the creative act—to transcend the conditions of everyday life. Plato had

argued that painting was mere slavish imitation of an already existing thing—it was a diminished reality. The Neoplatonists turned this argument on its head. Art now exceeded reality. It was a window, not upon nature, but upon divine inspiration itself.

Raphael learned much from both Leonardo and Michelangelo, and, in 1508, he was awarded the largest commission of the day, the decoration of the papal apartments at the Vatican in Rome. On the four walls of the first room, the Stanza della Segnatura, he painted frescoes representing the four domains of knowledge—Theology, Law, Poetry, and Philosophy. The most famous of

Peasants' Rebellion
in Germany
1524–25

English Reformation and
the dissolution of the monasteries
1535–40

1540

1533
Ivan the Terrible ascends
the Russian throne

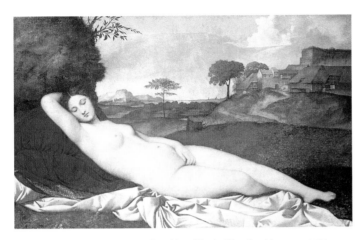

Fig. 658 Giorgione (completed by Titian), *Sleeping Venus*, c. 1510.
Oil on canvas, 42¾ × 69 in.
Staatliche Gemäldegalerie, Dresden. Scala/Art Resource.

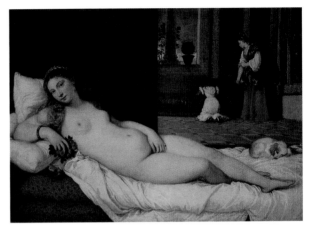

Fig. 659 Titian, *Venus of Urbino*, 1538.
Oil on canvas, 47 × 65 in.
Galleria degli Uffizi, Florence. Scala/Art Resource.

these is the last, *The School of Athens* (Fig. 657). Raphael's painting depicts a gathering of the greatest philosophers and scientists of the ancient world. The centering of the composition is reminiscent of Leonardo's *Last Supper,* but the perspective rendering of space is much deeper. Where in Leonardo's masterpiece, Christ is situated at the vanishing point, in Raphael's work, Plato and Aristotle occupy that position. These two figures represent the two great, opposing schools of philosophy: the Platonists, who were concerned with the spiritual world of ideas (thus Plato points upwards), and the Aristotelians, who were concerned with the matter-of-factness of material reality (thus Aristotle points over the ground upon which he walks). The expressive power of the figures owes much to Michelangelo, who, it is generally believed, Raphael portrayed as the philosopher Heraclitus, the brooding, self-absorbed figure in the foreground.

Raphael's commission in Rome is typical of the rapid spread of the ideals of the Italian Renaissance culture to the rest of Italy and Europe. In Venice, however, painting developed somewhat independently of the Floren-

tine manner. The emphasis in Venetian art is on the sensuousness of light and color and the pleasures of the senses. The closest we have come to it so far is in the mysterious glow that infuses Leonardo's *Mona Lisa,* but what is only hinted at in Leonardo's work explodes in Venetian painting as full-blown theatrical effect. Partly under the influence of Leonardo, who had visited Venice after leaving Milan in 1499, Giorgione developed a painting style of blurred edges and softened forms. After his teacher's death in the great plague of 1510, Giorgione's student, Titian, took this style even farther, developing a technique that employed a painterly brushstroke to new, sensuously expressive ends. Two paintings of Venus, the first by Giorgione, probably completed by Titian after his teacher's death (Fig. 658), and the second executed twenty-eight years later by Titian himself (Fig. 659), demonstrate the sensuality of the Venetian style. Giorgione's life-size figure, bathed in luminous light, is frankly erotic, but Titian's is even more so. Positioned on the crumpled sheets of a bed, rather than in a pastoral landscape, she is not innocently sleeping, but gazes directly at us, engaging us in her sexuality.

Death of Song poet
Su Tung-p'o
1101

1000

1105
Genghis Khan begins
Mongol invasions

Fig. 660 Albrecht Dürer, *Self-Portrait*, 1500.
Oil on panel, 26¼ × 19¼ in. Pinakothek, Munich. Art Resource, New York.

Fig. 661 Guo Hsi, *Early Spring*, 1072 (Northern Song dynasty).
Hanging scroll, ink and slight color on silk, length 60 in.
Collection of the National Palace Museum, Taipei, Taiwan, Republic of China.

In the North of Europe, the impact of the Italian Renaissance is perhaps best understood in the work of the German artist Albrecht Dürer. As a young man, he had copied Italian prints, and, in 1495, he traveled to Italy to study the Italian masters. From this point on, he strived to establish the ideals of the Renaissance in his native country. The first artist to be fascinated by his own image, Dürer painted self-portraits (Fig. 660) throughout his career. In this act, he asserts his sense of the importance of the individual, especially the individual of genius and talent, such as himself. Meaning to evoke his own spirituality, he presents himself almost as if he were Christ. Yet, as his printmaking demonstrates (see Fig. 313), not even Dürer could quite synthesize the northern love for precise and accurate naturalism—the desire to render the world of real things—with the southern idealist desire to transcend the world of real things.

ART IN CHINA

In 1275, a young Venetian by the name of Marco Polo arrived in Peking, China, and quickly established himself as a favorite of the Mongol ruler Kublai Khan, first emperor of the Yuan dynasty. Polo served in an administrative capacity in Kublai Khan's court and for three years ruled the city of Yangchow. Shortly after his return to Venice in 1295, he was imprisoned after being captured by the army of Genoa in a battle with his native Venice; while there he dictated an account of his travels. His description of the luxury and magnificence of the Far East, by all accounts reasonably accurate, was virtually the sole source of information about China available in Europe until the nineteenth century.

458 Part V *The Visual Record*

First Mongol invasion
of Japan
1274

Chinese voyages
to India and Africa begin
1405

1400

1368
Founding of
Ming Dynasty

Fig. 662 Wu Chen, *Bamboo*, 1350.
Album leaf, ink on paper, 16 × 21 in.
Collection: National Palace Museum, Taipei, Taiwan, Republic of China.

Fig. 663 Cheng Sixiao, *Ink Orchids*, Yuan dynasty, 1306.
Handscroll, ink on paper, 10⅛ × 16¾ in.
Municipal Museum of Fine Art, Osaka/PPS.

Since the time of the Song dynasty, which ruled the empire from 960 until it was overrun by Kublai Khan in 1279, the Taoists in China had emphasized the importance of self-expression, especially through the arts. Poets, calligraphers, and painters were appointed to the most important positions of state. After calligraphy, the Chinese valued landscape painting as the highest form of artistic endeavor. For them, the activity of painting was a search for the absolute truth embodied in nature, a search that was not so much intellectual as intuitive. They sought to understand the *li,* or "principle," upon which the universe is founded, and thus to understand the symbolic meaning and feeling that underlies every natural form. The symbolic meanings of Guo Xi's *Early Spring* (Fig. 661), for instance, have been recorded in a book authored by his son, Guo Si, titled *The Lofty Message of the Forests and Streams.* According to this book, the central peak here symbolizes the Emperor, and its tall pines the gentlemanly ideals of the court. Around the Emperor, the masses assume their natural place, just as around the mountain, the trees and hills fall, like the water itself, in the order and rhythms of nature.

At the time of Marco Polo's arrival, many of the scholar-painters of the Chinese court, unwilling to serve under the foreign domination of Kublai Khan, were retreating into exile from public life. In exile, they conscientiously sought to keep traditional values and arts alive by cultivating earlier styles in both painting and calligraphy. The bamboo in Wu Chen's painting (Fig. 662) was a political symbol aimed at the hated non-Chinese rulers—the plant might bend, but it would not break. Wu Chen's efforts to keep the traditions of China alive are also evident in his inscription to this painting, written in the wild "cursive" of the Tang dynasty. According to the inscription on Cheng Sixiao's *Ink Orchids* (Fig. 663) this painting was done to protest the "theft of Chinese soil by invaders," referring to the Mongol conquest of China. The orchids, therefore, have been painted without soil around their roots, showing an art flourishing, even though what sustains it has been taken away.

In 1368, the Mongols were overthrown when Zhu Yuanzhang drove the last Yuan emperor north into the desert and declared himself first emperor of the new Ming dynasty. China was once again ruled by the Chinese.

Chapter 20 *The Renaissance through the Baroque* **459**

4000 BCE

Fig. 664 Colossal head, Villahermosa,
Mexico, Olmec culture, c. 800–200 B.C.E.
Basalt, height 7 ft. Courtesy of The Embassy of Mexico.

Fig. 665 *Great Dragon*,
Maya, Quiriguá, Mexico, 6th century C.E.
Height 7 ft. 3 in. Courtesy of The Embassy of Mexico.

PRE-COLUMBIAN ART IN MEXICO

The term **Pre-Columbian** refers to the cultures of all the peoples who lived in Mexico, Central America, and South America prior to the arrival of the Europeans at the end of the fifteenth century. The cultures of the Pre-Columbian peoples are distinguished by their monumental architecture and their preference for working in stone, both of which lend their art a quality of permanence that differentiates it from the more fragile art forms of the Native American peoples who lived in what is now the United States and Canada. The permanence of Pre-Columbian art was the result of a cultural stability gained around 4000 B.C.E., when they developed agricultural, as opposed to nomadic, civilizations based especially on the production of maize, or yellow corn.

The major cultures of Mexico were the Olmec; the Maya, the civilization that developed with the great city of Teotihuacán as its center; and the Aztec, who called themselves Mexica, and whose culture was not even two hundred years old at the time of the Spanish conquest of Mexico in 1519. Led by Hernándo Cortés, the Spanish arrived at the Aztec capital of Tenochtitlan (now Mexico City), a city that was, in the words of one of Cortés's men, "like the enchantments in the book of [the late medieval romancer] Amadís, because of the high towers . . . and other buildings, all of masonry, which rose from the water. Some of our soldiers asked if what we saw was not a dream." Albrecht Dürer recounts seeing the treasures Cortés sent home to King Charles V: "a sun entirely of gold, a whole fathom broad; likewise a moon entirely of silver, just as big . . . all so precious that they were valued at a hundred thousand guilders. I have never seen in all my days that which so rejoiced my heart, as these things." Within seventy-five years of the Spanish conquest, disease had ravaged the native peoples of the region, reducing their population from about twenty million to about one million, and the Pre-Columbian culture that Dürer praised had vanished from the face of the earth. Indeed, the treasures themselves were melted down for currency.

| Classic period of Teotihuacán civilization **300–900** | Aztecs arrive in the Valley of Mexico **c. 1325** | Cortés invades Mexico **1519** | **1519** |

c. 164 BCE
Oldest Mayan monuments

c. 1000–1500
Inca civilization in
South America

1369
City of Tenochtitlan
founded

The first Pre-Columbian culture was that of the Olmecs, who lived in present-day Tabasco and Vera Cruz, states on the southern coast of the Gulf of Mexico. As early as 1500 to 800 B.C.E., the Olmecs created a huge ceremonial center at La Venta. La Venta's design, the basis of planning in Mexico and Central America for many centuries to come, centered on a pyramid, perhaps echoing the shape of a volcano. This pyramid faced a ceremonial courtyard, laid out on an axis that was determined astronomically. The courtyard was decorated with four giant stone heads, three to the south and one to the north (Fig. 664). More than a dozen such heads have been discovered, some of them twelve feet high. The closest source for the stone used to make this head from La Venta, in present-day Villahermosa, is sixty miles away, across swampland.

Mayan civilization began to reach its peak in southern Mexico and Guatemala around C.E. 250, shortly after the rise of Teotihuacán in the North, and it flourished until about the year 900. Narrative relief carving was one of the predominant means of artistic expression in Mayan culture. The so-called *Great Dragon* relief (Fig. 665), carved on the face of a huge river boulder, shows one of the last rulers of the Mayan city of Quiriguá, in present-day Guatemala. The king is shown sitting in the gaping mouth of a giant monster and wearing an elaborate headdress. The monster does not so much threaten the ruler as evoke his power.

By about the sixth century B.C.E., widespread use of both a 260-day and a 365-day calendar system began to appear throughout Mexico. The latter corresponds to the true solar year, while the former is based on the length of human gestation, from the first missed menstrual flow to birth. Both calendars were often used simultaneously. A given day in one calendar will occur on the same day in the other every fifty-two years, and each new fifty-two-year cycle was widely celebrated, particularly by the Aztecs. Such calendar systems, which were inscribed in stone, provide a sense

Fig. 666 *Coatlicue*, Aztec, 15th century.
Height 8 ft. 3 in. Werner Forman/Art Resource, New York.

of continuity between the Pre-Columbian cultures. Particularly among the Aztecs, who traced their ancestry to the merging of Mayan and Toltec cultures at Chichen Itzá, on the Yucatan peninsula, the calendar's tie to the menstrual cycle required blood sacrifice. *Coatlicue* (Fig. 666) was the Aztec goddess of life and death. Her head is composed of two fanged serpents, which are symbolic of flowing blood. She wears a necklace of human hearts, severed hands, and a skull. The connection of blood to fertility is clear in the snake that descends between her legs, which suggests both menstruation and the phallus.

1520

1521–22
Luther translates
New Testament into German

1545–63
Council of Trent reforms
Catholic Church in response
to Reformation

Fig. 667 Michelangelo, *The Last Judgment,*
"Guidizio Universale" (detail), 1531–1541.
Fresco, on altar wall of Sistine Chapel.
Photo: A. Bracchetti/ P. Zigrossi, February 1995. The Vatican Museums, Rome.

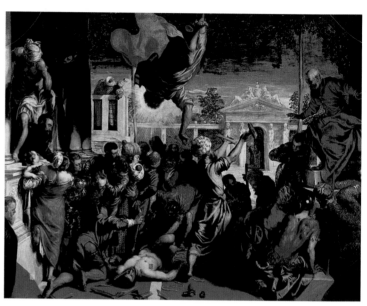

Fig. 668 Tintoretto, *The Miracle of the Slave,* 1548.
Oil on canvas, approx. 14 × 18 ft. Galleria dell' Academia, Venice. Scala/Art Resource, New York.

MANNERISM

Shortly after the Spanish conquest of separatist States within Spain in 1519 and the death of Raphael in 1520, many Italian painters embarked on a stylistic course that was highly individualistic and *mannered,* or consciously artificial. The call word of this **Mannerist** style was "invention," and the technical and imaginative virtuosity of the artist became of paramount importance. Each Mannerist artist may, therefore, be identified by his own "signature" style. Where the art of the High Renaissance sought to create a feeling of balance and proportion, quite the opposite is the goal of Mannerist art. In the late work of Michelangelo, for example, particularly the great fresco of *The Last Judgment* on the altar wall of the Sistine Chapel (Fig. 667), executed in the years 1534

to 1541, we find figures of grotesque proportion arranged in an almost chaotic, certainly athletic swirl of line. Mannerist painters represented space in unpredictable and ambiguous ways, so that bodies sometimes seem to fall out of nowhere into the frame of the painting, as in Tintoretto's *The Miracle of the Slave* (Fig. 668). The drama of Tintoretto's painting is heightened by the descent of the vastly foreshortened St. Mark, who hurtles in from above to save the slave from his executioner. The rising spiral line created by the three central figures—the slave, the executioner holding up his shattered instruments of torture, and St. Mark—is characteristic of Mannerism, but the theatricality of the scene, heightened by its dramatic contrast of light and dark, anticipates the Baroque style, which soon followed.

Often the space of a Mannerist painting seems too shallow for what is depicted, a feeling emphasized by the frequent use of radical foreshortening, as in the Tintoretto. Or the fig-

Birth of
William Shakespeare
1564

Defeat of Spanish Armada
by English fleet
1588

1600

1584
First English attempt to
colonize North America (Roanoke)

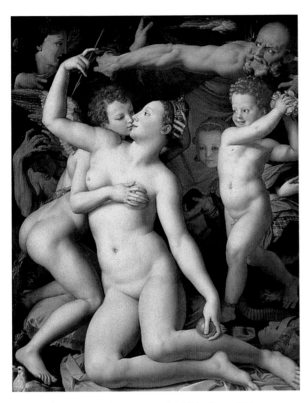

Fig. 669 Bronzino, *Venus, Cupid, Folly, and Time
(The Exposure of Luxury)*, c. 1546.
Oil on wood, approx. 61 × 56¾ in.
National Gallery, London.

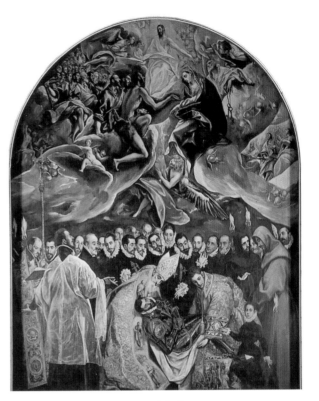

Fig. 670 El Greco, *The Burial of Count Orgaz*, 1586.
Oil on canvas, 16 ft. × 11 ft. 10 in.
S. Tomé, Toledo, Spain. SuperStock, Inc.

ure itself may be distorted or elongated, as in Bronzino's *Venus, Cupid, Folly, and Time (The Exposure of Luxury)* (Fig. 669). The colors are often bright and clashing. Time, at the upper right of Bronzino's painting, and Truth, at the upper left, part a curtain to reveal the shallow space in which Venus is fondled by her son, Cupid. Folly is about to shower the pair in rose petals. Envy tears her hair out at center left. The Mannerist distortion of space is especially evident in the distance separating Cupid's shoulders and head.

As in El Greco's *The Burial of Count Orgaz* (Fig. 670), Mannerist painting often utilizes more than one focal point, and these often seem contradictory. Born in Crete and trained in Venice and Rome, where he studied the works of Titian, Tintoretto, and the Italian Mannerists, El Greco moved to Toledo,

Spain, in 1576, and lived there for the rest of his life. In the painting we see here, the realism of the lower ensemble, which includes local Toledo nobility and clergy of El Greco's day (even though the painting represents a burial that took place more than 200 years earlier, in 1323), gives way in the upper half to a much more abstract and personal brand of representation. El Greco's elongated figures—consider the hand of St. Peter, in the saffron robe behind Mary on the upper left, with his long piercing fingers on a longer, almost drooping hand, to say nothing of the bizarrely extended arm of Christ himself—combine with oddly rolling clouds that rise toward an astonishingly small representation of Christ. So highly eclectic and individual is this painter's style, that it is difficult to label it even as Mannerist.

Chapter 20 *The Renaissance through the Baroque* **463**

Death of Elizabeth I
of England
1603

Jamestown founded
in Virginia
1609

1603
Cervantes begins
Don Quixote

1608
Quebec founded
by the French

1611
King James translation
of the Bible completed

Fig. 671 Aerial view of St. Peter's, Rome. Nave and facade by Carlo Maderno, 1607–1615, colonnade by Gianlorenzo Bernini, 1657.
CORBIS.

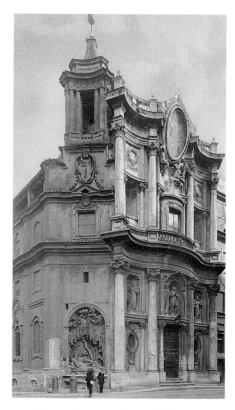

Fig. 672 Francesco Borromini, facade,
San Carlo alle Quattro Fontane, Rome, 1665–1667.
Marburg/Art Resource, New York.

THE BAROQUE

The **Baroque** style, which is noted particularly for its theatricality and drama, was, in many respects, a creation of the Papacy in Rome. Around 1600, faced in the North with the challenge of Protestantism, which had steadily grown more powerful ever since Martin Luther's first protests in 1517, the Vatican took action. It called together as many talents as it could muster with the clear intention of turning Rome into the most magnificent city in the world, "for the greater glory of God and the Church." At the heart of this effort was an ambitious building program. In 1603, Carlo Maderno was assigned the task of adding an enormous nave to Michelangelo's central plan for St. Peter's, converting it back into a giant basilica (Fig. 671). Completed in 1615, the scale of the new basilica was even more dramatically emphasized when Gianlorenzo Bernini added a monumental oval piazza surrounded by colonnades to the front of the church. Bernini conceived of his colonnade as an architectural embrace, as if the church were reaching out its arms to gather in its flock.

The wings that connect the facade to the semicircular colonnade tend to diminish the horizontality of the facade and emphasize the vertical thrust of Michelangelo's dome.

As vast as Bernini's artistic ambitions were, he was comparatively classical in his tastes. If we compare Bernini's colonnade at St. Peter's to Francesco Borromini's facade for San Carlo alle Quattro Fontane in Rome (Fig. 672), we notice immediately how symmetrical Bernini's design appears. Beside Borromini's facade, Bernini's colonnade seems positively conservative, despite its magnificent scale. But Borromini's extravagant design was immediately popular. The head of the religious order for whom San Carlo alle Quattro Fontane was built wrote with great pride, "Nothing similar can be found anywhere in the world. This is attested by the foreigners who ... try to procure copies of the plan. We

Figs. 673 and 674 Gianlorenzo Bernini, *The Cornaro Family in a Theater Box*
(marble, lifesize); and *The Ecstasy of St. Theresa* (marble, lifesize);
both 1645–1652, Cornaro Chapel, Santa Maria della Vittoria, Rome.
Scala/Art Resource, New York.

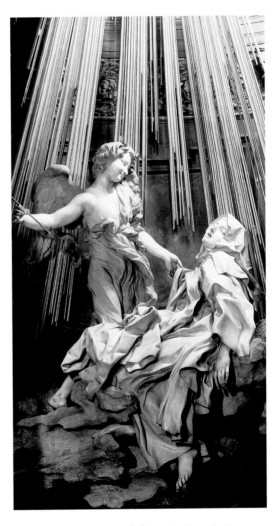

have been asked for them by Germans, Flemings, Frenchmen, Italians, Spaniards, and even Indians." We can detect, in these remarks, the Baroque tendency to define artistic genius more and more in terms of originality, the creation of things never before seen. Bernini's colonnade makes clear that the virtues of the classical were continually upheld, but emerging for the first time, often in the work of the same artist, is a countertendency, a sensibility opposed to tradition and dedicated to invention.

One of the defining characteristics of the Baroque is its insistence on bringing together various media to achieve the most theatrical effects. Bernini's Cornaro Chapel in Santa Maria della Vittoria (Figs. 673 and 674) is perhaps the most highly developed of these dynamic and theatrical spaces. The altarpiece depicts the ecstasy of St. Theresa. St. Theresa, a nun whose conversion took place after the death of her father, experienced visions, heard voices, and felt a persistent and piercing pain in her side. This was caused, she believed, by the flaming arrow of Divine Love, shot into her by an angel: "The pain was so great I screamed aloud," she wrote, "but at the same time I felt such infinite sweetness that I wished the pain to last forever. . . . It was the sweetest caressing of the soul by God." The paradoxical nature of St. Theresa's feelings is typical of the complexity of Baroque sentiment. Bernini fuses the angel's joy and St. Theresa's agony into an image that depicts what might be called St. Theresa's "anguished joy." Even more typical of the Baroque sensibility is Bernini's use of every device available to him to dramatize the scene. The sculpture of St. Theresa is illuminated by a hidden window above, so that the figures seem to glow in a magical white light. Gilded bronze rays of heavenly light descend upon the scene as if from the burst of light painted high on the frescoed ceiling of the vault. To the left and right of the chapel are theater boxes containing marble spectators, like ourselves witnesses to this highly charged, operatic moment.

1625

1630s
Japan adopts a national
policy of isolation

Descartes publishes
his *Laws of Method*
1637

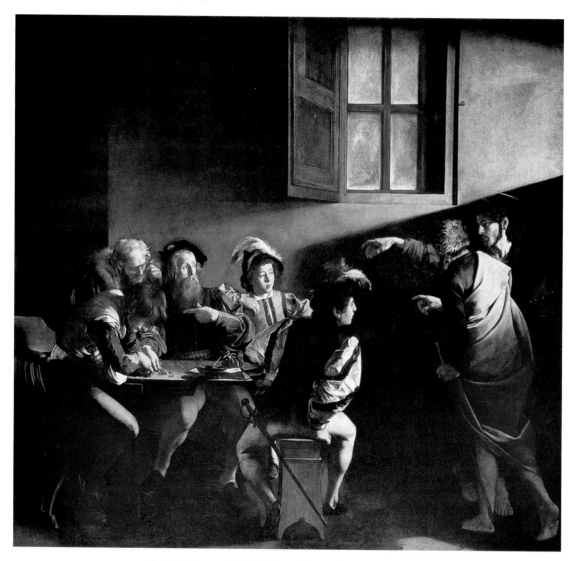

Fig. 675 Caravaggio, *The Calling of St. Matthew*, c. 1599–1602.
Oil on canvas, 11 ft. 1 in. × 11 ft. 5 in. Contarelli Chapel, San Luigi dei Francesci, Rome.
Scala/Art Resource, New York.

The Baroque style quickly spread beyond Rome and throughout Europe. Elaborate Baroque churches were constructed, especially in Germany and Austria. In the early years of the seventeenth century, furthermore, a number of artists from France, Holland, and Flanders were strongly influenced by the work of the Italian painter Caravaggio. Caravaggio openly disdained the great masters of the Renaissance, creating instead a highly individualistic brand of painting that sought its inspiration, not in the proven styles of a former era, but literally in the streets of contemporary Rome. When viewing his work, it is often difficult to tell that his subject is a religious one, so ordinary are his people and so dingy and commonplace his settings. Yet despite Caravaggio's desire to secularize his religious subjects, their light imbues them with a spiritual reality. It was, in

English Civil War and
Puritan Revolution
1642–49

1650

1640
Russians reach
the Pacific Ocean

fact, the contrast in his paintings between light and dark, mirroring the contrast between the spiritual content of the painting and its representation in the trappings of the everyday, that so powerfully influenced painters across Europe.

Caravaggio's naturalism is nowhere so evident as in *The Calling of St. Matthew* (Fig. 675) painted, somewhat surprisingly, for a church. The scene is a tavern. St. Matthew, originally a tax collector, sits counting the day's take with a band of his agents, all of them apparently prosperous, if we are to judge from their attire. From the right, two barefoot and lowly figures, one of whom is Christ, enter the scene, calling St. Matthew to join them. He points at himself in some astonishment. Except for the undeniably spiritual quality of the light, which floods the room as if it were revelation itself, the only thing telling us that this is a religious painting is the faint indication of a halo above Christ's head.

Though not directly influenced by Caravaggio, Rembrandt, the greatest master of light and dark of the age, knew Caravaggio's art through Dutch artists who had studied it. Rembrandt extends the sense of dramatic opposition Caravaggio achieved by manipulating light across a full range of tones, changing its intensity and modulating its brilliance, so that every beam and shadow conveys a different emotional content. In his *Resurrection of Christ* (Fig. 676), Rembrandt uses the emotional contrast between light and dark to underscore emotional difference. He contrasts the chaotic world of the Roman soldiers, sent reeling into a darkness symbolic of their own ignorance by the angel pulling open the lid of Christ's sepulchre, with the quiet calm of Christ himself as He rises in a light symbolic of true knowledge. Light becomes, in Rembrandt's hands, an index to the psychological meaning of his subjects, often hiding as much as it reveals, endowing them with a sense of mystery even as it reveals their souls.

Fig. 676 Rembrandt van Rijn, *Resurrection of Christ*, c. 1635–1639.
Oil on canvas, 36¼ × 26⅜ in. Alte Pinakothek, Munich. Artothek.

Fig. 677 Annibale Carracci, *Landscape with Flight into Egypt,* c. 1603.
Oil on canvas, 48¼ × 98½ in. Galleria Doria Pamphili, Rome. Scala/Art Resource, New York.

In Northern Europe, where strict Protestant theology had purged the churches of religious art, and classical subjects were frowned upon as pagan, realism thrived. Works with secular, or nonreligious, subject matter became extremely popular: Still life painting was popular (see Jan de Heem's *Still Life with Lobster,* Fig. 345), as were representations of everyday people living out their daily lives (genre painting), and landscapes. In Spain, where the royal family had deep historical ties to the North, the visual realism of Velázquez came to dominate painting (see Fig. 244). Spurred on by the great wealth it had acquired in its conquest of the New World, Spain helped to create a thriving market structure in Europe. Dutch artists quickly introduced their own goods—that is, paintings—into this economy, with the Spanish court as one of its most prestigious buyers. No longer working for the Church, but for this new international market, artists painted the everyday things that they

thought would appeal to the bourgeois tastes of the new consumer.

Of all of the new secular subject matter that arose during the Baroque Age, the genre of landscape perhaps most decisively marks a shift in Western thinking. In Annibale Carracci's *Landscape with Flight into Egypt* (Fig. 677), the figure and the story have become incidental to the landscape. Joseph has dreamed that King Herod is searching for the infant Jesus to kill him, and he flees into Egypt with Mary and the child, to remain there until after Herod's death. But this landscape is hardly Egypt. Rather, Carracci has transferred the story to a highly civilized Italian setting. This is the pastoral world, a middle ground between civilization and wilderness where people can live free of both the corruption and decadence of city and court life and the uncontrollable forces of nature. One of the most idyllic of all landscape painters goes even farther. Claude Lorrain—Claude, as he is usually known—casts the world in an

London Plague kills 100,000 people **1665**	Construction of Versailles Palace begins outside Paris **1668**	Native American population reduced to around 70,000 **1675**

1675

1667
Publication of Milton's
Paradise Lost

1669
Ottoman Turks seize
the island of Crete

Fig. 678 Claude Lorrain, *A Pastoral Landscape*, c. 1650.
Oil on copper, 15½ × 21 in.
Yale University Art Gallery, New Haven, Connecticut. Leo C. Hanna, Jr., B.A. 1913 Fund.

Fig. 679 Jacob van Ruisdael,
View of Haarlem from the Dunes at Overveen, c. 1670.
Oil on canvas, 22 × 24⅜ in.
Mauritshuis, The Hague, The Netherlands.

eternally poetic light. In his *A Pastoral Landscape* (Fig. 678), he employs atmospheric perspective to soften all sense of tension and opposition and to bring us to a world of harmony and peace. In this painting, and many others like it, the best civilization has to offer has been melded with the best of a wholly benign and gentle nature.

Landscape painters felt that because God made the earth, one could sense the majesty of his soul in his handiwork, much as one could sense emotion in a painter's gesture upon canvas. The grandeur of God's vision was symbolically suggested in the panoramic sweep of the extended view. Giving up two-thirds of the picture to the infinite dimensions of the heavens, Jacob van Ruisdael's *View of Haarlem from the Dunes at Overveen* (Fig. 679) is not so much about the land as it is about the sky—and the light that emanates from it, alternately casting the earth in light and shadow, knowledge and ignorance. Rising to meet the light, importantly, is the largest building in the landscape, the church. The beam of light that in

Caravaggio's painting suggests the spiritual presence of Christ becomes, in landscape, a beam of light from the "Sun/Son," a pun popular among English poets of the period, including John Donne. By the last half of the seventeenth century, it is as if the real space of the Dutch landscape had become so idealized that it is almost Edenic.

The example of landscape offers us an important lesson in the direction art took from the late seventeenth century down to our own day. The spiritual is no longer found exclusively in the church. It can be found in nature, in light, in form, even, as we progress toward the modern era, in the artist's very self. And by the end of the seventeenth century, the church is no longer the major patron of art as it had been for centuries. From Spanish kings, to wealthy Dutch merchants, to an increasingly large group of middle-class bourgeoisie with disposable incomes and the desire to refine their tastes, the patrons of art changed until, by the middle of the twentieth century, art came to be bought and sold in an international "art market."

CHAPTER 21

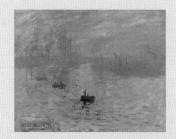

THE EIGHTEENTH AND NINETEENTH CENTURIES

THE ROCOCO

NEOCLASSICISM

ROMANTICISM

WORKS IN PROGRESS
Théodore Géricault's *The Raft of the Medusa*

REALISM

IMPRESSIONISM

POST-IMPRESSIONISM

The conflict of sensibility that became evident when, in the last chapter, we compared the architecture of Bernini to that of his contemporary Borromini—the one enormous in scale but classical in principle, the other extravagant in form and so inventive that it seems intentionally anticlassical—dominates the history of European art in the eighteenth century. In France, especially, anticlassical developments in Italian art were rejected. As early as 1665, Jean-Baptiste Colbert had invited Bernini to Paris to complete construction of the Louvre, the palace of King Louis XIV. But Louis considered Bernini's plans too elaborate—he envisioned demolishing all the extant palace—and the Louvre finally was built in a highly classical style, based on the plan of a Roman temple (Fig. 680).

La Salle takes possession of
Mississippi River for France
1682

Glorious Revolution establishes
constitutional monarchy in Britain
1688–89

1700

1687
Newton publishes
his law of motion

1690
John Locke publishes
Second *Treatise of Government*

Fig. 680 Claude Perrault,
with Louis Le Vau and Charles Lebrun,
east front of the Louvre, Paris, 1667–1670.
Giraudon/Art Resource, New York.

Fig. 681 Nicolas Poussin,
Landscape with St. John on Patmos, 1640.
Oil on canvas, 40 × 53½ in.
A. A. Munger Collection, 1930.500.
© 1999 The Art Institute of Chicago. All rights reserved.

The classicism of Bernini's colonnade for St. Peter's in Rome has been fully developed here. All vestiges of Baroque sensuality have been banished in favor of a strict and linear classical line. At the center of the facade is a Roman temple from which wings of paired columns extend outward, each culminating in a form reminiscent of the Roman triumphal arch.

One of the architects of this new Louvre was Charles Lebrun, a court painter who had studied in Rome with the classical painter Nicolas Poussin. Poussin believed that the aim of painting was to represent the noblest human actions with absolute clarity as far as possible. To this end, distracting elements—particularly color, but anything that appeals primarily to the senses—

had to be suppressed. In Poussin's *Landscape with St. John on Patmos* (Fig. 681), the small figure of St. John is depicted writing the *Revelations*. Not only do the architecture and the architectural ruins lend a sense of classical geometry to the scene, but even nature has been submitted to Poussin's classicizing order. Notice, for instance, how the tree on the left bends just enough as it crosses the horizon to form a right angle with the slope of the distant mountain.

As head of the Royal Academy of Painting and Sculpture, Lebrun installed Poussin's views as an official, royal style. By Lebrun's standards, the greatest artists were the ancient Greeks and Romans, followed closely by Raphael and Poussin; the worst painters were

1700

Louis XV assumes
the French throne
1715

Christianity banned
in China
1742

18th century
Literacy becomes
widespread

1726
Gulliver's Travels
published

mid-18th century
Beginning of
Industrial Revolution

Fig. 683 Jean-Honoré Fragonard, *Bathers,* c. 1765.
Oil on canvas, 25¼ × 31½ in. Musée du Louvre, Paris. Scala/Art Resource, New York.

Fig. 682 Peter Paul Rubens and his workshop,
The Arrival and Reception of Marie de' Medici at Marseilles, 1621–1625.
Oil on canvas, 13 × 10 ft. Musée du Louvre, Paris. Giraudon/Art Resource, New York.

the Flemish and Dutch, who not only "overemphasized" color and appealed to the senses, but also favored "lesser" genres, such as landscape and still life.

By the beginning of the eighteenth century, Lebrun's hold on the French Academy was questioned by a large number of painters who championed the work of the great Flemish Baroque painter Peter Paul Rubens over that of Poussin. Rubens, who had painted a cycle of twenty-one paintings celebrating the life of Marie de' Medici, Louis XIV's grandmother, was a painter of extravagant Baroque tastes. Where the design of Poussin's *Landscape with St. John on Patmos* (Fig. 681) is based on horizontal and vertical elements arranged parallel to the picture plane, Rubens's forms in *The*

Arrival and Reception of Marie de' Medici at Marseilles (Fig. 682) are dispersed across a pair of receding diagonals. In this painting, which depicts Marie's arrival in France as the new wife of the French king, Henry IV, our point of view is not frontal and secure, as it is in the Poussin, but curiously low, perhaps even in the water. Poussin, in his design, focuses on his subject, St. John, who occupies the center of the painting, whereas Rubens creates a multiplicity of competing areas of interest. Most of all, Poussin's style is defined by its linear clarity. Rubens's work is painterly, dominated by a play of color, dramatic contrasts of light and dark, and sensuous, rising forms. Poussin is restrained, Rubens exuberant.

THE ROCOCO

With the death of Louis XIV in 1715, French life itself became exuberant. This was an age whose taste was formed by society women with real, if covert, political power, especially Louis XV's mistress, Madame de Pompadour. The *salons,* gatherings held by particular hostesses on particular days of the week, were the

James Watt invents
the steam engine
1760

American War
of Independence
1775–83

United States
Constitution
1789

1789

1774
Louix XVI assumes
French throne

1776
Adam Smith publishes
Wealth of Nations

Fig. 684 Claude Michel (called Clodion),
Nymph and Satyr Carousing, c. 1775.
Terra cotta, height 23¼ in. The Metropolitan Museum of Art, New York.
Bequest of Benjamin Altman, 1913 (14.40.687).

Fig. 685 Marie-Louise-Elisabeth Vigée-Lebrun,
The Duchess of Polignac, 1783.
Oil on canvas, 38¾ × 28 in.
© The National Trust Waddesdon Manor, England/Art Resource, New York.

social events of the day. A famous musician might appear at one salon, while at Mme. Geoffrin's on Mondays, artists and art lovers would always gather. A highly developed sense of wit, irony, and gossip was necessary to succeed in this society. So skilled was the repartee in the salons, that the most biting insult could be made to sound like the highest compliment. Sexual intrigue was not merely commonplace but expected. The age was obsessed with sensuality, and one can easily trace the origins of Fragonard's *Bathers* (Fig. 683) back to the mermaids at the bottom of Rubens's painting (Fig. 682). Fragonard was Madame de Pompadour's favorite painter, and the *Bathers* was designed to appeal to the tastes of the eighteenth-century French court.

It is the age of the **Rococo**, a word derived from the French *rocaille*, referring to the small stones and shells that decorate the interiors of grottoes, the artificial caves popular in landscape design at the time. Architecturally, Rococo was an extension of Borromini's curvi-linear Baroque style. In sculpture, the Rococo was the Baroque eroticized. Clodion's *Nymph and Satyr Carousing* (Fig. 684), a small sculpture designed for a table top, is cloaked in the respectability of its Greek theme, but its purpose was to lend an erotic tone to its environment. In painting, the Rococo was deeply indebted to the Baroque sensibility of Rubens, as Fragonard's *Bathers* demonstrates. Vigée-Lebrun's portrait of *The Dutchess of Polignac* (Fig. 685) combines in exquisite fashion all of the tools of the Baroque sensibility, from Rembrandt's dramatic lighting to Rubens's sensual curves and, given the musical score in the Duchess's hand, even Bernini's sense of theatrical moment.

U. S. Bill of Rights
1791

Eli Whitney invents
the cotton gin
1793

1789
Beginning of
French Revolution

1793
Louis XVI of France
is beheaded

1798
Wordsworth and Coleridge
publish the *Lyrical Ballads*

Fig. 686 Jacques Louis David, *The Death of Marat*, 1793.
Oil on canvas, 65 × 50½ in. Musées Royaux des Beaux-Arts de Belgique,
Brussels. Giraudon/Art Resource, New York.

Fig. 687 Angelica Kauffmann,
Cornelia, Pointing to Her Children as Her Treasures, c. 1785.
Oil on canvas, 40 × 50 in. Virginia Museum of Fine Arts, Richmond.
The Adolph D. and Wilkins C. Williams Fund. Photo: Katherine Wetzel.
© Virginia Museum of Fine Arts.

Fig. 688 Thomas Jefferson, Monticello, Charlottesville,
Virginia, 1770–1784; 1796–1806.
CORBIS. Photo: David Muench.

NEOCLASSICISM

Despite the Rococo sensibility of the age, the seventeenth-century French taste for the classical style that Lebrun had championed did not disappear. When Herculaneum and Pompeii were rediscovered, in 1738 and 1748 respectively, interest in Greek and Roman antiquity revived as well. The discovery fueled an increasing tendency among the French to view the Rococo style as symptomatic of a widespread cultural decadence, epitomized by the luxurious lifestyle of the aristocracy. The discovery also caused people to identify instead with the public-minded values of Greek and Roman heroes, who placed moral virtue, patriotic self-sacrifice, and "right action" above all else. A *new* classicism—a *neo*classicism—supplanted the Rococo almost overnight.

The most accomplished of the Neoclassical painters was Jacques Louis David, whose work has been discussed at length in this text (see Figs. 112, 113, and 239). David took an active part in the French Revolution in 1789, recognizing as an expression of true civic duty and virtue the desire to overthrow the irresponsible monarchy that had, for two centuries at least, squandered France's wealth. His *Death of Marat* (Fig. 686) celebrates a fallen hero of the Revolution. Slain in his bath by a Monarchist—a sympathizer with the overthrown king—Marat is posed by David as Christ is traditionally posed in the Deposition (compare, for instance, Rogier's *Deposition*, Fig. 652), his arm draping over

Napoleon becomes First Consul and
absolute ruler of France
1799

Napoleon crowns
himself Emperor of France
1804

Wars of independence
in Latin America begin
1808

1810

1803
Louisiana Purchase

1807
Serfdom abolished
in Prussia

the edge of the tub. A dramatic Caravaggesque light falls over the revolutionary hero, his virtue embodied in the Neoclassical simplicity of David's design.

Virtue is, in fact, the subject of much Neoclassical art—a subject matter distinctly at odds with the early Rococo sensibility. Women are no longer seen cavorting like mermaids, or even luxuriously dressed like the Duchess of Polignac. In Angelica Kauffmann's *Cornelia, Pointing to Her Children as Her Treasures* (Fig. 687), Cornelia demonstrates her Neoclassical virtue by declaring her absolute devotion to her family, and, by extension, to the state. Her virtue is reinforced by her clothing, particularly the simple lines of her bodice.

The same sensibility informs the Neoclassical architecture of Thomas Jefferson. For Jefferson, the Greek orders embodied democratic ideals, possessing not only a sense of order and harmony but a moral perfection deriving from measure and proportion. He utilized these themes on the facade of his own home at Monticello (Fig. 688). The colonnade thus came to be associated with the ideal state, and, in the United States, Jefferson's Neoclassical architecture became an almost official Federal style.

Neoclassicism found official favor in France with the rise of Napoleon Bonaparte. In 1799, Napoleon brought the uncertain years that followed the French Revolution to an end when he was declared First Consul of the French Republic. As this title suggests, Napoleon's government was modeled on

Napoleonic Europe, and After

Empire of France
French satellites
Allied with France

Roman precedents. He established a centralized government and instituted a uniform legal system. He invaded Italy and brought home with him many examples of classical sculpture, including the *Laocoön* (Fig. 614) and the *Apollo Belvedere* (Fig. 28). In Paris itself, he built triumphal Roman arches, including the famous Arc de Triomphe, a column modeled on Trajan's in Rome, and a church, La Madeleine, modeled after the temples of the first Roman emperors. In 1804, Napoleon was himself crowned Emperor of the largest European empire since Charlemagne's in the ninth century.

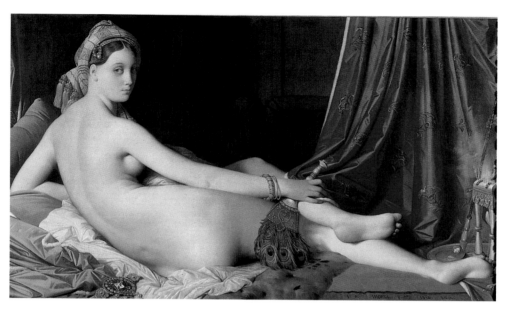

Fig. 689 Jean-Auguste-Dominique Ingres, *Grande Odalisque,* 1814.
Oil on canvas, 35¼ × 63¾ in.
Musée du Louvre, Paris. Giraudon/Art Resource, New York.

Neoclassical art was used to legitimate this empire. David saw Napoleon as the salvation of France (so chaotic had Revolutionary France been that David himself had been imprisoned, a sure sign, he thought, of the confusion of the day), and he received important commissions from the new emperor. But it was David's finest pupil, Jean-Auguste-Dominque Ingres, who became the champion of Neoclassical ideals in the nineteenth century. In 1806, he was awarded the Prix de Rome. He then departed for Italy, where he remained for eighteen years, studying Raphael in particular and periodically sending new work back to France, including the astonishing *Jupiter and Thetis* (see Fig. 120).

Ingres's Neoclassicism was "looser" than his master's. While Jupiter, for instance, is dogmatically classical in spirit, the sensuous Thetis is almost Rococo in treatment. Looking at a painting such as the *Grande Odalisque* (Fig. 689), with its long, gently curving limbs, we are more clearly in the world of Mannerist painting than that of the Greek nude. Ingres's color is as rich as Bronzino's in *The Exposure of Luxury*

(see Fig. 669), and, in fact, his theme is much the same. Like his odalisques in *The Turkish Bath* (Fig. 123)—an "odalisque" is a harem slave—Ingres's subject seems more decadent than not, deeply involved in a world of satins, peacock feathers, and, at the right, hashish. Certainly, it is not easy to detect much of the high moral tone of earlier Neoclassical art.

Beside Eugène Delacroix's own *Odalisque* (Fig. 690), Ingres's classicism becomes more readily apparent. To Ingres, Delacroix, who was a generation younger than he, represented a dangerous and barbaric Neo-Baroque sensibility in contrast to his own Neoclassicism.

Ingres and Delacroix became rivals. Each had his critical champions, each his students and followers. For Ingres, drawing was everything. Therefore, his painting was, above all, linear in style. Delacroix, however, was fascinated by the texture of paint itself, and in his painterly attack upon the canvas, we begin to sense the artist's own passionate temperament. Viewed beside the Delacroix, the pose of the odalisque in Ingres's painting is positively conservative. In fact, Ingres felt he was upholding

First British Reform Act
widens suffrage
1832

1835

1830s
First European
railroads

1833
Slavery abolished in
British Empire

Fig. 690 Eugène Delacroix, *Odalisque,* 1845–1850.
Oil on canvas, 14⅞ × 18¼ in.
Fitzwilliam Museum, University of Cambridge, England.

traditional values in the face of the onslaught represented by the uncontrolled individualism of his rival.

ROMANTICISM

We have come to call the kind of art exemplified by Delacroix **Romanticism**. At the heart of this style is the belief that reality is a function of each individual's singular point of view, and that the artist's task is to reveal that point of view. Individualism reigned supreme in Romantic art. For this reason, Romanticism sometimes seems to have as many styles as it has artists. What unifies the movement is more a philosophical affirmation of the power of the individual mind than a set of formal principles.

One of the most individual of the Romantics was the Spanish painter Francisco de Goya y Lucientes. After a serious illness in 1792, Goya turned away from a late Rococo style and began to produce a series of paintings depicting inmates of a lunatic asylum and a hospital for wounded soldiers. When Napoleon invaded Spain in 1808, Goya recorded the atrocities both in paintings and in a series of etchings, *The Disasters of War,* which remained unpub-

Fig. 691 Francisco Goya,
Saturn Devouring One of His Sons, 1820–1822.
Fresco, transferred to canvas, 57⅞ × 32⅝ in.
Museo del Prado, Madrid. Scala/Art Resource, New York.

lished until long after his death. His last, so-called "Black Paintings," were brutal interpretations of mythological scenes that revealed a universe operating outside the bounds of reason, a world of imagination unchecked by a moral force of any kind. In one of these, *Saturn Devouring One of His Sons* (Fig. 691), which was painted originally on the wall of the dining room in Goya's home, Saturn is allegorically a figure for Time, which consumes us all. But it is the incestuous cannibalism of the scene, the terrible monstrosity of the vision itself, that tells us of Goya's own despair. The inevitable conclusion is that, for Goya, the world was a place full of terror, violence, and horror. What we recognize in his work is his own despair.

Théodore Géricault's The Raft of the Medusa

Fig. 692 Théodore Géricault, *The Raft of the Medusa*, 1819.
Oil on canvas, 16 ft. 1¼ in. × 23 ft. 6 in.
Musée du Louvre, Paris. Giraudon/Art Resource, New York.

On July 2, 1816, the French frigate *Medusa* was wrecked on a reef off the African coast. The overloaded ship had been carrying soldiers and settlers to Senegal. The captain and other senior officers escaped in lifeboats, leaving 150 behind to fend for themselves on a makeshift wooden raft. After twelve harrowing days on the raft, only fifteen survived. The naval officer who rescued them reported: "These unhappy people had been obliged to fight a great number of their comrades who staged a revolt in the hope of taking over the remaining provisions. The others had been swept out to sea, had died of hunger, or gone mad. The ones I saved had been feeding on human flesh for several days, and when I found them, the ropes serving as maststays were loaded with pieces of such meat, hung there for drying."

The incident infuriated the young painter Théodore Géricault. The captain's appointment had depended on his connections with the French monarchy, which had been restored after Napoleon's defeat at Waterloo. Here, therefore, was clear evidence of the nobility's decadence. To illustrate his beliefs and feelings, Géricault planned a giant canvas, showing the raft just at the moment that the rescue ship, the *Argus*, was spotted on the horizon (Fig. 692). He went to the Normandy coast to study the movement of water. He visited hospitals and morgues to study the effects of illness and death on the human body. He had a model of the raft constructed in his studio and arranged wax figures upon it. His student, Delacroix, posed face down for the central nude.

And all the while he was sketching. An early sketch (Fig. 693) is horizontal in composition, a crowded scene from early on in the ordeal, a claustrophobic and amorphous mass of humanity, with no real focal point or sense of order. The final painting (above, left) turns the raft on its axis, creating two contradictory pyramidal points of tension. On the left, the mast not only suggests the crucifix but also reveals that the raft is sailing away from its rescuers, while on the right, the pyramid of survivors climb desperately in their attempt to be seen. Géricault's horrifying picture, exhibited only a few months after it was conceived, fueled the Romantic movement with the passion of its feelings.

Fig. 693 Théodore Géricault, *The Mutiny on the Raft of the Medusa*, 1818.
Black & white chalk, black crayon, brown & blue-green watercolor & white gouache on dark brown modern laid paper, 15¾ × 20 in. Courtesy of The Fogg Art Museum, Harvard University Art Museums, Bequest of Grenville L. Winthrop.
Photograph © President and Fellows of Harvard College, Harvard University. 1943.824.

Ralph Waldo Emerson
publishes *Nature*
1836

First regular Atlantic
steamship service
1840

1845

1837
Victoria assumes
British throne

1844
First telegraphic
message

Fig. 694 Caspar David Friedrich, *Monk by the Sea*, 1809–1810.
Oil on canvas, 42½ × 67 in. Schloss Charlottenburg, Berlin. Bildarchiv Preussischer Kulturbesitz.

This sense of the terrible is by no means unique to Goya. In his own *Journal,* Delacroix wrote, "[The poet] Baudelaire . . . says that I bring back to painting . . . the feeling which delights in the terrible. He is right." It was in the face of the sublime that this enjoyment of the terrible was most often experienced. Theories of the **sublime** had first appeared in the seventeenth century, most notably in Edmund Burke's *Inquiry into the Origin of Our Ideas of the Sublime and the Beautiful* (1756). For Burke, the sublime was a feeling of awe experienced before things that escaped the ability of the human mind to comprehend them—mountains, chasms, storms, and catastrophes. The sublime exceeded reason; it presented viewers with something vaster than themselves, thereby making them realize their smallness, even their insignificance, in the face of the infinite. The sublime evokes the awe-inspiring forces of Nature, as opposed to the Beautiful, which is associated with Nature at her most harmo-

nious and tranquil. A pastoral landscape may be beautiful; a vast mountain range, sublime.

No painting of the period more fully captures the terrifying prospect of the sublime than Caspar David Friedrich's *Monk by the Sea* (Fig. 694). It indicates just how thoroughly the experience of the infinite—that is, the experience of God—can be found in Nature. But the God faced by this solitary monk is by no means benign. The infinite becomes, in this painting, a vast, dark, and lonely space—so ominous that it must surely test the monk's faith. The real terror of this painting lies in its sense that the eternal space stretching before this man of faith may not be salvation but a meaningless void.

American landscape painters such as Albert Bierstadt (see Fig. 3), Thomas Moran (see Fig. 305), and Frederic Church continually sought to capture the sublime in their paintings of the vast spaces of the American West. Church even traveled to South America

1847
Charlotte Brontë,
Jane Eyre

Fig. 695 Frederic Edwin Church, *The Heart of the Andes*, 1859.
Oil on canvas, 66⅛ × 119¼ in. Signed and dated (on tree trunk, lower left): 1859/F.E. Church.
The Metropolitan Museum of Art, New York. Bequest of Margaret E. Dows, 1909 (09.95).
Photograph © 1979 The Metropolitan Museum of Art.

in order to bring evidence of its exotic and remarkable landscapes to viewers in America and Europe. His painting *The Heart of the Andes* (Fig. 695) was first exhibited in 1859 in New York in a one-picture, paid-admission showing. The dramatic appeal of the piece was heightened by brightly lighting the picture and leaving the remainder of the room dark, and by framing it so that it seemed to be a window in a grand house looking out upon this very scene. Deemed by critics "a truly religious work of art," it was a stunning success. The insignificance of humanity can be felt in the minuteness of the two figures, barely visible in this reproduction, praying at the cross in the lower left, but the scene is by no means merely sublime. It is also beautiful and pastoral in feeling, and, in the careful rendering of plant life, it is almost scientific in its fidelity to nature.

The Romantic painter was, in fact, interested in much more than the sublime. A Romantic artist might render a beautiful scene as well as a sublime one, or one so pastoral in feeling that it recalls, often deliberately,

Claude's soft Italian landscapes (see Fig. 678). It was the love of Nature itself that the artist sought to convey. In Nature, the American poet and essayist Ralph Waldo Emerson believed, one could read eternity. It was a literal "sign" for the divine spirit.

The painter, then, had to decide whether to depict the world with absolute fidelity or to reconstruct imaginatively a more perfect reality, out of a series of accurate observations. As one writer put it at the time, "A distinction must be made . . . between the elements generated by . . . direct observation, and those which spring from the boundless depth and feeling and from the force of idealizing mental power." As we have seen in our discussion of painting in Chapter 12, the idealizing force of the imagination in painting distinguished it from mere copywork. Nevertheless, and though Church's *The Heart of the Andes* is an idealist compilation of diverse scenes, in many of its details—in, for instance, the accuracy with which the foliage has been rendered—it depends on direct observation.

1848
The Communist Manifesto

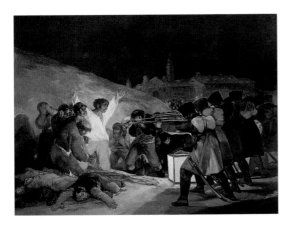

Fig. 696 Francisco Goya, *The Third of May, 1808*, 1814–1815.
Oil on canvas, 8 ft. 9 in. × 13 ft. 4 in.
Museo del Prado, Madrid. Scala/Art Resource, New York.

Fig. 697 Eugène Delacroix, *Liberty Leading the People*, 1830.
Oil on canvas, 8 ft. 6⅜ in. × 10 ft. 8 in.
Musée du Louvre, Paris. Giraudon/Art Resource, New York.

Fig. 698 Ernest Meissonier,
Memory of Civil War (The Barricades), 1849.
Oil on canvas, 11½ × 8¾ in.
Musée du Louvre, Paris. Scala/Art Resource, New York.

REALISM

Church's accurate rendering of foliage reflects the importance of scientific, empirical observation to the nineteenth century as a whole, an urge for **realism** that runs counter to, and exists alongside, the imaginative and idealist tendencies of the Romantic sensibility. If we compare three history paintings from the first half of the nineteenth century, we can see how the idealizing tendency of the Romantic sensibility gradually faded away. Faced with the reality of war, idealism seemed absurd. Francisco Goya's *The Third of May, 1808* (Fig. 696) depicts an actual event, the execution of citizens of Madrid by Napoleon's invading army. Its dramatic lighting and the Christ-like outstretched arms of the man about to be shot reflect the conventions of Baroque religious art, but the promise of salvation seems remote. The church in the background is shrouded in darkness, and the man will fall forward, like the others before him, a bloody corpse. Eugène Delacroix's *Liberty Leading the People* (Fig. 697) represents Liberty as an idealized allegorical figure, but the battle itself, which took place during the July Revolution of 1830, is depicted in a highly realistic manner, with figures lying dead on the barricades beneath Liberty's feet and Notre Dame Cathedral at the distant right shrouded in smoke. In Ernest Meissonier's *Memory of Civil War (The Barricades)* (Fig. 698) all the nobility of war has been drained from the picture. The blue, white, and red of the French flag has been reduced to piles of tattered clothing and blood, what one contemporary gruesomely described as an "omelette of men."

World population reaches
about 1.1 billion
1850

Admiral Perry's visit ends
Japanese isolation
1854

1851
Herman Melville,
Moby Dick

Fig. 699 Gustave Courbet, *Burial at Ornans*, 1849.
Oil on canvas, 10 ft. 3½ in. × 21 ft. 9 in. Musée d'Orsay, Paris. Giraudon/Art Resource, New York.

Fig. 700 Honoré Daumier,
***Fight between Schools, Idealism and Realism*, 1855.**
Embassy of the Federal Republic of Germany.

So thoroughly did the painter Gustave Courbet come to believe in recording the actual facts of the world around him that he declared, in 1861: "Painting is an essentially concrete art and can only consist of the presentation of real and existing things. It is a completely physical language, the words of which consist of all visible objects." Courbet and others ascribing to realism believed artists should confine their representation to accurate observation and nota-

tion of the phenomena of daily life. No longer was there necessarily any "greater" reality beyond or behind the facts that lay before their eyes. Courbet's gigantic painting, *Burial at Ornans* (Fig. 699) seems, at first glance, to hold enormous potential for symbolic and allegorical meaning, but just the opposite is the case. In the foreground is a hole in the ground, the only "eternal reward" Courbet's scene appears to promise. No one, not even the dog, seems to be focused on the event itself. Courbet offers us a panorama of distraction, of common people performing their everyday duties, in a landscape whose horizontality reads like an unwavering line of monotony. If the crucifix rises into the sky over the scene, it does so without deep spiritual significance. In fact, its curious position, as if it were set on the horizon line, lends it a certain comic dimension, a comedy that the bulbous faces of the red-cloaked officers of the parish also underscore. The painting was rejected by the jury of the Universal Exposition of 1855. To emphasize his disdain for the values of the establishment, Courbet opened a one-person exhibition outside the Exposition grounds, calling it the Pavilion of Realism. The cartoonist Honoré Daumier immediately

Fig. 710 Paul Gauguin,
The Day of the God (Mehana no Atua), 1894.
Oil on canvas, 26⅞ × 36⅛ in. Helen Birch Bartlett Memorial Collection.
Photograph ©1999 The Art Institute of Chicago, All Rights Reserved.

Fig. 711 Georges Seurat, *The Bathers*, 1883–1884.
Oil on canvas, 79½ × 118½ in. The National Gallery, London.
Reproduced by courtesy of the Trustees. Erich Lessing/Art Resource, New York.

features of the woman on the right capture a decadence that, by century's end, pervaded Parisian life. Van Gogh and Gauguin, it was felt even at the time, released artists from the need to copy nature. Color could now be used arbitrarily to express emotions (see van Gogh's *Night Café*, Fig. 202).

Like Toulouse-Lautrec, Paul Gauguin criticized the conditions of modern life, but he did so by leaving Europe and seeking out a new life in the South Seas. There, in paintings such as *The Day of the God (Mahana no Atua)* (Fig. 710), he tried to capture the mystery and magic of the "primitive" culture, a world of unity, peace, and naked innocence far removed from the turmoil of civilized life. The perfect balance of the painting's composition and the brilliant color of the scene are structural realizations of paradise on earth.

In paintings such as *A Sunday on La Grande Jatte* (Fig. 189), Georges Seurat sought to impose a formal order upon the world, and in the process, he revealed its rigidity, its lack of vitality. Though Seurat's subject matter in *The Bathers* (Fig. 711) is Impressionist, his composition is not. It is architectural, intentionally

returning to the seventeenth-century compositional principles of Poussin (see Fig. 681). And it subtly critiques the image of Impressionist leisure. These are not well-to-do middle-class Parisians, but workers (their costume gives them away), swimming in the Seine just downriver from the factory town of Asnières. Smokestacks belch soot in the distance. The spot, as observant Parisians knew, was directly across from the outlet of the great collective sewer from Paris. In the summer of 1884, according to the local press, "more than 120,000 cubic feet of solids had accumulated at the sewer's mouth; several hundred square meters of which are covered with a bizarre vegetation, which gives off a disgusting smell." Suddenly, the green material floating in the water is transformed.

Of all the Post-Impressionist painters, Paul Cézanne, working alone in the south of France, most thoroughly emphasized the formal aspects of painting at the expense of subject matter, and in this he looked forward most to the direction of art in the twentieth century. Cézanne pushed toward an idea of painting that established for the picture an independent existence, to be judged in terms of the purely

1890

Discovery of radium
1898

1895
Invention of
motion picture camera

1900
Sigmund Freud,
The Interpretation of Dreams

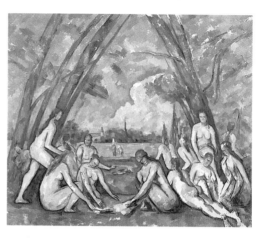

Fig. 714 Paul Cézanne, *The Large Bathers*, 1906.
Oil on canvas, 82 × 99 in. Philadelphia Museum of Art.
Purchased with the W. P. Wilstach Fund. W' 37-1-1.

Fig. 712 Paul Cézanne, *Still Life with Cherries and Peaches,* 1885–1887.
Oil on canvas. 19¾ × 24 in.
Los Angeles County Museum of Art, Gift of Adele R. Levy Fund, Inc., and
Mr. and Mrs. Armand S. Deutsch. M.61.1. Photograph © 2002 Museum Associates/LACMA..

Fig. 713 Paul Cézanne, *Mont Sainte-Victoire, and the Viaduct of the
Arc River Valley,* 1882–1885.
Oil on canvas, 25¾ × 32⅛ in. The Metropolitan Museum of Art, New York.
H. O. Havemeyer Collection. Bequest of Mrs. H. O. Havemeyer, 1929. (29.100.64).
Photograph © 1984 The Metropolitan Museum of Art.

formal interrelationships of line, color, and plane. In his *Still Life with Cherries and Peaches* (Fig. 712), he emphasizes the *act* of composition itself, the process of seeing. It is as if he has rendered two entirely different views of the same still life simultaneously. The peaches on the right are seen from a point several feet in front of the table, while the cherries on the left have been painted from directly above. As a consequence, the table itself seems to broaden out behind the cherries.

Similarly, *Mont Sainte-Victoire and the Viaduct of the Arc River Valley* (Fig. 713) collapses the space between foreground and background by making a series of formal correspondences between them: by the repetition of the shape of the lower righthand branch of the tree, for instance, the road below it, and the shape of the mountain itself. Finally, in the *Large Bathers* (Fig. 714), the pyramidal structure of the composition draws attention to the geometry that dominates even the individual faceting of the wide brushstrokes, which he laid down as horizontals, verticals, and diagonals. The simplification of the human body evident here, as well as Cézanne's overall emphasis on form, had a profound effect on painting in the twentieth century. It is in Cézanne that the art of the twentieth century dawns.

CHAPTER 22

THE TWENTIETH CENTURY

CUBISM

THE FAUVES

GERMAN EXPRESSIONISM

FUTURISM

DADA AND SURREALISM

WORKS IN PROGRESS
Pablo Picasso's *Guernica*

AMERICAN MODERNISM AND ABSTRACT EXPRESSIONISM

POP ART AND MINIMALISM

POSTMODERN DIRECTIONS

WORKS IN PROGRESS
Frank Gehry's *Guggenheim Bilbao*

THE CRITICAL PROCESS
Thinking about the History of Art

In the autumn of 1906 and throughout 1907, Pablo Picasso painted his portrait of *Gertrude Stein* (see Fig. 54) and then embarked on his monumental and groundbreaking painting *Les Demoiselles d'Avignon* (Fig. 69). At the time, Paris was inundated with exhibitions of the work of Cézanne, which were to have a profound effect on the development of modern art. Soon after Cézanne died, in October 1906, a retrospective of seventy-nine of his last watercolors was exhibited at the Bernheime-Jeune

1900

First radio message
sent across the Atlantic
1901

Wright Brothers
invent the airplane
1903

1901
Ragtime jazz develops
in United States

1905
Revolution in Russia

Fig. 715 Georges Braque, *Houses at l'Estaque*, 1908.
Oil on canvas, 28¾ × 23¾ in. Hermannn and Margit Rupf Foundation.
© 2003 Artists Rights Society (ARS), New York/ADAGP, Paris.

Gallery. At the Salon in the autumn of 1907, another retrospective of Cézanne's late paintings, mostly oils, appeared. In his letters to the painter Emile Bernard, which were published posthumously in the Paris press, Cézanne advised painters to study nature in terms of "the cylinder, the sphere, the cone."

CUBISM

Picasso was already under the influence of Cézanne when he painted *Les Demoiselles*, and when Georges Braque saw first Picasso's painting and then Cézanne's retrospective, he began to paint a series of landscapes based on their formal innovations. His *Houses at l'Estaque* (Fig. 715) takes Cézanne's manipulation of space even farther than the master did. The tree that rises from the foreground seems to meld into the roofs of the distant houses near the top of the painting. At the right, a large, leafy branch projects out across the houses, but its leaves appear identical to the greenery that is growing between the houses behind it. It

Fig. 716 Georges Braque, *Violin and Palette,* Autumn 1909.
Oil on canvas, 36⅛ × 16⅞ in.
Solomon R. Guggenheim Museum, New York. 54.1412.
© The Solomon R. Guggenheim Foundation, New York.
Photograph by David Heald.
© 2003 Artists Rights Society (ARS), New York/ADAGP, Paris.

becomes impossible to tell what is foreground and what is not. The houses descending down the hill before us are themselves spatially confusing. Walls bleed almost seamlessly into other walls, walls bleed into roofs, roofs bleed into walls. Braque presents us with a design of triangles and cubes as much as he does a landscape.

Together, over the course of the next decade, Picasso and Braque created the movement known as **Cubism**, of which Braque's *Houses at l'Estaque* is an early example. The name derived from a comment made by the critic Louis Vaux-

Einstein's Theory
of Relativity
1905

1905
Debussy, *La Mer*

First Soviet
5-year plan
1928

1930

928
sion broadcast

1929
U. S. stock market crash;
Great Depression begins

celles in a small review that appeared directly above a headline announcing the "conquest of the air" by the Wright brothers: "Braque . . . reduces everything, places and figures and houses, to geometric schemes, little cubes." It was, as the accidental juxtaposition of Cubism and the Wright brothers suggested, a new world.

Other artists soon followed the lead of Picasso and Braque, and the impact of their art can be felt everywhere. For the Cubist, art was primarily about form. Analyzing the object from all sides and acknowledging the flatness of the picture plane, the Cubist painting represented the three-dimensional world in increasingly two-dimensional terms. The curves of the violin in Braque's *Violin and Palette* (Fig. 716) are flattened and cubed, so much so that in places the instrument seems as flat as the sheets of music above it. The highly realistic, almost *trompe-l'oeil* nail at the painting's top introduces another characteristic of Cubist work. Casting its own shadow, it can be seen either as part of the painting, holding up the palette, or as real, holding the painting to the wall. Such play between the reality of painting and the reality of the world soon led both Picasso and Braque to experiment with collage, which we discussed in Chapter 14. Perhaps most important, Cubism freed painting of the necessity to represent the world. Henceforth, painting could be primarily about painting.

THE FAUVES

Though the Cubists tended to deemphasize color in order to emphasize form, Henri Matisse favored the expressive possibilities of color. Matisse, in a sense, synthesized the art of Cézanne and Seurat, taking the former's broad, flat zones of color and the latter's interest in setting complementary hues beside one another. Under the influence of van Gogh, whose work had not been seen as a whole until an exhibition at the Bernheim-Jeune Gallery in 1901, Matisse felt free to use color arbitrarily.

A number of other young painters joined him, and in the fall of 1905 they exhibited together at the Salon, where they were promptly labeled **Fauves** ("Wild Beasts"). Not long after the exhibition, Matisse painted a portrait of his wife known as *The Green Stripe* (Fig. 717) for the bright green stripe that runs down the middle of her face. The painting is a play between zones of complementary colors, and in its emphasis on blue-violet, red-orange, and green, it relies on the primary colors of light, not pigment. Although some critics ridiculed them, the Fauves were seen by others as promising a fully abstract art. The painter Maurice Denis wrote of them: "One feels completely in the realm of abstraction. Of course, as in the most extreme departures of van Gogh, something still remains of the original feeling of nature. But here one finds, above all in the work of Matisse, the sense of . . . painting in itself, the act of pure painting."

Amelia Earhart first woman to fly
across the Atlantic alone
1932

Hitler comes to power
in Germany
1933

1930

1932
30 million unemployed
in U. S. and Europe

1932–33
Mass famine
in the U. S. S. R.

Fig. 722 Marcel Duchamp, *Mona Lisa (L.H.O.O.Q.)*, 1919.
Rectified Readymade (reproduction of Leonardo da Vinci's *Mona Lisa*
altered with pencil), 7¾ × 4⅛ in. Private collection. © 2003 Artists
Rights Society (ARS), New York/ADAGP, Paris/Estate of Marcel Duchamp

Fig. 723 Marcel Duchamp, *The Fountain*, 1917.
Fountain by R. Mutt. Glazed sanitary china with black print.
Photograph by Alfred Stieglitz in *The Blind Man,* no. 2 (May 1917); original lost.
© Philadelphia Museum of Art: The Louise and Walter Arensberg Collection. 1998-74-1.
©2003 Artists Rights Society (ARS), New York, ADAGP, Paris/Estate of Marcel Duchamp.

DADA AND SURREALISM

Founded simultaneously in Zurich, Berlin, Paris, and New York during the war, **Dada** took up Futurism's call for the annihilation of tradition but, as a result of the war, without its sense of hope for the future. Its name referred, some said, to a child's first words; others claimed it was a reference to a child's hobbyhorse; and still others celebrated it as a simple nonsense sound. As a movement, it championed senselessness, noise, and illogic. Dada was, above all, against art, at least art in the traditional sense of the word. Its chief strategy was insult and outrage. Perhaps Dada's chief exponent, Marcel Duchamp, always challenged tradition in a spirit of fun. His *L. H. O. O. Q.* (Fig. 722) is an image of Leonardo's *Mona Lisa* with a moustache drawn on her upper lip. Saying the letters of the title with French pronunciation reveals it to be a pun, *elle a chaud au cul,* roughly trans-

lated as "she's hot in the pants." Such is the irreverence of Dada.

In New York, Duchamp submitted a common urinal to the Independents Exhibition in 1917, titled it *Fountain,* signed it R. Mutt, and claimed for it the status of sculpture (Fig. 723). At first it was rejected, but when Duchamp let it be known that he and R. Mutt were one and the same, it was accepted. Thus, whether something was art depended on who made it— or found it, in this case. It also depended on where it was seen—in the museum it was one thing, in the plumbing store, quite another. Furthermore, on its pedestal, in the context of the museum, Duchamp's "fountain" looked to some as if it were indeed sculpture. Duchamp did not so much invalidate art as authorize the art world to consider all manner of things in aesthetic terms. His logic was not without precedent. Cubist collage had brought "real things" like newspaper clippings into the space of painting, and photography, especially, often revealed aesthetic beauty in common experience. But Duchamp's move, like Dada gener-

Pablo Picasso's Guernica

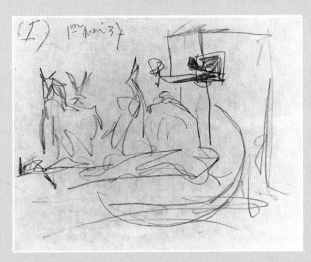

Fig. 727 Pablo Picasso, *Sketch 1, Composition Study*, 1 May 1937. Pencil, 8¼ × 10⅝ in. Arxiu Mas, Barcelona, Spain. Museo Nacional Centro de Arte Reina Sofia. ©2003 Estate of Pablo Picasso/Artists Rights Society (ARS), New York.

Fig. 728 Pablo Picasso, *Sketch 6, Composition Study*, 1 May 1937. Pencil, 21⅛ × 25½ in. Arxiu Mas, Barcelona, Spain. Museo Nacional Centro de Arte Reina Sofia. ©2003 Estate of Pablo Picasso/ Artists Rights Society (ARS), New York.

In January 1937, nearly four months before the bombing of Guernica, Picasso had been approached by representatives of the freely elected Republican government of Spain, who hoped that he might contribute a large mural for the entrance hall of a Spanish pavilion at the 1937 World's Fair in Paris. On May 1, as Paris papers headlined the tragedy that had occurred four days before, Picasso took pencil to paper, executing six sketches for the 25½-foot painting. Time was short. The pavilion was scheduled to open on May 28. Picasso would finish the painting on June 4.

The first sketch (Fig. 727) outlines the idea in the most cursory fashion. The bull is present, and so is the woman reaching out of the house, oil lamp in hand. Rising in the middle is the shape that will become the twisted neck and head of the horse. By the end of the day, the composition's themes have begun to be worked out (Fig. 728). Out of the wound in the horse's side, the animal's spirit seems to take wing. A slain soldier lies beneath it, and the bull watches over the scene. Here, the theme of the bullfight is introduced—the victorious bull, the slain picador (the chief antagonist of the bull who, on horseback, torments him with a lance), and the fallen horse are equated to

the war in Spain. But the bull's victory is temporary. In the bullfight, the bull's death is inevitable, just as death is inevitable for us all.

Within a week, Picasso had essentially arrived at the final composition. In a sketch of May 9 (Fig. 729), the idea of mass human suffering is finally

Fig. 729 Pablo Picasso, *Sketch 15, Composition Study*, 9 May 1937. Pencil, 9½ × 17⅞ in. Arxiu Mas, Barcelona, Spain. Museo Nacional Centro de Arte Reina Sofia. ©2003 Estate of Pablo Picasso/Artists Rights Society (ARS), New York.

introduced. The dead lying across the ground, the woman lifting her dead child in a scream of terror, the dramatic contrast between light and dark, all point to the final composition, which Picasso would arrive at four days later, on May 13.

1940

U. S. enters
World War II
1941

Enrico Fermi
splits the atom
1942

1940
Germans
invade France

1941–45
The Holocaust

1944
Allied invasion of Europe,
led by U. S. forces

Fig. 730 Lee Krasner, *Untitled*, c. 1940.
Oil on canvas, 30 × 25 in. ©Estate of Lee Krasner. Courtesy Robert Miller Gallery, New York. ©2003 Pollock-Krasner Foundation/Artists Rights Society (ARS), New York.

Fig. 731 Piet Mondrian, *Composition (Blue, Red, and Yellow)*, 1930.
Oil on canvas, 28½ × 21¼ in.
Courtesy Sidney Janis Gallery, New York. © 2003 Artists Rights Society (ARS), New York/Beeldrecht, Amsterdam.

AMERICAN MODERNISM AND ABSTRACT EXPRESSIONISM

With the outbreak of World War II, Picasso decided that *Guernica* should stay in the United States. He arranged for it to be kept at the Museum of Modern Art in New York, where it was to be held until the death of Franco and the reestablishment of public liberty in Spain. Franco, however, did not die until 1975, two years after Picasso himself. The painting was returned to Spain, finally, in 1981. It hangs today in a special annex of the Prado Museum in Madrid.

The painting profoundly affected American artists. "Picasso's *Guernica* floored me," Lee Krasner reported. "When I saw it first . . . I rushed out, walked about the block three times before coming back to look at it. And then I used to go to the Modern every day to see it." Krasner's own *Untitled* painting (Fig. 730) done soon after *Guernica*'s arrival in New York in 1939, reflects *Guernica*'s angular forms and turbulent energy. But it differs in important ways from *Guernica*. It is totally abstract, and where *Guernica* is a monochrome gray-brown, like burnt newsprint, Krasner's painting is vibrant with color. Probably more than any other artist of her day, Krasner understood how to integrate the competing aesthetic directions of European abstraction, fusing the geometric and expressionist tendencies of modern art in a single composition.

Like Krasner, and somewhat earlier, the Dutch painter Piet Mondrian, who had himself emigrated to New York in 1940, purged from his work all reference to the world. In paintings such as *Composition (Blue, Red, and Yellow)* (Fig. 731), he relied only upon horizontal and vertical lines, the three primary colors, and black and white, which were, he felt, "the expression of pure reality." Like the Russian

Fig. 739 Roy Lichtenstein,
Whaam! 1963.
Magna on two canvas panels,
5 ft. 8 in. × 13 ft 4 in.
Tate Gallery, London/Art Resource, New York.

Fig. 740 Frank Stella,
Empress of India, 1965.
Metallic powder in polymer emulsion on shaped canvas,
6 ft. 5 in. × 18 ft. 8 in.
Collection: Museum of Modern Art, New York.
Gift of S. I. Newhouse. Licensed by Scala-Art Resource,
New York. © 2003 Frank Stella/
Artists Rights Society (ARS), New York.

In the 1960s, inspired by Rauschenberg's example, a group of even younger artists, led by Andy Warhol, Claes Oldenburg, and Roy Lichtenstein, invented a new American realism, **Pop Art**. Pop represented life as America lived it, a world of Campbell's soup cans, Coca-Cola bottles, and comic strips. Based on an actual Sunday cartoon strip, Lichtenstein's giant painting *Whaam!* (Fig. 739) indicates, by its very size, the powerful role of popular culture in our emotional lives. This is an image of power, one that most American boys of the 1950s were raised to believe in wholly. One of the chief tactics of the Pop artists, in fact, was to transform the everyday into the monumental, as Oldenburg turned a garden trowel and a clothespin into giant sculptural objects (see Figs. 247 and 326). Most important perhaps, Pop Art left behind traditional artistic media like painting. Artists turned instead to slick renderings made by mechanical reproduction techniques, such as photolithography, that evoked commercial illustration more than fine art.

Another reaction against Action Painting led, in the same period, to a style of art known as **Minimalism**. In contrast to Pop works, Minimalist pieces were, in their way, elegant. They addressed notions of space—how objects take up space and how the viewer relates to them spatially—as well as questions of their dogmatic material presence. For Frank Stella, the shape of the painting determined its content, which might consist of a series of parallel lines that could have been drawn with a compass or protractor. "I always get into arguments with people who want to retain the old values in painting," Stella muses. "My painting is based on the fact that only what can be seen is there. It is really an object.... All I want anyone to get out of my paintings, and all I ever get out of them is the fact that you can see the whole idea without confusion. What you see is what you see." Thus, despite its title, *Empress of India* (Fig. 740) is contentless painting. It has no spiritual aspirations. It does not contain the emotions of the painter. It is simply there, four interlocked V's, before the viewer, a fact in and of itself. Stella has deliberately set out to make a work of art that has no narrative to it, that cannot, at least not very easily, be written about.

early 1970s
Rise of the modern
feminist movement

1973–74
Energy crisis in
Western countries

Fig. 741 Jimmie Durham, *Headlights*, 1983.
Car parts, antler, shell, etc. Private collection. Courtesy of the artist.

Fig. 742 Jaune Quick-to-See Smith, *Petroglyph Park*, 1986.
Pastel on paper, 30 × 22 in.
Private Collection. © Jaune Quick-to-See Smith. Courtesy of the artist.

POSTMODERN DIRECTIONS

From the time of Gauguin's retreat to the South Pacific and Picasso's fascination with African masks, Western artists have turned to non-Western cultures for inspiration, seeking "authentic" new ways to express their emotions in art. The African features of the two figures on the right in Picasso's *Les Demoiselles d'Avignon* (Fig. 69) are a prime example of this. At the same time, other cultures have been dramatically affected by Western traditions. Although we normally think of the Western world's impact on these other cultures in negative terms—in the process of Westernization, ancient customs are lost and cultural artifacts are looted and carried off for display in Western museums—many non-Western artists have incorporated the art of the West into their own art in positive ways. As Native American artist Jimmie Durham has put it: "We took glass beads, horses, wool blankets, wheat

flour for frybread, etc., very early, and immediately made them identifiably 'Indian' things. We are able to do that because of our cultural integrity and because our societies are dynamic and able to take in new ideas." Similarly, the aboriginal painters of Australia have adopted the use of acrylic paint, integrating the medium into their own cultural traditions (see Fig. 5). Durham himself makes what he calls "fake Indian artifacts." Categorically non-Indian materials, such as the bright chrome automobile fender depicted here (Fig. 741), are transformed into something that looks completely Indian. But the cultural forces at work are highly complex. As much as Indian culture has the ability to absorb Western materials and make them its own, anything an Indian makes, Durham knows, is always seen by the dominant Anglo-

Fig. 750 George Green, *Magician: Woman with Horns*, 1997.
Acrylic and horns on birch, 96 × 48 in.
Louis K. Meisel Gallery, New York. Photo: Aaron Johanson.

Fig. 751 Brice Marden, *Cold Mountain 3*, 1989–1991.
Oil on linen, 9 × 12 ft. Courtesy Mary Boone Gallery, New York.
© 2003 Artists Rights Society (ARS), New York.

*was forty years old, this love welled up in
me and united with my training in sculp-
ture to initiate and propel the work that
has occupied me ever since.*

Truitt's work seems, superficially, to fulfill the
desire of modernism to create art that explores
the formal dimensions of its own medium. But
it is her autobiographical anecdote that lends
the work its special richness.

Jonathan Borofsky's *Man with a Briefcase*
(Fig. 749) is, on the one hand, a monument to
the faceless mass of American workers. At the
same time, however, it addresses questions of
personal identity in a manner quite comparable
to Sherman and Truitt's works. Borofsky
explains: "This figure is me too—the traveling
salesman who goes around the world with his

briefcase full of images and thoughts. The brief-
case has always been a metaphor for my
brain." In painting, the styles of the past—from
the Renaissance to the Rococo, from Cubism to
Abstract Expressionism—have been raided and
appropriated to the context of the present.

George Green's *Magician: Woman with
Horns* (Fig. 750) is simultaneously abstract
and realistic. Painted on a single piece of birch
so as to appear composed of different ele-
ments, both painted and sculptural, it is a star-
tling piece of *trompe l'oeil* illusionism, evoking
both Picasso's collage, Renaissance perspec-
tive, Romantic landscape, geometric abstrac-
tion, and ancient totems.

A second example is Brice Marden's *Cold
Mountain 3* (Fig. 751), one of a series of recent
works that takes its name from the Chinese
poet called Cold Mountain. This painting is
like a minimalist version of Jackson Pollock. It
is as if the high energy of Pollock had turned
meditative, and the quick, almost violent
motion of Pollock's line had been reinvented as
a sort of slow dance suspended in a quiet space.

Frank Gehry's Guggenheim Museum Bilbao

Fig. 752 Frank Gehry, Guggenheim Museum Bilbao, north elevations, October 1991.
Sketch by Frank Gehry, 1991. © Frank O. Gehry & Associates.

Fig. 753 Frank Gehry, Guggenheim Museum Bilbao.
© Frank O. Gehry & Associates.

"I start drawing sometimes," architect Frank Gehry has said, "not knowing exactly where I am going. I use familiar strokes that evolve into the building. Sometimes it seems directionless, not going anywhere for sure. It's like feeling your way along in the dark, anticipating that something will come out usually. I become voyeur of my own thoughts as they develop, and wander about them. Sometimes I say 'boy, here it is, here it is, it's coming.' I understand it. I get all excited."

Gehry's early drawings of the north, riverfront facade for the Guggenheim Museum in Bilbao, Spain (Fig. 752), executed only three months after he had won the competition to design the building in 1991, reveal his process of searching for the form his buildings eventually take. These semiautomatic "doodles" are explorations that are surprisingly close to Gehry's finished building (Fig. 754). They capture the fluidity of its lines, the flowing movement of the building along the riverfront space, including the large gallery that houses Richard Serra's massive *Snake* (see opposite page).

Gehry moves quickly from such sketches to actual scale models. The models, for Gehry, are like sculpture: "You forget about it as architecture, because you're focussed on this sculpting process." The models, finally, are transformed into actual buildings by means of Catia, a computer program originally developed for the French aerospace industry (Fig. 753). This program demonstrated to builders, contractors—and the client—that Gehry's plan was not only buildable, but affordably so.

Fig. 754 Frank Gehry, Guggenheim Museum Bilbao, 1997.
Photo: David Heald.
© The Solomon R. Guggenheim Foundation, New York.

The Monica Lewinsky scandal
preoccupies the nation
1998

2000

1997
Princess Diana dies
in auto accident

Fig. 755 Richard Serra, *Snake,* 1994–1997.
Cor-Ten steel, 13½ × 102 × 24¾ ft. Interior view of Guggenheim
Museum Bilbao, Boat Gallery. Photo: David Heald
© The Solomon R. Guggenheim Foundation, New York.
© 2003 Artists Rights Society (ARS), New York/ADAGP, Paris.

Fig. 756 Jenny Holzer, selection from *"The Survival Series,"* 1986.
Dectronic Starburst double-sided electronic display signboard, 10 × 40 ft.
Installation, Caesar's Palace, Las Vegas. 1986.
Courtesy of the artist.

Increasingly, artists create work for specific spaces, works designed to relate to their surroundings. One such **site specific work** is Richard Serra's *Snake* (Fig. 755), commissioned for the new Guggenheim Museum in Bilbao (see opposite). Sculptor of the infamous *Titled Arc*, a similar site-specific work, now destroyed (see Fig. 84), Serra was allowed to create a mammoth piece for the new museum's largest space, a 450-foot-long, 80-foot-wide "boat" gallery (The space is so large that it could serve as the hangar for two Boeing 747s). *Snake* itself "invites" the viewer to walk its length between the tilted sides of its winding steel slabs. It is so large that it had to be installed before the walls of the building were completed, and it can never be removed.

Jenny Holzer's work is similarly site-specific, but transitory and immediate in its impact. Her medium is language displayed on electronic signboards (Fig. 756). From New York's Times Square to the Las Vegas strip, Holzer's sayings eerily invade the space of advertising like messages from our own cul-

tural subconscious. It is, perhaps above all, the new electronic technologies that are most affecting art at century's end. Today, CD-ROMs, the fax machine, cable television, and the Internet all promise to expand the world of art into an electronic "global village," a brave new world of art, in which our ways of seeing are almost limitless.

THE CRITICAL PROCESS

Thinking about the History of Art

Two days after the tragic events of September 11, 2001, *The New York Times* asked its cultural critics to contribute to a special section of The Living Arts section of the newspaper entitled "The Expression of Grief and the Power of Art." The section was introduced by editor Bruce Weber: "Nothing provokes the artistic sensibility like grief," he wrote.

In the artist, events like those of Tuesday morning bring about a meeting of universal emotions and an individual will to unearth

Fig. 757 Rex Amos, *911*, 2001.
Mixed media on canvas, 20⅜ × 18½ in. Private collection. Courtesy of the artist.

them, expose them understand them and accept if not outlast them.

In grief is a myriad of human terrors: the visceral blow that brings rage and outrage, the insidious settling in of pain and sadness; the concentric waves of anguish that continue through time. All of these have been evoked through the centuries with the power of great imaginations.

From Homer's tales of Troy to Picasso's "Guernica," . . . from the bloody dramas of Sophocles and Shakespeare to Maya Lin's Vietnam Memorial, artists have always combated grave tragedy with grave beauty.

At almost exactly the same time as these words appeared in print, artist Rex Amos, who was traveling in Idaho at the time, created a collage commemorating the tragedy (Fig. 757). Consisting of a flattened and rusted enamel washbasin, an old-fashioned straight-edge razor,

and a crucifix—all found in junkyards—as well as headlines from Lewiston and Boise, Idaho, newspapers, and *The New York Times*, the whole set on a full-page newspaper photograph of the World Trade Center towers collapsing, it captures something of the grief—and grave beauty—that was the subject of the *Times* special section.

Why, given the subject, is collage a particularly appropriate medium for Amos to work with here? What hope does it offer? Why did he choose the elements he did? the washbasin? the razor? the crucifix? How, one finally has to ask, can such an expression of grief—and outrage—function as a work of *art*? Or, to put it another way, how does art function in a context such as this? What, finally, does the history of art, from Grünewald's *Crucifixion* (Fig. 64) to Maya Lin's Vietnam Memorial (Fig. 80) to Picasso's *Guernica* (Fig. 726), tell us about art's purpose?

THE CRITICAL PROCESS
THINKING SOME MORE ABOUT THE CHAPTER QUESTIONS

CHAPTER 1 Andy Warhol's *Race Riot*, 1963
Warhol seems most interested in the second traditional role of the artist: to give visible or tangible form to ideas, philosophies, or feelings. He is clearly disturbed by the events in Birmingham. By depicting the attack on Martin Luther King, Jr., in the traditional red, white, and blue colors of the American flag, he suggests that these events are not just a local issue but a national one. Thus, to a certain degree, he also reveals a hidden truth about the events: All Americans are implicated in Bull Connor's actions. Perhaps he also wants us see the world in a new way, to imagine a world without racism. The second red panel underscores the violence and anger of the scene. As horrifying as the events are, it is possible to imagine a viewer offended not by the police actions but by Warhol's depiction of them, his willingness to treat such events as "art."

CHAPTER 2 Two representations of a *Treaty Signing at Medicine Lodge Creek*
Taylor's version of the events is the more representational by traditional Western standards, Howling Wolf's the more abstract. In many ways however, Howling Wolf's version contains much more accurate information. Formally, they are very different. As a reporter, Taylor tries to convey the actual grove of trees under which the treaty signing ceremony occurred. It seems as important to him to represent the trees and grasses accurately as the people present at the scene, but the scene could be anywhere. In contrast, by portraying the confluence of Medicine Lodge Creek and the Arkansas River, Howling Wolf describes the exact location of the signing ceremony. Taylor focuses his attention on the U. S. government officials at the center of the picture, suggesting their individual importance. The Native Americans in Taylor's picture are relegated to the periphery of the action. Even in the foreground, their individual identities are masked in shadow. From Taylor's ethnocentric perspective, the identities of the Native Americans present is of no interest. In contrast, Howling Wolf's aerial view shows all those present, including women, equally. Each person present is identified by the decoration of the dress and tipis. Women are valued and important members of the society. Their absence in Taylor's work suggests that women have no place at important events. In fact it is possible to argue that Taylor's drawing is about hierarchy and power, while Howling Wolf's is about equality and cooperation.

CHAPTER 3 Robert Mapplethorpe's *Parrot Tulip*, 1982
Like the cut flower in Philippe de Champaigne's *Vanitas*, Mapplethorpe's tulip represents the temporary and conditional nature of beauty. Unlike the flower in *Vanitas*, however, Mapplethorpe's tulip is dying in its vase, drooping down toward the flower. It becomes a symbol of Mapplethorpe's own imminent demise. Both the painting and the photograph depend on a dramatic contrast of light and dark, as if darkness and death surround the things of this world. The light's origin to the left suggests that it is late in the day. Time is running out. The tulip is itself a sexual organ—stamen and pistil—and as it droops over the vase's edge it suggests both sexual completion and sexual impotence. The aesthetic beauty of the work depends not only on its formal qualities, such as the contrast between light and dark and between the black vase and the brilliantly colored flower, as well as the rhythm of curves created by the vase and the stem, but also on our sense that this aesthetic beauty is extraordinarily fragile, a thing of the moment soon to be lost. And yet the photograph captures the moment forever, as if miraculously.

CHAPTER 4 Group Material's *AIDS Timeline* and *The AIDS Memorial Quilt*
Group Material assumes virtually every role of the artist. Their private experiences of the reality of AIDS have led them to report on the epidemic in their work. As reporters they have gone beyond a mere repetition of the facts and analyzed the meaning of these findings. Finally, in displaying the *Timeline*, they become activists, working to further public knowledge, encourage research, and influence legislation. The aesthetic dimension of their work lies in the idea that a world without AIDS would be a more beautiful world. Thus they see their work as having an ultimately aesthetic purpose. The *AIDS Memorial Quilt* possesses most of the same qualities, though like Maya Lin's Vietnam Memorial, it seeks to honor each AIDS victim individually, creating a giant patchwork of names. By 1997, more than 6,400,000 people had died of the disease worldwide, and 22,000,000 were HIV-positive. For either work to come to a conclusion, AIDS will have to be cured.

CHAPTER 5 Robert Mapplethorpe's *Lisa Lyon*, 1980
Robert Mapplethorpe's portrait of Lisa Lyon purposefully subverts convention. She poses in direct imitation of the Greek *Zeus* or *Poseidon* (Fig. 108), a fully classical posture of power and strength, more like Ingres's Jupiter than his Thetis. Rather than a passive object of display, Lyon is portrayed as an active athlete. By portraying herself in this way, Lyon asserts the power of the female and implicitly argues that the female body has been "conditioned" not so much by physical limitations as by culture.

CHAPTER 6 Michael Scroggins and Stewart Dickson's *Topological Slide*, 1993
The prefixes "cyber-" and "hyper-" suggest a lot about the nature of this space. *Cyber* refers to *cybernetics,* the study of mechanical and electrical systems designed to replace human functions. *Hyper* is a common prefix that usually means excessive or exaggerated in English but literally means "over" in Greek. Thus this space is mechanical and electrical, other than human, and "over" or beyond our space, in another dimension. It is two-dimensional insofar as it is created out of two-dimensional images. It is three-dimensional insofar as we enter it physically. If in experiencing such spaces we seem to move in and through a two-dimensional image, this space must be totally illusory. It suggests that we exist, or at least can exist, within illusion. The entertainment possibilities of such spaces are limitless and exciting, but in the wrong hands, such spaces could be used as devices of social manipulation and control.

CHAPTER 7 Tony Cragg's *Newton's Tones/New Stones*, 1982
Cragg's plastic pieces are arranged in a spectrum like that created by a prism. Not only light but also our whole material world passes through Cragg's prism. These fragments of everyday things are the "new stones" of postindustrial culture, a plastic conglomerate of debris. "Newton's tones" are the colors of the spectrum itself. The irony of Cragg's piece, of course, is that color transforms this waste into a thing of beauty, a work of art. The aesthetic beauty of this work is at odds with the material out of which it is made.

CHAPTER 8 Bill Viola's *Room for St. John of the Cross*, 1983
The simple geometric architecture of the small cell contrasts dramatically with the wild natural beauty of the scene on the large screen. The former is closed and contained, classically calm, the latter open and chaotic, romantically wild. The former is still and quiet, the latter active and dynamic. The larger room, lit only by the screen image, seems dark and foreboding. The cell, lit by a soft yellow light, seems inviting. Time is a factor in terms of our experience of the work. If we approach the cell, our view of the screen is lost. When we stand back from the cell, the rapid movement on the screen disrupts our ability to pay attention to the scene in the cell. The meditative space of the cell stands in stark contrast to the turbulent world around it. And yet the cell represents captivity, the larger room freedom, both real freedom and the freedom of imaginative flight.

CHAPTER 9 Claude Monet's *The Railroad Bridge, Argenteuil,* 1874

Monet uses one-point linear perspective to create the bridge. A gridlike geometry is established where the bridge's piers cross the horizon and the far riverbank. The wooden support structure under the bridge echoes the overall structure of grid and diagonals. In this the picture is classical. But countering this geometry is the single expression of the sail, a curve echoed in the implied line that marks the edge of the bushes at the top right. A sense of opposition is created by the alternating rhythm of light to dark established by the bridge's piers and in the complementary color scheme of orange and blue in both the water and the smoke above. The almost perfect symmetrical balance of the painting's grid structure is countered by the asymmetrical balance of the composition as a whole (its weight seems to fall heavily to the right). There are two points of emphasis, the bridge and the boat. We seem to be witness to the conflicting forces of nature and civilization.

CHAPTER 10 Pietro da Cortona's *Study for a Figure Group,* c. 1623

Thought not signed by Cortona himself, the fact that his name appears in the lower right suggests that the drawing was thought of as a work worthy of standing on its own. Cortona takes advantage of the fluid motion available to the hand using pen and ink, rendering the scene in an excited and dynamic style. One of the chief differences between the finished painting and this sketch is the figure of Charity on the right. In the painting, she is indifferent to her children, but in the sketch she is joyfully engaged with them.

CHAPTER 11 Andy Warhol's *30 Are Better than One,* 1963

Both Oldenburg and Warhol make use of earlier masterpieces in their works, and both take advantage of the fact that photographs can be easily transferred to the screen for printing. Like the engraving of Turner's *Snow Storm,* Warhol's work reproduces in black-and-white an original color painting. In printmaking, there is no "original," just a number of multiples. From Warhol's point of view, this is very much like modern manufacturing. Warhol's thinking that "thirty are better than one" reflects his "more-the-merrier" approach to art. Warhol's "job" is to "produce" images. Like Marilyn Monroe, Mona Lisa is an image, the face of a woman we can never know. Warhol suggests that, reduced to mere images, these women become tragically substanceless.

CHAPTER 12 Judith F. Baca's *Great Wall of Los Angeles,* 1976

Baca chose to work with acrylic paint as opposed to oil or fresco because it can withstand outdoor elements. The vibrancy of Baca's color is particularly expressive, and so is the way she manipulates space, exaggerating the size of the people in relation to their surroundings. While the work denotes the division of the Los Angeles Chicano community, its connotation is positive, calling for cooperation and unity. The community must work together just as Baca herself instills a spirit of collaboration in her mural work. Thus, just as Giotto's *Madonna and Child Enthroned* embodies the idea of love between mother and child, and by extension, the love of God for humanity, Baca's work embodies the necessity of love for one another, even in the face of social division.

CHAPTER 13 Anthony Caro's *Early One Morning,* 1962

The stark geometry of Caro's sculpture is emphasized by the way it echoes the geometry of the room. Furthermore, in the room, it seems enormous, almost filling the space. In the outdoors it would seem smaller. But like Beverly Pepper's *Cromlech Glen,* the viewer must walk around the sculpture to fully appreciate it. Like David Smith's *Blackburn,* it looks totally different from different points of view, compact and busy when seen from one side, open and spacious from the other. As much as it is an assemblage of disparate elements, it is unified by its overall red color. Caro's sculpture is mechanical and industrial in appearance, yet because it rests on the ground, not on a special base, it is not separated from us. It is part of our world. We interact directly with it.

CHAPTER 14 Ann Hamilton's *'a round,'* 1993

Hamilton's *'a round'* is a highly complex work of art that addresses many issues both formal and political. The pillars and thread, as well as the piles of cotton bags surrounding the room, are sculptural. Hamilton's material is fiber and hence is related to the craft media. The physical activity of weaving is performance-oriented, as well as the periodic eruption of the mechanized punching bags. The "feminine" activity of sewing takes place in an environment of "masculine" sport—wrestling and boxing. In probably no other work activity did men exploit women more than in the textile industry. This appearance of "woman's work" in "masculine" space is one of the many "crossings" in the work. Women have always worked in the context of men's violence. Other crossings include passive quiet and violent noise, the live body and the sawdust "dummies." The thread goes endlessly round and around the pillars, while each "round" in a boxing match lasts for a limited time, like the installation itself. The "dummies" form a membrane around the room that evokes skin, but at the same time they are like piled bodies, victims of some mindless carnage.

CHAPTER 15 Jeff Wall's *A Sudden Gust of Wind,* 1993

The greatest transformation is that the pastoral world of the Hokusai print has been replaced by what appears to be an industrial wasteland. The businessmen, of course, have created this landscape. No mountain could be seen in Wall's work, even if there were one. The sky is thick with what appears to be pollution. There is nothing spiritual about this place. Wall's photograph is like a "still" from a motion picture. It implies that we are in the midst of a story. But what story? How can we ever know what is "really" happening here? Knowing that Wall has completely fabricated the scene, we recognize that, in fact, nothing is "really" happening here. Wall's is a world of complete illusion, in which meaning flies away as surely as the papers on a sudden gust of wind.

CHAPTER 16 Charles Moore's *Piazza d'Italia,* 1976–1979

Ionic and Corinthian columns are readily visible, as well as a simplified column, reminiscent of the Doric but made of steel, and a more complex one made of what appears to be automobile chrome. Almost every moment of architectural history is referenced, including, but not limited to, post-and-lintel construction, the Roman arch, steel and reinforced concrete construction, and, naturally, postmodern design. The variety of materials employed by Moore, as well as the variety of texture and color, are distinctly postmodern features, which architect Robert Venturi describes as "the mixture of the seemingly incongruous" elements.

CHAPTER 17 Nigel Coates's *Caffè Bongo,* 1986

Like Moore's *Piazza d'Italia,* Coates's *Caffè Bongo* is a postmodern space. Readily visible in this restaurant are references to classical Greek art, Corinthian columns, vernacular brick, art nouveau, art deco, steel and reinforced concrete, and streamlining (suggested by the airplane wing and the bent steel I-beams). Nothing, for Coates, is sacred. He can use, and re-use anything, in any context, bring an airplane wing into a room and sit classical sculpture on top of it, reveal an old brick wall and interrupt it with classical columns. The room is a giant assembly of "found" styles.

CHAPTER 22 Rex Amos's *911,* 2001

Amos's use of collage is particularly appropriate because the medium takes human refuse and renews it in the context of art, thus restoring it to a condition of beauty. The crushed washbasin possesses the aura of a time long since past, the razor suggests wounds, and the crucifix, of course, martyrdom and sacrifice—but all offer the promise of renewed health, cleanness, and even salvation. Art functions here as a place in which we can reflect, both on the horrors that we create and the promise of creation itself.

GLOSSARY

Words appearing in italics in the definitions are also defined in the glossary.

absolute symmetry Term used when each half of a composition is exactly the same.

abstract In art, the rendering of images and objects in a stylized or simplified way, so that though they remain recognizable, their formal or *expressive* aspects are emphasized. Compare both *representational* and *nonobjective art*.

Abstract Expressionism A painting style of the late 1940s and early 1950s, predominantly American, characterized by its rendering of *expressive* content by *abstract* or *nonobjective* means.

acropolis The elevated site above an ancient Greek city conceived as the center of civic life.

acrylic A plastic resin that, when mixed with water and pigment, forms an inorganic and quick-drying paint *medium*.

actual texture As opposed to *visual texture*, the literal tactile quality or feel of a thing.

actual weight As opposed to *visual weight*, the physical weight of material in pounds.

additive (1) In color, the adjective used to describe the fact that when different *hues* of colored light are combined, the resulting mixture is higher in *key* than the original hues and brighter as well, and as more and more hues are added, the resulting mixture is closer and closer to white. (2) In sculpture, an adjective used to describe the process in which form is built up, shaped, and enlarged by the addition of materials, as distinguished from *subtractive* sculptural processes, such as carving.

aerial perspective See *atmospheric perspective*.

aesthetic Pertaining to the appreciation of the beautiful, as opposed to the functional or utilitarian, and, by extension, to the appreciation of any form of art, whether overtly "beautiful" or not.

afocal art Work in which no single point of the composition demands our attention any more or less than any other and in which the eye can find no place to rest.

afterimage In color, the tendency of the eye to see the *complementary* color of an image after the image has been removed.

ambulatory A covered walkway, especially around the *apse* of a church.

analogous colors Pairs of colors, such as yellow and orange, that are adjacent to each other on the *color wheel*.

analytic line Closely related to *classical line*, a kind of line that is mathematical, precise, and rationally organized, epitomized by the vertical and horizontal grid, as opposed to *expressive line*.

animation In film, the process of sequencing still images in rapid succession to give the effect of live motion.

apse A semi-circular recess placed, in a Christian church, at the end of the *nave*.

aquatint An *intaglio* printmaking process, in which the acid bites around powdered particles of resin resulting in a *print* with a granular appearance. The resulting *print* is also called an aquatint.

arbitrary color Color that has no *realistic* or natural relation to the object that is depicted, as in a blue horse, or a purple cow, but which may have emotional or *expressive* significance.

arch A curved, often semicircular architectural form that spans an opening or space built of wedge-shaped blocks, called *voussoirs*, with a *keystone* centered at its top.

architrave In architecture, the *lintel*, or horizontal beam, that forms the base of the *entablature*.

Art Deco A popular art and design style of the 1920s and 1930s associated with the 1925 Exposition Internationale des Arts Décoratifs et Industriels Modernes in Paris and characterized by its integration of organic and geometric forms.

Art Nouveau The art and design style characterized by undulating, curvilinear, and organic forms that dominated popular culture at the turn of the century, and that achieved particular success at the 1900 International Exposition in Paris.

assemblage An *additive* sculptural process in which various and diverse elements and objects are combined.

asymmetrical balance Balance achieved in a composition when neither side reflects or mirrors the other.

atmospheric perspective A technique, often employed in landscape painting, designed to suggest *three-dimensional space* in the *two-dimensional space* of the *picture plane*, and in which forms and objects distant from the viewer become less distinct, often bluer or cooler in color, and contrast among the various distant elements is greatly reduced.

autographic line Any use of line that is distinct to the artist who employs it and is therefore recognizable as a kind of "signature" style.

avant-garde Those whose works can be characterized as unorthodox and experimental.

axonometric projection A technique for depicting space, often employed by architects, in which all lines remain parallel rather than receding to a common *vanishing point* as in *linear perspective*.

Baroque A dominant style of art in Europe in the seventeenth century characterized by its theatrical, or dramatic, use of light and color, by its ornate forms, and by its disregard for *classical* principles of composition.

barrel vault A masonry roof constructed on the principle of the *arch*, that is, in essence, a continuous series of arches, one behind the other.

basilica In Roman architecture, a rectangular public building, entered on one of the long sides. In Christian architecture, a church loosely based on the Roman design, but entered on one of the short ends, with an *apse* at the other end.

bas-relief See *low-relief*.

Bauhaus A German school of design, founded by Walter Gropius in 1919 and closed by Hitler in 1933.

bilateral symmetry Term used when the overall effect of a composition is one of *absolute symmetry*, even though there are clear discrepancies side to side.

binder In a *medium*, the substance that holds *pigments* together.

buon fresco See *fresco*.

burin A metal tool with a V-shaped point used in *engraving*.

burr In *drypoint* printing, the ridge of metal that is pushed up by the *engraving* tool as it is pulled across the surface of the plate and that results, when inked, in the rich, velvety *texture* of the drypoint *print*.

calligraphy The art of handwriting in a fine and aesthetic way.

calotype The first photographic process to utilize a negative image. Discovered by William Henry Fox Talbot in 1841.

Canon (of *proportion*) The "rule" of perfect proportions for the human body as determined by the Greek sculptor Polykleitos in a now lost work, known as the *Canon*, and based on the idea that each part of the body should be a common fraction of the figure's total height.

cantilever An architectural form that projects horizontally from its support, employed especially after the development of reinforced concrete construction techniques.

capital The crown, or top, of a *column*, upon which the *entablature* rests.

Carolingian art European art from the mid-8th to the early 10th century, given impetus and encouragement by Charlemagne's desire to restore the civilization of Rome.

cartoon As distinct from common usage, where it refers to a drawing with humorous content, any full size drawing, subsequently transferred to the working surface, from which a painting or *fresco* is made.

cast iron A rigid, strong construction material made by adding carbon to iron.

cast shadow In *chiaroscuro*, the shadow cast by a figure, darker than the shadowed surface itself.

casting The process of making sculpture by pouring molten material—often bronze—into a mold bearing the sculpture's impression. See also *lost-wax casting*.

ceramics Objects formed out of clay and then hardened by *firing* in a very hot oven, or *kiln*.

chiaroscuro In drawing and painting, the use of light and dark to create the effect of *three-dimensional*, *modeled* surfaces.

cire-perdue See *lost-wax casting*.

classical line Closely related to *analytic line*, a kind of line that is mathematical, precise, and rationally organized, epitomized by the vertical and horizontal grid, as opposed to *expressive line*.

closed palette See *palette*.

close-up See *shot*.

coiling A method of *ceramic* construction in which long ropelike strands of clay are coiled on top of one another and then smoothed.

collage A work made by pasting various scraps or pieces of material—cloth, paper, photographs—onto the surface of the *composition*.

colonnade A row of *columns* set at regular intervals around the building and supporting the base of the roof.

color wheel A circular arrangement of *hues* based on one of a number of various color theories.

column A vertical architectural support, consisting of a *shaft* topped by a *capital*, and sometimes including a base.

complementary colors Pairs of colors, such as red and green, that are directly opposite each other on the *color wheel*.

composition The organization of the formal elements in a work of art.

connotation The meaning associated with or implied by an image, as distinguished from its *denotation*.

Constructivism A Russian art movement, fully established by 1921, that was dedicated to *nonobjective* means of communication.

Conté crayon A soft drawing tool made by adding clay to graphite.

content The meaning of an image, beyond its overt *subject matter*; as opposed to *form*.

contour line The visible border of an object in space.

contrapposto The disposition of the human figure in which the hips and legs are turned in opposition to the shoulders and chest, creating a counter-positioning of the body.

convention A traditional, habitual, or widely accepted method of representation.

cornice The upper part of the *entablature*, frequently decorated.

craft Expert handiwork, or work done by hand.

cross-cutting In film technique, when the editor moves back and forth between two separate events in increasingly shorter sequences in order to heighten drama.

cross-hatching Two or more sets of roughly parallel and overlapping lines, set at an angle to one another, in order to create a sense of three-dimensional, *modeled* space. See also *hatching*.

crossing In a church, where the *transepts* cross the *nave*.

Cubism A style of art pioneered by Pablo Picasso and Georges Braque in the first decade of the 20th century, noted for the geometry of its forms, its fragmentation of the object, and its increasing abstraction.

cyberspace See *virtual reality*.

Dada An art movement that originated during World War I in a number of world capitals, including New York, Paris, Berlin, and Zurich, which was so antagonistic to traditional styles and materials of art that it was considered by many to be "anti-art."

daguerreotype One of the earliest forms of photography, invented by Louis Jacques Mandé Daguerre in 1839, made on a copper plate polished with silver.

delineation The descriptive representation of an object by means of *outline* or *contour* drawing.

denotation The direct or literal meaning of an image, as distinguished from its *connotations*.

De Stijl A Dutch art movement of the early 20th century that emphasized abstraction and simplicity, reducing form to the rectangle and color to the *primary colors*—red, blue, and yellow.

diagonal recession In *perspective*, when the lines recede to a *vanishing point* to the right or left of the *vantage point*.

dimetric projection A kind of *axonometric projection* in which two of the three measurements—height, width, and depth—employ the same *scale* while the third is different.

dome A roof generally in the shape of a hemisphere or half-globe.

drypoint An *intaglio* printmaking process in which the copper or zinc plate is incised by a needle pulled back across the surface leaving a *burr*. The resulting *print* is also called a drypoint.

earthenware A type of *ceramics* made of porous clay and fired at low temperatures that must be *glazed* if it is to hold liquid.

earthwork An *environment* that is out-of-doors.

editing In filmmaking, the process of arranging the sequences of the film after it has been shot in its entirety.

edition In printmaking, the number of *impressions* authorized by the artist made from a single master image.

elevation The side of a building, or a drawing of the side of a building.

embroidery A traditional fiber art in which the design is made by needlework.

encaustic A method of painting with molten beeswax fused to the support after application by means of heat.

engraving An *intaglio* printmaking process in which a sharp tool called a *burin* is used to incise the plate. The resulting *print* is also called an engraving.

entablature The part of a building above the *capitals* of the *columns* and below the roof.

entasis The slight swelling in a *column* design to make the column appear straight to the eye.

environment A form of art that is large enough for the viewer to move around in.

etching An *intaglio* printmaking process in which a metal plate coated with wax is drawn upon with a sharp tool down to the plate and then placed in an acid bath. The acid eats into the plate where the lines have been drawn, the wax is removed, and then the plate is inked and printed. The resulting *print* is also called an etching.

ethnocentric Pertaining to the imposition of the point of view of one culture upon the works and attitudes of another.

Expressionism An art that stresses the psychological and emotional content of the work, associated particularly with German art in the early 20th century. See also *Abstract Expressionism*.

expressive line A kind of line that seems to spring directly from the artist's emotions or feelings—loose, gestural, and energetic—epitomized by curvilinear forms; as opposed to *analytic* or *classical line*.

extreme close-up See *shot*.

Fauvism An art movement of the early 20th century characterized by its use of bold *arbitrary color*. Its name derives from the French word "fauve," meaning "wild beast."

figure-ground reversal Term used to describe a two-dimensional work in which the relationship

between a form or figure and its background is reversed so that what was figure becomes background and what was background becomes figure.

firing The process of baking a *ceramic* object in a very hot oven, or kiln.

fixative A thin liquid film sprayed over *pastel* and charcoal drawings to protect them from smudging.

flashback A narrative technique in film in which the editor cuts to episodes that are supposed to have taken place before the start of the film.

fluting The shallow vertical grooves or channels on a *column*.

flying buttress On a Gothic church, an exterior *arch* that opposes the lateral thrust of an arch or vault, as in a *barrel vault*, arching inward toward the exterior wall from the top of an exterior *column* or pier.

focal point In a work of art, the center of visual attention, often different from the physical center of the work.

foreshortening The modification of *perspective* to decrease distortion resulting from the apparent visual contraction of an object or figure as it extends backwards from the *picture plane* at an angle approaching the perpendicular.

form (1) The literal *shape* and *mass* of an object or figure. (2) More generally, the materials used to make a work of art, the ways in which these materials are utilized in terms of the formal elements (line, light, color, etc.), and the *composition* that results.

fresco Painting on plaster, either dry *(fresco secco)* or wet *(buon* or *true fresco)*. In the former, the paint is an independent layer, separate from the plaster proper; in the latter, the paint is chemically bound to the plaster, and is integral to the wall or support.

fresco secco See *fresco*.

frieze The part of the *architrave* between the *entablature* and the *cornice*, often decorated.

frontal recession In *perspective*, when the lines recede to a *vanishing point* directly across from the *vantage point*.

frottage The technique of putting a sheet of paper over textured surfaces and then rubbing a soft pencil across the paper.

full shot See *shot*.

Futurism An early 20th century art movement, characterized by its desire to celebrate the movement and speed of modern industrial life.

genre In cinema, a narrative type, such as comedy, war films, and horror films. Also, in painting, the representation of scenes from daily life.

gesso A plaster mixture used as a *ground* for painting.

glaze (1) In oil painting, a thin, transparent, or semi-transparent layer put over a color, usually in order to give it a more luminous quality. (2) In *ceramics*, a material that is painted on a ceramic object that turns glassy when fired.

Golden Section A system of *proportion* developed by the ancient Greeks obtained by dividing a line so that the shorter part is to the longer part as the longer part is to the whole, resulting in a ratio that is approximately 5 to 8.

Gothic A style of architecture and art dominant in Europe from the 12th to the 15th century, characterized, in its architecture, by features such as *pointed arches, flying buttresses*, and a verticality symbolic of the ethereal and heavenly.

gouache A painting medium similar to *watercolor*, but opaque instead of transparent.

grid A pattern of horizontal and vertical lines that cross each other to make uniform squares or rectangles.

groined vault A masonry roof constructed on the *arch* principle and consisting of two *barrel vaults* intersecting at right angles to one another.

ground A coating applied to a canvas or printmaking plate to prepare it for painting or *etching*.

Happening A spontaneous, often multimedia, event conceived by artists and performed not only by the artists themselves but often by the public present at the event as well.

hatching An area of closely spaced parallel lines, employed in drawing and *engraving*, to create the effect of shading or *modeling*. See also *crosshatching*.

heightening The addition of *highlights* to a drawing by the application of white or some other pale color.

Hellenism The art of the 3rd and 2nd centuries B.C.E. in Greece characterized by its physical realism and emotional drama.

highlight The spot or one of the spots of highest *key* or *value* in a picture.

high- (haut-) relief A sculpture in which the figures and objects remain attached to a background plane and project off of it by at least half their normal depth.

hue A color, usually one of the six basic colors of the *spectrum*—the three *primary colors* of red, yellow, and blue, and the three *secondary colors* of green, orange, and violet.

hyperspace See *virtual reality*.

iconography The images and symbols *conventionally* associated with a given subject.

illusionistic art Generally synonymous with *representational art*, but more specifically referring to an image so natural that it creates the illusion of being real.

impasto Paint applied very thickly to canvas or support.

implied line A line created by movement or direction, such as the line established by a pointing finger, the direction of a glance, or a body moving through space.

impression In printmaking, a single example of an *edition*.

Impressionism A late 19th-century art movement, centered in France, and characterized by its use of discontinuous strokes of color meant to reproduce the effects of light.

infrastructure The systems that deliver services to people—water supply and waste removal, energy, transportation, and communications.

installation An *environment* that is indoors.

intaglio Any form of printmaking in which the line is incised into the surface of the printing plate, including *aquatint, drypoint, etching, engraving*, and *mezzotint*.

intensity The relative purity of a color's *hue*, and a function of its relative brightness or dullness; also known as *saturation*.

intermediate colors The range of colors on the *color wheel* between each *primary color* and its neighboring *secondary colors;* yellow-green, for example.

International Style A 20th-century style of architecture and design marked by its almost austere geometric simplicity.

in-the-round As opposed to *relief*, sculpture that requires no wall support and that can be experienced from all sides.

investment In *lost-wax casting*, a mixture of water, plaster, and powder made from ground-up pottery used to fill the space inside the wax lining of the mold.

iris shot In film, a *shot* which is blurred and rounded at the edges in order to focus the attention of the viewer on the scene in the center.

isometric projection A kind of *axonometric projection* in which all three measurements—height, width, and depth—employ the same *scale*.

ka In ancient Egypt, the immortal substance of the human, in some ways equivalent to the Western soul.

key The relative lightness or darkness of a picture or the colors employed in it; used in preference to *value*.

keystone The central and uppermost *voussoir* in an *arch*.

kiln An oven used to bake *ceramics*.

kinetic art Art that moves.

kiva In Anasazi culture, the round, covered hole in the center of the communal plaza in which all ceremonial life took place.

line A mark left by a moving point, actual or implied, and varying in direction, thickness, and density.

linear perspective A system for depicting *three-dimensional space* on a *two-dimensional* surface that depends on two related principles: that things perceived as far away are smaller than things nearer the viewer, and that parallel lines receding into the distance converge at a *vanishing point* on the horizon line.

linocut A form of *relief* printmaking, similar to a *woodcut*, in which a block of linoleum is carved so as to leave the image to be printed raised above the surface of the block. The resulting *print* is also known as a linocut.

lintel In architecture, the horizontal beam stretching between two posts. See also *post-and-lintel construction*.

lithograph Any print resulting from the process of *lithography*.

lithography A printmaking process in which a polished stone, often limestone, is drawn upon with a greasy material; the surface is moistened and then inked; the ink adheres only to the greasy lines of the drawing; and the design is transferred to dampened paper, usually in a printing press.

load-bearing construction In architecture, construction where the walls bear the weight of the roof.

local color As opposed to *optical color* and *perceptual color*, the actual *hue* of a thing, independent of the ways in which colors might be mixed or how different conditions of light and atmosphere might affect the color.

long shot In film, a *shot* that takes in a wide expanse and many characters at once.

lost-wax casting method A bronze-casting method in which a figure is molded in wax and covered with clay; the whole is fired, melting away the wax and hardening the clay; the resulting hardened mold is then filled with molten metal.

low- (bas-) relief A sculpture in which the figures and objects remain attached to a background plane and project off of it by less than one-half their normal depth.

Mannerism The style of art prevalent especially in Italy from about 1525 until the early years of the 17th century, characterized by its dramatic use of light, exaggerated *perspective,* distorted forms, and vivid colors.

mass Any solid that occupies a *three-dimensional* volume.

matrix In printmaking, the master image.

medium (1) Any material used to create a work of art. Plural form, media. (2) In painting, a liquid added to the paint that makes it easier to manipulate.

medium shot See *shot*.

metalpoint A drawing technique, especially *silverpoint*, popular in the 15th and 16th centuries, in which a stylus with a point of gold, silver, or some other metal was applied to a sheet of paper treated with a mixture of powdered bones (or lead white) and gumwater.

mezzotint An *intaglio* printmaking process in which the plate is ground all over with a *rocker*, leaving a burr raised on the surface that if inked would be rich black. The surface is subsequently lightened to a greater or lesser degree by scraping away the burr. The resulting *print* is also known as a mezzotint.

mihrab A niche set in the wall of a mosque indicating the direction of Mecca.

mimesis The concept of imitation, involving the creation of *representations* that transcend or exceed mere appearance by implying the sacred or spiritual essence of things.

minaret A tall, slender tower attached to a mosque from which the people are called to prayer.

Minimalism A style of art, predominantly American, that dates from the mid-20th century, characterized by its rejection of expressive content and its use of "minimal" formal means.

mixed media The combination of two or more *media* in a single work.

modeling In sculpture, the shaping of a form in some plastic material, such as clay or plaster; in drawing, painting, and printmaking, the rendering of a form, usually by means of *hatching* or *chiaroscuro*, to create the illusion of a *three-dimensional form*.

Modernism Generally speaking, the various strategies and directions employed in 20th-century art—*Cubism, Futurism, Expressionism*, etc.—to explore the particular formal properties of any given *medium*.

monotype A printmaking process in which only one *impression* results.

montage In film, the sequencing of widely disparate images to create a fast-paced, multifaceted visual impression.

mosaic An art form in which small pieces of tile, glass, or stone are fitted together and embedded in cement on surfaces such as walls and floors.

mudra The various hand positions of the Buddha.

naturalistic art Generally synonymous with *representational art*; but more specifically meaning "like nature"; descriptive of any work that resembles the natural world.

nave The central part of a church, running from the entrance through the *crossing*.

negative shape or space Empty space, surrounded and shaped so that it acquires a sense of form or volume.

Neoclassicism A style of the late 18th and early 19th centuries that was influenced by the Greek *Classical* style and that often employed Classical themes for its subject matter.

nonobjective art Art that makes no reference to the natural world and that explores the inherent expressive or aesthetic potential of the formal elements—line, shape, color—and the formal *compositional* principles of a given *medium*.

nonrepresentational art See *nonobjective art*.

objective As opposed to *subjective*, free of personal feelings or emotion; hence, without bias.

oblique projection A system for projecting space, commonly found in Japanese art, in which the front of the object or building is parallel to the picture plane and the sides, receding at an angle, remain parallel to each other, rather than converging as in *linear perspective*.

oculus A round, central opening at the top of a *dome*.

one-point linear perspective A version of *linear perspective* in which there is only one *vanishing point* in the *composition*.

open palette See *palette*.

optical color Spots or dots of pure *hues* set beside each other and mixed by the viewer's eye.

Optical Painting (Op Art) An art style particularly popular in the 1960s in which line and color are manipulated in ways that stimulate the eye into believing it perceives movement.

order In Classical architecture, a style characterized by the design of the *platform*, the *column* and its *entablature*.

original print A *print* created by the artist alone and which has been printed by the artist or under the artist's direct supervision.

outline The edge of a shape or figure depicted by an actual line drawn or painted on the surface.

overlapping A way to create the illusion of space by placing one figure behind another.

palette Literally a thin board, with a thumb-hole at one end, upon which the artist lays out and mixes colors, but by extension, the range of colors used by the artist. In this last sense, a *closed* or *restricted palette* is one employing only a few colors and an *open palette* is one utilizing the full range of *hues*.

pan In film, a *shot* in which the camera moves across the scene from one side to the other.

pastel (1) A soft crayon made of chalk and pigment. Also any work done in this *medium*. (2) A pale, light color.

pattern A repetitive motif or design.

pencil A drawing tool made of graphite encased in a soft wood cylinder.

pendentive A triangular section of a masonry hemisphere, four of which provide the transition from the vertical sides of a building to a covering *dome*.

penumbra The lightest of the three basic parts of a shadowed surface, providing the transition from the lighted area to the *umbra*, or core of the shadow.

perceptual color The color as perceived by the eye, changed by the effects of light and atmosphere, in the way, for instance, that distant mountains appear to be blue. See also *atmospheric perspective*.

performance art A form of art, popular especially since the late 1960s, that includes not only physical space but the human activity that goes on within it.

perspective A formula for projecting the illusion of *three-dimensional space* onto a *two-dimensional* surface. See also *linear perspective, one-point linear perspective, two-point linear perspective,* and *atmospheric perspective*.

photogenic drawing With the *daguerreotype*, one of the first two photographic processes, invented by William Henry Fox Talbot in 1839, in which a negative image is fixed to paper.

photorealistic art Generally used to describe *two-dimensional* images, a kind of *super realistic art* rendered with such a high degree of *representational* accuracy that it appears to be photographed rather than drawn or painted.

picture plane As opposed to the space depicted in the painting, an imaginary or theoretical spatial plane corresponding to the actual surface of the painting.

pigments The coloring agents of a *medium*.

planographic printmaking process Any printmaking process in which the print is pulled from a flat, planar surface, chief among them *lithography*.

platform The *base* upon which a *column* rests.

plein-air painting Painting done on site, in the open air.

pointed arch An *arch* that is not semicircular but rather rises more steeply to a point at its top.

polychromatic color scheme A color composition consisting of a variety of *hues*.

ponderation The principle of the weight shift, in which the relaxation of one leg serves to create a greater sense of naturalism in the figure.

Pop Art A style arising in the early 1960s characterized by its emphasis on the forms and imagery of mass culture.

porcelain The type of *ceramics* fired at the highest temperature that becomes virtually translucent and extremely glossy in finish.

position In the art process, a method of establishing space in a *two-dimensional* work by placing objects closer to the viewer lower and objects further away higher in the picture.

post-and-lintel construction A system of building in which two posts support a crosspiece, or *lintel*, that spans the distance between them.

Post-Impressionism A name that describes the painting of a number of artists, working in widely different styles, in the last decades of the 19th century in France.

Postmodernism A term used to describe the willfully plural and eclectic art forms of contemporary art.

potter's wheel A flat disk attached to a flywheel below that is kicked by the potter or driven by electricity, allowing the potter to pull clay upward in a round, symmetrical shape.

Pre-Columbian The cultures of all the peoples of Mexico, Central America, and South America prior to the arrival of the Europeans at the end of the 15th century.

primary colors The *hues* that in theory cannot be created from a mixture of other hues and from which all other hues are created—namely, in pigment, red, yellow, and blue, and in light, red-orange, green, and blue-violet.

print Any one of multiple *impressions* made from a master image.

proof A trial *impression* of a *print*, made before the final *edition* is run, so that it may be examined and, if necessary, corrected.

proportion In any composition, the relationship between the parts to each other and to the whole.

qibla wall The wall of a mosque that, from the interior, is oriented in the direction of Mecca, and that contains the *mihrab*.

radial balance A circular composition in which the elements project outward from a central core at regular intervals like the spokes of a wheel.

realism Generally, the tendency to render the facts of existence, but specifically, in the 19th century, the desire to describe the world in a way unadulterated by the imaginative and idealist tendencies of the Romantic sensibility.

realistic art See *representational art*.

registration In printmaking, the precise alignment of *impressions* made by two or more blocks or plates on the same sheet of paper, utilized particularly when printing two or more colors.

relief (1) Any sculpture in which images and forms are attached to a background and project off it. See *low-relief* and *high-relief*. (2) In printmaking, any process in which any area of the plate not to be printed is carved away, leaving only the original surface to be printed.

Renaissance The period in Europe from the 14th to the 16th century characterized by a revival of interest in the arts and sciences that had been lost since antiquity.

repetition See *pattern* and *rhythm*.

replacement A term for casting, by for instance the *lost-wax* process, in which wax is replaced by bronze.

representational art Any work of art that seeks to resemble the world of natural appearance.

reserve An area of a work of art that retains the original color and texture of the untouched surface or *ground*.

rhythm An effect achieved when shapes, colors, or a regular *pattern* of any kind is repeated over and over again.

rocker A sharp, curved tool utilized in the *mezzotint* printmaking process.

Rococo A style of art popular in the first three-quarters of the 18th century, particularly in France, characterized by curvilinear forms, *pastel* colors, and light, often frivolous subject matter.

Romanesque art The dominant style of art and architecture in Europe from the 8th to the 12th centuries, characterized, in architecture, by Roman precedents, particularly the round *arch* and the *barrel vault*.

romantic Pertaining to works of art possessing the characterisitics of *Romanticism*.

Romanticism A dramatic, emotional, and *subjective* art arising in the early 19th century in opposition to the austere discipline of *Neoclassicism*.

saturation See *intensity*.

scale The comparative size of a thing in relation to another like thing or its "normal" or "expected" size.

secondary colors *Hues* created by combining two *primary colors*; in pigment, the secondary colors are traditionally considered to be orange, green, and violet; in light, yellow, magenta, and cyan.

serigraphy Also known as screenprinting, a stencil printmaking process in which the image is transferred to paper by forcing ink through a mesh; areas not meant to be printed are blocked out.

shade A color or *hue* modified by the addition of another color, resulting in a *hue* of lower *key* or *value*, in the way, for instance, that the addition of black to red results in maroon.

shaft A part of a *column*.

shape In *two-dimensional* media, an area, the boundaries of which are measured in terms of height and width. More broadly, the *form* of any object or figure.

shell system In architecture, one of the two basic structural systems in which one basic material both provides the structural support and the outside covering of a building.

shot In film, a continuous sequence of film frames, including a *full shot*, which shows the actor from head to toe, a *medium shot*, which shows the actor from the waist up, a *close-up*, showing the head and shoulders, and an *extreme close-up*, showing a portion of the face. Other shots include the *long shot*, the *iris shot*, the *pan*, and the *traveling shot*.

silkscreen Also known as a serigraph, a print made by the process of *serigraphy*.

silverpoint See *metalpoint*.

simultaneous contrast A property of *complementary colors* when placed side by side, resulting in the fact that both appear brighter and more intense than when seen in isolation.

sinopie The *cartoon* or underpainting for a *fresco*.

site-specific art A work of art created for a specific location and designed to relate to that location.

sizing An astringent crystalline substance called alum brushed onto the surface of paper so that ink will not run along its fibers.

skeleton-and-skin system In architecture, one of the two basic structural systems, which consists of an interior frame, the skeleton, that supports the more fragile outer covering of the building, the skin.

slab construction A method of *ceramic* construction in which clay is rolled out flat, like a pie crust, and then shaped by hand.

solvent A thinner that enables paint to flow more readily and that also cleans brushes; also called *vehicle*.

spectrum The colored bands of visible light created when sunlight passes through a prism.

springing The lowest stone of an *arch*, resting on the supporting post.

star In the popular cinema, an actor or actress whose celebrity alone can guarantee the success of a film.

state In printmaking, an *impression* pulled part way through the process so that the artist can study how the image is progressing.

stippling In drawing and printmaking, a pattern of closely placed dots or small marks employed to create the effect of shading or *modeling*.

stoneware A type of *ceramics* fired at high temperature and thus impermeable to water.

stopping out In *etching*, the application of varnish or *ground* over the etched surface in order to prevent further etching as the remainder of the surface is submerged in the acid bath.

stupa A large mound-shaped Buddhist shrine.

stylobate The base, or *platform*, upon which a *column* rests.

subject matter The literal, visible image in a work of art, as distinguished from its *content*, which includes the *connotative*, symbolic, and suggestive aspects of the image.

subjective As opposed to *objective*, full of personal emotions and feelings.

sublime That which impresses the mind with a sense of grandeur and power, inspiring a sense of awe.

subtractive (1) In color, the adjective used to describe the fact that, when different *hues* of colored pigment are combined, the resulting mixture is lower in *key* than the original hues and duller as well, and as more and more hues are added, the resulting mixture is closer and closer to black. (2) In sculpture, an adjective used to describe the process in which form is discovered by the removal of materials, by such means as carving, as distinguished from *additive* sculptural processes, such as *assemblage*.

super realistic art A work of art so *illusionistic* or true to life that it appears to be real.

support The surface on which the artist works—a wall, a panel of wood, a canvas, or a sheet of paper.

Surrealism A style of art of the early 20th century that emphasized dream imagery, chance operations, and rapid, thoughtless forms of notation that expressed, it was felt, the unconscious mind.

symmetry Term used when two halves of a *composition* correspond to one another in terms of size, shape, and placement of forms.

tapestry A special kind of *weaving*, in which the *weft* yarns are of several colors that the weaver manipulates to make a design or image.

technology The materials and methods available to a given culture.

tempera A painting *medium* made by combining water, pigment, and, usually, egg yolk.

temperature The relative warmth or coolness of a given *hue*; those in the yellow-orange-red range are considered to be warm, and those in the green-blue-violet range are considered cool.

tenebrism From the Italian *tenebroso*, meaning murky, a heightened form of *chiaroscuro*.

tensile strength In architecture, the ability of a building material to span horizontal distances without support and without buckling in the middle.

tesserae Small pieces of glass or stone used in making a *mosaic*.

texture The surface quality of a work.

three-dimensional space Any space that possesses height, width, and depth.

time and motion The primary elements of temporal media, linear rather than spatial in character.

tint A color or *hue* modified by the addition of another color resulting in a hue of higher *key* or *value*, in the way, for instance, that the addition of white to red results in pink.

topography The distinct landscape characteristics of a local site.

transept The crossarm of a church that intersects, at right angles, with the *nave*, creating the shape of a cross.

traveling shot In film, a *shot* in which the camera moves back to front or front to back.

trimetric projection A kind of *axonometric projection* in which all three measurements—height, width, and depth—employ a different *scale*.

trompe l'oeil A form of *representation* that attempts to depict the object as if it were actually present before the eye in *three-dimensional space*; literally "eye-fooling."

truss In architecture, a triangular framework that, because of its rigidity, can span much wider areas than a single wooden beam.

tunnel vault See *barrel vault*.

tusche A greasy material used for drawing on a *lithography* stone.

two-dimensional space Any space that is flat, possessing height and width, but no depth, such as a piece of drawing paper or a canvas.

two-point linear perspective A version of *linear perspective* in which there are two (or more) *vanishing points* in the *composition*.

tympanum The space between the *arch* and *lintel* over a door, often decorated with sculpture.

Ukiyo-e A style of Japanese art, meaning "pictures of the transient or floating world," that depicted, especially, the pleasures of everyday life.

umbra The heart, or core, of a shadow.

value See *key*. Also the worth, monetarily and culturally, of a work.

vanishing point In *linear perspective*, the point on the horizon line where parallel lines appear to converge.

vanitas A kind of still life painting designed to remind us of the vanity, or frivolous quality, of human existence.

vantage point In linear perspective, the point where the viewer is positioned.

vehicle See *solvent*.

video art An art form that employs television as its *medium*.

virtual reality An artificial three-dimensional *environment*, sometimes called *hyperspace* or *cyberspace*, generated through the use of computers, that the viewer experiences as real space.

visual literacy The ability to recognize, understand, and communicate the meaning of visual images.

visual texture A *texture* on the surface of a work that appears to be actual but is an illusion.

visual weight As opposed to *actual weight*, the apparent "heaviness" or "lightness" of a shape or form.

voussoir A wedge-shaped block used in the construction of an *arch*.

warp In *weaving*, the vertical threads, held taut on a loom or frame.

wash Large flat areas of ink or *watercolor* diluted with water and applied by brush.

watercolor A painting *medium* consisting of *pigments* suspended in a solution of water and gum arabic.

weaving A technique for constructing fabrics by means of interlacing horizontal and vertical threads.

weft In *weaving*, the loosely woven horizontal threads, also called the *woof*.

weight An important element in creating balance in a *composition*. As opposed to *actual weight*, which is the physical weight of material in pounds, *visual weight* is the apparent "heaviness" or "lightness" of a shape or form.

wet-plate collodion process A photographic process, developed around 1850, that allowed for short exposure times and quick development of the print.

wood engraving Actually a *relief* printmaking technique, in which fine lines are carved into the block resulting in a *print* consisting of white lines on a black ground. The resultant print is also called a *wood engraving*.

woodcut A *relief* printmaking process, in which a wooden block is carved so that those parts not intended to print are cut away, leaving the design raised. The resultant *print* is also called a *woodcut*.

wood-frame construction A true skeleton-and-skin building method, commonly used in domestic architecture to the present.

woof See *weft*.

ziggurat A pyramidal structure, built in ancient Mesopotamia, consisting of three stages or levels, each stage stepped back from the one below.

PRONUNCIATION GUIDE

an—*man, tan*
ay—*day, play*
aw—*draw, saw*
ah—*that, cat*
eh—*pet, get*
er—*her, fur*
ih—*fit, spit*
oh—*toe, go*
ohn—*phone, tone*
ow—*cow, now*
uh—*bud, fuss*
eye—*sky, try*

No pronunciation guide is perfect, and this one is like all others. It is meant solely to assist North American readers in pronouncing, with some assurance that they will not be embarrassed, unfamiliar names and phrases. Foreign names and phrases, particularly, are not rendered here with perfect linguistic accuracy. Many of the subtleties of French pronunciation are ignored (in part because many North Americans cannot hear them), as are the gutteral consonants of German and its related languages. The Guide suggests, for instance, that Vincent van Gogh be pronounced "van GOH"—a perfectly acceptable North American pronunciation that wholly ignores the throaty glottal click of the the Dutch "g." Often, there is, even among scholars, disagreement about how a name is pronounced. We have tried to offer alternatives in such instances.

A simplified phonetic system has been employed. Some of the less obvious conventions are listed at the left.

Abakanowicz, Magdalena mahg-daw-LAY-nuh aw-baw-kaw-NOH-vich

Akhenaton aw-keh-NAH-ten

Anthemius of Tralles ahn-THAY-mee-us of TRAW-layss

Aphrodite ahph-roh-DYE-tee

architrave ARK-ih-trayv

Baca, Judith F. BAW-CAW

Balla, Giacomo JAH-coh-moh BAW-law

Barela, Patrocinio pah-troh-CHEE-nee-oh baw-RELL-uh

Bartolommeo, Fra fraw bar-toh-loh-MAY-oh

Baselitz, Georg GAY-ohrg BAZ-eh-litz

Basquiat, Jean-Michel jawn mee-SHELL boss-kee-AW

Bel Geddes, Norman bel geh-DEES

Bellini, Giovanni jyoh-VAHN-ee bell-EE-nee

Benin beh-NEEN

Bernini, Gianlorenzo jawn-loh-REN-soh behr-NEE-nee

Beuys, Joseph YO-sef BOYS

Bonheur, Rosa buhn-ER

Bonnard, Pierre pee-AIR boh-NAWR

Borromini, Francesco frahn-CHAY-skoh bore-oh-MEE-nee

Botticelli, Sandro SAN-droh boh-tee-CHEL-lee

Boucher, François frahn-SWAH boo-SHAY

Braque, Georges jorjh BRAHK

Breuer, Marcel mar-SELL BROO-er

Bronzino brawn-ZEEN-oh

Brueghel, Pieter PAYT-ur BROY-gul

burin BYOOR-in

Caillebotte, Gustave goos-TAWV kye-BAWT

camera obscura KAM-er-aw ob-SKOOR-uh

Caravaggio caw-raw-VAW-jyoh

Carracci, Annibale on-NEE-ball-ay car-RAW-chee

Cartier-Bresson, Henri on-REE car-TEE-ay Bress-OH(n)

Cassatt, Mary kaw-SAWT

Cellini, Benvento bin-vin-OOT-oh chel-EEN-nee

Cézanne, Paul say-ZAN

Chardin, Jean Baptiste Siméon jawn ba-TEEST see-may-ohn shar-DAN

Chartres SHAR-tr'

Chauvet shoh-VAY

Cheng Sixiao jong see-SHO

chiaroscuro kee-ar-oh-skoor-oh

Chihuly, Dale Chih-HOO-lee

Chirico, Giorgio de JOR-gee-oh day Kee-ree-coh

Christo KRIS-toh

Cimabue chee-maw-BOO-ay

cire perdue seer payr-DOO

Clodion, Claude-Michel klodh-mee-SHELL kloh-dee-OH(n)

contrapposto kohn-traw-POH-stoh

Corbusier, Le luh kor-boo-SEE-ay

Cortona, Pietro da pee-AY-troh daw kor-TOHN-naw

Courbet, Gustave goos-TAWV koor-BAY

Daguerre, Louis Jacques Mandé loo-ee JAWK man-DAY daw-GAYR

Dali, Salvador sal-vaw-DOHR DAW-lee or daw-LEE

Daumier, Honoré ohn-ohr-AY dohm-YAY

David, Jacques Louis jawk loo-EE daw-VEED

Degas, Edgar ed-GAWR deh-GAW

Déjeuner sur l'herbe, Le luh day-joon-AY ser LAIRB

de Kooning, Willem VILL-um duh KOON-ing

Delacroix, Eugène you-JEHN duh-law-KRWAW

Delaunay, Sonia de-law-NAY

Demoiselles d'Avignon, Les lay duh-mwoi-ZELL dah-veen-YON

Derain, André awn-DRAY deh-RAN

Diebenkorn, Richard DEE-ben-korn

Donatello dohn-aw-TAY-loh

Dubuffet, Jean jawn doo-boo-FAY

Duchamp, Marcel mar-SELL doo-SHAW(n)

Dürer, Albrecht AWL-breckt DYUR-er

Eggleston, William EHG-ul-stun

El Greco ell GRAY-koh

El Lissitzky ell lih-ZITZ-kee

entasis EN-taw-sis

Fauve fohv

Fragonard, Jean-Honoré jawn oh-noh-RAY fraw-goh-NAWR

Frankenthaler, Helen FRANK-en-thawl-er

Friedrich, Caspar David FREED-rik

frieze freez

Gaudí, Antoni ahn-TOH-nee gow-DEE

Gauguin, Paul goh-GAN

Gehry, Frank GAIR-ee

Gentileschi, Artemisia ar-tay-MEES-jyuh jen-till-ESS-kee

Géricault, Théodore tay-oh-DOHR jeh-ree-COH

gesso JESS-oh

Giorgione gee-or-gee-OH-nay

Giotto gee-YAW-toh

Giovanni da Bologna joh-VAWN-ee daw bo-LOHN-yaw

Gislebertus geez-lay-BARE-tuss

Goethe, Wolfgang von GUH-tuh

Gohlke, Frank GOHL-kee

Gómez-Peña, Guillermo Ghee-AIR-moh GOH-mes PAIN-yuh

gouache gwawsh

Goya, Francisco de frawn-SEES-coh day GOY-yaw

Grünewald, Matthias maw-TEE-ess GROON-eh-vawlt

Guernica GARE-nee-caw

Guimard, Hector heck-TOR GWEE-mar

Guo Xi gow zee

Hasegawa, Itsuko eet-SOO-koh haw-say-GAW-waw

haut-relief OH ree-leef
Hesse, Eva hess
Hiroshige, Ando AWN-doh heer-oh-SHEE-gay
Höch, Hannah HOHK
Hokusai, Katsushika kat-s'-SHEE-kaw HOH-k'-sye
Hung Liu hung loo
impasto im-PAW-stoh
Ingres, Jean Auguste Dominique jawn oh-GOOST dohm-een-EEK AING-r'
intaglio in-TAWL-yoh
ka kaw
Kahlo, Frieda FREE-duh KAW-loh
Kandinsky, Wassily vaw-SEE-lee kan-DIN-skee
Kaprow, Allan KAP-roh
Kirchner, Ernst Airnst KEERCH-nair
Klimt, Gustav goos-TAHV KLEEMT
Knossos KNAW-sohs
Koetsu, Hon'ami HOHN-aw-mee ko-ET-zoo
Kollwitz, Käthe KAYT-eh KOHL-vitz
Kwei, Kane KAYN KWAY
Laocoön lay-AW-coh-un
Lascaux las-COH
Ledoux, Claude-Nicolas klawd-NEE-coh-law Leh-DOO
Léger, Fernand fair-NAN LAY-zhay
Leonardo da Vinci lay-oh-NAHR-doh daw VEEN-chee
(in the U.S., often lee-oh-NAHR-doh)
Liang Kai lee-ong kye
Limbourg lam-BOOR(g)
Loewy, Raymond LOH-ee
Lorrain, Claude Klodh lor-REHN
Maciunas, George mass-ee-YOU-nehs
Magritte, René reh-NAY ma-GREET
Malevich, Kasimir kaw-zee-MEER MAW-lay-veech
Manet, Edouard ayd-WAHR ma-NAY
Mantegna, Andrea awn-DRAY-uh mawn-TAYN-yaw
Mapplethorpe, Robert MAYP-'l-thorp
Marey, Etienne-Jules ay-TEE-an jool ma-RAY
Marisol Maw-ree-SOHL
Masaccio maw-SAW-chee-oh
Matisse, Henri on-REE ma-TEESE
Maya MYE-yaw
Mesa Verde MAY-suh VAYR-day
mezzotint MET-soh-tint
Michelangelo mye-kel-AN-jel-oh; also mee-kel-AN-jel-oh
Mies van der Rohe, Ludvig LOOD-vig meese van dur ROH(uh)
mihrab MEE-rawb
Miró Joan HWAHN meer-OH
Mondrian, Piet PAYT MOHN-dree-awn
Monet, Claude klodh moh-NAY
Morisot, Berthe BAYR-t' mohr-ee-SOH
mudra muh-DRAW
Muybridge, Eadweard ED-ward MY-bridj
Mycenae my-SEEN-ay or my-SEEN-ee
Nauman, Bruce NOW-man
Neri, Manuel man-WHALE NAY-ree
Nolde, Emile ay-MEEL KNOWL-d'
Olmec OHL-mek
Paik, Nam June NAWM joon PIKE
Pei, I. M. PAY
Pfaff, Judy paff
Philippe de Champaigne fee-LEEP duh sham-PAYN
Piero della Francesca pee-AYR-oh DAY-law frawn-CHEE-skaw
Piéta pee-ay-TAW
plein air PLEHN-air
Pollaiuolo poh-LYE-you-oh-loh

Pollock, Jackson PAWL-uck
Polykleitos pawl-ee-KLY-tohs
Pont du Gard pohn doo GAHR
Poussin, Nicolas nee-coh-LAW poo-SAN
Pozzo, Fra Andrea fraw an-DRAY-uh POHTS-zoh
Quarton, Enguerrand in-gher-AWN kwar-TON
quiblah KEEB-law
Raphael RAF-fye-ell, or RAFF-yell
Rauschenberg, Robert ROW-shen-burg
Rembrandt van Rijn rem-BRANT fahn RINE
Renoir, Pierre-August pee-ayr oh-GOOST rehn-WAHR
Rietveld, Gerrit GARE-it REET-felld
Rococo roh-coh-COH
Rodchenko, Alexander rohd-CHINK-oh
Rodin, Auguste oh-GOOST roh-DAN
Rogier van der Weyden roh-JEER van dur VYE-den
Rubens, Peter Paul ROO-bins
Ruisdael, Jacob van YAW-kohb fahn ROYS-dawl
Saarinen, Eero EER-roh SAWR-uh-nen
Saenredam, Peter SANE-reh-dawm
Safdie, Moshe MOSH-uh SAWF-dee
St. Denis san deh-NEE
St. Sernin san sayr-NAN
St. Vitale san vee-TAHL-ay
Samaras, Lucas sah-MARE-us
santos SAWN-tohs
Seurat, Georges jorjh suh-RAW
Siqueiros, David Alfaro see-KAYR-ohs
Sirani, Elisabetta ay-leez-eh-BAY-tuh seer-AW-nee
Sottsass, Ettore ay-TOR-ay SAWT-sahs
Steir, Pat steer
Stieglitz, Alfred STEEG-litz
stupa STOO-paw
Teotihuacán tay-OH-tee-hwaw-CAWN
tesserae TESS-er-ee
Tiepolo, Giovanni Battista gee-oh-VAWN-ee baw-TEES-taw tee-EH-poh-loh
Tinguely, Jean jawn TANG-lee
Tintoretto teen-toh-RAY-toh
Titian TEE-shan, or TISH-an
Tlingit KLING-it
Toorop, Jan YAWN tour-AWP
Toulouse-Lautrec, Henri de awn-REE deh too-LOOS loh-TREK
trompe l'oeil trump LOY
Tutankhamum toot-an-KAW-mun
Uelsmann, Jerry OOLS-mawn
Ukeles, Mierle merl YOU-kell-ees
Ukiyo-e OO-kee-oh-ee
Utamaro, Kitagawa kee-taw-GAW-waw oo-taw-MAR-oh
Vallayer-Coster, Anna AWN-naw val-law-YAH cohs-TAY
Van Doesburg, Théo TAY-oh van DOHS-burg
Van Eyck, Jan YAWN van IKE
Van Gogh, Vincent van GOH
vanitas VAWN-ee-taws
Van Ruisdael, Jacob YAW-cub van ROYS-dawl
Vasari, Giorgio gee-OR-gee-oh va-SAHR-ee
Velázquez, Diego dee-YAY-goh vay-LAWSS-kess
Vermeer, Jan YAWN Vare-MEER
Vigée-Lebrun, Elisabeth ay-leez-eh-BETT vee-SJAY leh-BROH(n)
Viola, Bill vee-OH-luh
Voulkos, Peter VOOL-kohs
voussoir voo-SWAWR
Willendorf VILL-en-dohrf
Wodiczko, Krzysztof KRIST-off woh-DEESH-koh
Wu Chen woo JEHN

INDEX

All references are to page numbers. **Boldface** numbers indicate an illustration.